ARTIST
AND
AUDIENCE

SECOND EDITION

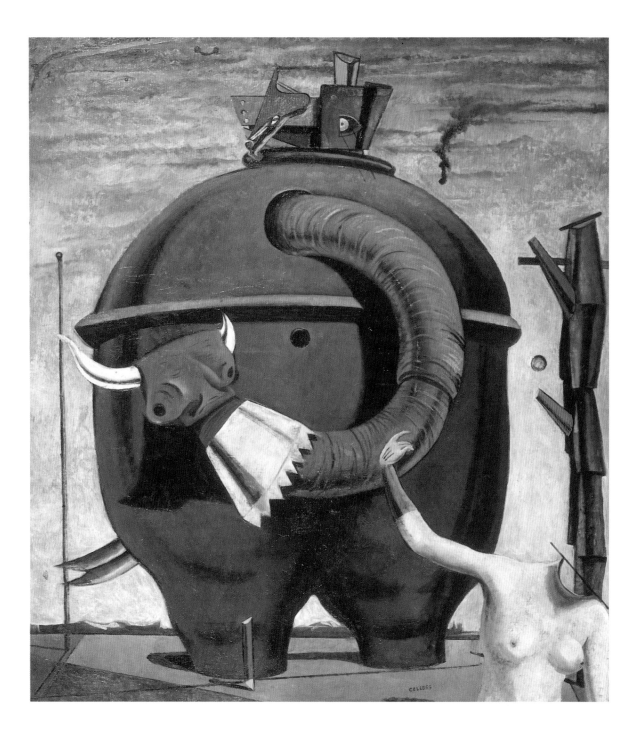

ARTIST
AND
AUDIENCE

SECOND EDITION

Terence Grieder
University of Texas at Austin

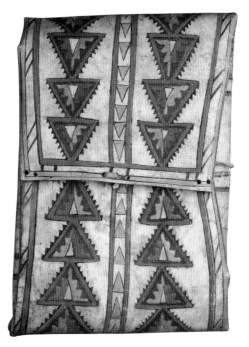

Boston Burr Ridge, IL Dubuque, IA Madison, WI New York San Francisco St. Louis
Bangkok Bogotá Caracas Kuala Lumpur Lisbon London Madrid Mexico City
Milan Montreal New Delhi Santiago Seoul Singapore Sydney Taipei Toronto

McGraw-Hill Higher Education

A Division of The McGraw-Hill Companies

ARTIST AND AUDIENCE

3 4 5 6 7 8 9 0 LK/LK 0 9 8 7 6 5 4 3

ISBN 0-697-28692-4

Library of Congress Catalog Card Number 95-080874

This book was designed and produced by
Laurence King Publishing Ltd
71 Great Russell Street, London WC1B 3BP

Printed in Singapore

Cover: The cover (detail) and title page of this book reproduce the design of a parfleche (*PAHR-flesh*), a large folded case made of untanned rawhide. This parfleche was created by an unknown woman of the Blood Tribe of the Blackfeet Confederacy in southern Alberta around the year 1885. It measures 21 by 14 inches and resides in the collection of the University Museum, University of Pennsylvania, Philadelphia. (The photograph was taken by Mark Tade and supplied courtesy of the Des Moines Art Center, Des Moines, Iowa.)

 Parfleches were made and painted by women of the northern Woodland and Plains tribes of North America using a freshly skinned hide that required much preparation. The design was composed, using straight willow sticks as rulers, and pressed into the wet hide as it was stretched and staked to the ground. In the early years, artists painted in natural colors derived from organic materials. For instance, by heating minerals rich in iron oxides, red could be produced. This color, to many tribes, symbolized the sacred life force. After the design was completed and the hide sufficiently dried, the parfleche was cut out and folded into a functional shape such as a cylinder or envelope to be used by a tribe member. Although numerous examples of parfleches survive, the name of no individual artist has been passed down. The visual power of their work remains to speak for them.

Frontispiece: Max Ernst, *Elephant of the Celebes*, 1921 Oil on canvas, 4 ft 1¼ in × 3 ft 6⅛ in (1.2 × 1m). Tate Gallery, London (Roland Penrose Collection)

www.mhhe.com

Preface

Artist and Audience is a fresh introduction to the art world and all its aspects: the people who are active in that world, the many kinds of works that are created, the sensations and ideas we receive from those works, and the ways of life art has transmitted across many times and places. The various roles that make up the art world and how we play those roles are emphasized. As artist or audience, as teacher or student, as critic or historian, as patron or dealer, we find many opportunities to be active members of the art world. The role of the audience is often ignored, but we all play that role. For as we experience the art world, we find abundant opportunities and also responsibilities to receive and interpret the arts.

As an important part of our global communication network, the visual arts, while new in many of their techniques and ideas, are also very ancient in the basic psychological needs for expression and communication they fulfill. It is sometimes thought that art meets such different needs in different societies that no useful comparisons can be made across these societies. But if we examine the ways that ideas and images circulate around the globe with an awareness of our own Western perspective, we do discover fascinating comparisons. This book includes non-Western art on an equal basis with traditional Western works in both the analytical and historical sections. Here students will find the opportunity to explore their own perspectives and how they fit into the global community. African, Asian, and Native American artists employ the same elements and principles of art as modern American or European artists. For that reason, art offers ways to transcend the barriers between people of different times and places.

Each section of this second edition focuses on an aesthetic, technical, or historical question and analyzes a variety of related works. Contemporary critics see equal potential for expression in all the art media, including those with functional applications such as buildings and furniture. Our concern will be with the messages that emerge into a society's intellectual life as artists create art and audiences interpret it.

The Revision

This new edition has been extensively revised with nearly a hundred new images, a new design, more color, and improved reproductions throughout. Many images that had not been in color in the first edition are now seen in full color in the second. New sections have been added on religious images, abstraction, calligraphy, photography, video, computer art, virtual reality, and avant-garde sculpture. Extensive additions have been made in the applied arts and in Gothic art. To accommodate new material on the contemporary American art scene, a subject of great interest to many students, the last two chapters have been expanded and entirely recast. Throughout the book, new marginal cross-references direct students to related material found in another part of the book. These changes and additions are designed to make the book more relevant to contemporary interests and to the current global scene in art.

Plan of the Book

The book is divided into five parts. In Part I we discover the main roles people play in the art world, how those roles interact, the galleries and museums where art is seen, and the common subject categories and their traditional meanings. In Part II the reader begins to build interpretive skills by analyzing the elements of art and the principles of design. In Part III the various media, from drawing and computer art to bronze casting and oil painting, are described. Part IV surveys the vast field of applied design in architecture, city planning, interiors, clothing, ceramics, metalwork, and industrial design. Historical examples enrich many of these discussions. For instance, a fantastic suit of armor puts modern metalwork into a longer perspective.

Part V is a selective history of world art that concentrates on styles that have the most contemporary relevance, including ancient American, Asian, African, Classical and Hellenistic Greek, Roman, Medieval, Renaissance, and Baroque. An introductory book cannot include the whole history of art, but carefully chosen examples can guide an exploration of art's function as the communicator of the ideas and concerns of people of a particular place and time. In the last two chapters European and American art of the last two centuries is discussed. Art has played a very important role in the development of Western culture during this period and the emphasis is on the expression of the history of ideas. The last chapter, with twenty-six new pictures, is entirely devoted to American art and its global component since 1940.

Pedagogy

In this edition each chapter opens with a *preview* of the content. The *preview* will also help students as they review the text. Popular with first-edition users, the simplified *pronunciation guides* for names and terms as they first appear in the text have been retained. In addition, short definitions of terms, highlighted in bold type in the text, appear in the glossary. *Timelines and maps of cultural regions* help readers locate art in its place and time. *Questions for self-directed study* are found at the end of each chapter, and for those wanting to research information, *footnotes and suggested readings* are also listed at the end of each chapter. Set apart from the main text are *boxed features*, each with their own illustrations, that focus on issues and questions. Under the new heading **Current Issues** can be found discussions of political and social issues, such as *Who is Admitted to the Art World?*, *Is it Art?*, and *Who Owns History?* Under the heading **A Point in Time** are significant periods in a particular artist's career, such as *Eric Fischl's Cargo Cults* and *Georgia O'Keeffe and New Mexico*. Features entitled **In Detail** concentrate on techniques of artists, *Leonardo: Artist-Scientist*, or of critics, *New Tools for Critics*.

Teaching Aids

A comprehensive package of teaching and learning aids is available. For the teacher, an **Instructor's Manual and Test Item File** provide a course outline based on a series of suggested reading assignments. Basic ideas, a vocabulary list, suggested objectives, and a set of text and discussion questions are provided for easy assignment. For the student, a **Student Study Guide** provides overviews, learning objectives, self-test questions, and more in a workbook format to help students understand and absorb the information in the text. The **Instructor's Manual** and **Student Study Guide** are closely coordinated with each other and the second edition. A set of color slides is also available to qualified adopters for use in classroom lectures and discussions.

Acknowledgments

The author would like to thank the many individuals who have contributed to the making of this book. First, of course, the many artists whose work has enriched his life and provided so much stimulation, and then the many students who have shared the pleasure of art over more than thirty-five years of teaching.

This book has benefited from the careful reading and thoughtful criticism of a group of expert reviewers, all professionals in the art world. The author thanks Patrick John Daugherty, Pennsylvania State University; Dedree A. Drees, Catonsville Community College; David E. Pactor, Broward Community College; Patricia B. Sanders, San José State University; Leo F. Twiggs, South Carolina State University; and Salli Zimmerman, Nassau Community College.

The author acknowledges the indispensable editorial help of Rosemary Bradley, M.J. Kelly and Damian Thompson, the work of Julia Hanson in gathering the illustrations, and the design skills of Ian Hunt.

Austin, Texas
February 1996

Picture Credits

The author, publisher, and Calmann & King thank the custodians of the works of art for supplying photographs and granting permission to reproduce them. Photographs have been obtained from sources noted in the captions, unless listed below. Every effort has been made to contact all copyright holders. Calmann & King would be pleased to hear from any such source that could not be traced.

Abbreviations

A/AR: Alinari/Art Resource, N.Y. **AFK:** A.F. Kersting, London. **BAL:** Bridgeman Art Library, London. **CNMHS:** Caisse Nationale des Monuments Historiques et des Sites, Paris. **HH:** Hans Hinz, Switzerland. **HV:** Hirmer Verlag, Munich. **MAS:** MAS, Barcelona, Spain. **N:** Nippon TV, Japan. **RMN:** Agence Photographique de la Réunion des Musées Nationaux, Paris. **S:** Scala, Italy. **WF:** Werner Forman Archive, London. All photographs of items from the collections of The Museum of Modern Art, New York, are © 1995 Museum of Modern Art, NY.

I.1 Courtesy of the artist.

CHAPTER 1. 3 © 1991 Hans Namuth Estate, Courtesy of the Center for Creative Photography, University of Arizona, Tucson. 8 Charles Pereira/US Parks Police, Washington D.C. 9, 10, 12, 13 Dolores Neuman, Washington D.C. 11 Dept. of Defense (Marine Corps), Washington D.C. 15 Photo Lucienne Block, Gualala, CA. 17 Property of ILGWU Unity House, Forest Park, Pennsylvania. 18 Subdirreccion de Documentacion e Informacion; CENIDIAP, Mexico City.

CHAPTER 2. 5, 10, 17, 20 RMN. 11 © ADAGP, Paris and DACS, London 1996. 14 Photo Richard Todd, Los Angeles. 18 A/AR. 19, 30 S. 21 © DACS 1996. 28 Photo Ann & Bury Peerless, Minnis Bay, UK. 29 WF. 33 © DACS 1996 Photo Jorg P. Anders, Berlin, 1994/BPK. 34 Photo Prof. Christina Lodder, Edinburgh. 35 © ADAGP, Paris and DACS, London 1996. 36, 37 Courtesy Reed Publishing, UK.

CHAPTER 3. 3 Dmitri Kessel, LIFE Magazine, © 1984, Time Inc. 5 © Succession H. Matisse/DACS 1996. 6 Photo Elke Walford, 9 Photo K. Oehrlein. 8 © DACS 1996 Photo RMN. 11 © DACS 1996 Photo CNMHS. 12 © Carl André/DACS, London/VAGA, New York 1996. 13 From Rudolf Arnheim, *Art and Visual Perception: A Psychology of the Creative Eye*, University of California Press. 15 Photo Lee Stalsworth, London. 16, 17 English Heritage, London. 19 From John Rewald, *The Woodcuts of Aristide Maillol*, Pantheon Books, p.168. 24 © DACS 1996. 26, 42 S. 30, 38 A/AR. 31 & 49 © Succession H. Matisse/DACS, London 1996. 35 © ADAGP, Paris and DACS, London 1996. 36 © DACS 1996. Courtesy Pierre Matisse Gallery, NYC. 43 Museum purchase with funds provided by Target Stores. 49 Cone Collection formed by Dr. Claribel Cone and Miss Etta Cone of Baltimore, Maryland. 51 © ADAGP/SPADEM, Paris and DACS 1996. 52 Courtesy John Weber Gallery, NYC.

CHAPTER 4. 1 Photo Michael Lindner. 3 © Succession Henri Matisse/DACS 1996. 7 © ARS, NY and DACS, London, 1996. Courtesy Marlborough Gallery, NYC. 8 © 1992 Arnold Newman. 10 Photo by Frederick Gutekunst, 8 x 10". Courtesy of the Museum of American Art of the Pennsylvania Academy of the Fine Arts, Philadelphia. Archives. 11 Photo © 1989 Cervin Robinson, NYC. 12 Photo Wayne O. Attoe, Cambria, CA. 13 MAS. 16 © ADAGP, Paris and DACS, London 1996. 21 © Margaret Bourke-White Estate. Courtesy of LIFE Magazine. 33, 34, 35 Courtesy Paula Cooper Gallery, NYC. 36, 39 S. 38 © DACS 1996.

III.1 © 1992 by Patricia Search. All Rights Reserved.

CHAPTER 5. 2 The Royal Collection © Her Majesty Queen Elizabeth II. 3, 4, 5, 6 © DACS, 1996. 11 © DEMART PRO ARTE BV/DACS 1996. 22 Christie's, London/BAL. 23 © ARS, NY and DACS, London 1996. 26 Photo Reale Fotografica Giacomelli, Venice. 31 AP/Wideworld. 32 Courtesy Josephus Daniels Gallery, Carmel, CA. 36 The Image Bank, London. 39 Berenice Abbott/Commerce Graphics Ltd, Inc, NYC. 40 Film Stills Archive, MOMA, NYC. 42 Ronald Grant Archive, London. 47 Still from TERMINATOR II: JUDGMENT DAY appears courtesy of Carolco Pictures Inc. Motion Picture © 1991 CAROLCO PICTURES INC. All rights reserved. TERMINATOR II is a trademark of Carolco.

CHAPTER 6. 1 From Harald Pager, *Ndedema*, 1971, p.131, Fig. 163. Akademische Druck und Verlagsanstalt, Graz, Austria. Photo British Library, London. 4, 6 N. 5, 7 A/AR. 8 Photo Tony Morrison/South American Pictures, Woodbridge, UK. 17 Collection of Brandywine River Museum. Purchased for the Museum by John T. Dorrance, Jr., Mr & Mrs Felix duPont, Mr & Mrs James P. Mills, Mr & Mrs Bayard Sharp, two anonymous donors, and the Pew Memorial Trust © 1996 Brandywine Conservancy. 19 Reproduced by permission of The Board of Trinity College, Dublin. 28 © ARS, NY and DACS, London 1996. 29 © 1991 Hans Namuth Estate, Courtesy Center for Creative Photography, The University of Arizona. 32 Photo Öffentliche Kunstsammlungen, Basel, Martin Buhler. 33 DACS. 34 © 1991 Hans Namuth Estate. 35/6 Courtesy of the Artist.

CHAPTER 7. 1 Photo Laurent Condominas. 3 Photo Donald M. Stadtner. 4 A/AR. 5 LS. 6 Gift of Jules E. Mastbaum. 7 © Estate of de Creeft/DACS, London 1996. 8 © ADAGP, Paris and DACS, London 1996. Photograph by David Heald © The Solomon R. Guggenheim Foundation, New York. 11 Photo Audrey Topping. 12 © ADAGP, Paris and DACS, London 1996. 15 S. 16 © DACS 1996. 18 The Michael C. Rockefeller Collection, Bequest of Nelson A. Rockefeller, 1979. Photo Schecter

Lee. 19 Hamburgisches Museum für Völkerkunder, Hamburg, Germany. 20 © Estate of David Smith/DACS, London/VAGA, New York 1996. 23 © Magdalena Abakanowicz/DACS, London/VAGA, New York 1996. Photo © Dirk Bakker. 24 Courtesy The Henry Moore Foundation, Much Hadham, Hertfordshire. 25 © Christo and Jeanne-Claude 1996. Photo Wolfgang Volz, Dusseldorf. 26 Photo © Gianfranco Gorgoni. 29 © ADAGP, Paris and DACS, London 1996 Photograph by David Heald © The Solomon R. Guggenheim Foundation, New York (FN 65.1737). 31 © ADAGP, Paris and DACS, London 1996. 34 MAS. 35 Photo © Harvey Stein, NYC. 36 Metropolitan Life Foundation Purchase Grant. 37 Purchase, with funds from the Painting and Sculpture Committee. Photo © Whitney Museum of American Art. 38 Courtesy of the Artist.

IV. 1 C. W. Fentress, J. H. Bradburn and Associates, P. C. Photo Nick Merrick, Hedrich Blessing.

CHAPTER 8. 1 Bulloz. 2 Photo Claus-Dieter Brauns, Bad Liebenzell-u, Germany. 8 Photo Russ Kinne/Comstock. 9, 10, 12, 25 Photo Alison Franz/American School of Classical Studies, Athens. 13 HV. 14, 17, 29 A/AR. 16 AFK. 20 French Government Tourist Office, NYC. 21, 49 Spectrum Colour Library, London. 24 Foto Marburg. 26 I. N. Phelps Stokes Collection, Miriam and Ira D. Wallach Division of Art, Prints and Photographs, The New York Public Library, Astor, Lenox and Tilden Foundations. 27 Library of Congress. 28 BAL. 30, 33 S. 32 Photo © Joan Lebold Cohen, NYC. 35 Eddie Hiromaka/The Image Bank. 36 The Royal Collection © Her Majesty Queen Elizabeth II. 37 Courtesy Murphy/Jahn. 40 Photo Richard Barnes. 41 Photo Chicago Historical Society. 42 Esto Photographics. 44, 45 Photograph by David Heald © The Solomon R. Guggenheim Foundation, NY. 47, 48 Photo Lucien Hervé, Paris. 50 H. Roger-Viollet, Paris. 51 Photo G. E. Kidder-Smith, NY. 52 Photo Balthazar Korab, Troy, MS. 53 Michael Graves, Princeton, NJ. 54 © Richard Bryant/Arcaid. 55 Waltraud Krase, Frankfurt, Germany. 56, 57 Eric Ansel Koyama, Santa Monica, CA.

CHAPTER 9. 2 © DACS 1996. 6 Giraudon. 7 Formerly in the Collection of Bernard Baruch Steinitz, Paris. 8 Bauhaus-Archiv, Berlin. 11 Photo Tim Street-Porter. 13, 18 RMN. 20 H. Roger-Viollet, Paris. 23 Photo Courtesy Staley Wise Gallery, NYC. 24 © Ryusei Arita. 25 Photo Dr. R. E. Reina. 27 Courtesy of the Artist. Photo American Ceramics Magazine. 28, 29, 34 All courtesy of the artists. 32 Photograph by permission of the Patrimonio Nacional, Madrid. 33 Courtesy of the artist. Photo Ark Antiques, New Haven, CT. 36 Photo Henry Wolf, NYC. 37 Photo John A. Condé. 38 Chrysler Corporation Historic Archives, Detroit, Michigan.

CHAPTER 10. 1 AP/Popperfoto, Northampton, UK. 4 HH. 5 © ADAGP, Paris and DACS, London 1996. Acquired through an anonymous gift, the Mr & Mrs Joseph Stifka & Armand G. Erpf Funds, and by gift of the artist. 8. Photo Jim Zintgraff. 10, 13 HV. 11 University of Pennsylvania Museum, Philadelphia. 17 Photo André Held. 20 Photo © 1976 Dr. Merle Green Robertson, San Francisco. 22 © President & Fellows of Harvard College 1972. All rights reserved. 32, 40 A/AR. 33, 35, 38 S. 34 RMN.

V.1 Courtesy of the Estate of Ana Mendieta and Galerie Lelong, New York.

CHAPTER 11. 1,19 S. 2, 16 Foto Marburg. 7, 8 AFK. 9 RMN. 11 CNMHS © DACS 1996. 12, 23, 45 Spectrum. 15 HH. 20 Photo Roger Wood, Canterbury, UK. 24 MAS. 28 Reproduced by kind permission of the Trustees of the Chester Beatty Library, Dublin. 29 Photo Rear Admiral H. S. Mearsham, British Museum, London. 31, 32 Photo Prof. F. Willett, Glasgow. 33 Aubiene & Michael Kirtley/A.N.A. Press. 34 Photo Jerry L. Thompson. 35 Photo Herbert M. Cole, Santa Barbara, CA. 36 Photo Jess Allen. 44 Sekino Masaru, Tokyo University.

CHAPTER 12. 2, 6, 9, 10, 30, 32 S. 5, 31 A/AR. 7, 14, 33, 40 RMN. 8 N. 11 The Royal Collection © Her Majesty Queen Elizabeth II. 17 MAS. 18 Photo Octave Zimmermann.

CHAPTER 13. 2, 3, 8, 15, 19, 30 RMN. 9 MAS. 11 AKG, London. 13 Novosti/BAL. 24 LS. 29 © DACS 1996. 30 © DACS 1996. 31 © ADAGP, Paris and DACS, London 1996. Photo Öffentliche Kunstsammlung Basel, Martin Bühler. 32 © ADAGP/SPADEM, Paris and DACS, London 1996. 33, 36 & 37 © ADAGP, Paris and DACS, London 1996. 34 © Succession Henri Matisse/DACS 1996. 38 © DACS 1996. 39 © DEMART PRO ARTE BV/DACS 1996. 40 © SPADEM/ADAGP, Paris and DACS, London 1996.

CHAPTER 14. 1, 2 © ARS, NY and DACS, London 1996. 3, 4 © Willem de Kooning/ARS, NY and DACS, London 1996. 8, 10 © ARS, NY and DACS, London 1996. 11 © James Rosenquist/DACS, London/VAGA, New York 1996. 14 Printed by permission of & © 1951 The Norman Rockwell Family Trust. 15 © Richard Estes/DACS, London/VAGA, New York 1996. 16, 17 Courtesy of the Artist. 17 Photo Ann Chwatsky. 18, 19 © ADAGP, Paris and DACS, London 1996. 21, 22 & 41 © DACS 1996. 22 Photo Abisag Tüllmann. 30, 31 Courtesy Marlborough Fine Art, London. 32, 33 Courtesy of the artist. 34 Courtesy Niman Fine Art, Santa Fé, New Mexico. 36 Courtesy Steinbaum Gallery, 132 Greene Street, NYC 10012. 37 Courtesy of the artist. 40 Courtesy Annina Nosei Gallery, NYC. 41 Courtesy Ronald Feldman Fine Arts, NYC. Photo D. James Dee.

Contents

PART V RECOGNIZING THE GREAT STYLES

PART I

COMMUNICATING IN A WORLD OF ART

Despite the seemingly infinite diversity of people and their ways of life, we all share certain basic capacities. Perhaps the most important of these is the capacity for inventing symbols, which we use to tell each other what we think and how we feel. The barriers between people who speak different languages, who worship different gods, and who live and work under completely different circumstances are high and hard to break down. Art is the most powerful medium of communication available to us that can break through those barriers. Art begins by attracting our eyes, enticing us to see as the artist saw. The barriers of language and culture can yield to a sympathetic observer who finds pleasure and meaning in the visual arts.

In his effort to make pictures that communicate Anselm Kiefer (b. 1945) returns to old symbols that are shared by many people: a mountain and a robed figure with wings (Fig. I.1). From ancient times divine power has been imagined as inhabiting mountain tops. Divine messengers, imagined as winged humans, bring inspiration. Although hardly any artists of our day mix their paint on an oval palette with a thumb hole, such as the one carried by the winged figure, most people have seen pictures of such antique palettes. Kiefer does not explain his painting, but relies on us to figure out that it shows us the divine inspiration of the artist. Communication in this case depends on thick paint on a heavy canvas, a very material experience. The world of art is composed of people involved in the paradox of intellectual and spiritual communication in solid, material form.

This book begins with an analysis of the roles people play in the creation and interpretation of art, with emphasis on the role of the audience, the one role that everyone plays. Compared with the active role of the artist, the audience has generally been considered merely a group of passive spectators. When we reconsider the relationship

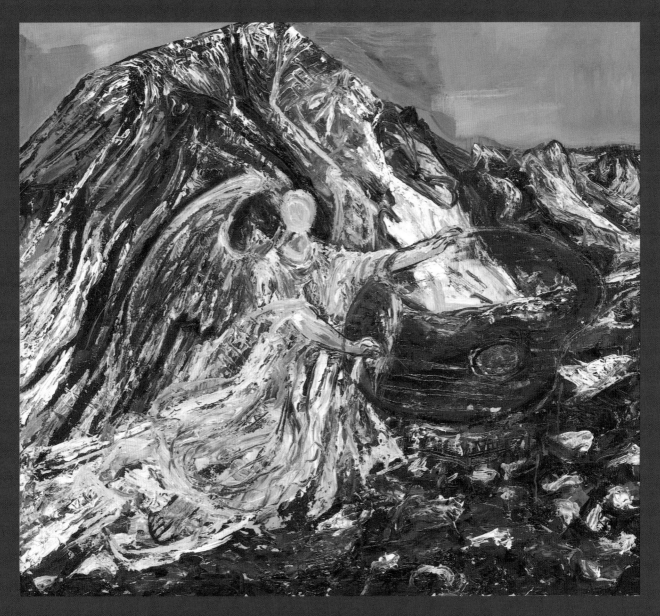

I.1
ANSELM KIEFER,
The Painter's Guardian Angel, 1975.
Oil on canvas,
4 ft 3 in x 5 ft (1.3 x 1.5 m).
Collection A. and G. Gercken,
Hamburg, Germany.

between the artist and the audience, we can see that the audience plays a more active and important role in art than has been thought. We will also trace art from its origin with the artist, through the dealers and collectors to the museums, where the public finds it. In Chapter 2 we will begin to consider what we, the audience, must know to play our role as interpreters of art, paying special attention to subject matter and originality.

Art is not the capricious invention of a few geniuses, but one of the most basic and ancient communication media of the human race. Just as people remain basically the same, yet are constantly changing, so art has common threads through time, yet is always new. The aim of this book is to find old things that still speak to us as strongly as ever and also to explore the new conditions in which art exists today.

1

Art Worlds

P R E V I E W To be a member of any social group, you must participate in its cultural life. Culture, which is learned, not inborn, consists of all the knowledge, skills, ideas and symbols known and used by the members of the group. The art world is made up of all those— artist, patron, critic, and audience—whose activities are necessary to the production of art. The roles of the first three are easy to distinguish, especially in public commissions. The important role of the audience, which is often neglected, is to decide what can be generally accepted as art, to define the cultural values (or ideas of what constitutes beauty) of a particular cultural group, and to interpret the meaning of the works of art. We can see the complex operation of the art world in such examples as Diego Rivera's design for a mural for Rockefeller Center and Maya Lin's Vietnam Veterans' Memorial. The main place where the audience participates in the art world is the art museum, an innovation of the last 200 years, which is dedicated to the cultural life of democratic societies. In the last fifty years art museums, especially those in the United States, have undergone tremendous expansion.

ALL HUMAN SOCIETIES ARE BOUND TOGETHER BY a shared way of life that sets us apart from the members of other social groups. That way of life, which anthropologists would call our culture, is composed of all the things we know, and know how to do. One of the important things we all do is to send symbolic messages back and forth among ourselves, and to other groups, about life as we see it, about truth, imagination, and all the things we want to share. These symbolic messages are our arts, which may take the form of painting or music, novels, poetry, or any of the forms we call art.

Our cultural groups—sometimes called ethnic groups ("a people who share a common and distinctive culture")— tend to have distinctive styles in the visual arts. We wear distinctive clothing, or do special kinds of sculpture or painting, or build certain kinds of buildings that are different from those of other groups. From the point of view of the arts, a cultural group is most accurately described as an audience, and in modern multicultural cities there are so many specialized audiences that we often call them subcultures.

Each of these cultural, or subcultural, groups has its own **art world*** defined as "all the people whose activities are necessary to the production of a particular kind of art."[1] Usually the members of the audience are the last people we think of as members of the art world, after artists, patrons, **critics**, museum people and art dealers, but, on reflection, it is obvious that we, the members of the audience, are indispensable. Cultural expressions of every kind disappear when the audience stops coming to them.

But the audience is not the only group that is indispensable. Artists produce the objects and events that the audience craves. Someone else may have asked the artist to make it, may have made more or less detailed requests and suggestions, and may even have refused to pay for it until certain changes were made. Another person may write an article about it, discussing its importance or advising the reader that it is not worth the cost of parking to see it. But finally, there are all of us who do, after all, go to see it, pay for parking, discuss it with our friends, and remember it later as somehow part of our way of life.

Artists, driven by their expressive powers, are constantly at work in their studios, and if you ask them they will tell you that they paint or carve only to please themselves. But that is simply to protect themselves from unkind comments from the audience and critics as they seek a sympathetic audience to receive their message. Many works of art—most, perhaps—are never seen by anyone but the artist and disappear from the historical record. The works of art that make up what we call our culture have entered the social life of the community by being the products of many individual efforts. The artist, the patron, the critic, and the audience must all play their parts, or the work will slip away into that limbo of undelivered messages.

It is for that reason you are right if you insist that everyone participates in the art world. Even people who would not be caught dead in an art museum cannot escape commercial art and design. They are part of its audience, and they are usually not timid about expressing their opinions about advertisements, clothes, or cars and all the other things that are not merely objects, but also symbolize in their design the way of life of their users. Thus they are part of the audience for commercial art.

Your friends may not recognize themselves as part of the audience for the visual arts, but they almost certainly admit to being part of the audience for certain kinds of music. Audiences at musical events are more conscious of themselves as an audience because they must all come together at one time, often pay admission, sit together, and experience and react in unison. Performers, critics, and the audience themselves all rate the quality of the audience just as they do that of the performing artists. Sometimes we hear that the audience was "sophisticated and enthusiastic," other times "ignorant and unworthy of the performers." Musical understanding can be greatly improved by study and experience. The same is obviously true of the visual arts.

We expect artists to be highly trained, but we usually forget that it takes as much education to understand a message as it does to send it. Artists and their audiences are almost always closely matched. You can find out a lot about yourself by examining critically the things for which you are a member of the audience. Honoré Daumier (pronounced *doe-MYAY*; 1808–79) painted a watercolor, *The Amateurs* (Fig. **1.1**), which shows ideal relationships in the art world. The noble old artist, wearing his beret and holding his mahlstick (to rest his hand on while painting), stands back as a patron or critic examines the work on the easel. Other friends look attentively at the work, and a mood of cordiality and pleasure prevails. Rarely do we have the opportunity to visit an artist's studio; usually we are on our own with the artist's work.

These four roles—artist, patron, critic, and audience—are the most important of the varied roles that make up the art world. There is a large category of support people—those who manufacture paint, sell canvas and sculpture tools, keep

* Terms in **bold face** are defined in the Glossary.

accounts for patrons, set type for critics' writings, guard museum displays, and carry out literally thousands of other activities without which our experience of art would be different; the contribution of these people will not be discussed here, despite its importance. But this widespread pattern of cooperation must be kept in mind when we think of art in society.

ROLES IN THE ART WORLD

We have been thinking about the art world as it exists in our own country and generally in Western cultures (which can be loosely defined as all the places where European languages are spoken). But there are many other countries with their own art worlds, where the roles are different. In Part V we will look at a variety of different art worlds, both in their history and in contemporary life. Great as the variations are, in all human societies there are people playing the roles we can call artist and audience, and we need remember only that our own cultural life is just one variety among the many.

If you were to trace the "life history" of a work of art in the United States, and in most Western countries, you might find it was born in the mind and hands of an artist, passed on to the gallery of an art dealer, purchased by a collector, inherited by his or her child, and donated to a museum, which will keep it and care for it, presumably forever. This typical pattern offers opportunities for a variety of

1.1
HONORÉ DAUMIER,
The Amateurs, 1877.
Crayon, watercolor with
pen and ink,
12¾ x 12¼ in
(32 x 31 cm).
Walters Art Gallery,
Baltimore, Maryland.

characters to play the roles of artist, dealer, collector, and museum director. In this section we will examine both people and institutions: the personality and education of the artist, the work of the critic and the art dealer, the nature and role of the audience, and finally a few of the great museums.

THE ARTIST

There is an old controversy: are artists born or made? Are artists those few individuals born with unusual gifts, or is art something that can be learned by anyone with sufficient motivation? According to the philosopher Suzanne Langer, "the average person has a little talent"; it is genius which is "the mark of the true artist." She continues:

> Talent is special ability to express what you can conceive; but genius is the power of conception. Although some degree of talent is necessary if genius is not to be stillborn, great artists have not always had extraordinary technical ability; they have often struggled for expression, but the urgency of their ideas caused them to develop every vestige of talent until it rose to their demands.[2]

1.2
ERIC FISCHL, *Cargo Cults,* 1984.
Oil on canvas, 7 ft 8 in x 11 ft
(2.3 x 3.4 m).
Mary Boone Gallery, New York.

Langer comes down on the side that says artists are born with special gifts, although she admits that "a small amount of genius is not a rare endowment," which suggests that a great many people have potential as artists. That accords with experience, for all of us know many people who are good at art, but only a few who are driven by the urgency of their ideas to develop their talent to its highest possible level. Considering the wide variety of visual art forms, from weaving to designing buildings and painting murals, probably almost everyone has some talent in at least one of those forms of art. What the audience is looking for in artists is that spark of originality that produces new conceptions, which Langer calls genius.

Jackson Pollock (1912–56), one of the most respected American artists, was described by his teacher Thomas Hart Benton as having "little talent." However, Benton continues,

> I sensed that he was some kind of artist. I had learned anyhow that great talents were not the most essential requirements for artistic success. I had seen too many gifted people drop away from the pursuit of art because they lacked the necessary inner drive to keep at it when the going became hard. Jack's apparent talent deficiencies did not thus seem important. All that was important, as I saw it, was an intense interest, and that he had.[3]

A POINT IN TIME

Eric Fischl's Cargo Cults

In 1984 Eric Fischl gathered a set of color snapshots he had taken on the beaches in France and began to compose a large oil painting, using the photographs as sketches. *Cargo Cults* (Fig. **1.2**) has the natural appearance of its photographic sources, but the mixture of figures, which were unrelated in the snapshots, suggests that a story full of sex and violence is about to be played out before our eyes. Cargo cults are Melanesian religions, based on the belief that ancestral spirits will return, bringing material riches, and the title seems to relate to the robed figure wearing a mirror pendant and brandishing a large knife. The mixture of clothed and nude figures also provokes the viewer to try to explain it. The audience's reaction to Fischl's work has been one of fascination with the stories behind the painting.

Fischl's first solo show was held in New York when he was thirty-two, and it consisted of a group of large oil paintings of people in normal middle-class American settings in which tragedy or sex has intervened. The nuclear family of dad, mom, brother, sister, and the family dog were the basic cast of Fischl's dramas. In *Cargo Cults* it is the gang of buddies on the beach who are caught between temptation and danger. This painting was one of a new series of subjects set on beaches, often dramatizing the clash of cultures, the contrasts of wealth and poverty, or the moral standards of traditional societies and of jet-setting wanderers. "I work within the realist tradition of meaning," he told an interviewer. "I work in the tradition of the moralism of Daumier." More recent paintings were based on travels in India, and the psychological relations of his cast of characters in these works were not so clear. The critics felt the artist was out of his depth as he represented a culture different from his own, and they praised his work when he returned to depictions of the physical and, especially, psychological life of his own culture, where his sense of "moralism" has more bite.

For the realist artist, especially, a sure sense of a place and its culture is important. Pictures about moral relationships are likely to result in confusion when the artist and the audience are of different cultural backgrounds. In addition, the depiction of other cultures risks quaintness or the giving of political offense. You can see how hard it is to express yourself freely in a multicultural world. Yet the most exciting thing in the world is contact with other people and other cultures. This is the territory, with all its dangers and confusions, that Eric Fischl has entered in this painting.

Quotations from Nancy Grimes, "Naked Truths," *ArtNews,* September 1986, p. 77

Pollock (Fig. **1.3**) was the youngest of five brothers, all of whom showed serious interest in art, inspired by their mother. The Pollock family is evidence that the early influence of a parent or role model has a powerful effect in directing a child's expressive powers toward art. At seventeen, having been expelled from his California high school, Pollock wrote a letter to one of his brothers: "As to what I would like to be. It is difficult to say. An artist of some kind. If nothing else I shall always study the Arts."[4] About a year later he arrived in New York and enrolled in the Art Students League, where a brother had studied and where Benton was currently teaching.

Those with talent, genius, and inner drive seek ways to develop their abilities by studying. In earlier times artists learned the craft of art by apprenticeship, usually between about the ages of ten and sixteen, helping the master with the preparation of paints and canvases or the other materials of the master's art and finally learning to carry out complete works on their own. Apprenticeship trained the hands more than the mind, and it is not surprising that patrons had little confidence in the ability of artists to imagine great subjects.

Only in Renaissance Italy, where the first art academies were founded, were artists accepted among the educated and considered capable of expressing themselves,

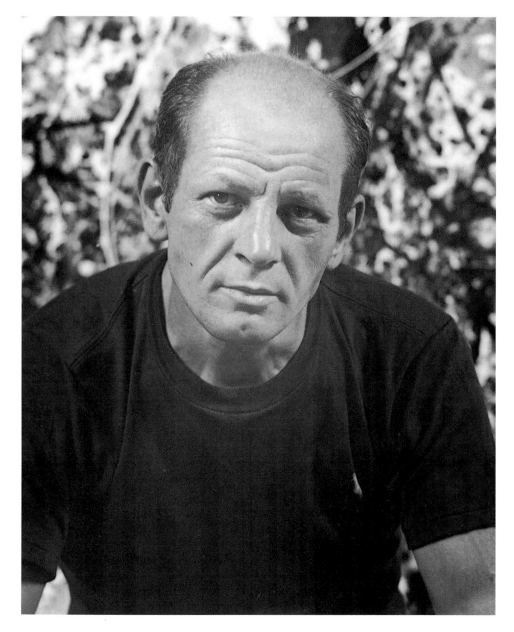

1.3
Jackson Pollock,
c. 1950.
Photograph by Hans
Namuth.

instead of merely acting as craftsmen carrying out the ideas of better educated patrons, who were usually members of the nobility or clergy. By the 1600s academies were teaching art as a science capable of being mastered by intellectual effort. Along with years of practice in drawing, there were required studies of mathematics, geometry, perspective, architectural design, and anatomy. An academic artist specialized in conception—the part requiring genius, as Langer says—and left the execution to artisans whenever it was dirty or laborious. The artisan, who had been apprenticed in a shop, may have been talented, but the definition of art as an intellectual discipline raised the social rank of artists in a society that considered manual work demeaning.

There was more controversy about art in the academies than modern critics have sometimes imagined. The Spanish painter Francisco Goya (1746–1828), whom we usually think of as a modern spirit, was director of the Royal Academy in Madrid, although he had some very unacademic ideas about how artists should be educated. Goya described his ideas in a letter:

> Academies should not be restrictive. ... There are no rules for Painting. ... To make everyone study the same way and follow the same path compulsorily, seriously impedes the development of those young people who practice this difficult art. ... I know of no better way to advance the arts ... than by ... allowing students of art to develop their own abilities in their own way, without forcing them to go in one particular direction, and without making them adopt a particular style of painting if it is against their inclination.[5]

Goya had advanced ideas for his time, but by 1875, when the Art Students League (where Jackson Pollock studied and Thomas Hart Benton taught) was founded in New York, those had become the dominant ideas. At the Art Students League there are no entrance requirements and students take the classes as they please; the instructors are professional artists who come in to give criticism and discussion twice a week. Benton wrote of his teaching:

> Looking back, I can see that I was not a very practical teacher, especially for novices. ... After indicating in a general way the directions I thought it profitable to pursue, I expected the members of my class to make all their own discoveries. I never gave direct criticisms unless they were asked for and even then only when the asker specified what was occasioning difficulty.[6]

This is the opposite of apprenticeship, for the student has to learn the craft pretty much alone, from books or from other students. Benton, who was a typical instructor, concentrated on criticizing composition and style, the expressive and intellectual side of art. This fulfills Goya's demand that students be allowed to "develop their own abilities in their own way."

Since the 1930s American colleges and universities have begun to offer education in both the practice of art and its history and criticism, and many of the independent art schools have become attached to local colleges. Currently most of the artists working in the United States have studied art in a college or university. The usual diploma showing completion of studies as an artist is the Master of Fine Arts (M.F.A.). Typically, students are selected by submission of a portfolio of previous work, and about sixty semester hours of studies (in theory about two years, but usually lasting longer) are required, with some form of examination and an exhibition of completed work at the end. Artists in our time are much better educated than ever before, especially in general studies designed to improve their power of conception. That kind of education fits with the contemporary audience's preference for expressions of genius, which shows in the ideas and design, over talent, which shows in skillful use of materials. An advanced art student studying at one of the modern art schools will learn some of the craft skills once taught by apprenticeship along with the intellectual disciplines found in the academies. In the end, it is not the artist's education that counts most, but the inner drive to express ideas creatively.

Beginning to study art, James Rosenquist was surprised to find that famous artists in New York in the 1950s "weren't successful like businessmen." (See p. 476.)

THE ART DEALER

In the second stage of its life history, a work of art is offered to the gallery of an art dealer. This is usually where the artist, the patron, the critic, and the audience first meet and interact. Galleries are the places where the deepest values of our culture, such as beauty and truth, are translated into market value, which is determined by how much money someone is willing to pay. It is a surprisingly large business. The greatest centers for art sales at the present time are New York and London. A commercial gallery has a permanent location to display the art it has for sale.

The owner, usually called a "dealer," shows the work of a group of artists who are often called the dealer's "stable," as if they were racehorses. The race, of course, is for acceptance by an audience. An art dealer has a similar function to an impresario or a manager for musicians or other performing artists and plays an essential role in bringing art to an audience.

One of the best known dealers in the history of art was Paul Durand-Ruel (*du-ROHN-ru-EL*; 1831–1922). His specialty was the work of the French Impressionist painters. "A true picture dealer," he said, "should also be an enlightened patron, that is, he should, if necessary, sacrifice his immediate financial interest to his artistic convictions." Today it is hard to believe that Impressionist paintings were ever a risky investment, but for many years it appeared that Durand-Ruel would never make a profit. The French public depended on the annual exhibits, called "the Salon," at the Academy of Fine Arts in Paris to define what was acceptable in art. The Academy was dominated by the most conservative artists, who considered the Impressionist painting bad art because it emphasized color more than drawing and concentrated on daily life in the modern world, which was not considered a subject suitable for art. Conservative collectors were not interested in paintings such as Monet's *The Thames and the Houses of Parliament, London* (Fig. **1.4**), which was painted when the artist was thirty-one and visiting London.

After fifteen years of showing their art in Paris and London, the Impressionists were still finding it difficult to support themselves, so Durand-Ruel decided to experiment with an exhibit in New York. In 1886 he took a large stock of Impressionist paintings—about fifty Monets, forty-two Pissarros, thirty-eight Renoirs, seventeen Manets, twenty-three Degas, fifteen Sisleys, nine Berthe Morisots,

1.4

CLAUDE MONET,
The Thames and the Houses of Parliament, London,
1871.
Oil on canvas,
18¾ x 25½ in
(48 x 65 cm).
National Gallery, London.

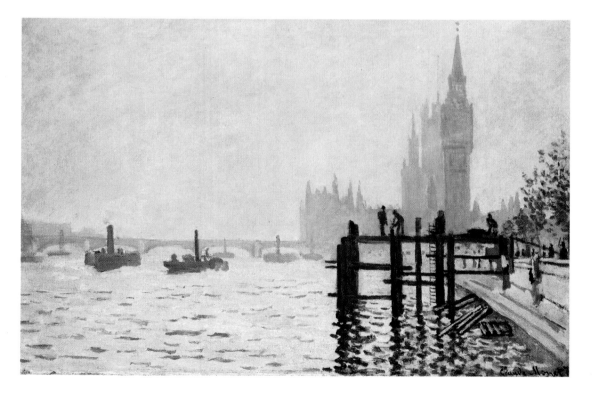

and others—to New York. The public in New York was less conservative, and the city's newspapers gave the show rave reviews. "New York has never seen a more interesting exhibition than this," wrote a reviewer for *The Critic*.[7] That same year the Impressionists had their last group show in Paris. The group was breaking up as styles changed and personal differences developed, but success had arrived. Durand-Ruel soon earned back the money he had gambled on Impressionist paintings, and he even opened a branch of his gallery in New York.

Another way art is bought and sold is by auction. Because prices paid at auctions are public knowledge, auctions are the way people keep track of market values in the business of art. In fact, high prices are often treated as newsworthy for the general public. You have probably seen newspaper articles featuring huge sums paid for art, money that goes to dealers and often does not reach artists or their heirs. People in the art world are often reluctant to talk about the value of art because several different values get confused. There are three kinds of value, which must be kept clearly separate: intrinsic value, cultural value, and market value. Art ordinarily has little *intrinsic value*, which is the value of things which support biological life, such as food, clothing, and shelter. Those things have value regardless of what anyone might think of them—the opposite of cultural value and market value, which depend entirely on what people think.

Cultural value is what people mean when they speak of beauty. A branch of philosophy called **aesthetics** developed around the question of what is beauty, and we still hear of *aesthetic value*. Beauty is often said to be "in the eye of the beholder," which is another way of saying it depends on the tradition, or culture, in which you have been educated.

An expert on cultural value can tell you whether the art work you are thinking of buying is good or not, but may not be able to tell you whether the price is too high. *Market value* is the price a work of art will bring when it is offered for sale. Market value fluctuates much more widely and rapidly than cultural value. Keeping track of the fluctuations is the specialty of the art appraiser; it is also basic to the work of dealers. Works of art are often hard to convert into cash, but they are part of the basic wealth of a community, setting a standard of value somewhat the way a hoard of gold does. Although their market value changes, in general works of art tend to grow more valuable as they get older, which is another way of saying that units of money have a long-term tendency to decline in value. That is why, during periods of inflation when money is rapidly declining in value, many people buy art in the hope that it will retain its market value.

The poverty of artists is legendary, but poverty is not a requirement in order to make good art. Some people think that any artist who earns money has "sold out"— become motivated by profit rather than quality. But artists need to earn enough to buy paint or stone, pay the rent on their studios, and feed their families. It is the business of art dealers to bring the artist and the audience together, and market value is fundamentally a way to keep this system of art creation and patronage in existence. While art has to pay well enough so that artists can continue to make it, money is not the basic need of the artists. Their basic need is for an audience.

THE PATRON AND THE COLLECTOR

Earlier we defined patrons as those who pay for the work and dictate the general character of the work. Patrons are usually individuals, because personal taste is a big factor in patronage, but often corporate bodies, such as governments, churches, and businesses, act as patrons, represented by a committee that acts for the group.

It is hard to separate the contributions of the artist and the patron when we look at a finished work, but historical research can sometimes cast a revealing light on this relationship. In his analysis of the patrons of Rembrandt van Rijn (1606–69), Gary Schwartz showed that the subjects of Rembrandt's paintings reflect the interests of their patrons.[8] Patronage of his paintings also stimulated Rembrandt to be creative in drawing and printmaking. The desires of the patron are most obvious in portraits,

such as the one of Frederick Rihel (Fig. **1.5**), who had himself depicted in a way usually reserved for a king or a victorious general. A wealthy bachelor businessman, Rihel kept fine horses and fine clothing, but the painting was meant to memorialize his participation in a visit of royalty to Amsterdam in 1660.

We usually think of great painters, such as Rembrandt, as free agents in the choice of subjects, but their patrons had definite preferences for certain Bible stories, mythology, history, or portraits. Even Rembrandt had to consider the interests and desires of his patrons. The role of patron requires respect for the role of the artist and the realization that a patron cannot control the style and content, but only the subject, materials, and perhaps the general character of the art.

Patrons often enjoy that role so much that they become art collectors, but most collectors buy art already completed, not made especially for them. Patrons and collectors are the life-blood of the art world, providing the money that keeps the whole operation alive. Although money is involved, investment seems to play a relatively small role—most collectors are driven by love for a certain kind of art.

People often think art collectors have to be millionaires, but collecting, like sports, is something everyone can do at their own level. The best known collection made with little money is that of Herbert and Dorothy Vogel, which has been borrowed for important museum exhibits. Herbert, a retired postal clerk, and Dorothy, a librarian, live on her salary and devote his pension to buying art. Since the 1960s they have bought over 1,500 works of art, which they keep in their one-bedroom apartment, along with pet cats, turtles, and fish. They have concentrated on drawings, rather than the more expensive paintings, and they have specialized in the most **abstract** styles, **Minimal** and **conceptual** art. Although they rarely spend more than a few hundred dollars on any work, their collection is known for its very high quality.

Art is the center of life for the Vogels, and their friendships with artists and gallery and museum people are based on their proven interest in the very highest quality. Although their collection is now priceless, investment was the farthest thing from their minds. "We never sell—it's just not for us," says Herbert. "When you buy

Italian Renaissance patrons considered a knowledge of art as the mark of a gentleman, a "proper subject for men of distinction to be able to discuss ..." (See p. 388.)

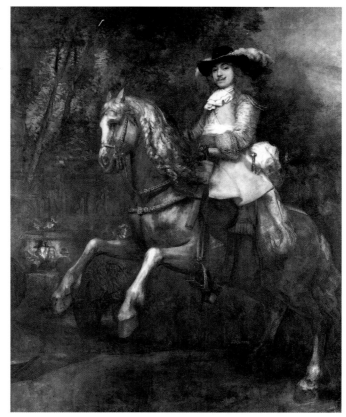

1.5
REMBRANDT VAN RIJN, *Frederick Rihel on Horseback*, 1663. Oil on canvas, 7 ft 10 in x 6 ft 2 in (2.4 x 1.9 m). National Gallery, London.

stocks, you do it to make money. Our dividends are looking at the work and knowing it's ours."[9]

Collectors often start young with very little money, buying something that, to their own surprise, they find fascinating. Keith de Lellis is a younger collector who started buying old photographs at flea markets and antique stores when he was in junior high school twenty years ago. He now owns 20,000 photographs and has turned his love of old photographs into a profession, specializing in buying and selling American photographs made during the years from the 1920s to the 1950s. Unlike the Vogels, he enjoys the trade in art, which grows out of his collecting and also supports his own collection.

A recent find was Edward Steichen's *Matches and Match Boxes* (Fig. **1.6**), a picture made in 1926 for the Stehli Silk Corporation, which had commissioned several artists to create works that could inspire textile prints. "I consider it one of the great photographs of the 1920s," de Lellis says. Not only is it a beautiful photograph, but also "an important innovation in contemporary American textile design."[10] De Lellis is still the typical collector, who started young with very little money and became an expert in the field he chose.

THE CRITIC AND THE ART HISTORIAN

We call someone who is an expert on cultural value a critic or an art historian. Those two roles overlap, especially when contemporary art is concerned, but in general critics specialize in the art of their own time, while art historians deal with earlier art, which may come from other cultures.

The role of the critic or historian is to perform an interpretation that serves as a sample for the audience. Besides demonstrating an interpretation of new art, he or she also keeps older art "alive" by acting as audience for it in a way that is appropriate to our time. This is a role played by performers in music and the theater. Four hundred years ago a play by Shakespeare was spoken in an English we could hardly understand by actors dressed in the style of their own day and acting in the

1.6
EDWARD STEICHEN,
Matches and Match Boxes,
1926.
Photograph. (Property of
Keith de Lellis;
reproduced by permission
of Joanna T. Steichen.)

style of that time. We bring the same play back to life by performing it in modern English, wearing costumes designed in our day and acting in the style of our time.

Writing about critics, Terry Barrett says: "Critics do not believe the cliché that 'art speaks for itself.' They willfully and enthusiastically accept the burden of artistic communication with the artist. They work for viewers of art and those members of society who want to think critically about the times and conditions in which we live."[11] Both good criticism and good art historical writing are based on careful description, which is the translating of visual art into literary art. Often, the descriptions of the critic and the historian will differ in emphasis, the critic choosing to concentrate on the expressive features, the style, and the historian choosing to emphasize information about the artist, the patron, and what people thought about it at various times.

The art historian Jenefer Robinson[12] writes that the critic and the historian meet when they discuss style, the historian to locate those expressive features of lines and shapes at a particular time and place and to understand what the art meant to its original audience, and the critic to look at one particular work of art and examine how the style was used to express a feeling or idea. It is, of course, possible for one person to make both kinds of analysis.

In recent years people have begun to think that it is also important for writers to reveal their points of view so that the reader can evaluate those views. Just as the passage of time affects the meaning and evaluation of a work of art, so do the viewpoint and life experiences of the members of the audience and the critics who write about it. Even though there is no truly objective criticism, we all hope for writing that is fair and enlightening, even when it is committed to a particular political, religious, or social viewpoint.

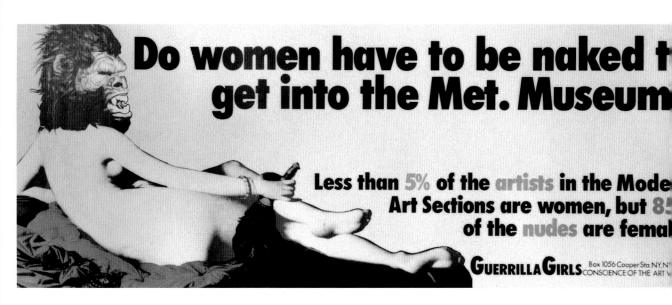

1.7
THE GUERRILLA GIRLS,
*Do women have to be naked
to get into the Met.
Museum?*, 1989. Poster,
11 x 28 in (27.9 x 71.1 cm).
Private collection.

One of the intriguing aspects of art criticism is that it reflects its own time, even when it deals with works of art that are centuries old. You can see that this means that the works of art are slowly, but constantly, changing their meaning in the minds of critics and their readers. The experiences of each generation of critics and audiences are different in some ways from those who have lived before, and they bring their experiences with them when they look at art or write or read criticism. All of us, and perhaps critics especially, see with our minds as much as we do with our eyes. The role of writers on art is to sharpen the eyes of the audience, but also to sharpen their minds as they consider what they see.

THE AUDIENCE

The audience in Western societies can be divided into three groups: a general audience of people who have a normal interest in their own culture, a serious audience of people who enjoy reading about art and who go out of their way to see new work, and students and professionals in art. The students and professionals are most interested in innovation and will tolerate boredom and confusion if they think something new may turn up. By their presence at exhibits and by talking about what they have seen, the student and professional audience, as well as the critics, pass the word to members of the serious audience that there is something to see. Eventually the general audience learns through newspaper and magazine articles and television interviews that an art style or an artist is becoming interesting or fashionable.

All three sectors of the audience together are absolutely indispensable to the existence of art. If a hostess gives a party and nobody comes, it isn't a party; we can say pretty much the same for art. The whole audience decides what is art and what

Artists, their patrons, and critics in the Roman Empire formed an art world comparable to our modern one (see p. 347).

CURRENT ISSUES

Who is Admitted to the Art World?

"Many, many women go to art schools—more than 50 percent of art students are females. And they somehow get lost, because when they leave, there's not a support structure for them. They don't have access to the system and their sensibility is lost." These are the words of one of the anonymous members of the Guerrilla Girls, a New York-based group of women artists and art professionals dedicated to agitating for a more open art world (Fig. **1.7**). "We speak for the people who want to participate and be part of the system," she added. A member of another New York group, Women's Action Coalition (WAC), spoke from a different point of view: "with the careers of non-white artists as much as ten years behind those of white artists of comparable talent, and with less discretionary time and income and proportionately greater demands on them, the women of color will not be as active. But unlike the black woman who told me, 'I have to deal with white people all day. I don't have the energy to jump into that bag at night,' those who do come [to WAC meetings] seem to feel

comfortable. We are able to speak freely and occasionally we are heard. Mostly middle-class artists ourselves, we may not have the temperament for the politically necessary task of organizing the poor women outside."

The speakers bring up a whole series of problems—gender relations, color barriers, poverty—that make it hard, if not impossible, for artists to be active in the art world. How would you solve the problems they bring up? How about a system in which each category of society is awarded a specific number of jobs and exhibits? Does the quality of the work count, and who could decide what counts as quality? Can we solve problems in the art world that remain unsolved in the world in general?

Suzi Gablik, "We Spell it like the Freedom Fighters: A Conversation with the Guerrilla Girls," *Art in America*, vol. 82, January 1994, p. 43; Lorrainne O'Grady, "Dada Meets Mama," *Artforum*, October 1992, pp. 11-12

is not, usually with surprising independence of the critics. The professional audience is usually first to accept new work as art, but if that opinion is not eventually accepted by the members of the serious and general audiences, the work disappears from view. We sometimes look back and say that the audience was wrong or made a mistake, but such a statement is almost meaningless, because every group of people defines art for themselves. The American writer and early patron of Picasso, Gertrude Stein, wrote that "nothing changes in people from one generation to another except the way of seeing."[13] The history of art is basically the history of the audience's way of seeing. Two psychologists of art made Stein's point in a different way: "the value, estimation, fate, and survival of a work of art" are determined principally by the audience.[14]

This is what happens in all art that finds a place in history. The artist has an idea and carries it out, hoping to find a patron and an audience. Sometimes the idea originates with a patron, who seeks an artist to bring it into existence as a work of art. In that case the patron must grant the artist liberty to carry out the work in a personal style. Both the artist and the patron have to grant the critic freedom to analyze its historical significance, and all three concede that the audience will decide whether it is good art or not and what it really means.

TWO CASE HISTORIES

Most of the time the art world operates smoothly, and it is hard to distinguish the contributions of all the participants. But when things go wrong it is easier to analyze the parts. It is like your car: you don't think about the engine until you begin to hear strange noises. Two famous American art projects in which the machinery of the art world did make some strange noises are revealing demonstrations of the art world in operation.

THE VIETNAM MEMORIAL

Between 1979 and 1984 a project to build a memorial in Washington to the dead and missing of the Vietnam War produced so much controversy that it seemed for a while as if everyone in the country would eventually be one of the artists, patrons, or critics, leaving no one as simply audience. But finally the audience was massive: more than 100,000 veterans and their families attended the dedication on Veterans Day in 1982, with the project still not entirely finished, and hundreds of millions saw it in the news media (Fig. **1.8**).

The project started with Jan Scruggs, who served in the U.S. Army Light Infantry Brigade in Vietnam in 1969–70.[15] Scruggs was among the wounded in a company of which half were killed or wounded, and on his return to the United States he became deeply involved in veterans' problems. In 1979 he organized the Vietnam Veterans Memorial Fund (VVMF), whose only purpose was to erect a national monument honoring those who had died in the war. The monument was to be paid for by private contributions and was to be nonpolitical. Congress voted to provide land between the Washington Monument and the Lincoln Memorial, and in 1980 President Jimmy Carter signed a bill authorizing the project, informing the VVMF that the design would have to have the usual approvals of the National Capital Planning Commission, the Commission of Fine Arts, and the Department of the Interior. Texas Millionaire H. Ross Perot contributed $160,000 to launch a competition to design the memorial to be open to all U.S. citizens over eighteen.

In his book *Art Worlds*, Howard Becker defined an art patron:

> Patrons pay, and they dictate—not every note or brush stroke, but the broad outlines and the matters that concern them. They choose artists who provide what they want. In an efficient patronage system, artists and patrons share conventions and an aesthetic through which they can cooperate to produce work, the patrons providing support and direction, the artists creativity and execution.[16]

You can see right off that there were many different organizations and individuals who considered themselves the patrons of the Vietnam memorial: Jan Scruggs and his VVMF, many members of the U.S. Congress, several governmental bodies, and H. Ross Perot. They all wanted to dictate, but they disagreed about the broad outlines and the matters that concerned them.

The VVMF, which was still in charge of the project, set just two basic requirements for the design: (1) the names of all 57,939 Americans who died or were missing in Vietnam had to be engraved on the memorial; (2) the design had to fit harmoniously with the Washington Monument and the Lincoln Memorial. These requirements meant that a wall for the names had somehow to be part of the design and that the memorial had to be low enough not to compete with its tall neighbors. A prize of $20,000 was offered and drew a large response: 1,421 designs were entered. A jury of eight well-known architects, sculptors, and landscape designers judged the entries, which were presented anonymously, and the VVMF promised to accept their choice. You can see that the jury also played one of the roles assigned to the patron.

1.8
Maya Lin,
The Vietnam Veterans'
Memorial, Washington,
D.C., 1982.

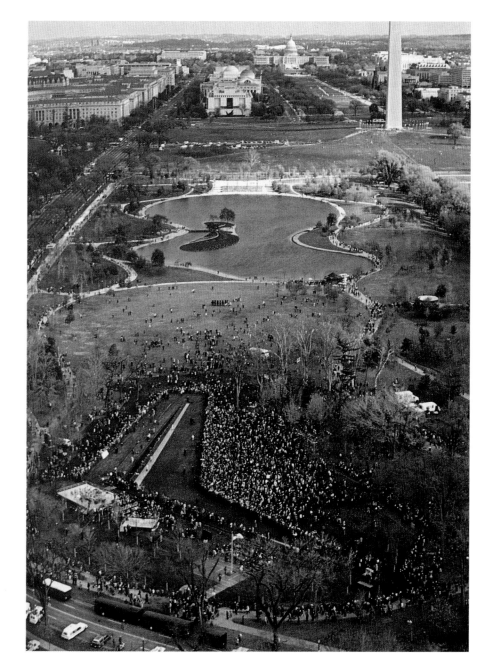

1.9 (*right*)
MAYA LIN,
The Vietnam Veterans'
Memorial,
Washington, D.C.,
1982.

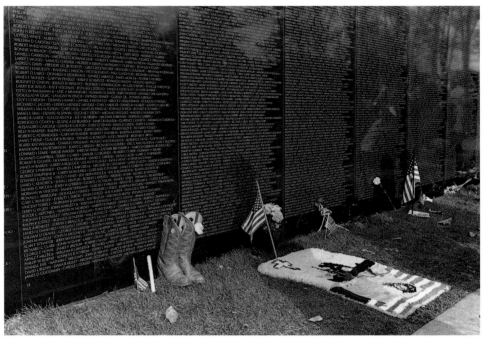

1.10 (*above*)
Maya Lin (*right*).

The jury's choice was a very simple design of two 10-foot (3-meter)-high polished black granite walls set at a 125-degree angle, each 250 feet (76 meters) long, set into a slight rise in the lawns. The names of the dead were to be engraved, not alphabetically, but in the order in which they had been killed; the designer planned that observers would see their own reflections in the polished stone (Fig. **1.9**). The design may have been chosen for its simplicity and modesty, but it provoked tremendous controversy.

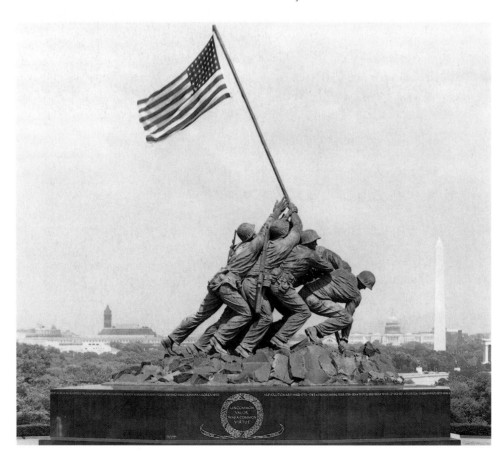

1.11
FELIX W. DE WELDON,
Marine Corps War
Memorial,
Arlington, Virginia,
1954.
Cast bronze, over life-size.

Everyone was surprised to discover the artist was a twenty-one-year-old Chinese-American, Maya Lin, an art student at Yale, who had made the design as a class project (Fig. **1.10**). The Commission of Fine Arts met on October 13, 1981, with Maya Lin to discuss the choice of granite. A surprise visitor to the meeting was Tom Carhart, a wounded veteran and member of VVMF who had helped raise money for the monument. He had even entered the design competition with the first art work he had ever attempted. An interested party in several different ways, Carhart was upset by the chosen design, calling it a "degrading ditch"; he demanded a white memorial. That was the opening gun of sixteen months of argument between those who favored the Lin design, which had been legally accepted and could not be withdrawn, and those who wanted at least to add a sculpture of realistic figures with a flag, more like the Marine Corps War Memorial, a sculpture based on a news photograph of Marines raising the flag on the island of Iwo Jima during World War II (Fig. **1.11**).

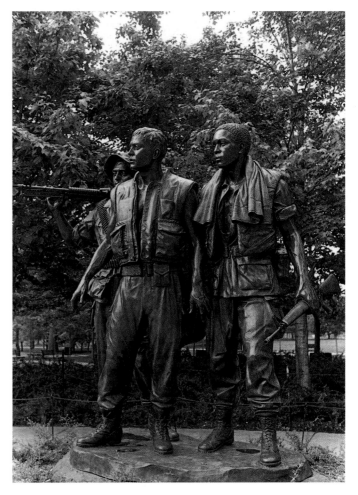

Anyone who believes that art is meaningless has a hard time explaining this controversy. Everyone involved was certain that they understood the art and that it meant something definite. Both sides saw the Lin design as anti-war, and those who had favored the war wanted a monument that would emphasize the glory of the cause. The bitter controversy that the war aroused in the American public and the hostile treatment many veterans received on their return made it almost impossible to get widespread agreement on a memorial.

Finally, bowing to pressure from Perot and a group of powerful members of Congress, Scruggs and the VVMF concluded a separate agreement with the sculptor Frederick Hart, whose design for a monument with realistic figures had placed third in the original competition. Some hoped to place his contribution, with a flag, at the junction of Lin's walls, thereby reducing them to a background, but the government agencies overseeing the project ruled that Hart's figures could not be visible from the walls. His sculpture, an 8-foot (2.4-meter) bronze group of three soldiers, was finally set in place in 1984, with the flag, at the entrance to the monument (Fig. **1.12**). Hart's sculpture, though traditional in style, is not heroic, for the young soldiers stand quietly, and their expression has been described as "stunned" or "bewildered."

1.12
FREDERICK HART,
Soldier Group,
Vietnam Veterans'
Memorial, Washington,
D.C., 1984.
Cast bronze,
8 ft (2.4 m) high.

The attention of the public and critics has centered almost entirely on Maya Lin's black-walled memorial. A columnist who visited it alone shortly before it was dedicated found it too depressing: seeing the names of so many dead, "the feeling of waste and emptiness would not leave me," he wrote.[17] A colleague of his who attended the dedication a week later wrote:

> I think it is one of the most impressive memorials I ever saw. ... In the crowd we looked at each other, deeply moved. ... Some have said they think the Memorial is too negative; perhaps they have spoken before seeing its powerful effect on visitors. Crowds increased each day at the dedication ceremonies. Officials agreed to add a conventional sculpture of three soldiers next year. They can do nothing, I think, to increase its impressiveness.[18]

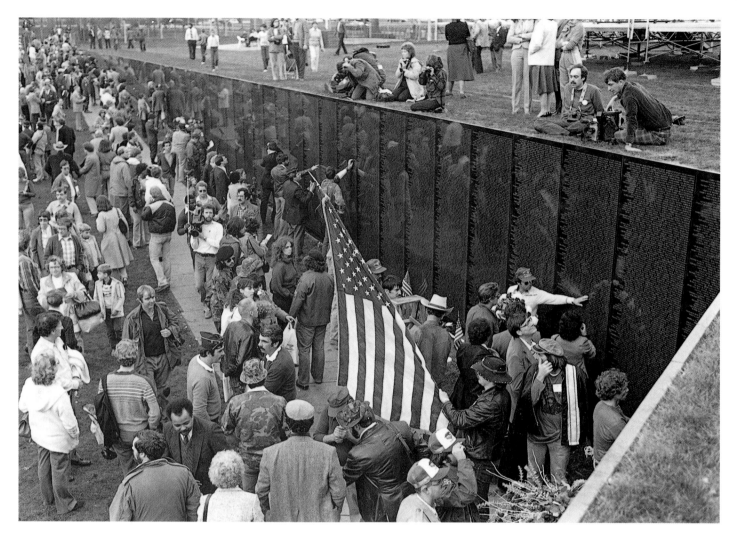

1.13
Offerings at the Vietnam
Veterans' Memorial.

Veteran William Broyles, Jr., probably spoke for many: "this memorial is not a monument to the abstract ideal of war, to glory and victory or even to a cause. It is a reminder of the cost of war. ... Like the war itself, the memorial is less than the dead deserved." The deepest meaning of the war, he wrote,

> is in the fate of those who fought there. The veterans gave the war that meaning, and they and their families quickly, and spontaneously, did the same for the memorial. Through countless acts of pure emotion they completed a monument that seemed incomplete. It invited them, somehow, to make it their own. They propped roses beside it, set photographs of dead sons and brothers on it, bedecked it with wreaths, touched it constantly and washed it with tears (Fig. **1.13**).
>
> As I stood in front of the polished granite I saw the names, but I also saw my own reflection. It fell across the names like a ghost. "Why me, Lord?" we asked ourselves in Vietnam. It was a question that came back as I stood there: "Why them?" It was a terrible sadness that brought the tears. But also, beneath it, there was a deep relief tinged with guilt: my name isn't on the wall.[19]

After Maya Lin's walls had been dedicated, a *Washington Post* editorial writer concluded: "The argument over the memorial dissolves the moment you get there." Most of the members of the audience, it seemed, had decided that Maya Lin's conception was art enough. In this very imperfect world, those stark walls gave people a chance to add whatever they felt was missing to make the monument complete. Three years later, with Frederick Hart's three soldiers and the flag in place on the hill nearby, all points of view seemed to find satisfaction.

THE ROCKEFELLER CENTER MURAL

If the controversy over the Vietnam Memorial represented sincere differences over a tragic theme, an earlier controversy has some lighter elements. In 1932 the great Mexican painter Diego Rivera (1886-1957) was commissioned by John D. Rockefeller, Jr., to paint a mural in the newly completed Rockefeller Center in New York. Although Rivera (Fig. **1.14**) was an outspoken communist, he was still willing to paint murals commissioned by wealthy capitalists in San Francisco and Detroit, including a fine series on the auto industry under the patronage of Edsel Ford. Rivera submitted designs (Fig. **1.16**) to Rockefeller for approval on the theme *Man at the Crossroads* and set to work on the wall, with a large group of politically aware assistants. As the painting began to emerge (Fig. **1.15**), it became clear that the "crossroads" was between the capitalist and communist worlds, with a portrait of Lenin on the communist side (to the right of the central figure, between the ellipses). The artist claimed that Lenin's portrait was in the sketches that had been approved and, besides, was an indispensable part of the design, but if you compare the approved drawing (see Fig **1.16**) with the mural that was beginning to appear on the wall (see Fig. **1.15**), you will see that Rivera had revised the design considerably.

1.14 *(above)*
DIEGO RIVERA, *Self-portrait*,
1930.
Lithograph, $15\frac{7}{8}$ x $11\frac{1}{8}$ in
(40 x 28 cm).
Harry Ransom Humanities
Research Center, University
of Texas at Austin.

1.15 *(left)*
DIEGO RIVERA,
Man at the Crossroads
(unfinished), May 1933.
Fresco, central wall,
19 ft x 40 ft 10 in
(5.8 x 12.5 m).
Destroyed 1934.

1.16 *(below)*
DIEGO RIVERA, study for
Man at the Crossroads,
1932.
Pencil on brown paper,
2 ft 7 in x 5 ft 11 in
(80 x 180 cm).
Museum of Modern Art,
New York.

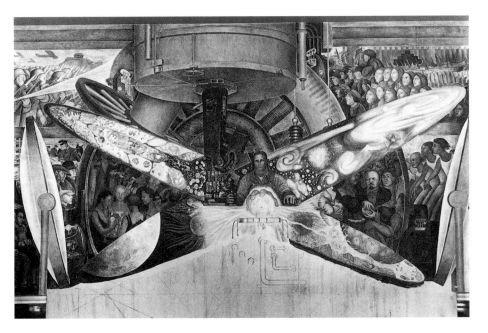

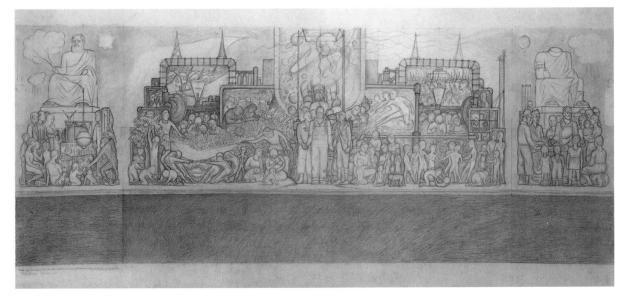

It is obvious that cooperation had broken down between artist and patron. When Rivera refused to change the mural, he was paid for his work and locked out of the building. This dispute quickly became a popular cause. To understand the situation, you have to remember that in 1933 the United States was at the depths of the worst depression in its history; it really looked as if the country was at a political and economic crossroads. There was a natural tendency to see a very wealthy person as a villain and an artist as the representative of freedom of expression. But it is also obvious that Rivera was less than open with Rockefeller and was treated as well as he deserved. Rivera, working in the politically agitated environment of New York City, discovered, perhaps after the designs were already approved, that he had to make a political statement to retain his reputation as a radical. He also planned to return to Mexico, which had just elected a new, liberal president, and it was important to Rivera to prepare a hero's welcome for himself in his own country. Mexico was

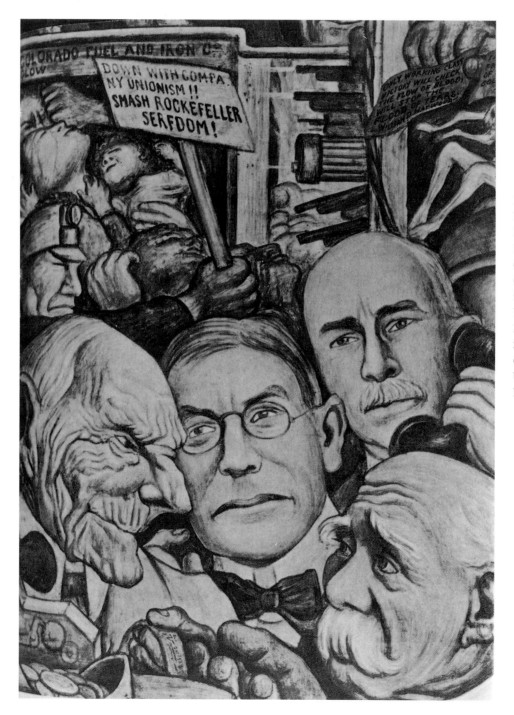

1.17
DIEGO RIVERA,
Portrait of America, 1933.
Fresco panels,
6 ft x 5 ft 10 in
(183 x 178 cm);
foreground heads life-size.
Destroyed by fire February
28, 1969. New Workers'
School, New York.
(Property of ILGWU,
Unity House, Forest Park,
Pennsylvania.)

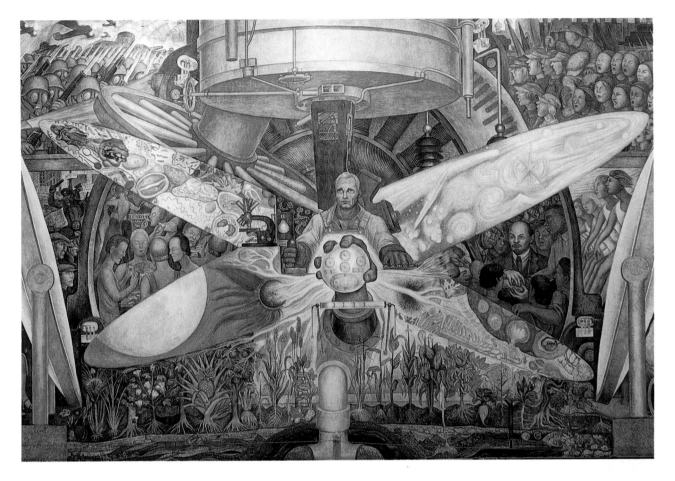

beginning the dangerous process of regaining control of its oil fields—of which Rockefeller companies were major owners—and the Mexicans feared U.S. intervention. It is clear that Rivera intentionally destroyed the cooperative relationship between artist and patron to keep his own political position; the result was that the unfinished mural was scraped off the wall. Rivera quickly found a more sympathetic patron in the New Workers' School in New York, for which he did a series of movable mural panels entitled *Portrait of America*. One panel included a sarcastic caricature of the senior John D. Rockefeller with workers carrying an anti-Rockefeller sign (Fig. **1.17**). Back in Mexico in 1934, Rivera arranged to paint *Man at the Crossroads* again in the Palace of Fine Arts (Fig. **1.18**).

In the end the work came into existence with a new patron, the government of Mexico. Critics have accepted it as one of the standard works of the artist, and it has been widely reproduced. In the more than sixty years since it was painted the capitalist world has survived the challenge of communism, and Rivera's vision of such a "crossroads" is merely historically interesting. The other crossroads, between the microscopic and the astronomical, where Rivera placed his worker operating a colossal machine, is still relevant to our experience and shows Rivera as a good predictor of some future trends. These arrangements among groups and individuals are so complicated you wonder how anything ever gets made.

But even Rivera's mural found a patron and a location, and the Vietnam Veterans' Memorial was built, despite the controversy. Perhaps wrangling is a necessary part of the process and we should call it negotiation. In the end, the most important thing is that works of art come into existence.

ART MUSEUMS

The usual place where the audience meets the art world is the museum. While many of our greatest art treasures are to be found in parks, churches, or government buildings (as we have seen in the cases of Rivera's mural and Maya Lin's Memorial),

1.18
DIEGO RIVERA,
Man at the Crossroads,
1934.
Fresco,
15 ft 10 in x 37 ft 7 in
(4.9 x 11.5 m).
Palace of Fine Arts,
Mexico City.

portable works of art often find a permanent home in a museum. Occasionally an artist will give a work directly to a museum; sometimes museums buy from the art dealers; often a collector will give or sell to a museum. Museums rarely sell works from the museum collection, a practice that sounds shocking to many in the art world, who think of museums as perpetual guardians of art. The ideal of the museum is to be the protector of the cultural values of its community. The modern form of the museum is a very recent development, and it is surely no exaggeration to say that we are living in the great age of museums.

When the Americans won their Revolution they won no palace full of art, but a different situation confronted the French only a few years later. When you have executed the king, what do you do with his palace and his art collection? In 1793 the revolutionary leaders proclaimed that the royal collections belonged to all citizens, and the Louvre (*LOOV-ruh*) Palace in Paris was opened three days a week to the public (Fig. **1.19**). When Napoleon emerged as emperor of France, his conquests allowed him to loot most of the great collections of Europe, and even of Egypt, enriching the Louvre—now a public museum—on a vast scale. Even though much of the loot had to be returned when Napoleon was finally defeated, the Louvre remained legendary.

When James Jackson Jarves, the Boston-born editor of Honolulu's first newspaper, visited the Louvre in 1851, he was so overwhelmed that he devoted the rest of his life to art. Jarves settled in Florence, Italy, and slowly formed a collection of Italian paintings (Fig. **1.20**), which he brought back to New York and, when he needed money, tried to sell. Educated taste was still too narrow to include the Gothic and early Renaissance paintings that Jarves had purchased, so no buyer could be found. Finally Yale College reluctantly loaned Jarves $20,000 with the paintings as collateral. When Jarves was unable to pay, the college ended up with the collection, which is now a major attraction at the Yale University Art Gallery.

In 1871, when Yale tried unsuccessfully to auction the Jarves Collection, there were already movements afoot in New York and Boston to form art museums—the

1.19 (*below*)
HUBERT ROBERT,
View of the Grande Galerie of the Louvre, 1796.
Oil on canvas,
3 ft 9 in x 4 ft 9 in
(1.2 x 1.5 m).
Louvre, Paris.

1.20 (*right*)
TADDEO GADDI, *Entombment of Christ,* c. 1345.
Tempera on wood panel, 3 ft 9⅝ in x 2 ft 5¹¹⁄₁₆ in (115 x 75 cm).
Yale University Art Gallery. (University Purchase from James Jackson Jarves.)

Metropolitan Museum of Art in New York and the Museum of Fine Arts in Boston were both founded in 1870. In a little over one hundred years the people of the United States have built hundreds of museums, by far the larger number devoted to art, some supported by federal taxes, others by state or local governments, and many of them by private foundations. A small guidebook to U.S. art museums lists 283, and covers only the most important ones.[20] Between 1950 and 1980 this country built the equivalent of fourteen Louvre museums, more than enough square footage to pave a road 6 feet (2 meters) wide from New York to California,[21] and that pace of construction still continues.

Walking around a large American museum, with its collections of ancient sculpture, modern painting, reconstructed rooms from colonial houses filled with antique furniture, its bookstore and its restaurant, with busloads of school children sitting on the floor for lectures on weekdays and hordes of visitors thronging the galleries on weekends, you may well ask what is going on here. Even more is going on than is visible to the visitor: in a laboratory works of art are examined, conserved, and restored (Fig. **1.21**); and an art conservator in a white coat is positioning a wooden sculpture for radiation to stop decay; in a handsome office the director and his staff are discussing the insurance costs for shipping a painting; in a gallery a curator examines a painting borrowed for an exhibit; in a silent library one of the curators is trying to figure out the ceremony a Polynesian sculpture was used in; and in a cool, shadowy storeroom a staff member replaces paintings on racks after a show is taken down. Is this a school? Or a community treasure house? Or a strange kind of church? Art museum professionals have asked themselves those questions for years, and the answer seems to be "All of the above."

You can visit your own local museum and judge for yourself what kind of institution it is, but let us take a look now at two famous museums in New York which embody very different ideas. The Frick Collection (Fig. **1.22**) is located in a mansion at 1 East 70th Street in Manhattan. The mansion was built in 1913 by Henry Clay Frick as a home, but with the museum it would become always in mind. Frick had nothing in his Pennsylvanian farm background to nourish a love of art; he was apparently born with it. When he applied for a bank loan at the age of 21 in 1871, the banker thus evaluated him: "On job all day, keeps books evenings, may be a little too enthusiastic about pictures but not enough to hurt."[22] A millionaire coke

The Guggenheim Museum in New York (1956-59) and the New State Gallery in Stuttgart, Germany (1977) are among the most admired museums of this period (see Figs **8.44**, **8.45**, **8.54**, and **8.55**).

1.21 (below left) The Sherman Fairchild Center for Objects Conservation at the Metropolitan Museum of Art, New York.

1.22 (below right) The living hall, the Frick Collection, New York.

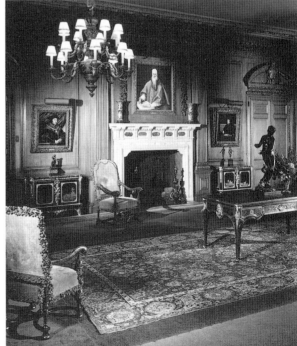

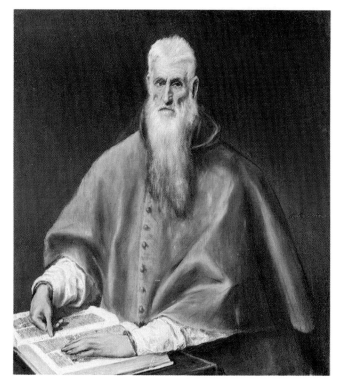

1.23
EL GRECO,
Saint Jerome, c. 1610.
Oil on canvas,
3 ft 6⅛ in x 2 ft 10¼ in
(107 x 87 cm).
Frick Collection, New
York.

and steel manufacturer by the time he was thirty, his success unaffected by a notorious record as a strike-breaker, Frick could afford the best. He bought Rembrandt's *The Artist as a Young Man* and *The Polish Rider*, Vermeer's *The Music Lesson*, Velázquez's *King Philip IV*, and many others. Frick had the courage of his own taste and knowledge to buy the work of some artists who were not then popular, such as El Greco (1541–1614), whose *Saint Jerome* (Fig. **1.23**) was the first El Greco in a private collection in this country. The Frick Collection is a place to see a permanent collection of fine "old master" paintings in a quiet, elegant setting, and hear occasional chamber music concerts.

The Museum of Modern Art (Fig. **1.24**) was meant to be something entirely different when it was founded in 1929 by three wealthy women—Lillie P. Bliss, Abby Aldrich Rockefeller, and Mary Quinn Sullivan—over a lunch table. It attracted crowds from its first show and has been one of the most influential art institutions in the world. Dedicated to showing the work of the most important living artists and their precursors in the Modern movement back to about 1875, it has also shown other kinds of art—African and American Indian, for example—which were of special interest to artists working in the Modern movement. It has gradually built up a first-class collection of its own, but it also shows temporary exhibits of work borrowed from other owners. It has an excellent library devoted to the history of modern art, a film library with regular showings, a photography department, and collections of industrial art and design. You can hear music at MOMA (its nickname, said as a word, not letters), as well as at the Frick, but it will probably be jazz. Even the building is different. While the Frick Collection is housed in an elegant low mansion, the Museum of Modern Art occupies part of a skyscraper.

Recent years have seen important new museums built all over the United States—Atlanta, Houston, Los Angeles, Denver, Fort Worth, among others—rivaling the great older museums of Chicago, Cleveland, Philadelphia, Kansas City, and others. There is most likely a museum within visiting distance of your home.

When you arrive at an art museum, the first thing is to examine a map of the building and look over parts with a quick walk-through just to see what is there. Then you may want to concentrate on a few things that especially interest you. At the information desk you may want to inquire about events such as concerts, films, or lectures, and the cost of membership and what privileges it gives. Since most

1.24
CESAR PELLI AND ASSOCIATES,
Abby Aldrich Rockefeller
Sculpture Garden,
Museum of Modern Art,
New York, 1984.

museums have more work than they can pay for, you may wish to ask if there are any interesting jobs for unpaid volunteers that you might like to do. Most people go to museums too rarely, and when they go they feel obliged to stay too long. A break for lunch or a drink in the restaurant is a good way to give your eyes and feet a rest. It is important to remember that a museum is supposed to be a place for pleasure, for spiritual renewal; a visit should not be turned into a chore. Even though museums may serve as an educational resource for study of our culture and history, that must never interfere with our pleasure in using them.

The fact is that looking at pictures, and other kinds of art, seems to satisfy many different needs of all kinds of people (Fig. **1.25**). An accountant in Boston said the following in an interview:

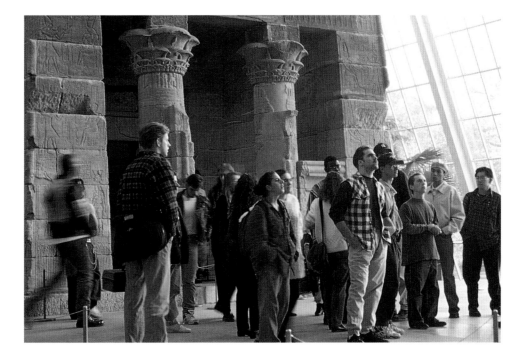

1.25
Visitors in front of the Egyptian Temple of Dendur, Metropolitan Museum of Art, New York.

It's been a long hard road for me, and I'm just 34. I'm the first in my family to graduate from college. ... Once I stopped in at the Museum of Fine Arts myself, just on a lark. I was driving by, and I felt like breaking out of the rat-race for half an hour. So, I pulled over—I almost got in an accident, because I did it so suddenly. And I walked in, and I just moved along, from picture to picture. It was like being in another world. I couldn't believe it. All the worries left me. I felt like I was becoming—well, you know, a philosopher. I got some distance on my life. I came home and told my wife that it was better than beer, better even than a good movie; because you could be alone with yourself, standing there.[23]

FOR REVIEW

Evaluate your comprehension. Can you:

- define at least five roles for people in the art world and describe how they interact with each other?
- explain how artists were educated during different times in history?
- discuss the definition of beauty and explain how it reflects a society's estimation of value?
- describe the general history of art museums during the last 200 years and some of the functions and activities we find in modern American art museums?

Suggestions for further reading:

- Howard S. Becker, *Art Worlds* (Berkeley: University of California Press, 1982)
- Elizabeth Hess, "A Tale of Two Memorials," *Art in America* (April 1983: 120-128)
- Diego Rivera, *My Art, My Life* (New York: Citadel Press, 1960)
- Karl E. Meyer, *The Art Museum: Power, Money, and Ethics* (New York: Morrow, 1979)
- Many museums publish magazines or bulletins. Look for the *Bulletin of the Metropolitan Museum of Art, New York*, or the *Bulletin of the Cleveland Museum.*

2

Interpreting Works of Art

The first thing most members of the audience look for in art is the **subject**—what is represented—but the subject is only part of the message, or **content**, of any work of art. Every society has certain preferred subjects, although several appear in many cultures: the human face, the human body, landscape and still life, images of gods or spirits, and certain kinds of abstraction. Each of these subjects has a traditional meaning in each culture, meanings that the audience is expected to know in order to understand new versions, which always add something or change something in the traditional meaning. This is one of the ways in which artists are original, and one of the ways in which symbols and culture in general are constantly changing.

P R E V I E W

IN EVERY ART TRADITION THERE ARE CERTAIN FAVORITE SUBJECTS that seem to offer inexhaustible material for art. Usually the subject is the first thing we look at in art, so we will examine a few of those favorite subjects: portraits, still life, the nude, landscape, divine beings, and a couple of types of abstraction. The creativity of artists is rarely bound by those traditional categories, however, and artists are often at their most interesting when they invent subjects that cross the boundaries.

Frida Kahlo's (*FREE-dah KAH-lo*; 1907-54) *The Little Deer* (Fig. **2.1**) seems to be a landscape, but the deer's head looks like a portrait. Actually it is a self-portrait, part

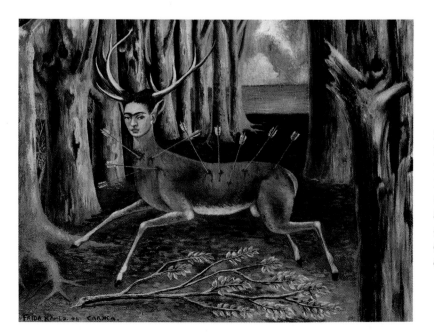

2.1
FRIDA KAHLO,
The Little Deer,
1946.
Oil on masonite,
8¾ x 11¾ in
(22 x 30 cm).
Collection of
Carolyn Farb.

of Kahlo's lifelong examination in art of herself and her life. Only by studying her life can we interpret the symbolism of the painting. Her face, sensitive but expressionless, appears on the wounded deer leaping over a fallen branch. Perhaps it is significant that she kept a deer as a pet and perhaps identified with it, but more important are the arrows, which surely refer to Kahlo's own wounds. She suffered polio as a child and was slightly lame, but much worse was a bus accident in which she was nearly killed when she was sixteen. She survived with a smashed pelvis and her back broken in several places. Those injuries finally killed her at the age of forty-four, but for about fifteen years she lived very intensely, married to the mural painter Diego Rivera and producing great paintings of her own. The little deer is surely fatally wounded and, like the broken branch, is sure to die. The forest of thick tree trunks, solidly rooted in the earth, offers no shelter for the deer, which, like the branch below, seems rootless and vulnerable.

To say that the subject of this painting is "a wounded deer with a woman's face running through the forest," would be correct, but the meaning, or content, of the painting would require more explanation. The deer is clearly a symbol for the artist, whose face it bears. The study of the symbolism of subjects is called **iconography** (*ikon-OG-raf-e*). It is fascinating to learn to read the iconography of works of art, but it takes patience. Many artists have their own personal language of symbols, as Frida Kahlo did. What we could call their private iconography can be interpreted confidently only when we know the artist's life story, and after we have examined several of their works. It is more common for artists to share the symbols and subjects of their period, or the art tradition of which they are a part.

Art is notoriously subject to different interpretations, and the same sculpture or painting may be explained in entirely different ways by different individuals or by people of different periods or cultures. Is there any way to be sure that your interpretation is more than a personal fantasy and that it has something in common with the ideas of the artist? One of the best ways to enter the field of interpretation is through traditional subjects that have been used at different times and in different countries and are truly part of the world's artistic heritage. They change their meanings with the passage of time, but nevertheless the old meanings echo through like an overtone, even in the most original new versions.

THE TRADITIONAL SUBJECTS OF ART

One of the best clues to understanding the meaning the artist intended to convey is to study the subject represented.

"What shall I draw?" Anyone who has taught a children's art class has heard that phrase and probably answered it by suggesting that there is an endless number of good subjects. The possibilities may be endless, but every culture has chosen just a few subjects to sum up its view of reality. Artists are constantly trying out new subjects, but only a few are accepted by the audience. Yet there are general themes with a broad appeal that has lasted for centuries. We will look at six of them: portraits of individuals, the still life, the nude figure, the landscape, the divine powers and the category of **non-representational** abstraction. All of these have been popular with audiences in many different cultures and periods.

The challenge to the artist is to put original, sincere feelings and thought into forms that are conventional enough to be recognized by an audience that is unable to receive a communication that is one hundred percent original. Originality can be seen only as a contrast with its opposite, conventionality, and artists are always trying to stay on that narrow path between the purely conventional, which everyone understands instantly and is soon bored with, and the totally original, which no one recognizes as art. Originality consists of a variation on a well-known form, controlled by the artist to express an independent point of view.

For these reasons, the traditions of subject matter are not boring old bins of exhausted ideas. They are well-worn paths, and at the end of them the audience waits for the artist to come out and say something original.

PORTRAITS OF INDIVIDUALS

How do we remember other people? We need a face that can be named, or at least a face that is distinctive enough for us to see a unique personality. Not all representations of people are portraits. Often artists have had other intentions that fall outside the conventions of the purely representational portrait; Michelangelo, for example, put generic faces on his memorials to two members of the Medici family, saying "In a thousand years who will care what they looked like?" Michelangelo wanted to represent the active and the contemplative ways of life in his figures, not individuals. But in the portrait we do care what the person looked like, and one of the pleasures of art is the cast of characters we meet. Here are just a few examples.

The name of the Roman (Fig. **2.2**) is unknown, but that hardly seems to matter. His face is so full of expression that we feel we know the man. We can sense his personality and intelligence, almost hear his voice. This terracotta (fired clay) head is under life-size, but it is so natural that critics assume it was based on a life mask— that is, a plaster mold made of the living face. A life mask probably provided the basic structure of the face, but the significant parts of this face are the eyes and the mouth, where the expression is to be seen, and those had to be modeled by the sculptor. Among the many surviving portraits of people of the ancient world, this one is especially revealing of an individual personality. Romans kept such family portraits to fulfill some of the same needs the photo album fills for us: this portrait must have been a valued memento for the family, who were the main audience for such a work.

A more mysterious portrait is one from the Moche (*MO-chay*) kingdom of Peru (Fig. **2.3**). No one knows exactly why it was made or who is represented. The Moche made many portraits of individuals, always as part of a pottery vessel to go into a tomb. The Moche were expert with molds, but this face is so thoroughly

2.2 (*below left*)
Man of the Republic
(Roman), 1st century B.C.
Terracotta,
14 in (36 cm) high.
Museum of Fine Arts,
Boston, Massachusetts.
(Contribution, purchase of
E. P. Warren.)

2.3 (*below right*)
Stirrup spout head vessel
(Moche from Peru),
A.D. 100–700.
Painted pottery,
10 in (25 cm).
Art Institute of Chicago,
Illinois. (Buckingham
Fund.)

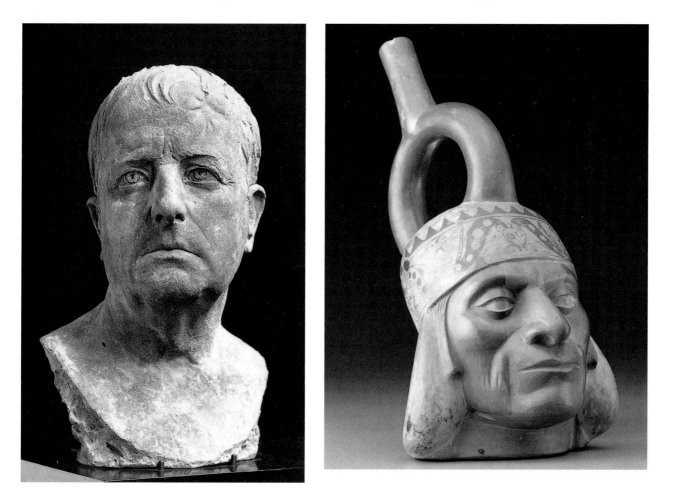

marked with hand-held tools that the use of a mold could have played little part. You can see the large, almost abstract forms that make up this powerful masculine face. Moche art was mostly concerned with religion and ritual, but all we know of this portrait head is that it was placed as an offering in a tomb, but not necessarily in the tomb of the person portrayed. That suggests the man portrayed here was a person of ritual or political leadership, meant to identify or protect the dead in the afterlife. Who might be the audience for art placed in a tomb is hard for us to understand, but ancient Peruvians seem to have considered that the dead, who continued to exist in an afterlife, were an important audience.

Portraits are often meant to tell us about the social position of the sitter, which sometimes seems more important than the individual's personality. Mary and Elizabeth Royall (Fig. **2.4**), daughters of one of New England's wealthiest families, were painted as a family memento, a common practice now largely replaced by photographs. Already a skilled portraitist when he was only twenty years old, John Singleton Copley (1738–1815) established the individuality of the girls by subtle differences in their expressions. Gowned and posed like young debutantes, the girls give reality to their luxurious setting by their lively expressions. In some ways, this is the most conventional of all the portraits we are considering, since it follows a well-established tradition of depictions of European nobility. That, of course, was the message the Royall family wanted Copley to convey, and they definitely did not want

2.4
JOHN SINGLETON COPLEY, *Mary and Elizabeth Royall*, c. 1758. Oil on canvas, 4 ft 9½ in x 4 ft (1.5 x 1.2 m). Museum of Fine Arts, Boston, Massachusetts. (Julia Knight Fox Fund, 1925.)

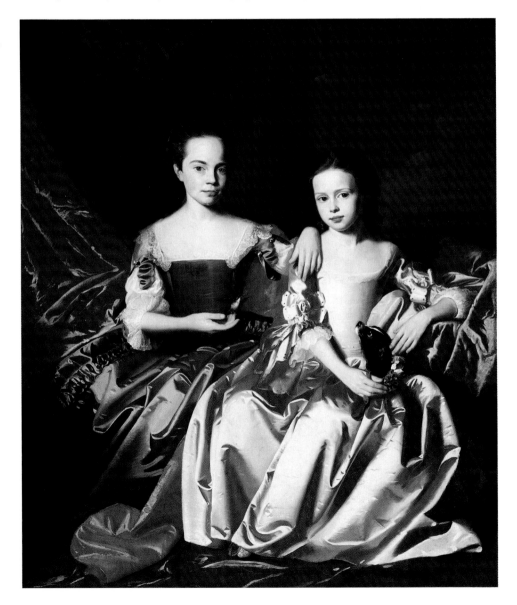

him to be original. Within those boundaries, Copley managed to reveal the individual personalities of the girls, and the result is sufficiently original and sincere to give life to the conventional subject. This portrait seems to be intended for the eyes of more than the members of the family; it was intended to establish forever the social position of Mary and Elizabeth Royall in the eyes of their social circle.

One of the reasons for painting a face is to try to understand it, to read its expression and to fathom its message. When the face is the artist's own, the audience first examines the image to discover why it was painted. Is it an image of vanity and self-assertion, or one of self-discovery? In the case of Vincent van Gogh (*van GO*; 1853–90) there can be no doubt that his self-portraits were painted for self-discovery (Fig. **2.5**). They seem to be painful and searching answers to the question, "Who am I?" In this painting from the last year of his life, the body in its blue suit merges with the blazing blue and white pattern of the background. The face is strongly drawn in dark lines and modeled in blue and orange around the penetrating eyes. Despite its intensity, the figure has a tendency to slip away into the misty whirling space behind it—one can see the eyes willing the body into material existence against the background forces that threaten to carry it off. Fortunately, few self-portraits show such an effort to prove the question of existence; fewer of us have such a desperate need to reaffirm the fact of our being.

There are as many reasons to paint a portrait as there are people in the world, but the sitter and the painter have different reasons in every case. The sitter has a self-image that must be conveyed, and the artist sees a unique individual who must be revealed. Those two images are always different, unless the sitter and the painter are the same person, when the unity of intention makes self-portraits especially powerful and revealing.

Two American sculptors' self-portraits show different aspects of personality: the artist as observer, and as a mystical spirit (see Figs **7.35** and **7.36**).

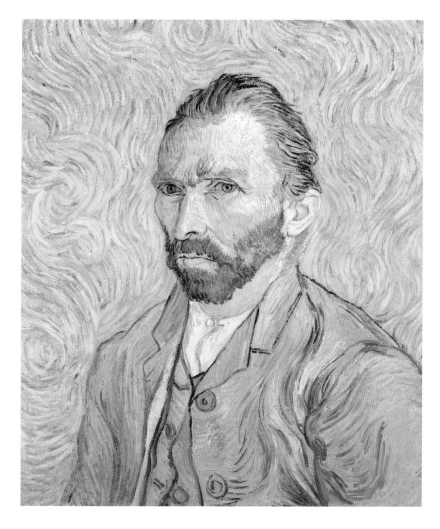

2.5

Vincent van Gogh, *Self-portrait,* 1890. Oil on canvas, 25½ x 21½ in (65 x 55 cm). Louvre, Paris.

THE STILL LIFE

Painters sometimes consider the **still life**—the name that covers a variety of paintings of all kinds of food and drink, table settings, and other household objects, as well as flowers—to be a kind of study or practice subject, since the models will sit patiently while the artist carefully examines the color, light, and composition. But still life is a very old subject with traditional meanings of pleasure, abundance, and security—it is the hedonistic subject.

In an ancient still life painted in **fresco** on the wall of a Roman house (Fig. **2.6**) peaches still on their leafy branch show the sweet gifts of nature, but the artist was also fascinated by the challenge of the transparent glass jar of water. Only a few still-life paintings from ancient times remain, but they were popular, especially with city people who liked to be reminded of nature and its abundant production of food.

The next two paintings (Figs **2.7** and **2.8**) make a striking contrast. Rachel Ruysch (*roysh*; 1666–1750) was the last of the great Dutch flower painters, an internationally famous and successful artist. Her father was an anatomy professor and her mother was the child of a famous architect, so Rachel was provided with the best education and opportunities available to an artist. Her *Flower Still Life* (Fig. **2.8**), done about 1700, portrays each leaf and blossom as an individual botanical specimen, but gathered into a swirling design bursting with life.

Juan Sánchez Cotán's (*hwan SAN-chase ko-TAN*; 1561–1627) *Quince, Cabbage, Melon, and Cucumber* (Fig. **2.8**) has no flowers at all, but each fruit and vegetable is portrayed with hypnotic intensity. Sánchez Cotán joined a monastery in his native Toledo, Spain, and observers have always seen his still lifes as mystical. The dark space behind the shelf or window sill hints at an invisible presence, which shows these living forms as evidence of its power. They hang in space, forming a descending arc, like a demonstration of the planets.

Ruysch's flowers are so beautiful and the picture is so full that at first we may miss its message about the richness of nature, and in many of her later paintings the message changes to one of the transitoriness of earthly pleasures. But here she glories in the flowers, as her Dutch patrons did in their famous flower gardens during this period. The botanical learning her paintings exhibit only reinforces their

2.6
Still Life with Peaches,
c. A.D. 50. Fresco,
approximately
14 x 13½ in
(36 x 34 cm).
Museo Nazionale, Naples,
Italy.

complex compositions, the colorful blossoms entwined in curling stems. Unlike Sánchez Cotán's painting, in which forms are set against darkness, Ruysch's bouquet suggests a reasonable, scientific study of nature in natural light.

William M. Harnett (1848–92) had a successful career as a still-life painter in Philadelphia and New York between 1875 and his death in 1892. *After the Hunt* (Fig. **2.9**) is an American version of a type of painting very popular in Europe called "trompe l'oeil" (*trawmp loy*), or "fool-the-eye," which usually shows objects on

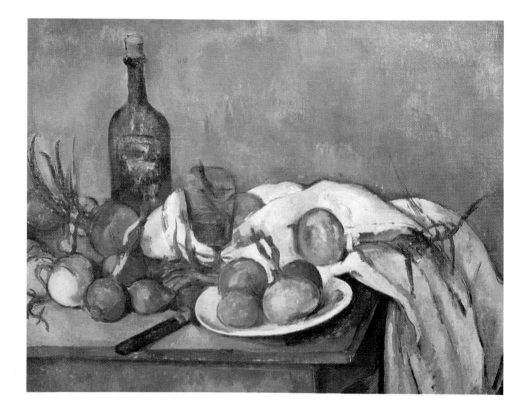

shelves or tacked on a wall or door. The inspiration for Harnett's "sporting still lifes" was a set of black-and-white still-life photographs by Adolphe Braun. With the advantage of color, Harnett was, and remains, popular for his "most natural-looking" pictures. The illusion is one of the pleasures of this kind of still life. But even in Braun's photographs and Harnett's paintings the illusion is not the only point—the dead game animals, the hunting horn, and so on, are symbolic, recalling the pleasures of hunting and the sense of the richness of nature from which this harvest was taken.

The style of Braun's photographs has survived mainly in advertising, where it glorifies the abundance of our consumer products, and although modern still-life painting has the idea of natural abundance behind it, it has turned away from the path pursued by Harnett. Painters have used this subject as a way to work out compositions that carry over into other subjects. Paul Cézanne's *Pink Onions* (Fig. **2.10**) has such grandeur it could be turned into a landscape of rocks, trees, and a waterfall. One critic sees its cool color scheme of pinks and blues as "a harmony of sadness and disenchantment,"[1] a far cry from the feeling of pleasure traditional in the still life. Cézanne took the still life to its expressive limits, making it hint at larger, sometimes more tragic, ideas. The sky-like background, the erect form of the monument-like bottle, the simplified, colorful globes of the onions (like rocks or projectiles), and the relaxed "reclining" white cloth: they all seem to rhyme with other, larger things. His still lifes are as rich in meaning as his other subjects, including his figure paintings and landscapes.

Painters of the **Cubist** movement took off from Cézanne's work to make still life one of their basic subjects. Georges Braque (*brock*; 1882–1963), with his love of music and the Classical traditions of ancient Greece, remained closest to the old traditions of still life (Fig. **2.11**). The guitar, sheet music, fruit, and bottle on a round table must have been easily available in his studio, but they have been painted with a scale and soberness that suggests they are important things. Braque's paintings make us understand that nothing has more dignity than the objects surrounding us in daily life.

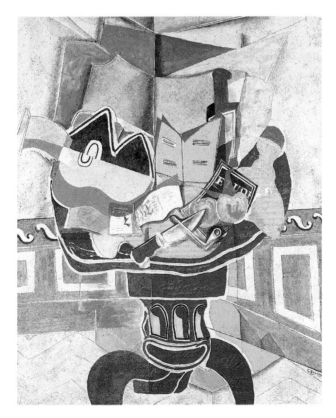

2.11

GEORGES BRAQUE, *The Round Table*, 1929. Oil on canvas, 4 ft 9¼ in x 3 ft 8¾ in (3.7 x 2.9 m). Phillips Collection, Washington, D.C.

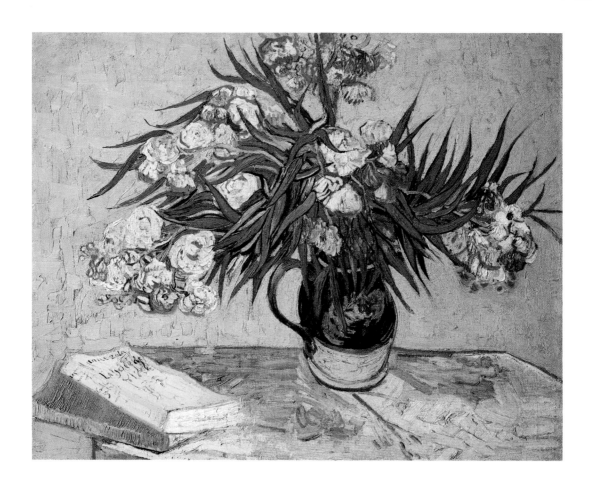

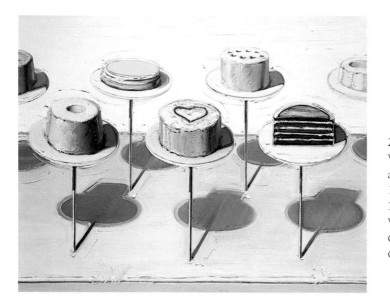

2.14 (opposite)
Warrior chief with sword
and head,
19th century. Wood,
3 ft 7⅝ in (1.1 m) high.
Walt Disney-Tishman
Collection of African Art,
Glendale, California.

2.13 Wayne Thiebaud,
Cake Window, 1970–6.
Oil on canvas,
4 ft x 4 ft 11⅜ in (1.2 x 1.5
m).

Van Gogh's Oleanders

Self-revelation is not limited to the self-portrait, for artists reveal themselves in all their work. Vincent van Gogh's *Oleanders* (Fig. **2.12**) gives the still life an intensity that belonged to the artist, not the flowers.

Vincent (which was the way he signed his work) was the son of a Dutch Protestant minister. When he was sixteen he went to work for a firm of art dealers, first in The Hague and later in London and Paris. An unsuccessful love affair plunged him into depression, and he decided to pursue a religious life, studying for the ministry. Although he failed the educational requirements, he became a missionary and worked among the poverty-stricken coal miners in the mining district of Belgium. His extreme identification with the miners shocked church officials, and he was dismissed. At the age of twenty-seven, Van Gogh turned definitely to art, which he hoped would provide a way to serve humanity. In the remaining ten years of his life (1880–90) he produced the hundreds of paintings that place him among the great masters.

The intensity of his temperament led to continual frustration in his love affairs and friendships. His closest friendship was with his younger brother Theo, who worked in a Paris art dealer's shop and who supported Vincent throughout his later years; Vincent wrote wonderful letters to Theo describing his work. Vincent settled in Arles, in the south of France, hoping to form a colony of artists, but only Paul Gauguin joined him. Their relationship was stressful, and Van Gogh's depression grew so severe that he committed himself to asylums, first near Arles and later at Auvers, near Paris. During these final years, 1888–90, he kept up a tremendous production as an artist and began to receive recognition, although he sold almost nothing. Finally, in despair over his severe depression and worried that his brother could no longer afford to support him, he shot himself. He died on July 27, 1890, at the age of thirty-seven.

Considering his tragic life, it is surprising that Van Gogh was an important still-life painter, since still life is conventionally about the pleasures of life. In *Oleanders* Vincent reveals his knowledge of that traditional meaning by including in the composition a book by Émile Zola whose title is *La Joie de Vivre* ("The Joy of Life"). But the painting is so dramatic in its colors and in the spiky leaves of the plant that our conventional idea of pleasure is given a very original twist.

2.12
Vincent van Gogh, *Oleanders*, 1888.
Oil on canvas, 23¾ x 29 in (60 x 74 cm).
Metropolitan Museum of Art, New York.
(Gift of Mr and Mrs John L. Loeb, 1962.)

Pop Art of the 1960s and 1970s gave still life a new lease on life. The abundance Pop Art showed was not that of nature, but that made by cooks and bakers. *Cake Window* (Fig. **2.13**) by Wayne Thiebaud (*TEE-bo*; b. 1920) was painted from memories and the imagination, not from life, but the cakes are meant to be everyday objects. "I'm interested in the dignity of the thing, the object, so long as it has some sort of genuineness," Thiebaud has said. "When my students worry about what to paint I tell them what James Joyce said—that any object deeply contemplated may represent a window on the universe."[2]

The audience for Cézanne, Braque, and Thiebaud has always understood that a theme of natural abundance lies behind their still lifes, but their originality lies in the ways they have departed from the conventional idea. Their work has appealed particularly to educated observers seeking new ways to see reality. Originality is especially easy to see in subjects in which the conventions are firmly established, as they were in still life.

THE NUDE FIGURE

In many of the world's cultures clothing is the great subject of symbolism, defining both rank and a person's spiritual role. Nakedness, on the other hand, is just normal or common. We see this in the African Tikar/Bamileke larger than life-size wooden figure of a warrior-chief, a royal ancestor (Fig. **2.14**). The figure holds a sword (whose blade was lost long ago) and a head, which probably represents a portrait of his ancestor, but its expressive laughing face is the most impressive feature of all. Nudity of this sort might be compared to that used in the depiction of ancient Greek

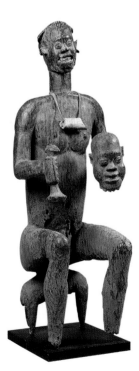

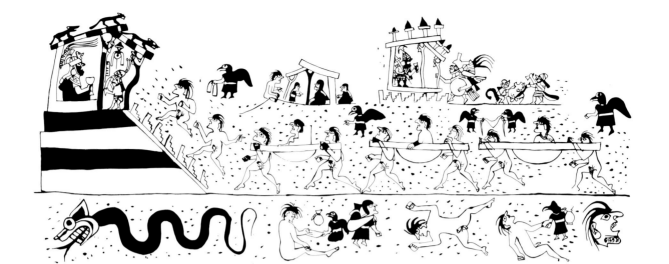

2.15 (above)
The presentation of
prisoners to the victorious
chief, A.D. 500–600.
Fine-line drawing on a
pottery bottle.
(Roll-out drawing by
Donna McClelland.)

2.16 (left)
Zeus,
460–450 B.C. Bronze,
6 ft 10 in (2.1 m).
National Archaeological
Museum, Athens.

gods (see Fig. **2.16**) and rulers, in which nakedness was normal or superhuman, but not especially meaningful in itself. The figures in the drawing from a Moche bottle (Fig. **2.15**) are different because nakedness was not part of the everyday life of the Moche, and clothes gave the wearer status in society. The drawing shows a line of prisoners, carrying their chiefs and wounded comrades in litters, as they run across the desert to be presented to the king of the victorious forces. Vultures and women dressed in black deal with the dead and wounded, all of whom have been stripped of the armor and weapons that gave them rank.

The very ancient idea that the earth has a feminine nature and the sky a masculine one seems to be present in all parts of the world, but unlike other world regions, the Western tradition used the naked human body to symbolize those cosmic roles of the restless heavens orbiting around the stable earth. While you might think that one naked person is, symbolically, pretty much like any other naked person, those ancient ideas produced a tradition in which the figures of women and men unclothed have entirely different meanings in art. That is apparent, first of all, in the fact that traditionally male nudes are doing something, such as throwing a spear (Fig. **2.16**), while female nudes are simply standing or sitting. The restless, moving sky with it circling planets and stars, sun and clouds, as opposed to the stable and fertile earth—those are the ancient ideas behind that difference.

That traditional difference is summed up in *Fête Champêtre* (*fet shawm-PET-ruh*) by Titian (*TI-shun*; 1487–1576) (Fig. **2.17**), long attributed to Giorgione (*jor-JO-nay*; 1478?–1511). Here two clothed young men are playing music on a country hillside, oblivious to two nude women, one holding a flute, the other dipping water from a fountain. One gets the impression that the women are invisible to the young men,

2.17
Titian,
Fête Champêtre
("Pastoral Concert"),
c. 1508.
Oil on canvas,
3 ft 7½ in x 4 ft 6¼ in
(1.1 x 1.4 m).
Louvre, Paris.

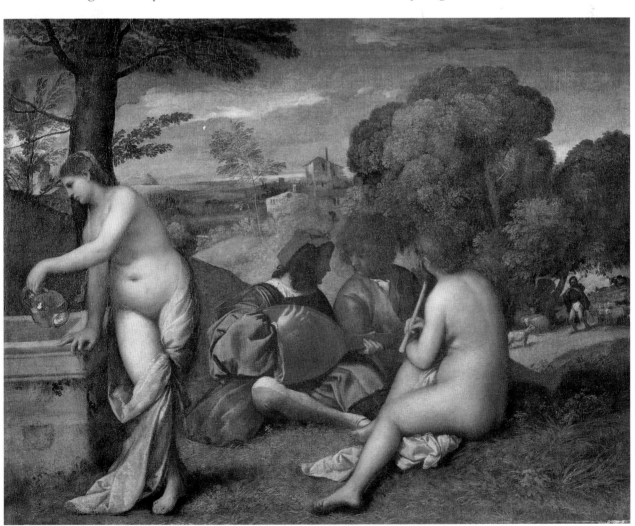

that they are imaginary or symbolic, in a way that the men are not. The shepherd with his flock, the lush landscape, and the lute we are supposed to hear in our minds bring a vision of the simple, sweet pleasures of country life. The ancient Greeks set poetic stories about that kind of life in the region called Arcadia; this painting still speaks to us of "arcadian" pleasures. The arcadian life is lived under the patronage of female nature spirits—Mother Nature, we would say. The women in Titian's painting occupy the foreground because they are the most important figures, the supernatural ones who rule this happy country of natural pleasures.

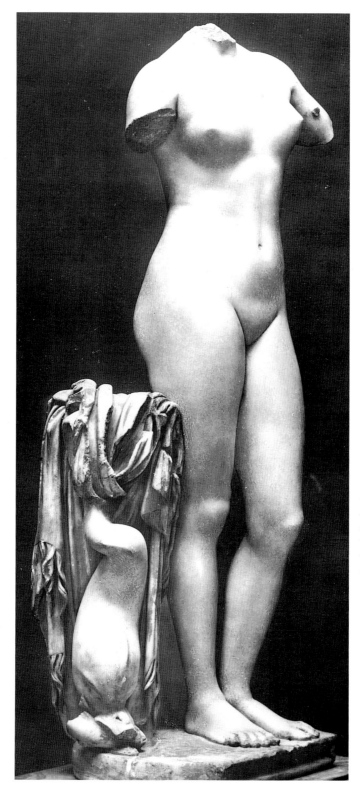

2.18
Aphrodite of Kyrene,
c. 100 B.C.
Marble, 4 ft 8 in (1.4 m).
Museo Nazionale Romano,
Rome.

Titian's women show no sign of shyness about their nakedness; it seems to be their natural condition. Most of us in such a situation would feel naked, a word that implies we are accustomed to appear in public wearing clothes. The word "nude," however, belongs to art and refers to human figures that were never clothed and that represent the eternal idea of the human body.[3] The men in Titian's painting are placed at a certain time in history by their clothing, but the women are timeless. For that reason we are shocked when we look at nude portraits of real people. Both George Washington and Napoleon were portrayed by sculptors who had the misguided notion that they could be represented in the nude, like Greek gods. But both men belonged to a particular time in history, and we expect to see them in the clothes of their period.

The Greeks had a different attitude to nakedness than we do today. For men it was the normal way to engage in sports or war, but women were more sheltered. It was also considered proper to portray male gods as if they were warriors or athletes (see Fig. **2.16**), but early Greeks represented goddesses clothed like women. When the Greek sculptor Praxiteles (*c.* 390–330 B.C.) carved a nude figure of a goddess for the people of Cnidos they were so shocked that they rejected the work, but in later centuries even goddesses could be represented nude (Fig. **2.18**). The power of the nude depends only partly on the abstract beauty of its lines and shapes. The unknown sculptors who created the *Zeus* and the *Aphrodite of Kyrene* knew that the sexual drive was given by the gods, that it was the motor for our ideals as well as for the continuation of our species.

When Renaissance artists began to revive ancient Greek and Roman subjects, the nude was among the first to return. An ancient poem describes Venus (the Roman name for the Greek Aphrodite), the goddess of love, as being born from the sea, and those lines were the inspiration for a commission to Botticelli (*bot-tih-CHEL-lee*; 1444–1510). The result was the most famous nude of its period (Fig. **2.19**). *The Birth of Venus* is a **tempera** painting, unusual in being on canvas and in the large size of about 6 by 9 feet (2 by 3 meters), with the soft pastel colors and linear style characteristic of that medium. The figure of Venus is mainly produced by a narrow

2.19
BOTTICELLI,
The Birth of Venus,
c. 1485.
Tempera on canvas,
6 ft 7 in x 9 ft 2 in
(2 x 2.8 m).
Uffizi Gallery, Florence,
Italy.

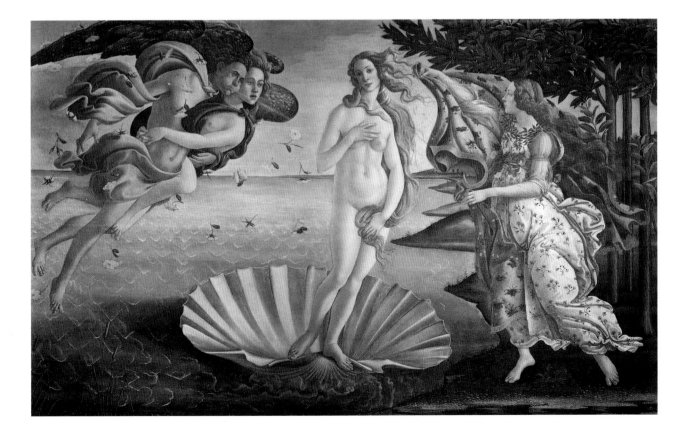

2.20
Rembrandt van Rijn,
Bathsheba, 1654.
Oil on canvas,
4 ft 8 in x 4 ft 8 in
(1.4 x 1.4 m).
Louvre, Paris.

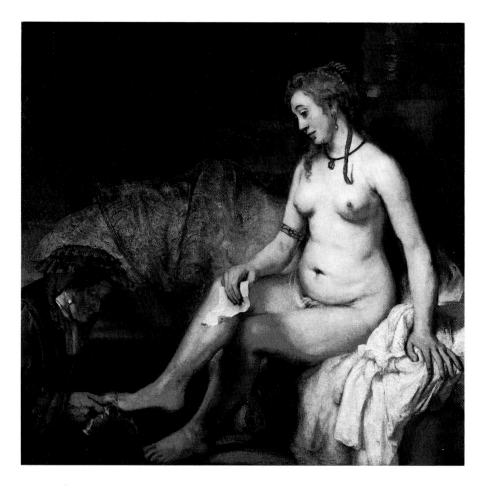

2.21
Pablo Picasso,
Woman in an Armchair,
1929.
Oil on canvas,
6 ft 4¾ in x 4 ft 3⅛ in
(2 x 1.3 m).
Musée Picasso, Paris.

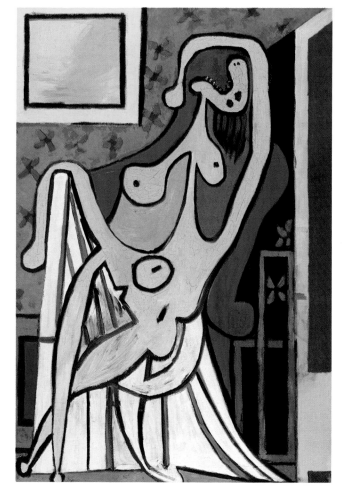

brown line that outlines her body and, combined with yellow lines, forms the graceful flow of her hair. Her body is very lightly shaded, so we get a strong sense of her body as a flat shape, which increases her elegance and unearthliness. Because her body is almost entirely to the right of the supporting foot, she appears weightless, floating on her shell and blown by the winds. These things make her the most spiritual, least physical, of all the nude figures. The result is to change her meaning from the Spirit of Nature to the Spirit of Unearthly Beauty.

Rembrandt, who fluctuated between the earthly and the spiritual in his art, painted one nude that is the perfect combination of the two (Fig. **2.20**). The model for this painting, entitled *Bathsheba*, was probably his faithful mistress Hendrickje, playing the role of King David's beloved in the Bible, whom the king saw bathing. A real woman with a plump body and practical hands and feet, not an imaginary ideal, Bathsheba has an expression that is so full of thought, doubts and regrets that her whole story (told in chapters 11–12 of the Second Book of Samuel) is summed up in her face. Natural as Bathsheba is, she is treated by Rembrandt as a timeless figure, not as a portrait of an historical person.

With the rise of **Modernism** at the beginning of the 20th century the nude entered a new chapter. Modern artists were trying to overthrow all the traditions, which included the nude as an ideal. On the other hand, they wanted art to be based on creative imagination, not on copying the visible world. It turned out that many of the most important Modernist paintings included nude figures because one of the forms found in every imagination is the human body. *Woman in an Armchair* (Fig. **2.21**) by Pablo Picasso (1881-1973) is a Modern version of the nude which rejects tradition. Those earlier nudes, Picasso seems to say, are idols I no longer worship. The body can make other expressions—it can scream, for example. Critics have commented on the pain and agony the figure conveys, not only by the pose and expression but also in the red and green colors and the brushwork, which are harsh.

THE LANDSCAPE

The common way to represent nature and her moods in ancient Western art was by **personification**—that is, by using a human figure to represent the goddess of nature (for a good example see Fig. **10.33**). In China, however, old religious ideas led to landscape paintings being used to express some of their deepest beliefs. Since about the 6th century A.D. landscape has been one of the most admired categories of Chinese art, and during the Song Dynasty (A.D. 960-1279) a distinctive style was invented that used black ink on paper or silk mounted as vertical hanging scrolls or handscrolls, to be unrolled between the two hands. *Travelers on a Mountain Path* (Fig. **2.22**) by Fan Kuan (*fahn kwahn*), is one of the few original paintings by a known artist to have survived from that period. A hanging scroll nearly 7 feet (2.1 meters) tall, it presents a scene of wild mountains and cascading streams only made grander by the tiny mule train approaching the ford. Chinese philosophies suggested that nature has a moral dimension: "Nature is vast and deep, high, intelligent, infinite, and eternal," as one Confucian tract says.[4] Those are exactly the qualities Fan Kuan sought to convey, but he painted the rocks and trees realistically, without the personification that might be indicated by attributing intelligence to nature, and also without the stylization and abstraction found in the work of his many followers. Later painters developed the style of Fan Kuan into a very conventional scene of rocks and streams, losing much of the

2.22
FAN KUAN,
Travelers on a Mountain Path, c. 1000.
Hanging scroll, ink on silk, 6 ft 9¼ in (2.1 m) high.
National Palace Museum, Taipei, Taiwan, Republic of China.

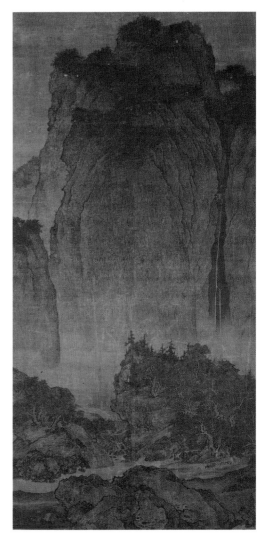

2.23

CLAUDE LORRAINE,
Landscape,
1663.
Brown ink on blue paper,
7¾ x 10 in (20 x 26 cm).
British Museum, London.

dignity and power conveyed by his attempt to show nature as it appeared. His seriousness about representing rocks and trees convinces us that he saw a moral significance in nature that could be expressed only by a faithful depiction.

The glories of Chinese landscape painting were unknown in Europe until the 18th century, by which time the Europeans had developed landscape painting of their own. By the 16th century the old tradition of the female nude as Mother Nature began to take a new form. The moods of nature that had been personified in the goddess began to appear as seasons and weather in depictions of scenes from nature, with the human figure confined to the role of providing scale for nature, as in the Chinese paintings.

Landscape (Fig. **2.23**) by Claude Lorraine (1660–82) shows the new Western idea: animals in a green pasture, noble trees, ruins of a Classical building, and a distant view of the sea and sky. Classical gods still appear—here it is Mercury bribing the cowherd to forget he saw the theft of Apollo's cattle—but the ancient story serves only as a reminder that the earth goddess is somewhere nearby. Claude's drawings and paintings of such scenes were accepted by artists and the public alike as the new conventional version of nature as the expression of divine creation. Claude (Lorraine, in France, was his birthplace; Gellée was his real last name) made his career in Rome and spent much time sketching the countryside. Drawings such as *Landscape* are the result of these sketching trips and are closer to the natural scenes than the oil paintings he produced later in his studio. More than any other artist, he defined the standards for Western landscape painting.

The English painter John Constable (1776–1837) studied Claude, whom he described as "the most perfect landscape painter the world ever saw,"[5] but in *The White Horse* (Fig. **2.24**) we see that it is nature alone—its light, water, and vegetation—which expresses his sense of the sacred, with no Classical gods to be seen. "Every tree seems full of blossoms of some kind & the surface of the ground seems quite living," Constable wrote in a letter; "every step I take & whatever object I turn my Eye that sublime expression in the Scripture 'I am the resurrection & the life' seems verified about me."[6] Paired diagonals spreading left and right from the reflection of the sky in the water show careful composition, but Constable's intimate knowledge of his country dominates the geometry. He shows an actual place on the River Stour where bargemen loaded their towing horse into the bow of the barge to

be poled to the opposite bank where the towpath continued. The gestures of the bargemen and our sense of the barge drifting smoothly into the scene enliven the natural setting.

After Constable the picturesque (meaning "like a picture") frequently became the quality most sought in landscape, an aim almost guaranteed to produce a conventional result, but a radical change soon emerged with **Impressionism** in the last quarter of the 19th century. Camille Pissarro's *Place du Théâtre Français, in the Rain* (Fig 2.25) is an extreme example: wilderness has given way to the creations of

2.24
JOHN CONSTABLE,
The White Horse, 1819.
Oil on canvas,
4 ft 4 in x 6 ft 2 in
(1.3 x 1.9 m).
Frick Collection, New York.

2.25
CAMILLE PISSARRO,
*Place du Théâtre Français,
in the Rain*, 1898.
Oil on linen,
28¾ x 36¼ in
(73 x 92 cm).
Institute of Arts,
Minneapolis, Minnesota.
(William Hood Dunwoody
Fund.)

2.26
NEIL WELLIVER,
The Birches, 1977.
Oil on canvas,
5 x 5 ft (1.5 x 1.5 m).
Metropolitan Museum of
Art, New York. (Gift of Dr
and Mrs Robert E.
Carroll.)

For more on the ideas behind
Impressionist landscapes, see p.
440.

people. Cityscape had existed as a category in earlier times (as works by Butteri and Canaletto in this book show), but its aim had been to glorify the life of the community rather than represent the natural world. In his later years Pissarro gave up outdoor painting and would rent a room and paint the view from the window, which permitted him to paint even on rainy days. The results truly reflect the world most of us inhabit: great streets full of traffic, massive buildings, a smoky sky, and imprisoned trees struggling for survival. Pissarro's *Place du Théâtre Français* is that modern creation, the completely secular landscape. Pissarro knew this landscape as intimately as Constable knew his corner of England, and probably loved it as much, but we can hardly imagine him saying "the surface of the ground seems quite living." The aim of landscape painting had changed to the authentic representation of personal experience, and it rejected any philosophy or convictions that were not based purely on experience learned through the senses. Pissarro's Impressionist colleagues shared that attitude.

At the present time landscape is emerging from a period when abstract or non-objective art took its place. Post-Modern landscape painters look at recent abstractions (by such artists as Mondrian, Pollock, or de Kooning) as their antecedents, not Claude or Constable. Neil Welliver's (b. 1929) *The Birches* (Fig. **2.26**) has a lively pattern over its whole surface which calls our attention to the flatness of the canvas, as in many non-objective paintings. Yet Welliver says, "I am very interested in the idea of the spectator entering a picture, being able to, in fact, not see the picture as an object but really actively entering into it."[7] The 5 by 5-foot (1.5 by 1.5-meter) size of *The Birches* is large enough to seem to envelop a viewer standing close to it.

Those contrary aims of wanting the painting to look both abstract and representational coexist in Welliver's art, as in the work of many of the leading contemporary artists. This is a new version of the contrary aims that have stimulated landscape painters, from Fan Kuan and Claude to our own time: to combine the actual and the ideal. For Welliver the ideal is geometry and abstract marks on a flat canvas; that is the intellectual realm in which the eternal is found now. The actual is the natural environment, which for Welliver has been rural Pennsylvania, where he grew up, and rural Maine, his home for the last twenty-five years. To combine those contrary aims, as Welliver says, "I look very hard, then I make it up as I go along."[8]

THE DIVINE POWERS

One of the most ancient and persistent subjects of art is the spiritual powers that rule the world. One of the most important things an artist can do is to make the invisible visible, and such spiritual beings are by definition invisible. In all philosophies and religions artists have been among those who sought some concrete way to represent spiritual ideas. Early societies, such as the Chavin (*chah-VEEN*) kingdom of ancient Peru, represented some of their most powerful spirits in animal or bird form, or in a mixture of animal and human (Fig. **2.27**). The ancient South Americans knew the jaguar as one of the few animals powerful enough to kill humans, and its superhuman power made it the animal considered to be the guardian of nature and the protector of other animals against human hunters. In ancient times rituals and prayers were probably offered to the jaguar deity by hunters before their expeditions, just as they are by some modern groups. Because people kill animals and plants in order to live, many ancient people thought of nature as having guardian spirits to whom humans should pray and sacrifice before hunting or harvesting.

Quite a different kind of animal spirit is exemplified by Ganesha, the elephant-headed son of the Hindu deity Shiva (Fig. **2.28**). Ganesha, the patron of new beginnings and thus a special guardian of children, the destroyer of obstacles and a bringer of wealth and wisdom, is a beloved divinity in India. The multi-armed figure

2.27 (*below*)
The Lanzón,
c. 900 B.C.
Stone, about 13 ft (4 m)
high.

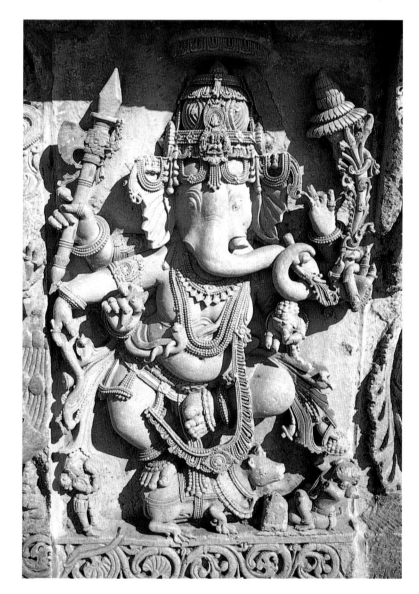

2.28 (*left*)
Ganesha,
12th or 13th century.
Schist (stone)
Hoysale Habedid, India.

holds a rosary, a bowl of sweets, a broken tusk, and a battle-ax in his hands, and above his veined ears his hair is arranged in tiers. At the bottom is a large mouse on which Ganesha rides. The divinity embodies an idea of the beneficent side of nature as a spirit that is full of animal life.

It is a great leap from the small stone figure of Ganesha to the large bronze figure of a Greek god (see Fig. **2.16**), probably Zeus, ruler of the heavens, although he has also been considered to represent Poseidon, god of the sea. The nude figure stands tense and concentrating, balanced to throw his spear, but there is no question that a supernatural being is portrayed. It is hard to imagine that this god, who is so preoccupied with his own activities, would have time to listen to human prayers. Yet we sense in this figure the majesty and momentous power of nature.

The stone sculpture of the *Mucalinda Buddha* (Fig. **2.29**) from Cambodia is about stillness and meditation. This life-size fragment of a larger sculpture tells of an episode in the life of the Buddha, just after he attained enlightenment. Seated under a tree, the Buddha meditated for seven days, during which a thunderstorm arose, with darkness and freezing winds. A huge serpent-king named Mucalinda came out of the earth and sheltered the meditating Buddha in his coils, spreading his cobra hood above the Buddha's head. This sculpture shows the blissful face of the Buddha, deep in meditation, with the now-broken hood of the cobra spreading behind him. The serenity that Buddhists seek is exemplified by this figure of a historical person who became divine by enlightenment.

Christian art, inspired by the teachings of Jesus Christ, sought an image more kindly than the ancient Greek gods and less meditative, more involved in earthly activities, than the Buddhist. The Ghent Altarpiece (Fig. **2.30**), painted by Jan van Eyck (*yan van IK*, rhymes with "like"; 1370–1440?) and his brother Hubert (d. 1426), sums up heavenly power on a grand scale. The dozen panels focus on a youthful, bearded Christ enthroned in heaven, wearing a red robe with pearl borders and a triple crown. Mary and John the Baptist are beside him, and a heavenly choir sings as Adam and Eve look on at the sides. In the panel below, devout pilgrims gather around the altar of the self-sacrificing Lamb and the Fountain of the Living Waters, while the white dove representing the Holy Spirit flutters above.

An early oil painting on wooden panels, the Ghent Altarpiece is one of the high points of painting, but not just because it is so well painted. The variety of its subjects, which is all-encompassing, and the solemnity and richness of its depictions make a very convincing vision of the supernatural personalities ruling the universe. Christ is majestic, but he looks at us and raises his hand in a gesture of teaching or blessing. It has been suggested that as humans have gained more control over their surroundings, the divine powers of nature begin to seem more kindly. The Europeans of van Eyck's time actually were in reasonably good control of their environment, and the feeling that nature is not an overwhelming threat is communicated in this very orderly and systematic painting.

El Greco's large painting of *The Trinity* (Fig. **2.31**) was originally set at the very top of a tall altarpiece, which explains the setting of the figures in the clouds. El Greco (meaning "The Greek," the nickname of Domenikos Theotokopoulos; 1541–1614) shows God the Father as a distinguished old man holding the powerful, athletic body of the dead Christ, as God the Son. Both these figures are different from those in the Ghent Altarpiece and they were invented as subjects of art during the century and a half after the Ghent Altarpiece was painted. The white dove was a traditional symbol for the Holy Spirit, just as in the Ghent Altarpiece.

The mood of *The Trinity* is much more emotional than in any of the earlier examples. The Father holds the Son tenderly and looks with loving sadness down into his face as mourning angels surround them. The idea that the universe is ruled by a power that can understand and experience human emotions is one that had not been shown very often before in art. The worshipper with the Greek Zeus sculpture in mind would approach the altar in quite a different frame of mind from one who had been looking at El Greco's painting, which might suggest that God would pay attention to prayers.

2.29
Mucalinda Buddha,
Angkor Vat style,
late 12th century.
Stone,
approximately life-size.
Musée Guimet, Paris.

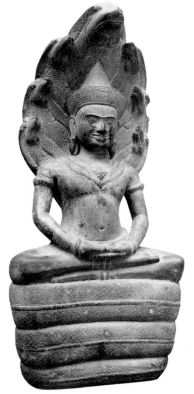

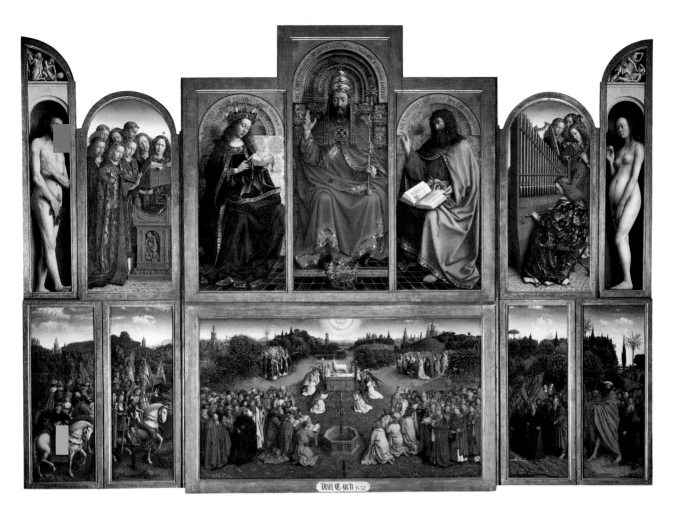

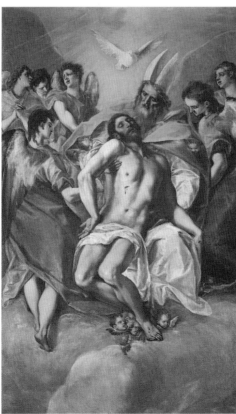

2.30 (*above*)
JAN AND HUBERT VAN EYCK,
the Ghent Altarpiece,
1425–32.
Oil on wooden panels,
11 ft 5¾ in x 15 ft 1½ in
(3.5 x 4.6 m).
Cathedral of St Bavon,
Ghent, Belgium.

2.31 (*left*)
EL GRECO,
The Trinity, 1577.
Oil on canvas,
9 ft 10⅛ in x 5 ft 10⅛ in
(3 x 1.8 m).
Prado, Madrid.

ABSTRACT ART

Perhaps the hardest thing for many people to accept is that art is not, and never has been, pictures of things. It is a way of thinking and recording thought; *things* often appear in art because the artist is thinking about them, often using them as examples of *ideas*. Composing a design is a way of organizing our thoughts.

When an artist represents a person, a still life, or a landscape as accurately as possible, avoiding the expression of personal thoughts (if such a thing is possible), the style is called **naturalistic**. You might argue that naturalistic art is pictures of things and not a way of organizing your thoughts, but no one has ever worked out how to make a picture without *some* mental control. Simply taking the decision to make a naturalistic art is a complicated symbolic act.

Thoughts, of course, are abstract in the sense that they are not objects. Organizing our thoughts often results in a design that is abstract, as in the work of El Lissitzky (1890–1941). *Composition* (Fig. **2.32**) shows invented shapes that never existed anywhere except in Lissitzky's mind and in this painting, and that makes the painting non-representational, since it does not represent anything that has a material existence. A synonym for non-representational is **non-objective**, which means that no material object is represented.

There are many varieties of abstract art, based on the infinite variety of human thought, so we will look at just two of them: **Constructivism** and **calligraphy**. The former is capitalized because it is a movement within Western art with an accepted theory and style and a well-known history, but it also has unity of subject, so that it can be conveniently discussed here. Calligraphy is just the opposite: it is the creation of art out of writing, and it has been used wherever and whenever writing has been in use. The subjects of the written words are everything that has ever been written, but the subject of the calligraphy is the art of writing. Writing as a self-conscious act takes precedence over the message of the words in most calligraphy, or at very least competes with it.

For critic Harold Rosenberg's explanation of how Abstract Expressionism began in American painting of the 1950s, see p. 467.

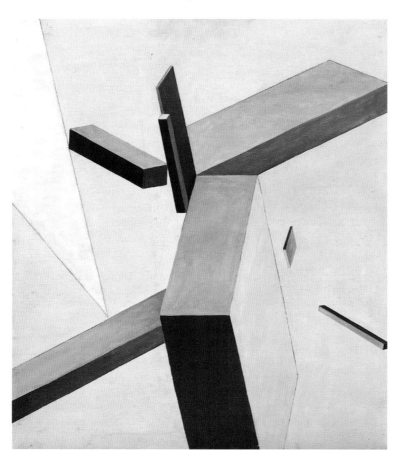

2.32
El Lissitzky, *Composition,* 1922.
Oil and tempera on wood panel,
28 x 24¾ in (71 x 63 cm).
Museum of Modern Art, New York.
(The Riklis Collection of McCrory Corporation, fractional gift.)

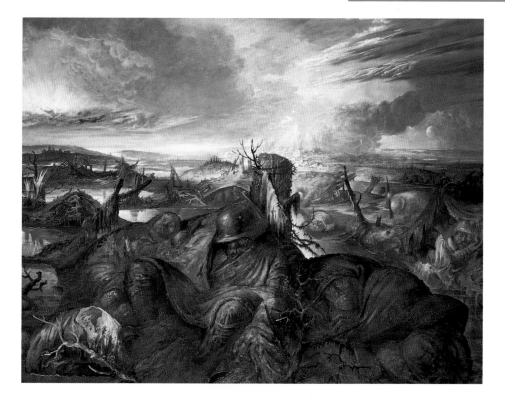

Censorship

2.33 OTTO DIX, *Flanders*, 1934–6.
Mixed media on canvas, 6 ft 6 in x 8 ft 7 in
(2 x 2.5 m). National Gallery, Berlin.

In 1990 the Contemporary Arts Center in Cincinnati, and its director, Dennis Barrie, were charged with obscenity for exhibiting the sexually explicit photographs of Robert Mapplethorpe. The jury finally acquitted them of the charges, ruling that the photographs were art. This was just one of many controversies over what can be shown in public exhibitions. Perhaps the question could also be stated: What are the limits of art? or What are community standards of acceptable expression?

Museum directors and curators told an interviewer* that it is their responsibility to choose what is shown, but persistent controversy can lead the board of trustees to fire a museum professional. In the United States such controversies currently center around sex or religion, but in other times and places other subjects have been controversial. The question always remains: What are the limits on displaying art that many members of the public disapprove of?

A German museum director was forced to resign after he purchased an anti-war painting, *The Trench*, by Otto Dix (1891–1969), a wounded hero of World War I. The painting was said to "sap the will of the German people to defend themselves" and its goriness was offensive to those who had lost family members in the war. (It disappeared during World War II.) Dix was not deterred by the public outrage and continued to paint antiwar subjects, such as *Flanders* (Fig. 2.33), a cosmic view of devastation based on World War I, but meant as a warning as another world war loomed on the horizon.

Let's say you have organized an exhibit of works of art that you think are beautiful, although you know some people in your community will consider them outrageous. Is it enough to put up a sign by the door saying "No one under 18 admitted. Viewer discretion advised. Admission $3.00"? Anyone who pays their money after reading the sign, you could argue, has agreed not to be shocked. But some people will be shocked and consider your show a crime. These things usually end up in court and are decided by a judge. If you were the judge, what would you decide? How do you find out what community standards are? If you violate them, what should be the penalty? Are you advocating censorship? Are there good reasons for censorship? Who gets to be (or has to be) the censor?

* Judd Tully, *ArtNews*, October 1991, p. 156

Constructivism

Russia was one of the important centers of Constructivism during the 1920s, when this abstract style was at its height. El Lissitzky, one of the important figures in this movement, produced designs for buildings and their interior furnishings, lithographic prints, sculptural installations, and many other works besides paintings. In Constructivism there was always a feeling that art and life should be closely linked, and that the work of the artist should have some practical use, even if it was in another art, as for example, in designs for settings and costumes for the theater. That bias toward function helps to explain the machine-like design of much Constructivist art. Its geometric precision also made it easy to adapt Constructivist designs to machine production.

Lyubov Popova (1889–1924) was, along with Lissitzky, one of the leaders of the Russian **avant-garde**, or progressive group. She was especially interested in theories of abstraction, such as Cubism, and her later work was concerned with applying abstract art to stage design and textile printing. Her textile design (Fig. **2.34**), done

2.34
Lyubov Popova
textile design, c. 1924.
Pencil and inks on paper,
9¼ x 7½ in
(23.5 x 19 cm).
Private collection, London.

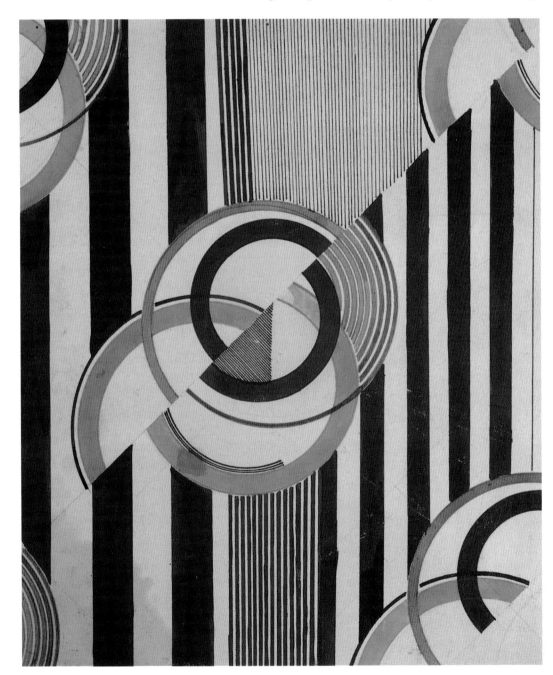

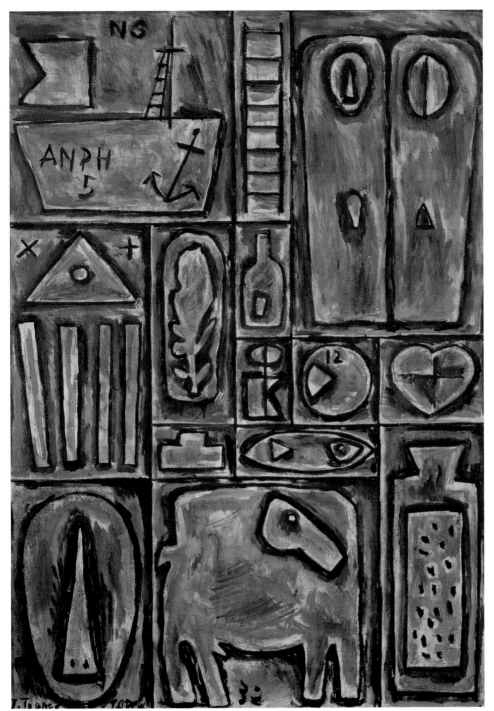

2.35
JOAQUIN TORRES-GARCIA,
*Composition with Primitive
Forms,* 1932.
Oil on canvas,
50 x 34½ in
(127 x 88 cm).
Collection of Elizabeth K.
Fonseca, New York.

the year she died, shows the striking geometry of her work, which glorifies the
concept of the machine with its wheels and planes. Popova described her work as a
"laboratory experiment" concerned with the construction of planes of color, lines,
shapes, and the materials out of which the work was made.[9]

Not all Constructivist art is so precise and machine-like. The Uruguayan painter
Joaquin Torres-Garcia (1874–1949) rejected the mechanistic idea and developed a
humanistic abstract style in which geometry provided a filing system for symbols of
every aspect of life: the intellectual, the emotional, the realms of animals, plants, and
minerals—that is, the whole cosmos. In *Composition with Primitive Forms* (Fig. **2.35**),
Torres-Garcia lays out a set of fourteen signs that stand for human technology and
ambition (the ship and the ladder, upper left), and humans (upper right), the
Classical temple symbolizing the ideal (left center), a mask (the irrational) on the

lower left, and an animal (in the lower center), among other things. The rough brush strokes are intended to remind the audience that this painting is handmade by a person, not a machine, and its nearly monochrome color is meant to remind us that it is a thing, with light and shadow, as if it were a sculpture. Torres-Garcia called his art "Universal Constructivism," meaning that it was not about functional machines or buildings, but about the structure and function of the universe.

Constructivism was important, both as a style and as a subject early in this century, and its influence continues to reappear in more recent work. The subject was the idea of structure, that things are interconnected and work harmoniously together, both on the cosmic level and in the everyday world. The abstraction of Constructivism emphasizes that these are philosophical ideals.

Calligraphy

Writing is the subject of calligraphy and often the subject of the writing is only somewhat related to the style of the calligraphy. Indeed, the style of the calligraphy expands the meaning of the words. Commentaries by Chiang Yee on samples of calligraphy are revealing. On Fig. **2.36** he comments: "Each character is strongly constructed and designed and the strokes are sharp and powerful. One imagines the artist to have been a well-built man with a fine, handsome appearance." On Fig. **2.37** he remarks: "In his style one can discern the loose flesh and easy manner of a fat person. Su Tung-Po's reputation as a happy humorist has engendered the saying that one will live longer if one practises Su Tung-Po's style."[10] Connoisseurs of Chinese calligraphy evidently feel that writing style reveals not only the personality,

2.36 (below left)
Ou-Yang Hsün,
calligraphic inscription,
Tang Dynasty
(A.D. 618–906).
Brush and ink.
From Chiang Yee,
Chinese Calligraphy.

2.37 (below right)
Su Tung-Po,
calligraphic inscription,
Sung Dynasty
(A.D. 960–1279).
Brush and ink.
From Chiang Yee,
Chinese Calligraphy.

but also the physical appearance of the writer, neither of which could be learned from the words that were written.

Calligraphy can be done with many different tools. The Chinese brush is one of the most responsive tools ever invented, changing its mark with every change in pressure or direction. Calligraphy in the Muslim world is done with a broad pen, which can make wide or narrow lines as it shifts back and forth between the width and the thickness of the flat point. Like Chinese, Arabic (Fig. **2.38**) is written from right to left: "a flowing continuum of ascending verticals, descending curves, and temperate horizontals. ... The range of possibilities is almost infinite, and the scribes of Islam labored with passion to unfold the promise of the script." The anonymous poem is trivial and used merely as an excuse for a flamboyant display of gorgeous writing.[11]

2.38
Quatrain written for Fath 'Ali Shah, 1820–34.
Ink, color
and gold on paper,
11¼ x 6¼ in
(28.5 x 16 cm).
Fogg Art Museum,
Harvard University Art
Museums.
(Bequest of John Goelet.)

The tapestry tunic (Fig. **2.39**), which would have been worn by an Inca nobleman, is covered with a kind of script that is called *tocapu* in the Inca language, Quechua (*KECH-wah*), of Peru. Tocapu is so far known mainly on textiles, and because relatively few examples of this script have been found, it remains undeciphered. Although it would be interesting to know the meaning of the ideograms, they may have been secondary to the rich appearance they made. There is a rather small range of signs, but considerable variation in color, which probably affected the meaning. While Chinese and Muslim calligraphers could express their individuality with the stroke of the brush or pen, the Inca tapestry weavers, who probably worked as a highly skilled team, seem to have had little opportunity to express their individual personalities.

In this age of the computer and the ball-point pen, calligraphy might seem to be neglected in modern life, but writing as art continues to be done by contemporary artists almost everywhere. We might return to Russia for a recent example: Eric Bulatov's (b. 1933) *Sky-Sea* (Fig. **2.40**), a large oil painting in a realistic style in which the huge letters slant like rays of light from the horizon toward the observer. Like much calligraphic art, the meaning of the words is unimportant. The massive block letters tell us something else—that the letters leap out into the audience's space, defining a very controlled space in which social life takes place, while the sea and sky, which can be seen quite clearly, spread inwards in pale blues and yellows, defining another space that opens to infinity. Bulatov has said: "the space of the picture I paint must spread to both dimensions—on the one hand toward us, toward the space of our daily life, and on the other hand toward, and within, the space of the picture itself."[12] Calligraphy in modern art merges with the picture, becoming just another tool for the artist to use to represent a complicated modern world.

2.39
Tunic with tocapu design, c. 1500.
Cotton and wool tapestry, 36¼ x 30¼ in (92 x 77 cm).
Dumbarton Oaks Research Library and Collections, Washington, D.C.

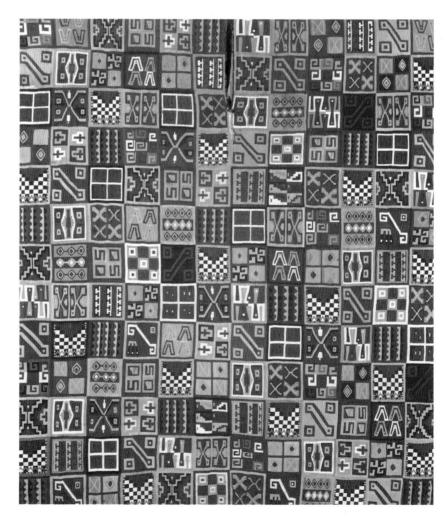

2.40
ERIC BULATOV,
Sky–Sea,
1984.
Oil on canvas,
79 x 79 in (2 x 2 m).
Phyllis Kind Gallery,
Chicago, Illinois.

Abstraction has been a rich field for artists because it opens the field of art to their imaginative creativity. What already exists, which sets certain limitations on representational art, is no boundary for the abstract artist. Whatever is in the mind can be the subject of an abstraction, and whatever is in the mind can be given an outward form and can enter into the field of things that exist, by taking on an existence in art.

FOR REVIEW

Evaluate your comprehension. Can you:
- analyze a work of art into its subject and content?
- explain the conventional meanings of the still life, the nude, and the landscape?
- describe some depictions of divine spirits in the art of several cultures?
- explain examples of Constructivism and calligraphy as abstraction, contrasting it with naturalistic art?

Suggestions for further reading:
- Hayden Herrera, *Frida Kahlo* (Chicago: Museum of Contemporary Art, 1978)
- Charles Sterling, *Still Life Painting* (New York: Harper & Row, 1981)
- Kenneth Clark, *The Nude, a Study in Ideal Form* (New York: Pantheon, 1956)
- Kenneth Clark, *Landscape into Art* (London: John Murray, 1952)
- Max Loehr, *The Great Painters of China* (New York: Harper & Row, 1980)

PART

II

ANALYZING WORKS OF ART

In the painting *Flood* (Fig. **II**.1) by Melissa Miller (b. 1951) the subject is everything that is represented: a river in flood, two tigers and a crane taking refuge on a hill. The **form** is all the things that have actual material existence, that are presented rather than represented. Those are the linen canvas, thickly covered with oil paint in which we see large brushstrokes, the horizontal design with a strong diagonal (the river) interrupted by two vertical masses (crane on one side, tigers on the other). All the colors, lines, and shapes and the way they are organized into a composition are parts of the form. The subject and the form together produce meaning, which we call the content.

You immediately see the crane and tigers escaping the flood, which is the subject, but you probably feel there is more to be said. There is a feeling of powerful forces unleashed, of danger made amusing by being fantastic. Each of us would use different words to describe the painting, but we would probably agree on the mood of danger and mystery and the need to include the action and energy suggested by the strong colors, brush marks, and curving shapes. When you talk about art it is often easier to discuss the form and subject separately, but they join to produce meaning. Inexperienced observers sometimes think the form is merely the vehicle for the subject, just a way to make the subject visible. Looking at the pictures in this book should dispel that idea. The form can be so powerful that it gives meaning to subjects and ideas that seem trivial when described in words.

People sometimes think that meaning can be expressed only in words, which are imagined as pure ideas having no material existence. That error—since spoken words are sound waves and printed words are visible marks—makes art, with its material existence, seem unable to express meaning, being just a group of mute things. The two chapters in this part show how lines, shapes, masses and spaces, colors and textures express feelings and ideas when they are arranged in compositions. The elements of art are its voice, and the design its grammar.

II.1

In Chapter 3 we will look at the marks the artist can make and their ranges of meaning, and in Chapter 4 we will consider some of the ways in which these marks can be arranged into meaningful compositions. Surprising as it may seem, this kind of analysis of art form represents an achievement of mostly 20th-century artists and scholars working in the fields of Gestalt psychology and pragmatic philosophy. Although they are still largely unrecognized, the great names in this research include Ernest Fenollosa and Arthur Wesley Dow (see page 412) and Rudolf Arnheim. What they sought, and found, was an objective universal understanding of the expressive power of art form. When we realize that the making of art is uniquely human, a basic part of our communicative ability, we can see the importance of a "scientific" understanding of the language of art. As you will see, this research is still in its infancy, for we are still struggling to understand the art around us.

3

The Elements of Art

P R E V I E W

You might compare a work of art to a theater. The actors on the stage would be lines and shapes, and the other elements of art. Each of them would be a character, with a personality and a certain way of expressing themselves. "Line" would make dramatic gestures, would move energetically. "Shape" would hardly move, preferring to take elegant poses, while "Mass" would just crouch, unmoving, as "Space" pranced airily around him. "Color" and "Value" would be close friends, "Color" radiant and joyful, but "Value" (black, white, gray) constantly changing moods. You could write speeches for these characters, which is more or less what artists do when they convert their ideas into actual works.

We call one play in which these actors combine their talents **perspective**. In it, three-dimensional spaces are displayed on a flat surface. Symbols of time and motion are another subject, usually calling for the participation of several different elements. The elements of art, you might say, are the actors in art and nothing can be expressed without employing them.

A WORK OF ART MUST BE COMPOSED OF SOMETHING. In music it is notes or tones; in art it is lines, shapes, masses and spaces, size and scale, light and dark, texture and color. For the artist the problem is to use those things in an expressive way, just as a musician must use tones in an expressive way. These elements have unusual independence in *Posted Mimbres Forest* (Fig. **3.1,** *overleaf*), a painting by James Havard (b. 1937), in which a green and white background tone is a stage on which lines and shapes, masses and colors play their parts. Notice that the thick orange lines have sufficient mass that they cast shadows on the background, creating an illusion of space, despite the abstraction of the elements. The rough background is meant to remind us of the cliff walls on which ancient American artists, Havard's ancestors, drew and painted. He makes sure we see the real material—no longer rock, but modern paint—just as one saw it in ancient rock art.

The most basic fact about art is that it exists in the material world; it doesn't count if it exists only in your mind. The reason there are pictures in this book is to keep our minds focused on concrete examples. We look at the work of a number of artists who have made the kind of deep analysis of the elements of art that people think of when they speak of scientific research.

The study of the elements of art is only little more than a century old and was initiated by Ernest Fenollosa (see p. 412).

JAMES HAVARD,
Posted Mimbres Forest,
1986.
Acrylic collage on canvas,
6 ft ½ in x 5 ft 5½ in
(1.8 x 1.7 m).
Elaine Horwitch Galleries,
Santa Fe, New Mexico.

LINE

There are no lines in nature; they are products of the human mind. One can imagine that the first **line** was a circle drawn in the earth by a magician to divide a sacred space from the everyday world outside. All later lines have something in common with such an act, being human marks placed in an environment. They serve as traffic signs for our eyes and our minds, showing patterns of movement like the lines on roads, the edges of surfaces, and the boundaries of solids. We will examine line in its primary uses—as a sign, as a gesture or energy, as the boundary of a shape or the contour of a mass, and finally as having qualities of length, direction, strength, and variability of its own (Fig. **3.2**).

"Each thing has its own sign," Henri Matisse (1869–1954) said. "The importance of an artist is to be measured by the number of signs he has introduced into the language of art."[1] Matisse had an unusual criterion for evaluating the importance of artists, but in the photograph (Fig. **3.3**) we can begin to see what he meant. Working on the symbols to ornament the walls of a chapel he designed in southern France, Matisse uses lines as signs. When we write with the alphabet we are making such signs, but they stand for sounds rather than things. Writing in Chinese is more like Matisse's signs, since Chinese ideograms developed from pictures rather than from sound symbols.

One might disagree with Matisse about the importance of an artist being measured by the number of signs he has introduced, but it is one of the commonest uses of line. Signs are the simplest possible mark with a specific meaning. Matisse

arrived at this very simple way of drawing after years of practice—he is eighty-two in the photograph. It is not easy to find the line that is the absolute sign for something. You can probably think of the logo of a company that aims to be the memorable identification of the company and its product. Company logos are the carefully considered work of artists and designers, but all of us who open a bank account have to provide our own personal logo, our signature, which is a linear sign that stands for us.

A line is the product of an action or gesture, and it always retains that active appearance. "Drawing," Matisse told his students, "is like making an expressive gesture with the advantage of permanence."[2] Lines have direction, as gestures do, and they exert psychological pressure in the direction of their imagined motions.

To be perceived as energetic a drawn line must have open ends rather than being closed into a shape. Line plays a special role in the expression of energy and mass, lines with free ends being an important way to express energy, and lines with their ends joined to form shapes a way to indicate the existence of masses. The quality of

3.2
Varieties of lines:
(a) line of gesture or action with open ends;
(b) lines as arrows to imply movement beyond their own ends;
(c) line as the edge of a two-dimensional surface—the boundary of a shape—and line as texture;
(d) lines as contours of a mass and as hatching and crosshatching for shading;
(e) lines as contours of a mass;
(f) variations in line quality: direction and curvature, weight and width.

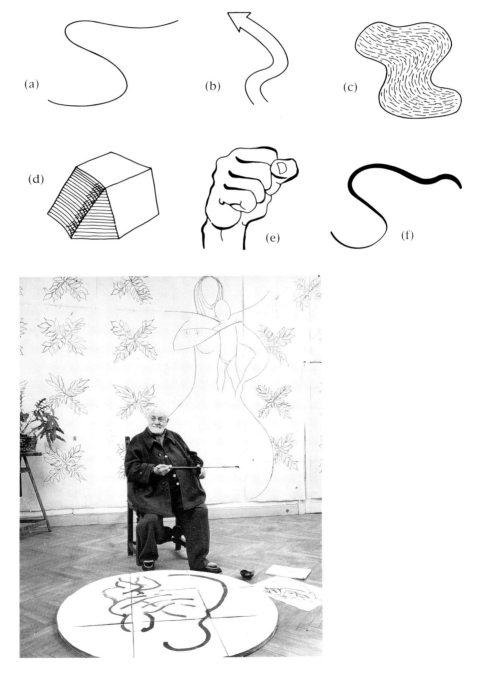

3.3
Henri Matisse drawing a medallion of the Virgin and Child for the chapel at Vence, France, about 1950.

the lines—their direction, smoothness, variability, and the apparent speed with which they were drawn—controls the amount and kind of energy or mass and gives meaning to the action or shape.

Vincent van Gogh's drawing *Grove of Cypresses* (Fig. **3.4**) is mostly composed of short curving lines with free ends. It would be hard to imagine a more energetic design. Most of the lines end in space and do not close into shapes. That increases the feeling that they represent a gesture rather than a boundary. Many of the things represented in the drawing are solid masses—tree trunks, a farmhouse, the surface of the earth—but Van Gogh used mostly unclosed lines to represent them, which reduces their massiveness. The gestures of his hand are clear in the short curving or spiraling marks, which show a strong motion and no hesitation. Van Gogh is letting us see that the trees seem to him more important for the growing life they embody and the agitation of their leaves than for their solidity and permanence.

The style of drawing for which Matisse is most famous is that seen in his portrait of Louis Aragon (Fig. **3.5**), in which simple lines try to tell us everything. Many of

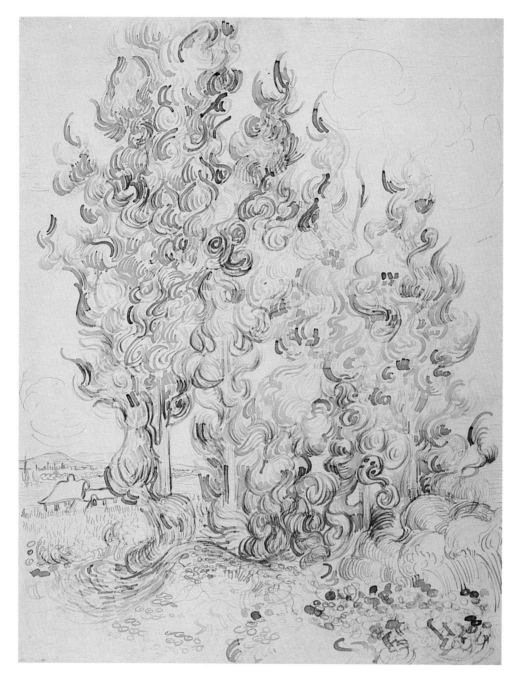

3.4
Vincent van Gogh,
Grove of Cypresses,
1889.
Reed pen and ink over pencil on paper,
24⅝ x 18 in
(62 x 46 cm).
Art Institute of Chicago, Illinois. (Gift of Robert Allerton.)

the lines have free ends, suggesting the energy of the man. Yet the lines are long enough that we begin to see shapes. The outline of the head is almost entirely closed, even though it runs off the page, and that helps us see it as a solid and the area outside the line as space. The effect of solids and spaces is strong enough that we see the right hand, especially, as overlapping the body and coming forward. This is another use of line, as the contour of a mass. A contour line, the ancient Roman Pliny wrote, "should appear to fold back, and so enclose the object as to give assurance of the parts behind, thus clearly suggesting even what it conceals."[3] These lines do not show us what we would call "the shape of a hand," but they suggest its mass as viewed from a particular angle.

The smoothly flowing lines of *Louis Aragon* send a message of calm good humor, but every line in *Suicide* (Fig. **3.6**) by Käthe Kollwitz (1867–1945) cries out with pain and fear. This difference is what we call line quality, which can be defined as differences of length, width, straightness, solidity, direction—and every characteristic that a line can have. The thickness, solidity, straightness, and blackness of Kollwitz's lines express the emotion; the title is an anticlimax because the word does not begin to convey the pain found in the drawing.

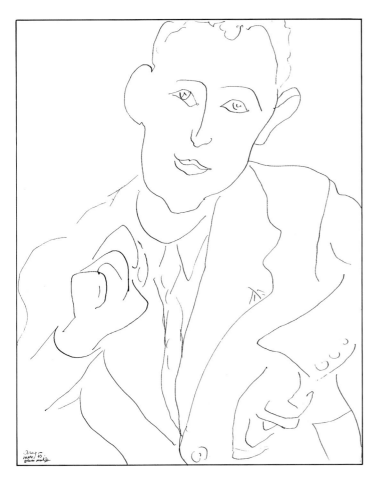

3.5 *(left)*
HENRI MATISSE,
Louis Aragon, 1942.
Pen and ink on paper,
20¾ x 15¾ in
(53 x 40 cm).
Private collection.

3.6 *(below)*
KÄTHE KOLLWITZ,
Suicide,
1928. Brush and ink,
16½ x 15½ in
(41.6 x 39.3 cm).
Kunsthalle, Hamburg,
Germany.

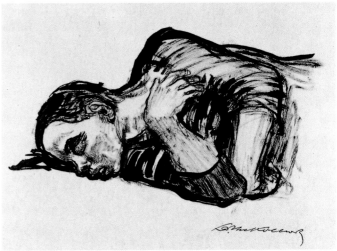

Line quality is especially affected by the speed with which the line was drawn. Artists often call a rapidly drawn line "free" and a slowly drawn line "tight." One is not better than the other, but in different periods the audience may strongly prefer one or the other. Matisse and most modern artists draw with a fast free line, but in the time of Rogier van der Weyden (*RAH-ger van der VI-den*; 1400–64) a slow, controlled line was preferred. Rogier's drawing *Saint Mary Magdalene* (Fig. **3.7**) has firm outlines and lighter patterns of lines as shading, every line placed exactly right. The lines give a sense of propriety, even primness, that adds to the meaning of this drawing of a woman who has turned away from worldly things.

Pablo Picasso's *An Anatomy* (Fig. **3.8**) shows the use of lines to make shapes. These strange human-like constructions seem to have no energy at all, and it is not just because they are made out of boards and pillows. All the lines which represent them have been carefully closed. A simple line passes behind the figures, interrupted by their legs, and it too makes the edge of a shape, which is the floor. Short parallel lines, called **hatching**, have been used to shade the shapes and indicate shadows on the floor, a way to give the shapes a third dimension, or mass. In this way, line, which is one of the least massive of the elements, can be used to describe mass.

The uses of line are vast and varied, and it is especially in line that we see the human mind in contact with the world of experience. "My line drawing is the purest and most direct translation of my emotion," Matisse said.[4]

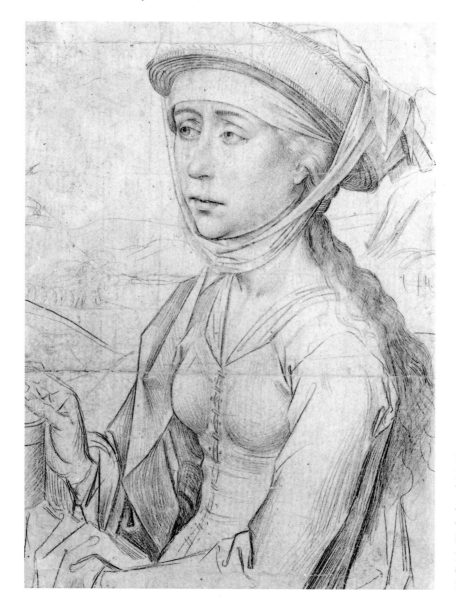

3.7
ROGIER VAN DER WEYDEN,
Saint Mary Magdalene,
c. 1450.
Silverpoint on ivory prepared paper,
6¾ x 5 in (18 x 13 cm).
British Museum, London.

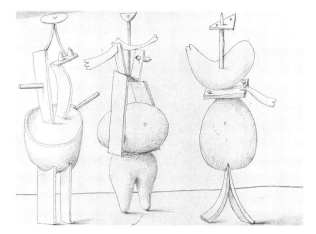

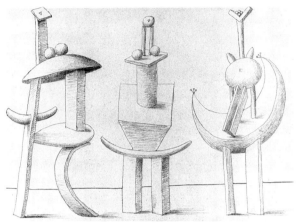

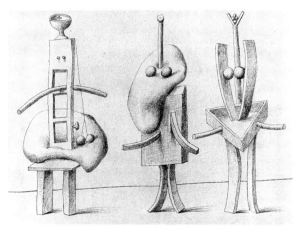

3.8
PABLO PICASSO,
An Anatomy,
1933.
Pencil on paper. Musée
Picasso, Paris.

Classical Line

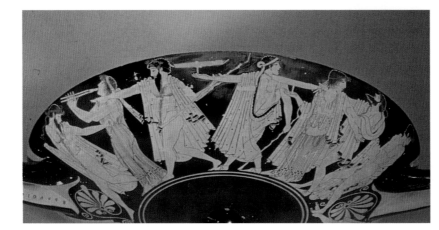

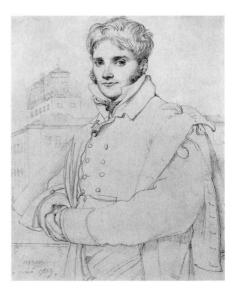

3.9 (*above*)
THE BRYGOS PAINTER,
Procession of Revelers,
c. 490 B.C.
Detail from a kylix from
Vulci. Martin V. Wagner
Museen der Universität,
Würzburg, Germany.

3.10 (*below*)
JEAN AUGUSTE
DOMINIQUE INGRES,
*Portrait of Merry Joseph
Blondel*, 1809.
Pencil on white paper,
7 x 5½ in (18 x 14 cm).
Metropolitan Museum of
Art, New York. (Bequest of
Grace Rainey Rogers,
1943.)

A particular style of drawing with long, even contour lines has been associated with Classical style for more than two thousand years. Drawings done with this kind of line, even by a 20th-century artist, bring with them echoes of ancient Greece. Line drawing was the basis of ancient Greek painting, especially as we see it on Greek vases, which are almost the only surviving paintings from that period.

In the procession of revelers carrying wine cups (Fig. **3.9**), painted by the Brygos Painter about 490 B.C., we see in the anatomy and drapery the controlled lines that the Greeks admired.

Line is even the subject of legend. The Greek painter Apelles of Kos went to the island of Rhodes to visit the famous painter Protogenes, whom he had not met. He called at Protogenes' house, but an old woman guarding his studio told him the artist was out. Seeing a large panel on the easel ready for painting, Apelles snatched up a brush and painted a single fine line across the panel; then he left. When Protogenes returned he examined the line on the panel and concluded that Apelles must have visited him, for no one else could have drawn such a line.

That kind of precise drawing was admired in Roman times and has been revived repeatedly over the centuries, down to our own times. It is always associated with the idea of Classicism, or an intellectual, controlled kind of art in which line and shape are more important than color. In the Renaissance this style was used by Botticelli. In the 19th century, Jean Auguste Dominique Ingres (*ANG-gruh*; 1780–1867) not only used the style but thought everyone else should too. Since he was the most influential person on the committee choosing artists to receive government commissions and fellowships, his intolerance of styles that were freer or more emotional became a controversial issue—an issue that lasted, in fact, for about a century.

In spite of Ingres' intolerance, his own drawings are still much admired. His portrait drawing of Merry Joseph Blondel (Fig. **3.10)** is typical of his work. He was one of the early artists to draw with graphite pencils (what we usually call "lead pencils"), which permitted shading and gray tones that the Greek vase painter could not achieve. But Ingres allowed himself only very limited effects of light and shadow, preferring to concentrate on a very pure line. The purity of the lines gives the picture a dream-like quality which would be lost in a style with contrasts of light and dark or heavier textures and illusions of mass. Classical line drawing, we can be sure, will always find artists to use it and audiences to appreciate it.

SOME USES OF LINE IN SCULPTURE

Before we leave the element of line we must go to the other extreme, from lines drawn to lines carved, modeled, and constructed in sculpture. Boundary lines of shapes and contour lines of masses exist also in three-dimensional forms.

The unknown sculptor who carved the figure called *Saint Theodore* (Fig. **3.11**) saw his problem differently: how do you represent the soul in stone? All artists face that problem to some degree—how to use materials such as paint or stone to represent the immaterial—the spirit, or thought. This artist did not have the opportunity to choose a less massive material because his sculpture was part of the decoration of a Gothic cathedral and had to be made of stone. Yet he did everything possible to help us see the soul within the stone. The man is slender, with a long face, which helps us believe he is not given to such earthly vices as gluttony. Even more important, though, is the long tunic which is almost flat near the shoulders and falls into a dense pattern of shallow folds which make vertical lines, many of them ending in spear-like shapes at the top. These unclosed lines are not only vertical, leading our eyes heavenward, but they maximize energy and minimize mass. We might doubt that the saint had the strength to be a soldier if we could not see his arms, their solidity and breadth emphasized by the texture of the chain mail over them. The sculptor avoided horizontal lines, which would recall the horizon

A linear style was used on boats, jewelry, and book illustration in Celtic and Viking lands (see Figs **11.3**, **11.4**, and **11.5**).

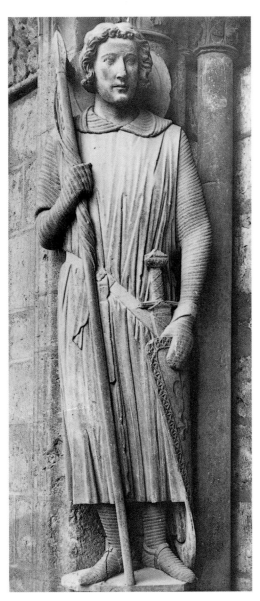

3.11
Saint Theodore,
1230–36.
Limestone,
over life-size. Chartres
Cathedral, France.

3.12
<small>Carl Andre,</small>
97 Steel Line, 1977.
Steel plates,
environment.
Westfalisches
Landesmuseum für Kunst
und Kulturgeschichte,
Münster, Germany.

and the earthly world, and indeed gave the saint such a heavy sword that even his belt is dragged down to a steep diagonal. Along with the sword and spear, the belt adds to the pattern of rising lines. Here line played an important part in opposition to the massive character of the stone.

In 1977 the American sculptor Carl Andre (b. 1935) made a sculpture for the German city of Münster consisting of, as the title says, *97 Steel Line* (Fig. **3.12**). A work of art always changes its surroundings by its presence, but this line of steel plates incorporates its surroundings and makes them become art along with it. The lake and distant steeple become lines and shapes by the force of the line pointing to them. This is not an imaginary line—we will examine the compositional uses of imaginary lines later—but a material reality. It is an open line, which makes it active, like the gesture of pointing or the motion of walking. Its separate plates suggest stepping stones, drawing us into a quick measured movement along its length. Since the grass remains the same on both sides, it is not a boundary or a contour. It seems miraculous that such a simple thing could unify everything within the horizon, but that is the power which the elements of art have, to give form and meaning to the random experience of the world.

SHAPE

In our common language we use the word **shape** for both two- and three-dimensional forms—we speak of "the shape of a car," for example. But artists usually use the word "shape" mainly for two-dimensional forms and speak of three-dimensional forms as "forms" or "masses" because for artists there are great differences between the two- and three-dimensional arts. This section will be concerned with two-dimensional shapes. Three-dimensional shapes will be discussed under the heading "Mass and Space."

3.13
Five-year-old,
Man with a Saw,
c. 1960.
Crayon on paper.

A shape, then, is a two-dimensional surface with a boundary or edge—the basic way we represent a thing. As small children we move from scribbling toward drawing and begin to make circles that stand for everything—people, animals, houses, trees. A five-year-old even shows the teeth of a saw as circles, not thinking of them as shapes but merely as signs for "thing"[5] (Fig. **3.13**). Later we learn how to make more different shapes, but even as adults we diagram things by drawing simple shapes, showing one category by circles, another by squares. In other words, generalization about conceptual or visual reality starts with shapes. Still, shapes are remote from earthly experience because there are no two-dimensional things in nature. Perhaps it is that "purity" that gives shape its elegance for us. Just as lines express action and textures hint at mass and strength, shape expresses a state of existence divorced from gross material.

3.14
KITAGAWA UTAMARO,
*The Tea-house Waitress
O-hisa.*
Woodblock print,
1791–92.
British Museum,
London.

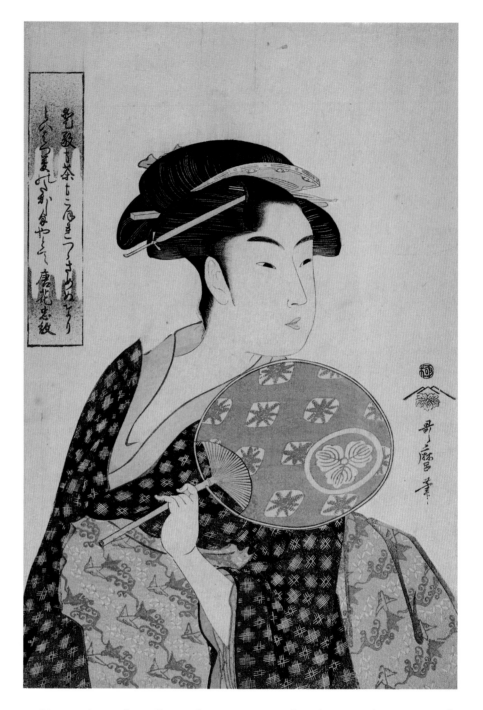

Utamaro's woodcut *The Tea-house Waitress O-hisa* (Fig. **3.14**) is composed entirely of shapes, each with its outline and color, many of them with textile patterns. If you consider it carefully, you can see the flat patterns of the hair as the elaborate three-dimensional hairdo that it represents, and the pose of the body, indicated by the position of the shoulder and the arm and hand, can be figured out but is not immediately obvious. The feature of this picture that is immediately obvious is its elegance, which is beyond what any of us can hope to achieve in real life, in which we exist as masses rather than as shapes.

Utamaro's *O-hisa* is seen as a figure against a white background. It demonstrates the idea of *figure-ground* relationship, which artists must keep in mind as they work with shapes. The relationship of a line to the paper on which it is drawn is often uncertain: is the line the edge of an imaginary shape, or perhaps a cut in the paper? As soon as the line is closed into a shape we see the shape surrounded by a background surface or space. The background is the **ground**, the shape the **figure**. It

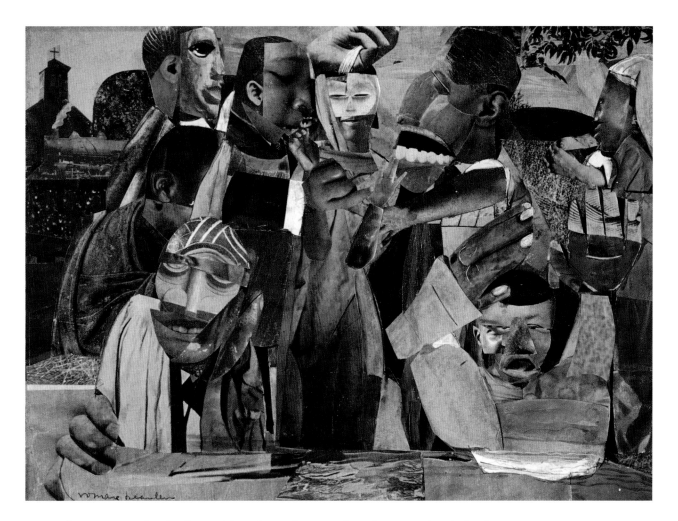

is usually easy to make the figure (shape) stand out against the ground; it is harder to keep the two closely related by color, texture, or additional shapes to preserve the unity of the design. Artists employ the term "negative shape" for those places in a design where the ground shows between elements of figure, which might be called "positive shapes."

Cut paper has often been used for designs in which shapes are important. Cut paper combined with drawing or painting, sometimes with other pasted materials, is called **collage** (*ko-LAZH*) (French for pasting). This medium originated in Cubist art around 1912 and has grown steadily more popular. During the 1960s Romare Bearden began to add cut-up photographs, cloth, and cut pieces of painted paper to his paintings, turning them into collages (Fig. **3.15**). Bearden's awareness of Picasso's use of collage to emphasize shape and texture was enhanced by his experience in Paris in the 1940s, and African spiritual traditions and contemporary cultural politics also found expression in these collages. He emphasizes faces and hands, the most expressive parts of a person. The use of photographs makes the shapes only semi-abstract, suggesting African masks, which are three-dimensional masses, but Bearden cut them into shapes that insist on their flatness, making the elegance of the design struggle with the physicality of real life. We feel a contact with people and their activities in these collages, despite the flatness of the shapes.

For the artist the most important feature of shape is its expressive potential. We observers identify with those expressions, as if the shapes were actors dramatizing them for us. We identify instinctively with the restfulness of horizontal lines and shapes and their relation to the earth, with the dignity and alertness of the vertical, and the energy and action of diagonal lines and shapes. We understand without being told that curving shapes are like our bodies and other living things, whereas angular shapes relate to inorganic or manufactured things.

3.15

ROMARE BEARDEN,
The Prevalence of Ritual: Baptism, 1964.
Collage of paper and synthetic polymer paint on composition board, 9 x 11⅞ in (23 x 30 cm). Hirshhorn Museum and Sculpture Garden, Smithsonian Institution, Washington, D.C. (Gift of Joseph H. Hirshhorn, 1966.)

VALUE

Our eyes are sensors of light; without light we cannot see color or shapes, or anything else, and in that respect light is the most basic attribute of the visible world. For the artist representation of light and shadow grows out of the effects of **value**, which in this case means not market or cultural value, but the range from black through an infinite gradation of grays to white. You can get an idea how that works by examining *The Guitar Player* (Fig. **3.16**) by Jan Vermeer (1632–75). Bright white light pours in from the upper right on the young woman, grading across the cream-colored wall from very dark brown below the window to nearly white at the far left. The side of the woman away from the light is in dark values, the side toward the light, in light values. Her hair and flesh, the yellow of her coat, and the green of her skirt all change value dramatically depending on their illumination. If we extract a slice of the painting (Fig. **3.17**) and look at it in black and white we can see the full range of values used by Vermeer, an infinite gradation of tones from black to white.

3.16 *(right)*
JAN VERMEER,
The Guitar Player,
1671.
Oil on canvas,
21 x 8¼ in (53 x 46 cm).
Iveagh Bequest, Kenwood,
London.

3.17 *(below right)*
Section across the center
of Vermeer's
The Guitar Player
to show value
relationships.

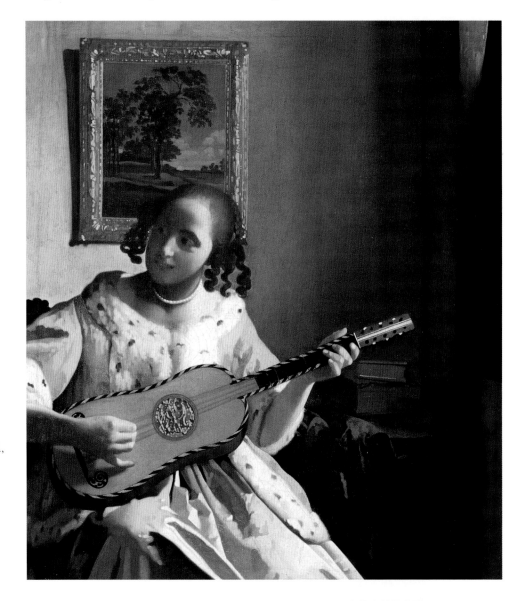

3.18
ALBRECHT ALTDORFER,
*Salome with the Head of
John the Baptist,*
c. 1517.
Chiaroscuro drawing on
gray-green paper.
Cleveland Museum of Art,
Cleveland, Ohio. (John L.
Severance Fund.)

The use of light and shadow to produce illusions of mass and space was a subject of careful study by artists of the Renaissance in Europe. The Italian word **chiaroscuro** (*kee-aro-SKOO-ro*: light, chiaro, and shadow, oscuro) is still used to refer to a kind of drawing popular in the Renaissance. It was done in black and white on colored paper, as we see in Albrecht Altdorfer's (1480–1538) spooky *Salome with the Head of John the Baptist* (Fig. **3.18**), in which the black acts as shadows, the white as highlights, with the gray-green paper as the middle tone. Chiaroscuro drawings were done on paper of various colors—brick red or brown, gray-green or gray-blue—but as long as the paper was a medium value, comparable to a gray, the result was a convincing illusion of mass. The extreme contrast of light and dark in such drawings also heightens the drama. Works in which the value range is very limited tend to have a cooler emotional tone, while high contrasts give a stronger expression.

Modern book designers and illustrators have to consider abstract value because it appears in the text. To harmonize with a text (in Latin), Aristide Maillol (*my-OL*; 1861–1944) made a woodcut design of two wild forest spirits (Fig. **3.19**) in solid black and white. Notice how similar the printed marks of the figures and background are to the printed marks of the text. Yet the picture is easy to understand, and we do not confuse it with the writing.

3.19
ARISTIDE MAILLOL,
title page for *Carmina*
by Quintus Horatius
Flaccus, c. 1928.
Woodcut print on paper,
7½ x 5½ in (19 x 14 cm).

COLOR

For the artist color is usually light reflected from a surface, but it may be a beam of light from an electric source or a sunbeam through a prism. Whatever the source, the color will have a certain hue, an intensity, and a value. **Hue** is the named color, such as red, defined scientifically as light of a certain wave-length. **Intensity** (sometimes called saturation or chroma) describes the purity of the color. Value refers to the amount of black or white mixed with the color. Intensity is naturally reduced by the addition of black (which makes a **shade** of the color) or white (which makes a **tint**).

Artists working in different media think of color in somewhat different terms. A painter thinks of colors as paint in a tube or can which take their color from a **pigment**, a mineral or organic powder. Every painter knows that the three basic colors—called **primary colors**—from which all the other colors can be mixed are red, blue, and yellow. For an artist working in video, or in any medium in which color is cast by a bulb or electric source rather than reflected from a colored surface, color is a beam of light and the primary colors are red, blue, and green. Light reflected from a surface and cast light mix in surprisingly different ways. Here we will consider color from the standpoint of the artist using paint or pastels.

Color relationships are shown diagrammatically on a **color** wheel (Fig. **3.20**). The primaries are red, yellow, and blue, and from them all other pigment colors can be mixed. A mixture of red and yellow in equal parts produces orange; yellow and blue make green; and blue and red make violet, or purple. Orange, green and violet, which are mixtures of primaries, are called **secondary colors**. At that point we run

3.20

The color wheel.
Primary colors are labeled "P," secondary colors "S," and tertiary colors "T ."

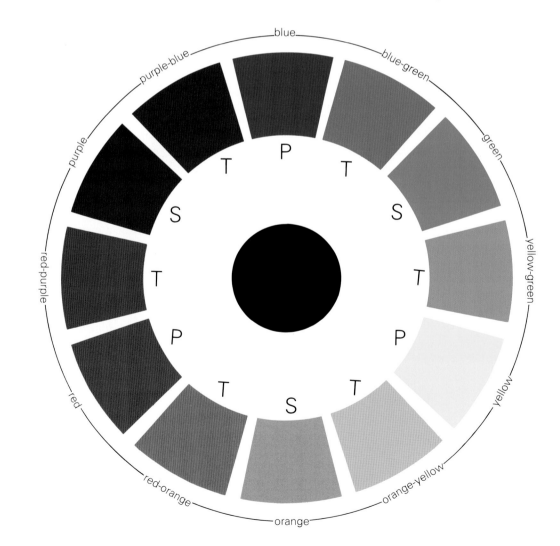

3.21

Value and intensity scale. The black and white scale on the left shows the range of values. Full saturation, or intensity, of color pigment is on the right, with reductions shown by percentages of added black or white moving toward the left.

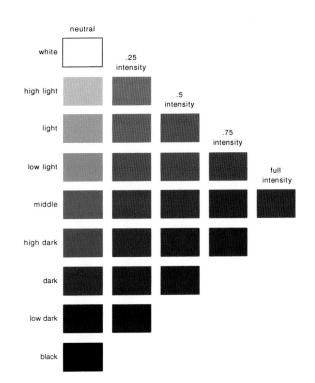

out of basic color names and the **tertiary colors**, which are mixtures of a primary and a secondary, have names that show their source, such as red-orange, or a name based on some object or product, such as chartreuse for yellow-green.

Pigment colors are produced by reflection, a red, for example, being the effect of the red wave-length of light being reflected from the surface while all other wave-lengths are absorbed. Pigment color is thus sometimes called "subtractive" because colors can also be mixed by "addition" by using light. The additive method of mixing light is used in theatrical lighting and in video and electronic color, in which beams of colored light are mixed. The primaries in additive color are red, green, and blue—surprisingly different from the pigment primaries. All colors mixed together in the additive system results in white light, while all colors mixed together in the subtractive (pigment) system results in black, all the light being absorbed. The complexity of these color relationships is evident in the fact that when a computer artist transfers a design from a video output to a printed paper "hard copy," the color mixing changes from the additive system of video to the subtractive system used by the printer, which has four color ribbons in cyan (a blue-green), yellow, magenta (a purplish-red), and black.

The color wheel places primaries opposite secondaries: red and green opposite each other, yellow opposite purple, blue opposite orange. Those pairs are called **complementary** colors. If you mix complements in equal measure, you get a neutral gray in which the intensity of each color is canceled by that of its opposite. The mixture of complements produces the least intense reflection of light from the painted surface. If a color in your painting is too intense, too radiant—you may say it is "too bright"—then you can add a few drops of its complement to gray it. You can also use black to reduce the intensity of a color by making a shade, or dilute it with white to make a tint (Fig. **3.21**).

One of the reasons painters must rely on experiment when they work with color is that our eyes produce afterimages in complementary colors. You can try this by staring for a few seconds at any intensely colored surface and then quickly looking at a plain white surface. You will see the shape of the colored area but in the complementary color. Such optical effects inevitably occur when we look at paintings, and the artist must simply look and change colors until the intended effect is achieved.

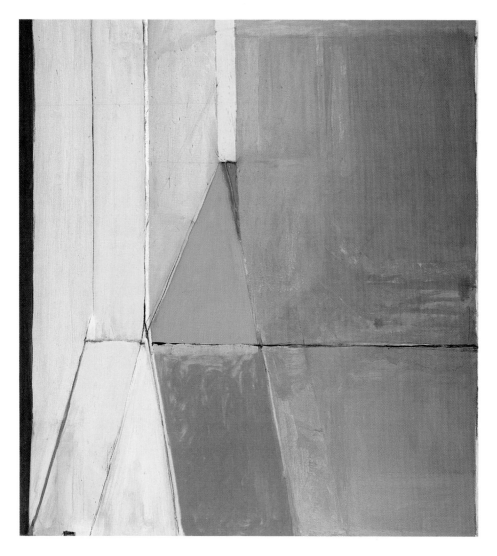

3.22
RICHARD DIEBENKORN,
Ocean Park No. 21,
1969.
Oil on canvas,
7 ft 9 in x 6 ft 9 in
(2.4 x 2.1 m).
The Art Museum,
Princetown, New Jersey.
(On loan from the Schorr
Family Collection.)

Richard Diebenkorn's (b. 1922) *Ocean Park No. 21* (Fig. **3.22**) is a subtle study in color on a canvas so large (7 feet 9 inches by 6 feet 9 inches; 2.4 by 2.1 meters) that it seems to surround you with color as you stand before it. At the upper center are tiny strips of red and blue, and a larger strip of yellow. Those primary colors orient your eyes, providing a solid base from which you can float off into mixtures and grays. Moving downward, you enter a green that has been grayed with red (and also lightened with white), and then a red that has been grayed with some green. Off to the left you find grayed yellows, with tiny areas and lines of blue, and a border of an intense red, its shade darkening toward the top. Right of the center are large areas of very grayed blue; that is, orange has been added, along with white to make a tint. The painting is about color. Each of the primaries is presented once; then they reappear in mixtures which reduce their intensity. Such a description sounds very scientific, but the result is not cold-blooded. It could be compared to a musical theme and variations or a deliciously seasoned dish.

Bahram Gur in the Turquoise Palace on Wednesday (Fig. **3.23**), a Persian book illustration, shows a decorative use of color. For the Persian artist each color belongs to the surface or thing represented, which is called "local color." That is quite a different attitude from Diebenkorn's, in which color belongs only to the painting and serves mainly to evoke a particular mood in the spectator. Color represents tile walls and floors, plants in the garden, sky, and clothing, but which color is chosen for each part is dictated by the artist's experience of such scenes and by decorative considerations. The natural color of the things shown gives the artist a general hue, but each color appears at a high intensity, undiluted by shades for shadows and

TEXTURE

Whether rough or smooth, there is no surface that lacks texture. The word texture refers to our experience of touch, either actual roughness or smoothness or illusions produced by value contrasts such as we see in Michelangelo's (1475–1564) drawing (Fig. **3.26**). Modern life tends to sensitize us to visual experience and make us somewhat indifferent to touch, but texture is one of the important resources of the artist. Most people find soft or rough textures, with their strong appeal to the sense of touch, relaxing and pleasant, and for that reason they are often used in interior designs for homes and environments meant to be restful. Real texture is a basic consideration in all the things we use in our daily life—clothing, furniture, the interiors of our houses and cars, the settings of our tables—and we can treat them as art or not, yet they serve to express our way of life even when we think of them as purely utilitarian.

Even in the representational arts, real texture plays another role that we have not yet considered. This is the texture of the marks made by the artist, which form a kind of screen through which we experience the world of his or her creation. As soon as you have become accustomed to Vincent van Gogh's rugged texture of brush strokes in *Starry Night* (Fig. **3.27**) you accept it unconsciously and "see through it" to the subject. The texture of brush strokes performs two functions: it unifies the various separate parts of the design into one composition (the paint texture is the only thing every part has in common with every other part), and it reminds us that the painting was made by an individual who made this distinctive texture as a personal mark, like a signature.

Representational artists have the problem of placing shapes on a background— the figure and ground relationship mentioned earlier. We think of the figure as solid and textured and the ground as empty space without a texture. Artists rarely have any difficulty in making figures stand out from the ground; it is more difficult to keep them sufficiently unified to provide a single artistic experience that fills the whole canvas or paper. Textured surfaces are also perceived as closer than empty surfaces, and that reinforces the tendency of textured surfaces to separate from

3.26 (*below left*)
MICHELANGELO,
Nude Figure from the Back,
1496–1500.
Pen and ink on paper,
16½ x 14¼ in
(42 x 36 cm).
Casa Buonarroti, Florence,
Italy.

3.27 (*below right*)
VINCENT VAN GOGH,
Starry Night,
1889.
Oil on canvas,
29 x 36½ in (74 x 93 cm).
Museum of Modern Art,
New York. (Lillie P. Bliss
Bequest.)

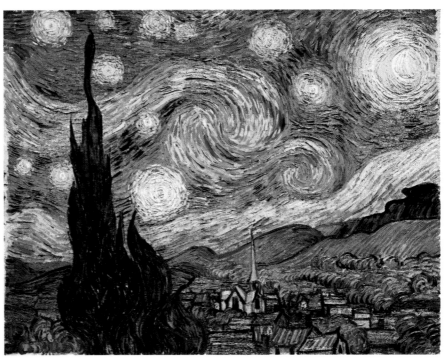

3.28
EDWIN SMITH,
In the Chestnut Avenue,
Croft Castle,
Herefordshire,
1959.
Photograph.

empty ones. To keep the figure and ground unified, to keep them from separating too much, Van Gogh employed his heavy brushstroke over the whole canvas, for solids and spaces alike.

Edwin Smith's (1912–1971) black-and-white photograph *In the Chestnut Avenue, Croft Castle, Herefordshire* (Fig. **3.28**), is a composition in light and dark, but it is also a study in texture. It is doubtful that we would be able to appreciate illusions of texture, such as that of the chestnut trees in the photograph, if we had never been able to experience such textures with our fingers. Knowing real textures permits us to understand the illusions of texture that play important parts in the two-dimensional arts. The shapes and masses in a work of art all have textures, and the artist must take into account not only the real texture but also the represented texture. The chestnut trees in the picture have rough textures, but the photograph has a smooth texture, and the viewer experiences both. Often we are unconscious of one of these textures—most often of the real texture of the work, since we take it for granted—but they both influence our understanding. It is strange, but generally we pay more attention to illusions of texture perceived with our eyes than to real textures perceived with our fingers.

MASS AND SPACE

With mass and space we enter the third dimension: mass is solid material, space is the emptiness between solids. Real masses and spaces belong to sculpture, architecture, and the applied design fields such as furniture, clothing, and automobiles. Illusions of mass and space play an important part in the two-dimensional arts; they will be discussed below, after we have examined the uses of real mass and space.

Mass and space cannot exist separately, but artists have often tried to emphasize one and minimize the other. An Aztec sculpture in stone (Fig. **3.29**) of the ancient god Quetzalcoatl (*KET-zal-CO-atl*, meaning Feathered Serpent) is one in which

space plays a small part, mainly as the space required by the observer. The masses of the body, somehow both human and serpent, bulge out as if growing from some central kernel. The figure looks up into the sky, which was Quetzalcoatl's domain (he appeared as the morning star), but he seems unaware of the space around him occupied by mere humans. Despite his heavenly powers, this Aztec spirit is represented as powerfully massive.

Several of our senses work together to help us appreciate mass and space. We can walk through spaces, touch masses, but mostly we rely on our eyes to show us spaces and the masses that shape them. Our eyes are dependent on light; it is only by light and shade that we can see masses and interpret the form of the spaces between them. All artists working with mass and space learn how to help the audience see mass by providing textures and controlled light; those two elements are indispensable for the perception of mass and space.

When Michelangelo began to plan a sculpture he made drawings in pen and ink in which hatching and crosshatching suggest the rough surfaces of masses seen in light (see Fig. **3.26**). Those pen lines were not imaginary, but represented the parallel grooves cut in the surface of the stone mass when Michelangelo used a flat chisel with comb-like teeth to refine the masses of his sculptures (Fig. **3.30**). That texture intensifies the effects of light and shade, helping us see the masses of the torso more clearly. Our hands can detect the presence of mass without the aid of light or texture, but those elements are essential for our eyes to perceive mass. When variations of light and texture are present in a drawing we perceive an illusion of mass even in that non-massive art form.

3.29 (*above left*)
Quetzalcoatl
("Feathered God"),
c. 1500.
Gray lava,
10¾ in (27 cm) high.
Museum of Art, Cleveland,
Ohio. (Purchase from the
J. H. Wade Fund, 41.46.)

3.30 (*above*)
MICHELANGELO,
detail of unfinished
Bearded Slave,
1530–34.
Marble, 8 ft 7½ ins
(2.63 m) high.
Accademia, Florence,
Italy.

SCULPTURAL MASS AND SPACE

When Michelangelo was working, more than four hundred years ago, sculpture was thought of as an art concerned with masses, while spaces were considered more a problem for the architect. But modern sculptors have claimed spaces as part of their

3.31 (right)
HENRI MATISSE,
The Serpentine,
1909.
Bronze, 22¼ in (57 cm)
high.
Museum of Modern Art,
New York. (Gift of Abby
Aldrich Rockefeller.)

3.32 (far right)
Primordial Couple,
19th century.
Wood,
29 in (74 cm) high.
Metropolitan Museum of
Art, New York.

art. If we compare Matisse's bronze *The Serpentine* (Fig. **3.31**) we find that the audience's space surrounds the figure and penetrates into it. The spaces between the body and the pedestal, the legs, and the arms and the body, seem to have as much form as the masses; they appear designed.

Such interdependence of spaces and masses has been especially interesting to sculptors in this century, who have been inspired by the study of African sculptures in which those abstract relationships are especially important. Matisse was the first modern artist in Paris known to have purchased an African sculpture. *Primordial Couple* (Fig. **3.32**) by a sculptor of the Dogon (*DO-gahn*) nation, in the modern country of Mali, balances masses and spaces in a way modern European and American artists were trying to do. The sculpture represents the couple who were the first divine ancestors of human beings, the Dogon nation's Adam and Eve. The slender, angular masses, rigid and vertical, tell us that these are not merely human beings. The open spaces are larger than in natural human figures, which is meant to suggest that these beings are especially spiritual. Matisse's *The Serpentine* and the African *Primordial Couple* have in common a near equality between masses and spaces. Although it is not a religious figure, *The Serpentine* has a spiritual quality also in that it seems to be deep in thought.

As the balancing of masses with spaces has become of interest to sculptors, their work has developed a closer relationship with architecture, as we can see in Henry Moore's (1898–1986) sculpture *The Arch* (Fig. **3.33**). The artist stands beyond the opening of the natural-looking rocky gateway (actually this is a fiberglass cast). The opening is clearly part of the sculpture, perhaps the most important part. Moore's sculpture plays with the relation between masses and spaces in a way we usually associate with architecture—the name *The Arch* shows that Moore recognizes that fact. The visible interior space of *The Arch* reveals Moore's desire to emphasize the elments of mass and space for their own sakes.

Some younger sculptors have taken over a different kind of space, space quite unlike Moore's preferred outdoor settings, where the unlimited space of nature flows around and through his work. *3-D, 1983* (Fig. **3.34**) by Judy Pfaff (b. 1946) was built into a room 22 by 35 feet (6.7 by 10.7 meters) and about 12 feet (3.7 meters) high, and that is all the space it allows itself. As with *The Arch*, you can enter the space of the sculpture. "Peripheral vision is and always has been crucial to my

work," Pfaff says. "If you can look and see it all at once—then there is a false sense that you know it. I think that if half the work is in back of you, you'll never be coaxed into believing you know or see it all." That can happen only in sculptures which have spaces that can be entered by the audience. But Pfaff says, "I tried to include all the things that were permissible for painting, but absent in sculpture."[6] Line and color, which are important in her work, are elements that have traditionally played a larger part in painting than in sculpture; the room becomes a kind of three-dimensional canvas—we have entered inside the imaginary space of an abstract painting. The design of such complex works as Pfaff's is usually done now on a computer, which allows the artist to see on the screen an illusion of the space with all its shapes and masses. Computer programs permit the artist to rotate the design, move the masses around, and finally print the exact specifications. The final work is constructed by hand, but the computer serves as a sketchbook.

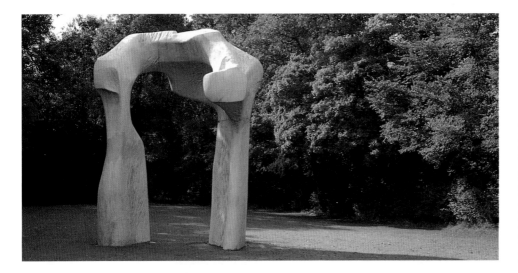

3.33 (*left*)
HENRY MOORE,
The Arch, 1963–69.
Fiberglass to be cast in
bronze, approximately
20 ft (65 m) high.
Henry Moore Foundation,
Much Hadham,
Hertfordshire, UK.

3.34 (*right*)
JUDY PFAFF,
detail of *3-D, 1983,*
1983.
Installation using mixed
materials,
22 x 35 ft
(6.7 x 10.7 m).
André Emmerich
Gallery, New York.

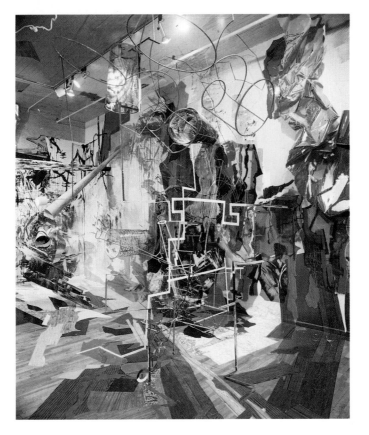

ILLUSIONS OF MASS AND SPACE

Illusions of mass and space play an important part in all the two-dimensional arts. Artists must know how to create illusions or avoid them when they want a flat two-dimensional appearance. As mentioned above, texture and light and shadow can be used to represent mass and space in two-dimensional arts, but in this section we will consider the effects of size and scale, perspective systems, and color in the representation of masses and spaces. Artists use these elements both to create illusions and to avoid illusions, depending on the content they wish to express.

SIZE AND SCALE

In shape and color everything in *The Personal Values* (Fig. **3.35**) by René Magritte (*mah-GREET*; 1898–1967) is just as we would expect to see it in our daily experience. If you concentrate on one item at a time, they are all faithfully depicted. But even if we admit that someone might have a realistic sky painted on the bedroom walls, this is still a very strange room indeed because the sizes of things do not have the usual relationships. The simplest way to explain this is to say that Magritte wanted to startle us. Such variations from natural scale make us wonder, imagine symbolism, and look at our surroundings to make sure that nature truly remains as we thought it was.

Every artist who ever made a picture or sculpture had to make decisions about size and scale—size being the actual measurements of the work of art and of things presented or depicted in it and scale being the relationships of size among things.

3.35
RENÉ MAGRITTE,
The Personal Values,
1952.
Oil on canvas,
31½ x 39 in
(80 x 100 cm).
Collection of Harry
Torczyner, Lake Mohegan,
New York.

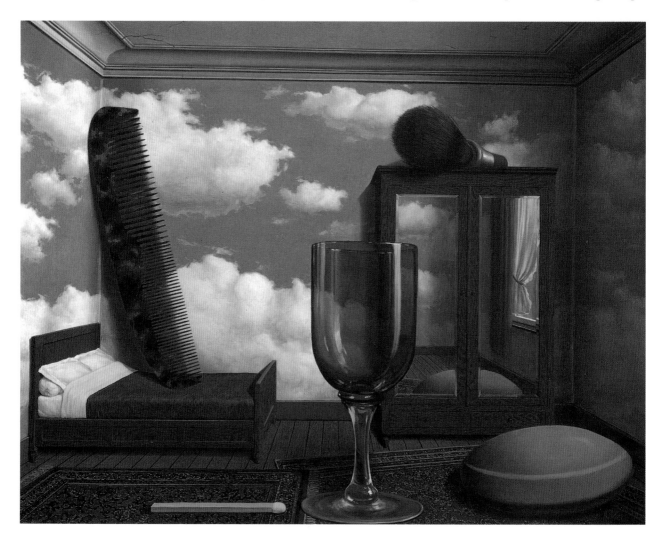

Decisions about size are straightforward and depend on the circumstances, but decisions about scale are a different matter. Scale is a graduated series of steps or degrees. In Magritte's painting the bar of soap, the match, and the comb are all size 1, followed by the shaving brush and glass, size 2, and the bed, cabinet, and rugs at 3—quite a different series of steps from those we see in daily life.

As we try to see Magritte's painting as natural, we may suggest to ourselves that the bed and cabinet must be farther away, but the locations of the comb and shaving brush prevent us from explaining the scale as produced by distance. *The Extinction of the Species II* (Fig. **3.36**), by Yves Tanguy (*eve tahng-GHEE*; 1900–55), demonstrates the power of scale to represent distance. Without a horizon line or any natural object whose size is known, Tanguy convinces us that we see a limitless plain populated by weird forms. Cast shadows and some thin white lines contribute to this impression, but the main factor is the size and position of the forms, all the smaller ones being higher on the canvas. *The Extinction of the Species II* is organized by size and position, but not in linear perspective (see the next section), of which size and position are just parts.

A graduated series of steps may be a perspective based on distance, or it may represent something entirely different, such as importance. *The Buddha's First Sermon* (Fig. **3.37**) shows the Buddha much larger than the other figures to represent his significance, although in life he was the same size as other people. If we look back at Magritte's *The Personal Values* (see Fig. **3.35**) with this idea in mind, the title becomes more meaningful: some things have more personal value to the painter than others and are shown larger. Grooming and habits (drinking, smoking) rank above furniture in his scale of values, and thus in size.

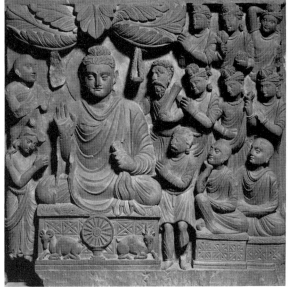

3.37 (*below*)
The Buddha's First Sermon,
c. A.D. 200.
Stone,
26⅜ in (67 cm) high.
Freer Gallery of Art,
Washington, D.C.

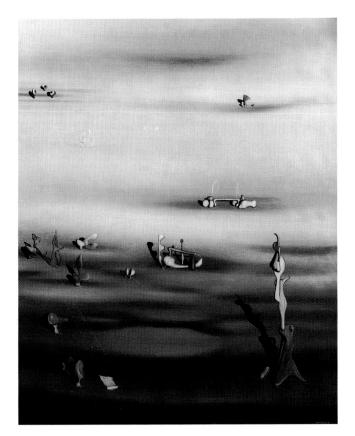

3.36 (*above*)
YVES TANGUY,
The Extinction of the Species II, 1938.
Oil on canvas, 36¼ x 28¾ in (92 x 73 cm).
Patricia K. Matisse Collection, New York.

FOUR SYSTEMS OF PERSPECTIVE

We will examine four important systems of perspective: linear perspective, isometric perspective, an Eastern system of perspective, and aerial (or color) perspective. Each of these systems has something in common with our experience of the natural world, but in each case it is something different. Linear perspective, for example, shares with vision the factor of things diminishing in size as they are farther away from the observer. Eastern perspective shares the feeling that we are at the center of our own experience and that the world expands outward from where we stand. Isometric perspective conforms to our knowledge that parallel lines are parallel, whatever they may look like from any particular position. And aerial perspective places colors in relationships that conform with our experience of nature. Each of these systems is true to nature in its own way and untrue in other ways.

Linear Perspective

Linear perspective is a system for representing masses in space using a scale in which size represents distance, closer things being larger than those farther away. Linear perspective seems so natural that it is hard to imagine that it needed to be

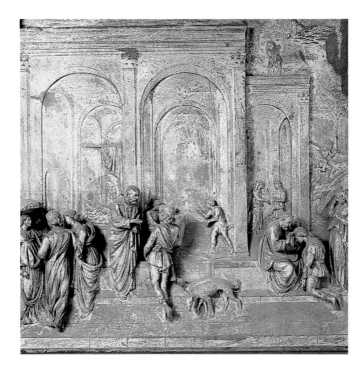

3.38

LORENZO GHIBERTI, the *Sacrifice of Isaac,* panel of the doors of the Baptistery, Florence Cathedral, Italy, c. 1435. Bronze relief, 31¼ x 31¼ in (79 x 79 cm).

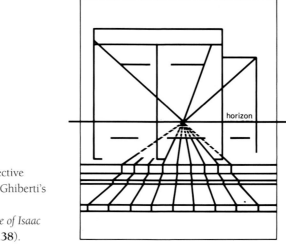

3.39
The perspective scheme in Ghiberti's panel, the *Sacrifice of Isaac* (see Fig. **3.38**).

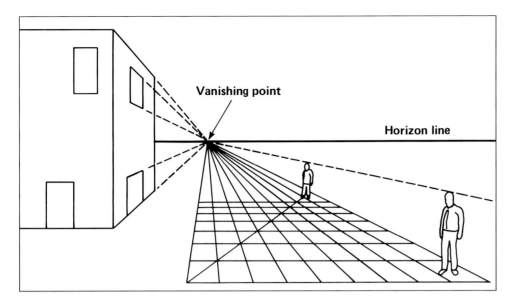

Vanishing point

Horizon line

3.40
Central perspective or
one-point perspective.

3.41
Two-point perspective.

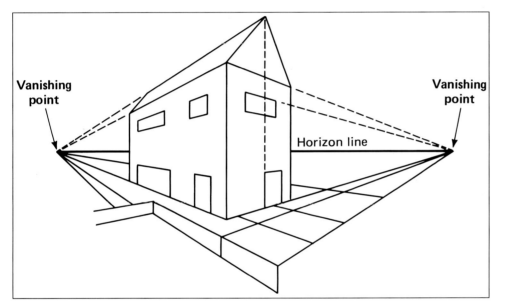

Vanishing
point

Vanishing
point

Horizon line

invented, but it was, and the inventor was the Italian architect and sculptor Filippo Brunelleschi (*BROO-nuh-LESS-kee*; 1377–1446) in the 1420s. Artists had been experimenting with scales of size based on distance for more than a century, but Brunelleschi discovered the vital principle in the system: that the scale of sizes had to reach zero at one point on the horizon (or eye level, which is the same thing), called the **vanishing point**.

One of the earliest examples of linear perspective (dated about 1435) is a bronze relief of the story of Isaac (Fig. **3.38**) by Lorenzo Ghiberti (*ghee-BARE-tee*; 1378–1455). Even though Ghiberti does not show the horizon line, you can easily find its location by extending all the lines that seem to be receding: the tops of the walls and the edges of the floor tiles (Fig. **3.39**). Where those lines meet—and they must meet at one point—is on the horizon line, and it is the zero point of the scale, the vanishing point. You notice that the building is seen straight from the front; all the walls that do not recede are exactly parallel to the picture plane (that is, the actual surface of the bronze relief). This is very natural-looking but rather limited, since we cannot see any building from a corner view in this system. The kind of perspective Ghiberti used here is sometimes called central perspective (Fig. **3.40**), since the vanishing point is in the center, or near it. It is also called one-point perspective to distinguish it from two-point perspective (Fig. **3.41**), in which we see

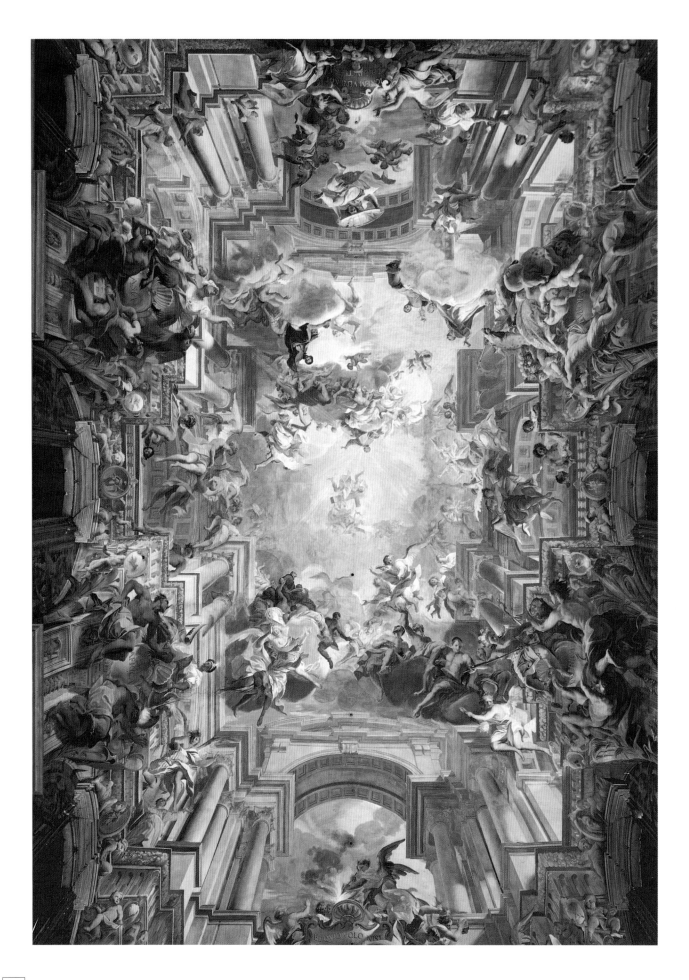

a corner view and the receding lines meet at two vanishing points at the outer edges of the horizon line. The more vanishing points that are used, the more natural is the representation. Tall buildings, for example, diminish upwards, or, if we are on top looking down, downwards.

The most extravagant use of linear perspective was in **Baroque** churches and palaces, where it was used to make large buildings even larger by adding the illusion of still more space. Andrea Pozzo (*POT-so*; 1642–1709) painted on the flat ceiling of the Church of Saint Ignatius in Rome a scene symbolizing the missionary work of the Jesuit Order (Fig. **3.42**). The vanishing point is in the center of the ceiling, where Jesus accepts the saint into heaven. Everything that ascends toward the sky grows smaller as it approaches that point. At the edges of the photograph you can see the windows and arches of the real architecture of the building, but above the windows all the architecture is pure illusion. The flat ceiling acts as the picture plane, with the elaborate Classical architecture vanishing upward through it evenly from all four walls.

When photography was invented early in the nineteenth century, it took the public some time to accept the fact that it represented the truth about natural appearances. But when the audience had learned to understand photography, it had also learned to see in linear perspective in a way that had never before seemed so powerfully convincing. The camera, with its single eye, is a perfect tool for producing linear perspective views. That is especially clear in photographs of geometric spaces in buildings or within the Space Shuttle, as we see in Fig. **3.43** in which Dr Mae C. Jemison floats weightless within the orbiting capsule precisely in the center of the linear perspective.

Linear perspective has always fascinated people. The illusions can be very convincing because what it shares with our experience is one of the basic parts of vision: that more distant things appear smaller. The scale works best when everything in the picture is angular, such as buildings, railroad tracks, and roads, and it provides only general guidance in landscape paintings of hills and trees. Ghiberti made no attempt to fit the small area of landscape into his perspective scheme (see Fig. **3.38**), beyond making the figure and the tree of a size approximately correct for their positions, and Pozzo (see Fig. **3.42**) relied on the architecture, not the clouds and the human figures, to create the illusion of space opening through the ceiling.

3.42 (*opposite*)
ANDREA POZZO,
Triumph of Saint Ignatius Loyola, 1691–94.
Ceiling fresco.
Church of Saint Ignatius,
Rome.

3.43 (*below*)
National Air and Space Administration (NASA),
Dr Mae C. Jemison, the first African-American woman astronaut, weightless in Space Shuttle 47, *Endeavour*, September 12–20, 1992.
Dye-transfer photograph.
Museum of Fine Arts, Houston, Texas. (Target Collection of American Photography.)

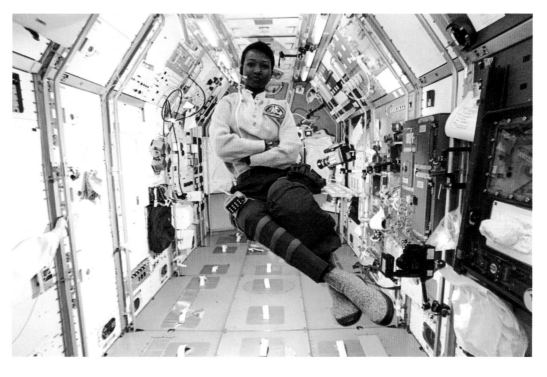

3.44
GUO XI,
Clear Autumn Skies over Mountains and Valleys,
c. 1060.
Ink on silk, detail from scroll,
10¼ in x 6 ft 9⅜ in (0.26 x 2.1 m).
Freer Gallery of Art, Washington, D.C.

Eastern Perspective Systems

The Chinese painter Guo Xi (old style Kuo Hsi; *gwo-shee*; 1020–90) advised landscape painters: "There are three sizes for things. The mountain is bigger than the trees, and the trees are bigger than the men. If the mountains are not several dozen times larger than the trees, they are not considered big." He also described three types of views of mountains, which may be translated as "perspectives": "Looking up from below is called the high perspective; looking from the rim at the interior of mountains is called deep perspective, and looking toward the distance is called level perspective."[7] It is obvious that this does not refer to what Westerners mean by perspective, and when we look at Guo Xi's paintings, such as *Clear Autumn Skies over Mountains and Valleys* (Fig. **3.44**), we can see both the three sizes of things and the

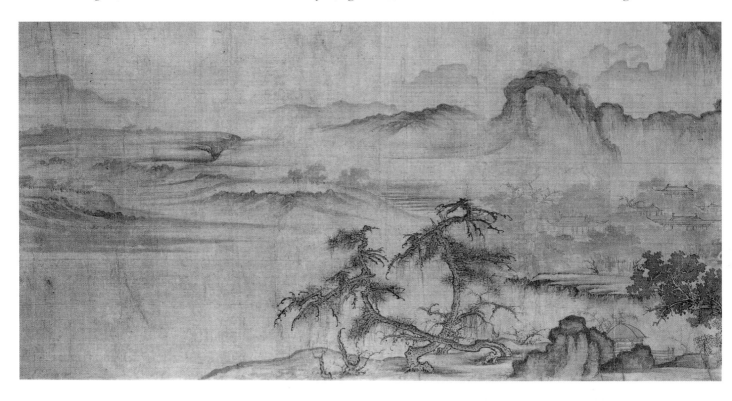

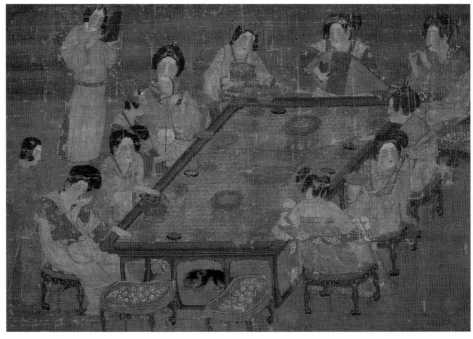

3.45
SCHOOL OF CHOU WEN-CHU,
A Palace Concert,
10th century. Ink and colors on silk,
19 x 27 in (48 x 69 cm).
National Palace Museum, Taipei, Taiwan, Republic of China.

different kinds of mountain views. Guo Xi also understood that mountains, trees, and men or houses appeared smaller if they were farther away, but neither he nor any other Far Eastern artist defined in writing a scale for representing things as they receded in the distance.

Yet when we look at Chinese and Japanese paintings we often find that a viewpoint was used in which the observer seems to be standing on the focal point of the scene and the world seems to expand outward from that point. That feeling is especially appropriate in landscape paintings, such as the one by Guo Xi (see Fig. **3.44**). When Chinese and Japanese artists represented buildings or furniture, such as the table in *A Palace Concert* (Fig. **3.45**), they usually showed them with the parallel sides drawn parallel but on a diagonal, in what we shall see below is called an isometric view. But even in architecture artists sometimes used a perspective in which parallel lines actually spread apart as they recede into the distance, as shown by the sides of the platform used by a maker of rectangular floor mats (*tatami*) in a panel of a Japanese screen showing *The Professions* (Fig. **3.46**). If you extend the sides of the rectangular platform, and walkways, they meet in the foreground (Fig. **3.47**), harmonizing with that tendency we see in Eastern landscapes to suggest that the world expands to infinite size in the distance, rather than contracting into a single point, as Western linear perspective suggests.

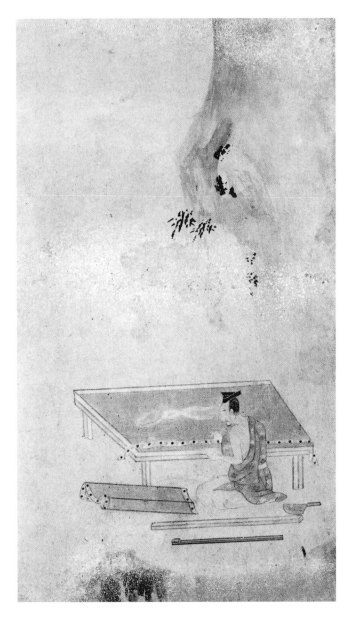

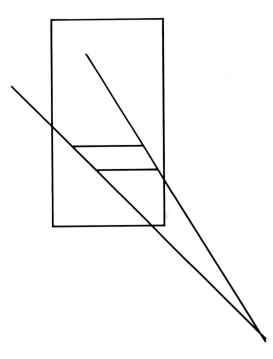

3.46 (*left*)
*The Maker of Straw
Floor Mats,*
c. 1600.
Watercolor and ink on
paper, from a six-panel
folding screen,
The Professions,
each panel 21⅞ x 12 in
(55 x 30 cm).
Art Museum of Greater
Victoria, British Columbia,
Canada.

3.47 (*above*)
The perspective scheme in
*The Maker of Straw
Floor Mats* (see Fig. **3.46**).
This is in reverse
perspective. Tatami (floor
mats) are rectangular, and
this appears to be larger the
farther away it gets.

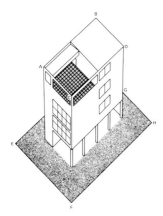

When the horizon is shown in Chinese and Japanese paintings it is usually a vast stretch of mountains or water, spreading into an infinity of space. "As to landscapes," wrote Zong Bing (Tsung Ping) (who lived from 375 to 443), "they exist in material substance and soar into the realm of the spirit."[8]

Isometric Perspective

Iso (equal) metric (measure) means that the lengths of equal lines in nature remain equal in the drawing; the result is that parallel lines remain parallel and things do not get smaller as they get more distant. This system of scale is especially useful for technical and architectural drawing, so that with a scale ruler it is possible to measure every line and get the actual dimensions. The drawing (Fig. **3.48**) shows an isometric perspective. It is the angle view from above which is called isometric. The observer is, theoretically, at an infinite distance from the house, so parallel lines remain parallel. Three views (top and two sides) are combined in an isometric drawing, all their lengths in proper scale, but the angles distorted; you can see that the posts of the house are not drawn at right angles to the line of the floor, though we know they must be at right angles in reality. Lines AB and CD are parallel in the drawing as they are meant to be in the house, and the same is true of lines EF and GH. In linear perspective those sets of lines would be drawn meeting at a vanishing point or points.

Isometric perspective has been used in much drawing and painting, but for a different purpose. When Henri Matisse painted *Pink Nude* (Fig. **3.49**), it was not his purpose to provide us with this woman's measurements. You must remember that Matisse's audience in 1935 was familiar with linear perspective. In traditional painting a figure would seem to recline on a surface which receded according to linear perspective. For that effect the white lines on the blue background should be focused on a vanishing point on the horizon. Matisse denied that he was making illusions; like a good Modernist, he was making only a painting.

3.48
Isometric perspective. Based on a house design by Le Corbusier.

3.49
HENRI MATISSE, *Large Reclining Nude*, formerly *Pink Nude,* 1935. Oil on canvas, 26 x 36½ in (66 x 93 cm). Museum of Art, Baltimore, Maryland.

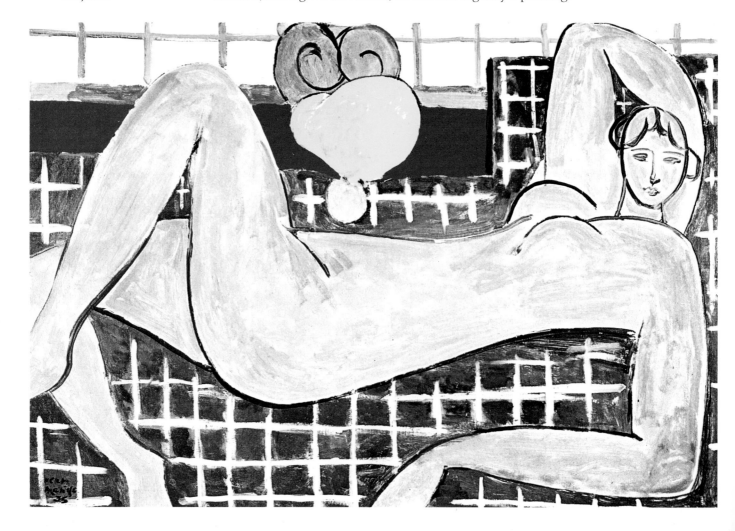

Although linear perspective produces a superior illusion of natural appearance, it has the limitation of narrowing our view of the world down to a few specified points where all lines must focus. The vanishing point is defined as infinity in that system. The concept of infinity is important in both the other systems of scale, too. In Eastern perspective the whole horizon is infinity. In isometric perspective the position of the observer is defined as infinity, where we see the truth about parallel lines, not the accidental distortions produced by seeing things from a particular place. There are good reasons for using each of these perspective systems.

Aerial Perspective

Color has its own system of perspective, traditionally called **aerial perspective**, or atmospheric perspective. It is also sometimes called "color temperature," since it is based on what are called "warm" and "cool" colors. What we see is not really temperature, but the apparent relative distance of the paint surface from the viewer's eyes. This natural phenomenon began to be considered seriously only when landscape painting first became popular. The name "aerial perspective" was given it because things in the distance look more blue because we see them through more air, but now we know that the explanation is not so simple. Each surface that reflects light appears to be a certain distance away from the viewer. Painters have learned that areas of different color on the same flat surface appear to be slightly different distances away from the viewer. The relative distances of those areas can be changed by changing the colors, so that one that seemed farther away can be made to appear closer. As a rule, red, orange, and yellow—the so-called warm colors—appear to be a little closer than they are, while blue, purple, and green—the cool colors—appear to be a little farther away. But that general rule is only a very rough guide, for the positions of the colors are always related to their neighbors. Light and dark also have an effect, but it is even less predictable than the effect of warm and cool colors. For example, white may seem closest of all, or it may be the most distant.

Annibale Carracci (*ah-NEE-bah-lay kah-RAH-chee*; 1560–1609) was one of the early landscape painters. His *Landscape* (Fig. **3.50**) has deep yellows and browns in the foreground, with rough-textured dark brown tree trunks and detailed patterns of leaves. The middle ground is green, blue-green in the water, with grayed browns and

3.50
ANNIBALE CARRACCI,
Landscape,
c. 1590.
Oil on canvas,
2 ft 10¾ in x 4 ft 10¼ in
(0.9 x 1.5 m).
National Gallery of Art,
Washington, D.C. (Samuel
H. Kress Collection.)

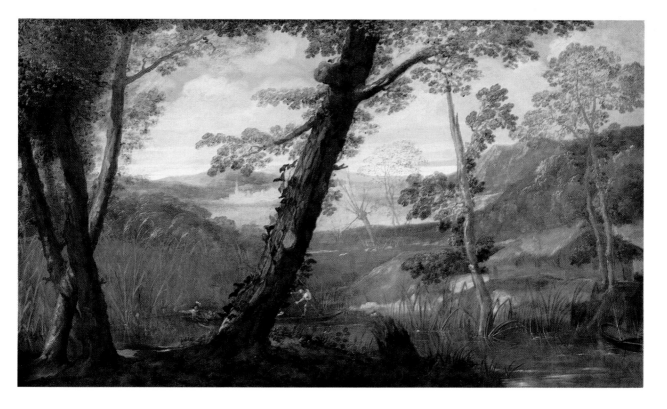

greens on the left. In the background, around the pale gray-yellow of the cityscape, are blue-gray mountains and pale blue and purple hills. This pattern of colors, from warm (yellow, brown) in the foreground, through cooler greens in the middle ground, to very cool (pale gray blue) in the background, follows the system of aerial perspective. Carracci seems to have considered this system mainly useful for landscape painting and the result of seeing through air into deep distances. In more recent times it has become clear that aerial perspective is not an effect of the air, but is a feature of the colors and their interrelationships. That means that solid forms can be represented in painting as if they were sculptural solids by coloring nearer parts warm and farther parts cool. The colors then act as a kind of perspective.

Composing pictures on the basis of color was the special obsession of the French painter Pierre Bonnard (*bo-NAR*; 1867–1947). Color has become the main element in Bonnard's *Interior with Woman at Her Toilette* (Fig. **3.51**). We are in a small dressing room with bright yellow walls, a tile floor in red, white, and blue, a mirror, and a white dressing table. Through an open door (note the doorknob) we see into a shadowy room where a woman can be seen bending over a wash basin. The pattern on the floor of the farther room intrudes into the area of the dressing room; the walls and floors suggested by the shapes are confusing and give us little help in figuring out the shape of the rooms. Bonnard intended us to rely on the color. The large area of intense yellow is relatively close compared with the bluer and purpler areas through the door. Notice that some of the farthest parts and some of the closest are both white. What is the effect of that spot of blue on the white dressing table? Does it make the dressing table seem closer or farther? If you block it from your vision you can see that it plays an ambiguous, but very important, part in the composition by making a cool accent in a predominantly warm area, by tying the yellow side more closely to the shadowy room with its bluer tones, but also by making the spatial position of the white table uncertain relative to the yellow walls. Bonnard accepted the ambiguity, letting the dressing table slip back in space about even with the walls. Really convincing illusions of space were not part of his artistic intentions, even though his composition relied on the apparent distance of the colors in relation to each other. At first it looks as if the Persian illustration (see Fig. **3.23**) might have a lot in common with the Bonnard, but their aims in the use of color were entirely

3.51
PIERRE BONNARD,
Interior with Woman at Her Toilette, 1938.
Oil on canvas,
4 ft 1¾ in x 4 ft 1¼ in
(1.3 x 1.3 m).
Yale University Art Gallery, New Haven, Connecticut. (Katharine Ordway Collection.)

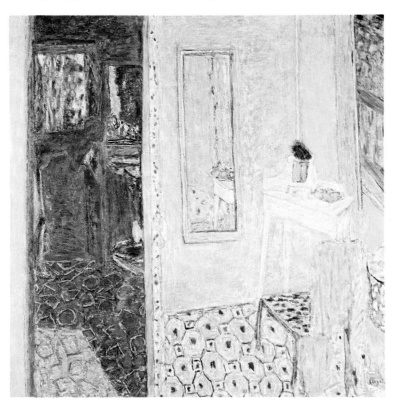

different. The color is the most important element in both paintings, but for Bonnard each color belongs to a position in space within the painting, while for the Persian artist each color belonged to a thing portrayed.

There is more to color than its spatial expression. Although color provides much of the beauty and emotional expression we enjoy in art, understanding how an artist uses color demands some active mental effort. The artist has to think intelligently about color and may use it either for its decorative beauty or its emotional effect, but also to create illusions of masses and spaces, or to remind us of the atmospheric effects of nature.

TIME AND MOVEMENT

We can perceive the passage of time, which has been called the fourth dimension, only by change. Most commonly the changes that suggest time are movements, like the movement of the hands of a clock, but they can just as well be changes of light or color. We think of time as a regular continuous stream, but our sense of its passage is very irregular. One of the powerful effects of a work of art can be to stop time as we become absorbed in the details of the work before our eyes.

Yet change goes on ceaselessly in the natural world. Nancy Holt (b. 1938), like the builders of such ancient monuments as Stonehenge, in which the movements of celestial bodies dictated the plan of the temple, has designed modern sculptures that dramatize the passage of time in nature. Her *Sun Tunnels* (Fig. **3.52**) is composed of four concrete conduits 9 feet (2.7 meters) in diameter and 17 feet (5.2 meters) long, aligned to the sunrise and sunset at the solstices. The passage of time, measured by the movement of the sun, is an important part of their meaning. "I'm interested in

Change also goes on in the cultural world. Art often looks back in time; for example, pictures of Classical ruins (see Figs **8.19** and **13.4**).

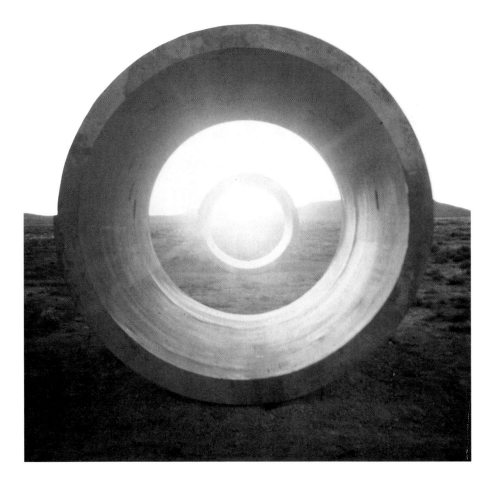

3.52
NANCY HOLT,
Sun Tunnels, 1973–76.
Four concrete conduits,
each 9 ft (2.7 m) in diameter
and 17 ft (5.2 m) long.

conjuring up a sense of time that is longer than the built-in obsolescence we have all around us," Holt says.[9] The slow, regular rhythms of the sun and seasons may be the basis of all our sense of time and change.

In recent art there has been considerable interest in actual movement of parts of the art. Earlier artists sometimes brought real movement into art using water in fountains, but in recent times **kinetic art**, or art that really moves, has been most often powered by wind or electricity. Alejandro Otero's (b. 1921) *Delta Solar* (Fig. **3.53**), which stands beside the National Air and Space Museum in Washington, is unusual in that it is powered by sunlight, which hits the very light-weight reflecting sheets with sufficient force to keep them in rippling motion. Their movement is reflected in the pool, which also reflects the play of light from the structure, which seems about to take off into space. Like Holt's *Sun Tunnels*, *Delta Solar* is tuned to the sun, its motion and reflections turned on by sunlight and turned off by darkness, as time and motion occur in the universe.

Modern people seem to grow constantly more aware of time and motion. Surely those elements will play parts in our future art which we cannot even imagine now.

3.53

Alejandro Otero, *Delta Solar*, 1977. Stainless steel, 46 ft 8½ in x 27 ft (14.2 x 8.2 m). National Air and Space Museum, Washington, D.C. (Gift of the people of Venezuela to the people of the United States on its Bicentennial.)

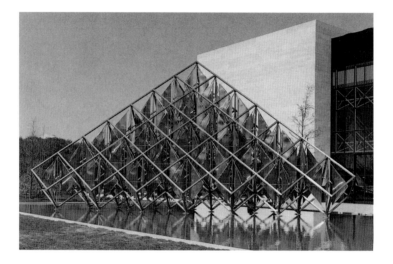

FOR REVIEW

Evaluate your comprehension. Can you:

- distinguish between form and subject in a work of art?
- pick out the elements of art in a work of art and describe the range of expression each one has?
- draw a diagram of a color wheel and describe how mixing produces secondary and tertiary colors?
- describe four systems of perspective and explain the reasons for using each of them?

Suggestions for further reading:

- Rudolph Arnheim, *Art and Visual Perception* (Berkeley: University of California Press, 1954)
- Robert W. Gill, *Basic Perspective* (London: Thames & Hudson, 1980)
- Clark V. Poling, *Kandinsky's Teaching at the Bauhaus* (New York: Rizzoli, 1986)
- John Gage, *Colour and Culture* (London: Thames & Hudson, 1993)
- Jan Butterfield, *The Art of Light + Space* (New York: Abbeville Press, 1993)
- Jim Jenkins and David Quick, *Motion motion kinetic art* (Salt Lake City: Peregrine Smith, 1989)

4

Understanding Design

<table>
<tr><td>P R E V I E W</td></tr>
</table>

Unity, variety, balance, rhythm, emphasis, and proportion are the principles, or features, that our minds seek in a design. They are produced by the relative importance that the artist gives the elements of art. Unity allows the audience to see the work as a single thing, variety makes it interesting. Symmetrical or asymmetrical balance allows the observer to identify with the art as existing, as we do, in a universe of gravitation. Rhythm controls the movement of the observer's attention through the work. Emphasis and proportion reveal relationships of power and significance. Geometric systems have been used for proportions of human figures and for composing designs (the Golden Mean, the circle, square or grid, or triangle). But personal style, which is the product of the artist's choice among the elements of art and the principles of design, is not bound by traditional rules. Personal style is the unique expression of the individual artist, but because artists living in the same time and place have much in common, so do their personal styles. It is those common features of many personal styles that historians describe as the style of a period.

OUR MINDS REQUIRE THAT CERTAIN CONDITIONS be fulfilled before we understand a work of art, or anything else. These conditions are called the principles of design. The human mind operates on a set of rules—a kind of owner's manual for the mind—which reflect our need for pattern or order in our thinking. The way we fulfill that need we call "design." Because the mind is our main tool for dealing with the universe, we naturally see the universe as designed. That fact has given rise to most of the world's great religions and philosophies. Art, which is a product of the mind, is also organized by those same principles of design so that it can be grasped by other minds.

Works of art are designed by putting together the elements of art we looked at in Chapter 3, just as a writer puts together words and a composer puts together sounds. Various authorities define these principles differently, but everyone agrees on the fundamental idea, that design makes creative acts understandable by others. These are the major principles:

1. The principle of **unity**. The work must be understandable as a coherent unit. The audience must be able to tell what is the work and what is unrelated environment.

2. The principle of **variety**. The work must have enough variability to sustain the viewer's attention. The human eye moves constantly and is attracted by contrasts, so the work must appeal to the eye's need for change.

3. The principle of **balance**. The parts of the work must be in equilibrium. Since we observers are balancing ourselves against gravity, we identify with things in our environment which do the same. While we enjoy things that are precariously balanced, we will not look long at things that are disturbingly unstable.

4. The principle of **rhythm**. There must be an orderly pattern of movement through the work for our eyes, or in the case of city plans and buildings, for our bodies. Order is given to movement by rhythm, which is repetition according to a rule.

5. The principle of **emphasis**. Relationships among the parts of a composition reflect their relative power or significance. One part may be emphasized by a design which draws the observer's attention to that part, or the design may give equality to all parts.

6. The principle of **proportion**. The parts must be related according to a plan based on the artist's intentions. Proportions are affected by function and by meaning; the height of a chair is proportioned to the size of the people who will use it, and the size of the hands in a painting of a person depends on their importance to the meaning.

Designers and artists do what looks right to them, paying little conscious attention to the principles of design. These principles were discovered when people began to try to explain what qualities are shared by the works of art they like best. Both works of art from ancient Egypt and by the younger American artists have unity and variety; they look balanced, and we find that our eyes move around them in a

4.1
The priest Niajj and his wife obtaining food from the tree goddess,
c. 1310 B.C.
Painted limestone relief from Abu Sir, Egypt,
22 x 23½ in (56 x 60 cm).
Kestner Museum,
Hanover, Germany.

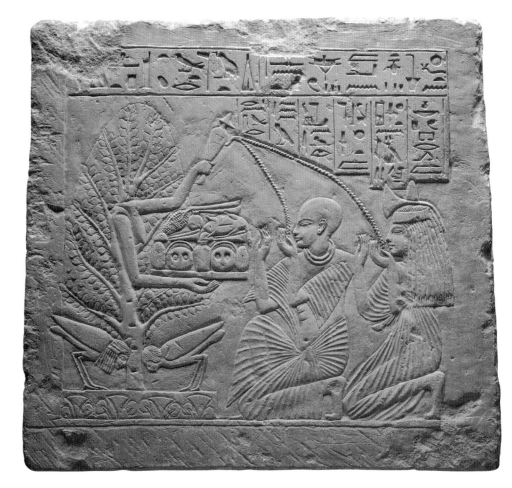

controlled pattern, as much in one as the other. All this means is that the human mind operated according to the same principles back in ancient Egypt, four thousand years ago, as it does today. You can easily imagine an ancient Egyptian artist reminding his apprentices, "You must not confuse your audience with too much variety, but, on the other hand, you must not bore them with too much unity."

When you look at the painted limestone relief (Fig. **4.1**) of the priest Niajj and his wife you see how an Egyptian artist actually expressed those principles. To understand the relief you need to know that the Egyptians believed that one of the possibilities of life after death was to return to the world of the living during the day as a bird and to be fed by the tree goddess. The priest and his wife appear twice, once kneeling before the tree goddess, who blesses them with water and food (including even a roast duck), and again as human-headed birds. The design on the square slab of limestone is complete, so we can make an accurate judgment about the composition.

Only two carving styles were used on the Egyptian relief, a very low relief for all the pictorial parts, and narrow incised lines and shapes for the hieroglyphic writing. The writing and the picture tend to separate, but the way the picture overlaps the panels of writing in the streams of water and the woman's headdress keeps them joined. The nearly vertical and horizontal shapes in the tree, its arms, tray, and platform, and the straight backs and arms of the couple join the two parts of the composition, which is also tied together by the streams of water. All those features contribute to the unity of the design.

The contrast of the writing and pictures, of the pleated clothing with the large, round shapes of the food and the small shapes of the leaves, contribute to variety. The design balances around the center formed by the man's head and hands. His head is set apart and emphasized by his collar or neck ornament. A series of repetitions produces rhythm: branches and leaves, pleats and locks of hair, to name only the most obvious. Our eyes tend to move from the priest's head down to the bird-people, up the tree, down the streams of water to the couple, especially to the woman, and are led by their legs back to the bird-people again. The proportions tell us that the people are important, but dependent on the power of the tree, which is a little larger. The bird-spirits are smaller and not the real form of these people; the proportions make it clear that Niajj and his wife remain human beings.

In modern African societies we find the principles of design stated in different words, but with some similar meanings. The art historian Robert Farris Thompson[1] interviewed about two hundred Yoruba (*YOR-uh-buh*) people of Nigeria, individuals the Yoruba would have considered connoisseurs (*amewa*), and summarized their main critical principles as (1) a balance between naturalism and abstraction (*jíjora* in Yoruba), resulting in "an impersonal calm and dignity;" (2) "visibility" (*'ifarah'on*), or we might say clear definition of masses and details; (3) luminosity (*dídón*), smooth finish to make a shiny surface, and (4) symmetry of design, proportion, and idealization (*'odó*). Violations of these criteria are permitted, but they are understood as social criticism or humor.

These criteria define the particular style of the Yoruba, which we see embodied in the 19th-century wood sculpture of a twin (*ibeji*) (Fig. **4.2**), a common subject in Yoruba art, used to ritually memorialize a twin who has died. Twins are considered spirit beings and require special observances by the parents, and the *ibeji* figure is kept as company for a surviving twin child. The sculpture is of the same sex as the child who died and bears its name. This sculpture has the idealized naturalism (*jíjora*), and the balance of the large masses of the body forms with sharp detail in the facial features and hair required by "visibility." The symmetry of the pose, the large eyes, and the dignified good-humor of the mouth all convey the spiritual power (*ashé*) and noble character (*iwa*) honored by Yoruba society.

The Yoruba style is based on choices of emphasis among the more general principles of design. Unity, symmetrical balance, orderly rhythms, emphasis on certain proportions that symbolize social ideals—those are the design principles underlying this modern African style.[2]

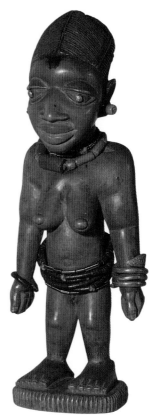

4.2 (*above*)
Ibeji
(twin figure),
19th century.
Wood, 10 in (25 cm)
high.
Linden Museum, Stuttgart,
Germany.

Portraits of ancient Yoruba nobility
show these same design principles
(see Figs **11.31** and **11.32**).

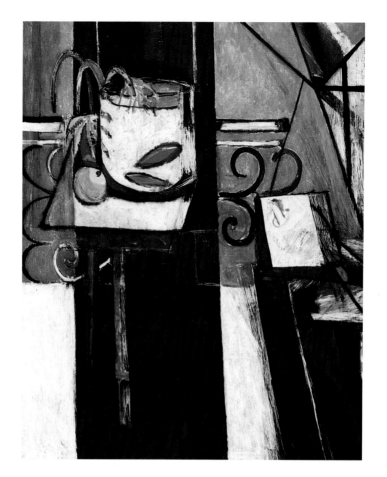

4.3

Henri Matisse,
Artist and Goldfish,
1915.
Oil on canvas,
4 ft 9½ in x 3 ft 8 in
(1.5 x 1.1 m).
Museum of Modern Art,
New York. (Florence M.
Shoenborn and Samuel A.
Marx Collection.)

Speaking to his painting students, Henri Matisse told them, "What you are aiming for, above all, is unity."[3] In *Artist and Goldfish* (Fig. **4.3**) we can see the strong unity Matisse sought, achieved by color as well as by shapes. The large areas of white at the bottom, upper right, in the fishbowl, the top of the wrought iron, and the block at the right (probably the end of a couch), with the pale blue sky, form a unifying background, firmly joined by black shapes and lines. Variety is introduced with red and raspberry-colored fish, yellow and orange fruit, green leaves, maroon table legs, and some red areas on the right margin. The wrought-iron curls are important variations from the dominant straight lines. This painting has large, severe rhythms like powerful drumbeats (the black areas), and its vertical proportions and large plain shapes in black and white make it dignified and serious.

The Egyptian and Yoruba sculptures and the painting by Matisse help us see how the six principles work together, but it is also useful to examine each of the principles separately.

UNITY

A work of art must appear to be one thing, easy to distinguish from its background and complete in itself. When the parts cooperate there is unity, but that also means there must be identifiable parts that possess their own identities. Unity is produced when the parts share something; it may be a color or texture, a shape, or indeed any of the elements.

In *Night Sea* (Fig. **4.4**) Agnes Martin (b. 1912) uses one kind of line, two shapes, and two colors to compose a very highly unified work. The grid pattern of metallic gold lines establishes such a powerful unity that our eyes seek variation. It becomes important to us that the rectangles of the grid do not repeat the shape of the canvas and that the gold of the lines contrasts with the blue of the shapes. Martin is aware that the relationship between unity and variety is important in the meaning of her

4.4
AGNES MARTIN,
Night Sea, 1963.
Gold leaf and oil on
canvas,
6 x 6 ft (1.8 x 1.8 m).
Private collection.

Very unified rectangular designs
are found in recent Minimalist
sculpture, such as Judd's untitled
work (Fig. **14.9**).

work. "My formats are square," she has said, "but the grids are never absolutely square, they are rectangles a little bit off the square, making a sort of contradiction, a dissonance, though I didn't set out to do it that way. When I cover the square surface with rectangles, it lightens the weight of the square, destroys its power."[4]

In Edward Hopper's (1882–1967) *Room in New York* (Fig. **4.5**) the content is the isolation of people from each other, but Hopper still had to bring the man and woman together in the composition. He accomplished it with rectangles: pictures on the wall, panels in the door and exterior wall, and the shape of the window we look through. That dark-framed box, with its many boxes, dramatizes the situation of two people, with nothing to say to each other, shut up together in a small space.

Unity is a primary consideration in composition and it is always based on repetition of some element or attribute in various parts of the work of art. Once unity has been established, the artist must start worrying about introducing enough variety to keep the audience from getting bored.

4.5
EDWARD HOPPER,
Room in New York,
1932.
Oil on canvas,
29 x 36 in (74 x 91 cm).
Sheldon Memorial Art
Gallery, University of
Nebraska, Lincoln.
(F. M. Hall Collection.)

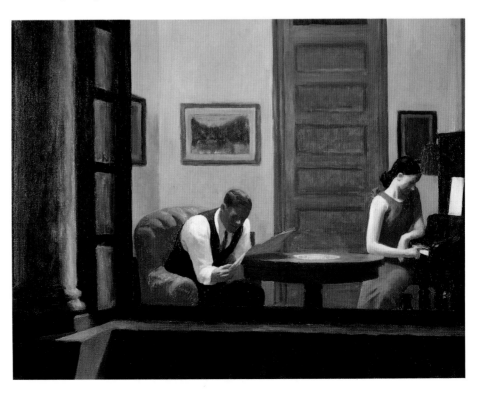

VARIETY

If we say that unity is based on similarities among the elements, variety is produced by differences. Any of the elements—line, color, shape, etc.—can be varied, but not every element can vary without destroying unity, which must be the dominant principle at the end.

In Michael Gallagher's (b. 1945) *Shuffling* (Fig. **4.6**), the paint shapes, most of them made with a single broad stroke, are so varied in size, shape, color, direction, and placement in space that a flat grid of squares is needed to unify them into a single picture. Even so, the feeling of explosive energy is so strong that the picture is barely held together. The shadows cast by these blobs of paint show us that they are in the air above that gridded background, and some cast shadows on others, making a series of levels in space. This is a wonderful demonstration of the idea that variety is a matter of form, not really a question of having a variety of objects in the picture.

One of the most varied art experiences ever presented to the public was *Ruckus Manhattan*, a walk-through portrait of the city of New York built in 1975 by Red Grooms (b. 1937), Mimi Gross, and about twenty helpers. It was constructed mainly of metal, plastic, wire, and paint in twelve large sections, of which *Subway* (Fig. **4.7**) is one. About 200,000 people walked through this sculpture that year, and probably all of them were overwhelmed with its variety in somewhat the same way they were overwhelmed by the chaos of the big city that inspired it. Yet, like the city, there was a fundamental unity given by the materials, the scale (from life size to miniature), the exaggerations and distortions, and the similarities to real life in the city. Those things gave the unity necessary for the audience to feel they had had one identifiable experience. Still, the differences between sculpture and flat, painted scenes, and the irregular ups and downs of all the surfaces, combined with the bright color, gave the observer a sense of the genuine variety of the big city. It was both funny and scary.

Variety always has to be subordinated to unity, but it gives art its flavor and its surprise. It is in variety that the artist's personality and the special tastes of the moment can have free rein.

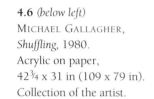

4.6 *(below left)*
MICHAEL GALLAGHER,
Shuffling, 1980.
Acrylic on paper,
42¾ x 31 in (109 x 79 in).
Collection of the artist.

4.7 *(below right)*
RED GROOMS,
Subway
(detail of *Ruckus
Manhattan*), 1976.
Mixed media (metal,
plastic, etc.),
9 ft x 18 ft 7 in x 37 ft 2 in
(2.7 x 5.7 x 11.3 m).
As installed at
Marlborough Gallery, New
York.

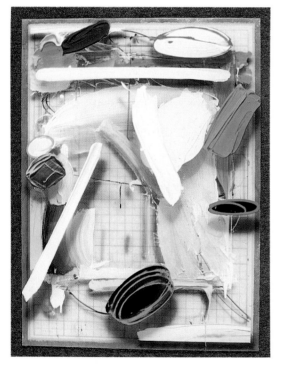

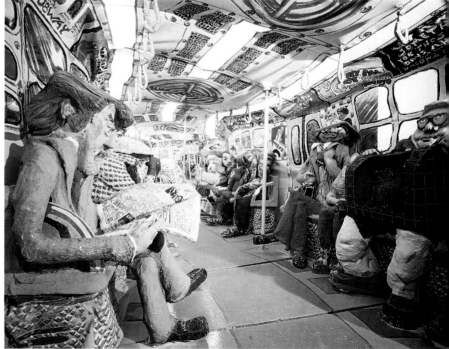

BALANCE

Because we live in a world of gravity, against which we must balance ourselves every minute, we become very conscious of the way in which the things around us maintain their balance. We can usually tell at a glance whether an object is stable or dangerously unstable, or just barely balanced in some exciting way. We often enjoy balancing games, and the feeling of being unstable for a moment is either terrifying or exhilarating. Art tells us things by the way it is balanced. Buildings, which share our space and must stand up to gravity in the same way as we do, are especially expressive of balance.

To consider the balance of anything we start with two ideas: a vertical line or axis in the center, which is directly in line with the force of gravity, and the areas on both sides of that axis, which must have equal weight in a visual or psychological sense. When Arnold Newman (b. 1918) made a portrait photograph of composer Igor Stravinsky (Fig. **4.8**) he took twenty-six pictures, tackling the problem of balancing the composer and his piano. Newman began the session by placing Stravinsky's head in the center of his pictures, giving a symmetrical balance, but as he worked the photographer began to realize that an asymmetrical balance centering on the notch in the piano lid was more interesting. Like children on a seesaw, balance required placing the heavier (the great black swirl of the piano lid) nearer the center, and the lighter (the small triangular shape of the composer) farther from the center. That process of adjustment is easy to do with designs in two dimensions, in which the image—in the camera's viewfinder or in the printing—can be moved around until the invisible center of gravity is in the center of the paper (Fig. **4.9**).

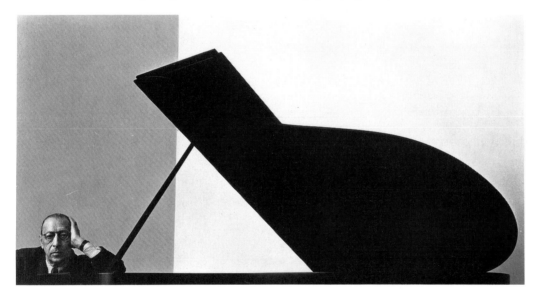

4.8 (*above*)
Arnold Newman,
Igor Stravinsky,
1946.
Photograph.
Collection of the artist.

4.9 (*right*)
Diagram of the balance of Newman's
Igor Stravinsky
(see Fig. **4.8**).

A symmetrical design, in which the two halves are alike, has such a simple and powerful balance that it can make almost any amount of variety stable and unified. Frank Furness (1839-1912) proved that with his design for the Pennsylvania Academy of Fine Arts in Philadelphia (Fig. **4.10**). Two colors of brick and two colors of stone, and an amazing variety of architectural forms and decorative elements are controlled by the matching of the two sides of the front of the building.

Asymmetry, in which the two halves are different in measure or size, can also be balanced. The portrait of Stravinsky (see Fig. **4.8**) is a good example of asymmetric balance, but we find it commonly in architecture as well. Frank Furness balanced tall against wide and advancing against receding in the Rhawn House (Fig. **4.11**). The tall section on the right has a part which advances toward us, balanced by the wider part on the left, which has a deeply shadowed porch. Although the two halves of the design are about as different in form as they could be, they balance in a satisfactory way. Furness avoided the varied color and decoration that he felt a symmetrical design could control. Asymmetry is interesting by itself, and hard enough to balance, without additional ornament.

Balance is not simply a matter for art. The bankers who had a billboard-like symmetrical **pediment** (the gable of a Classical Greek temple) put up in front of their mobile-home bank (Fig. **4.12**) were joking, but not entirely. Banks have often been designed to look like Greek temples because that style has the perfect balance, stability, and seriousness you want your banker to have, even if his office is in reality a mobile home.

4.10

Frank Furness, Pennsylvania Academy of Fine Arts, Philadelphia, 1876.

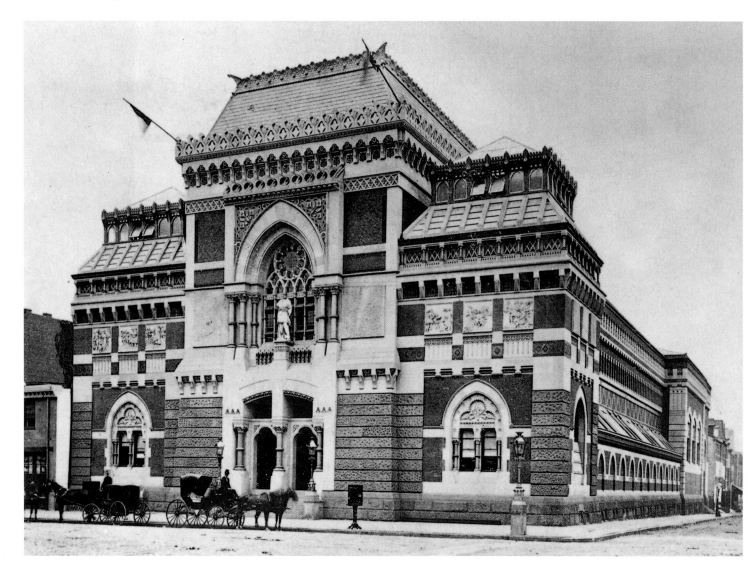

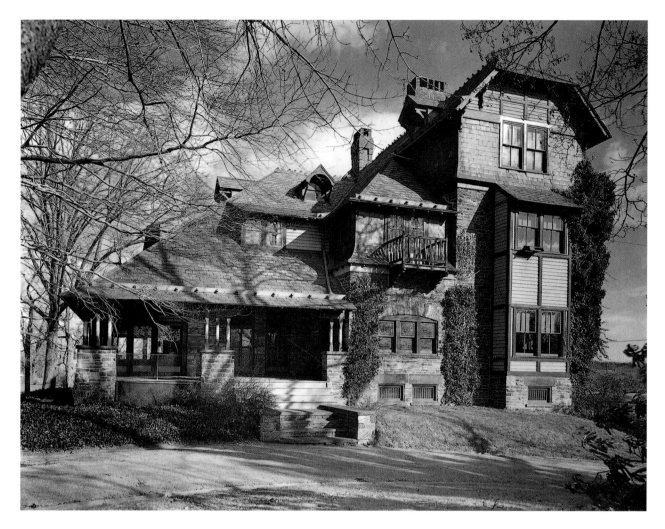

4.11 (*above*)
FRANK FURNESS,
William H. Rhawn House
("Knowlton"),
exterior from south,
Fox Chase, Pennsylvania,
1879–81.

4.12
ANONYMOUS,
Security State Bank,
Madison, Wisconsin,
c. 1971.

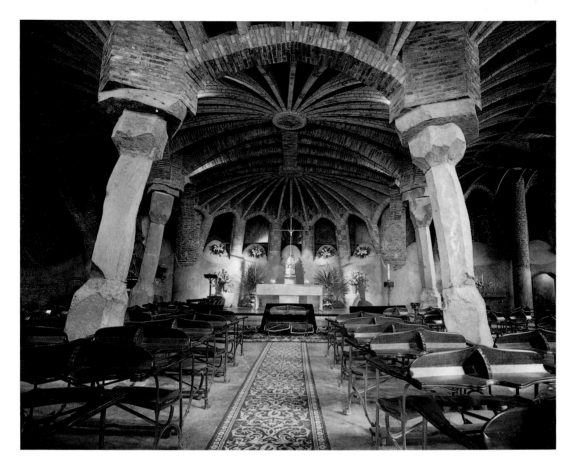

4.13

We have been looking at buildings in which the walls and columns all stand vertically, demonstrating very clearly that they oppose the force of gravity. It is rare to find buildings that seem intentionally to be giving in to gravity. One of those is Antonio Gaudí's (*gow-DEE*; 1852-1926) Guëll Chapel in Barcelona, Spain (Fig. **4.13**). Even seen directly from the front, many of the columns and parts of the vaulted ceiling seem about to collapse. But they do not collapse. Gaudí was an expert structural engineer and built this design on purpose. It seems to suggest to the worshipper that earthly things are very precarious and held up only by the

4.14

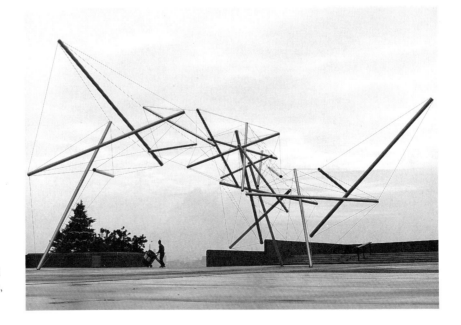

power of God, a reasonable idea to present in a chapel. This is how the terror and exhilaration of teetering on the edge of balance can take a religious turn.

Traditionally, sculptors have used symmetrical balance to show the spiritual or ritual, rather than daily life in this world. More characteristic of our times are the sculptures made of aluminum pipe and steel cables by Kenneth Snelson (b. 1927). His *Free Ride Home* (Fig. **4.14**) is described by the artist as "a force diagram in space."[5] Supported only at a few points at each end, with none of the tubes touching each other, Snelson's sculptures are best seen outdoors against the sky where they vibrate in the wind, seeming to vault across space. What kind of balance is this? Perhaps it has ancient sources in the string game called cat's cradle, but mostly it is based on modern knowledge of the forces of compression (in the pipes) and tension (in the cables), and it is those two forces that are in balance, rather than weights in the usual sense.

In two-dimensional art there is far greater freedom in composing for balance since the picture will not fall off the wall even if it is unbalanced, while a building or a sculpture may actually fall down. One of the great inventors of compositions was the Spanish painter and printmaker Francisco Goya (1748–1828). His etchings show scenes of bullfighting as it was done in about 1800. In *Tauromaquia: Death of the Mayor of Torrejon in Madrid* (Fig. **4.15**) we see a design presented as if caught on the run, like a news photograph. Goya pretends he had no time to organize a balanced design but only to show us what happened. The crowd fleeing from the triumphant bull, which stands stock still with the body of the mayor impaled on its horns, fills the right side, with nothing but a box and one small observer on the left. The slant of the railing helps center the crowd, but still the design is unbalanced. The scene is also strange in its space, for we seem to look up at the bull at the top of the seats, but the small observer seems to be standing in the arena. All these oddities are surely no accident, but meant to impress us with the greatest accident of all, the victory of the bull over the human. The bullfight was traditionally a dramatization of the struggle between the forces of unreason and darkness (the bull) and the powers of reason and order (the human). Here we see the powers of darkness have triumphed, and reason and order have disappeared from the scene—literally, in this composition, which dramatizes the violation of principles in the same way Yoruba sculptors do, by discarding unity, balance, dignity, and clarity of design. When the powers of darkness triumph we can no longer understand the universe. As animal lovers we may have trouble with Goya's symbolism, but we can be sure that this was a powerful image to Goya's own audience.

A house designed by Frank Lloyd Wright shows another kind of asymmetrical balance (see Fig. **8.6**).

4.15

FRANCISCO GOYA, *Tauromaquia: Death of the Mayor of Torrejon in Madrid*, 1816. Etching, $7\frac{5}{8}$ x $11\frac{5}{8}$ in (19 x 29 cm). Bibliothèque National, Paris.

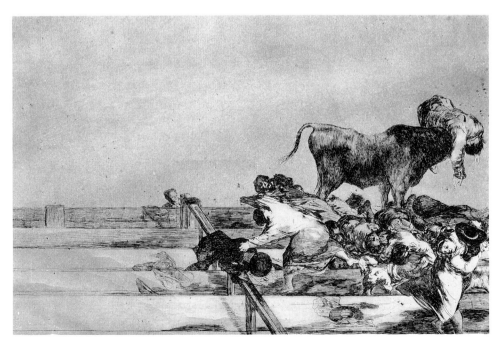

RHYTHM

Rhythm is the repetition of some element (in art most commonly line, shape, or color) according to a rule. The rule might require a shape to be repeated at least three times with equal spaces between, or a line to be repeated with uneven spaces. To succeed as rhythm the repetition must be obvious. Rhythmic repetitions in still compositions suggest movement, but actual motion, as of a motorized sculpture, must be controlled by the design according to a rule, which is rhythm.

It is rare to find an art movement devoted to the expression of a single principle, but it is no exaggeration to say that the **Futurist** movement, founded in Italy in 1909, was concerned mainly with rhythmic movement. They didn't call it "rhythmic movement," but "dynamism," and they were thinking more of machines—racing cars, motorcycles, and trains, especially—than they were of human movement. Still, one of them painted a dancer (Fig. **4.16**), not the smoothly flowing movements of classical dance, but the staccato action of a popular tap dancer. The painter, Gino Severini (1883–1966), repeated arms and hands, eyes and curls of hair, so we feel as if we are seeing the dancer by strobe light. The visual arts are mostly still and must resort to repetition or elongation of forms to convey natural movement. Severini chose several different shapes which he standardized and repeated over and over—the semicircles in the skirt, strips and curves in the arms, painted ribbons with real sequins attached to them, and broad angular areas in the background. He repeated colors as well, to emphasize the repetition: blue in the semicircles of the skirt, tan in

4.16

GINO SEVERINI,
The Blue Dancer, 1912.
Oil on canvas,
24⅛ x 18¼ in
(61 x 46 cm).
Private collection, Milan.

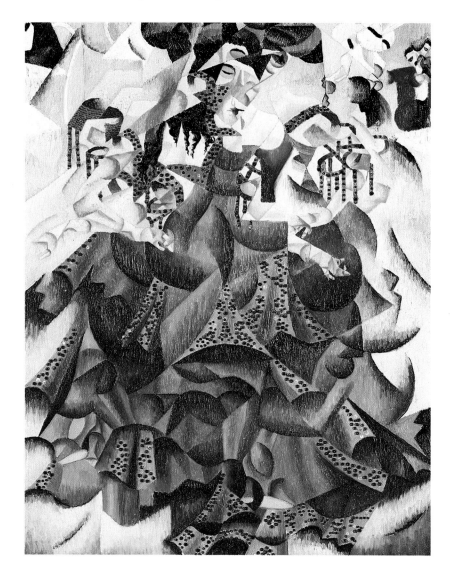

the arms, blue with sequins in the ribbons, gray in the background shapes. As your eyes jump from shape to shape and color to color they absorb the quick, snappy rhythm of the dance, like the beats in the music.

The most famous piece of Futurist art is Umberto Boccioni's (*bah-CHO-nee*; 1882–1916) bronze sculpture entitled *Unique Forms of Continuity in Space* (Fig. 4.17). To have called it "Man Running" would have sounded too simple and would have brought the wrong kind of sculpture to mind. The powerful flow of muscular action was what he had in mind. That called for long curves, ending in smooth pointed shapes, which are repeated throughout the design.

4.17
Umberto Boccioni, *Unique Forms of Continuity in Space*, 1913. Bronze, 43½ in (110 cm) high. Museum of Modern Art, New York.

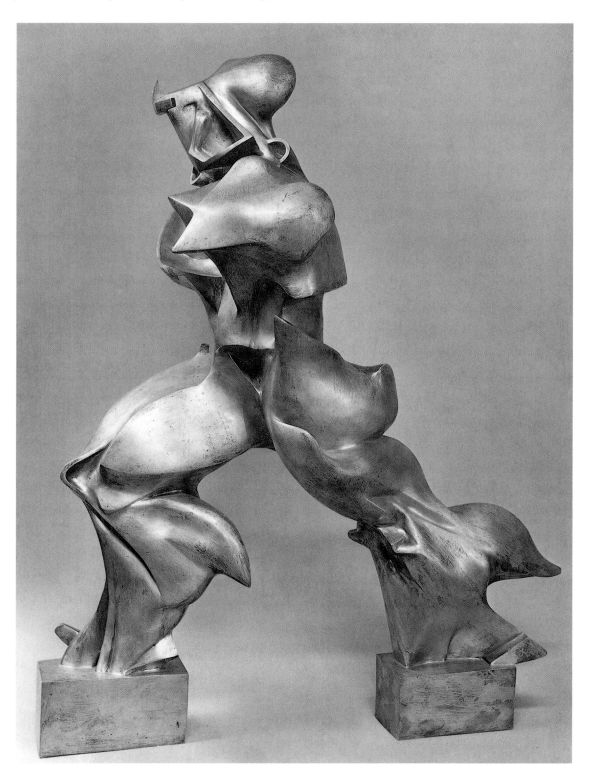

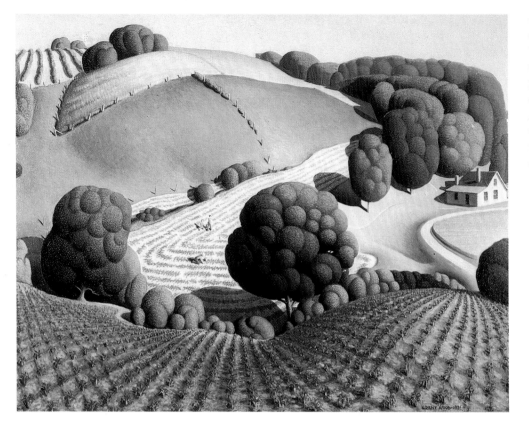

4.18
GRANT WOOD,
Young Corn, 1931.
Oil on masonite panel,
23½ x 29½ in
(60 x 75 cm).
Art Association,
Community School
District Collection,
Cedar Rapids, Iowa.

Balanced rhythmic poses were
popular in Greek and Hellenistic art
(see Figs **10.30** and **10.32**, and
pp. 341-2).

But rhythmic movement is part of pictures that do not represent any actual motion. Aside from three small human figures, there is nothing in Grant Wood's (1892–1942) *Young Corn* (Fig. **4.18**), which is moving, and the painting conveys a feeling of calm and stillness entirely different from the frenetic action of Severini's *The Blue Dancer.* The rhythmic movement in *Young Corn* is the movement of the observer's eyes—or perhaps we should say the observer's attention—moving over the shapes in the painting. Wood, too, repeats standardized shapes which lead the attention through the design. We enter along the rows of young corn at the bottom, and its lines lead us back to the large tree on the left and the pattern of green lines in the center, or to the road and the house on the right. The gentle curves of the hills at the bottom are echoed by the hills at the top, and our eyes are attracted by that similarity, just as the round shapes of the trees lead our eyes around the design by their repetition. Between lines (of corn plants, harvested grain, fence posts, and so on) and shapes (hills, bushes, trees), Wood skillfully controls the movement of the audience's attention.

Rhythm cannot be separated from our sense of time and movement, but the basic design problem for the artist is controlling the movement of the observer's eyes and attention. Merely adding real moving parts does not solve the problem; it may make it more complicated.

EMPHASIS

Often artists emphasize one part of a composition, designing the piece so that the viewer's attention is drawn irresistibly to that part. Unlike unity and variety, emphasis is not required by the human mind, but it is used when the meaning of the design requires it. The bronze plaque (Fig. **4.19**) from the palace of the Oba (king) of Benin (part of modern Nigeria) shows the Oba himself in the center on horseback, with two attendants holding up his hands and two more shading or fanning him. There can be no doubt about which figure is the important one in the design, and in Benin society. The Oba is larger, is in the center, and receives the service of the other figures in the picture, just as he was the "biggest" and in the

center of real life in the kingdom. The emphasis on the Oba expresses the most important idea in this sculpture, which is the importance of the king.

We could go back to Agnes Martin's *Night Sea* (see Fig. **4.4**) for a design in which emphasis is not used, but that might suggest that such unstressed designs belong in landscape or abstraction, as opposed to scenes with human figures. Jan Vermeer's *The Little Street* (Fig. **4.20**) is evidence to the contrary; it is a very natural scene of a Dutch town that does include four small figures. And yet there is no center of emphasis. If our eyes are attracted to the arched doorway we find it closed and move to the open passage with the figure of a woman, which leads us on to the larger woman sewing in the doorway, back to the children playing on the narrow tiled porch, to the green shutters, to the various dark windows. All of these things seem to be about equally important: one person is not more important than another and the people are not more important than the houses; it is from these relationships that we extract the meaning of the scene, which is that life is a harmony of modest equals in this town.

Emphasis reveals relationships of meaning or power among the parts of a work of art. Those relationships always reflect, often in very subtle ways, relationships in the artist's real world. Power in Benin was concentrated in the person of the Oba, as the artist saw it, but all the elements in *The Little Street* were equal in power and meaning to Vermeer.

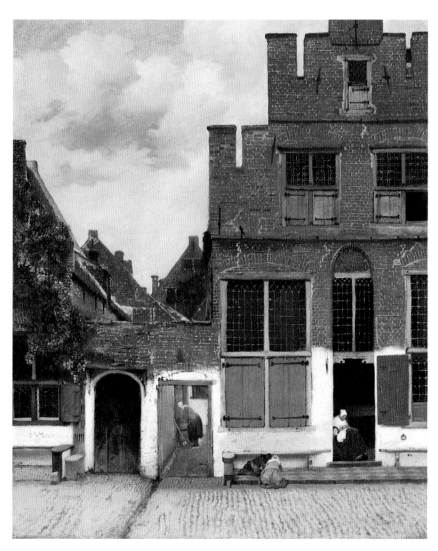

4.19 (*above*)
The Oba (king) mounted with attendants, 16th–17th centuries. Bronze plaque, 19½ x 16½ in (50 x 42 cm). Metropolitan Museum of Art, New York. (Michael C. Rockefeller Memorial Collection, gift of Nelson A. Rockefeller, 1965.)

4.20
JAN VERMEER,
View of Houses,
known as *The Little Street,*
c. 1658.
Oil on canvas,
21⅜ x 17⅜ in
(54 x 44 cm).
Rijksmuseum-Stichting,
Amsterdam.

PROPORTION

The size of things and their placement in relation to each other are the problems of proportion. The audience is quick to criticize works of art on the basis of proportion—odd proportions are something we can all spot instantly. But it is rare for an artist to make a real mistake in proportion; however odd it looks, it is usually what the artist really meant. In fact, proportions, along with emphasis, are among the main ways an artist can express ideas and attitudes.

Photographs are the easiest way to see the expressive use of proportion, since we usually know how big the objects in the picture really are. In *Hamilton, Alabama* (Fig. **4.21**), a photograph taken by Margaret Bourke-White (1904–1971) about 1936, during the hard years of the Great Depression, we know what the natural proportions are. The first thought in considering proportions in a work of art is that big things are more important than little things—it is not always true, but it is a good starting point. The hands on the plow handle, Bourke-White tells us, are the important things in this picture. This picture was made as a documentary and was accepted by the audience as true, though it is obvious that Bourke-White used her point of view to emphasize her own interpretation of this woman's life. Proportion is a strong tool of self-expression in the hands of the artist.

Every work of art is designed in a system of proportion. The expressive use of proportions is especially clear in photographs and representational paintings, but proportional systems are not based on nature. Proportion is a basic way of expressing the meaning of the work of art and it belongs only to art. One of the first considerations in designing a composition is the proportions of the parts in relation to each other. Size and scale are closely related to proportion, but while scale leads to considerations of perspective and the representation of distance, proportion is mainly concerned with solid forms and the relationships between their parts. Whether the artist thinks actively about a system of proportion or just does what seems natural, a system of proportion will find its way into the work. This is a good place to look at a couple of systems which have been influential over the centuries, one for dividing up the picture plane and one for constructing the human figure.

4.21
Margaret Bourke-White, *Hamilton, Alabama: "We manage to get along"*, 1936, Photograph.

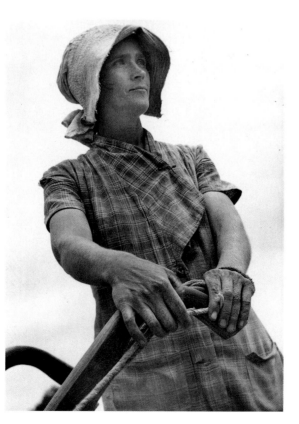

THE GOLDEN MEAN

A proportional system called the **Golden Mean** or Golden Section was used by the ancient Greeks and Romans and revived by the Italian mathematician Lucas Pacioli (1450–1520). It proposed that the most beautiful division of a line is into segments in which the shorter is to the longer as the longer is to the whole line, which results in a proportion of approximately 8 to 13. Many artists, among them Leonardo da Vinci and Albrecht Dürer, experimented with compositions based on the Golden Mean. In the United States great interest in such proportional systems was stimulated by Jay Hambidge (1867–1924) in the 1920s, under the name Dynamic Symmetry. Hambidge taught that the square was the basis of proportional composition and that it was converted into satisfying proportions by using the diagonal as a radius which gave the base of a new rectangle, which he called a "root 2 rectangle." The diagonal of the root 2 rectangle would produce a root 3 rectangle, and so on (Fig. **4.22**). The shape called the Golden Mean rectangle is a development from the root 5 rectangle; its sides have that approximate 8-to-13 proportion (more accurately 1 to 1.618).

George Bellows (1882–1925) was one of those who was impressed by the proportional system taught by Hambidge, and he used it as a starting point for many compositions. *Circus* (Fig. **4.23**) shows how complicated this system can get. In Fig. **4.24** some of the basic proportions are shown diagrammatically. Notice that Bellows began with a large square in the top center and expanded it by the length of the diagonal on the bottom and both sides, making two interlocking "root 2" rectangles. The areas along the sides and in the corners were also first thought of as squares. Within this strict system Bellows felt free to paint spontaneously. Perhaps that was why he liked it: it gave him a firm foundation for a free style.

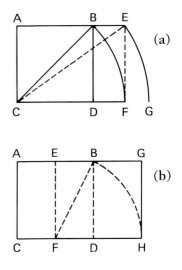

4.22 *(top)*
The Golden Mean.
(a) The square is lengthened to a root 2 rectangle by using the diagonal of the square as the length of the long side (CDF).
(b) The so-called Golden Mean rectangle has sides related as 1:1.618 made by bisecting the square, drawing the diagonal of half the square, and drawing the arc (BH) to find the length of the long side (CFDH).

4.23 *(left)*
GEORGE BELLOWS, *Circus,* 1912. Oil on canvas, 34 x 44 in (86 x 112 cm). Addison Gallery of American Art, Phillips Academy, Andover, Massachusetts. (Gift of Elizabeth Paine Metcalf.)

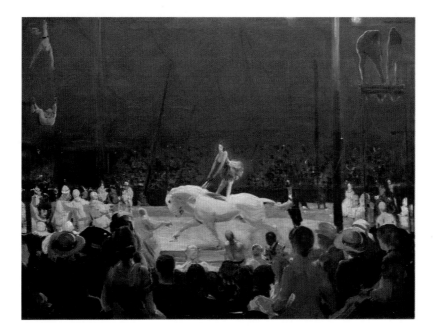

4.24 *(right)*
Diagram of the composition of George Bellows' *Circus* (see Fig. **4.24**). ABCD is the basic square. The diagonal AD gives the arc that establishes the left side (E), and the same on the right (G) and the base (HIJ). Quartering the central square locates the bareback rider (F).

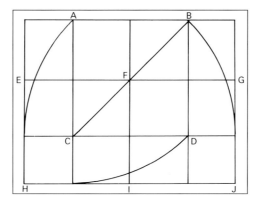

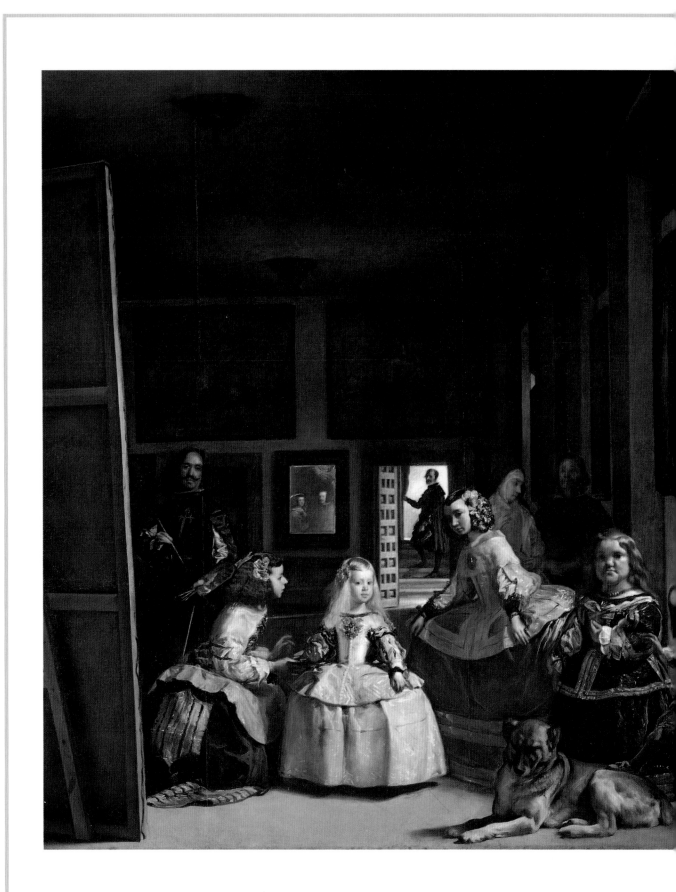

Velázquez's Maids of Honor

Painters always use proportions to make their point, sometimes in subtle ways. Perhaps the most subtle was Diego Velázquez (*ve-LATH-keth*; 1599-1660), court painter to the king of Spain. Although descended from minor nobility, as a court painter he was officially ranked with the royal barber. He believed that art was the highest calling and in that snobbish court he wished for the social rank he believed he deserved. His friend the king rewarded Velázquez with nomination to the Order of Santiago, but the members of that exclusive order of noble knights rejected him until the pope interceded on Velázquez's behalf. The problem the painter faced was to show the truth, as he saw it, about relative rank at the court, without losing his head.

In the great painting called *The Maids of Honor* (Fig. **4.25**) Velázquez shows himself working on a very large painting, but since we see it from the back we cannot tell what its subject is. It might be the little princess in the center, accompanied by her maids of honor and her dog, or it might be a double portrait of the king and queen, who are reflected in the mirror on the back wall. As you stand before this painting (in the Prado Museum in Madrid), the painter and most of the faces in the picture look directly at you, as if you were posing, not they, and you are in the place occupied by the king and queen, as the mirror tells us.

But in the painting as it really exists, the painter has a very strong position, rivaled only by the little princess. Historians who have studied this painting believe that the large paintings depicted on the back wall can be identified among those in the royal collection and that their subjects are myths telling how the Greek gods invented the arts. Diego Velázquez made a subtle but strong claim here: that his art was a sacred activity descended from the ancient gods and that, in the world of art, at least, even kings and queens are tiny compared with him. Surrounded by snobbish courtiers, it must have done his heart good to show this, in the only way open to him.

This painting shows people in a variety of sizes, which makes us consider their relative proportions. They include adults and children, men and women, full-grown and dwarfs, and even a large dog. Velázquez, standing at his easel on our left, sets a standard for adult size in the middle of the room. We compare him with the very small man in the doorway, whose smaller size we take as an indication of distance since he appears to be a full-grown adult. The five figures across the front of the scene present a different problem. The small blonde person in the center is a child, judging by her size compared with the painter and her soft features and small hands. Historians identify her as Princess Margarita, about five years old in this painting. Flanking her are two young women—their hands tell us they are grown, even if the one on our left is shown no taller than the princess; the fold in her skirt informs us that she is kneeling. But on our right is a woman who looks like an adult but is the height of the princess; thus, she must be a dwarf, and the boy with her looks very small, also. The dog, on the other hand, looks very large. The names and careers of all these people are known. The dwarf woman on the right, for example, was a German woman named Maribárbola who lived at the Spanish court for many years until 1700, when she returned to Germany.

Jonathan Brown, *Velázquez, Painter and Courtier* (New Haven: Yale University Press, 1986), pp. 250–51

4.25
DIEGO VELÁZQUEZ,
The Maids of Honor (*Las Meninas*), 1656.
Oil on canvas, 11 ft 5¼ in x 9 ft ¾ in (3.2 x 2.8 m).
Prado, Madrid.

THE CANON OF HUMAN PROPORTIONS

The Egyptians and Mesopotamians, and later the Greeks, were all fascinated by geometry and the mathematical analysis of nature. That led them to develop systems of proportion, especially for the human figure. The system that has had the longest popularity derives from the sculpture of Polyclitus, a Greek sculptor of the 5th century B.C. who specialized in idealized portraits of athletes. Polyclitus created a sculpture of a spearbearer called *The Canon*, meaning the standard or rule, because it embodied his system of proportions. Both the original sculpture and the essay Polyclitus wrote about it have been lost over the centuries, but the sculpture was copied several times (Fig. **4.26**) by later Roman sculptors, and the essay was quoted by later writers. This became the basic system of proportion for the human figure among many later artists: the whole figure is seven and a half heads tall, divided at the chin, nipple, navel, crotch, and above and below the knee. Actual human beings vary from these proportions in infinite ways, of course, but they make a useful starting point for artists.

Polyclitus gave his figure proportions that are strong but not very elegant, and other artists often lengthened the legs to make a figure whose height was eight times the height of the head, which is still a common proportion for the ideal figure.

INTUITIVE PROPORTIONS

No artist has ever exceeded Piet Mondrian (*peet* MON-dree-ahn; 1872-1944) in the study of proportion from the artist's point of view. His compositions were inspired not by mathematics but by mystical philosophy, and were calculated by eye. A friend once analyzed his paintings to show they were based on the Golden Mean and showed the calculations to Mondrian. "This is very interesting," Mondrian said, "but it is not how I paint." In an article on abstract art, Mondrian wrote that "the apparently mathematical must be consciously expressed."[6]

Composition Gray-Red (Fig. **4.27**) has one perfect square (the gray upper left), but all the other shapes were designed intuitively, by moving strips of tape until the design was satisfactory. Mondrian then painted in the heavy white background and

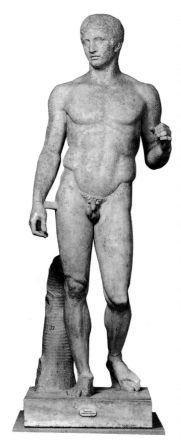

4.26
POLYCLITUS,
The Canon or The Spearbearer, 450–444 B.C.
Marble copy of lost bronze original, 6 ft 6 in (2 m) high.
Museo Nazionale, Naples, Italy.

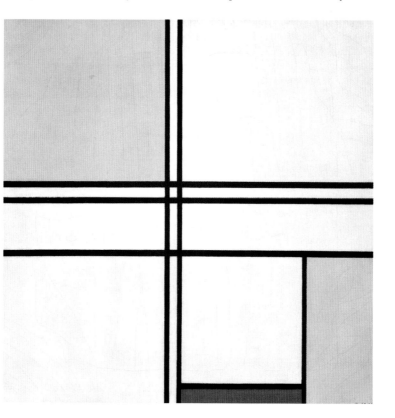

4.27
PIET MONDRIAN,
Composition Gray-Red,
1935.
Oil on canvas,
22⅜ x 21⅝ in
(57 x 55 cm).
Art Institute of Chicago, Illinois. (Gift of Mrs Gilbert W. Chapman, 1949.)

the black lines, and finally the color areas. This very cool and intellectual looking art was, for Mondrian, full of human feeling. "The importance of purely abstract painting is … showing the richness and fullness that are expressed in and are requisite to the joy of living," Mondrian wrote.[7]

Proportion is a basic question in composition; it is concerned with how the parts of the design fit together. Whether the answer is arrived at by geometry, by a traditional system or a new personal invention, or is achieved by contemplating each design problem intuitively, an answer must be found. How big, how long, how dark, and many of the other questions that the artist ponders during the making of art are questions of proportion.

The artist consciously considers the principles of design, but there is no set order or system in applying them. Each one contributes, balancing the others. Unity has to be one of the first considerations, so the audience will see the work as an object, and the artist will not call the work finished until unity has been achieved. The observer's attention is always considered: variety attracts and sustains attention, which is satisfied by the order and balance of the design. The observer's attention moves through the work in a controlled, rhythmic way and finally draws conclusions based on proportion, as well as on the way all those other principles are expressed. These principles are the point at which the mind of the audience and the work of the artist meet and interact.

COMPOSING DESIGNS

Three geometric patterns—the circle, the square, and the triangle—lie behind composition. Artists consciously plan their compositions in these geometric patterns, choosing the pattern that helps convey their ideas.

THE CIRCLE AND THE SQUARE

Paul Klee (clay; 1879–1940) believed that compositions based on the circle and the square depended on our knowledge of nature, and he provided diagrams based on that point of view. In one (Fig. **4.28**) he shows us the shape we know the earth to have—a massive sphere with a gravitational center and an enveloping atmosphere. This suggests a composition of concentric circles which expresses the power of the center, a useful pattern when the composition is meant to emphasize something in the center. In another drawing (Fig. **4.29**) Klee shows us how we experience our natural surroundings: the earth is a horizontal plane and gravity pulls vertically. That suggests a composition of verticals and horizontals, and these lead to the square or the checkerboard grid used for compositions in which emphasis is spread over the whole picture and no single part is dominant.

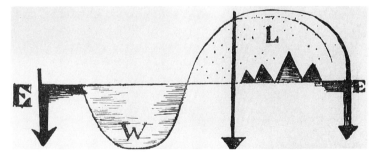

4.28 (left)
PAUL KLEE, *The Earth as We Know It to Be*, 1923. Pen and ink. From *Paul Klee Notebooks*, Vol. II, *The Nature of Nature*, 1973.

4.29 (above)
PAUL KLEE, *The Earth as We Experience It*, 1923. Pen and ink. From *Paul Klee Notebooks*, Vol. II, *The Nature of Nature*, 1973.

4.30

4.31 (*below*)

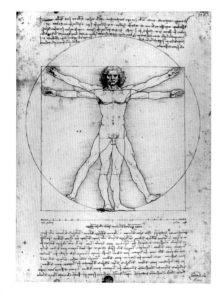

Klee used both these compositions in his own work. In *Highways and Byways* (Fig. **4.30**) the squares and rectangles have been scaled to recede into the distance, but it is clear that a grid of vertical and horizontal lines was the starting point of the composition. Klee still wanted some emphasis even in this design, which he achieved by permitting the center "highway" to be the only one whose sides run straight back to the horizon. Even so, the vertical and horizontal grid diffuses, or spreads out, the dominance of the center.

The circle and square also have a very long association joined together to make a design called a **mandala** (*MAHN-da-la*), an ancient symbol of the universe. The circle represents the sky, the square or grid the earth's plane. Leonardo da Vinci (1452–1519) placed a man in the center of that ancient pattern (Fig. **4.31**), the best illustration of the saying that "man is the measure of all things." Leonardo was drawing an old proportional system, described by a Roman writer, showing how the human figure relates to the circle and the square. But many people of earlier times would have considered Leonardo's drawing too proud, since the center of a mandala should be occupied by a divine figure, one who rules the universe, not a mere human. Buddhist painters in Nepal and Tibet have specialized in painting mandalas showing Buddhist divinities at the center, with the four directions of the world

represented by gateways and with saints and divinities around the heavenly circle, as we see in the Tibetan Mandala of Vairocana (*vi-RO-chah-nuh*), the Buddha at the center of the universe. In the mandala (Fig. **4.32**) the circle's emphasis on the center is more powerful than the square's diffusion of the stress.

Although there are differences between compositions made by people in different cultures, there are also many points in common. It is interesting to look at compositions by the contemporary American artist Jennifer Bartlett (b. 1941) that were done during the fifteen months after December 1979. During that time she exchanged homes, sight unseen, with an acquaintance—her New York studio for his house in southern France. She grew tired of sightseeing, the weather was bad, and she found it hard to carry on her work, but one day she sat down by the large dining room window and began to draw the view, which she described as "the awful little garden with its leaky ornamental pool and five dying cypress trees."[8] In 1981, 197 of her drawings were exhibited under the title *In the Garden*, and they were subsequently published. Among those drawings one finds a wide range of compositional approaches based on the square and the circle.

4.32
Mandala of Vairocana,
17th century.
Gouache on cotton,
31 x 28 in (78 x 72 cm).
Museum of Fine Arts,
Boston, Massachusetts.
(Gift of John Goelet.)

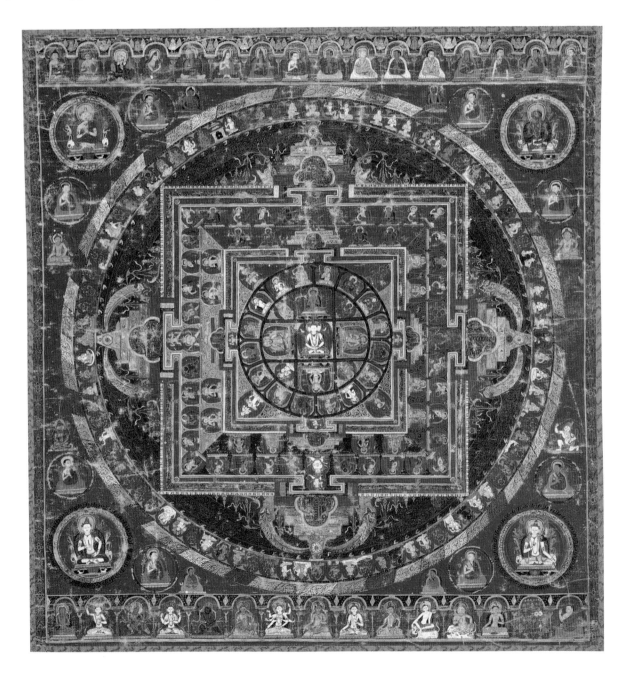

4.33 (right)
JENNIFER BARTLETT,
In the Garden, Number 154, 1980.
Brush and ink on paper,
26 x 19¾ in (66 x 50 cm).
Charles Saatchi Collection,
London.

4.34
JENNIFER BARTLETT,
In the Garden, Number 191,
1980.
Pencil on paper,
19¾ x 26 in (50 x 66 cm).
Private collection.

Number 154 (Fig. **4.33**), in brush and ink, gives an easily understandable picture of the garden as seen from the window: a lawn, a rectangular tiled pool with a statue of a small boy urinating into it, and a border of trees. This composition is clearly based on the grid, taking the tiles of the pool as a point of departure. The value division between the lawn and the trees is nearly horizontal, and the verticals of the cypresses and the dark band on the right margin reinforce the rectangularity of the grid pattern. The small statue acts as a center, but there is little emphasis on it.

In *Number 191* (Fig. **4.34**) the grid reappears, but the pool is repeated in each of ten squares, being isometric in the two lower corners but receding in perspective in all the others. To give the grid more movement diagonal lines and shapes have been added, using the shape of the pool and the dark slanting shape of the cypress trees in the background. The center is not stressed, although the darker values move around the margin to give some variety to the grid. The grid provides strong unity, but variety and emphasis can be introduced only by departures from the grid.

Number 136 (Fig. **4.35**) is an example of the complexity that can occur as these basic patterns merge and interact. This softly toned pastel places the small turquoise rectangle of the pool at the bottom, with gigantic cypress trees on the left and a swirl of oval and diamond shapes rising on the right, appearing to radiate from a center whose position, somewhere just left of the pool among a group of oval shapes, is most strongly indicated by the curves of the upper right corner. The slight emphasis Bartlett allows in this design is on the red line representing the little statue.

Jennifer Bartlett's *In the Garden* series is a good example of the power of art to create meaning using subject matter that, in itself, has no meaning. When you scan these three compositions it is clear they are all "saying" different things about reality and the way a human mind interacts with a place. The content of art is not something the artist finds in the subject; it is in the composition. The lines, shapes, colors, and so on create a mood and a vision of the world, each composition creating a new and entirely different mood and vision. These works of visual art are capable of being translated into words no more easily than a piece of music can be recreated in words.

4.35
JENNIFER BARTLETT,
In the Garden, Number 136, 1980.
Pastel on paper,
26 x 19¾ in (66 x 50 cm).
Amerada Hess Corporation
Collection.

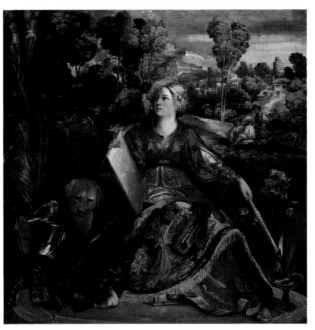

THE TRIANGLE

The geometric pattern that provides the greatest stability is the triangle or, in three dimensions, the pyramid. The ancient Egyptian pyramids were designed not only to be eternally stable but also to look eternally stable—their shape clearly tells us that. Even designs that are full of action are often stabilized by a triangular composition. Pablo Picasso's mural about the destruction of the town of Guernica (see Fig. **5.6**) seems at first to be violent and frenzied, but the composition is stable: a triangle at the center with a vertical rectangle on each side.

The triangle has always been especially useful for compositions of seated figures. A good example is Dosso Dossi's (1479?–1542) painting of *Circe* (*SIR-see*), the witch in *The Odyssey* who turned men into animals (Fig. **4.36**). This exotic figure is so glamorous that we can easily imagine the attraction that lured the human-looking dog to his fate. The artist's design reminds us that the idea of the *femme fatale* is as eternal as the pyramids. The figure of Circe is not simply a triangle, but suggests a pyramid with the foot in the lower right corner marking a corner of the base and the form receding in space up the skirt toward the face of the seated figure. Circe seems tied to the ground, like a pyramid. For this reason, triangular and pyramidal shapes are used for figures whose stability or earthliness are important to their meaning.

When we consider composition and the principles of design it is easy to lose sight of the main point, which is that all these organizational considerations are meant to help us express ourselves and understand the expressions of other people. These geometric designs are tools that may be combined, or ignored in favor of some more personal or more natural composition. But many artists have been sure that geometry is the basis of design, in somewhat the way nouns and verbs are the basis of sentences.

4.36
DOSSO DOSSI,
Circe, c. 1512–20.
Oil on canvas,
5 ft 9⅜ in x 5 ft 8⅝ in
(1.8 x 1.7 m).
Borghese Gallery, Rome.

THE PROBLEM OF STYLE

"Style is a fraud,"[9] Willem de Kooning said, implying that he never cultivated a style. Writing about the New York artists of the 1950s, museum director Thomas Hess wrote: "The classical 'look' of a painting no longer mattered. ... Art could be rough and hairy, like a Pollock; it could burst with high-velocity shapes, like a de Kooning; or, to an unfamiliar eye, seem completely empty, like a Newman. What mattered was the ethical pressure informing the work: its truth."[10] The artist (de Kooning) and the museum director (Hess) agree that art aims at "truth" and that style ("look") not only doesn't matter but is actually false. These views were common during the great days of American Abstract Expressionism in the 1950s.

Art critics of the 19th century saw it a little differently. A style was something an artist found while technique was something learned. The skills, or what de Kooning might have called the "tricks of the trade," were impersonal and any good painter learned them and used them when needed. Style, on the other hand, could not be learned but had to be found in a process of self-discovery. Mid-20th-century artists, Hess and de Kooning seem to be saying, have been tempted (perhaps by studying art history) to learn to paint in some appealing style, Cubist today and Impressionist tomorrow. Most authorities would probably agree with them that such use of styles is, if not outright fraud, at least an affectation.

It sounds as if style in everyone's views is something so personal that it is hard to discuss. Yet the newspaper thrown in my driveway every day contains a section entitled "Lifestyle," containing columns on automobile "styling," clothing "styles," and all the voluntary activities that make up our lives. That is obviously a use of the word that is not personal at all.

The art historian Richard Shiff points out that our word "style" has a double ancestry. From the Greek we get *stylos*, meaning a column in a specific decorative order, which is a social, not a personal achievement. From the Latin we get *stilus*, a writing tool, suggesting a personal manner of handwriting.[11] If one examines the current use of the word by art historians and critics, it is evident that both of these ways of thinking of style survive and are combined in our theory of art. Erwin Panofsky wrote: "The Renaissance believed its 'modern style' (*maniera moderna*) to be nothing but the 'good antique style',"[12] clearly using the social and impersonal sense of the word, as did Nikolaus Pevsner, when he wrote, "A style in art belongs to the world of mind, not of matter. ... It is the spirit of an age that pervades its social life, its religion, its scholarship and its arts."[13] Jenefer Robinson summarizes current art historical definition of style as all the characteristics of a work of art "which serve to identify when, where, and by whom it was produced." She cites philosopher Nelson Goodman that "style ... consists of those features ... characteristic of author, period, place or school."[14]

In our times *style* has these twin meanings: the personal expression of the individual, and the sum, or perhaps we should say the mean, of all that those personal expressions share during a period of time, which makes up the style of a period. In Chapters 3 and 4 we have been examining the elements of art and the principles of design, but when we look at the work of different artists, or the art production of different periods in history, they often look so different it is hard to imagine they started with the same elements and principles. That difference in appearance is what we call style. It can be defined as "an emphasis on particular elements of art and principles of design for the sake of expression." The elements and principles come together in style.

It is fascinating—and often upsetting—to discover that we really do not understand what is going on in other people's minds. Even when we are sure we know what our friends think, they often surprise us. In art this variation among individuals shows up as personal style, and it is true that a person's authentic style has to be found. The way it is found is by persistent practice of the art you have chosen. Not only artists have personal styles; all of us express unconscious preferences in whatever we do. Most of us feel at home in the period in which we

Looking at recent art in the United States, we see how varied personal styles are (see Figs **14.32**, **14.35**, **14.37**, **14.40**, and **14.42**).

live, which suggests that most of our unconscious preferences are shared with many other people around us. Those shared preferences are basic to the culture of a society and they produce styles that define a period in history. Those shared preferences are also the basis of almost everything else in our social life: happy marriages and happy families, successful businesses, funny jokes (which are especially based on unconscious attitudes). In Part V, we will look at the styles that were created by groups of people at different times and places, but here we will begin with some examples of personal style.

As you look at a lot of art you gradually begin to recognize the personal styles of individual artists. The next three illustrations are major paintings by famous artists, each with a strongly individual personality.

It is easy to recognize the paintings of Paul Gauguin (*go-GAN*; 1848–1903), the French painter best known for his paintings of Polynesian subjects. *We Hail Thee, Mary* (Fig. **4.37**) is a traditional Christian subject set in Tahiti, with the Virgin and Child transformed into Polynesians. But it is not only the Polynesian setting that tells us the artist was Gauguin; we also recognize his style. We soon learn to identify Gauguin's color: the purple path, the brown strip of bushes behind the path, the pink field behind Mary. Those areas of color change very little from part to part, but stand as areas and seem nearly flat despite the small marks of the brush. Color areas are also outlined in narrow black lines, which makes them even flatter. Other artists use bright, flat colors and black outlines, but their work nevertheless looks different from Gauguin's.

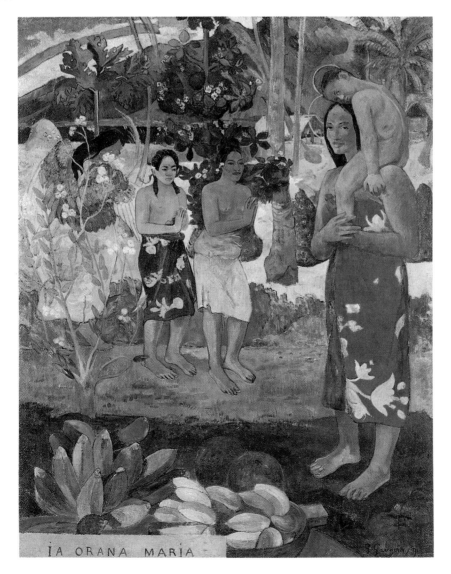

4.37
PAUL GAUGUIN,
We Hail Thee, Mary
(Ia Orana Maria), 1891.
Oil on canvas,
44¾ x 34½ in
(114 x 88 cm).
Metropolitan Museum of
Art, New York. (Bequest of
Sam A. Lewisohn, 1951.)

Max Beckmann (1884–1950) painted *Actors* (Fig. **4.38**) in 1942 when he was a refugee from Nazi Germany. That may account for the desperate mood, totally different from the peacefulness of Gauguin's painting. Like Gauguin, Beckmann painted in flat, strong colors outlined in black. Beckmann surely learned from the work Gauguin did fifty years earlier, but still their styles are different. Beckmann's paintings are full of people and things, their proportions adjusted to their importance in the composition, while Gauguin's figures are in natural scale to each other and to a wide environment. In *Actors* the black outline around shapes and colors has expanded and taken on an importance that Gauguin never allowed it to have. For Gauguin the color was the main thing, but for Beckmann the black line was most important. Style is the emphasis put on certain selected elements of art or principles of design.

The personal styles of Beckmann and Gauguin are easy to tell apart, but they were both Europeans of modern times. Their work has as much in common as we might expect, and we would not be surprised to find that the work of an artist from a different time or place would be very different from that of both of them.

The Averoldi Altarpiece (Fig. **4.39**) by the Italian painter Titian has something in common with both the Gauguin and the Beckmann paintings. It is on a religious subject, as is Gauguin's, and it is composed of several panels, like Beckmann's. (We would call *Actors* a **triptych** *[TRIP-tick]*, meaning it has three panels; The Averoldi Altarpiece is a **polyptych** *[pah-LIP-tick]*, the term for any number over three.) But in style it is very different, which is accounted for partly by differences in temperament among the individuals, but mainly by the long lapse of time between them (370 years between Titian and Gauguin and 420 between Titian and Beckmann). Titian was not thinking mainly of the color, or of the line, and certainly was not trying to make the shapes appear flat. Titian's brush strokes do not show unless one examines the painting up close. Light and dark was Titian's main concern—he took the trouble to illuminate all five panels from the upper left, which gives them unity. All Titian's figures cast shadows; some of Beckmann's do, but they are inconsistent; none of Gauguin's do. Light and dark help to bring out the three-dimensional solidity of Titian's figures; he made sure we would understand that the figures are solid enough to cast shadows. His representation of light and its effect unifies the separate panels by suggesting a continuous space filled with massive bodies and lighted from a single source.

4.38

Max Beckmann, *Actors*, 1941–42. Triptych, oil on canvas; center 6 ft 6½ in x 4 ft 11 in (2 x 1.5 m); wings 6 ft 6½ in x 2 ft 9⅜ in (2 x 0.8 m). Fogg Art Museum, Harvard University, Cambridge, Massachusetts. (Gift of Mrs Culver Orswell.)

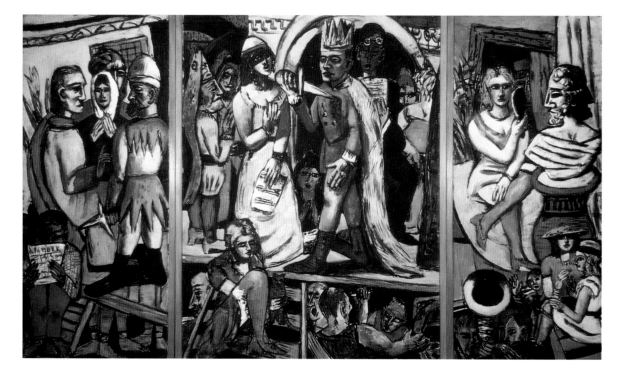

4.39

Titian,
the Averoldi Altarpiece,
1522.
Oil on wooden panels;
center 9 ft 1½ in x 4 ft
(2.8 x 1.2 m);
upper side panels 31 x
26 in (79 x 65 cm);
lower side panels 6 ft 6 in
x 2 ft 2 in (2 x 0.7 m).

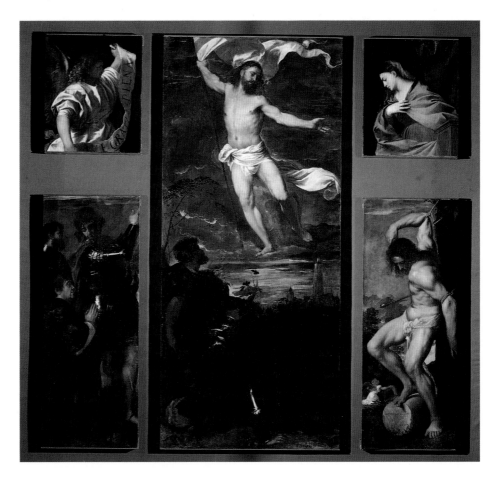

These three artists are much admired, not because they recorded nature accurately, but because they used the elements and principles of art to "speak" in a personal way about their thoughts and their experiences. Each of them created a complete world in which their style is simply "reality." As you look at *Actors* it is hard to imagine another way for this scene to appear, and the same is true of other successful works of art. The emphasis and viewpoint of a style are the expression of a mind and personality living within a particular set of historical circumstances.

FOR REVIEW

Evaluate your comprehension. Can you:

- name and define the principle of design in Western or Yoruba art?
- define the word "style" and describe analytically different styles when you see them?
- explain the reasons for using a triangular, grid, or circular composition?
- describe examples of proportional systems, such as the Greeks used for human figures?

Suggestions for further reading:

- Robert Farris Thompson, *Flash of the Spirit* (New York: Random House, 1984)
- Romare Bearden and Carl Holty, *The Painter's Mind* (New York: Crown, 1969)
- Jennifer Bartlett, *In the Garden* (New York: Harry N. Abrams, 1982)
- Christine Herter, *Dynamic Symmetry: A Primer* (New York: Norton, 1966)

PART III

ART MEDIA

The talent we attribute to artists is mainly evident in their skill in using materials and tools—the brushes, chisels, paints, camera, stones, computers, and all the other innumerable things we find in the studio. As members of the audience we need to develop enough knowledge about the tools and materials of the artists to understand their effects on the meaning of the art. Art media are part of the technology of the times—technology that has many other uses but that artists have figured out ways to use for expression.

Patricia Search is one of the leading artists in computer graphics. She designed the computer painting *Intermezzo* (Fig. III.1) by defining geometric forms and giving exact numerical designations to their colors and their transparency or reflectivity. Since she is working with light, the primary colors are red, green, and blue, and each beam of light that she designs into the scene is defined by source, direction, and color. She uses software that follows each beam of light, by ray-tracing algorithms, to show its reflection or refraction when it strikes a solid form in the design. The completed computer painting was photographed to make a Cibachrome print for display. Search predicts that such computer paintings will soon be displayed on computer screens on our walls, which will give the pictures a precision and detail that are lost in their translation into the photographic medium.

Search's composition is motivated by the powerful examples of non-Euclidean geometry and quantum physics to seek ways to "raise our intuitive knowledge of space and time to a higher level of abstraction" so we can visualize the world that science is discovering beyond our native perceptual abilities. This has been the great 20th-century quest in the visual arts since Cubism, to find ways to express the fourth dimension (as they said at the beginning of the century), or n-dimensions, as we might say today. The computer, which can deal with the mathematics and geometry of n-dimensions, is the ideal tool for attacking the problem of displaying these profound ideas in visual terms. Patricia Search uses forms that seem to be moving, merging, and passing through each other in more than three dimensions, with variations in color, texture, transparency, and reflection of light to suggest the multidimensionality of space-time.

III.1
PATRICIA SEARCH,
Intermezzo, 1992
Raster image/Cibachrome
print, 16 x 20 in
(40.6 x 50.8 cm).
Collection of the artist.

It is the expression of individual ideas and feelings that produces art, since the materials and tools of the artist all have other uses. The range of art media is tremendous, from the pencil and paper, to the etching of a copper plate, the digital camera, the brush loaded with acrylic paint, or the block of marble cut with a chisel. In the following three chapters we will examine a wide range of media, which reflect the whole history of human technology and expression. Members of the audience rarely develop much expertise in more than one or two media, but, like artists, they specialize in a certain medium that particularly appeals to them. It is that special personal quality that sets art apart from the general technology of its society, in which materials and tools are usually means to ends very different from individual expression.

5

The Graphic Media

In this chapter we examine that chain of related inventions that begins with the invention of paper (which freed drawing from dependence on rock walls or human bodies), runs through printmaking to photography, video, and digital computer graphics. The vital

PREVIEW

thread is drawing, and we recognize in all these inventions the "sketches" used to note down ideas, the "studies" used to practice, and the final versions comparable to "finished drawings." Prints, which first democratized art by making editions (multiple copies), range from woodcuts to etchings, engravings, lithographs and silk screen prints. Photography, which developed from lithography and has remained a chemical process, has led to a series of electronic and digital media: video, computer arts, digital photography, cinema, and virtual reality. This chain of inventions, usually grouped under the heading of "The Graphic Arts," remains the most progressive, experimental, and democratic sector of the art world. In the midst of that progress, we must remind ourselves that no art medium ever becomes obsolete, since each one has its own unique range of expressive potential.

THE WORD GRAPHIC REFERS TO ALL THE SYMBOLIC MARKS we make in drawing, writing, or printing, whether on paper, film, or a computer screen. Painting is often considered to be among the graphic arts, but we will set it aside for the next chapter. Here we will discuss drawing and the many ways drawings can be produced in multiple copies or replaced by photographic or electronic imagery. All the arts serve for research and development in technology, but the graphic arts are in the forefront of technical progress, and there is intense competition to find new ways to make and record marks. Some of the oldest techniques are still useful and have changed very little, while other ways of drawing and printing have been superseded and forgotten. It might be imagined that electronic methods will completely supersede chemical or mechanical methods, but that is not the case because each method produces a particular appearance, and thus a particular range of expression. The audience's taste for a particular appearance and artists' desires for certain kinds of expression dictate the methods that are popular. Technical progress responds to those tastes and desires in very unpredictable ways.

DRAWING

Drawing may be the oldest of the arts, but it is more alive than ever because it is the purest record of the human mind in action, rivaled only by spontaneous speech. Drawing and speaking are the natural expressive activities of each of the two halves of our brains. Research on brain function has shown that language abilities are largely located in the left hemisphere of the brain, while the synthesizing, relational abilities which control drawing are largely located in the right hemisphere. Just as speaking has its codes, which we call languages, each with its grammar and vocabulary, so does drawing have its codes, which we call styles, each with its materials, intentions, and emphases. That is why it is impossible to concentrate on drawing and talk at the same time. The pictures in this book challenge you to turn off, for just a moment, the left hemisphere of your brain which reads the text, to allow your right hemisphere to take in the pictures. But the left hemisphere also has to work on the pictures, taking the design apart and analyzing the meaning part by part. Art, both in the making and in the understanding, is a whole-brain activity, both synthesizing to see the whole design and analyzing to appreciate the significance of the parts.

Vincent van Gogh's drawing *View of Arles* (Fig. **5.1**) shows what a code in drawing can look like. Van Gogh started with paper, brown ink, a brush, and probably two pens of different widths. He had in mind a set of marks that could be made with those tools: narrow and wide lines, either short or long, straight or curving, parallel or radiating; spots of solid ink, of various sizes; shapes made of lines with empty centers. Each kind of mark stood for an identifiable material in the natural scene, large spots and open shapes for irises, small dots and close set lines for different plants in agricultural fields, close-set dots and lines for the trees and walls of the town. Beginning students of drawing often hope to reproduce exactly the appearance of the scene before their eyes, but in the end they must consider the set of marks they can make and what each one can represent. Language and drawing are both descriptive codes, each with its own powers and limitations. To draw and to understand drawings requires a realistic idea of both the powers and the limitations of the medium.

THE SKETCH, THE STUDY, AND THE FINISHED DRAWING

There are three reasons for making a drawing, and the result in each case has its own name. Since they have different uses, they also have different appearances. Those three reasons are:

5.1
Vincent van Gogh,
View of Arles, 1888.
Ink on paper,
17 x 21½ in (43 x 55 cm).
Museum of Art, Rhode
Island School of Design,
Providence.

1. To make a note of an idea or something seen, which results in a **sketch**.
2. To plan for another work, which results in a **study**. The word **cartoon** is also used for studies done full size, usually for a large work such as a mural; its meaning has expanded to include humorous or satirical finished drawings, which belong in the next category.
3. To make a work of art in its own right, which results in a **drawing** or, to distinguish it from other kinds of drawings, a **finished drawing**.

The reason is important only to the extent that it is reflected in the appearance of the drawing, but those reasons also bring to our attention the role of drawing in our thinking, from first thoughts, to planning future activities, to making final statements.

Leonardo da Vinci's sketches of cats (Fig. **5.2**) show his eyes stimulated by the poses and activities of living cats. But this sheet also shows his mind stimulated by the cats' movements—a kind of stream of consciousness that led him to think of lions and even a dragon. Leonardo had no reason to make sketches of cats except that they interested him.

One of the most famous series of studies is that for Pablo Picasso's mural *Guernica*. When the government of Spain commissioned Picasso to paint a mural for its pavilion at the Paris World's Fair to open in the fall of 1937, he had about eight months to complete the project. During the first four months he did no drawings, but he was surely considering how the mural could express the struggle for survival of the democratic Spanish government against an overpowering attack by Fascist armies. Then on the sunny Monday afternoon of April 26 the defenseless city of Guernica was attacked by the German air force, employed by the Spanish rebels. In three and a quarter hours of bombing and strafing the city was destroyed, the first time in history that a city was destroyed by aerial bombing. Like Hiroshima later, Guernica (*gare-NEE-kah*) became a symbol of brutality and the senseless destruction of war. Within the week Picasso was hard at work on his mural, the theme clear in his mind.

5.2
LEONARDO DA VINCI,
Sketches of Cats,
c. 1506.
Pen and ink over black
chalk, 10⅝ x 8¼ in
(27 x 21 cm).
Royal Library, Windsor
Castle, UK.

Of the hundreds of studies made for the mural we will examine just three. The first (Fig. **5.3**), in pencil on blue paper, dated Saturday, May 1, 1937, shows Picasso's first thoughts: a bull and horse, a Pegasus crouched on the bull's back, ruins in the background, and a scribble at the upper right that will turn into a woman holding a lamp. Interpretations of these symbolic creatures vary, and there is no right, or wrong, interpretation; Picasso was wise enough to make only a few ambiguous remarks and, as we know, it is the right and duty of the audience to make such interpretations. To me, then, the horse and bull are the actors in the drama of the bullfight, a subject Picasso frequently depicted. The bull represents the powers of nature, brute force, or darkness; the horse is the ally of the human bullfighter, who represents the powers of civilization, humanity, and enlightenment. Pegasus, or victory, alights on the powers of darkness.

The design developed rapidly as Picasso continued to draw. On Sunday, May 2, he did another drawing of the plan for the whole mural (Fig. **5.4**). The Pegasus has disappeared, the bull leaps triumphantly over the fallen horse, the woman in the upper corner is nearly in final form, and the scrawls in the foreground of Figure **5.3** have turned into a dead warrior and woman, of which only the warrior will be retained in the final mural, and then turned into a statue.

The head of a weeping woman (Fig. **5.5**) is a study for the head of the woman in flames on the right of the mural, a figure not part of the earlier studies and one that was taking on an independent existence as the sole subject of Picasso's other paintings. Even here, on May 24, as he was painting on the Guernica mural, this study was becoming a painting in its own right, since it is done in pencil, crayon, and oil paint on canvas.

5.3 (*left*)
PABLO PICASSO,
Study for *Guernica,*
May 1, 1937.
Pencil on blue paper,
10⅝ x 8¼ in
(27 x 21 cm).
Museo Nacional Centro de
Arte Reina Sofia, Madrid.

5.4 (*right*)
PABLO PICASSO,
Study for *Guernica,*
May 2, 1937.
Pencil and gouache on
gesso wood panel,
23⅜ x 28¾ in
(60 x 73 cm).
Museo Nacional Centro de
Arte Reina Sofia, Madrid.

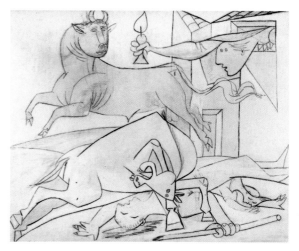

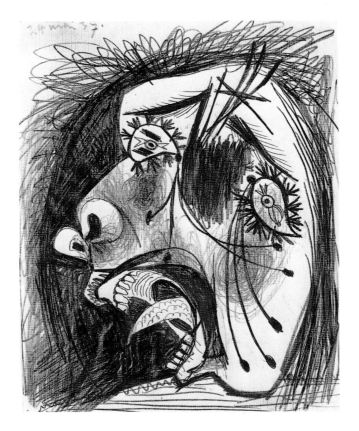

5.5

As early as May 11 the canvas had been stretched, its dimensions 11 feet 6 inches by 25 feet 8 inches (3.5 by 7.8 meters), and the figures drawn in. But over the next few weeks all the figures except the woman with the lamp underwent drastic changes (Fig. **5.6**). Picasso continued to draw, on paper, on other canvases, and on the mural itself, which even as a finished work is nearly pure black, white, and gray, more like our idea of a drawing than a painting. The absence of color makes the painting more stark and somber and more like a newspaper photograph and deprives us of any pleasure we might find in color. Although it is a large oil painting, *Guernica* still has the spontaneous appearance that we associate with drawings. Since

5.6

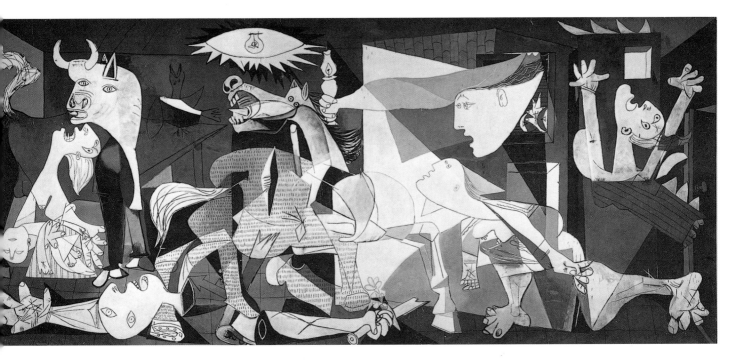

5.7
GEORGES SEURAT,
Portrait of Edmond-François Aman-Jean, 1882-83.
Black conté crayon,
24½ x 18¾ in
(62 x 48 cm).
Metropolitan Museum of Art,
New York. (Bequest of Stephen C.
Clark, 1961.)

Picasso had planned the painting carefully in many preliminary studies and it was not really a spontaneous production, that appearance was clearly Picasso's intention.

But, of course, there is no rule that drawings must appear to be spontaneous. Many finished drawings are as thoroughly planned and as carefully executed as paintings. Georges Seurat's (*sur-RAH*; 1859–91) portrait of Edmond-François Aman-Jean (Fig. **5.7**) is as large as many paintings (a little over 24 by 18 inches, or about 61 by 46 centimeters) and very carefully finished. Seurat was famous as a painter in the Post-Impressionist style of **pointillism**, using dots of pure color, but in this black crayon drawing on textured white paper the style shifts to dots of pure value (black to white range). Although we might think we see lines, Seurat was careful to work only in areas of value tone, all of them perfectly modulated to create a perception of lighted masses, some of them solid black and light absorbent, in a dusky space.

THE TOOLS AND MATERIALS OF DRAWING

It is hard for us to realize how modern an art drawing really is. Before paper was available and inexpensive it was hard to find a surface to draw on, and most of the surfaces that were used were hard to preserve. People drew in the sand and on cave walls, on clay tablets, and on animal hides, all surfaces that were very inconvenient by our standards. The Egyptian invention of papyrus paper was a tremendous breakthrough, producing a smooth sheet which was easily transportable and more durable than most modern paper. Although it never became inexpensive, it was used for many fine ancient drawings and paintings, though few have survived to our day. Paper, made of pulverized organic fiber, was supposedly invented in China in A.D. 105, replacing ancient bark paper. It was first made in Europe in the 13th century, but it did not become common until the Renaissance. Villard de Honnecourt, whose sketchbook survives from the 13th century, drew on parchment and vellum, made from animal hides. The surface, or ground, on which drawings are made is particularly interesting now because we are in the midst of another revolution much like that caused by the invention of paper; the new surface is the cathode ray tube computer screen, which we will examine later.

As soon as a good drawing surface was easy to obtain, the next problem was to find a tool that made a mark. Several tools had been known since ancient times, used by scribes, manuscript illustrators, and artists. Pencils made of real lead or silver, which made pale marks on a white surface; pens made of a bird quill (usually from a goose), which produce a flexible, cursive line, or from a reed, which produce a strong angular line; brushes; and ink (usually brown or blue-black); and chalks of various colors (usually brick red, black, or white) had all been known and employed since ancient times.

The detail from *Nine Dragons* (Fig. **5.8**), a handscroll by Ch'en Jung (active 1235–50), shows a dramatically spontaneous style of drawing—it has been described as "an ultimate achievement in the splashed ink style."[1] The artist takes pride in a seemingly effortless drawing with the flexible brush and ink, making sharp lines for the scales and claws, drawing long smooth lines for waterfalls, smudging in the ink for the darkest areas, and literally splashing the ink onto the paper in some places. This black ink drawing style developed from calligraphy (see Chapter 2), and only an artist who was completely comfortable with the writing brush could use it with such abandon as Ch'en Jung demonstrates.

Sometimes the drawing tools were mixed, producing unusually rich effects, as we see in Rembrandt's *Cottage near the Entrance to a Wood* (Fig. **5.9**). The main dark

5.8
CH'EN JUNG,
detail from *Nine Dragons*,
1244.
Ink and slight color on paper handscroll,
18¼ in x 35 ft 10 in (0.46 x 10.96 m).
Museum of Fine Arts, Boston, Massachusetts.

5.9
REMBRANDT VAN RIJN,
Cottage near the Entrance to a Wood, 1644.
Pen and bistre wash with red and black chalk,
11¾ x 17¾ in
(30 x 45 cm).
Metropolitan Museum of Art, New York. (Robert Lehman Collection, 1975.)

areas and shadows were laid in with a brush and brown ink, with wide variations in its tone. Then a reed pen was used to draw details on the cottage and the foreground areas of trees, logs, and ground. The blunt, stiff lines show the nature of the reed pen. Finally red and black chalks were used to reinforce some darks and add a brightening warm touch.

Colored chalks, or **pastels** (made by mixing colored pigments with glue formed in sticks), and crayons (pigments mixed with wax or grease) were popular new media in the 18th century and led to important art. In the 19th and 20th centuries pastels have been considered an ideal medium for impressionistic effects of light and color, since the pastel stick can be very soft (with little glue) to give rough spots of color without sharp edges, as well as hard (more glue and less pigment) to give sharp detail. Artists have recently shown new interest in pastel and used it in new ways. *Revelations/Revelaciones* (Fig. **5.10**) is John Valadéz's (b. 1951) vision of a couple lost in the universe between the dark opening to the mythic underworld of earth gods (to whom one sacrifices chickens) and the demons of the heavens (one wearing a Pre-Columbian mask). Pastel on paper is rarely used on the scale of Valadéz's work, in which the figures are nearly life-size. The colored chalks in this drawing are applied on a dark blue paper, which gives a mystic, nocturnal mood. Product of an East Los Angeles Chicano community, Valadéz inherited the photorealist techniques and Pre-Columbian myths of the Mexican-American tradition. He began to concentrate mainly on pastel after a 1988 trip to see European museums. That trip, and perhaps the change to pastel, resulted in large-scale, ambitious drawings in powerful color. His style is independent of the French traditions that we are accustomed to seeing in pastel, and his subjects are chosen

5.10

JOHN VALADÉZ,
Revelations/Revelaciones,
1991.
Pastel on paper,
61¾ x 50½ in
(1.57 x 1.28 m).
Daniel Saxon Gallery, Los
Angeles, California.

from real life in America, often with a mythic or visionary twist that pastel, with its pure colors, seems to enhance.

The first really new drawing tool to be added to the artist's kit was the graphite (mineral carbon) pencil—what we usually call a "lead" pencil—which was introduced a little before 1800. It was an improved version of the old lead pencil, which was made with real lead, or the silverpoint, both of which were rather faint and could not be easily erased.

Although tools and materials play important roles in the artist's expression and often inspire the artist to make a particular kind of drawing, from the audience's point of view the artist's creativity is revealed in more subtle ways. Drawing, like speaking, reveals the mind of the artist, and the audience is looking to see the mind in spontaneous action. Like our minds in dreams, drawings are very literal; what is shown is "there" and everything shown has symbolic meanings. Salvador Dalí (*dah-LEE*; 1904–89), in his *Cavalier of Death* (Fig. **5.11**), tried to gain access to a dream-like state-of-mind by making ink blots like a psychological Rorschach test, which he then interpreted in his drawing. Both the horse and its rider are skeletal, the rider gloomy, but the horse laughing triumphantly. Although it is not really an ink-blot test, it has a strangeness and richness of symbolism that really are like a dream.

Pentimenti (Italian for "repentances") are changes of mind visible in a drawing (or painting). At first thought it might seem that such "mistakes" and corrections would ruin a drawing, but the audience has never felt that way about them. On the contrary, they are of special interest since they reveal the mind of the artist in action. Michelangelo's black chalk drawing *Resurrection* (Fig. **5.12**) shows ghostly ideas for figures on the left and right and in the center foreground, none of them brought to completion. They involve the observer in the action of drawing, making us speculate on why Michelangelo tried them and then rejected them and forcing us to visualize the drawing as it might have been.

To leaf through an artist's sketchbook is just about as intimate a contact as we have with another person, like reading someone's diary. That intimacy is both the special appeal and also the limitation of drawings—each one is unique and can have only one owner. So it was natural that, as drawings became more common, the question of duplicates arose.

5.11 (*above left*)
SALVADOR DALÍ,
Cavalier of Death,
1934.
Pen and black ink on paper, 33½ x 22⅜ in (85 x 57 cm).
Museum of Modern Art, New York. (Gift of Miss Ann C. Resor.)

5.12 (*above right*)
MICHELANGELO,
Resurrection,
1532-33.
Black chalk on paper, 12½ x 11⅛ in (32 x 28 cm).
British Museum, London.

PRINTMAKING

Quickly following paper from Asia to Europe was its use to make multiples of a drawing, which we call an **edition**. Like paper, printmaking had a long history in Asia; techniques were known in India at least as early as the 7th century and in Japan by 770, when an edition of a million prints of the Buddha was stamped from wood blocks.

Editions of prints vary tremendously in size, and that is one of the reasons prints may vary in price. A wooden block used for a woodcut is fragile compared to a copper plate used for an etching and will simply wear out. But the copper plate also wears out after a few hundred trips through a heavy press. Fine-art prints are usually made in editions of a few hundred, each print requiring special care and handling. Photolithography used for magazine illustrations can produce thousands of excellent pictures in the time required to make a few prints, but the hand-made prints still set the standards for quality in printing.

RELIEF PRINTS: WOODCUT AND LINOCUT

Japanese woodcuts are part of a long tradition which is independent of Western art. Hokusai (*HO-koo-si*; 1760–1849), in the early part of the 19th century, revolutionized the tradition by introducing landscape subjects, most famously in his series *The Thirty-six Views of Mount Fuji*. One view of the volcano (Fig. **5.13**) is between two stores in Edo (now Tokyo). The Mitsui Store, on the right, whose sign reads "Dry Goods, cash payment, fixed prices," is having its roof repaired, and one man flings packets of tiles up to the roofers. The tall roofs, the flying kites, and the gestures of the workmen make a pattern of nearby elements to contrast with the spacious sky and distant peak. Like all Japanese printmakers, Hokusai made the original design and the printing was done by a team of specialists. Each color required a separate block, which was carefully registered so that its print fitted

5.13

HOKUSAI,
The Thirty-six Views of Mount Fuji: The Mitsui Store at Suruga-machi in Edo, 1830-31.
Color woodcut on paper, 10 x 15 in
(25 x 37 cm).
Metropolitan Museum of Art, New York. (Rogers Fund, 1922.)

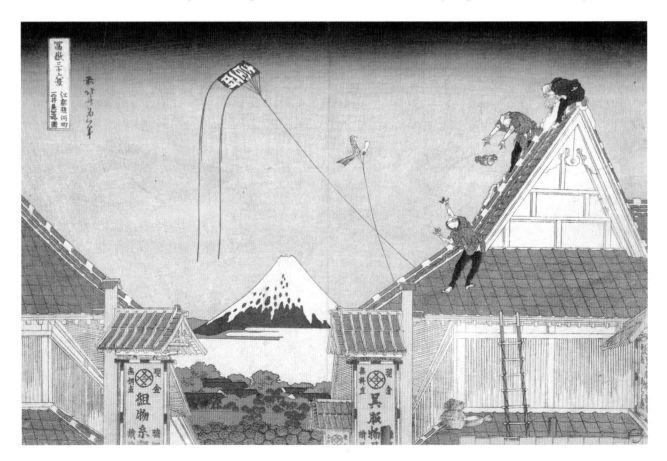

exactly with the other blocks to form the complete image in color. Gradations of color, such as we see in the sky, were made by uneven inking of the blocks.

Woodcuts and linoleum cuts (sometimes called **linocuts**) are the common methods of making relief prints, in which the artist cuts away the negative areas, leaving the positive parts in relief to catch the ink and print on the paper. We are all familiar with rubber stamp impressions, fingerprints, tire tracks in the mud, and so on, all of them relief prints. Woodcuts were first made in Europe for humble uses, such as playing cards, but they soon came to the attention of serious artists.

Woodcut

Albrecht Dürer (1471–1528) accepted the challenge of duplicating the style of Renaissance pen drawings in woodcut. You can judge his success in one of a series of prints on the Apocalypse (Fig. **5.14**), or the end of the world as seen in a vision by John the Evangelist, who kneels at the lower left. John recorded his vision in Revelation, the last book in the New Testament. Dürer interpreted John's words (1:12–16) literally: "I saw seven gold lampstands, and among them a being like a man, wearing a long robe, with a gold belt around his breast. His head and hair were white as wool, as white as snow; his eyes blazed like fire. … In his right hand he held seven stars; from his mouth came a sharp double-edged sword, and his face shone like the sun at noonday." It is hard to believe that those fine lines were printed from lines left on a block of wood as the white areas were cut away.

5.14
ALBRECHT DÜRER,
The Vision of the Seven Candlesticks, 1498.
Woodcut on paper,
15¼ x 11 in (39 x 28 cm).
National Gallery of Art,
Washington, D.C. (Gift of Philip Hofer.)

PAUL GAUGUIN,
Te Atua (The Gods),
c. 1893-95.
Color woodcut on paper,
8 x 13¾ in (20 x 35 cm).
Art Institute of Chicago,
Illinois. (Clarence
Buckingham Collection,
1948.)

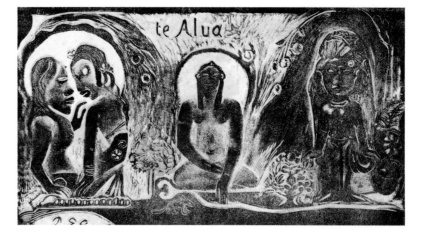

Woodcut (done on the length of the board, which has grain) and wood engraving (done on the end of the board, which has no grain) remained in use, mainly for commercial illustration, until photography took over in the 1890s. But just at that point, woodcut was revived in a totally unexpected way by Paul Gauguin, working in the Polynesian Islands. He was inspired by his romantic view of Tahitian life and his knowledge of Asian, especially Indonesian, art. *Te Atua (The Gods)* (Fig. **5.15**) shows that Gauguin was not trying to reproduce a drawing, but thinking more in terms of a painting, with printing in both black and tan, each color from a different block of wood, and yellow, orange, and green added with a brush, probably using stencils. Dürer's prints impress us with their absolute control; Gauguin's give an impression of technical freedom and spontaneity. All modern printmaking has been influenced by Gauguin's woodcuts; relief printing as a technique was brought back to life by his example.

Another woodcut, *The Kiss* (Fig. **5.16**), done in 1902 by Edvard Munch (*moonk*; 1863–1944), shows how quickly the understanding of Gauguin's prints spread among artists. The main idea was to take advantage of the natural character of the materials—in this case the grain of the plank of wood. Two blocks were used; one coarse-grained block, probably from weathered wood to let the grain show, was printed lightly to create an atmosphere, and a separate heavily inked block (still the plank but finer grained and inked so heavily that the wood grain does not show) was used for the lovers.

5.16

EDVARD MUNCH,
The Kiss, 1902.
Woodcut, printed from
two blocks (gray and
black), 18⁵⁄₁₆ x 18⅜ in
(46 x 47 cm).
Museum of Modern Art,
New York. (Gift of Abby
Aldrich Rockefeller.)

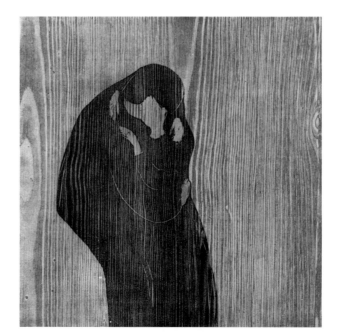

INTAGLIO PRINTS: ENGRAVING AND ETCHING

Albrecht Dürer realized that a finer line could be made by cutting it into a surface than by cutting away the background around it. The result would be a more durable printing surface, since very thin lines in a woodcut have a tendency to break under the pressure of printing. As the son of an armor maker, Dürer learned the crafts of intaglio at his father's knee, for engraving and etching were used to put ornamentation on fancy armor. In **intaglio** (*in-TAL-yo*) the lines which will print are cut into the surface of the plate or block (usually a copper plate), the ink is rubbed into the cuts, and the plate surface is rubbed clean of ink, though ink remains in the cuts. Then the plate is laid on the steel table (called the "bed") of a press, dampened paper is laid over it, and together they are subjected to heavy pressure from the press rollers. The ink from the cuts is pressed onto the paper; the wider and deeper the

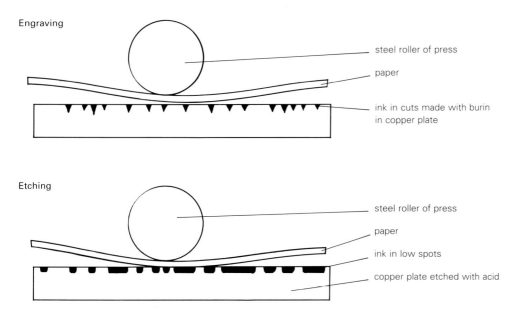

Engraving

steel roller of press

paper

ink in cuts made with burin
in copper plate

Etching

steel roller of press

paper

ink in low spots

copper plate etched with acid

cuts the more ink they hold and the darker the line. In **engraving** the cuts in the copper plate are made by hand with a small hardened steel chisel called a **burin**. In **etching** the cuts in the copper plate are made with acid. In other respects the two techniques are similar. An intaglio print is always identifiable by the *plate mark* where the edge of the copper plate was embossed into the paper by the hundreds of pounds of pressure from the rollers of the press. The design, of course, was also embossed and would show up even if it contained no ink.

A view of a printmaker's studio in the 17th century (Fig. **5.17**) shows three men hard at work printing intaglio plates. In the right background a man applies ink to a

5.17
ABRAHAM BOSSE,
*View of a 17th-century
printmaker's studio,*
1642.
Engraving on paper,
10 x 12½ in (26 x 32 cm).
Albertina Graphische
Sammlung, Vienna.

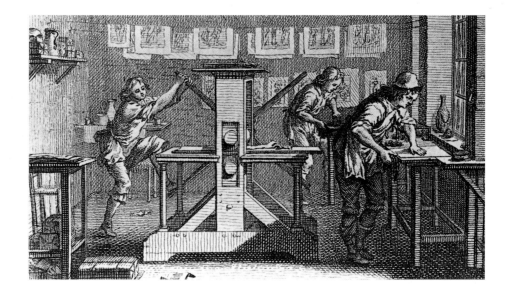

plate which already has an engraved or etched design. The nearer man on the right is wiping the surface ink from a plate. He would have started with cotton waste (the rag in his right hand) to get most of the ink off, but the final wiping is done with the heel of the hand, which is hard enough that it leaves ink in the cuts but wipes the surface clean. On the left the third man has laid an inked plate on the bed of the press, laid paper over the inked plate, and covered them both with felt blankets. The final step is cranking the bed of the press through the heavy rollers of the press. Then the blankets will be thrown back, the paper peeled from the plate and hung on a wire to dry.

Dürer was one of the first artists to print by these methods, and one of the greatest. *The Knight, Death, and the Devil* (Fig. **5.18**) was part of a pair on a favorite Renaissance topic; the difference between the knight's active life in the world and the quiet life of study, represented by a saint. The knight rides through a dangerous world of wild forests and mountains, threatened by Death and a grotesque devil, but neither he nor his horse nor his dog shows any fear. Renaissance people, such as Albrecht Dürer, took their images of lifestyles from the Middle Ages, from the monastery and the medieval warrior, but even today we can identify with the ideas this print expresses. The picture is composed entirely of lines cut into a copper plate with the burin. Dürer's working method was to cut a strong line around the main shapes in one part of the design, then add details until that part was finished before going on to the next part. Variations in values were made by hatching and crosshatching; all the gray and black areas were made by overlapping lines.

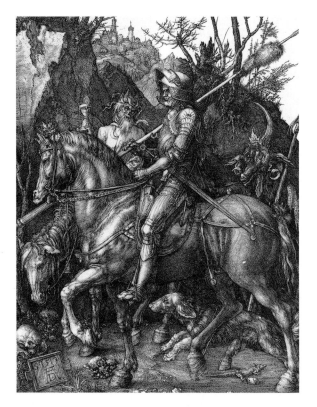

5.18 (*above*)
ALBRECHT DÜRER,
*The Knight, Death,
and the Devil*, 1513.
Engraving on paper,
9¾ x 7½ in (25 x 19 cm).
British Museum, London.

5.19 (*right*)
REMBRANDT VAN RIJN,
The Three Trees, 1643.
Etching on paper,
8¼ x 11 in (21 x 28 cm).
Rijksprentenkabinet,
Amsterdam.

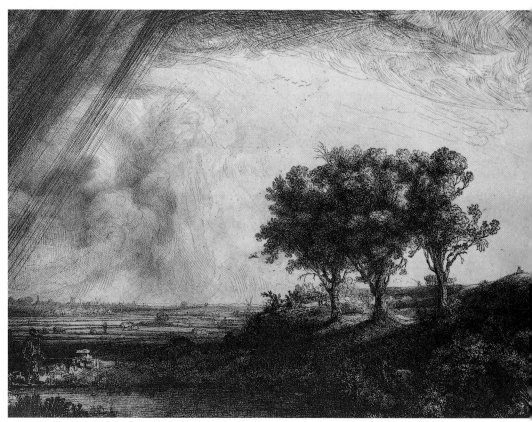

Dürer sometimes used etching, but he seems to have preferred engraving, which gives a sharper, stronger appearance to the design. The etcher can simply sketch lightly on the copper plate, which is covered with a soft asphalt surface, called the ground, which resists acid. Wherever the sharp steel tool (called an etcher's needle) scratches through the ground the acid will cut a line. The depth of the cut is controlled by removing the plate from the acid bath at intervals and "stopping out" by varnishing the lines that are deep enough. Rembrandt was one of the great etchers, and his *The Three Trees* (Fig. **5.19**) shows the atmospheric effects he attained, with deep dark areas, heavily etched, and cloud areas with the finest patterns of line.

Etching remained the most popular medium for art printing through the 19th century, the black-and-white tones serving very well the desire for atmospheric effects and a passionate mood so characteristic of that century. Charles Meryon (*mare-YOn*; 1821–68), the most admired Parisian etcher, had about five years of work before madness ended his career. His views of Paris often contain strange figures. In *The Morgue* (Fig. **5.20**) a drowned man is carried from the river by his friends, and mourned by his wife and child as a policeman directs them to the morgue. The dark windows, tall houses, smoking chimneys, waterpipes, and enigmatic figures create a mood well suited to the etching medium, which allows heavy darks and irregular sketchy marks that express more emotion than the tightly controlled engraved line.

For another Rembrandt etching, see Figure **12.35**.

Mary Cassatt's color etchings show how the technique had developed by the 19th century (see Fig. **13.22**).

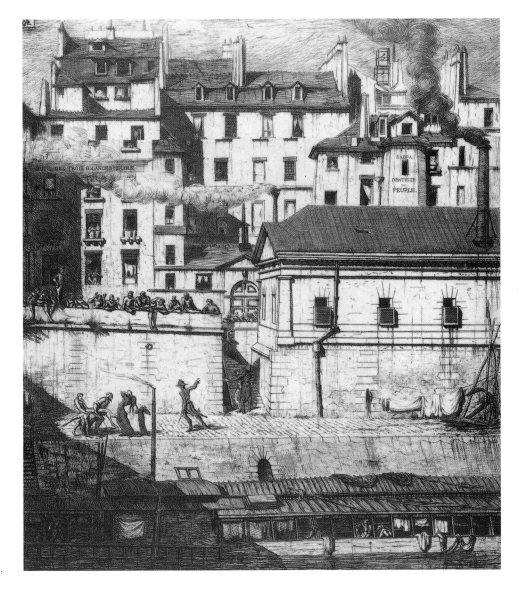

5.20
CHARLES MERYON,
The Morgue,
1854.
Etching on paper,
9 x 8 in (23 x 21 cm).
British Museum, London.

LITHOGRAPHY

Unlike the older print techniques, whose origins are lost, the invention of lithography is a well-known story of genius and obsession. Alois Senefelder (*ZEN-uh-fel-der*) began to write plays and music when he was eighteen, in 1789, and wanted to publish them himself inexpensively. The printing press using movable type had been invented long before (by Gutenberg about 1450), but it did not offer a method for printing music, which was still copied by hand. Senefelder was mixing his ink on a piece of smooth limestone and by accident discovered that a greasy liquid he planned to use as a ground for etching his writing onto copper could be used to mark on the limestone. It took nine years of experimenting before he could obtain a patent for his new method of printing, which was quickly adopted as a way to print pictures, often with text (as in advertising), as well as music. Senefelder's method of making "chemical prints," as he called them, quickly spread to other countries. As early as 1802 a young French artist received a patent from the French government on the technique, and in 1809 a manual on lithographic printing was published. The technique spread around the world within a quarter of a century and began the surge of printing developments that historians in future centuries are certain to see as one connected story from **lithography** to photography and electronic printing.

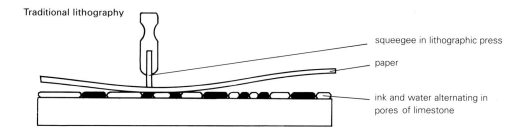

Traditional lithography

squeegee in lithographic press

paper

ink and water alternating in pores of limestone

Senefelder's invention consisted of drawing with a grease crayon on a smooth limestone, which gave the medium its name (litho = stone, graphy = marking). The drawing on the stone is treated with a very weak nitric acid solution ("etched") to make the grease of the drawing penetrate the stone and to make the areas without drawing more receptive to water. For printing, the stone is kept damp so that it repels the ink everywhere except where the greasy crayon has left its residue. Paper is laid over the inked stone and it is passed through a press under moderate pressure. Artists soon learned that lithography had the potential for printing color, using a separate stone for each color. The design on each stone must be carefully fitted (or "registered") to its place in the design, but the process is identical except that colored ink is applied to the stone for printing. The process is sufficiently complicated that most artists have their lithographs printed by specialists.

Two French artists brought lithography to unsurpassed levels. Honoré Daumier used it for rapid black-and-white drawings and cartoons and Henri de Toulouse-Lautrec (*ahn-REE* duh too-looz-lo-TREK; 1864–1901) perfected the large multicolor poster. Both these artists worked in what were considered commercial arts, which were printed on short-lived papers and expected to have a short life as art. Looking back at their work now we see clearly that it is of a standard we consider fine art, which we hope will endure.

Daumier's print of the famous photographer Nadar making the first aerial views of Paris from a balloon was published in the magazine *Le Boulevard*, May 25, 1862. It was entitled *Nadar Raising Photography to the Level of Art* (Fig. **5.21**). (The photographer returned the favor by making the best-known portraits of Daumier.) Nadar actually had a huge, propeller-driven balloon made for aerial photography, and we see him precariously perched in a tiny gondola (surely it was larger!) high above the city, which seems to consist entirely of photographers' studios. During

most of his life Daumier was terribly poor, working as a lithographic illustrator from the age of fourteen, and once jailed for six months for cartoons attacking the government. The pressure to produce drawings every day resulted in the free, sketchy style we see in this print. To Daumier these were crayon drawings. The lithographic medium, used in this way, is a very direct technique for making editions of drawings.

If one had to choose the supreme masters of lithography, Henri de Toulouse-Lautrec would certainly be among them. He is famous for posters that give us a vivid picture of Parisian entertainment of the 1890s. Lautrec did studies for the lithographs, usually as drawings in charcoal, but sometimes as paintings in **gouache** (water-base paint) or oil on cardboard mounted on canvas. His print *Napoleon* (Fig. **5.22**) was done in 1895 for a competition to choose a poster to publicize a biography of Napoleon, but since another (less interesting) print won, Lautrec's remains without lettering. It gives a good sample of his way of working. The main lines of the study done in oil paint were transferred to the stone. Lautrec placed tracing paper over the stone to try out colors, about which he was very particular, mixing the inks himself to get subtle shades. He drew in the outlines with black crayon, then dramatized parts with a brush, especially on the horses and the French general on the right. Napoleon's horse was left as a shape in the natural color of the paper, with the background around it spattered with color dots, a technique invented by Senefelder, but one that Lautrec liked so well he sometimes claimed he invented it. The radiating pattern of the riders, the contrasts of shape, texture, and color, and the somber but human mood of Napoleon—all make this an unusually interesting print, a lesson in lithographic art.

SERIGRAPHY

Silkscreen printing, called **serigraphy** (*suh-RIG-ra-fee*) as an art technique, had a long history as a commercial and industrial stencil technique before it began to be used as a fine-art medium in the United States in the 1930s. Since that time it has become very popular, partly because it is relatively inexpensive to do and the basic processes are easy to learn.

5.21 (*above left*)
HONORÉ DAUMIER,
Nadar Raising Photography to the Level of Art,
1862.
Lithograph on paper.
Metropolitan Museum of Art, New York. (Harris Brisbane Dick Fund, 1925.)

5.22 (*above right*)
HENRI DE TOULOUSE-LAUTREC,
Napoleon,
1895.
Lithograph on paper,
23⅜ x 18 in (59 x 46 cm).
Private collection.

5.23

The screen is a wooden frame with silk cloth stretched over it. Placed over a piece of paper, the screen receives the printing ink and spreads it evenly as a scraper, or squeegee, is run across it. To make a design a stencil may be cut and attached to the silk, or glue may be painted onto the silk and allowed to dry to prevent the ink from passing through parts of the silk. It is in the stencil, of course, that the art is composed. Serigraphy is easily used for color printing: a separate stencil or a separate screen is used for each color, and often twenty or more screens are printed on the same piece of paper, making prints which rival paintings in the complexity of their color.

Serigraphy has been used by many well-known American artists. Andy Warhol (1931–87) and other members of the Pop Art movement of the 1960s found silkscreen printing the ideal medium because of its strong connection with popular commercial culture since it was often used for posters and advertising. The cool, impersonal precision of its shapes and the flat color tones it naturally produced were considered desirable qualities in prints such as Warhol's *Campbell's Soup Can* (Fig. **5.23**). At first it was considered an insult to art and art lovers, but it has become a famous image of its period.

Silkscreen has the power to print both the flat color areas and sharp edges we expect in a poster or the personal brush stroke and modulated color more typical of painting, and contemporary printmakers are exploiting a range of such effects.

Timothy High (b. 1949) used a variety of techniques in *rebel earth, Ramath lehi* (Fig. **5.24**). The jawbone (with which Samson killed a thousand Philistines) and darts in the foreground were printed from five silkscreen stencils made from photographic negatives, each one showing one level of light or shadow. The rest of the picture was made by **hand-reduction**, the laborious process of printing the largest areas of the lightest color and value, then slowly reducing the open area of the stencil by covering areas by hand with lacquer "block-out." Then the next color is printed and the blocking-out process continued—eighty-three times on *rebel earth, Ramath lehi*. Some areas, particularly large ones, were printed by placing two colors of ink in the screen and allowing them to blend as they were pulled across the screen with a squeegee, a process called "split fountains." These complicated processes result in great variation of color and detail. In this print High symbolizes the conflict between pagan powers represented by the ancient Peruvian dolls with their dart weapons and Samson's Old Testament God, who met in battle at Ramath-Lehi ("Jawbone Hill").

This combination of handwork and photographic processes was used in Melissa Miller's print *Ablaze* (Fig. **5.25**). Miller painted twenty-one clear acetate sheets with black acrylic paint, each sheet representing a color or value of ink. Each acetate sheet was converted to a stencil by printing it photographically on a silk screen coated with photo-emulsion, which acted as a negative, leaving openings in the screen where the black paint had been brushed on. Printing with colors resulted in a print notable not only for its variety of colors and values but especially for its exact recording of the artist's brush stroke. Each of the fifty prints in the edition is an original, and preserves much of the individuality of brush stroke that we would expect in a one-of-a-kind painting.

Like High's *rebel earth, Ramath lehi*, Miller's *Ablaze* is an image of spiritual conflict. The viewer identifies with the panther, standing like a human being, beset by demonic spirits in the forms of skeletons, howling masks, glowing ectoplasm, and leaping enemies. The savage intensity of Miller's brushstrokes expresses the mood even more forcefully than those subjects.

5.24 *(above left)*
TIMOTHY HIGH,
rebel earth, Ramath lehi,
1983.
Hand reduction serigraph,
40 x 26 in (102 x 66 cm).
Collection of the artist.

5.25 *(above right)*
MELISSA MILLER,
Ablaze, 1988.
Silkscreen print,
40 x 30 in (102 x 76 cm).
Texas Gallery, Houston,
Texas.

PHOTOGRAPHIC AND COMPUTER ARTS

As we come to the beginning of a new century a new set of media is emerging in the art world. The foundations of these media lie in photography and electricity, both 19th-century discoveries, and they have unleashed a chain of innovations and inventions during the 20th century. Among the first applications of many of these media were entertainment, games, and art, which tells us something about human beings.

We will examine the growth of these related media as they developed historically, beginning with photography in black and white, and color, followed by cinema, video, and early computer art. Finally, we will look at digital photography and film, digital computer art and virtual reality. To speak of these developments "historically" seems strange, since black and white photography is still a fairly new artform, which we are still exploring, and most of the real pioneers of video and early computer art are still in mid-career. The digital arts and virtual reality are so new that they have not gained what we might call "critical mass"—that is, a large enough body of good work to permit us to make evaluations.

Nevertheless, the electronic arts are shaking up many of our cherished ideas about what it means to be an artist or a member of an audience. They call into question what defines a medium, and, perhaps most of all, they challenge our understanding of such basic ideas as "truth" and "experience." Solving these puzzles may be both much harder and more important than the inventions of the technologies. Before we consider such questions, however, we need to look at what exactly artists are achieving with these media.

PHOTOGRAPHY

We think of photography and its descendants in film and video as *the* 20th-century media, but their roots go back at least to the 10th century and an empty room in Cairo, Egypt, that had a round hole in one wall. By some process that the medieval Egyptians found hard to explain, on sunny days the image of the scene viewed through that hole was projected upside-down on the opposite wall of the dark room. We may still find that hard to explain, but we have become accustomed to it and have learned to make images that are even harder to explain.

5.26
Camera obscura stamped with the name of Canaletto, 18th century. Glass lens, ground-glass plate,
7½ x 8¼ in (19 x 21 cm), in wooden box.
Correr Museum, Venice, Italy.

The Latin words for "dark room" are "camera obscura," a term that is still used, and from which we get also the word "camera." The room in Cairo was a camera without the film, which remained absent for about 800 years. But lack of film did not keep artists from using this kind of camera. Eventually they put a lens in the hole, mounted paper opposite it, and drew the image projected through the lens. Such a filmless camera used for drawing is still called a **camera obscura** (Fig. **5.26**); it was frequently employed by artists before the invention of photographic film. For example, Frederick Catherwood (1799–1854) drew his detailed rendering of Mayan architecture at Uxmal (Fig. **5.27**) by means of a camera obscura. In the final lithographic print he added figures from his imagination. The value of the camera obscura was in the exactness and accuracy of the drawings, the best possible before photographic film existed.

Photography and the other art media have always had a close relationship, fertilizing each other with new ideas. Philippe Halsman's (1906-79) *Dalí Atomicus* (Fig. **5.28**), showing Salvador Dalí in an "atomic" environment, is an amusing attempt by a photographer to rival the imaginative fantasies of Dalí himself. The

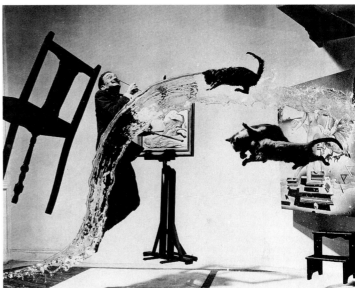

5.27
Frederick Catherwood,
part of La casa de las
Monjas, Uxmal, Mexico,
1844.
Lithographic print from
camera obscura drawing,
16¼ x 11⅝ in
(41 x 30 cm).
From *Views of Central
America, Chiapas, and
Yucatan.*

5.28
Philippe Halsman,
Dalí Atomicus,
1948.
Photograph. Copyright
Halsman Archive, 1989.

moment they think of their pictures as art, photographers begin to show the influence of paintings and sculptures. On the other side, painters and sculptors use photography as a sketching tool and a source of inspiration. Before photography, artists often used "pattern books" of engravings of parts of the body, architecture, and of every detail an artist might suddenly need as a model. Photographs have largely taken over the job of showing us what the world looks like.

The trust that the audience places in the truth of photographs is often misplaced because it has always been easy to manipulate and fake photographs, and the development of digital photography has made it so easy that we should probably assume that all photographs have been "retouched" to some extent. Our continuing faith in their truthfulness often gives added impact to those pictures we know are manipulated (for example, see pages 182–5). Nevertheless, the fact that photography can be used to make an objective visual record still accounts for its great significance. Since our eyes are our major source of information and photography serves as an extension of our eyes, photography is certainly more important as a source of information than it is as an art medium. That is to say, the feelings and ideas of the artist and audience are in the long run less important than the fact that the information is recorded. Photography allows expression and interpretation, but it is alone in making possible an objective record.

From about 1870 to 1895, William Henry Jackson (1843–1942) traveled on foot, with an assistant and a mule heavily loaded with photographic equipment, all over the western United States. His thousands of photographs were among the documents that showed Americans the frontier lands of the West. *War Dance at Zuñi Pueblo* (Fig. **5.29**) is a wonderful record of that Indian town when white settlers were just beginning to invade its territory. The artist's feelings are impossible to ascertain from the photograph, and surely that is one of its great advantages. Such photographic records have been made of other countries, wars and political events, astronomical and experimental data in science—all extending our knowledge of the world in ways we now take for granted.

Some of the great photographers manage to combine the objectivity of the medium with their subjective intentions. A famous example is Lewis Hine (1874–1940), a sociologist who began about 1905 to take research photographs showing people at work. Using a large camera with 5-by-7-inch (13-by-18-centimeter) negatives, he took some of the early open-flash pictures using explosive magnesium powder, which extended the photographer's range into dark places and night times. Hine's *Carolina Cotton Mill* (Fig. **5.30**) helped to convince the public that children were being exploited in American factories and mines. Its power to

5.29
WILLIAM HENRY
JACKSON,
War Dance at Zuñi Pueblo,
c. 1874.
Photograph. Colorado
State Historical Society,
Denver.

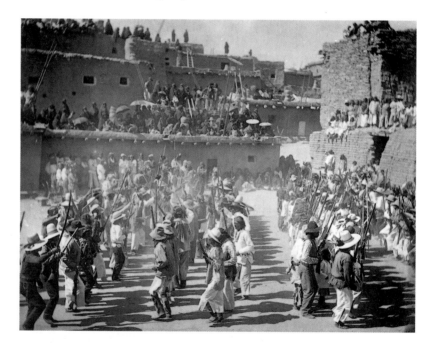

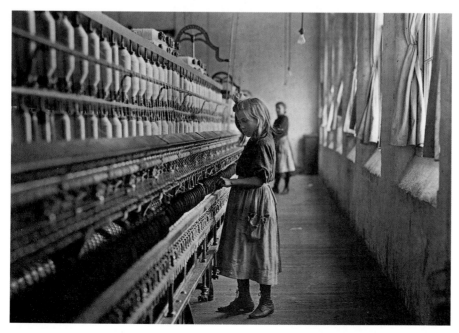

5.30
LEWIS W. HINE,
Carolina Cotton Mill,
1908.
Gelatin-silver print
photograph.
Museum of Modern Art,
New York.

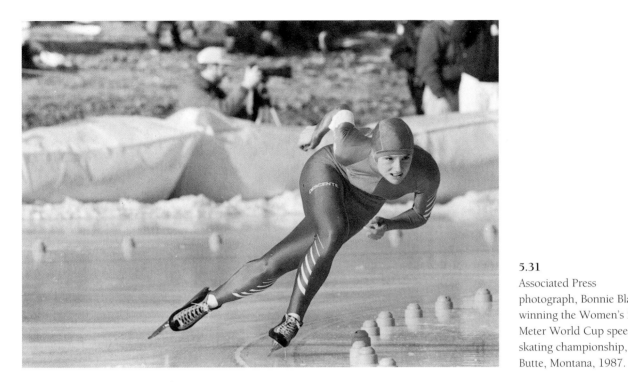

5.31
Associated Press
photograph, Bonnie Blair
winning the Women's 500
Meter World Cup speed-
skating championship,
Butte, Montana, 1987.

convince comes from the fact that Hine did not intrude and dramatize—he showed the scene as his eyes saw it.

Photographic technology has improved so much that it is hard to imagine taking pictures with the equipment W. H. Jackson or Lewis Hine used, even though we still admire their work. High-speed film, electronic flash, and small and miniature cameras have made it possible to take pictures under almost any conditions. Sports, in which humans are stretched to the limits of their strength and skill, have always had a strong attraction for both photographers and their audiences. It is hard to imagine the sports pages of the newspaper without photographs, and many sports pictures are among the most dramatic images we see. The picture of speed skater Bonnie Blair (Fig. 5.31) by an Associated Press photographer is typical of the fine images we almost take for granted in the daily news-papers and in magazines.

5.32
BRETT WESTON, *Century Plant,* 1977. Photograph. Collection of the artist.

Century Plant (Fig. 5.32) by Brett Weston (b. 1911) is the kind of photograph that is obviously intended as a work of art, not a record of an event. If you could examine the original print, rather than the reproduction in this book, it would be still more evident that it is a work of art, for Weston specializes in a very refined printing process that gives a fine-grained, silvery tone to the prints. It must not be forgotten that the original print of a photograph, like any other original print, is the work of art. Reprintings in books and magazines are simply reproductions.

5.33
JERRY N. UELSMANN,
Kudzu House,
1982.
Photograph. Collection of
the artist.

5.34
SEBASTIÃO SALGADO,
Serra Pelada, 1987.
Magnum Photos.

Jerry Uelsmann (*YULES-man*; b. 1934) has written, "For me the darkroom functions as a visual research laboratory."[2] The idea that the photographic image is a product of visual research done in the artist's studio (darkroom) is one that some photographers disagree with, arguing that the photographer should print only what the camera records in one exposure. Uelsmann has been one of the leading photographers to take the view that photographic images are starting points for artistic composition. *Kudzu House* (Fig. **5.33**) was constructed of four negatives: one of the kudzu vines, one of an abandoned building, another of an ocean beach, and finally one of a small human figure. The sharp detail and the objectivity which we associate with the photographic medium give this image a strong psychological realism, like a vivid dream.

One of the most influential of the documentary photographers working at the end of the 20th century is the Brazilian Sebastião Salgado (*say-bahs-tee-OW sal-GAH-jew*; b. 1944), who was educated as an economist and still thinks of his work as partly economic reporting. "We photograph with our ideology," he says of his concern for human suffering, "and my work is my life, my way of life." His photographs of the Serra Pelada mine (Fig. **5.34**) in the Amazon region of Brazil were taken in 1987 when about 50,000 men rushed to extract gold from a mountain, tearing it down with their hands until a hole 600 feet (180 meters) deep and a half mile (0.8 kilometers) wide was left. "A lot of people were killed each day by accidents," Salgado says. He travels light and alone, working with 35 mm cameras, and living for long periods with his subjects. "It is very important for me, the time you spend. You understand many things; you are accepted by the people; you don't break any of the rules of the culture. That takes time."[3] The result is an art so rich in content that you could write a book about almost every image.

COLOR PHOTOGRAPHY

From the earliest days of photography color was considered the goal. The separate stones for each color in lithography was one of the clues that inventors had in their minds, and the craft of the artist was very much in the minds of early photographers. Not until 1907 was a form of color photography, the Autochrome, put on the market. This used a glass plate coated with starch grains dyed orange, green, and violet, each of which absorbed light of its complementary color and allowed its own color to print. This French process had a dotted "impressionistic" appearance, which may be more than mere coincidence. Yet the Autochrome dots are invisible—a million per square centimeter, a much finer grain than a television screen. Léon Gimpel's Autochrome *Family of Acrobats, Paris* (Fig. **5.35**) gives an idea

5.35
Léon Gimpel,
Family of Acrobats, Paris,
c. 1910.
Autochrome color
photograph. Collection de
la Société Française de
Photographie, Paris.

of the soft, natural color of this method. The long exposure it required (one second in bright sunlight) was too much for two of the children, who moved slightly.

With modern color film, which came on the market in the late 1930s and the 1940s, the technical limits of color photography have disappeared. Now the limits are mental, spiritual, and artistic, the same as in any other art. In this most competitive international field, we are slowly beginning to be able to distinguish art from expertness.

Hideki Fujii's brilliant blue-and-yellow bathing suit picture (Fig. 5.36) makes full use of the power of color and the power of shape, to the point that we nearly forget that a three-dimensional body is inside the suit. Powerfully contrasted colors, printed flat without highlights and shadows, produce a design of pure shapes that exceeds that made by Matisse by cutting plain blue paper. It could be compared with the Japanese kimono designs, which manifest the same abstract design sense, an important part of the Japanese tradition in art.

Although color photography offers a great temptation to make gorgeously colored abstractions, it also has the power to record the real world objectively. The color picture (Fig. 5.37) taken by Susan Meiselas of a mass demonstration in Nicaragua in memory of a murdered young woman comes from the real world of pain and struggle. Yet it is a fascinating work of art, too, that turns that moment into a symbol of all struggles of people for justice. The presence of the dead woman herself, in an enlarged black-and-white photograph, a beautiful face dreaming above the angry crowd, reminds us of the uses and powers of photographic images in our lives, both public and private.

An entirely different kind of photography results from David Hockney's work in photo collage (Fig. 5.38), in which many views of the subject—a desk—give it a strangely hypnotic intensity. A painter and printmaker, Hockney spent several years exploring Polaroid photography. "The important thing," he says, "was that those

5.36
HIDEKI FUJII,
untitled, 1985.
Image Bank.

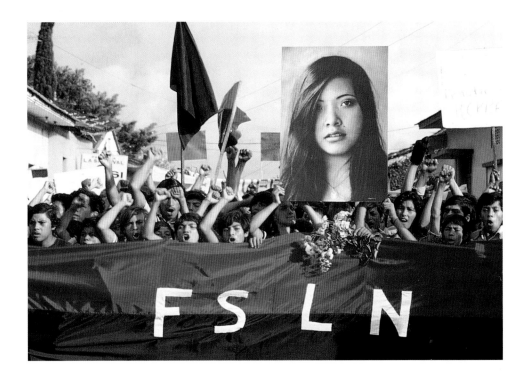

5.37
SUSAN MEISELAS,
Nicaragua,
1978.
Magnum Photos.

experiments with photography led me back to the hand. … You need the hand to piece it together because, essentially, you are drawing." Hockney explains the multiple views as a way to get beyond Renaissance central perspective, which the single "eye" of the camera automatically produces. He cites Picasso's Cubism as "the only thing that's broken the grip of the old perspective." His quarrel with perspective is that it does not permit the depiction of the passing of time, which is recovered in the sense the observer has of moving around the desk, looking at it from many angles. Some of Hockney's concerns are echoed, as we shall see, by artists working with computers and virtual reality.[4]

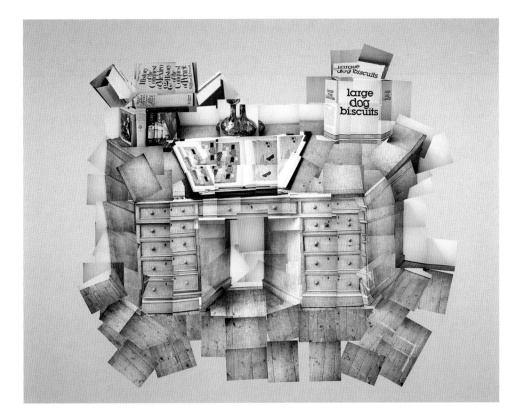

5.38
DAVID HOCKNEY,
The Desk, July 1st,
1984.
Photo collage.

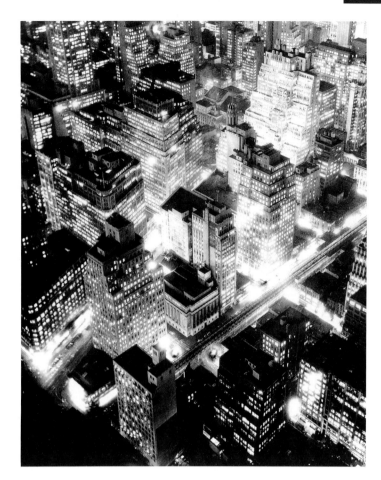

Berenice Abbott Recording New York

5.39
BERENICE ABBOTT,
Nightview,
c. 1935.
Photograph.

To photograph New York City means to seek to catch in the sensitive and delicate photographic emulsion the spirit of the metropolis, while remaining true to its essential fact, its hurrying tempo, its congested streets, the past jostling the present. ... Already many an amazing and incredible building which was, or could have been, photographed five years ago has disappeared. The tempo of the metropolis is not of eternity, or even of time, but of the vanishing instant.

Berenice Abbott wrote this in 1935, during a period of ten years dedicated to photographing the city.

Nightview (Fig. **5.39**) was taken about that time on a large view camera that accepted 8-by-10-inch (20-by-25-centimeter) negatives, with an exposure of fifteen minutes. To catch the windows lighted Abbott had to take the picture after dark but before offices closed at 5:00, which gave her about half an hour in the early darkness of December. She wrote about taking this photograph: "In this case I was at a window, not at the top of the building; there would have been too much wind outside. It was, of course, hard to get permission [to photograph in the building]. They always thought you wanted to commit suicide and superintendents were always tired, lazy and annoyed. They usually had to be bribed." We see the seemingly endless expanse and depth of the city as an organism pulsing with light and life. Abbott always had, from her earliest work, the ability to understand and capture on film the significant truth about what could be seen. *Nightview* is a good example of Abbott's conviction that in photography interpretation is achieved by the artist's understanding of the subject, not by darkroom manipulation of the negative.

Abbott, who was born in Springfield, Ohio, in 1898, learned photography when she got a job as laboratory assistant to the American photographer Man Ray in Paris in 1921. In 1961 she moved to Maine, where she lived in a restored inn that became a mecca for those interested in photography. In the forty years between she made every kind of photograph: portraits, revealing views of experiments in physics, and documentary pictures. She never showed any interest in manipulating the image to make it more expressive or imaginative. To Abbott photography was a means to document historical or scientific truth.

Quotations from Hank O'Neal, *Berenice Abbott, American Photographer*, with commentary by Berenice Abbott (New York: McGraw-Hill, 1982), p. 2

CINEMA

Cinema is a photographic medium (based on chemistry rather than electronics) that was raised to an art form in the early 20th century. It was in film that ways were found to use pictures to tell a story, and those cinematic conventions of storytelling have become the foundations on which new arts are being developed at the end of the century. The art of cinema is what is on the film and, like any other art, its content can be analyzed from two aspects, the form and the subject. The form is the film, the camera, and all the lights, dollies, microphones, projector, screen, and other equipment that help put the image and sound track on the film. But it is also the planning of shots and the editing into a continuous series of images. The subject is the story. The content is the meaning, both emotional and intellectual, of the story.

The early directors, such as D. W. Griffith (1875–1948) in the United States and Abel Gance (*gawnse*) in France, saw the movies as a chance to produce dramas on an epic scale that was impossible on the stage. The camera could record immense panoramas, with a cast of thousands. Panning (from the word "panorama"), in which the camera turns across a scene, converted the whole surrounding environment into a stage. Although he had begun as a playwright, Griffith learned how to take advantage of the epic possibilities of cinema that differentiated it from stage drama. *Birth of a Nation* (Fig. **5.40**), filmed in 1914 in nine weeks (which was considered a long time) for $125,000 (a record amount at the time), was the culmination of Griffith's film-making. He had learned the art of cinema by trial and error, making more than 400 short films between 1908 and 1913. Two of the many

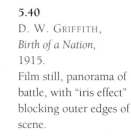

5.40
D. W. GRIFFITH,
Birth of a Nation,
1915.
Film still, panorama of battle, with "iris effect" blocking outer edges of scene.

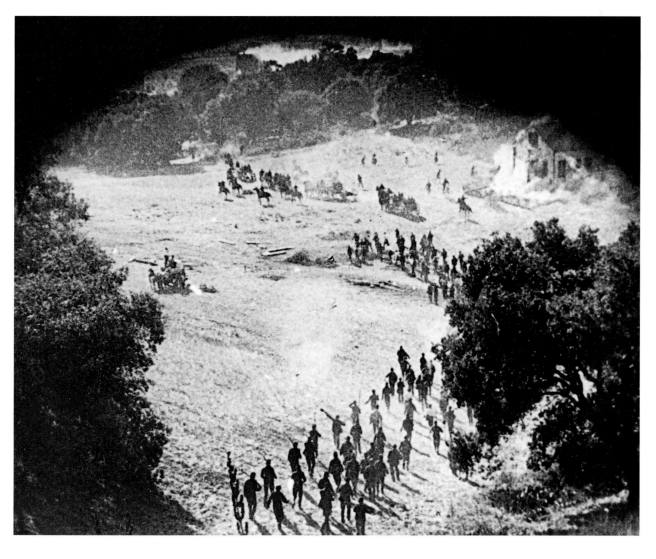

Mickey Mouse

5.41
Walt Disney Studios, Mickey Mouse in *The Band Concert*, 1935. Drawing for animated film. Copyright 1935 The Walt Disney Company, Burbank, California.

Walt Disney, then twenty-six years old, and his collaborator Ub Iwerks, were faced with a crisis: the hero of their animated cartoons, a small black animal with a white face and big ears named Oswald the Lucky Rabbit, was legally the property of their film distributor, and he wanted to cut Disney out of the company. In self-defense Disney and Iwerks invented Mickey Mouse, who debuted in 1928, when sound film was brand new. Mickey had to have a voice, and after many auditions it was decided that only Walt Disney himself could speak Mickey's lines in the proper falsetto. Disney spoke for Mickey Mouse for twenty-five years. *Steamboat Willie*, Mickey Mouse's first film, was the first sound cartoon and *The Band Concert* (1935) (Fig. **5.41**) was one of the early films in Technicolor. Sound and color film were not Disney inventions, but he was responsible for a style of film animation that has so thoroughly dominated that art that we can hardly imagine there is another way to do it. Strangely enough, Walt Disney never drew a figure himself after about 1926, leaving the drawing of the thousands of figures and scenes required for animation to a huge crew of hard-working artists. But Disney knew exactly what he wanted and worked very closely with the animators.

The action in film animation is achieved by a series of pictures ("frames"), which show transitions in the movement. This is done now largely by computer programs, but in Disney's time every picture was entirely drawn by hand. Disney's artists understood the active power of the curved line; if we look at Mickey we see almost nothing but curves, each one ready to expand into motion as the frames pass through the projector, the more transitions shown, the smoother the action. Cartoons were action comedies. In *The Band Concert* Mickey conducts the town band in "The William Tell Overture" but finds his music interrupted by a swarm of bees, a street vendor (played by Donald Duck) playing "Turkey in the Straw" on his harmonica, and finally a tornado. Almost every line drawn for the thousands of frames of the short cartoon had a springy curve. The Disney style took such complete advantage of the curving action line that it is difficult for animators to find an action style that does not appear to derive from Disney.

things he learned were the usefulness of varied shots and the importance of editing, both basic differences from staged theater. The shot (a piece of film in which the camera appears to have run without stopping[5]) that was commonly used for a whole picture when Griffith began his work was what is now called the "full shot" or "far shot," showing the full figures of the actors within a stage-like environment. Griffith began to move the camera closer or farther away, to pan by turning the camera to follow action, and even to use "tracking shots" by moving the camera on a track. Then in editing these varied shots were combined to tell the story. The drama of *Birth of a Nation* focused on a Southern family (the Camerons) and a Northern family (the Stonemans) who struggled and suffered through the Civil War but were finally united by a marriage. The colossal theme of the war and Reconstruction called for panoramic scenes of battles and politics, but the intimate life of the families had to be portrayed in closer, more intimate, psychological form. Griffith laid the groundwork in film technique for both those aspects of cinematic art.

Today, perhaps even more than in Griffith's day, editing remains at the core of the art of film-making. Carol Littleton edited her first Hollywood film in 1974 and has since been the editor of a long series of notable movies, among them *Body Heat*, *The Big Chill*, *Places in the Heart*, *Silverado*, and *Brighton Beach Memoirs*. In an interview published in 1987, Littleton discussed her work, describing the process of learning by doing, learning the tools of a complicated technical skill. An editor, she said, has to have "a good mixture of an analytical approach—understanding characterization, structure, and so forth—and an emotional approach—being able to let yourself go and enjoy the movie. ... as a member of the audience." The biggest problem, she said, is time pressure from producers who count the cost of a film in hours of work. "But it doesn't work that way," Littleton insisted. "We're not manufacturing tires. We're not stamping out cookies. It's so much more than a mechanical process." Editing is "truly collaborative," she explained. "I have a role to play as an editor. I am not doing my own movie; I am interpreting the director's movie. There's a great deal of myself in it, undoubtedly, but I need to understand the director's point of view— what he or she needs to do—and execute it as best as possible."[6]

The video artist Nam June Paik, commenting on "the painstaking process of editing" his videotapes, mentions that editing is a simulation of the brain function of changing the time structure of real life experience, cutting from one shot (or memory) to another, shortening or lengthening the time in terms of its emotional meaning.[7]

We have all grown so accustomed to the horizontal rectangle of the projected movie image that we never think how different it is from the shape of other art forms, which are often vertical rectangles or three-dimensional forms of space or solid. But there are several good reasons for the shape of the image (which we usually call the screen) in a horizontal rectangle. First, it conforms to our natural visual field, which is about twice as wide as it is high. Second, it provides stable horizontal and vertical margins for the changing and moving viewpoint of the camera's shots. The commonest proportions for the screen are 1:1.33, or three units high to four wide.[8] That is a compromise between the natural visual field, which is much wider, and our desire to look closely at details, especially details of faces, which are called "close-up shots" (close-ups, for short). Experiments with wide-screen movies show that they are most effective in showing landscape. They show too much irrelevant background in the close-ups and thereby reduce the effect of psychological drama. And it is in psychological drama that the film excels.

It is not only the close-up and the dramatic story that contribute to the psychological power of the film, but also the fact that the audience experiences movies as a group. The group reinforces and enhances the mood and meaning experienced by each individual in it, a factor ordinarily absent from our experience of other visual arts, in which each member of the audience is alone with the work of art. This grouping of the audience, which cinema inherited from its live-theater ancestors, has been eliminated in art based on virtual reality, which we will examine below, on page 184.

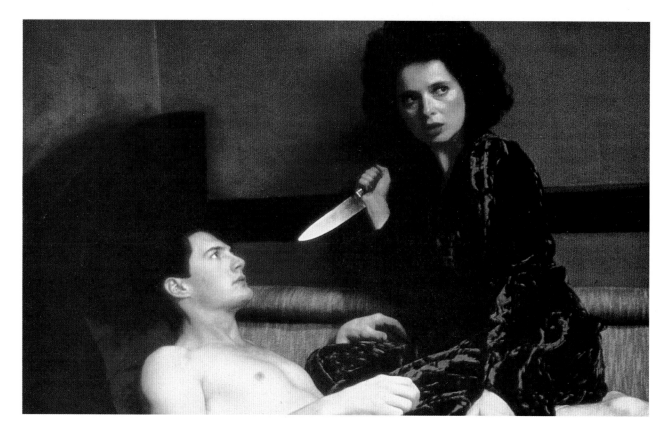

5.42

The 1987 film *Blue Velvet* (Fig. **5.42**) is a gripping psychological thriller based on two traditional story types: the coming-of-age and the Freudian version of the Greek myth of Oedipus (*ED-i-pus*). The screenplay was written by its director, David Lynch. The film was photographed by Frederick Elmes and edited by Duwayne Dunham. On the surface it is the story of a romance between Jeff, just back from college, and Sandy, the pretty high school senior. But from the opening scenes, which descend from a typical American small town into the lawn where insects struggle violently beneath the grass, we know that we are to penetrate beneath surface appearance. It is Jeff's subconscious mind we penetrate, not through close-ups but by a dream-like drama played by symbolic characters in symbolic settings. Jeff is surrounded by characters in pairs: his father and the insane villain Frank, his mother and the night club singer Dorothy. The dark red walls and curving entrance of Dorothy's apartment create a womb-like sensuality for scenes played between Jeff and Dorothy. By the end of the film, when Jeff has had an affair with Dorothy and killed Frank, he is liberated from his psychological conflicts, and the reward for his coming-of-age is Sandy (whose story should be told in another film).[9] The impact of the film is as much in its dark and mysterious colors as in the spoken dialogue, for the words are often conventional but the colors used in the film are unusual and convey their messages to our subconscious minds.

VIDEO

The next development in this story is the conversion from the photographic medium of cinema to an electronic medium.

Video art is the adaptation of the television medium, which we ordinarily think of as the expression of large corporate bodies, to individual expression. Video art has a history of about thirty years, during which all aspects of the video form have been used by artists. The first element of video to become available was the television set, or monitor, which is used as one object in an assembled complex of forms. About 1965 the portable video camera became available, permitting simultaneous recording and display of the image, as well as delayed display or taping. From the

first, video has had strong connections to performance arts, social criticism, and experimental art.

Video is unusual in its ability to involve the viewer in the image—"interactive video." Bill Viola's *He Weeps for You*, made in 1976, was one example. This was a subtle application of interactive video requiring a viewer, a source of water falling in drops onto a toy drum, a video camera, and screen projection of the video image 4 feet (1.2 meters) high. The drops of water reflected the viewer and were recorded highly magnified by the zoom lens of the camera. The viewer saw his or her own image on the screen as reflected in the magnified drops and heard the amplified sound of the drops as they hit the drum[10]. Interactive video has no fixed form, but provides certain conditions within which the viewer's activity produces an image.

The first artist to make a name in video art was Korean-born Nam June Paik (*payk*; b. 1932), who bought thirteen used television sets in 1963 for use in his art. He has used television in several ways: the monitor is part of a sculpture, sometimes "preparing" it by taking it apart or manipulating the screen image with magnets, and more recently by making videotapes. In 1986 he produced a *Family of Robots*, composed of assembled TV sets. *Mom, Dad, Aunt, Uncle, Grandma,* and *Grandpa* were all assembled of old, long-used monitors, *Baby* (Fig. **5.43**) is made of sixteen

5.43

NAM JUNE PAIK, *Family of Robots: Baby,* 1986.

Thirteen television sets, VHS player with thirty-minute tape, 52½ x 38 x 13¼ in (133 x 96.5 x 34 cm). Carl Solway Gallery, Cincinatti, and Holly Solomon Gallery, New York.

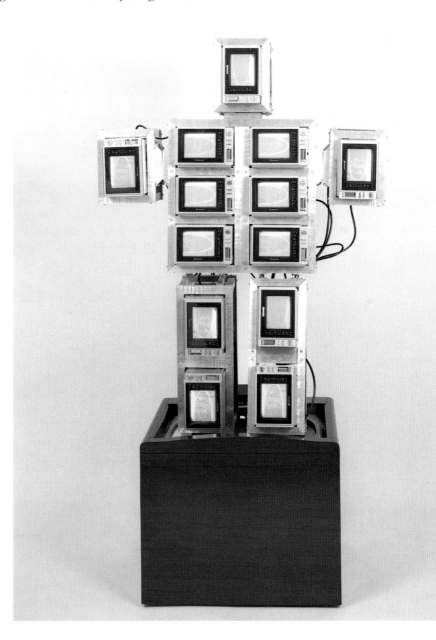

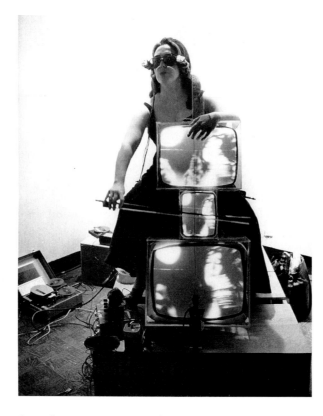

5.44
NAM JUNE PAIK,
TV Cello and TV Glasses,
1971.
Video camera, three monitors,
glasses. Collection of Charlotte
Moorman, New York, and the
artist, New York. Copyright 1971
by Peter Moore.

brand-new miniature color sets. Computer-generated videotaped imagery by Paik runs on the screens.

Paik, who has an advanced education in musical composition, has given performances of his own avant-garde music in which the use of the tape recorder and electronic sound are vital, but he also wanted to expand the *visual* expression of music. Video, music, and performance combine in some of Paik's best-known work, done in collaboration with cellist Charlotte Moorman. In *TV Cello* (Fig. **5.44**) Moorman plays a cello made of three video monitors with their casings removed, larger screens on top and bottom to suggest the shape of a cello. The screens show Moorman, a camera recording the event and projecting it as it occurs. She also wears *TV Glasses*, invented by Paik, in which she sees herself.

Paik has been inventively exploring the medium, emphasizing its involvement with time—as a still object (the monitor), a mirror of the present, or record of the past for future projection, or any combination of those—projecting abstract designs made by electronic and magnetic means, as well as showing images from the real world. His work has gradually shifted from mainly sculptural forms to an increased use of videotape.

Guadalcanal Requiem (Fig. **5.45**), made during the 1970s, is Paik's most complex videotape, the latest version running twenty-nine minutes. The central imagery focuses on Charlotte Moorman playing the cello on the beach of Guadalcanal Island, in the South Pacific, surrounded by wreckage of the great battles fought there in 1942. The subject has both a present and a past. It is also pictorial and abstract, as Paik presents it, and has both a purely visual effect and an anti-war message. Videotape allows Paik greater complexity than attainable in his sculptural video art because it represents much that cannot really be present and it permits time to see a variety of images.

Paik is concerned about the worldwide effects of television. "Video has immeasurable magical powers," he has written. "This means that the Eskimos' ancient traditional culture is in danger of being rapidly crushed by the bulldozers of Hollywood. The satellite's amplification of the freedom of the strong must be accompanied by the protection of the culture of the weak."[11] As a person who has bridged the Eastern and Western cultures and the traditional and avant-garde arts,

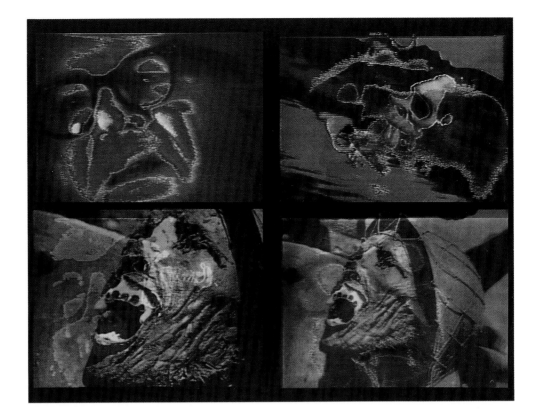

Paik sees both the danger that electronic media will bring us boring similarity around the world and the opportunity that these media will bring peace and understanding. His work is his statement that artists, as well as commercial entrepreneurs, must be involved in the development of electronic media.

Video images, including those on video laser discs, are analog information, recording complete pictures as light and dark patterns. The latest development in video imagery is digital information, in which pictures are broken into **pixels** (a word coined from "picture element," meaning a dot of light or darkness on the computer or video screen) and the brightness of each pixel is measured and coded on magnetic tape as a number in a zero-to-one binary system. Analog images are much more complicated, but as they are copied over and over they develop "noise," or distortions and degradation. Digital images can be copied or transferred without degradation because copies are perfect clones, existing only as numbers. The main problem is that they require a large amount of wiring and computer memory to carry and store the images, and if the power is low the pictures become unintelligible.

Color, on the video screen or the computer, increases the complexity of these problems. The primary colors of cast light (as opposed to pigment) are red, blue, and green, which must be measured separately by running the image through color filters. The measurements are then digitized. So much data is produced that fiber optic cables are required to carry the files, fiber optic being thousands of times faster than copper cables.

These technical aspects of image making are some of the background knowledge artists need to work in the electronic arts now, but when they are understood they quickly take a back seat to the basic problems of artistic expression. It is those problems that we will concentrate on here as we look toward future forms of art. Nam June Paik, who has been in the forefront of technical innovation in art, predicts that art will soon be sold on videodiscs like music and there will be a top ten chart of the most popular hits. Such art will be displayed on our walls, he says, on mural-size television screens.[12] Yet the vital element is how technology releases the artistic imagination.

5.45
NAM JUNE PAIK,
Guadalcanal Requiem,
1977.
Videotape, twenty-nine minutes. Distributed by Electronic Arts Intermix, New York.

DIGITAL PHOTOGRAPHY AND COMPUTER GRAPHICS

Although the invention of digital imagery dates from the 1920s, only recently has equipment been available to everyone to participate in this revolution in picture-making. In 1985 scanners became available at low cost to enter pictures into the computer, and in 1986 home computers began to use color. By 1988 color slides could be entered in the computer and produced as computer output. In 1989 the electronic still video camera was introduced. This records up to fifty pictures on small, reusable magnetic disks that can be shown immediately on a television set or transmitted electronically to a publisher's office. By 1990 digital cameras were available that recorded images digitally instead of in video format, permitting the disk to be entered into the computer instead of a video player or recorder. Although digital cameras are still expensive, the history of the computer is one of rapid reduction in the cost of equipment. In the early years of computer art only scientists working in major laboratories had the equipment to produce high quality digital pictures, and it seemed questionable whether these machines had the potential to produce art. The availability of the equipment to individuals working in their own homes and studios has allowed its expressive potential in art to be explored by many more people.

The typical computer set-up, called a "paint system," is a computer with graphics cards and a frame buffer installed, a color monitor, a computer terminal, a digitizing tablet, and a stylus or mouse for graphic input. A graphic or paint software must be installed. The production of a print you can hold in your hands or hang on the wall has also been the focus of technical innovation. Currently the computer can produce printer drawings in color, plotter drawings (which may spray paint in video-like lines), color Xeroxes, video images, film or slides, or the computer screen can be photographed. The color printers use ribbons of cyan (bluish-green), yellow, magenta (purplish-red), and black in order to make full-color pictures. A good color printer can provide 32,768 color variations, and the best provide more than 16 million variations.

If the computer cannot duplicate exactly the appearance of some kind of visual art now, it is certain that within a short time every form, shape, color, and texture that an artist can produce by hand can also be produced by the operator of an electronic tool, who can then make as many more identical products as you wish. Not only that, but the operator can also transmit them instantly anywhere in the world where the equipment exists to receive them. But it is only when the operator is an artist, with the aims and imagination of the artist, that the output of the computer is art.

It is hard to define at what point in its production a digital photograph can be definitely called "a work of art." An authoritative book on digital photography uses the term "soft proof" for the image on the computer screen. "Your image is represented on the screen and you can manipulate it, but it remains intangible, just a lot of numbers and electrons floating in its color space."[13] We have always thought that art consisted only of "hard copy," objects that can be touched. Is this soft proof the work of art?

There are two methods by which the computer extends photography. One is to begin with photographs, which were taken on one of the new digital cameras, or else are "scanned" (that is, digitally encoded in a scanner) into the computer. The photographic images can then be combined or changed by using a "paint" program. Whatever photographic or other material is fed into the computer is simply raw material for a new creative process. This raises all sorts of new legal and ethical issues: do artists have the right to use the work of other artists as raw material? Do these new computer images use news or documentary photographs in ways that could be called "lies" rather than artistic "fiction"?

The other way the computer can be used to extend photography is to begin with a set of mathematical instructions, instead of a photograph, and to generate a picture

Computer-aided design (CAD) and production of auto parts turn drawing into machines (see p. 314).

M. Maguss

by giving instructions to the computer. Such instructions can simulate directional light and a particular point of view. This is seen everyday in television and film animations, but it was also one of the first ways that original works of art were produced on the computer. Martin Maguss's *Rex Goes on Vacation* (Fig. **5.46**) was produced by this method. Light and shadow are convincingly suggested to give a fantastic realism to this funny picture, full of incompatible things such as lightning in a starry sky, the floor in isometric perspective and the chair in central perspective, not to speak of the dinosaur in the swimming pool. To produce a hard copy Maguss made a Cibachrome color photograph of the computer screen, converting the digital picture back into a chemical one.

The cutting edge of computer art is in digital cinema, of which we are seeing in the 1990s the primitive founders of what is certain to be a new artform. Computers have been used in moviemaking for about a decade (as in *Tron* of 1982), but by 1995 they have become basic tools, not spectacular gimmicks. Films, which used to be constructed of "takes" or scenes, which were photographed as continuous and then edited into a coherent story, are increasingly assembled in the computer out of filmed raw material. Post-production is the creative stage, when actors can be added to the scene, or erased from it, or partly erased (as Gary Sinise's legs were erased in *Forrest Gump*). George Lucas, founder of the Industrial Light and Magic Company, and James Cameron, of Lightstorm Entertainment and Digital Domain, are currently the leaders in digital film. In earlier work the challenge was to produce special effects and stunts that would be impossible to act or model, such as a liquid-metal man, first imagined by Cameron for his first *Terminator* film, but only realized in the sequel. The T-1000 killer in *Terminator 2: Judgment Day* was a spectacular effect, transforming from solid creature to mercury-like liquid metal, freezing in liquid nitrogen (Fig. **5.47**, overleaf) and melting in molten steel. Most such effects were computer-generated.

The challenge facing the technicians now is to make the computer effects invisible. "Photorealism is a goal for me on this film," Cameron says of his work on *True Lies*, "because it expands the applicability of these techniques to all films." The moviemaker of the future will sit at the computer, very much like the artist at the easel or the drawing table, composing a story and its pictorial expression out of the raw footage shot previously, in what will increasingly be considered "pre-production." The visual effects art director for *Jurassic Park*, TyRubin Ellingson, told an interviewer, "This is the digital renaissance. It's Florence, and I'm here."[14]

5.46
MARTIN MAGUSS,
Rex Goes on Vacation,
1987.
Cibachrome photograph (created on a Genigraphics 100D computer, several multiple exposures), 20 x 30 in (51 x 76 cm).
Collection of the artist, San Francisco, California.

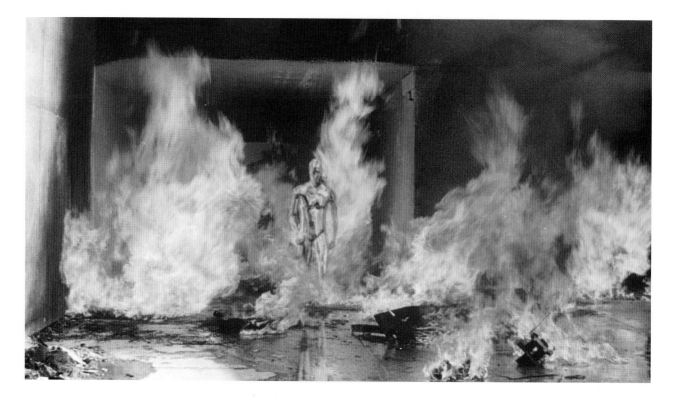

5.47

JAMES CAMERON,
Robert Patrick as T-1000
from *Terminator 2:
Judgment Day,* 1991.
Still from color film.

VIRTUAL REALITY

The most recent development in the electronic arts is virtual reality. Virtual reality is the experience of an electronically simulated world "with the help of computerized clothing that covers your sense organs."

The audience in virtual reality usually consists of one person who wears electronic goggles and a glove that interface with a computer program.

Toni Dove and Michael Mackenzie designed a virtual reality (VR) installation called *Archaeology of a Mother Tongue* at the Banff Centre for the Arts in Canada in 1993, Dove designing the visual experience and Mackenzie the narrative. This piece, which lasts forty minutes, is too long to be seen comfortably through a headset, so a "driver" using a data glove reacted for the audience by touching objects, moving forward or stopping to look around the graphic environment. This adaptation of VR by artists designing installations to be experienced by audiences in groups, as in a theater, has been called artificial reality.

One of the two main characters in the narrative by Dove and Mackenzie is the Pathologist, whose voice is heard, very quietly and intimately in the ears of the audience. When the driver touches the Pathologist's skull it grows larger and the audience moves inside to a wireframe brain as the character describes her long-term memories (Fig. **5.48**).

"The sense of being inside a narrative space is a pleasurable sensation," Toni Dove says, calling "immersion...the most compelling aspect of VR." She contrasts immersion, with its continuous flow of time and space, with the cut in film, which interrupts the flow of time and space to move the story along. The ability of the audience to interact with the program is restricted, Dove feels, by the artist's control of the content and by the limited choices in the program. The presentation of choices to the audience also interrupts the flow and focuses the audience on the medium. When we read a story or see a movie "it is a transparent wall through which one passes to enter a world... we accept the conventions or structures of the medium and agree to forget them in order to participate in an illusion. The activity of choice in the computer novel becomes a constant interruption." The manipulative features of the VR medium "represent the agendas of marketplaces and economies whose priorities are served by them," Dove says. The alternative she proposes is to

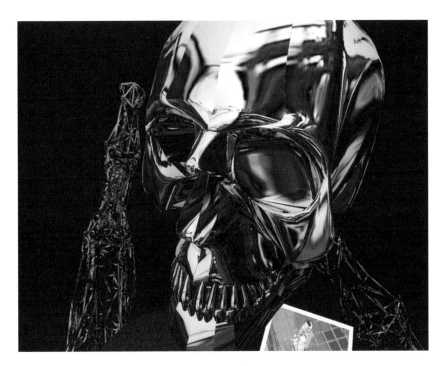

5.48

replace audience choice with programmed response to audience actions. "I liked the idea that people using a piece might receive completely different emotional responses depending on the way they handled the interface [that is, the data glove]; rough or gentle, fast or slow."[16]

Fred Ritchin, an authority on photography and interactive communications, is skeptical of our uses of these new powers. "Using virtual-reality-style headsets and bodysuits, children can already 'enter' their television sets to engage in interactive home video games. Bombarded by Barbie, Barney, Super Mario and cereal commercials, children will now be able to feel even more connected, one might even say resident, within the Image Society—finally entering the sacred space of 'snap, crackle and pop'."[17] That "sacred space" is what Toni Dove calls the "narrative space" of the VR "computer novel," and the pleasure Dove finds there is the same as children find. Ritchin concludes that when the medium is used mainly as a tool of marketing it holds little of more long-term interest, a statement with which most of the artists working in VR would agree. The challenge of VR, and of the whole electronic "information highway," is to increase the content levels to match the technical capacity of the medium. Artists, it appears, are going to have to become far more broadly educated than ever before to be able to fill these powerful media with ideas, sensations, and stories that will capture the eyes and minds of adult audiences. Where can be found the Michelangelo, the Orozco, the Titian or Picasso of this medium?

The challenge to VR is to compete with the experiences offered by architecture and installation art. See Figures **3.34**, **8.1**, **8.24**, **11.41**, **12.30**, and **14.41** for examples of that challenge.

ORIGINALITY AND TRUTH

The tremendous enthusiasm generated by developments in electronic imaging has made many people believe that the extinction of handmade art is only a matter of time. The French painter Paul Delaroche (1797–1856), on seeing the first photographs in 1839, is supposed to have exclaimed, "From this day on, painting is dead."[18] The idea that a new medium absolutely destroys all other forms of art is a common one, but it turned out that Delaroche was wrong. Digital photography and computer art have inspired comments similar to Delaroche's, and, it seems, with better reasons.

There are good historical and psychological reasons to think that all or most of the techniques now used by artists will survive the challenge of the computer. Historically, it is hard to find an art technique that has been permanently

extinguished by new inventions. Even though some have become rare, artists seem to feel that older ways still remain available to them, and can still offer their own unique expressive potentials. The feature of digital art that probably guarantees the survival of other art forms is the lack of a clearly definable original. The soft proof, which may be considered the real original, is invisible, and all the video displays and potential millions of hard copies are identical and equally original.

One of the main characteristics of art collectors and art lovers alike is their desire for contact with other personalities. Collectors and museum visitors who might like to see or to own Vincent van Gogh's straw hat would almost certainly have little interest in seeing or owning a hat exactly like Van Gogh's. Even though we do not touch most works of art, part of their value to the audience is that the artist did touch them. Computer art, at every stage, including hard-copy printout, is one of the least intimate art media. A predictable effect of computer art is to sharpen the audience's appreciation of intimacy in other media, and that appreciation will probably encourage artists to make art that is multi-sensory—not only capable of being seen but touched, with many "fingerprints" and "autograph" marks on it—and clearly one of a kind.

If the idea of "an original work of art" seems to be in question, the idea of the photograph or film as a record of the truth is even more threatened. The idea that photographs show the truth is one we have learned to accept,[19] to the point that we now unthinkingly consider photographs to be truthful and objective records of what the eye could see. That is very clearly something we must now unlearn, and we must require of photographers and publishers proof of the truth of their pictures in those cases in which truth is important. That leaves us in the situation in which photography and all the electronic and digital systems of imagery are tools of the imagination. Pictures, it seems, are similar to writing, in which we can tell the truth or we can lie, and it is important for the audience to be able to tell the difference.

Each new medium sheds light on the other media, revealing what is special about each one in the light of what is special about the new medium. Our natural human desire for art demands all kinds and cannot be satisfied by any one alone. Each new medium also changes our world, posing new challenges to all of us both for expression and for understanding.

FOR REVIEW

Evaluate your comprehension. Can you:

- explain how drawings differ from prints, and how one or two of the basic printmaking techniques (woodcut, etching, engraving) are done?
- describe the fundamental differences between lithography and serigraphy, which is to say between a chemical reaction and a stencil?
- explain what photographer Sebastião Salgado meant when he said, "We photograph with our ideology?"
- describe some of the effects electronic tools (computers, digital cameras, virtual reality) have had on our ideas about art?

Suggestions for further reading:

- Betty Edwards, *Drawing on the Right Side of the Brain* (Los Angeles: Tarcher, 1979)
- Donald Saff and Deli Sacilotto, *Printmaking: History and Process* (Fort Worth: Holt, Rinehart and Winston, 1978)
- Toni Stooss and Thomas Kellein, *Nam June Paik, Video Time-Video Space* (New York: Harry N. Abrams, 1993)
- Cynthia Goodman, *Digital Visions: Computers and Art* (New York: Harry N. Abrams, 1987)

6
Painting

P R E V I E W

There are five major painting media—fresco, watercolor, tempera, oil, and acrylic, but paint can be made by mixing pigment (powdered mineral color) with any kind of glue that makes the pigment stick to a surface. Although the materials are simple, painting has had special prestige not only because of its long history as an extremely personal means of expression but also because it crosses many boundaries of language and culture. Each of the painting media has certain advantages. Acrylic, for instance, a modern chemical product, resists weather and can be placed outdoors. Oil can be blended to create the illusions of light and space, which was the original aim of the glazing technique in oil painting. Modern oil painting, done "wet into wet" in a spontaneous technique, remains popular because it offers the widest choice of effects. Both fresco and watercolor are spontaneous and transparent, but the former is used to paint the walls of buildings, while the latter is often found in books and albums, in smaller scale. Many of the greatest paintings in the history of art were done in fresco, but these days acrylic is often used for painting walls. Tempera, an opaque water-based paint, has perhaps the longest history and the most uses, but here again acrylic is now often used in its place. New kinds of paint, such as acrylic, lead to new kinds of paintings, such as the stained canvases and sprayed or dripped designs that acrylic is well adapted to produce.

PAINTING HAS A STRANGE PRESTIGE. You might well wonder why people would travel to see famous paintings, write books about them and pay large amounts to own them. They are, after all, just pieces of paper or cloth with paint on them.

Paintings have been around for a very long time, the oldest ones probably were on rocks, cave walls, and the bodies of humans. Representational paintings must have had special prestige from the beginning because they permit communication across the boundaries of language. The beautiful paintings of eland antelope and San (Bushman) hunters found in South African rock shelters (Fig. **6.1**) are recent enough for anthropologists to have been able to ask San people what the pictures mean to them, but the paintings are also popular with people of Western culture, to whom

they suggest a life close to nature, in the midst of herds of animals. To the San the paintings are records of visions seen in trances in which the eland symbolized abundance of food and fertility, life-giving rain, and initiation of the young into adult life. In Figure **6.1** we see a tall hunter (center) and five smaller hunters, holding their bows and striding in single file to the right, with the whole group surrounded by the antelope, which are given to them by a deity for their sustenance.

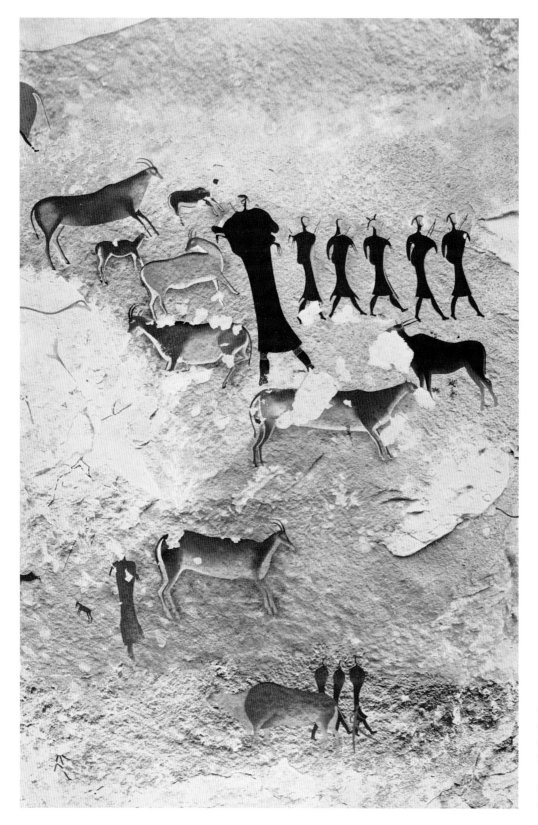

6.1 Hunters with elands and roan antelope, rock painting, 18th or 19th century. Botha's Shelter, Ndedema Gorge, South Africa.

It is clear that painting is not a universal language, but more like a language that all of us can read to some extent. We can, for example, understand Italian paintings better than we can understand Italian novels without any lessons in Italian. And because paintings were in use long before writing was invented, their long usefulness as a medium of communication, mainly within cultures but also between cultures, may account for their great prestige.

As members of the audience we must break through the barrier that prestige often seems to set between us and works of art. It may help to regard them as material objects, as an artist does as they are created and as a restorer does. We need to consider five major painting media: fresco, watercolor, tempera, oil, and acrylics. Each of those media is distinguished by its use of a different kind of glue, called the **binder**, to hold the colored pigments together and to attach them to a surface. Pigment is colored powder, usually made of minerals (which distinguishes paint pigment from a dye or stain, which usually has color from plants). Ultramarine, for example, is a blue pigment that is now made in chemical laboratories but that used to be made by grinding up the semi-precious stone lapis lazuli. To make paint, pigments are thoroughly mixed with a binder, which is the most important part in the sense that its chemical characteristics require certain methods of painting. Each binder requires a different **solvent** or thinner, each can be applied to a different group of grounds, or surfaces, and each may require a different set of painting tools and different techniques. The painting may be able to survive outdoors, or it may need to be protected from bright light, depending mainly on the binder. The term **medium**—the plural is either media or mediums—refers to any system that carries communications or expressions. In painting, the word is used for the whole process in which a specific solvent, binder, and ground are used together. In some, the medium takes its name from the solvent (watercolor), in others from the binder (oil).

We will examine those five major media, but you should remember that there are others that are less commonly met. **Encaustic**, for example, uses pigments mixed with melted wax, the solvent being heat. That technique was commonly used for decorating Egyptian mummy cases and it is still used occasionally (see Fig. **6.2**). From time to time you are certain to encounter media that are new to you, because artists are constantly experimenting with new materials. The basic problem for the artist and the collector is to find out the characteristics of the medium, how it can be used effectively, and what kind of care paintings in that medium need.

FRESCO

The ancient medium of **fresco** has been given up for dead every few centuries, but whenever there are good solid walls to paint on it comes back to life. It was practiced by the ancient Greeks and Romans, was largely ignored by Gothic artists, who made stained-glass windows instead, was brought back to glorious life in the Renaissance, was given up for dead in the 19th century, and revived again in modern Mexico. It grew out of a simpler technique for painting on dry plaster walls called "fresco secco," a name meaning dry fresco. It appears that some painter must have been in a hurry and painted on a lime plaster wall that was still wet, later discovering that those parts were much more durable than the parts painted on dry plaster. Fresco ("fresh") uses the wet lime plaster as the binder, the pigments being mixed only with water. As the plaster sets, calcium carbonate forms a protective coating on the surface. Fresco is naturally used to decorate buildings, because the plaster is too heavy and fragile to be easily used for an easel picture. Thus it is appropriate for us to look at two decorated buildings.

Although we see few frescos in the United States, there are many great examples in world art, including several of supreme importance—the "superstars" of world art. Michelangelo's Sistine Chapel Ceiling is at the top of that list, and we should look also at a modern fresco series, Orozco's murals in the Cabañas Orphanage in Guadalajara, Mexico. Between those two great series we can learn most about the potential of the fresco medium.

Ancient Roman fresco painters were very expert. For their murals from Pompeii and Herculaneum, see Figures **10.33** and **10.41**.

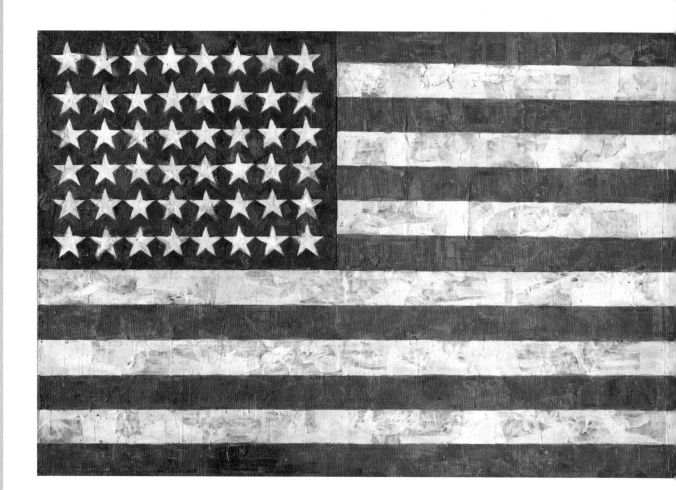

Jasper Johns' First Show

6.2
JASPER JOHNS, *Flag*, 1955.
Encaustic, oil, collage on fabric,
3 ft 6¼ in x 5 ft ⅝ in (1 x 1.5 m).
Museum of Modern Art, New York.
(Gift of Philip Johnson in honor of
Alfred H. Barr, Jr.)

6.3
Jasper Johns in 1959.

In 1958 the New York art dealer Leo Castelli presented a show by the twenty-nine-year-old painter Jasper Johns that not only sold out but that changed the direction of American art. A reviewer called Johns "the brand-new darling" of the art world. Castelli recalls that he was introduced to Johns by the painter Robert Rauschenberg. "I walked into the studio and there was this attractive, very shy young man, and all these paintings. It was astonishing, a complete body of work. It was the most incredible thing I've ever seen in my life." Among the unusual features of Johns' work was his use of encaustic, in which the pigment is mixed with hot wax and troweled on with a palette-knife. What led up to this show, and where did it lead?

Johns, born in Augusta, Georgia, in 1930, studied at the University of South Carolina, then served in the Army, and in 1953 went to New York, intending to finish college. He had been painting for several years and planned to study art. After one day of classes he dropped out, took a job in a bookstore, and kept on painting. A year later he destroyed all his art work. He explained, "Before, whenever anybody asked me what I did I said I was going to become an artist. Finally I decided that I could be going to become an artist forever, all my life. I decided to stop *becoming*, and *to be* an artist." As a result, he started over from scratch.

The New York art world of the early 1950s was dominated by the **Abstract Expressionist** style, a style that called for large, dramatic expressions of individual personality. Johns has said, "If I could do anything I wanted to do, then what I wanted to do was find out what I did that other people didn't, what I was that other people weren't." It turned out that there were several things he did that were unusual. Among them were painting with

encaustic, building up a heavy, rather sculptural-looking surface; another was casting in plaster; and a third was making paintings of such things as the American flag (see Fig. **6.2)**, targets, and numbers and alphabets incorporating plaster casts of faces. These were the paintings that amazed the art world in 1958. Johns, along with several other artists, was considered a major figure in the new Pop Art movement, with the idea that such things as flags and targets were public (*pop*ular) themes, not private symbols invented by the artist. No one had seen this kind of art before, even though the subjects were things everyone had seen many times.

The art historian Leo Steinberg wrote about his reaction to Johns' show: "My own first reaction was normal. I disliked the show. ... I was angry at the artist, as if he had invited me to a meal, only to serve something uneatable." That kind of reaction was common, but the originality and skill of the work were unmistakable, and collectors and museums flocked to buy.

Johns' own reaction was perhaps not what you would expect. For a young artist who has just sold out a show and become the darling of the art world, he looks very somber in a photograph taken at the time (Fig. **6.3**). Johns says he "liked the attention," but during the next year he changed from the style that was so successful. *False Start* was the title he gave to a painting in his next style, an abstraction in bright splashy colors painted in oil paint. A very private person, Johns appears to have been bothered by his sudden celebrity. It might almost seem as if he wanted to destroy all his work again and start anew from scratch. In spite of this sensitivity and his rejection of personal celebrity, Johns has remained one of the most productive and original artists of his time.

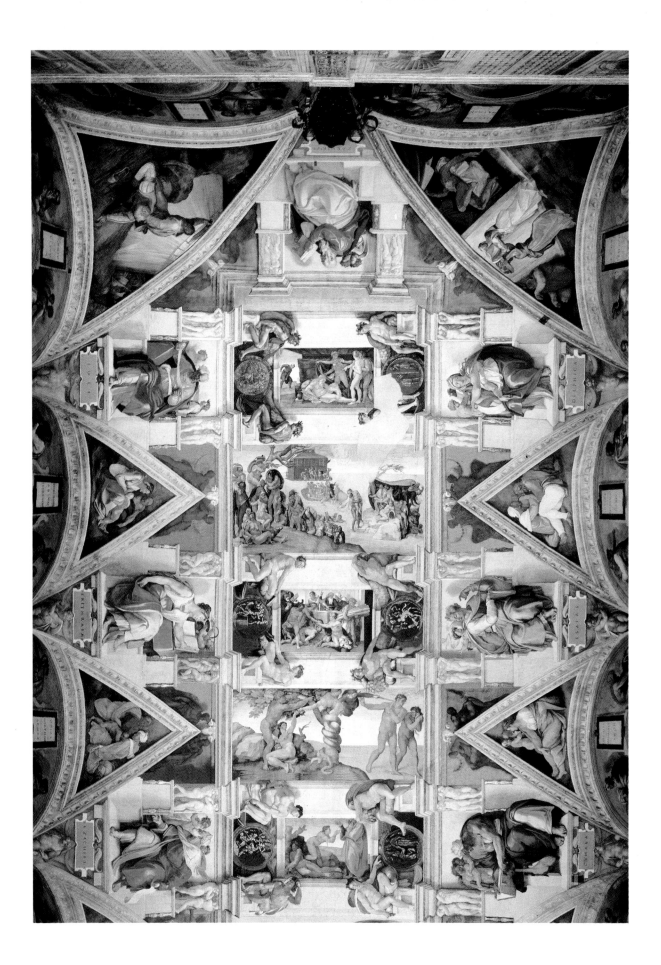

MICHELANGELO'S SISTINE CHAPEL CEILING

The Sistine Chapel (Fig. **6.4**), built by Pope Sixtus IV, was used for the private devotions of the papal court and as a meeting place for the College of Cardinals, and it served as the nerve-center of Christendom of its time. Its side walls already had fresco murals of an earlier generation of artists, including Botticelli, when in 1508 Pope Julius II asked Michelangelo to paint the ceiling. The Pope's idea was to paint the Twelve Apostles, but Michelangelo objected to the design. In later years Michelangelo remembered the Pope telling him to paint anything he liked, but the vast theological story embedded in the paintings presupposes the presence of a scholar as Michelangelo's adviser. That adviser was almost certainly Cardinal Marco Vigerio, a close associate of Pope Julius II.

Work began on stories from Genesis telling of the beginnings of the world, with hundreds of drawings, in which the artist invented figures and compositions to express the great theme. Then the **cartoons**—the full-scale drawings—were made. Ready to begin painting, Michelangelo instructed his mason where to place the first patch of new lime plaster. Since painting could be done only on fresh plaster that had not chemically set, the patch for one day's work would be about a square yard or the size of one head, that being considered one day's production. The cartoon would be held up over the fresh plaster and a sharp point would be run over the main lines, pressing them into the soft plaster (which explains why few cartoons survive). The torn remains of the cartoon would be discarded and painting would begin on the smooth, damp plaster surface.

Michelangelo began painting at the end farthest from the altar and with the end of the story, Noah's Ark and the Flood (Fig. **6.5**). Michelangelo needed two tries on the first parts he painted because the plaster had the wrong composition. He was deeply depressed about his work. Looking at the Flood panels critically he realized that the scale of the figures had to be enlarged and the setting simplified to be seen effectively from the floor. Beginning with the Temptation and Expulsion from Eden, he enlarged the scale of the figures and simplified the scenes. He alternated wide panels with narrow panels framed by medallions and male nudes, added powerful athletes with no connection to the Bible story, then a band of illusionistic architecture and a series of enthroned Prophets and Sibyls, who had predicted the coming of Christ. All of these figures grew larger, more effectively lighted and colored, as Michelangelo gained experience with the fresco medium.

6.4 (*opposite*)
MICHELANGELO,
ceiling of the Sistine
Chapel, Vatican, Rome,
1508–12.
Fresco, 44 x 128 ft
(13.4 x 39 m).

6.5 (*right*)
MICHELANGELO,
Noah's Ark and the Flood,
detail of ceiling of the
Sistine Chapel, Vatican,
Rome, 1509.
Fresco.

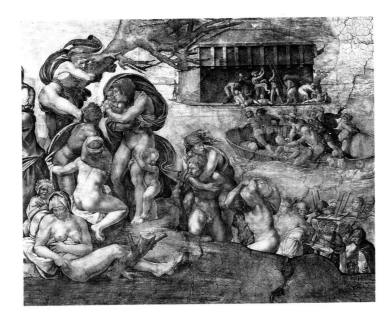

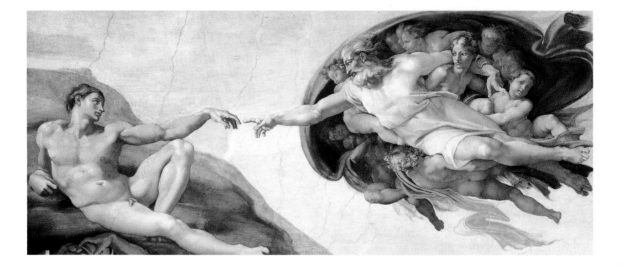

6.6

The most famous individual panel is the Creation of Adam (Fig. **6.6**), in which we see God transmitting the spark of life into the drowsy body of Adam. You can see the plain white plaster of the background, with cracks that have developed in the ancient building. You can see the lines pressed through the cartoon on the top of the bent leg (Fig. **6.7**). At the end of the day the edge of the plaster was carefully trimmed with a trowel and new plaster was put on at the beginning of the next day's work. Ordinarily, the painter tried to divide the work so he would not have to match colors from one day's work to the next. Those joints can be seen at the top of the outstretched arm and, very faintly, at the base of the neck and around the top of the head, that head being one day's work for Michelangelo.

Michelangelo's imaginative power rested on the Judeo-Christian conception that God created the human body "in His own image." Going far beyond his many drawings of the human figure, in the powerful figures of the Creator and Adam he gave that conception a form that has never been rivaled.

OROZCO'S CABAÑAS ORPHANAGE

Summing up the work of José Clemente Orozco (*o-ROS-ko*; 1883–1949), a critic wrote: "he has left vast works that are considered by many to be among the best examples of modern American art."[1] The frescoes that fill the Cabañas Orphanage

6.7

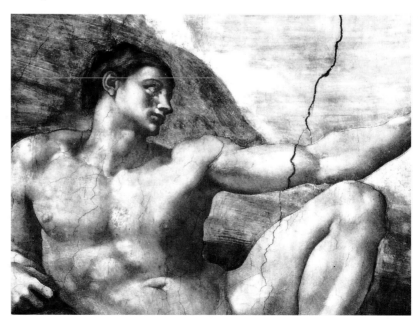

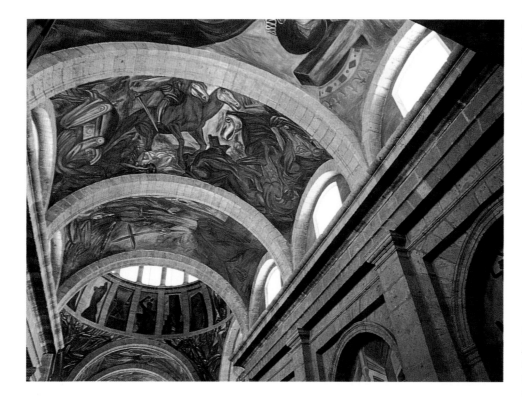

6.8
JOSÉ CLEMENTE OROZCO,
Cabañas Orphanage,
Guadalajara, Mexico,
1939.
Fresco.

6.9 (*below*)
JOSÉ CLEMENTE OROZCO,
Cortez and the Conquest,
detail of ceiling of Cabañas
Orphanage, Guadalajara,
Mexico, 1939.
Fresco.

are among his finest paintings (Fig. **6.8**). The 200-year-old chapel with a high dome forms the entrance to a group of orphanage buildings in the city of Guadalajara, in western Mexico.

Orozco spent seven years in the United States in the late 1920s and early 1930s, painting important murals at Pomona College and Dartmouth College and taking part in New York art life. In 1934 he was attracted back to Mexico by commissions from the Mexican government, but his terrific, pessimistic murals would hardly be called government propaganda. Between 1936 and 1940, about the same length of time it took Michelangelo to paint the ceiling of the Sistine Chapel, he painted a large group of important murals in state government buildings in Guadalajara.

More than Michelangelo, Orozco was given independence to choose his own subjects, and he chose the history of the Americas as the general theme of the Cabañas murals. Not one to glorify ancient times as a golden age, he shows the gloomy and threatening gods of ancient Mexico, then the arrival of the Spanish conquerors as machine-men, literally heartless, inspired by a mechanical angel as they butcher the native people (Fig. **6.9**). Mixed with these historical subjects are others of more general symbolism, such as the Apocalyptic horses charging across the sky above a Mexican village, the houses looking like rows of coffins, the invisible riders

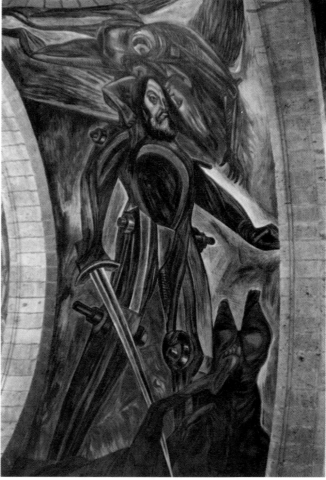

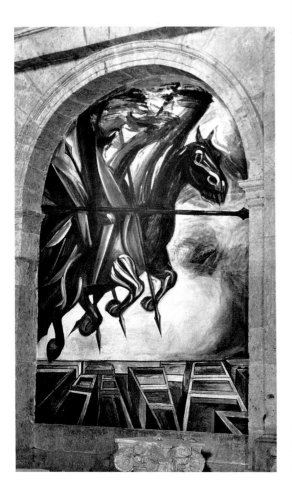

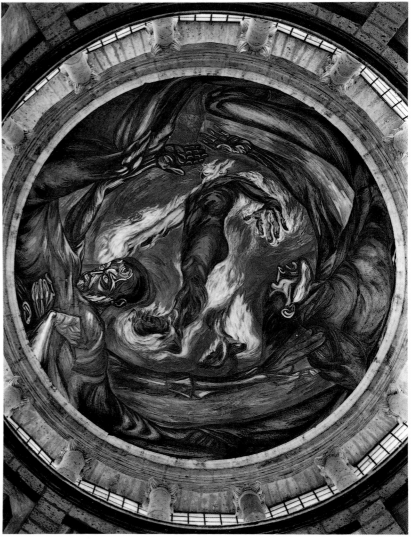

6.10 (above left)
José Clemente Orozco,
the Apocalypse,
detail of wall of Cabañas
Orphanage, Guadalajara,
Mexico, 1939.
Fresco.

6.11 (above right)
José Clemente Orozco,
Man of Fire,
dome of Cabañas
Orphanage, Guadalajara,
Mexico, 1939.
Fresco, diameter 30 ft 6 in
(9.3 m).

brandishing spears (Fig. **6.10**). Around the base of the dome are armed workers climbing a rocky cliff, then symbols of the arts and professions, and, finally, above a ring of windows, the red-and-black composition *Man of Fire* in the dome (Fig. **6.11**). Earth, Water, and Air, as gray figures of the material world, recline around the edge of the dome, while the dematerialized spirit of Fire disappears in steep foreshortening into the heavens.

Both of these mural series were strong examples for their times. Succeeding centuries continually returned to the ceiling of the Sistine Chapel as the supreme expression of Western art. Orozco's example has been followed less obviously; his most successful followers were not in Mexico, but in New York, where about ten years later his grand scale, slashing style of brushwork and personal expression were adopted for oil paintings by the Abstract Expressionists.

The two artists' techniques, being very different, show the range of possibilities in fresco. Michelangelo did not allow brushstrokes to show, turning each mark into a colored light or shadow and producing illusions of mass and space. Orozco never lets us forget that the picture was made by the movement of a human hand; each mark remains as a mark even though it forms part of a person or a horse. Orozco tried not to close his lines into shapes, since that would reduce their energy. Michelangelo, who always considered himself basically a sculptor, tried not to let lines show, but to blend them into the illumination of masses to make the figures as sculptural as possible. He relied on bright color and vigorous forms to give spirit and energy to the design.

WATERCOLOR

The binder of **watercolor** is the resin of the acacia tree, which is called gum arabic. The solvent, of course, is water. By about 1780 European painters in watercolor no longer had to mix the pigment and gum arabic themselves, but could buy cakes of paint ready-made at pharmacies; one English merchant advertised himself as "Superfine Water-Color Cake Preparer to Her Majesty and the Royal Family." At the same time fine watercolor paper was invented and offered for sale. Thus all the ingredients were ready to launch a great period of watercolor painting: the paints, the paper, and the interest of a royal patron.

Pigments mixed with gum binders had been used earlier—for centuries in China, where watercolor was often applied to silk—but the inventor of transparent watercolor of the modern sort was Albrecht Dürer, who used it for sketching landscapes on a trip to Venice in 1494. It remained in use for painting miniatures and for tinting maps and drawings, but not until the 18th century did its delicacy and luminosity become fashionable and appealing to a wide audience.

It was in England that the best work in watercolor was done, and it was used mainly for landscape. It was part of the newly popular "sightseeing," the search for the picturesque ("like a picture"), the sublime and awe-inspiring, which accompanied the beginnings of the scientific study of nature. "The art of sketching is to the picturesque traveller, what the art of writing is to the scholar," said a writer of travel books in that period.[2] Despite the fragility of watercolor paintings, which will fade if hung in bright light, there was a large audience eager to purchase them, especially if they showed a famous or dramatic scene.

Two of the finest English masters of watercolor were born the same year (1775): Joseph M. W. Turner and Thomas Girtin. Girtin died at the age of twenty-seven, but Turner lived to be seventy-six and produced many more paintings, in oil as well as in watercolor. Turner's oils were criticized for looking like his watercolors, and there is truth to the charge; he tried to retain in oils the effects of light that are natural to watercolor. The watercolor, *The Burning of the Houses of Parliament* (Fig. **6.12**), was based on an actual event but was painted from memory and imagination. The atmosphere is enhanced by the varying strength of the color washes, and the

Watercolor has an ancient history in China (see Figs **11.37**, **11.38**, and **11.39**, and pp. 379-80).

6.12
JOSEPH M. W. TURNER, *The Burning of the Houses of Parliament,* 1834. Watercolor and gouache on gray paper, 11¾ x 17¾ in (30 x 45 cm). Tate Gallery, London.

agitation of the crowd is conveyed by the simple shapes and lack of detail. Gum arabic is such a weak glue that it can hold only a little pigment, so the brilliance of the color is enhanced by the light reflected from the white paper through the thin washes of color. It is this light reflected through color that is meant by the term "luminosity" in referring to watercolor. In fact, the power of color is a large part of the appeal of Turner's work. He used the medium with maximum freedom, scratching the paper to give white lines and dots and sometimes adding opaque white paint—a practice that proper English watercolor painters regarded as breaking the rules. Turner was not concerned with that rule, nor with the one that says no corrections should be made, since they will inevitably show through the transparent color.

In *The Gorge of Wathenlath with the Falls of Lodore, Derwentwater* (Fig. **6.13**), Thomas Girtin showed a famous tourist sight. A popular travel writer described a visit there: " 'Which way to Wathenlath?' said one of our company to a peasant. 'That way,' said he, pointing to a lofty mountain, steeper than the tiling of a house."[3] The tangled crags and wooded gorge rise to the clouds, the trees blowing in the wind. No artist exceeded Girtin in bringing atmosphere into a painting, and no medium adapts so well as watercolor to wind, mist, clouds, and rain. The nature of the medium is ideal for landscape.

6.13

THOMAS GIRTIN,
The Gorge of Wathenlath with the Falls of Lodore, Derwentwater, Cumberland, c. 1801.
Watercolor, reed, pen on paper, 21 x 17 in (8 x 7 cm).
Ashmolean Museum, Oxford, UK.

The American painter Winslow Homer (1836–1910) gave the watercolor technique and its subjects an American twist. Hunters, fishermen, and pioneers abound in his landscapes, such as *Woodsman and Fallen Tree* (Fig. **6.14**). Homer was expert at retaining the paper as his white and at drawing freely but with perfect control. Watercolor, of all the media, is the one that demands an unhesitating hand. Homer's confident placement of shadows on the fallen tree, leaving the white of the paper for the highlights, appears a simple matter, but it can be achieved only by years of practice with the brush.

Contemporary watercolor painters are working on a scale earlier artists would have found hard to imagine. *Blueberry Jam* (Fig. **6.15**) by Carolyn Brady (b. 1937) measures 39 by 28½ inches (99 by 72 centimeters), a size that used to be considered appropriate for oil paintings but too large for watercolor, which was thought to be delicate, intimate, and properly small. Recent watercolors often reach sizes much larger than this example and often have a ruggedness that would be out of place on a breakfast table. The effects of light and the subtle variations of white used by Brady would be hard to match in any other medium. Those qualities, achieved so well in *Blueberry Jam*, are part of the natural luminosity of watercolor, produced by very faint washes of thin color on the white paper.

6.14
WINSLOW HOMER,
Woodsman and Fallen Tree,
1891.
Watercolor on paper,
14 x 20 in (36 x 51 cm).
Museum of Fine Arts,
Boston, Massachusetts.
(Bequest of William
Sturgis Bigelow.)

6.15
CAROLYN BRADY,
Blueberry Jam, 1979.
Watercolor on paper,
39 x 28½ in (99 x 72 cm).
Nancy Hoffman Gallery,
New York.

TEMPERA

The ancient medium of tempera, in which pigment is mixed with egg yolk, has been especially important in 20th-century American art. Tempera had been ignored for several centuries when the young Peter Hurd (1904–84) began to experiment with it in 1930. He had recently married Henriette Wyeth (daughter of the famous illustrator N. C. Wyeth and sister of Andrew Wyeth) and moved back to his native New Mexico. Tempera appealed to him for its precision and detail and for the brilliance of the light reflected from the **gesso** (gypsum, or plaster of Paris) coating of the wood or masonite panel often used as the ground for this medium. In *El Mocho* (Fig. **6.16**) every brush stroke is revealed, since the paint dries almost instantly—notice the jacket. But Hurd was expert at modeling forms in light and shade by adding fine lines of the shading color—notice the hills. Oil paint is different from tempera because oil dries so slowly the painter can blend different colors together. In tempera that is not possible; the transitions must be made by feathery strokes, each slightly changing the color.

In the late 1930s Hurd taught both his father-in-law and brother-in-law to paint in tempera; it became the basic medium for Andrew Wyeth (b. 1917). A very talented painter in watercolor, Wyeth discovered he liked tempera because it did not allow any flashiness. As he has said, it put a brake "on my real nature—messiness."[4] *Indian Summer* (Fig. **6.17**) shows the detail accomplished with a small brush and the subtle textures and lighting that Wyeth gives to his temperas. It is painted in tones of brown, with each stroke making a tiny strip of light or shade.

Modern American tempera painters have used tempera in a way that is opposed to the basic nature of the medium, which favors large areas of flat color. The patience and expertise of Hurd and Wyeth and their many followers appeal to the American taste for seriousness and skill in art. Despite its long history, the tempera medium has never been used more successfully than by these American painters.

The history goes a long way back, for until oil paint was invented in about 1400, tempera was the basic painting medium. Egg yolk and its solvent, water, were easy

6.16
PETER HURD,
El Mocho, 1936.
Tempera on panel,
30 x 25⅛ in (76 x 64 cm).
Art Institute of Chicago,
Illinois. (Watson F. Blair
Purchase Prize, 1937.)

6.17
ANDREW WYETH,
Indian Summer,
1970.
Tempera on panel,
3 ft 6 in x 2 ft 11 in
(1 x 0.9 m).
Brandywine River
Museum, Chadds Ford,
Pennsylvania.

to obtain, and it was a reasonably permanent and durable medium (if you have washed the breakfast dishes you know how firmly egg yolk can bind to a surface!). The eggs of birds or of sea turtles were used as paint binders by Australian Aboriginal painters, who used natural rock walls or sheets of bark as painting surfaces. Modern Aboriginal artists still use those binders, or the juice of plants like orchid bulbs or bloodwood leaves, for paintings in traditional style, such as Figure **6.18**. The illustrators of medieval manuscripts made use of tempera for decorated initial letters and symbolic designs (Fig. **6.19**), as well as for pictorial illustrations (Fig. **6.20**).

Notice that both Figures **6.18** and **6.19** were made with linear designs in which each color remains unchanged. The artists were concerned with the natural local color of things or with the decorative effect, but they were not interested in the light

6.18 (*right*)
NAMILGI,
*Sacred Rocks of Early
Dreamtime,* 1970.
Tempera on eucalyptus
bark, 18½ x 10½ in
(47 x 27 cm).
Private collection.

6.19 (*far right*)
Chi-rho monogram from
The Book of Kells,
8th century.
Tempera on parchment.
Trinity College Library,
Dublin.

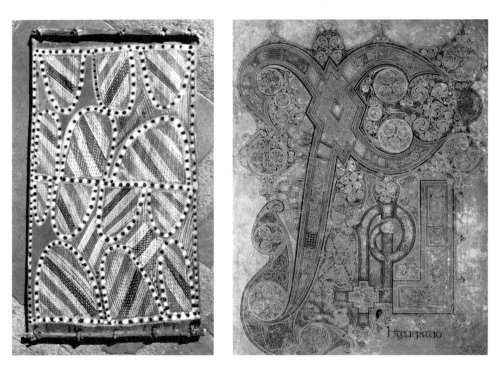

and shadow that concerned Hurd and Wyeth. This technique using a generalized light is appropriate for subjects that are timeless, in which the light of morning or the shadows of dusk play no part. The Four Horsemen of the Apocalypse (Fig. **6.20**), painted by a Spanish monk in the early Middle Ages, is about the end of the world, and no particular time of day or quality of light need be represented. The powerful flat colors in tan, orange, yellow, and blue bands seem to have been chosen for their richness and emotional effect. Notice that the corners are ornamented with interlace designs similar to those on the Irish ornamented initial (see Fig. **6.19**).

Effects of light and shade (that is, chiaroscuro) began to appear in tempera paintings at the end of the Middle Ages. The illustrations (Fig. **6.21**) for *The Book of the Heart Possessed by Love*, written by King René of Anjou, tell a symbolic tale in which the Knight Heart (the hero, naturally) is defeated by the Black Knight Trouble and has to be pulled from the river by Lady Hope. The painter who decorated the text in the lower half of the page added both white highlights and dark shades to give the floral pattern a hint of the third dimension, which it needs to harmonize with the very spacious scene above. In that scene you can easily distinguish the small brush strokes which model the colors. There are very few areas of flat color; the bright red horse at the left edge is one of the few. A common way to blend colors in tempera during this period was to use pure saturated color for the darkest parts, then add white little by little to make the lighter areas. This artist used that method on some parts of the landscape, and mostly on Lady Hope's blue gown (where there is also a very sparing use of black in the deepest shadows). That way of shading with pure color, instead of shading with black, gives the paintings a brilliant cheerfulness. You can easily imagine that such paintings as this were an inspiration to Peter Hurd when he was learning to paint in tempera.

Tempera is basically an opaque watercolor. Any paint made by mixing pigment with a water-soluble glue is similar to egg tempera, and all these paints can be

6.20
The Four Horsemen of the Apocalypse, folio 135 of The Commentary of Beatus on the Apocalypse of Fernando and Sancha,
11th century.
Tempera on parchment.
Biblioteca Nacional, Madrid.

applied to watercolor paper, wooden panels, or cloth coated with gesso. The "poster paint" or gouache (*gwash*) used in school art classes is of this type, with simple hide glue as the binder. Just because it is used in school doesn't mean it cannot be used for serious art. *Under the Trees* (Fig. **6.22**) was painted by Édouard Vuillard (1868–1940), who frequently painted with gouache. There is absolutely no shine on the surface of a painting in gouache—it looks much like a pastel—which makes the colors clear and soft, with no sense of depth or shadow in the darker colors. Vuillard liked that appearance, like a carpet, and covered his paintings with rug-like textures. Surely he also liked the fact that he could paint over and over, making endless changes and additions that completely hid whatever was there before. That is, of course, an advantage of opaque watercolor; no matter how much the artist reworks, it still looks fresh.

6.21 (*above*)
The Book of the Heart Possessed by Love, 15th century.
Tempera on parchment. National Library of Austria, Vienna.

6.22 (*right*)
ÉDOUARD VUILLARD, *Under the Trees,* 1894.
Gouache on canvas, 7 ft ½ in x 3 ft 2½ in (2.1 x 1 m).
Museum of Art, Cleveland, Ohio. (Gift of the Hanna Fund.)

6.23
JACOB LAWRENCE,
*The Migration series, No. 54: For the migrants,
the church was the center of life,* 1940–41.
Tempera on gesso on composition, 18 x 12 in
(46 x 31 cm).
Museum of Modern Art, New York.
(Gift of Mrs David M. Levy.)

6.24
JACOB LAWRENCE,
*Harriet Tubman series:
Daybreak—A Time to Rest,* 1967.
Tempera on hardboard,
30 x 24 in (76 x 61 cm).
National Gallery of Art,
Washington, D.C.
(Gift of an anonymous donor.)

OIL PAINTING

Oil painting was originally invented in Europe to produce amazing illusions of solid objects in space, with the lifelike textures and subtle shadings of light and shadow that such an illusion requires. The artists and their audiences all agreed that oil painting was infinitely superior to tempera in the important matter of illusions, and tempera nearly disappeared from European painting for several centuries. We now refer to that early oil painting style as a glazing method, since many thin coats of transparent paint, or **glazes**, were applied over a long period of work. In the later years of the 19th century, as modern styles began to be invented, illusions of natural forms with their textures and light began to seem old fashioned and a new way of using oil paint appeared. Modern oil painters and their audiences began to believe that spontaneity and change were the main characteristic of modern life and a free,

Jacob Lawrence's Tempera Series

The revival of the tempera medium by Hurd and Wyeth owed much to Renaissance painting. Jacob Lawrence (b. 1917) has evolved a tempera style that grew out of Cubism and **Expressionism** of the 20th century. "I'm just interested in putting paint on paper," Lawrence says. "Since I have always been more interested in what I wanted to say rather than the medium, I just stayed with it. I know this medium so well that my thinking is in terms of the tempera medium. It's like a language—the better you know the medium, the better you can think in it."

The Migration: For the migrants, the church was the center of life (Fig. **6.23**) is the fifty-fourth in a series of sixty tempera paintings on panels painted during 1940–41. Lawrence's parents had been part of the migrations out of the South, and he grew up in Philadelphia and New York. "As a youngster, you just hear stories. ... I didn't see the migration as an historical event, but people were talking about it." The Migration series was the result of research and many sketches and studies. "My work had always been flat, geometric. I didn't think in terms of Cubism, but later in my development I became more aware of it. Most people at that time worked cubistically without thinking about it." The steep, distorted perspective and strong contrasts of light and color give the style a powerful emotional content, which was Lawrence's main motive.

Lawrence has always been attracted to painting in a series. Each painting can stand alone, but together they tell a powerful story. The story of Harriet Tubman, who rescued hundreds of people from slavery in the middle of the 19th century, has inspired two sets of paintings by Lawrence. The second set, a series of seventeen, was done in egg tempera on panels and was published as a book for children, for which it was awarded a prize. *Daybreak—A Time to Rest* (Fig. **6.24**) shows Harriet Tubman with a rifle, resting with her refugees. A librarian complained that the artist had made Harriet look grotesque and ugly, as he here exaggerates her feet, on which she was traveling and which were the subject of the painting. Lawrence responded: "If you had walked in the fields, stopping for short periods to be replenished by underground stations; if you couldn't feel secure until you reached the Canadian border, you, too, madam, would look grotesque and ugly. Isn't it sad that the oppressed often find themselves grotesque and ugly and find the oppressor refined and beautiful?" The paintings, in spite of this sentiment, are refined and beautiful.

Lawrence's work illustrates a central purpose of art: the media and techniques of the artist and the style in which they appear are meant to be in the service of an idea and a meaning.

Quotations from E. H. Wheat, *Jacob Lawrence, American Painter* (Seattle: University of Washington Press/Seattle Art Museum, 1986), pp. 190, 60, 62, 116

dashing, spontaneous style came into fashion. That style, called **alla prima** ("all at once," or painted in one session rather than over many days or weeks), has been characteristic of the great majority of late 19th- and 20th-century oil paintings. Thus oil painting reflects basic changes in how the public sees reality.

Even so, painters in both methods agree about the basics of grounds, binders, and solvents. The ground is canvas, linen being better than cotton because it expands and contracts less with changes in humidity, which helps prevent cracking of the paint surface. The canvas is tacked on a wooden frame (called a stretcher) and sized with a coat of glue to keep the paint from penetrating the canvas. Then it is given a first coat (a "prime" coat) of white oil paint whose binder is linseed oil and whose solvent is turpentine. These preparations keep the later paint film, which is the art, separate from the canvas that supports it. The paint film is much more durable than the canvas, and an old, rotting canvas can be reinforced (by a professional art

6.25
PETRUS CHRISTUS,
*Portrait of a Carthusian
monk,*
c. 1446.
Oil on panel,
11½ x 8 in (29 x 20 cm).
Metropolitan Museum of
Art, New York. (Jules
Bache Collection, 1949.)

conservator) by attaching a new canvas to the back with glue or wax, a process called "relining."

The original appeal of oil paint was its durability, since it resists moisture and abrasion better than tempera and watercolor. By 1400 some artists in northern Europe realized they could paint very thinly with linseed oil (from the flax plant) over their tempera paintings to give them a glossy durable surface. They also realized they could add colored pigments to the oil film, making something like colored glass, or what we call a glaze in contrast to an **impasto**, which is thick, opaque paint. The way of painting associated with the term "old master" uses impastos in the first coats, especially for white in highlighted areas where the thick coat of paint reflects more light than places where the thinner paint allows the canvas texture to absorb some light. When the impastos have dried (which may take weeks), colored glazes made of a little colored pigment in linseed oil thinned with turpentine are added to give color to the highlights and to vary and modulate the colors in other places.

The portrait of a Carthusian monk (Fig. **6.25**) by Petrus Christus (*c.* 1400–73) was painted in that early phase, and it makes clear why oil painting became popular. Petrus Christus had a valuable advantage in the market and, like other early oil painters, he tried to keep his formulas secret. The slow drying of linseed oil permitted the artist to blend colors for several days, getting very subtle gradations of light and shadow and amazingly lifelike textures of skin, hair, cloth, and metal. Petrus Christus even stoops to teasing his audience by painting a fly on the painted frame around the monk.

Although oil painting was invented in Flanders (modern Belgium), the secret was soon learned by the Italians. It became especially popular in Venice, where Giovanni Bellini (c. 1430–1516) founded an unsurpassed tradition of oil painting with works such as *The Feast of the Gods* (Fig. **6.26**). That painting, which has additions by Bellini's great pupil Titian (the left half of the landscape and some changes in the figures), was the first of the "picnic" paintings, scenes of leisure and flirtation in a beautiful landscape. The atmosphere created by the soft blending of colors and light and shadows, the radiant colors that oil permits, and the variety of textures (earth, trees, cloth, flesh, metal) produce a mood of supernatural beauty. Bellini visualized a rather sedate party around Mercury (in helmet), Bacchus (drinking), Juno, and Jupiter, amidst a regular line of trees. Titian tried to liven up the party with a more dramatic setting and by revealing more nude bodies, but Bellini's mood remains the dominant one.

The sense of atmosphere in *The Feast of the Gods* was attainable only with oil paint, and such expressions of mood were an irresistible attraction to viewers. The glaze technique, with colors modulated by thin, transparent tones applied over earlier colors which had been allowed to dry completely, is the only way to get the effects we admire in Bellini's work.

6.26
GIOVANNI BELLINI AND TITIAN,
The Feast of the Gods,
1514.
Oil on canvas,
5 ft 7 in x 6 ft 2 in
(1.7 x 1.9 m).
National Gallery of Art,
Washington, D.C.
(Widener Collection.)

Leonardo da Vinci was another early painter in oil (see Fig. **12.10** and p. 394).

South Beach Bathers (Fig. **6.27**) by John Sloan (1871–1951) is similar in subject to Bellini's *The Feast of the Gods*, but of course brought down to earth in America. It is painted in the alla prima, or direct, technique. This technique is sometimes called painting "wet into wet" because a color can be modulated or changed only by applying more wet paint on top of a wet coat, which almost always causes some uncontrollable mixing of the colors. The freedom of the brushwork and the simple, strong areas of color seem more appropriate than subtle glazes for portraying average Americans at the beach.

Alla prima painting has been the dominant method for about 200 years, not because it is necessarily the best method, but because it fits with our ideas of what is real and important. The illusions of solid masses and open space, which are the main results of glazing, have seemed less important than energy, immediacy, and spontaneity in our world in which change seems more normal than permanency. Alla prima painting is more quickly done, and looks quick and sketch-like, as we see in Sloan's painting.

Mark Rothko (1903–73) painted in oils in a technique somewhere between the two general methods. *Number 10* (Fig. **6.28**) was painted on a canvas that had been toned a reddish brown tint on top of a thin white prime coat. That reddish tone shows through all the other colors to some degree. The blue, white, and yellow were painted in flat colors over the dry background. Rothko used a technique called **scumbling** to modulate and unify his colors. Like glazing, scumbling allows some of the background color to show through a later coat, but instead of being transparent it is opaque, fairly dry color which has been dragged with a brush over the slightly rough background color. Its incomplete coverage of the background permits the reddish tone to affect the other colors and act as a unifying element in the design.

For alla prima painters the slow drying of oil paint is no advantage; in fact, it is a disadvantage, and the impatience of modern painters led them to experiment with new paint media first developed for industrial work. That brings us to the latest developments in painting.

John Brealey, Art Conservator

6.29
John Brealey in his laboratory
at the Metropolitan Museum
of Art, New York,
1985.
Photograph by Hans Namuth.

Art conservation has existed as a profession in the United States for only sixty years, but with the spread of museums and art collections it is becoming ever more important. John M. Brealey, chairman of the Department of Paintings Conservation at the Metropolitan Museum of Art in New York, is not only the most respected conservator working today but an important teacher of art conservation. Several doctoral students in art history and young conservators study with him and his assistants. Gisela Helmkampf, a professional conservator and Brealey's principal assistant, says it is important for the students "not to be terrified, although this is very scary work." You can imagine the heavy responsibility of working on a great painting, a unique and priceless national treasure. Brealey has had that responsibility, most famously in his successful work on Velázquez's *The Maids of Honor* (see Fig. **4.15**).

John Brealey grew up in England, the son of a portrait painter. "I wasn't interested in being a painter," he says, "in projecting my own personality. Tuning in—that's what interested me. The thrill of being associated with great minds." He did not go to college, but apprenticed himself to the best conservator in London and eventually opened his own laboratory. He has been at the Metropolitan since 1975. In 1987 Brealey described his work to interviewer Calvin Tomkins.

We're here to serve the artist. The poor bloody artist long since deceased, and the grandeur of his creation looking like a messed-up jigsaw puzzle. ... But you just do your damnedest to identify in the most servile way with the artist. To allow your personality to be eclipsed, as though you were standing behind the artist while he painted and following his thinking. His thinking happens to be expressed in visual terms, but it's thinking. ... what we are dealing with is visual truths. If the visual aspect of a painting changes, the meaning changes—because the look is the meaning. ... In a painting, somebody's personality and intellect are expressed by colored muds. Colored muds held together by a sticky substance—that's painting.

We see Brealey in the laboratory in front of two paintings he has recently cleaned and restored (Fig. **6.29**): Ingres' portrait of the Countess of Haussonville, which belongs to the Frick Collection, and Lorenzo Lotto's *Venus and Cupid*, a recent purchase of the Metropolitan. Brealey's approach to conservation is cautious: "When in doubt, abstain," he has said. Gisela Helmkampf says of Brealey's special skill, "It is not in the hands. ... it is all in the head. It is his way of seeing into pictures, and sensing what the artist is attempting to do."

Based on Calvin Tomkins, "Profiles: Colored Muds in a Sticky Substance," *The New Yorker,* March 16, 1987, 44–70; quotations from pp. 60, 49, 48, and 53–4; and Philip Jodidio, "L'homme qui a osé restaurer les ménines," *Connaissance des Arts* (Paris), July-August 1985, pp. 62–7

ACRYLIC PAINTING

Acrylic paint is one of a number of related paints that have synthetic resins as their binders. This weather-resistant paint was originally intended for the protection of cars and machinery that had to be outdoors. Industrial chemists found carbon compounds, such as acrylic acid, that can be treated to make extremely durable binders for pigment.

In the 1930s these industrial paints were adopted by artists as a revolutionary act in art, under the leadership of the Mexican painter David Alfaro Siqueiros (*see-KAY-ros*; 1896–1974). Not only was he an important painter, but Siqueiros was also one of the leaders in the theory of art in this century, showing how still and movie cameras could be applied to painting, advancing the spray gun as a tool, doing the first outdoor mural paintings, as well as experimenting with new kinds of paint. Siqueiros painted the murals (Fig. **6.30**) in the Chapultepec Castle, a museum in Mexico City, in 1957. Notice the wall on the right, behind the scaffold, where sprayed lines suggest the larger areas of the design. The air compressor for the spray guns sits against the wall. On the table, under a tool kit, are large cans of industrial paint. On the left are the finished

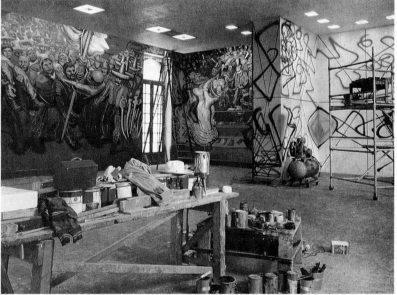

paintings of a strike and the dictator, scenes from the Revolution of 1910. Siqueiros applied the final coat of paint with brushes (Fig. **6.31**). You can tell that the paint is thick and opaque, with an almost sculptural solidity. The synthetic resin and acrylic binders are the strongest glues known and can hold a large amount of pigment, resulting in solid, opaque paints. They also dry very fast, which means that blending colors is nearly impossible. The painter's technique has to be more like that for tempera than for oil. To blend and mix colors on the painting, the painter adds wet paint over dry with a brush to achieve scumbling or thinly sprays on the new color. Acrylic paints can be thinned with water (which makes an emulsion, not a solution) and applied as glazes, giving the appearance of watercolor or oil paint. But the powerful effects Siqueiros liked in his art depended on spraying and scumbling with the brilliant, opaque industrial colors.

"We must look to physics and chemistry to supply us with materials suitable for modern conditions," Siqueiros said.[5] Many of the industrial paints, although they are tremendously durable and tough, are mixed with solvents that are so dangerous that painters must wear protective masks. Acrylic paint is safe to use because it is thinned with water and has no dangerous fumes.

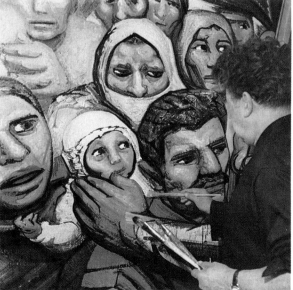

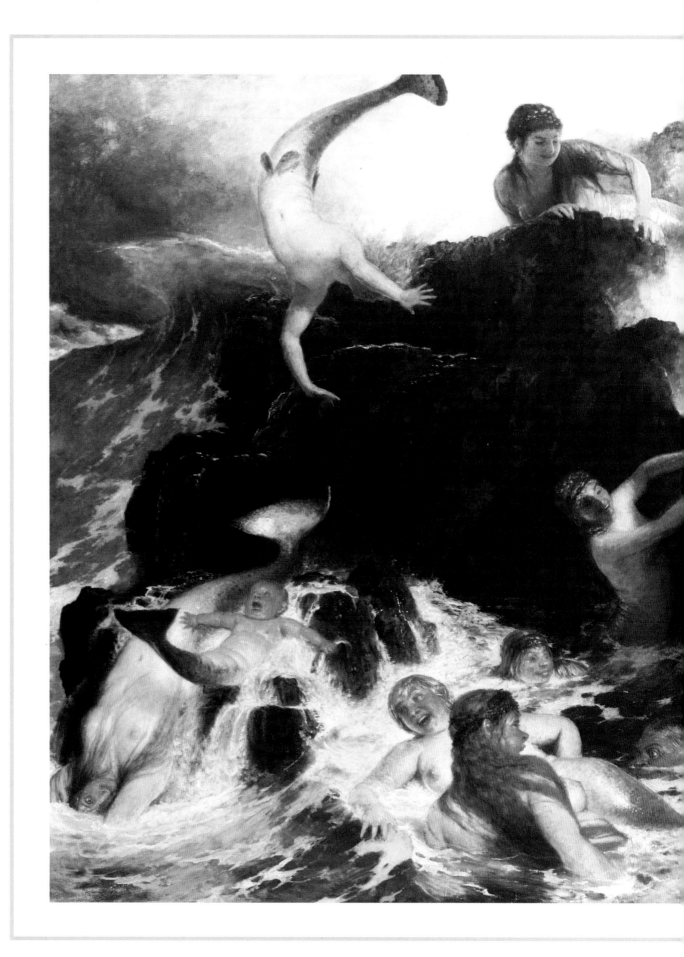

Is Quality an Issue?

6.32
ARNOLD BÖCKLIN, *The Play of the Naiads*, 1886.
Oil on canvas, 5 ft x 5 ft 10 in (1.5 x 1.8 m).
Kunstmuseum, Basel, Switzerland.

No other painter's reputation fell so far as that of Arnold Böcklin (1827–1901) in the half-century after his death. The art historian Fritz Novotny, writing in the 1950s, summed up the complaints about him: "Böcklin's development becomes the paradigm of a typical 19th-century aberration. ... His ambition was manifold invention. His landscapes, already full of symbols, with their rocks and trees, waters and seashores and ruins, were in addition peopled with woodland sprites and other fabulous beings, centaurs, nymphs, fauns, and tritons, battling heroes, and personifications of the ages of man and the forces of nature. He ... loved humorous allusions and resounding laughter. ... Böcklin presented ideals which were simple and crude enough to appeal to the taste of the artistically minded upper-middle-class society. ... In other words, strictly artistic problems played a limited role in his work."

The Play of the Naiads (Fig. **6.32**) fits this description perfectly. The painter has invented a world of rocks and ocean inhabitated by a crowd of naiads, or mermaids, mostly young women and children, with two suspicious-looking male sea-monsters slithering in among them. Perfectly at home in their world, somersaulting over the rocks and laughing, they transmit a humor, energy, and fantasy that is hard to find in art.

In the 1970s Böcklin's reputation began to rise. The National Gallery in Washington brought his painting *Hercules' Tomb* out of storage and hung it again and several important exhibits and publications of his work appeared. What are we to make of this? Did "simple and crude" ideals become fashionable? Did the later 20th-century art world grow tired of "strictly artistic problems"? The questions arise: do judgments of quality have any objective or lasting value? Is there anything beyond knowing what you like? Can upper-middle-class people rise above their simple tastes by studying art, and if they do, will they see that Böcklin's painting is just amusing? Or, if they like it, will it prove they have no taste?

To put it another way, is quality in art an *issue*? Can we argue with each other about artistic quality, or is it just a matter of taste?

Based on Fritz Novotny, *Painting and Sculpture in Europe, 1780–1880*.
New York: Penguin Books, 1960/1971, pp. 319–20

The famous "drip paintings" by Jackson Pollock (1912-56), such as *Cathedral* (Fig. **6.33**), were a phase in Pollock's production when he took advantage of the special properties of synthetic resins. In Hans Namuth's photograph of Pollock at work (Fig. **6.34**), the artist has his large canvas on the floor and a can of synthetic lacquer in his left hand. The paint is so viscous that he can draw in the air with his brush and the syrupy paint will fly out into the air following his gesture, then fall to the canvas. Many of Pollock's heavily textured paintings were done in traditional oil painting in an alla prima technique with scumbling, but he was also one of the first to take advantage of the abstract possibilities of the new medium.

Acrylic paint is widely used both for fine art and for commercial art and design, in which its quick drying is a great advantage. Many artists are experimenting with the variety of things that can be done with this medium. Two examples of techniques and styles developed especially for acrylic are the colorful brushstroke-textured paintings of Pierre Dunoyer (see Fig. **6.35**) (*dü-NWAH-yay*; b. 1949) and the staining of raw canvas, as we see in *Triple Variant* (Fig. **6.36**) by Sam Gilliam

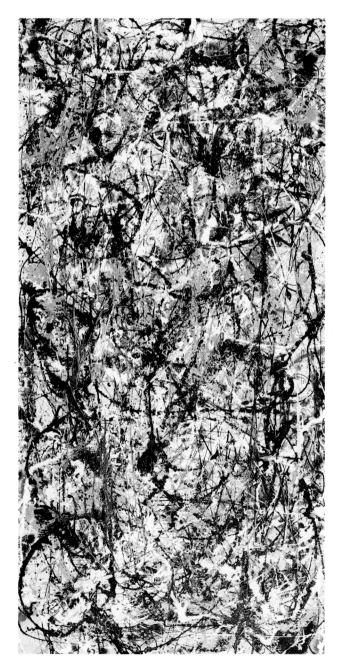

6.33
JACKSON POLLOCK,
Cathedral,
1947.
Enamel and aluminum
paint on canvas,
5 ft 11½ in x 2 ft 11 in
(1.8 x 0.9 m).
Museum of Art, Dallas,
Texas. (Gift of Mr and Mrs
Bernard J. Reis.)

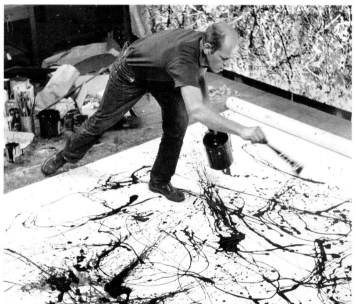

6.34
Jackson Pollock at work,
1951.
Photograph by Hans
Namuth.

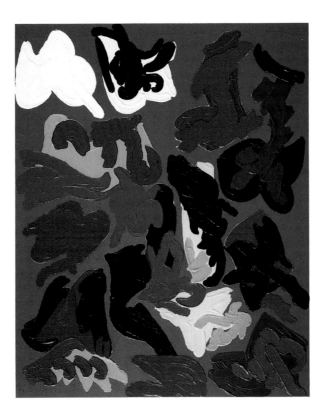

6.35
PIERRE DUNOYER,
Blue, 1985.
Acrylic on canvas,
7 ft 10½ in x 6 ft 1 in
(2.4 x 1.6 m).
Nohra Haime Gallery, New
York. (Private collection.)

6.36
SAM GILLIAM,
Triple Variant, 1979.
Acrylic on canvas, with
stone and aluminum,
10 x 16 x 2 ft
(3 m x 4.9 m x 61 cm).
At the Runell Federal
Building, Atlanta, Georgia.

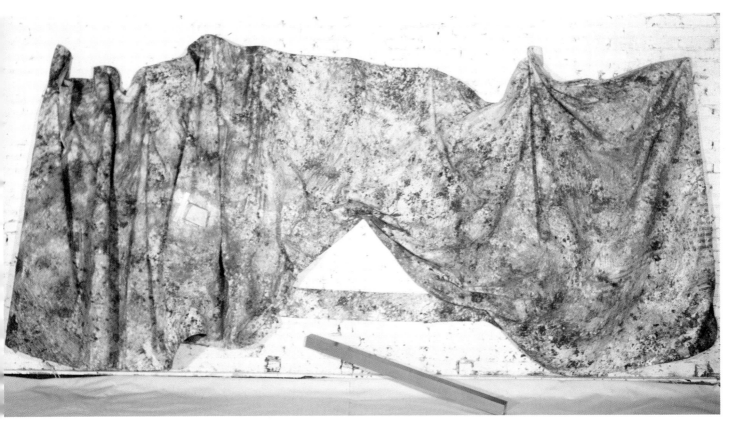

(b. 1933). Dunoyer's *Blue* (Fig. **6.35**) looks at first much like an oil painting, but two features are especially appropriate to acrylic: the thick impasto brushstrokes, which dry very quickly in acrylic, and the flat unmodulated colors. This kind of painting can be done in oil, but the thick paint would require several weeks, at least, to dry completely, and the capacity for blending and varying color tones, which was the reason oil paint was developed, is not needed here. Dunoyer's painting uses acrylic in ways that harmonize with the nature of the medium.

Unlike oil paint, acrylic will preserve a canvas soaked in it, so there is no need for the glue sizing and white lead priming used on canvases for oil painting, and since dried acrylic is more flexible than oil paint it is less necessary to stretch the canvas. Art conservators may have problems cleaning acrylic canvases without removing the stain that is the art, but that, say the painters, is the conservators' problem. Sam Gilliam has found a style that uses these qualities of acrylic to express his deepest sentiments. In his earliest work Gilliam used precisely painted acrylic stripes, but they began to seem confining and they gradually turned into stained spots and areas. Even the tightly stretched canvas seemed unnatural and he began to hang his paintings in flowing draped forms. "All my paintings are about open expanses," he says, thinking of the freedom and spiritual resonance he finds in natural landscapes. In *Triple Variant*, which flows across 16 feet (5 meters) of wall, Gilliam contrasts the colorful canvas with a large rock and an aluminum beam. The canvas is made to represent flowing earth forms covered with vegetation, in contrast to the rock foundations of the earth and man-made structures. Artists choose their paints to dramatize their ideas.

For other contemporary paintings in acrylic, see Figures **14.34** and **14.42**. Both these examples use thick paint rather than staining.

FOR REVIEW

Evaluate your comprehension. Can you:

- explain the differences between watercolor, tempera, and acrylic paints?
- explain why fresco is often used for mural painting?
- describe an example of glazing technique and contrast it with an example of *alla prima* oil painting?
- give a brief history of acrylic and synthetic resin painting?

Suggestions for further reading:

- Michael Clark, *The Tempting Prospect* (London: British Museum, 1981) on English watercolor painting
- Metropolitan Museum of Art, *The Great Age of Fresco* (New York, 1968)
- Paul Horgan, *Peter Hurd: A Portrait Sketch from Life* (Amon Carter Museum, Fort Worth, 1965)
- Ralph Mayer, *The Artist's Handbook of Materials and Techniques* (New York: Viking Press, 1981)
- Antonio Rodriguez, *A History of Mexican Mural Painting* (New York: Putnam, 1969)

7

Sculpture

Sculpture is defined by its three dimensions, with categories such as "low relief," "high relief," and "in the round" to indicate how deep the third dimension is. Unlike painting, sculpture is not an art of illusions, but of solid materials in space. That is why sculpture is

P R E V I E W

often associated with architecture, as reliefs on buildings or as focal points in open spaces. What the materials are and how they are worked is an important part of the appeal of sculpture. The basic techniques of carving wood or stone, modeling clay or wax, and casting metal are ancient, and we can trace the history of technology in the skills of sculptors. In this century sculpture has changed greatly, partly under the influence of newly discovered African and Oceanic sculpture that is often constructed of carved parts in abstract or geometric forms. Nowadays, sculpture is often constructed (rather than carved or modeled) out of hard materials (wood, metal, or plastic), soft materials (cloth or fibers), energy beams of light or color, and it sometimes moves and changes.While earlier sculpture emphasized three-dimensional masses, and more recent sculpture has stressed structures of masses and spaces, a still newer trend has been toward sculptures intended for a particular place and adapted to the environment of that location.

The human body has always been the chief subject of sculpture. Two different designs have been invented: the figure in motion and the figure still. The still figure, called *frontality*, is eternal, timeless, while the moving figure, in *contrapposto*, appeals to a living, moving audience. In the last twenty years there has been a revival of interest in sculptures representing the human body, often based on casts made from living bodies. The traditional glorification of the human body is absent from most of these works, which show humans as suffering creatures.

WHAT ARE THE BOUNDARIES OF SCULPTURE? Niki de Saint Phalle (b. 1930) seems to ignore all boundaries in her sculpture park based on the twenty-two tarot fortune-telling cards (Fig. **7.1**). Built into an old quarry in Italy, the constructions of iron rods sprayed with concrete and covered with mirrors, glass, and ceramic mosaic are too big, too colorful, and just too wild to be considered serious sculpture. Besides, some of them are really buildings: the artist has a studio inside *The Empress* (seen on the left side of Fig. **7.1**) and there are interior spaces in (left to right) *The Tower*, *The Castle of the Emperor*, and *The High Priestess*. A joyful enthusiasm has been the unmistakable expression of Niki de Saint Phalle's work, which tells us that boundaries and rules are not what art is about at all. To name it "sculpture" is just a convenience to allow us to speak of it, and maybe to compare it with other things.

The other things with which we might be tempted to compare Saint Phalle's work would probably be three-dimensional objects, which is the defining feature of sculpture. We usually think of color as belonging to painting, but it has not always been true that sculpture was unpainted. Four hundred years ago a Spanish writer on art defined the difference between sculpture and painting this way: "Sculpture has existence. Painting has appearance."[1] The special quality of sculpture is that it exists in the same way that the people looking at it exist, as a solid thing in real space. In contrast, paintings exist in imaginary or illusory space, more like a dream—something seen but without a material existence.

RELIEF AND ROUND

Actually, sculpture spans the gradations between illusion and full material existence by different levels of massiveness, which we call low relief, high relief, and sculpture in the round. Low **relief** is characterized by forms that barely rise above the background. In high relief parts of the figures are free of the background, but there

7.1
Niki de Saint Phalle, sculpture garden of the Major Arcana (tarot cards), Garavicchio, Tuscany, Italy, 1993.

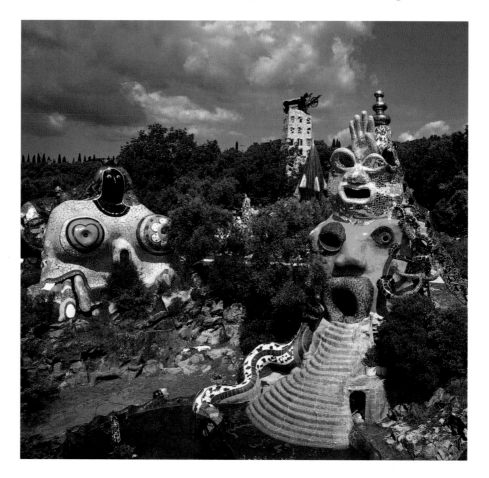

still is a background plane to which they are attached. Sculpture in the round has no background plane and can be seen from all sides. Each relief level has particular uses and settings and the gradations between them are infinite.

Doors of Death (Fig. **7.2**), by Giacomo Manzù (mahn-SOO; b. 1908), was composed of ten low-relief panels which had been modeled in clay and then cast in bronze. If we look closely we can perceive the touch of the artist's fingers and his wooden modeling knife on the clay. The subtle highlights and shadows give an effect often called "impressionistic," a sculptural analogue of the light and color effects of Impressionist painting. Like a painting, this low relief suggests that there is more space in the background than is really there, and more mass in the figures, which are practically flat. Illusions of this type are something we expect in painting and find in sculpture only in low relief. Manzù's panels form a pair of impressive bronze doors for St Peter's in Rome. Door panels are a common use of low-relief sculpture; low reliefs may also be hung on walls like paintings.

High relief also typically has an architectural setting. The wall of the Hindu temple of Khajuraho (KA-joor-AH-ho; Fig. **7.3**) in India acts as the background for an array of human figures (such as the woman on the left pillar), gods (such as the

7.2 *(below left)*
GIACOMO MANZÙ,
Doors of Death,
1964.
Cast bronze,
25 ft 3½ in x 12 ft ¾ in
(7.7 x 3.6 m).
St Peter's Basilica, Vatican,
Rome.

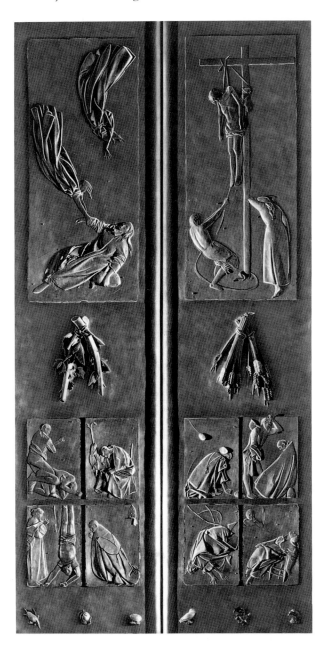

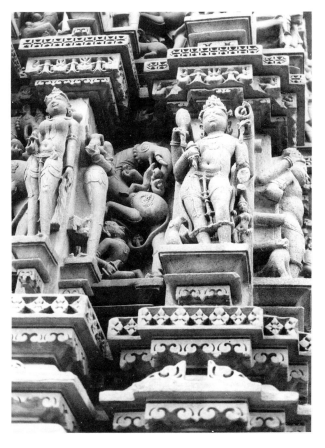

7.3 *(above)*
Lakshmana Temple at
Khajuraho, Madhya
Pradesh, India.
c. A.D. 950.
Stone, high relief.

male figure on the right pillar), and mythical creatures and animals. The building has such a complicated shape that many of the figures at first glance seem to be sculptures in the round, but those seen in side view show how they are attached to the wall. The plumpness of the sculptural forms stresses the physical reality of everything represented—these are not gods and myths to be seen only in visions but are shown as having an earthly existence. The relief setting tells us that we are not supposed to examine them from all angles; there is one point of view that is correct, the view from which they are best seen. Hindu sculpture is very rich in high relief. It gives an impression of tremendous, licentious exuberance, but the architectural setting and the high-relief composition provide a firm set of controls within which the sculpture operates, like a wild dance with carefully choreographed steps set to strict music.

Sculpture in the round is sometimes placed in architectural niches or against a wall, and often that fulfills the sculptor's intentions. Michelangelo's *David* (Fig. **7.4**), now set in a rotunda, was originally intended for a place before the massive walls of the Florence city hall, the Palazzo Vecchio. Although it was carved in the round and set where it was visible from at least three sides, it was conceived with one best view, the front view of the body, which gives a width sufficient to support visually the massive head. Michelangelo's biographer tells us that he would make a small wax model of the figure he was about to carve from marble and lay it in a pan of water. Slowly lifting it from the water, he would note which parts emerged first, and then carve the marble from one side, freeing the figure from the stone just as the model had emerged from the water. A dominant view is characteristic of Michelangelo's sculptures and makes an architectural setting particularly appropriate for them.

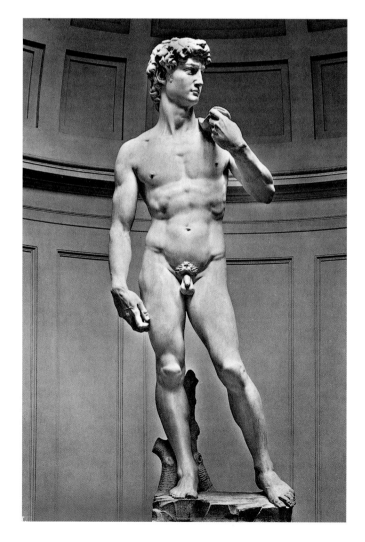

7.4
MICHELANGELO,
David, 1501–4.
Marble, 13 ft (4 m) high;
with base 18 ft (5.5 m)
high. Accademia,
Florence, Italy.

Auguste Rodin (*ro-DAN*; 1840-1917) admitted that not all views of his *The Burghers of Calais* (Figs **7.5** and **7.6**) were equally good, but he considered six or seven views satisfactory. In a group composed of six free-standing figures there is great potential for a sculpture truly in the round, and Rodin's monument fulfills that potential exceptionally well. The sculpture was a public memorial to six leading citizens of the city of Calais who, in 1347, gave themselves up to the enemies who had besieged their city for a year in exchange for the lifting of the siege. Dressed in

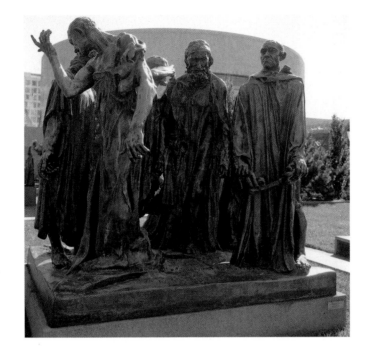

7.5
AUGUSTE RODIN,
The Burghers of Calais,
1886.
Bronze,
6 ft 10½ (2 m) high,
7 ft 11 in (2.4 m) long,
6 ft 6 in (1.9 m) deep.
The cast in the Hirshhorn
Museum and Sculpture
Garden, Smithsonian
Institution, Washington,
D.C.

7.6
AUGUSTE RODIN,
The Burghers of Calais,
1886.
Bronze,
6 ft 10½ (2 m) high,
7 ft 11 in (2.4 m) long,
6 ft 6 in (1.9 m) deep.
The cast in the Rodin
Museum, Philadelphia,
Pennsylvania.

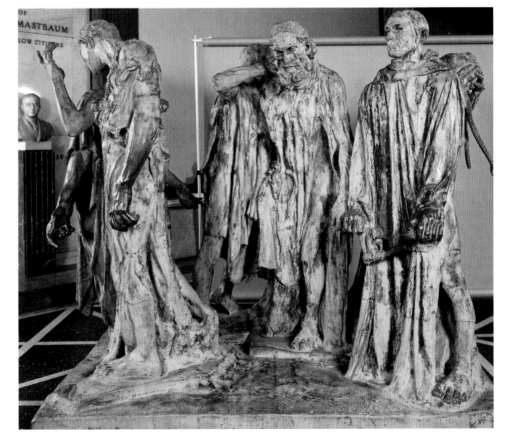

sackcloth and rope halters, they are shown marching to their deaths. The monument was to be set in the square before the town hall, to be visible from all sides. The sculptor considered several ways of setting the figures, finally deciding to set them directly on the ground to increase the observer's identification with the personal tragedy of each individual. The people of Calais were offended by the openly displayed emotion and preferred to set the sculpture apart from daily life by placing it on a pedestal. The figures have a multiplicity of views, which suggests that there are also a multiplicity of meanings concerning the individual tragedy of each figure and the way each finds to face death.

TRADITIONAL MATERIALS AND TECHNIQUES

Some of the oldest art is carved in stone and ivory (see Figs **10.2**, **10.3**, and **10.7**).

Carving, modeling, and casting are very ancient skills, but they will never be out of date as long as artists have ideas that need to be embodied in wood or stone, clay or metal. As we shall see, another group of constructive techniques for other materials has come into use in this century, but they have added to the range of sculpture, not driven out the traditional techniques and materials.

CARVING

Carving involves removing material to reveal a form, and it is done with chisels and hammers or mallets on wood and stone. In contrast to many earlier sculptors, who usually planned to remove the marks of their tools, modern sculptors usually prefer to reveal both the material and the tool marks. In *The Cloud* (Fig. **7.7**) by José de Creeft (1884–1982) the heavy stone is balanced so delicately on its base that it appears light as a cloud. The contrasts of smooth, rounded forms and rough, linear shapes suggest the form of a cumulus cloud whipped by the wind. De Creeft chose a stone for its texture and color and allowed his chisel marks to show in order to provide contrasts of texture.

The artist's concern with the material and the marks of the tools is clear in *Adam and Eve* (Fig. **7.8**) by Constantin Brancusi (*brahn-KOO-see*; 1876–1957). A block of limestone (for the base) and three pieces of wood were selected. The oak and chestnut show different grain and color, and the cuts by saws and the curved blade of the wood chisel, struck with a wooden mallet, can be distinguished. As we examine such a piece, the nature of its materials and the processes by which it was

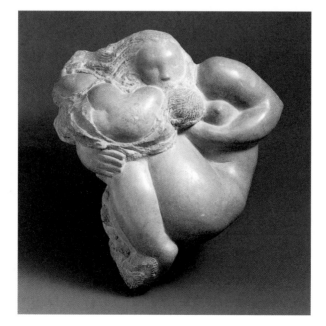

7.7
JOSÉ DE CREEFT,
The Cloud, 1939.
Greenstone,
13½ in (34 cm) high.
Whitney Museum of American Art, New York.

made are among its most striking features. Then we begin to see the subject emerging, with a feminine form above and a rugged masculine one below. The relative roughness or smoothness of the materials and chisel cuts contributes to the masculine or feminine idea.

MODELING

The most personal sculptural technique, since much of it is done with the fingers, is modeling of clay, wax, or plaster. Tiny clay figurines (Figs **7.9** and **7.10**) modeled by ancient Mexicans show both the marks of their fingers and the cuts and punches of small wooden tools. They were expert at building up the bodies with fillets (narrow ribbons of clay) and balls of clay to make hair, jewelry, nipples, and clothing, and at cutting various textures into the soft surfaces. These figures fit snugly into the palm of your hand; both their small size and expert modeling contribute to their irresistible charm.

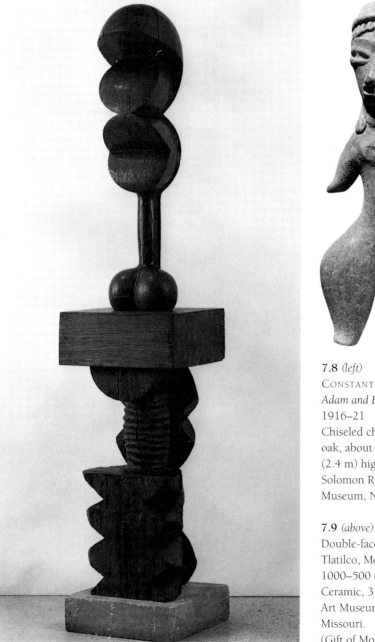

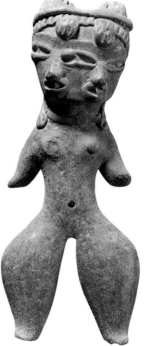

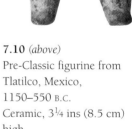

7.8 *(left)*
CONSTANTIN BRANCUSI,
Adam and Eve,
1916–21
Chiseled chestnut and old
oak, about 8 ft 9 in
(2.4 m) high.
Solomon R. Guggenheim
Museum, New York.

7.10 *(above)*
Pre-Classic figurine from
Tlatilco, Mexico,
1150–550 B.C.
Ceramic, 3¼ ins (8.5 cm)
high.
Museum of Art, Dallas,
Texas

7.9 *(above)*
Double-faced figurine from
Tlatilco, Mexico,
1000–500 B.C.
Ceramic, 3¼ in (8 cm) high.
Art Museum, St Louis,
Missouri.
(Gift of Morton D. May.)

Pottery clay is used when the final product is meant to be in clay rather than cast into another material. The sculpture must be small enough to fit into the kiln—the potter's furnace for hardening the clay into pottery. A large ceramic sculpture requires a large kiln, which requires a lot of fuel. Since clay shrinks in the heat of the kiln, the walls of sculpture must be thin enough that they shrink all at once when the heat of the kiln strikes them; thick walls and solid clay forms simply break.

The most spectacular example of ceramic sculpture is the army and administration of the emperor of China, about 6,000 figures, all life-size and actually portraits of individuals (Fig. **7.11**). These were no doubt very happy to pose, because the ceramic figures took the place of the people themselves in ancient sacrificial traditions. This emperor, who died in 210 B.C., also built the Great Wall— he was clearly not intimidated by large projects. The photograph shows archaeologists unearthing the figure of a soldier and recording its measurements. The human scale of the figures, and even horses, was a feat of modeling and firing. The kilns must have been room-size, and the amount of fuel they required must have been staggering. China was deforested in ancient times, and we can understand what happened to some of the forests when we see an imperial army made of ceramic. Life-size ceramic figures are so unusual that one must remind oneself that they are not just a technical achievement, but also artistic achievements in a very realistic style.

CASTING

A full-scale clay model, ready to be made into molds for casting in metal, is shown in Figure **14.17**.

Sculptors sometimes want to convert a modeled form into a tougher material, often for outdoor use, so they make molds from the modeled original and cast the sculpture in metal. Although the technique has been known since ancient times, it is an expensive procedure and is usually carried out by specialized technicians in a professional foundry. For the sculptor it means planning the design so that it can be cast effectively, and then knowing how to **chase** (to clean, ornament, or sharpen detail of) the finished casting and apply the proper **patina** (*PA-tuh-nuh* or *pa-TEE-nuh*), meaning an acid finish to color and protect the metal).

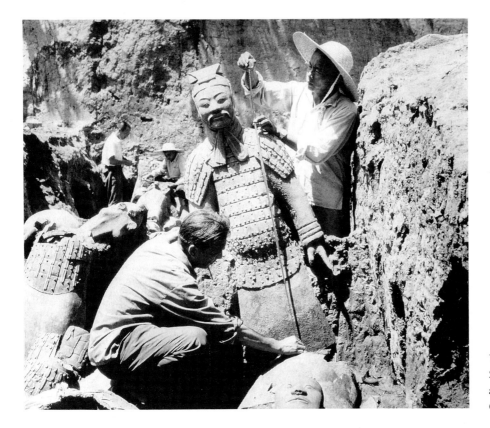

7.11
Soldier of the Chinese imperial army, Ch'in Dynasty, c. 210 B.C. Ceramic, 6 ft (1.8 m) high.

The Swiss sculptor Alberto Giacometti (*jah-ko-MET-tee*; 1901-66) worked obsessively on his figures such as *Man Pointing* (Fig. **7.12**), building up plaster around the metal rods of the armature, or framework that holds the plaster, and then cutting it away again. He described his own work:

> A large figure seemed to me false and a small one equally unbearable, and then often they became so tiny that with one touch of my knife they disappeared into dust. But head and figures seemed to me to have a bit of truth only when small. All this changed a little in 1945 through drawing. This led me to want to make larger figures [such as *Man Pointing*], but then to my surprise, they achieved a likeness only when tall and slender.[2]

Although the technique in modeling and the way in which the plaster is applied is easy to see, from the start it was intended that the plaster should be replaced by **bronze** (an alloy of copper and tin). Casting is done by making molds (of a special clay called "fireclay") in several pieces from the plaster or clay model. The molds are then usually coated with wax to the thickness intended for the final metal sculpture. The molds are assembled and filled with a core of fireclay, which will make the final metal sculpture hollow by acting as an interior mold. All the wax is melted out—one drop of wax in the mold will cause a terrible explosion when the molten metal is poured in. The bronze is melted and the channel between the furnace and the mold is opened and the molten bronze flows into the narrow space between the inner and outer molds. This technique is called **lost wax** casting, *cire perdu* (*seer-pair-DÜ*) in French, because the wax is entirely eliminated before the bronze enters the mold.

The cast bronze of a small equestrian figure (Fig. **7.13**) just as it came from the mold shows all the channels through which bronze flowed into the mold still

7.12 *(below left)*
ALBERTO GIACOMETTI,
Man Pointing,
1947.
Bronze, 5 ft 10½ in
(1.8 m) high.
Museum of Modern Art,
New York. (Collection of
Mr and Mrs John D.
Rockefeller III.)

7.13 *(below right)*
Cast after Martin
Desjardins, unfinished
equestrian figure of Louis
XIV, late 17th century.
Bronze, 22 in (56 cm)
high.
State Art Museum,
Copenhagen.

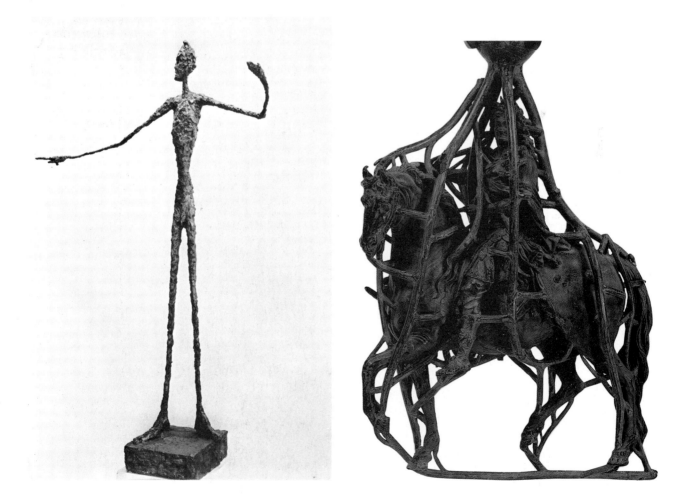

THE LOST-WAX PROCESS

A positive model ...

... is used to make a negative mold ...

...which is then coated with wax. Cool fireclay is poured into the wax shell; the mold is then removed.

Metal rods are added to hold the layers in place, as are wax vents for even flow of bronze.

The whole structure is immersed in sand; wax is burned out. Investment ready for molten bronze.

Bronze head, ready for removal of gates and metal rods.

attached, as well as vents for the escape of air, which also fill with bronze. The sculptor's next job would be to cut all those channels off, polish the metal, chase it (cutting fine details into the cold metal with chisels), and perhaps apply an acid patina to color the bronze.

Casting in metal can be done by several different processes, including simply pouring the molten metal into a box of fine sand modeled to the pattern desired, which produces a low relief sculpture. For sculpture in the round some form of lost wax casting was by far the commonest technique, known nearly worldwide. Metal was always a prestige material, particularly in Africa, where it was used for royal portraits and the furnishings of royal ancestor altars. The figure of a warrior on horseback (Fig. **7.14**) was probably originally made to be placed on such an altar to symbolize the military power of the Benin king, or Oba. Benin sculptors used both brass (copper and zinc) and bronze (copper and tin), casting hollow heads, figures, and high relief plaques by the lost wax method. This close-up picture shows the fine detail and variety of textures that are common in Benin castings. This African sculpture is almost exactly the same period and the same size as the French sculpture in Figure **7.13**, and both were cast by the same process. When the Benin sculpture first came from the mold, it also had metal remaining in the channels for casting and for escaping air, and if the figure of Louis XIV had been finished it would have looked similar to that of the Benin warrior, although the actual styles would have been different.

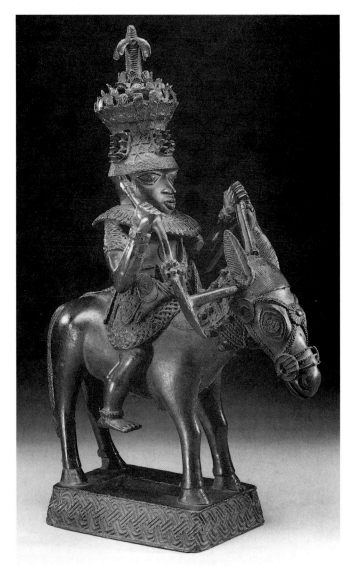

7.14
Benin warrior on horseback, late 17th to early 18th century.
Bronze,
23½ in (60 cm) high.
British Museum, London.

Cellini Casts a Bronze

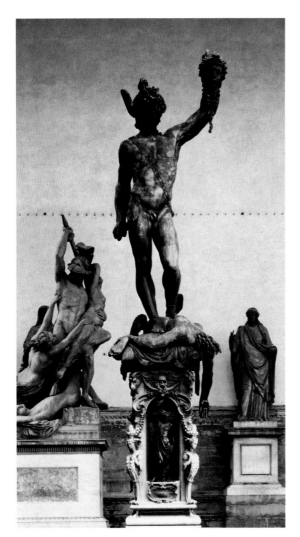

7.15
BENVENUTO CELLINI,
Perseus with the Head of Medusa, 1554.
Bronze, 10 ft 6 in (3.2 m) high.
Loggia dei Lanzi, Florence, Italy.

furnace above the mold. "At last," writes Cellini, "I called out heartily to set the furnace going. ... [It] worked so well I was obliged to rush from side to side to keep it going. The labor was more than I could stand. ... To increase my anxieties, the workshop caught fire, and we were afraid lest the roof should fall on our heads." Finally, exhausted and feverish, Cellini took to his bed, telling his men, "I shall not be alive tomorrow!" But the copper did not melt properly and a workman woke him to announce, "O Benvenuto, your statue is spoiled and there is no hope whatever of saving it!" Cellini writes, "No sooner had I heard the shriek of that wretch than I gave a howl which might have been heard from the sphere of flame. Jumping from my bed, I seized my clothes and began to dress. ... I went immediately to inspect the furnace and found the metal was all curdled, which we call "being caked." He fortified the fire and threw in more metal, but still the metal did not flow smoothly.

Bronze casting has always been an exciting experience. The best account of it was written by Benvenuto Cellini (*chuh-LEE-nee*; 1500–71), who describes in his autobiography how he set to work "with all the forces of my body and purse" to cast into bronze the model of his statue of Perseus with the head of Medusa (Fig. **7.15**). He built the foundry in a courtyard of his house and laid in a stock of firewood and ingots of copper and bronze. He set up the molds with their thin coat of wax, which would eventually be replaced by bronze. Cellini wrote: "I began to draw the wax out by means of a slow fire. This melted and issued through the numerous air-vents I had made." The next step was to build a brick furnace around the mold and to increase the fire enough to vaporize the last trace of wax and fire the mold to brick-like hardness. Finally, a deep pit was dug in the floor of the furnace, the mold was lowered into it as a safety measure in case it broke or exploded during the pouring of the molten metal. The ingots of copper and bronze were stacked in the

Accordingly I sent for all my pewter platters, porringers, and dishes, to the number of some two hundred pieces, and had a portion of them cast, one by one, into the channels, the rest into the furnace. This expedient succeeded and ... my mold was filling ... and seeing my work finished I fell upon my knees and with all my heart gave thanks to God. After all was over, I turned to a plate of salad on a bench there, ... and drank together with the whole crew.

After two days of cooling, the mold was broken open and found to have cast perfectly except for the toes of one foot, which the artist repaired later.

Cellini's account of the casting of a bronze statue is the most famous, and surely the most dramatic, description of that process.

From *The Autobiography of Benvenuto Cellini*, translated by J. A. Symonds (New York: Random House Modern Library, no date), pp. 411–19.

THE MATERIALS AND TECHNIQUES OF 20TH-CENTURY SCULPTURE

If you had asked Rodin to name the materials of sculpture he would have said stone (mainly marble) and bronze, with models made in clay, wax, or plaster. But in the years since Rodin's death in 1917 sculpture has been revolutionized by new materials and ways of working them. The most important factor in this shift has been the study of the art of other civilizations, especially Africa and the Pacific Islands (called Oceanic art). Artists who had been exposed to foreign styles began to see new ways to use materials such as wood and metal and to see sculptural possibilities in materials such as cloth, plastics, or the earth itself. The change in sculpture has been so rapid and so complete that few people understand what has happened, and all of us are just beginning to comprehend what the changes mean. It seems that these changes herald a large-scale shift in public attitudes and beliefs.

The changes are part of the Modern movement. Among its first manifestations in sculpture was Pablo Picasso's *Guitar* (Fig. **7.16**), which was made in 1912 of sheet metal and wire. To understand what inspired Picasso, we must look at the kind of thing he was seeing. The Mambila mask (Fig. **7.17**) from Cameroon represents an animal and is part of a dance costume. In the free geometry of its forms, Picasso saw an art liberated from the imitation of natural forms, yet still making meaningful comments on the natural world. Picasso's *Guitar* posed a challenge to modern sculptors to represent their experience of the real world without copying the forms of natural things.

Although Europeans had explored Africa and Oceania earlier, little attention was given to the peoples and their ideas until early 20th-century artists began to take a serious interest in their art. Artists began to imagine how such things could be made (Figs **7.18** and **7.19**). Most of them involved construction in some way. African and Oceanic examples freed artists for all kinds of experiments. Four new tendencies

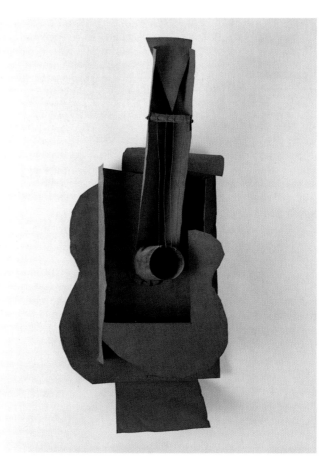

7.16
PABLO PICASSO,
Guitar, 1912.
Sheet metal, wire,
$30\frac{1}{2}$ x $13\frac{1}{4}$ x $7\frac{5}{8}$ in
(77 x 35 x 19 cm).
Museum of Modern Art,
New York. (Gift of the
artist.)

7.17 (right)
Mask from Mambila,
Cameroon,
late 19th century.
Wood,
17½ in (44 cm) high.
Metropolitan Museum of
Art, New York. (Nelson
Rockefeller Collection.)

7.18 (below)
*Helmet mask (The Woman
Ancestor of the Society
Carrying her Son) from
Malekula, New Hebrides
(Vanuatu),* late 19th to
early 20th century.
Wood, straw, compost,
paint, tusks, glass,
26 in (66 cm) high.
Metropolitan Museum of
Art, New York.

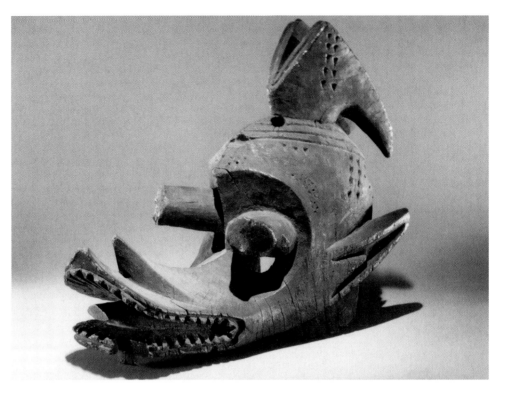

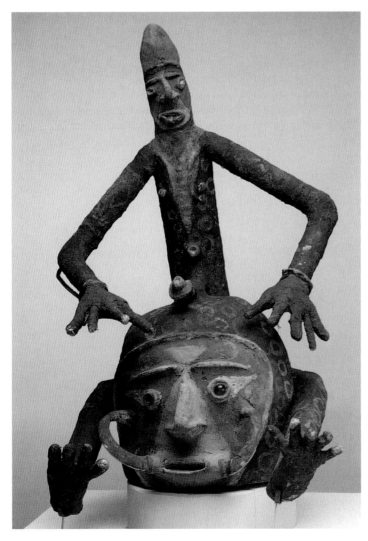

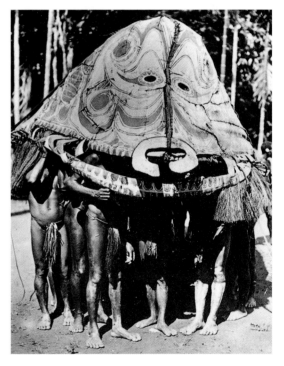

7.19 (above)
Mask of supernatural being from Angoram village,
Sepik River, New Guinea, 1912.
Palm fiber,
16 ft (4.9 m) long.

have emerged in the past fifty years and they are still full of potential: construction in hard materials, mainly wood, metal, or plastic; construction in soft materials, cloth or fiber; site-specific or environmental sculpture, in which materials are planned to fit a particular place which the observer enters; and sculptures based on energy rather than mass, in which color, light, or motion is the means of expression.

CONSTRUCTION IN HARD MATERIALS

One sculptor who accepted the challenge posed by Picasso's *Guitar* to represent nature without copying it was the American David Smith (1906–65), a worker in iron and steel. His *Cubi XVIII* and *Cubi XVII* (Fig. **7.20**) are stainless steel boxes assembled on high steel pedestals, which are abstract forms yet suggest bending and leaning human figures. The surfaces have been burnished irregularly, allowing us to see the motions of the artist's hand, like brush strokes, on the shining metal, which reflects the light of the environment. Picasso's *Guitar* is a high relief, but Smith's sculptures are in the round, adding a level of complexity. Because the sculptures stand on high pedestals they are silhouetted against the sky, which makes grasping the third dimension—to see that these are massive forms receding into space—more difficult. The effort enhances the meaning, making us compare flat shapes with deep masses and encouraging us to walk around to get other views. David Smith is one of the most important of the sculptors who inherited Picasso's abstract "cubistic" attitude to form.

A more recent phase in hard constructions is represented by Alice Aycock (b. 1946), whose *Collected Ghost Stories from the Workhouse* (Fig. **7.21**) is a large "machine" that does no work, except in our imaginations. Aycock takes the kinds of constructions that Smith did as pure statements in abstract form and uses them to make us imagine mystical stories. Smith took mechanism seriously and glorified it as abstract form, but Aycock belongs to "The End of the Mechanical Age," the name of an exhibit of her work at the Museum of Modern Art in New York in 1968. Her sculptures make us feel nostalgic about large clanking machines, which belong more to the period of Edgar Allan Poe than to the age of the electronic robot. Aycock's work is part of a Post-Modern tendency to create representational art, in this case representations of machines, not abstract forms that are the products of machines.

7.20
Dᴀᴠɪᴅ Sᴍɪᴛʜ,
Cubi XVIII (left),
1964.
Stainless steel,
9 ft (2.7 m) high.
Museum of Art, Dallas,
Texas. *Cubi XVII* (right),
1963. Stainless steel,
9 ft 7¾ in (2.9 m) high.
Museum of Fine Arts,
Boston, Massachusetts.
(Gift of Stephen D. Paine.)

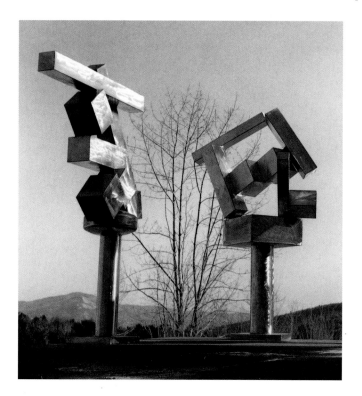

CONSTRUCTION IN SOFT MATERIALS

Construction in cloth and fiber began to play a part in modern sculpture about 1960. Although it is one of the most recent developments, it has already produced many important and original works.

Among the earliest sculptures in soft materials were the Pop Art constructions by Claes (*klawss*) Oldenburg (b. 1929), such as the *Giant Soft Fan—Ghost Version* (Fig. 7.22). The softness of the "Fan" tells us it is impotent—despite its giant size, ghostly and hanging in the air—and not to be feared. Oldenburg had been making sculptures out of every available material, and perhaps it was inevitable that he would eventually use textile fabrics, but it is hard to believe that fiber works such as

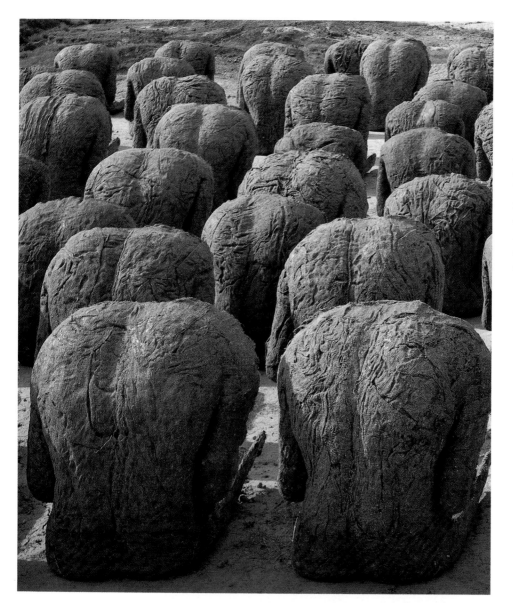

7.23
MAGDALENA
ABAKANOWICZ,
80 Backs, 1976–82.
Eight pieces of textile,
impregnated with glue
and molded;
5 ft 1 in, 5 ft 9 in, or 6 ft
(1.5, 1.6, or 1.8 m) high.
Collection of the artist.

7.24
HENRY MOORE,
*Crowd Looking at a Tied-up
Object*, 1942.
Pen and ink, chalk,
crayon, watercolor,
17 x 22 in (43 x 56 cm).
British Museum, London.

Figure **7.19** were not ancestors of such soft constructions, which did not emerge from the textile craft traditions of the Western countries.

Magdalena Abakanowicz (*ah-bah-KAH-no-witz*; b. 1930) is a Polish sculptor who works in fiber, often building her structures on a loom. But her sources lie outside the utilitarian traditions of Western textile arts and the pictorial traditions of tapestry, closer to the expressive fiber forms of Oceania or the ancient Americas. Of her sculptures such as *80 Backs* (Fig. **7.23**), figure forms of burlap impregnated with glue, she has said: "My three-dimensional woven forms are about my opposition to the systematization of life and art. They grow with a leisurely rhythm like creations of nature and, like them, they are organic. Like other natural forms, they are also something to contemplate."[3]

In a drawing the sculptor Henry Moore shows us a sculpture wrapped in cloth, as if ready to be unveiled (Fig. **7.24**). This was one of Moore's thoughts about the way to meet Picasso's challenge to represent nature without copying it—by wrapping a natural form so that it only hints at the contents of the package. That idea has been the basis of the Christos' (b. 1935) long series of wrapped objects and veiled landscapes, which we contemplate wonderingly, very much like the audience in Moore's drawing. In *Surrounded Islands* (Fig. **7.25**) the "veils" are parted to reveal the small islands, which we would scarcely notice without this powerful "clothing." The artists used 6.5 million square feet (603,850 square meters) of shiny pink polypropylene cloth to outline eleven islands in Biscayne Bay, in Miami, Florida, for two weeks. The "skirt" of each island was sewn to follow the island's contours, was staked on the shore and was supported with anchored floats at the outer edge. All this was paid for by the sale of Christo's drawings and studies for the project. In earlier work Christo and Jeanne-Claude wrapped a piece of the Australian coastline, put an orange curtain across a Colorado valley, and erected a cloth fence 24½ miles (39 kilometers) long across the California hills. With each project, the environmental aspect of the design has become more important, but the Christos'

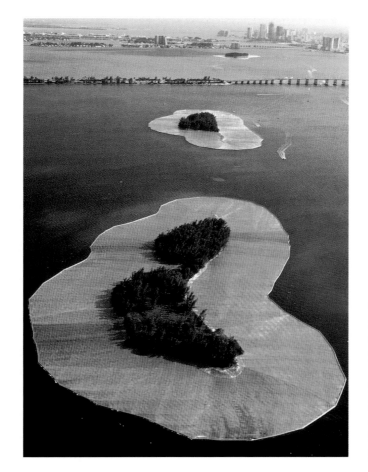

7.25
CHRISTO AND JEANNE-
CLAUDE,
Surrounded Islands,
1980–83,
Biscayne Bay, Greater
Miami, Florida. 6,500,000
sq ft (603,850 sq m) of
floating pink woven
polypropylene fabric.

source of inspiration lies in the possibilities of textiles for making interesting forms, with folds, bulges, colors, and textures.

Surrounded Islands made people see a group of deserted and unnoticed islets as part of a total landscape—and seeing is what art is about. The Christos' sculptures originated in the older tradition of the sculpture as a form, one that can be set in various places without significantly altering the meaning of the work. Their later works, such as *Surrounded Islands*, has used the cloth not to conceal, but to reveal the environment. Each of these environmental sculptures is designed for a particular place and exists for a short time. The Christos' work has led a large audience to consider site-specific environmental art.

SITE-SPECIFIC AND ENVIRONMENTAL SCULPTURE

There is a debate between a younger idea and an older one: the older idea maintains that a beautiful thing is always beautiful, whatever the circumstances, while the younger idea insists that beauty depends on the circumstances, that something may be beautiful in one place and ridiculous in another. The sculptor Carl Andre, a supporter of the younger idea, summarized the history of sculpture: "The course of development: sculpture as form; sculpture as structure: sculpture as place."[4]

Site-specific sculpture is designed for just one location; the place is recreated by the sculpture, which uses the environment as one of its features. The idea of site-specific sculpture grew out of the work of Robert Smithson in the 1960s and the environmental movement as it affected architecture and city planning. The younger idea, that a thing is good or beautiful only if it fits its circumstances, has been gaining ground. Currently it is an important trend in architecture and city planning, as well as in sculpture, and it brings these three fields of art together.

We usually think of earth moving as something we do for utilitarian reasons, for roads or housing developments. Ancient people modeled the earth for symbolic reasons, and recently that art form has appeared again. Robert Smithson (1938–73), one of the re-inventors of site-specific art, designed *Amarillo Ramp* (Fig. **7.26**) to rise out of an artificial lake in the Texas plains. The artist died during work on this project when the small plane he was using to view the site from the air crashed. His work and ideas have inspired a new role for sculpture as rehabilitation of landscapes devastated by modern misuse. Although *Amarillo Ramp* is an abstract form, the curve rising from the water suggests organic growth. Smithson was also beginning to

7.26
ROBERT SMITHSON,
Amarillo Ramp,
1973.
Formed earth. Collection of Stanley Marsh, Amarillo, Texas.

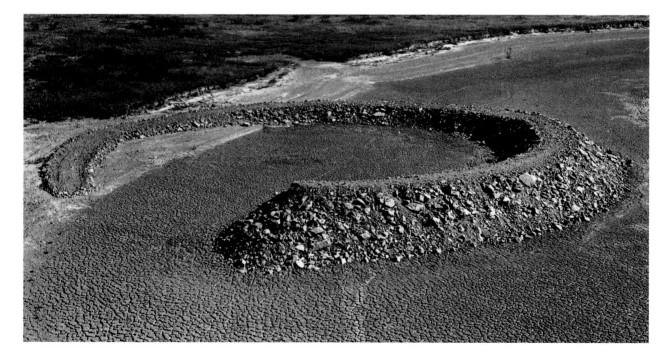

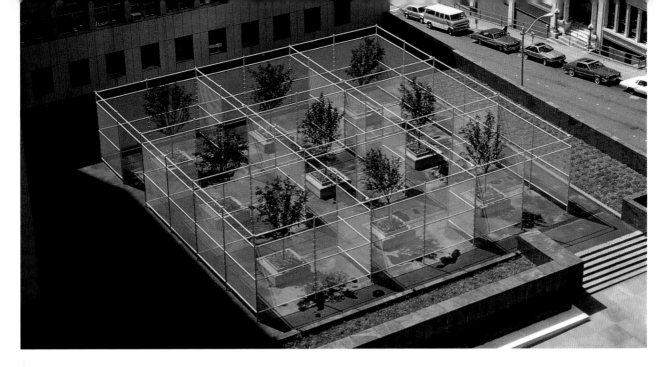

think about making sculpture that would do work in the real world. He proposed designing the terrain around a new international airport built between Dallas and Fort Worth, with the intention of rehabilitating a landscape ruined by development, and while Smithson's proposal was rejected and he did not live to have another chance, his idea has been carried on by other artists.

9 Spaces, 9 Trees (Fig. **7.27**) was commissioned by the city of Seattle to humanize a small rectangular plaza in front of a city office building and jail. The artist, Robert Irwin (b. 1928), described the site as "a very forlorn, isolated, even hostile plaza surrounded by very grey architecture."[5] The police department garage is under the plaza, and Irwin's design was limited by the fact that the plaza is really the garage roof and would support little weight. Irwin designed a maze-like garden with a tennis-court asphalt floor, blue plastic-coated fence, concrete planters planted with sedum and reddish-leaved plum trees. They make spaces protected from the surroundings, where you might eat lunch on a nice day. Irwin considers this a new form of public monument to replace the traditional "statue-in-the-park." Irwin believes there is no standard form, such as a statue, but that each monument has to be tailored to its surroundings.

Only very recently has a representational form appeared in environmental sculpture. Michael Heizer (*HI-zer*; b. 1944) created *Effigy Tumuli Sculpture* (Fig. **7.28**) to cover a 200-acre (84-hectare) site beside the Illinois River that had been ruined by mining. Effigy mounds were made by American Indians as part of their

7.27
ROBERT IRWIN,
9 Spaces, 9 Trees,
1980.
Plastic-coated fencing,
concrete, plum trees.
Seattle, Washington.

7.28
MICHAEL HEIZER,
Effigy Tumuli Sculpture
(water strider), 1085.
Earth mounds covering
200 acres (84 hectares).
Buffalo Rock, Ottawa,
Illinois.

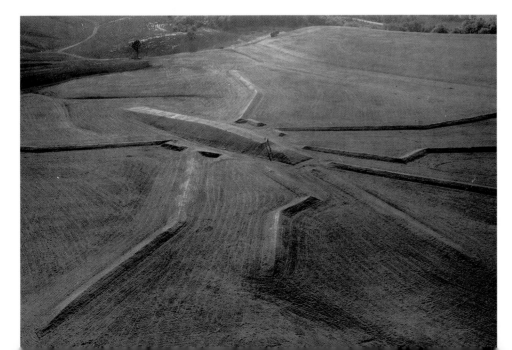

belief in the sacredness of the landscape, so it is fitting that effigy mounds return as a way to restore and give meaning to land. Heizer, the son of an archaeologist, grew up visiting Indian mounds and is deeply aware of traditional Indian attitudes toward the landscape. The water strider (along with a frog, catfish, turtle, and snake not shown here) depicted in Heizer's mounds are all native to the Illinois River, and they represent the return of life to a landscape when the industrial poisons have been removed. Grass planted over the mounds will eventually merge them into the natural scene.

Site-specific sculpture has changed our thinking about how art, and all other human activities, fit into the real world. Everything is connected, in space and in time, these sculptures suggest. Architects such as Frank Gehry (*gary*) and Christopher Alexander and many contemporary city planners are carrying these ideas over into their designs.

SCULPTURES BASED ON ENERGY

A kinetic sculpture powered by the energy of sunlight is shown in Figure **3.53**, and an electronic vibrating sculpture in stroboscopic light in Figure **14.28**.

Sculptures in which the main appeal is based on energy rather than mass seem like a new idea, but moving, or kinetic, sculpture was made as early as the 1st century B.C. A Hellenistic sculptor used water power as his energy source to make a group of his sculptured figures dance in a circle and turn on their bases. Beginning about the 13th century, weight-driven clockwork mechanisms drove all sorts of **automata**, most of them in clocks or theater settings, with musicians, dancing bears, sacred figures, and astronomical designs moving around. So people's fascination with sculptures in motion is nothing new, yet we have given kinetic sculpture a form of our own in the modern period.

Alexander Calder (1898–1976) is the best known of the kinetic sculptors, with his wind-driven **mobiles** representing the modern idea of sculptural movement. The name "mobile" was suggested to Calder by the artist Marcel Duchamp (*dü-SHAH*), who liked it because in French it also suggests "motive," or idea, and Calder's sculptures ordinarily have some reference to nature; they are not just a play of forms. Calder tried out movable sculpture operated by hand crank and by electric motors, but by the mid-1930s he had turned to natural air currents as his preferred source of motion. The advantage of wind was its unpredictability; mechanical or electrical movement had to be programmed and would repeat itself eventually.

Red Lily Pads (Fig. **7.29**) is a delicate suspended mobile painted red, which shimmers as it moves. It was made for the great round space of the Guggenheim Museum in New York, and was intended to be a subtle complement to the complex architectural setting.

Sculptors working in all media have grown more conscious of the setting of their work in recent years, perhaps reflecting the growing influence of environmental ideas or perhaps reacting to the thoughtless placement of many earlier sculptures in locations with unfavorable light. The sculptures of Dan Flavin (b. 1933), which are in fluorescent light tubes, show this change in attitude. A single 8-foot (2.4-meter) lighted tube set at a diagonal could be set "across anybody's wall,"[6] according to Flavin in 1963. In 1971 a pink fluorescent light installation was set up in the center of the rotunda of the Guggenheim Museum in New York (see Chapter 8, pages 278–9, for more on the building), with the vertical tubes ascending just one story in the seven-story space (Fig. **7.30**). More recently, in 1992, Flavin expanded the design to raise the column of pink light the whole height of the rotunda, and installed arrays of lights in various colors—yellow, green, blue, and white—on the balcony galleries. All of these installations were designed for the specific spaces they occupy; for another space the design would have been different.

That is one of the basic laws of sculpture as it has emerged in recent years, and, as is the case for all laws in art, the next generation of artists will discover creative ways to violate it. But a wider focus on environment and natural conditions is important in many areas of contemporary thought and design, and it is sure to remain an important concern in sculpture.

7.29
ALEXANDER CALDER,
Red Lily Pads, 1956.
Solomon R. Guggenheim
Museum, New York.

7.30
DAN FLAVIN,
Untitled, 1992.
pink fluorescent light
installation, 1992.
Solomon R. Guggenheim
Museum, New York.

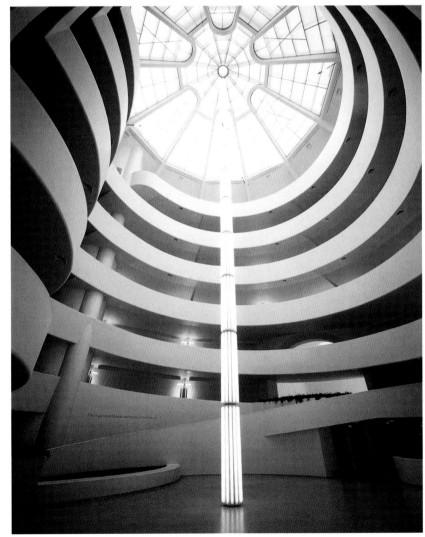

Is It Art?

7.31

MARCEL DUCHAMP, *Bottle Rack*,
Ready-made, 1914.
Musée National D'Art Moderne,
Centre Georges Pompidou, Paris.

In Chapter 1 the role of the audience was defined as deciding what art is and what it means. But sometimes it is hard to decide, despite much discussion. In 1914 the French artist Marcel Duchamp (1887–1968) selected a factory-made rack for drying bottles as his contribution to an art exhibit. That was a shock to the art world of the time, and in 1994, eighty years later, sculptor Glynn Williams used Duchamp's *Bottle Rack* (Fig. **7.31**) as the main example of a threat to the traditional "language of sculpture."* Duchamp and his *Bottle Rack* are a good example of the avant-garde in art, "the group whose works are characterized chiefly by unorthodox and experimental methods." What is surprising is that a sculpture (if it is one) can remain shocking and controversial for such a long time. In most fields it seems as if experiments either become part of the tradition or are forgotten.

Glynn Williams says the *Bottle Rack* is not art because sculpture uses a language of expression based on human touch and vision—"hand-eye coordination," we might say—and is not merely an idea in the mind that can choose examples from all the things that already exist to express that idea. Williams gives us the orthodox viewpoint. Art, to Williams, is making things that exactly express your idea; it is not having ideas and looking for things that more or less

express them or finding interesting-looking things that stimulate ideas.

Robert Morris, who has produced a lifetime of avant-garde art, defended Duchamp's contribution as art.† "New art always disorients," he tells us, and only later does the audience see the pattern and understand the design. Duchamp considered a work of art unfinished until the audience defined its meaning, Morris reminds us. The avant-garde viewpoint, expressed by Morris, argues that automation, machine production, and concentration on the activity and process of art-making are important parts of art now, perhaps more important than the final product. What the viewer is intended to see, he says, is the "process of making" more than the product.

These two witnesses seem to leave the question unresolved. If the process were carried out largely by machines in a factory and repeated a million times, is the process an interesting human communication? And are the processes used by Williams in carving or modeling less interesting? The larger issue the avant-garde wants us to see is that our culture is based on machine production; that is our basic cultural expression. Machine-made *products* are abundant and cheap, it is the *machines* that are rare and expensive. The processes used by machines and the ways we humans interact with them are important in our daily lives, more important than the products. Morris considers the *Bottle Rack* a true expression of the ability of modern processes to make a virile pattern.

But is it art? Duchamp's *Bottle Rack* is still unfinished because the audience has not made a decision. Man versus machine, product versus process: where do we draw the lines around art versus all those other things? How long will it take the audience to decide whether this experiment was successful, or a failure we can forget about?

*Glynn Williams, "Sculpture: An Endangered Species," *Sculpture*, July/August 1994, vol. 13 (4), pp. 34–9
†Robert Morris, "Some Notes on the Phenomenology of Making: The Search for the Motivated," *Sculpture*, March/April 1994, vol. 13 (2), pp. 22–9

DESIGNING NEW FORMS FOR THE HUMAN BODY

We are all sure we know what the human body looks like—we have one of our own to look at—but the history of art provides abundant evidence that there are many different ideas about the proper way to represent people. The great subject for sculpture throughout the ages has been the human body, with animals running a poor second. There is no doubt about the reason: it is with our bodies that we express ourselves most clearly and honestly, and we all understand the language of the body. In sculptures of the body there are two basic possibilities: the body still and the body in motion. Those very general categories have been idealized and given meanings that differ somewhat from one culture to another. Nonetheless, stillness is always more timeless, motion more momentary.

A large white stone seated figure (Fig. **7.32**) discovered on the high plateau of Bolivia and attributed to the Tiahuanaco civilization is in a symmetrical pose, the two sides of the body perfectly balanced. Its ribs show, its eyes stare, and it is seated in the pose used for the burial of the dead in all periods in the regions of the South American Andes. No doubt this figure represents a dead man, someone who was very important in life. His pose is one that could be held for eternity, and like ancient Egyptian sculpture, this one was probably meant to exist in a timeless universe parallel to our perpetually changing time-bound one. Such still, symmetrical poses are called frontal poses; the figure is said to possess **frontality**. Standing or seated, its message is always the same: this figure is eternal.

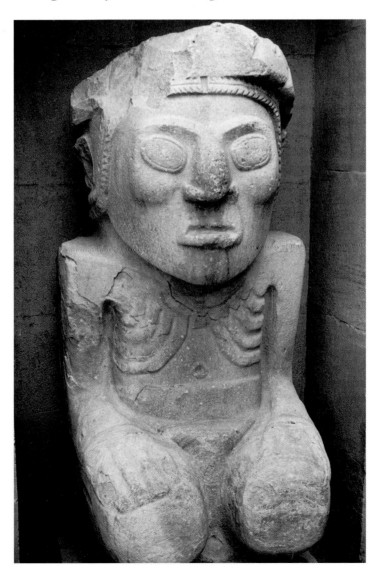

7.32
Seated figure of
Tiahuanaco ancestor,
c. 1st century A.D.
Stone, c. 5 ft (1.5 m) high.
National Museum, La Paz,
Bolivia.

The figure in motion expresses the opposite: this figure is alive and participates with us in constant change. Its appeal is to a human audience, not to eternal spirits. Because the body must balance even when it is in action, there is a graceful interaction of the parts as the weight is redistributed. In the Renaissance that counterpoise of the parts of the body was given the Italian name **contrapposto**, but it was first systematized by the ancient Greeks. They had for several centuries represented figures in frontal poses, probably following the Egyptian example, but about 480 B.C. sculptors suddenly began to design figures in contrapposto. It appears that the artists or their patrons and public began to believe that the audience for sculpture was a human audience, not an audience of the Greek gods, and the stone figures began to imitate the poses of the living, not the stillness of the dead. That was certainly the idea in the minds of the Renaissance artists and their audience. Donatello (1386-1466), the greatest sculptor of the generation before Michelangelo, made his bronze *David* (Fig. **7.33**) an appealing child as well as a victorious warrior. The pose is exactly as the Greeks had codified it: the weight is on one leg (the engaged leg), which pushes that hip up, and the opposite shoulder is higher to compensate. In a similar way, the free leg is balanced by the relaxed shoulder on the opposite side. The body often twists on its spine and the head is usually turned slightly.

It is interesting to compare Donatello's *David*, done about 1430, with Michelangelo's (see Fig. **7.4**) done 70 years later. Both are in contrapposto poses, but the scale and mood changed from the lively and delicate to the superhuman. The political, social, and artistic changes during those seventy years produced a period of confidence and pride we call the High Renaissance, well represented by Michelangelo's sculpture.

The human figure is still the subject of sculpture, but the ways in which the figure is represented are very different from Renaissance sculpture. One of the common methods of forming the figure now is to make casts directly from the bodies of living people. The aim of such contemporary sculptors is to make absolutely truthful statements, and what could be more truthful than a cast of a living body?

7.33
DONATELLO,
David, c. 1430.
Bronze, 5 ft 2¼ in
(1.6 m) high.
Museo Nazionale,
Florence, Italy.

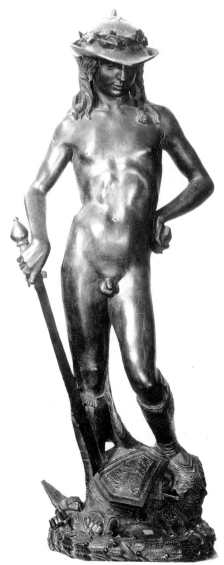

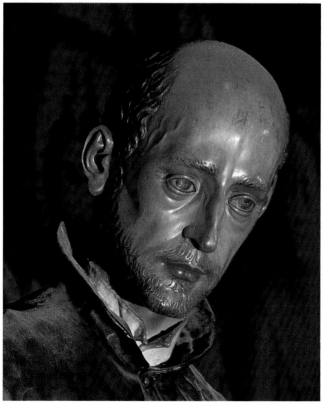

7.34
JUAN MARTÍNEZ
Montañés, detail of head of
Saint Francis Borgia,
1610.
Wood painted with oil
paint, life-size. University
Chapel, University of
Seville, Spain.

7.35

DUANE HANSON,
Self-portrait with Model,
1979.
Polyvinyl, painted with oil
paint, real clothing, life-
size. (The living artist
appears in the center.)

The same intention has not always required casts from life, however—we find a tradition of extremely lifelike figures in European religious sculpture from the 12th to the 17th century. For example, *Saint Francis Borgia* (Fig. **7.34**) by Juan Martínez Montañés (*mar-TEE-nes* mon-tan-YASE; 1568–1648) shows what can be done by simply carving the figure from wood and painting it with oil paint.

In the contemporary mode, Duane Hanson (1925–96) makes figures that also look very natural, not from wood but from fiberglass and plastic resins; the body forms are cast in parts from living models, then reassembled, carefully painted, and dressed. Hanson chooses his models from people he meets in daily life, but in the process of making a sculpture the figures are generalized to convey the artist's message that relates to the tragic struggle of American working people in a dehumanizing world.

Relaxed poses, skin tones painted in acrylic and oil, with real eyelashes and strands of hair placed one by one and clothing, usually used, selected to identify each character make the figures eerily realistic. In this picture (Fig. **7.35**) the artist sits between his own self-portrait and his sculpture of a woman; only the stillness of the sculptures sets them apart from living people. Yet Hanson rejects the "super-realist" label, considering himself an Expressionist making a strong statement about life, though he leaves it to the audience to decide exactly how he should be classified: "It is not up to the artist to say whether he is this or that," Hanson says. One member of the audience commented: "In their faces, you see a sadness and suffering, too, for the lives they've had. They weren't easy lives. They upset me in a way. People look like this, because they have to struggle to live. I don't want to see it, yet I do—every day. I know it exists."[7]

7.36 *(below left)*
RENÉE STOUT,
Fetish #2, 1988.
Mixed media,
c. 5 ft 3 in (160 cm).
Museum of Art, Dallas,
Texas.

7.37 *(below right)*
KIKI SMITH,
untitled, 1990.
Detail: Beeswax and
microcrystalline wax
figure on metal stand.
Installed height 6 ft 1½ in
(1.86 m).
Collection of Whitney
Museum of American Art.

Castings made from her own body are the basic forms for *Fetish #2* (Fig. **7.36**) by the Washington, D.C. artist Renée Stout. The castings, which were made piece by piece over several months, were painted with a heavy coat of black paint and all sorts of objects were attached: a small case with a mirrored back containing a baby's photograph, baby's breath, and a stamp from Africa were attached to the abdomen, and cowrie shells (often used in African sculpture) were inlaid as eyes. Small bags of spiritual medicines were attached to a mesh collar, and parts of her grandfather's watch were attached to a necklace. The hair was made of a monkey pelt. This mystical self-portrait was shown with a large show of *minkisi,* the spiritually active images carved by Yombe sculptors of Zaire. Critic Curtia James, writing about that show, commented: "While Stout's pieces never really claim the ceremonial roles of their African counterparts…she blends a belief in spirits with contemporary art…the artist's powers were clearly visible. Her creativity matches that of the *minkisi* makers of old."[8] If Stout is seeking the spiritual parts of the person and her ancestral roots, an entirely different approach to the human body is found in the work of Kiki Smith, who concentrates on the physical from a clinical point of view. In 1985 Smith spent three months training as a technician in the New York Emergency Medical Service. She commented on how that experience affected her

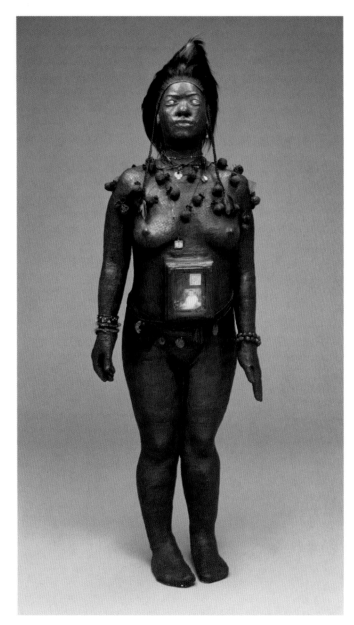

idea of the human body: "I thought it was interesting to have a different perspective on it. I was interested in people's bodies in a trauma situation. It is physically very beautiful to look at the exposure of their insides and outsides at the same time."[9]

The untitled wax figure of a woman (Fig. **7.37**), about life-size, hangs in the air from a metal support, with its head hanging. We look at the eyes of people we meet in order to make a spiritual or psychological contact, but the eyes are shut—we are left with only the body, limp and powerless, composed of the soft, vulnerable, flesh-colored wax. Milk flows from the breasts, hinting at all the bodily fluids contained, or perhaps being lost, from this body as it loses its control and individuality. Smith's expression of the human condition is unusual in history, but its focus on the victim and the basic processes of life are very much contemporary concerns.

At the end of the 20th century in most Western art the image of the human being has lost the dignity and grandeur often attributed to it in earlier sculpture. Whether the subject was living or dead, walking or sitting in eternal stillness, earlier sculptors sought to create an impressive image of a personality. The skillful use of the techniques of sculpture contributed to the idea that it was worth spending time, materials, effort, and trained abilities on the image of a human being. *The Red Man* (Fig. **7.38**) was carved of willow wood in 1984–85 by the German painter and sculptor Georg Baselitz, and then painted red with oil paint with a blue base. Although the figure is tall, nearly 10 feet (3 meters) with the base, he is hardly a hero, with his pot-belly and skinny body. The way the wood has been hacked into shape emphasizes that the human being is not a subject of great significance. Baselitz, who is in fact an expert technician both in painting and in carving, made his reputation with broadly brushed oil paintings of people upside down; the first reaction of the audience is always that the paintings are hanging upside down. In his sculpture you see the same inversion of the traditional dignity of the human figure.

Looking at the history of sculpture reveals to us that earlier times and other societies were interested in aspects of being human quite different from those being shown these days. Those other times and places seem to have ignored many things that are on our minds, or at any rate, did not make sculptures and paintings about them. Does this tell us something about our own society, or the times we live in?

7.38
Georg Baselitz,
The Red Man
(Der rote Mann),
1984–85.
Wood (willow) with red
and blue oil paint,
9 ft 9 in x 3 ft 4 in x 3 ft
4½ in (299 x 54 x 55 cm).
Kestner-Gesellschaft,
Hanover, Germany.

FOR REVIEW

Evaluate your comprehension. Can you:

● explain the difference between low relief, high relief, and sculpture in the round?
● describe examples of the three traditional techniques in sculpture (carving, modeling, casting)?
● explain how African and Oceanic sculpture, plus the work of Picasso, affected the development of twentieth-century sculpture?
● describe recent developments in sculptures of the human figure?

Suggestions for further reading:

● Hugh M. Davies and R. J. Onorato, *Sitings* (La Jolla, California: Museum of Contemporary Art, 1986)
● Whitney Museum of American Art, *200 Years of American Sculpture* (New York, 1976)
● Diane Waldman, *Transformations in Sculpture: Four Decades of American and European Art* (New York: Solomon R. Guggenheim Museum, 1985)
● Walker Art Center, Minneapolis, *Sculpture Inside Outside* (New York: Rizzoli, 1988)
● Rosalind E. Krauss, *Passages in Modern Sculpture* (New York: Viking Press, 1977)

PART

IV

ARCHITECTURE AND APPLIED DESIGN

The most important thing we need to know about architecture and applied design is that they are arts. Usefulness and beauty are always the twin considerations in the applied arts, but it is hard to reach the perfect balance. The new International Airport in Denver had problems with its baggage system and cost overruns, but its design is highly functional and its main hall is a beautiful space (Fig. **IV.1**). Skyrocketing costs and complaints from the city council that the building lacked a "strong image" led to the replacement of the original structural steel roof with white, tent-like fabric towers, which echo the Rocky Mountain peaks visible on the western horizon.

The history of architecture tells of a search for structural systems to make exciting places for spiritual and ritual events. Just as Denver tries to make air travel an exciting experience, the ancient Greeks and the French of the Middle Ages designed buildings that would increase the power of religious rituals. Both those societies knew that the structure was basic to the spiritual meaning, so we find Greek temples with simple, rational relations of weight and support, while French Gothic churches have tall arches that amaze the observer by appearing to stand only with divine assistance. In the late 20th century the Denver architects have given us a roof so light that it looks as if it could fly, or we could fly off into space right through it. In the applied arts engineering serves usefulness and meaning.

One of the important insights of our times is that buildings do not stand alone: they fit into towns and cities, and they contain spaces where life is lived. Earlier architects often ignored the design of the city, and believed that what people put in the rooms

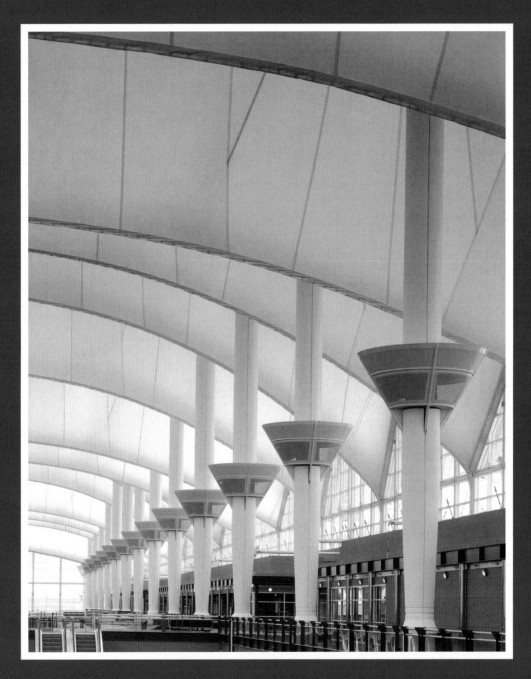

IV.1
The main passenger terminal,
Denver International Airport,
Colorado, 1994.

was not their business. Modern architects began to consider how people traveled to their buildings, whether parks were available nearby, and what furnishings and clothing might be needed in the spaces they designed. Paying attention to the "whole picture" means considering all those things, which have changed drastically during the past century. Public parks were first introduced in Western cities only 200 years ago, and they have become common in the past century, while transport through our cities has gone from horse-drawn to electric railways and private cars. Meanwhile our clothing has become drastically simplified and our rooms are decorated in styles that combine Asian and European elements. Chapters 8 and 9 deal with these "real world" activities of artists, architects, and designers.

8

Styles and Structures in Architecture and the Environment

Architects have to balance function with appearance and expression. Many of the most famous buildings serve some spiritual or symbolic purpose in which the expressive factor far outweighs practicality, but both must be present. Two main material forms are found

P R E V I E W

in the structure of buildings: **beams** of wood or steel, or **blocks** of stone or brick. Beams lend themselves to the post-and-lintel, truss, cantilever and suspension, and Classical Greek architecture is an important expression of this type. Building with blocks produces the arch, vault and dome that are found in Roman and Gothic building. That these structural forms are not separate from the styles and ideas they embody is most dramatically shown by the Renaissance dome, an invention in the 1400s that came to symbolize a community. Architecture and city planning go hand in hand, and the design changes from the orderly grid of ancient cities to the dense, irregular clustering of medieval and Renaissance cities, reflecting the rise of private interests. The range of modern architecture is epitomized by the work of Frank Lloyd Wright and Le Corbusier, and the modern city is defined by the problems of balancing community functions, especially transport, which continually expand, and recreational open space, which tends to decline. Trends in late 20th-century architecture are exemplified by the work of Graves, Stirling, and Gehry, which is based on adaptation to urban environments and respect for architectural traditions.

WHAT MAKES SOME BUILDINGS BETTER THAN OTHERS? "Durability, convenience, and beauty" were the three criteria chosen by Vitruvius, an ancient Roman writer on architecture. We usually hope to find durability and beauty in any art, but we expect convenience only in the applied arts. Convenience is surely a criterion we could agree on, meaning that the building performs its assigned functions efficiently. What is surprising, however, is that convenience, or functional efficiency, has actually played a rather small part in architecture. Serious architecture over the millennia of human building has mostly been concerned with temples and churches in which public ceremonies are almost the only functions to be served. Barns, forts, and workshops, in which function was always the main criterion, have usually been considered beneath the level of architecture. We think of a Classical temple, but not a Classical barn or fort.

Architects and sculptors, who are both working with masses and spaces, and who are both deeply concerned to make expressive forms, are divided by functional convenience, which is usually of no concern to the sculptor but is very important to the architect. The idea that usefulness is the most important factor in design, which we call **functionalism**, has been important in 20th-century building but also controversial. Louis Sullivan (1856–1924) stated one side in his famous saying: "Form follows function." The other side—"Forms always follow forms and not function"—was expressed by Philip Johnson (b. 1906), who saw art traditions as more influential on design than any intended function. The function of buildings has become a specialty in the field of ergonomics (or human engineering), which concentrates on how people interact with all the things they use, a field that provides a foundation for architectural solutions.

Although functional efficiency can never be ignored, the traditional job of architecture has been to make places where rituals can be enacted, to make buildings that express spiritual and philosophic ideals. For example, a practical person looking at a Gothic church (Fig. **8.1**) might suggest that the interior could easily accommodate ten or twelve floors, instead of only one. The church could then provide space for Sunday schools, child care, meeting rooms, church offices, and many other useful services, as well as having a large—low ceilinged, of course—sanctuary on the ground floor. But anyone standing in a Gothic church realizes that the function of the church is to inspire awe and a sense of spiritual elevation, a function that the vast empty spaces crossed by beams of light successfully accomplish. It is clear that functionalism is a useful criterion, provided that we define "function" broadly enough to include fulfilling our mental and emotional

8.1
The Gothic vaults of Beauvais Cathedral, France, begun in 1247. Stone, 157 ft (48 m) high.

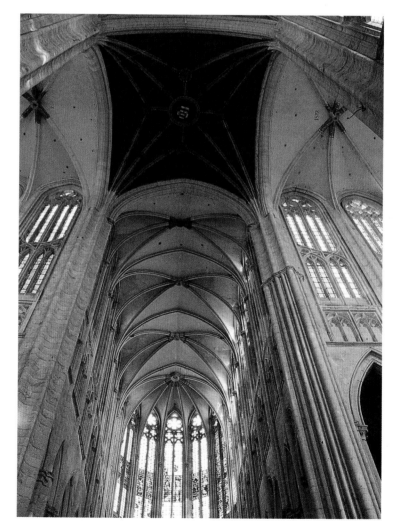

needs as well as our material ones. Those needs that people feel change from one period to another, and if we are to understand what people were feeling during any period, we must examine what they built.

Artists, like the rest of us, are stimulated by problems and puzzles. The most important puzzle facing an architect, the one that must be solved before anything else is considered, is, "How will the roof be supported?" The answer will fall into one of only a few categories, depending on the materials available for building. If the materials to be used are mainly straight beams of wood or metal, the roof will be supported by a **post-and-lintel**, a **cantilever**, or a **truss** system. If cables (of fiber or steel) are to be used, a suspension system will be chosen (see Fig. **8.5e**). If blocks (stone, bricks, or mud bricks) are to be used, the roof will be an arch, vault, or dome (see Fig. **8.17**). (All these terms are explained in the following pages.) It is clear that a building whose roof is a dome will be quite different in style, and hence different in meaning, from one whose roof is flat and rests on beams. None of these structural systems is obsolete, and one of the great challenges and pleasures of architecture today is the availability of the whole range of inventions put to practical use in many times and places.

In this chapter we will look at three styles that are basic in Western civilization and the structural systems on which they depend: the **Classical**, depending on a structure of **beams**; the **Gothic**, built of **blocks** forming **arches** and **vaults**; and the **Modern**, using steel in structures of beams. Educated people in every land are able to understand several different kinds of "language;" one of these is the design of buildings. Particularly in building there is a double "vocabulary," which is composed of the forms themselves that belong to each style and the words that refer to those forms. Western culture is rich in its architectural language, which forms the physical and mental environment that surrounds us.

BUILDING WITH BEAMS

THE POST-AND-LINTEL SYSTEM

The Classical style of the Western countries uses post-and-lintel structure, a system these countries share with the rest of the world. Traditional ways of building in the tropical regions make use of bamboo for both posts, the verticals, and lintels, the horizontals. The house (Fig. **8.2**) under construction by Mru tribal people in Bangladesh is a sample of traditional architectural technology. Bamboo is amazingly strong and light and it can be joined by lashing—there are no nails in this house. The basic structure is formed by the heaviest poles, which make up the grid of posts and lintels, but bamboo is also split and intertwined to make the walls, and bamboo leaves are used for the roof thatch.

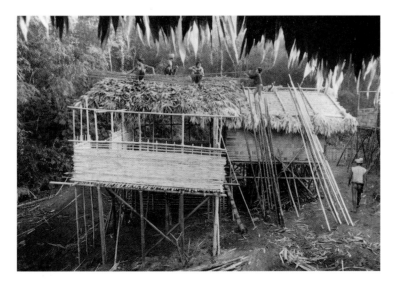

8.2
Bamboo house under construction by Mru tribal people, Bangladesh, c. 1972.

The Egyptian temple of Khonsu at Karnak (Fig. **8.3**) and the bamboo house look as different as two buildings can look, but they are both post-and-lintel structures. Bamboo is very light and strong; stone is very heavy, and it is also strong under compression (as a post). It is, however, weak under tension (as a lintel). The Egyptians built temples and tombs from stone because the buildings were meant to be eternal, but to make sure that the stone lintels would not break they had to be very short. While the fragile-looking bamboo house can have long beams, leaving a large floor space free of posts, most of the floor space of the Egyptian temple is occupied by the massive posts that support the beams (or lintels) that hold up the roof. Aside from the difference between their locations—in a jungle and a desert—the criteria of durability, convenience, and beauty are entirely different for these two buildings. The jungle house needs comfortable spaces sheltered from the rain but open to the breeze for a family's activities. Its materials need to be inexpensive; if they wear out quickly they can be replaced easily. The temple, on the other hand, needs to be emotionally impressive, even awe-inspiring, and durable for eternity, at least in appearance, but it does not matter much whether it is comfortable or not.

Although the post-and-lintel system is very ancient, it is also very up to date. The twin apartment buildings built by Herbert Greenwald at 860–880 Lake Shore Drive (Fig. **8.4**) in Chicago were designed by Ludwig Mies van der Rohe (1886–1969) in 1948 in a style given the name **International Style**. They became models for thousands of tall buildings in the United States and around the world for the next

8.3
Temple of Khonsu,
Karnak, Egypt,
c. 1150 B.C.
(20th Dynasty, reign of
Rameses III).

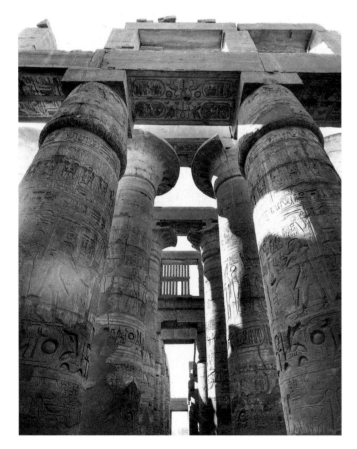

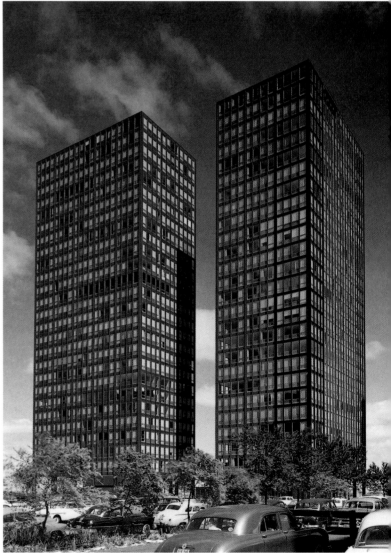

8.4 (*right*)
LUDWIG MIES VAN DER
ROHE, 860–880 Lake
Shore Drive, Chicago,
Illinois, 1948–51.
Steel and glass.

quarter century. Each building has a steel frame of 21-foot (6.4-meter) squares, repeated three times on the short side, five times on the long side, and raised to twenty-six stories with a flat roof. Each square is divided into four windows, which Mies had curtained in identical off-white draperies; tenants could add their own colored draperies inside, but they were not allowed to show through the windows. That dominant artistic intention extended to adding an extra steel I-beam welded onto the vertical posts and window frames to emphasize the verticality of the design. The Lake Shore Drive apartments use steel posts and beams in a way similar to the bamboo of the house in Bangladesh. Both of them are the purest expressions possible of the post-and-lintel system; for Mies van der Rohe that simplicity and revelation of structure had become an artistic ideal that went far beyond function.

The post-and-lintel (Fig. **8.5a**) is the basic form of building with beams, but there are other possibilities.

THE CANTILEVER

The cantilever is a horizontal beam that extends beyond its vertical supporting post (Fig. **8.5b**). Cantilevers are used where a building extends over areas where supporting posts are inconvenient. The most famous cantilevered building in the United States is a house built in 1936 by Frank Lloyd Wright for Edgar Kaufmann in the Appalachian Mountains outside Pittsburgh (Fig. **8.6**). The house is named "Fallingwater" because it hangs in space over the rocky bed of a stream that flows beside and under the house. The beams in the floor of the porch rest on posts which are nearly invisible in the shadows beneath it. Then the beams continue on under the massive stone walls of the house, whose weight easily balances the porch. Though we rarely see it used as conspicuously as in "Fallingwater," the cantilever is frequently employed in modern building.

8.5
Structural systems with beams:

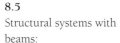
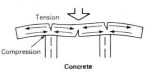

8.5(a) post-and-lintel;

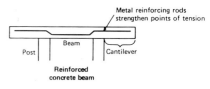

8.5(b) cantilever;

8.6
FRANK LLOYD WRIGHT, Kaufmann House, "Fallingwater," Bear Run, Pennslyvania, 1936.

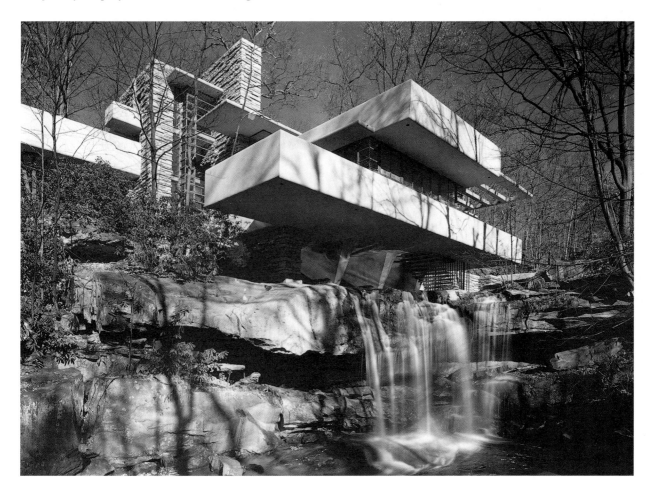

8.5(c) truss;

8.5(d) geodesic dome;

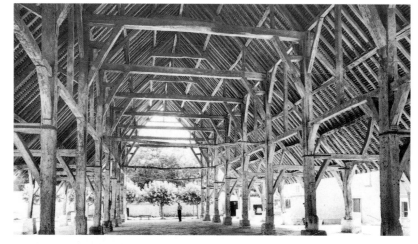

8.5(e) suspension.

8.7 (*right*)
Market hall, Mereville,
France, 1511.

THE TRUSS

There is no question that the truss is one of the most useful inventions in history, nearly rivaling the wheel for both utility and simplicity. A truss is a triangle of beams. Triangles are rigid, and they can be attached to each other in a variety of patterns to form larger rigid structural forms. The basic truss is made by a diagonal beam that converts a post-and-lintel into two triangles (Fig. **8.5c**).

The basic truss is what we see in the roof and its supports in a medieval market hall at Mereville, France (Fig. **8.7**). The tall wooden roof is divided on the inside into a series of ascending trusses by the posts and lintels of the roof supports. Then, each of the post-and-lintel systems is reinforced with a diagonal to form another truss.

The visionary engineer Buckminster Fuller (1895–1983) was especially interested in the adaptability of the truss, using it for all kinds of structural forms. The most famous of these is what he called the geodesic dome (Fig. **8.5d**). It is not a dome in the traditional sense described below, but is actually a series of curved trusses. At the World's Fair in Montreal in 1967 a huge geodesic dome was built for the United States Pavilion. Figure **8.8** shows the pavilion under construction, with the steel pipe components stacked in the foreground. The great advantage of the geodesic system, and of trusses in general, is that they can span long distances or cover large areas with very little material. They are both lighter in weight and less expensive than a solid material would be.

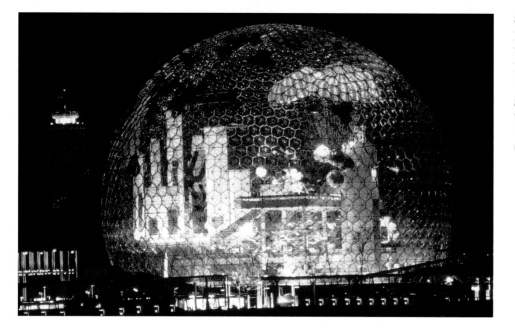

8.8 (*left*)
BUCKMINSTER FULLER,
United States Pavilion,
EXPO '67, Montreal,
1967. Steel and plexiglass
geodesic dome, shown
under construction,
137 ft (42 m) high, 250 ft
(73.3 m) in diameter.

CLASSICAL ARCHITECTURE

The style of architecture called Classical was invented in Greece about 2,500 years ago. The name "Classical" signifies its continued acceptance, which is based on its deeply considered use of beams as an architectural form. The only illogical factor is that the Greeks used blocks of stone, usually marble, to build their post-and-lintel buildings. Even when Classical style is out of fashion, as it has been until recently, no one thinks it is gone forever. As you examine its basic ideas you will begin to see what the word "classic" means: that a designer can reach a simple, logical form that expresses its structure and use in every feature. Many Modern architects have been deeply impressed by Classical Greek buildings, even when they were trying to eliminate specific Classical design features from their buildings.

Although no Classical temple built of wood exists today, the design of the existing stone buildings makes it seem certain that they are descended from wooden precursors. The system of Classical building is based on the post-and-lintel, with trusses (made of wood) forming the gable roof. Every part could have been designed originally in wood, but the design has been translated into marble in all the famous ancient buildings which have survived to our time. Two temples on the Acropolis ("upper city"), the sacred precinct of Athens, have miraculously survived to allow us to see the astonishing perfection of Greek Classical building. They are the Parthenon (Fig. **8.9**; see Fig. **10.24**), which is dedicated to Athena as guardian of the city, and the smaller Erechtheum (*air-ek-THEE-um*; Fig. **8.10**), which contains three small sacred shrines. In the first instance we will look at the plans of both buildings, then at their elevations.

The **plan** of a building is the shape it makes on the ground (Fig. **8.11**). The Parthenon, whose plan is the typical one for Greek temples, is a long rectangle,

8.9
Iktinos and
Kallikrates,
the Parthenon, Athens,
448–432 B.C.
White marble,
228 x 104 ft
(69.5 x 31.7 m);
columns 34 ft (10.4 m)
high.

8.10 *(below right)*
Mnesikles,
the Erechtheum, Athens,
c. 421–409 B.C.
White marble,
37 x 66 ft (11.3 x 20.1 m).

8.11 *(below)*
Plan of the Acropolis in Athens at the end of the 5th century B.C.

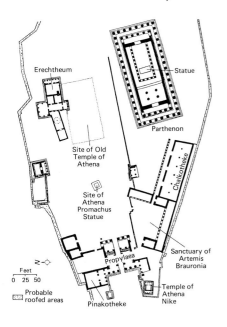

Erechtheum
Statue
Parthenon
Site of Old Temple of Athena
Chalkotheke
Site of Athena Promachus Statue
Sanctuary of Artemis Brauronia
Propylaea
Temple of Athena Nike
Pinakotheke
Feet
0 25 50
Probable roofed areas

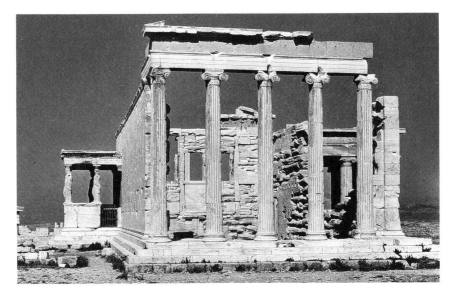

whose proportions were based on the number of columns that could be set along its edges; the long sides each held double the number of columns on each end, plus one. The line of columns around the edge of the platform is called the **peristyle** (peri = surrounding; style = column, as in our word stylus). The Parthenon was unusually fancy in having double rows of columns on each end. Within the peristyle is the chamber (called *naos* in Greek, *cella* in Latin) with the shrine containing the statue of the goddess. A small chamber at the other end of this building served as the city treasury.

The plan of the Erechtheum (see Fig. **8.11**), however, shows that this building violates the common rule that the plan is a simple rectangle. It is a unique design because it was built to shelter three shrines to a mythical contest between Poseidon, the sea god, and Athena for the rule of Athens. They were a rock scratched by Poseidon's trident, a salt-water spring, and an olive tree, none of which could be moved. The Erechtheum (named for an Athenian hero in the story) shows that Greek Classicism could accommodate variations from its preferred regularity.

While the plan is the horizontal layout, the **elevation** is the design of the vertical structure. By comparing the elevations we discover subtle differences in these two buildings which show they were obeying different sets of rules—or we could say they follow different orders. **Order** is a key idea in Classical architecture. We see two basic orders, or styles, in these two buildings, expressed mainly in the way the post-and-lintel system is proportioned and ornamented. The Parthenon follows the **Doric** Order (Fig. **8.12**), the Erechtheum the **Ionic** Order (Fig. **8.13**). The most obvious difference is the top, or capital, of the column, the Doric having two distinct parts: a pillow-like echinus (*e-KY-nus*) and a square slab, or abacus (*A-buh-kus*). The Ionic capital is adorned with scroll-like volutes. The volutes are not the same on all four sides, which caused problems at the corners where the Greeks preferred to see the spiral of the scroll on both outside walls. This design problem led the Greeks to develop a third order, the **Corinthian** (Fig. **8.14**), in which the capital is elaborately decorated like the Ionic but is the same on all four sides and thus solves the problem of the corner capital.

These were very expensive buildings—Pericles, the Athenian dictator, used the city-state's defense funds to build them—constructed with a care and precision hardly ever equaled. But the structural system is the simple post-and-lintel. All the weight and forces in the building are pressing straight down, and each part

8.12

Doric Order:
(a) the parts of a column;
(b) Doric columns of the Parthenon, with the west cella (sanctuary) wall and frieze behind, c. 440 B.C.

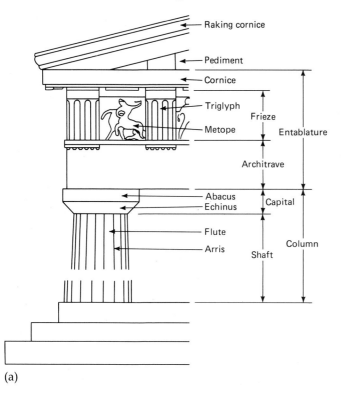

Raking cornice
Pediment
Cornice
Triglyph
Frieze
Metope
Entablature
Architrave
Abacus
Capital
Echinus
Flute
Arris
Shaft
Column

(a)

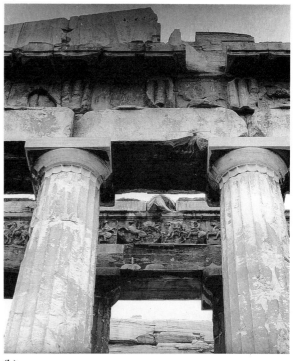

(b)

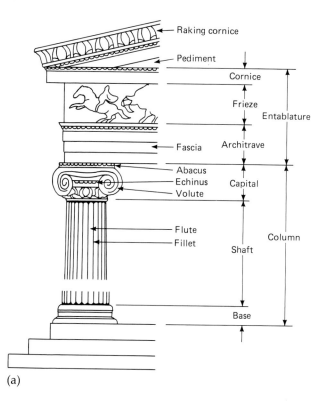

(a)

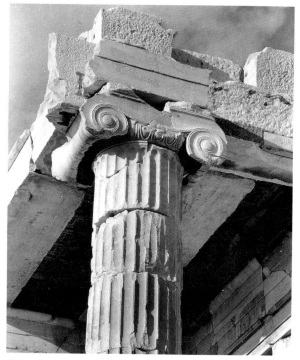

(b)

expresses clearly, like an abstract sculpture, the role it plays in the building. The lintel—called an entablature (*en-TAB-la-chur*)—is divided (in three parts in the Doric Order and four in the Ionic) to give a horizontal line, and it is perfectly clear that it acts as a horizontal beam, pressing down on the tops of the columns. The columns dramatize their vertical position and ability to carry a load by their flutes. If you look at a Doric capital (see Fig. **8.12**), you can see that its two parts clearly reflect the transition from being a load (the abacus) to carry a load (the echinus), like a tray with a hand under it. It would not be too much to say that Classical architecture is about "building with beams." That is why it has never gone out of style for good, but keeps being revived over and over. There are other styles that also express the stable, timeless forces of structure, but none in a more satisfactory manner than the Classical style invented in Greece.

8.13 (*above*) Ionic Order: (a) the parts of a column; (b) an Ionic column of the Propylaia (gateway) of the Acropolis, c. 437–432 B.C.

8.14 (*below*) Corinthian Order: (a) the parts of a column; (b) a Corinthian column of the tholos (round building) at Epidaurus, Greece, c. 360–320 B.C.

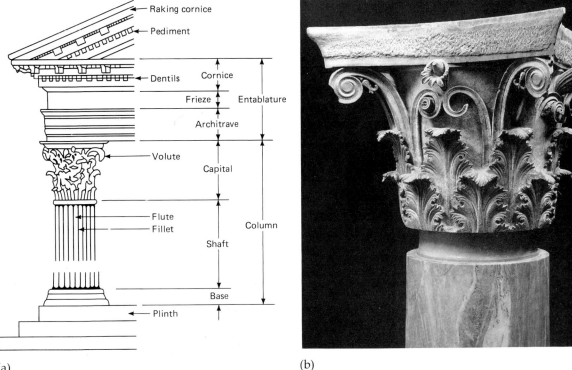

(a)

(b)

BUILDING WITH BLOCKS

THE ARCH

Building with blocks is reinvented whenever people need permanent shelter in a region lacking wood. Eskimos cut blocks of snow; desert people use precious water to make mud bricks or they shape stones into blocks to make arches and vaults. Since the greatest builders of arches and vaults were the ancient Romans, we will concentrate on several of their buildings. Then, for a different style of arches and vaults, we will examine the Gothic style.

Builders refer to an **arch** as "alive," meaning that it has forces in its structure that must be balanced. An arch by itself is not a stable unit—during construction it must have "centering" (an arch-shaped wooden form) on which the blocks of the arch are laid. As soon as the last block has been fitted into the arch, the centering can be taken down, but **buttressing** is required (Fig. **8.15a**). The basic arch form can be extended into the third dimension to form the **vault** (Fig. **8.15b**); vaults can be joined in various ways, but most commonly they are set at right angles to make a **groin vault** (Fig. **8.15c**). An arch can also be spun on its center to form a **dome** (Figs **8.15d** and **8.15e**). But we must return to the basic form, the arch itself.

The aqueduct (Fig. **8.16**) built by the Romans to bring water from a mountain stream to the town of Segovia, in Spain, has to cross a valley just before reaching the town. To keep the water flowing smoothly by gravity the channel had to be kept at a constant angle, so an **arcade** (a line of arches) was built under the channel. If you examine the stone masonry you will notice that no mortar was used; each stone was cut to the proper shape for its position, and the structure is supported by the pressure of stone against stone, without cement. Wooden centering had to be in place as each arch was built, but only enough wood was needed to build one arch since it could then be moved on to the next. At each end of the aqueduct buttresses were not necessary, since each arch is supported by its two neighbors. If one stone in any arch suddenly pulverized, that arch would collapse, and then its neighbors, which had each lost one of their buttresses, would collapse, and so on until the whole line had fallen.

8.15
Structural systems with blocks:
(a) arch; (b) barrel vaults; (c) groin vault; (d and e) dome; (f) Gothic arch; (g) section of a Gothic church with flying buttresses.

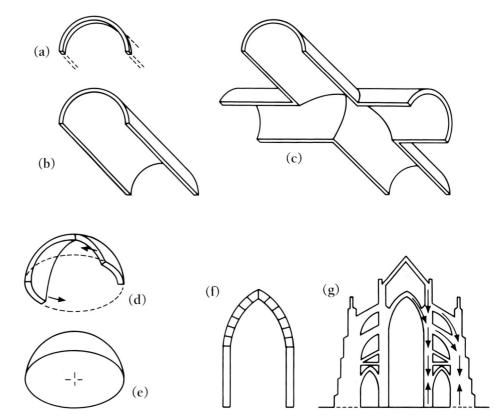

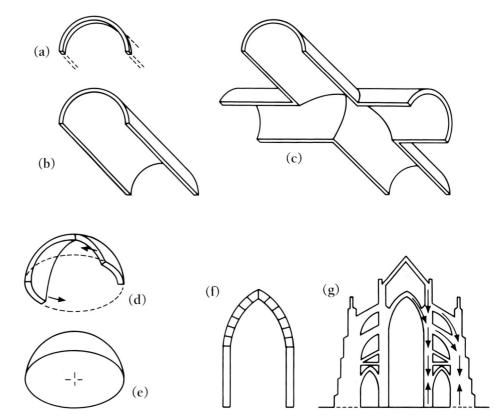

We see many arches in modern buildings, very few of them made with live arches. They are mostly built with curved beams or reinforced concrete cast in the shape of an arch. They belong to the structural system of post-and-lintel, even when they give the appearance of arches.

THE VAULT

We use the term vault for a strongroom because in medieval wooden buildings the arched stone foundations were the strongest and only fireproof part of the building. But the wealth of the Roman Empire permitted huge constructions with vaulted ceilings. Vaults were an ideal solution for the Roman need to accommodate large crowds in public buildings such as markets, administration buildings, arenas, and baths. They were built of brick (the long flat brick that we still call "Roman brick") with lots of cement, using a mass of unskilled laborers. The important public buildings were then covered with marble.

There are still many Roman buildings standing in ruins which show the structural system. The ruins of the Basilica of Maxentius in Rome (Fig. **8.17**) show the large brick and concrete vaults, with "coffers" inset into the vaults to lighten and decorate them. Typical of Roman vaults, these are perfect semicircles, each vault an elongated semicircular arch called a **barrel vault**. The upper parts of the building collapsed long ago, but it is known that they were roofed with groin vaults composed of barrel vaults meeting at right angles.

The painter Raphael gives us a good picture of Roman vaults in Figure **12.7**. Although the painting is named *The School of Athens,* no Classical Greek building had such vaults.

8.17
Basilica of Maxentius, Rome, A.D. 307–312. (The Colosseum, A.D. 72–80, is in the background.)

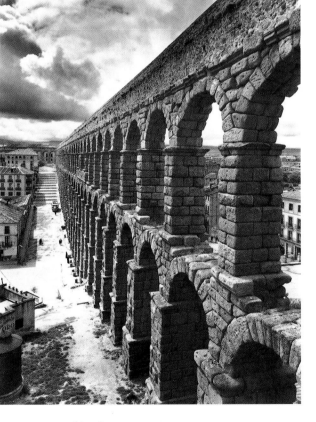

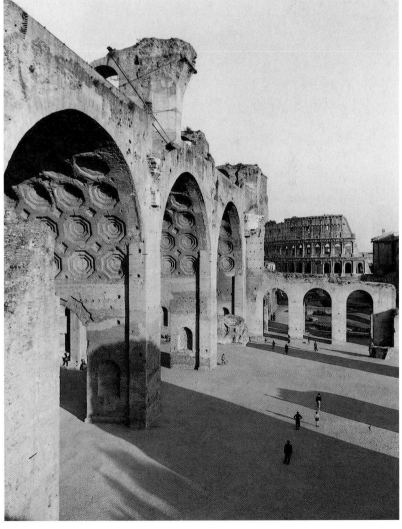

8.16 (*above*)
Aqueduct, Segovia, Spain, Roman.
Stone arches without mortar.

THE DOME

For ancient people the word dome brought to mind the shape and symbolism of the sky. Like the sky, a dome was something seen from underneath, not from outside, so the external appearance of a dome was not considered significant. A dome was appropriate in some "heavenly" context—in a temple or a tomb—and it was ordinarily decorated with pictures of the gods or astrological symbols. There is only one great ancient dome still to be seen and it is still the largest masonry (brick and cement) dome in existence: the Pantheon in Rome (Fig. **8.18**). It is 140 feet (43 meters) in diameter and also 140 feet from top to floor. The name (pan = all; theon = gods) tells us that statues of all the heavenly gods stood in the niches around the circle, all positions being equal in importance. But the building was not merely a house for the gods; it was a model of the universe in the shape of a globe (except for its flat floor), with its axis a great shaft of sunlight entering through a 29-foot (9-meter) hole, or oculus ("eye"), at the center of the dome. This was the eye of the supreme god of the heavens, with the shaft of light, like a searchlight, moving as the hours passed. The shaft of light was also the absolute limit of existence in the universe, as we still think light to be. So physically encompassing is the interior of the Pantheon that it is impossible to photograph without serious distortion. Giovanni Pannini's (1691–1765) *Interior of the Pantheon* (Fig. **8.19**), painted about 1750, shows the building as it is in modern times, converted to a Christian church.

All Romans understood the live forces of the arch and they must have been fascinated by the huge dome in which every arch was incomplete, broken by the oculus. The perfect circle in the center received equal pressure all around its periphery and so was stable, like an arch laid at right angles to the curve of the dome. The surprising simplicity of the Pantheon is very satisfying, as any good engineering is likely to be, and the oculus was copied in most later domes.

From the outside the dome is nearly invisible, hidden behind a huge collar of masonry that acts as a buttress (see Fig. **8.18**). But the weight of the dome was reduced as much as possible by being made largely of brick set in concrete, which sticks together and reduces the live forces of the arch. Still, buttressing was necessary, and the walls, over 20 feet (6 meters) thick, accomplished it by extending up in the collar.

8.18
The Pantheon, Rome,
A.D. 118–125.
Brick, concrete, stone.

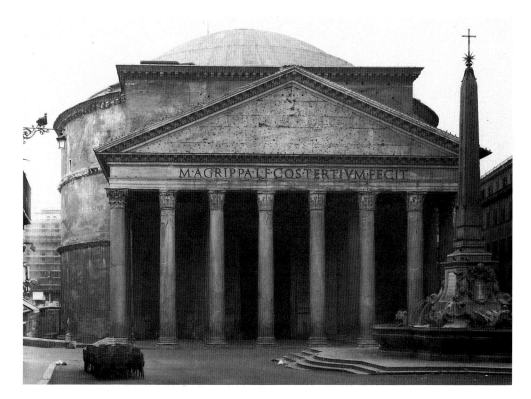

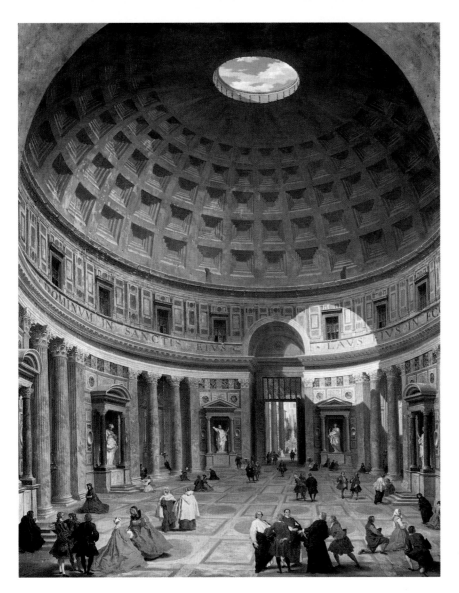

8.19
GIOVANNI PANNINI,
*Interior of the Pantheon,
Rome,* c. 1750.
Oil on canvas,
4 ft 2¼ in x 3 ft 3 in
(1.3 x 1 m).
National Gallery of Art,
Washington, D.C. (Samuel
H. Kress Collection.)

Two other well-known dome designs are the huge dome of the Church of Holy Wisdom (see Fig. **11.2**) and the small plaster domed ceiling of the Moorish Alhambra (see Fig. **11.24**).

You will notice the gabled porch in Greek Classical style attached to the front of the circular domed building. By A.D. 118, when the Pantheon was built, the Classical style was traditional throughout the Mediterranean world, used by the Romans for all the decorative detail on buildings that, structurally were entirely different from the Greek Classical temples. This was the beginning of that continuing tradition of Classical ornament which we still see today on buildings employing still newer structural systems.

GOTHIC ARCHITECTURE

Modern architects constantly look back at Classical and Gothic architecture for inspiration, but when one is popular, usually the other is not. That suggests, correctly, that they are based on opposing principles.

While the Classical style is based on the post-and-lintel structure, the Gothic style is based on the arch and vault. Classical buildings show a balance of the vertical posts with the horizontal lintels, but in the design of Classical buildings the horizontal lines often dominate. Not so in the Gothic, in which the vertical lines are far stronger than the few horizontals. The verticality of Gothic buildings can be seen by comparing Roman semicircular arches with Gothic arches, which are pointed, like an upward-pointing arrow (see Fig. **8.15f**). Gothic arches also gave the architect much greater freedom to vary the width and height of the arches, which are not controlled by a strict form like the semicircle. The Gothic style emphasized the principle of variety, in contrast to the unity of the Classical style.

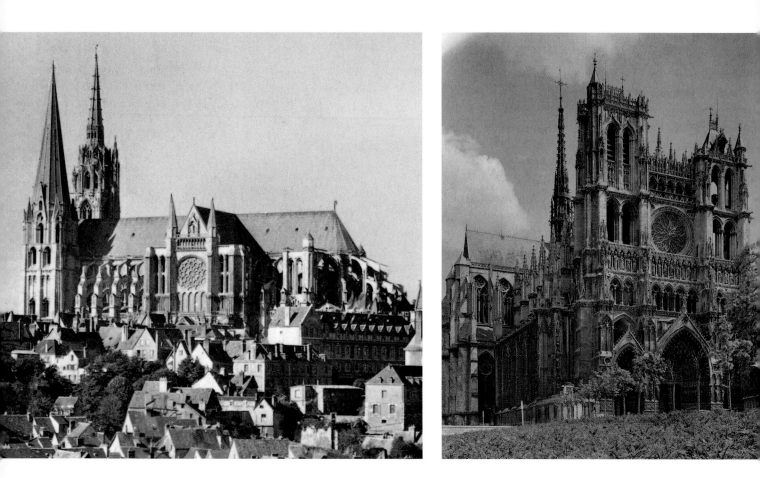

8.20 (above)
Chartres Cathedral,
France, begun 1194.
View from the south.

8.21 (above right)
The west front, Amiens
Cathedral, France,
1220–69.

The Gothic style was invented in northern France (Fig. **8.20**) around 1150, and it quickly spread to all the neighboring countries and eventually around the world. It was very popular in the United States about a century ago, under the name Neo-Gothic, and was used for churches and almost every other kind of building. Northern France has large deposits of hard, lightweight limestone—the perfect material for building high vaults, arches, and pinnacles such as those of Amiens Cathedral (Fig. **8.21**). When you examine the plan of the church (Fig. **8.22**), you see the pattern of the ceiling groin vaults indicated by lines between the great stone **piers** (a cluster of columns), showing the pattern of the reinforcing ribs of the groin vaults. The drawing (Fig. **8.23**) shows the building of the Gothic church, with small cut stones being raised to the scaffolds where the masons are building the ribs of the vault on wooden centering. Just below the suspended stone you see the finished vault over one section (called a **bay**) of one of the side aisles, with the centering still in place for one of the ribs. On each side of that aisle bay are the massive stone bases for the buttresses which rise to the height of the highest vaults and support arched arms leaning out against the upper walls to catch the weight of the main vaults. Since there is a space between those buttresses and the arches they support, they are called **flying buttresses** (see Fig. **8.15g**).

Modern architects have always found the plans of Gothic churches fascinating because they look so modern—more like the design for a steel building than one built of stone. The wider black areas are solid stone walls and columns, and you see immediately that there are no continuous solid walls, but merely supports for the ceiling, with the line of the exterior wall to be filled with glass. The interior of Amiens Cathedral (Fig. **8.24**) shows the amazing result of all that architectural engineering: the vaults leap across the ceiling at 144 feet (44 meters), about the height of a fourteen-story building. At the east end of the church, behind the altar, you see the slender stone colonnettes (small or thin columns), which frame three layers of variously shaped windows. (There are actually windows at the first level, too, although they are not visible in this picture.) From the interior one gets no hint

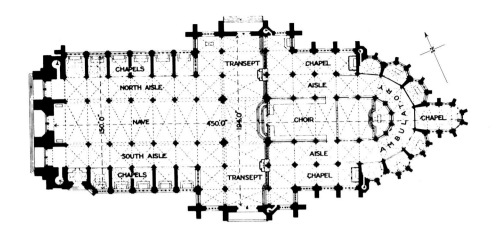

of the great cage of buttresses on the outside, which are required to hold the building up. Gothic worshippers could be forgiven if they got the impression that their churches were supported by miraculous powers.

If the Classical style is about "building with beams," the Gothic is about "building with arches and vaults," with the interior spaces and windows that vaulting permits. But the Gothic is more than engineering—it is also the style most accepting of variety. In this it contrasts with the Classical, in which all the columns are alike and in which there was an accepted best form for every element. Like the "live" arch of its structure and the varying designs of columns and decorative features, Gothic form and decoration try to contain and express everything in life. There are sculptures and stained-glass windows representing God, the saints, and angels, but

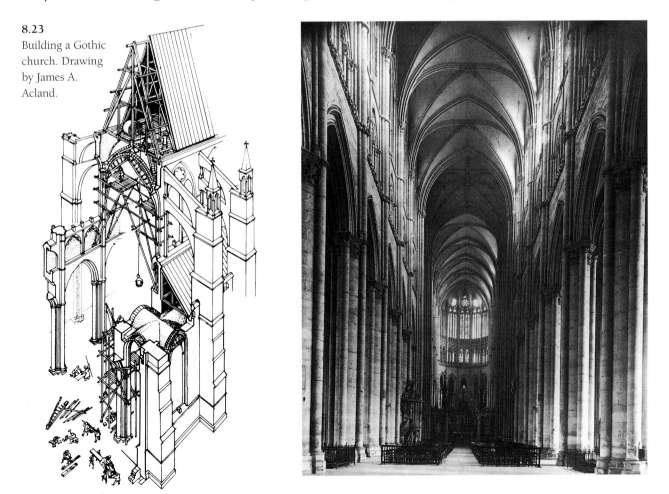

also human beings and even devils. The past and future, as told in the Bible, and even scenes from the present, are represented to include all history and all Creation in the decorative program.

The tolerance of Gothic design for variations is manifested most obviously in the different styles of towers on several of the greatest churches, as we see at Amiens (see Fig. **8.21**) and at the famous cathedral of Chartres (see Fig. **8.20**). Although monuments to faith, they are among the most humane of buildings.

THE RENAISSANCE DOME

The word "dome" brings to our modern minds a great round vault silhouetted against the sky, quite different from the dome of the Roman Pantheon, which can hardly be seen from the outside (see Fig. **8.18**). We expect a dome to be more impressive from the outside than from the inside, unlike the Pantheon. The high dome was the principal contribution of the Renaissance to architectural structure, and we find it as the point of emphasis on buildings whose decorative styles derive from the Gothic (in an Italian version) or the Classical (in a Roman version).

The first dome with this high shape, standing completely free of external buttressing and designed to be seen from the outside, was built on the Cathedral (or, in Italian, *Duomo*) of Florence in the years after 1420. The design, by Filippo Brunelleschi, became a basic part of every architect's training thereafter.

The high dome was given its standard form around a century later by Michelangelo in his design for the dome for Saint Peter's in Rome (Fig: **8.25**). When he designed it in 1546, Michelangelo was seventy-two years old, and he had outgrown the styles of his own lifetime. In this superhuman design he summed up the sculptural massiveness of the ancient Roman buildings he had been studying and anticipated the Baroque style of the next century. The powerful design of the drum, with its paired columns, is carried by ribs up to the lantern, where it is repeated in smaller scale. The shape of the dome is rounder than Brunelleschi's, but it is still taller than a semicircle. That shape and the more massive form set the pattern for later dome-builders.

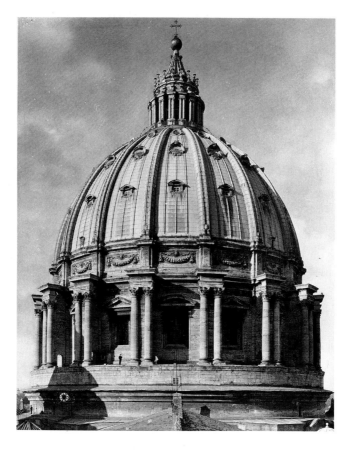

8.25
MICHELANGELO,
the dome of Saint Peter's,
Vatican, Rome, 1546.

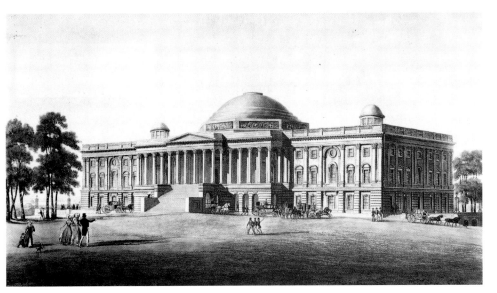

8.26 *(left)*
WILLIAM THORNTON AND
BENJAMIN LATROBE,
United States Capitol,
Washington, D.C.,
c. 1808.
Engraving by
T. Sutherland, 1825.
New York Public Library.

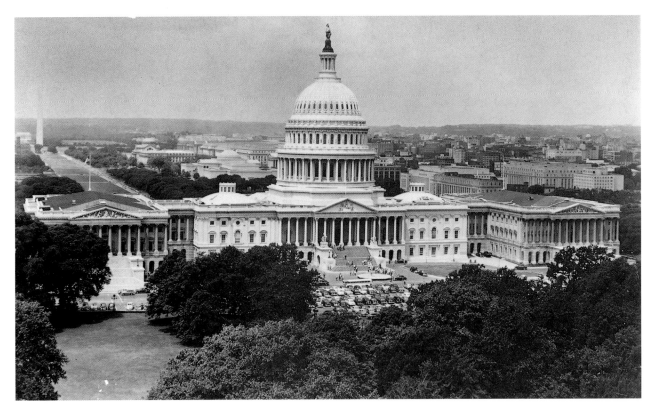

The United States Capitol in Washington has always had a dome, seen by the people of the country as a symbol of the nation. The first capitol building, designed by William Thornton (1759–1828) and Benjamin Latrobe (1764–1820), was begun in 1793, when President Washington laid the cornerstone. It was burned by British troops during the War of 1812 and rebuilt with the same Roman-style dome the architects had envisioned (Fig. **8.26**). You can see that the dome the designers had in mind was the Pantheon. By 1851 the government had outgrown the building, and Thomas Walter (1804-87) was commissioned to design a new Capitol (Fig. **8.27**). The new dome is modeled on Michelangelo's Saint Peter's dome, with the drum doubled to gain more height. But the new element is that this dome was built of cast iron, instead of stone or brick, a major engineering achievement at that time. The Capitol, with its high dome against the sky, has the same symbolism as its antecedent on the cathedral in Florence—the idea of community.

8.27
THOMAS U. WALTER,
United States Capitol,
Washington, D.C., 1865.
Cast-iron dome,
268 ft (81.7 m) high.

The First High Dome

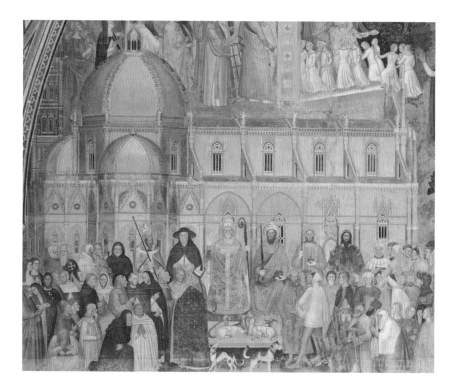

8.28
ANDREA DA FIRENZE,
detail from *Dominican Allegory*,
1366–68.
Fresco.
Spanish Chapel, Santa Maria
Novella, Florence, Italy.

The high dome was the invention of one man, Filippo Brunelleschi (*broo-nuh-LES-kee*; 1377–1446), to solve a particular problem. The cathedral of Florence was being rebuilt in the 14th century with a very large east end, where the main altar was to be set under a dome. We know this was the plan because a Florentine artist named Andrea or Andrea da Firenze (active c. 1350–70) painted an imaginary view of the building, probably based on a model, when the walls below the dome were still under construction (Fig. **8.28**). There was just one problem: given the thin, high walls and the very wide octagonal opening—131 feet (40 meters) across—no one knew how to build the dome. Centering on such a scale was impossible, and there was no way to place buttresses against the dome without completely encasing the new building in massive supports.

Enter Brunelleschi, who was described by his biographer Vasari as "puny in person and insignificant of feature," but endowed with "much greatness of soul."* When he was twenty-one he came second in an important sculpture competition in Florence, and, disgusted, set off for eight years in Rome studying architecture. He was already thinking of the problem of the dome, for the cathedral had been standing for some years with its huge opening covered with canvas and no one able to design a way to finish it. In Rome Brunelleschi made a careful study of the Pantheon and all the remains of Roman vaulted buildings. In 1407 he returned to Florence to attend an

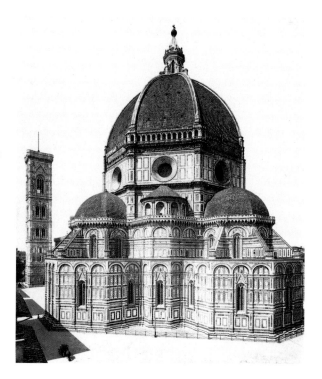

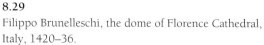
8.29
Filippo Brunelleschi, the dome of Florence Cathedral,
Italy, 1420–36.

architectural congress on the problem of the cathedral dome and offered his ideas about the design, but the commission was not finally given to him for another fifteen years. Even then he worked in a constant rain of public discussion and criticism. But the ingenuity of his plan and his machinery and scaffolding for the work eventually silenced the critics, although Brunelleschi himself did not live to see the dome completed. Even today the gallery around the base of the dome remains unfinished (Fig. **8.29**).

The problem, Brunelleschi saw, was the opposite of the Pantheon, in which the weight of the vault pressed inward on an opening at the top of the dome. In the cathedral at Florence the main problem was that there was no convenient way to buttress the outward pressure at the base of the dome. Brunelleschi proposed to solve that problem with a chain of oak beams bolted together around the base. That chain, along with the steep angle of the dome, its octagonal shape, and hollow core walls to lighten the weight, made it possible to raise a large dome high into the air without exterior buttresses.

Now, when a Florentine is homesick, he says he is "sick for the dome." It has become the symbol of the city, but even more than that, it has become a worldwide symbol for a community. As early as 1445, with the dome still unfinished, the painter Piero della Francesca (*fran-CHES-ka*; c. 1415–92) had painted a Madonna (Fig. **8.30**) sheltering the community beneath her dome-shaped cloak, her head copying the design for the "lantern" on top of Brunelleschi's dome. More than five-and-a-half centuries later, far from Florence, we still think the proper design for a building symbolizing the community is the "maternal" form of a dome against the sky.

* Giorgio Vasari, *Lives of the Most Excellent Architects, Painters, and Sculptors*, first ed. 1550. Quotation from *Vasari's Lives of the Artists*, abridged and edited by Betty Burroughs (New York: Simon & Schuster, 1949), p. 69

8.30
PIERO DELLA FRANCESCA, detail from *Madonna della Misericordia*, center panel of altarpiece, 1445.
Oil on wood panel, 10 ft 7¼ in x 8 ft 11½ in (3.2 x 2.7 m).
Town Hall, Borgo San Sepolcro, Italy.

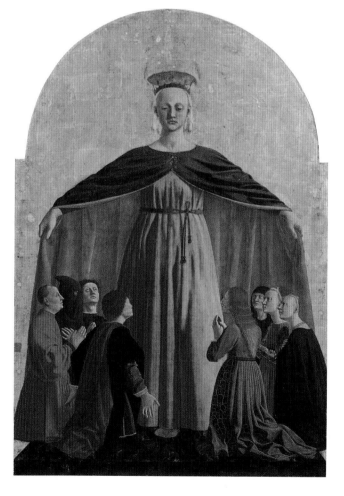

THE DESIGN OF CITIES

THE ANCIENT CITY

Human beings have always tried to design not only the structures they inhabit but also the environment in which those structures are set, and one of the oldest plans for human occupation of the world is the checkerboard. It was the concept behind the Inca Empire in Peru, which the Incas called the Empire of the Four Quarters (or Tawantinsuyu). It was used for the plans of ancient cities in the Roman Empire and in Asia. Even the chess game was originally a war game for control of the world, for the black and white squares of the checkerboard served to symbolize the flat surface of the earth.

Chang-an, the capital of China around A.D. 600, was one of the greatest cities of the world, laid out on a rectangle measuring 6 by 7 miles (9.6 by 11 kilometers) on cardinal directions (Fig. **8.31**). Like all traditional Chinese cities, it lay behind massive walls, pierced at intervals with gates. North was the dominant direction, so the imperial palace and government buildings were located on that side, but from the outside nothing could be seen but their walls. Like the private residences of their subjects, the emperors' palaces were one-story houses around courtyards (Fig. **8.32**), and only temple pagodas rose above the first story. The city was bisected by a center street into eastern and western districts, each with its own market square. The residential districts were divided into blocks, each house ordinarily occupying one quarter of a block and designed around an open central courtyard. These ancient cities worked reasonably well for most of their inhabitants because they were produced by populations small enough to have plenty of land to expand into, and large margins of safety in food, water, and air. Functional buildings were the result of tried-and-true traditions of form for each function. Like cities in all times and places, Chang-an depended for food on a surrounding hinterland of farming villages.

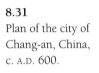

8.31
Plan of the city of Chang-an, China, c. A.D. 600.

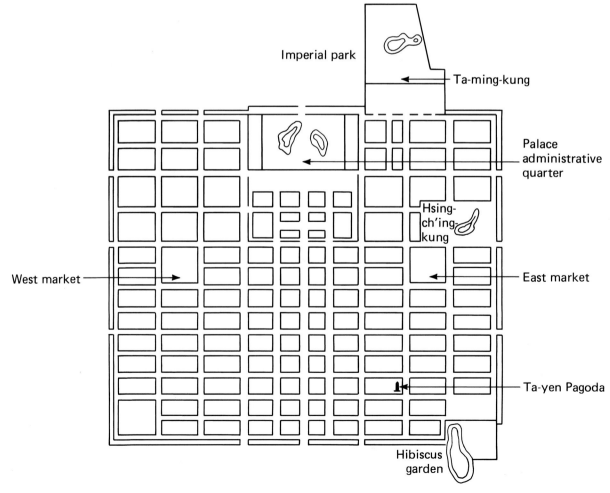

Imperial park

Ta-ming-kung

Palace administrative quarter

Hsing-ch'ing-kung

West market

East market

Ta-yen Pagoda

Hibiscus garden

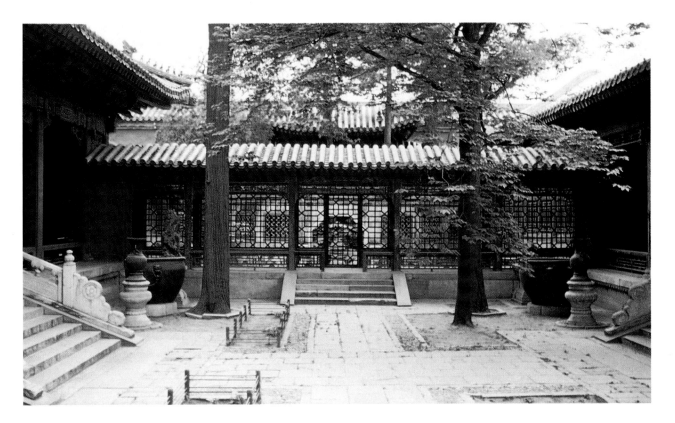

It is easy to see that most of the towns and cities we still inhabit are based on this most ancient grid pattern of environmental planning. In the same way, we still build most of our buildings using the post-and-lintel system, the truss, and the cantilever. But just as other structural systems developed, so did other designs for the environment.

8.32
The courtyard of the Hall of Repose, 18th century. Imperial Palace, Beijing, China.

THE TRADITIONAL CITY

Medieval and Renaissance Europe developed entirely different patterns of city building from those found at Chang-an. The Chinese city gave away none of its secrets at first glance. One glance at a European city showed a dominant structure, a castle or a church, with the houses of the citizens clustered around it, a clear demonstration of the relationships of power and duty within the city. Our modern idea of a city is deeply conditioned by old European cities, which have served as models for our own cities and towns.

The old European cities have become modern cities, but pictures of them as they looked in earlier times show the ways of life that gave them their character. Giorgio Vasari (1511–74), best known for his biographies of Renaissance artists, painted the view of Florence in fresco in the Palazzo Vecchio (the city hall) in 1561–62, but he showed it during a siege by the armies of the Holy Roman Empire thirty years earlier (Fig. **8.33**). That explains the camps, armies, and cannons around the walls of the city. Like Chang-an, Florence was surrounded by a fortress wall, but it followed no predefined geometric plan, simply enclosing the built-up parts of the city on an irregular design. In the ancient rectangular city, the total plan reflected the imagined shape of the world, and human settlement was obliged to fit into the geometric pattern. The Western attitude was just the opposite: the pattern of the walls had to accommodate the settlement of the people, which was dictated by the lands people owned and the ways they had used them. In ancient China land was not considered private property, and investment and speculation in land did not occur, which led to different patterns of human settlement. The power held by individuals over land can be seen in the view of Florence. The large house on the lower left, for example, is the palace of the Pitti family, an unmistakable expression of pride and power.

8.33

The focal points of Florence were, and still are, the buildings that dominate public life, the cathedral, with Brunelleschi's famous dome, clearly visible in the center of Figure **8.33**, and the medieval city hall, the Palazzo Vecchio, with its tall tower, just to the right of the dome. Each of these buildings faced on an open square, which served as a public meeting place, and the squares were surrounded by the tall stone houses of merchant families. Streets were narrow corridors, many of them passable only by pedestrians, or perhaps by horsemen, winding between the massive outer walls of palatial houses. Florentines had good evidence that life was not perfectly safe and secure; the city walls were attacked and defended on several occasions, and within the city many houses could be turned into fortresses if the need arose, as it did from time to time.

Within and between the massive houses were an infinity of small workshops for every kind of craftsman: carpenters and furniture makers, weavers and tailors, goldsmiths and painters. In the residential areas open squares were devoted to markets, mainly for food. The streets and squares were brought to life with frequent processions and festivals on religious holidays, when leaders of the city and the church were joined by costumed and masked citizens and actors to represent sacred and mythological figures and scenes. In a Florentine street scene (Fig. **8.34**), the horse, which had won in a festival race, is being led through the streets in triumph. The narrow stone-paved street is a stage for the audience observing from their windows. The streets were full of life every day, for they were practically the living rooms of the public and were only incidentally used as thoroughfares. There is no hint of green in these stony streets, but in a city the size of Florence people could escape to the country in a few minutes' walk. The city walls marked a sharp division between city and country, unlike our modern situation where city melts slowly through suburbs into country.

The features we find in Florence and the other traditional European cities provide a set of elements that we still regard as basic: a dominant center with some public structure and its square for public gatherings, residential areas with markets close by, and industrial workshops somehow connected. All these features must be joined by a system of circulation or transportation, which in Florence took up very little of the city's space. You can see that the design principles of unity, variety, emphasis, and movement are basic considerations in city planning.

8.34

THE MODERN CITY

We define individuals as well balanced when they are effective and contented in a variety of different circumstances. They have a comfortable home where they enjoy life with their family and friends, they keep up with their work and are reasonably happy with it, and they enjoy some recreation (both physical and mental). Individuals who have serious problems in any of those areas of life are usually considered unfortunate or neurotic. The role of environmental planning is to help us maintain that kind of well-balanced life, with good places to live, work, and relax. Those criteria are the principles of design applied to the environment in which we live. It is an educational, but often disturbing, experience to visit and analyze modern cities with those criteria in mind. Can we live well-balanced lives in unbalanced environments?

All our cities have residential areas, commercial and industrial districts, parks, sports, and cultural institutions. The problem in 20th-century cities, and especially American cities, has been a lack of unity. In practice that means these functional areas are too far apart, making movement from one to the other time- and energy-

8.35
Aerial view of a
freeway in Los
Angeles, California.

consuming. About three quarters of the land area of typical American cities is dedicated to the movement and parking of motor vehicles (Fig. **8.35**); that land is thus removed from productive use and becomes a cost of the city to maintain, rather than producing gain through taxation. The city in the picture happens to be Los Angeles, but it could be any American city. The main freeway is about five lanes each way, with two on the entrance-exit ramps, and the cross streets are about four lanes; the left half of the picture is mostly parking lots. We are so used to this that we hardly notice it, but if you have the opportunity to look carefully at a large American city from a tall building or a traffic helicopter, you will be amazed by the amount of land taken up by our transportation system. Emphasis in urban planning is clearly on the principle of movement.

Our cities have developed diseases of the circulatory system that interfere with the healthy, well-balanced lives the system was built to support. Transport has always been necessary in cities, and sometimes it has been one of the principal attractions of the city. What would be so special about Venice, for example, if its canals were filled and one could drive around there in a car (Fig. **8.36**)? Is there a way to solve our current problems, short of digging canals and bringing in thousands of gondoliers?

Various proposals have been made by planners to deal with this problem, some focusing on improving the transportation systems, others on reducing the need to have such extensive systems. The starting point of current planning is that highways cannot be expanded enough to solve the problem; the city of the future will require quicker movement for more people, using less space.

One solution is the electric railroad, usually mainly subterranean; these are being constructed in many cities. The high cost of such systems is justified only by very dense concentrations of people, such as those who want to travel between downtown Chicago and O'Hare International Airport. With the subway system in place, the architect Helmut Jahn (*yahn*; b. 1940) has designed the O'Hare Station to have as pleasant an environment as possible, with curved, vari-colored, lighted glass-brick walls (Fig. **8.37**), to reduce the tension these noisy, crowded stations usually produce in passengers. Recent research on human biology shows that natural daylight is more healthful for people, and the nearest approach to natural daylight in a subway is mixed colors of fluorescent light, which is what Jahn provides in the O'Hare Station.

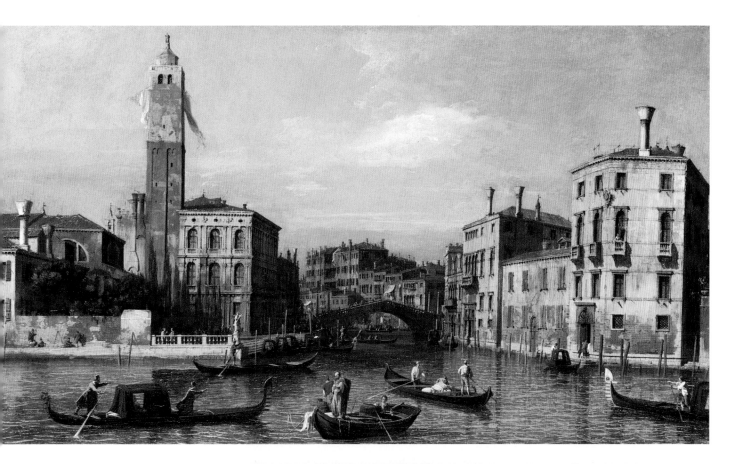

8.36 (*above*)
ANTONIO CANALETTO,
The Grand Canal, Venice,
c. 1760.
Oil on canvas,
18½ x 31 in (47 x 97 cm).
Windsor Castle, UK.

8.37
HELMUT JAHN,
O'Hare Station, Chicago,
Illinois, 1984.

The Atoyuure Family Compound, Sirigu, Ghana

8.38
The Atoyuure family compound, Sirigu, Ghana, 1986–89.
Photograph by Margaret Courtney-Clarke.

The photographer Margaret Courtney-Clarke traveled widely in West Africa, recording the architecture of women, a building technique, and a decorative style different from the Western traditions we have been examining. Round houses and granaries, linked by curving walls, form a compound in which the Atoyuure family lives in the midst of its agricultural lands (Fig. **8.38**). Building is done by the women, who mix and stack mud, model it into walls and smooth its surfaces. Each wife has a house of her own and supervises its decoration, choosing designs and colors, which she and the women who help her add to the walls. We see Adumpoka splashing on reddish clay for a crocodile relief, while Asaamaligo outlines a crocodile with black lines before the surface dries. This very organic architectural style, a long tradition in West Africa, is declining as the result of the drought and impoverishment of rural West Africa, and young women prefer to take their chances in the cities. These buildings remind us that architecture is something people can do for themselves, with little more than their hands. Perhaps it also tells us that doing that kind of building, rather than hiring professional specialists, is more likely to result in art.

From Margaret Courtney-Clarke, *African Canvas, The Art of West African Women* (New York: Rizzoli, 1990), pp. 157–8

A completely different approach to the problem of circulation in cities has been proposed by a group of California architects.[1] They recommend work places scattered throughout the community, most of them self-governing groups of from five to twenty workers, with about fifteen workshops clustered around a pair of shared courtyards, and surrounded by residential areas. Different kinds of workshops should mix. Most workers could walk to work, return home for lunch if they liked, and require little transport. At first glance this proposal could be considered utopian and impractical, but economists have emphasized the economic fertility of dense concentrations of small, independent workshops. The Apollo project, which contracted with more than 30,000 independent firms to produce components of space vehicles to the moon, is an example of the kind of work situation proposed.

Probably both these alternatives—better public transport and a denser mix of functions—will be found in the 21st-century cities. City planning is a community business requiring political activity by all the members of the community to control zoning for use, providing areas for noisy work and for quiet homes, for transport lines and interchanges, and for natural parks. It is important that the members of the community have the principles of design in mind as they study the problems of the environment.

Simultaneous Perception and the Public Park

Awareness of our environment requires a kind of behavior different from concentration on a landmark or any individual work of art. It calls for unfocused attention to all our sensory experience—the quality of light; the movement and temperature of the air; the feeling of closeness of people, plants, and buildings; odors; sounds; our freedom of movement. This kind of awareness has been called "simultaneous perception,"[2] and it is only partly a visual experience. It may be satisfied by buildings, large or small, but it is an experience often associated with parks because it is an experience that is relaxing as well as stimulating, drawing us out of our focused concentration on our thoughts into a wider awareness.

Several studies of city parks show that people will use a park often—every day, or even several times a day—if it is within three blocks of their home.[3] If it is farther away, frequency of use drops rapidly. A survey of apartment-dwellers shows that they want two kinds of outdoor space: a usable private balcony and a quiet public park within a three-block walk. The best estimate for the minimum size for such a neighborhood park is 60,000 square feet (5,574 square meters) or about 150 by 400 feet (46 by 122 meters), which is large enough for a person in the middle of it to feel entirely surrounded by nature, protected from the buildings and traffic of the surrounding city. The availability of natural parkland—and the feelings of protection from the city that it brings—has been shown to be not merely relaxing but also mentally stimulating—good for us both physically and mentally.

That, of course, is not a new idea. It was perhaps best expressed by Frederick Law Olmsted (1822–1903), America's greatest park designer, in an address he delivered in Boston in 1870:

> We want a ground to which people may easily go after their day's work is done, and where they may stroll for an hour, seeing, hearing, and feeling nothing of the bustle and jar of the streets. ... We want the greatest possible contrast with the streets and shops and the rooms of the town which will be consistent with convenience and the preservation of good order and neatness. We want, especially, the greatest possible contrast with the restraining and confining conditions of the town, those conditions which compel us to walk circumspectly, watchfully. ... Practically, what we most want is a simple, broad, open space of clean greensward. ... We want depth of wood enough not only for comfort in hot weather, but to completely shut out the city from our landscapes.[4]

The ecologist John Falk, who has surveyed people from many countries about their preferences in landscapes by showing them photographs, has found that even those

whose familiar environments had no grasslands, showed "a deep innate preference for a grass landscape." He theorizes that the preference may be genetically transmitted, since the human species evolved on the grassy savannas of East Africa.[5]

There has been a persistent trend in American town planning toward bringing parks into city centers and planning residential areas, especially, around parks. An early and influential plan was that of Radburn, New Jersey (Fig. **8.39**), developed in 1928 with about 300 houses occupying about 150 acres (60 hectares). It was built around several long parks, with tennis courts and swimming pools, with each house facing onto a cul-de-sac on one side and a sidewalk and yard on the other. This pattern is visible in the groups of houses in the original plan. A survey conducted in 1970 that compared the habits of Radburn residents with those of the residents of nearby unplanned communities found that Radburn residents were much more likely to shop for groceries on foot (47 percent to 8 percent), less likely to use their car for recreational trips (48 percent to 73 percent), and much more likely to use a bicycle for utilitarian trips. Radburn residents rated their community higher than residents of any other community in the survey.[6]

As we prepare to enter the 21st century the problem of designing the environment looms as one of our greatest challenges. Obviously, the achievements of the 20th century in industry, science, and communications have produced not only solutions but also many problems. Art has its role in attempts to solve these problems. "Art is the replacing of indifference with attention,"[7] as an art historian has written. The particular contribution of art to environmental planning is to pay attention to the "whole picture" as an expression of the principles of design.

8.39

CLARENCE S. STEIN AND HENRY WRIGHT, plan of residential districts, Radburn, New Jersey, begun in 1928.

Julia Morgan, Architect

8.40
JULIA MORGAN,
Cottage A, San Simeon,
California,
1920–22.

In June 1896 Julia Morgan (1872–1957), then aged twenty-four, 5 feet (1.5 meters) tall, and weighing 100 pounds (45.4 kilograms), arrived in Paris to study architecture. The great school of architecture at that time was the École des Beaux-Arts, the French national academy, and it did not admit women. She began studying privately with architects, but suddenly, the following fall, bowing to the demands of women, the art classes at the academy were opened to women. Julia was the first woman to apply to the Architecture Department, taking the entrance exam in October 1897. Out of 376 applicants she was ranked forty-second—very good, but only thirty were accepted. She tried again the next April, and was again turned down, but her teacher angrily remarked it was only because the jury "did not want to encourage young girls." Finally, in October 1898 she passed, ranking thirteenth in her year.

The next challenge was to finish the difficult studies before she turned thirty (in January 1902) when she would no longer be eligible for academy certification. She entered the final competition the month she was to turn thirty, was passed with honor, and received the certificate that was the basis of a career in those days. Returning to California in 1904, she opened her own office in San Francisco, her home town, and began designing buildings. In 1906 the great San Francisco earthquake destroyed her office, but this disaster provided an opportunity to an architect, because most of the city's buildings needed to be rebuilt. A young architectural engineer, Walter Steilberg, began working in Julia's office in 1910 and years later recalled: "She ran as efficient an office as I've ever been in." He was especially impressed with her courage in making inspections of her projects. She was commissioned to repair the broken tile cornice on top of the thirteen-story building where her office was located and Walter discovered her coming in the window from the scaffold. "When she reached the floor," he wrote, "(her neat gray suit all dusty and spattered with mortar and her wide-brimmed hat over one ear) she was quite a-glow with enthusiasm." She had discovered the cause of the problem and urged Walter to examine it. "I went," he wrote, "conquering my trembling, and did see for myself."

"Miss Morgan," as her staff always called her, designed over 700 buildings from Utah to Hawaii in her long career. Perhaps the most spectacular was the princely palace of San Simeon, built by William Randolph Hearst on the coast of California. Besides the main building, the plan included three "cottages." Like the others, Cottage A (Fig. **8.40**) was a small palace in itself. The Mediterranean style Morgan used, with its arches and tiled roofs, defined a whole period in California architecture.

Based on Sara Holmes Boutelle, *Julia Morgan, Architect* (New York: Abbeville Press, 1988)

MODERN ARCHITECTURE

In earlier centuries most buildings were designed and built by traditional artisans according to time-honored plans, but in our century almost everything we build is "architecture"—meaning it is a new invention built with art and science. Two architects, Frank Lloyd Wright and Le Corbusier, are among the great inventors of 20th-century architecture. Although there are many other important architects in many countries, those two names would appear on any list of the major innovators.

FRANK LLOYD WRIGHT

Frank Lloyd Wright (1867–1959) claimed that architecture was the "mother art," meaning that it generated the other arts and that they remained dependent on it. The arts are so interdependent that to choose one as basic is just a personal point of view, but Wright's buildings and interior designs suggest that those were not empty words for him. The power of his designs rests on his conviction that architecture is the basic human expression. Wright, probably the best-known American architect, made a unique, personal, and very American contribution to modern architecture.

Earlier we looked at his cantilevered house, "Fallingwater" (see Fig. **8.6**), and here we will examine two buildings that show other aspects of his work: the house built in Chicago for the Robie family in 1908–9 and the art museum built in New York for the Solomon R. Guggenheim Collection in 1956–59.

The Robie House (Fig. **8.41**) is one of the sources of our typical suburban "ranch house." Although it actually has three stories, the house appears to sprawl in long horizontal lines appropriate to the American plains and prairies, protected by a wide-eaved roof and centered around a fireplace and its chimney. The two pairs of main rooms—living and dining on the main floor, with the playroom and billiard room below on the ground floor—are separated only by the fireplace, providing the free-flowing space that the client and Wright both wanted. A view of the living room

Wright's design for a dining table and chairs of 1899 is in the next chapter (see Fig. **9.1**).

8.41

FRANK LLOYD WRIGHT, Robie House, Oak Park, Illinois, 1908–9.

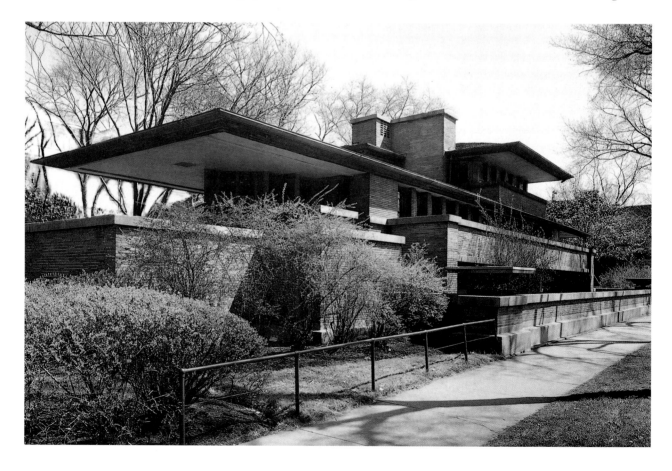

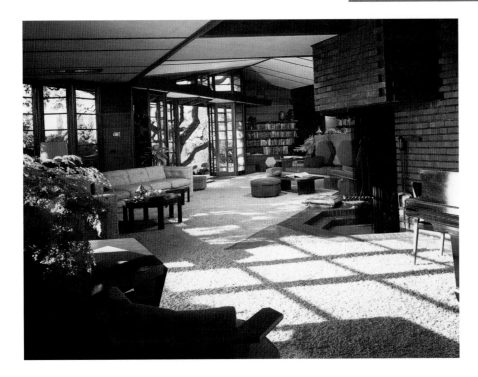

8.42
FRANK LLOYD WRIGHT,
the living room, Hanna
House, Stanford,
California,
1936–38.

A Client's View of Frank Lloyd Wright

In 1930 Paul and Jean Hanna read Wright's book *Modern Architecture* aloud to each other and wrote Wright a fan letter. That was the beginning of an association with Wright's architecture that lasted the rest of their lives.

In 1935 Paul Hanna joined the faculty at Stanford University, in California, and immediately the couple began planning with Wright to build a house there. He visited them in the spring of 1936 to see the lot, and soon a set of plans arrived showing a complex group of hexagons, with a letter: "I hope the unusual shape of the rooms won't disturb you because in reality they would be more quiet than rectangular ones and you would scarcely be aware of any irregularity." Much discussion ensued between the Hannas and Wright, focusing on such things as separate bedrooms for the three children, and in January, 1937, construction began. The projected costs were originally $15,000, but by the time construction began they had reached $50,000, far beyond the Hannas' budget. But work continued, the clients angrily at one point telegraphing for completed plans. Wright responded mildly, "BEST NOT GET TOO EXCITED LONG WAY TO GO," and sent plans as and when they were completed. The Hannas,

looking back on this period, commented: "As we reread this exchange of messages, we are amazed by both the sharp, even abrasive, language of our letters to Mr. Wright and the extraordinary tolerance with which he reacted."

Finally, in November, 1938, the Hannas moved into their new house and "began adjusting to the reality" (Fig. **8.42**). Later they wrote: "The two floor levels were just right: an illusion of two stories without all those stairs. The variation in ceiling heights from 6 feet 7 inches to 16 feet 3 inches (2 to 5 meters) delighted us. We enjoyed the openness of the plan and the free flow of space generated by the 120-degree angle." Four months after the Hannas moved into the house, Wright and twenty of his apprentices arrived for a visit. The architect had not seen the house since it had been finished; as he stood in the living room and looked around for the first time, he said "Why, it's more beautiful than I had imagined; we have created a symphony here."

From Paul R. and Jean S. Hanna, *Frank Lloyd Wright's Hanna House: The Clients' Report* (Cambridge: M.I.T. Press, 1981)

(Fig. **8.43**) shows the band of uncurtained windows ornamented with leaded glass which unify the interior and the outdoors. Roman brick with limestone trim, varnished wood interior details, built-in furniture, and the architect's custom-designed carpets were Wright's attempts to "eliminate the decorator," making the materials and structure of the house its decoration.

One of Wright's last buildings, the Solomon R. Guggenheim Museum in New York of 1956–59 (Fig. **8.44**), is the result of the triumph of form over function. Some critics, in fact, consider the building a sculpture because it serves its museum function poorly and, far from forming a quiet background for the art, it competes with the work exhibited. But the public has always accepted the building. The main exhibit area is a six-story spiral ramp around an open glass-domed circular court (Fig. **8.45**), Wright's idea being that the visitor could take the elevator to the sixth floor and effortlessly stroll down the ramp, glancing at the paintings as they flowed by. While that is certainly not the way to see art, the building itself is unquestionably a work of art. Wright saw its perfect circular form as "the quiet unbroken wave," a satisfying sculptural form.

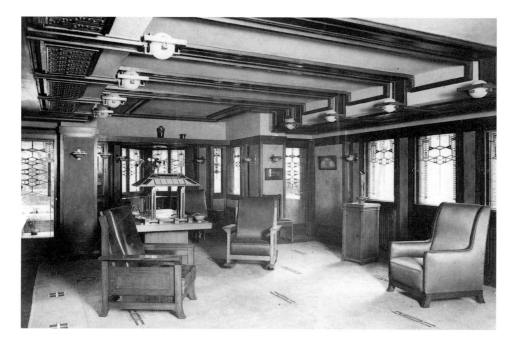

8.43
FRANK LLOYD WRIGHT, the living room in 1910, Robie House, Oak Park, Illinois, 1908–9.

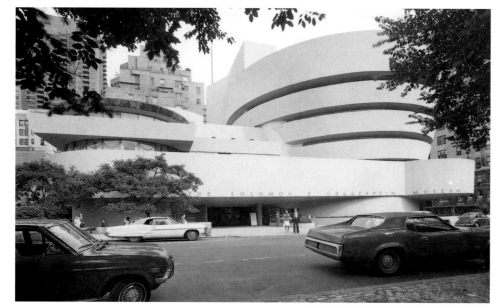

8.44
FRANK LLOYD WRIGHT, Solomon R. Guggenheim Museum, New York, 1956–59.

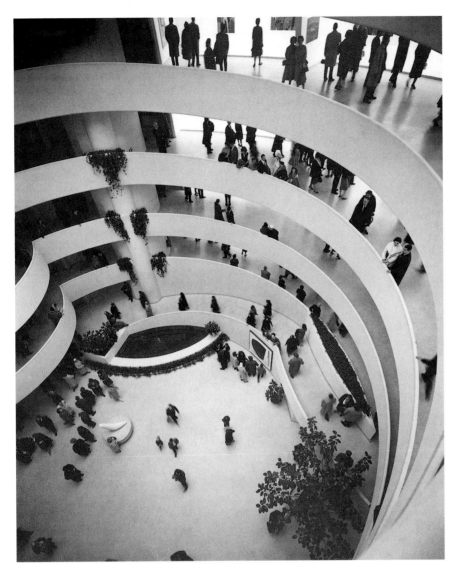

LE CORBUSIER

In 1920 the Swiss-French architect Le Corbusier (*luh* kor-bü-ZEEAY, the pseudonym adopted by Charles Edouard Jeanneret; 1887–1965) published a manifesto in which he made the famous remark, "a house is a machine for living in." In other writings he compared houses to ocean liners, airplanes, cars, and motorcycles, all machines in which we live during travel and that have no room for frills. It is hard for us now to understand his remark because we take functional housing for granted. We hardly realize that most houses at the turn of the century did not have a bathroom; there was either a chamber pot under the bed or a "privy" in the back yard, and bathing was done in a movable tub in the bedroom or kitchen. At that time, a house ordinarily had a certain number of rooms, each of which could be adapted to any purpose. Le Corbusier proposed to make each room serve one function, as a machine does, so that a dining room was perfect for eating but almost useless for anything else. Actually, it is the rooms that have the most machinery in them—kitchens and bathrooms—that are the most clearly functional. A machine is designed to do one job perfectly, and nothing else.

Le Corbusier was working in a period when the housing of most people was far out of date and did not begin to meet their material needs, much less their emotional needs. Reformers of his period proclaimed that housing was a social need to be solved by purely machine functionalism, but Le Corbusier always insisted that it was a problem of architectural design. Although his large apartment blocks are

important contributions to the development of public housing, it is in the single-family houses that one gets the best understanding of his work. Le Corbusier's most famous house is the Villa Savoye, a Spartan but elegant country house built near Paris in the years 1929–30 (Fig. **8.46**). The house exemplifies "the five points of a New Architecture" as Le Corbusier had defined them: (1) Leave the ground free by setting the building on stilts; (2) place a garden on the flat roof to make use of the space; (3) keep the supporting structure—which in the Villa Savoye consists of twenty-five steel posts—independent of the walls; (4) make the exterior and interior design completely flexible and controlled only by function and appearance; (5) use continuous strips of windows to allow natural light to penetrate the building. The ground floor is reserved for servants' quarters; the family quarters are reached by a ramp to an open terrace modeled on the deck of a ship, with an upper-deck roof garden on the highest level. The living areas have glass on all sides, an open plan, and a monastic simplicity of form (Fig. **8.47**). The bathroom (Fig. **8.48**), with its sunken bath and tiled reclining sofa, may be compared to Le Corbusier's description

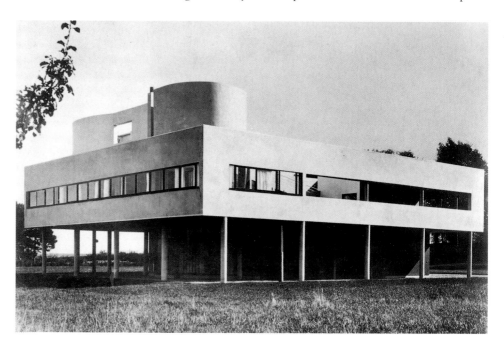

8.46 (right)
LE CORBUSIER,
Villa Savoye,
Poissy-sur-Seine, France,
1929–30.

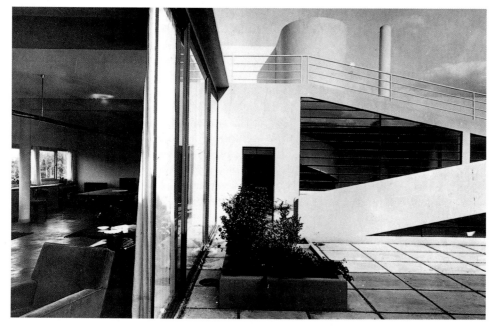

8.47 (left)
LE CORBUSIER,
the interior, Villa Savoye,
Poissy-sur-Seine, France,
1929–30.

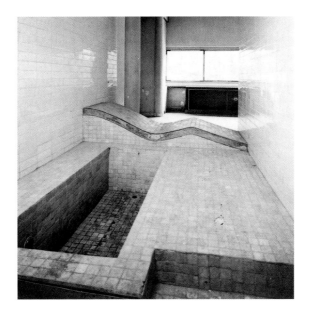

8.48
LE CORBUSIER,
the bathroom, Villa Savoye, Poissy-
sur-Seine, France, 1929–30.

of the ideal bathroom: "Demand a bathroom looking south, one of the largest rooms in the house. … One wall to be entirely glazed, opening if possible onto a balcony for sun baths; the most up-to-date fittings with a shower-bath and gymnastic appliances."[8] In 1929 that was revolutionary, but his idea of the bathroom is one of his many ideas that have been widely accepted.

As a young man Le Corbusier traveled in Greece and saw the Parthenon, which he described, rather melodramatically, as a "terrifying machine," whose design had been perfected to the point "when nothing more might be taken away, when nothing would be left but these closely-knit and violent elements sounding clear and tragic like brazen trumpets."[9] In his own buildings he hoped to achieve a stripped-down clean-lined intellectual design, a modern version of the Parthenon. The Villa Savoye fulfills Le Corbusier's idea of "a machine for living in" in various ways; it is a thoroughly rational design from which nothing might be taken away.

Later in life Le Corbusier designed another very influential building, this one a chapel to be a memorial to members of the French Resistance who had died in World War II. The chapel (Fig. **8.49**), on a wooded hill near the village of

8.49
LE CORBUSIER,
Notre Dame du Haut,
Ronchamp, France,
1950–55.

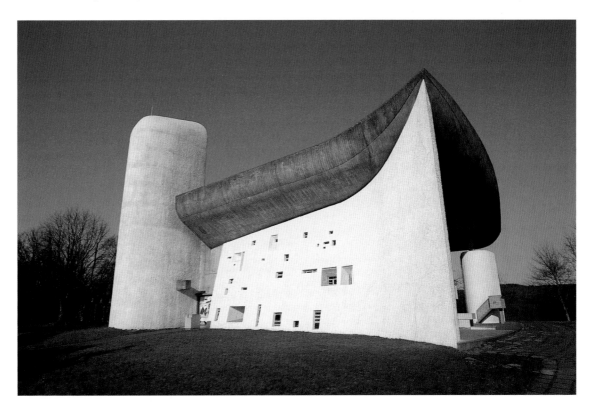

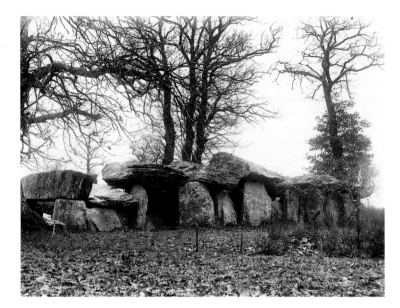

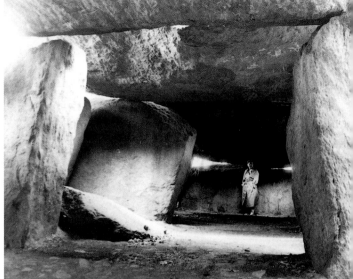

8.50 *(above and right)*
Neolithic tomb, La Roche
aux Fées, Essé, France,
3000–2500 B.C.:
(a) exterior; (b) interior.

Ronchamp, has been described as "the most religiously convincing building of the twentieth century," despite the fact that its designer was an atheist who commented, "The requirements of religion have had little effect on the design, the form was an answer to a psychophysiology of the feelings."[10] Le Corbusier's sources for the design go back to prehistoric French tombs (Fig. **8.50**), whose massive rock structures he sketched as he thought about a timeless memorial to heroism. The great rolled concrete roof, thick slanting wall pierced by small stained-glass windows (Fig. **8.51**), irregular plan, and silo-like bell towers form a rich ensemble of architectural forms. Many years earlier Le Corbusier had written the following words, which he would have considered an explanation for the success of the Ronchamp chapel:

> suppose that walls rise toward heaven in such a way that I am moved. I perceive your intentions. Your mood has been gentle, brutal, charming or noble. The stones you have erected tell me so. You fix me to the place and my eyes regard it. They behold something which expresses a thought. A thought which reveals itself without a word or sound, but solely by means of the shapes which stand in a certain relationship to one another.[11]

8.51
LE CORBUSIER,
the interior, Notre Dame
du Haut, Ronchamp,
France,
1950–55.

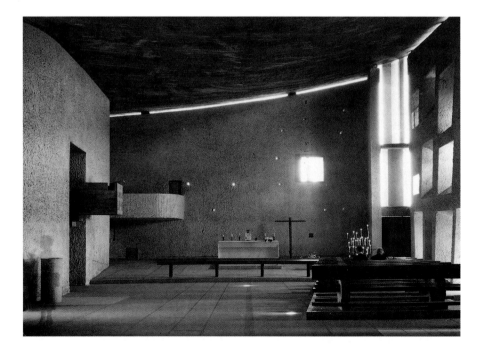

RECENT TRENDS IN ARCHITECTURE

About 1970 many people in the art world began to be alert to signs of change. Architecture was the first of the arts to search openly for a style that broke with the principles of Modernism. The architect and critic Charles Jencks dated "the death of modern architecture" to 3:32 p.m. on July 15, 1972, when a large housing project in St. Louis was blown up and demolished; the American Institute of Architects had given it an award when it was built in 1951.[12] When we look at architecture since 1970 it is clear that the break with Modernism as expressed by Wright and Le Corbusier is far from complete, but we do not yet see a unified style that can be distinguished from earlier Modern architecture. Several important new ideas have emerged, however, and the best way to understand them is to see them embodied in some recent buildings.

The design for the Humana Building (Fig. **8.52**) in Louisville, Kentucky, was opened for competition, and the winner was Michael Graves (b. 1934), a Princeton professor, architect, designer, and artist, whose architectural drawings are unusual for their beautiful finish. The needs of the client dictated a tall, rectangular tower in the middle of an old city between well-kept, low 19th-century buildings and a tall glass and steel tower. Graves's solution was to build a tall building that rejects all the qualities of the traditional American skyscraper. That means he did not try to dramatize its height, but, on the contrary, tried to make it look short. The main entrance to the building is into a seven-story section that harmonizes with the older low buildings along the neighboring streets. The vertical rise of the tall section of the building is broken into several distinct parts with different shapes; the rectangular windows were placed to make horizontal lines; and a visible arched roof was designed to send our eyes back toward the ground. Varied warm "earthy" colors also help make the building seem closer to the earthbound observer. The result is that the building compromises between the surrounding buildings, forming a focal point that unites all the opposing types around it.

Two features of Michael Graves's designs are original and distinctive: the color schemes and the revival of early 20th-century design style. For example, the balcony on the twenty-fifth floor (Fig. **8.53**) has "Cubistic" shapes and proportions and

8.52 (below left)
MICHAEL GRAVES,
Humana Building,
Louisville, Kentucky,
1982–85.

8.53 (below right)
MICHAEL GRAVES,
the cantilevered balcony at
the twenty-fifth floor,
Humana Building,
Louisville, Kentucky,
1982–85.

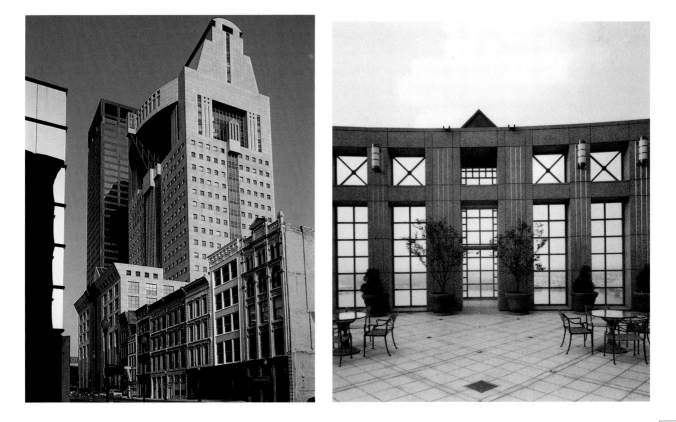

simple cylindrical lamps on the wall copied from "Modernistic" designs of the 1930s. Color for Graves is not just decoration, it is an essential feature of his designs. If you commission a house from Graves, then paint it a different color, you have seriously altered the building. As there are historical overtones in his architectural forms, the color schemes also have a historical flavor, suggesting the styles of the 1920s and 1930s, but even more of Roman Classical decoration, which used the same warm tans, earth reds, and violets.

We have looked at an important Modern design for an art museum—the Guggenheim Museum in New York—and one of the principal examples of recent architecture is also an art museum. The British architect James Stirling (b. 1926) won an international competition in 1977 for the design of the New State Gallery in Stuttgart, Germany. The new building was required to harmonize with an older gallery building and adapt to a shallow lot along a busy multi-lane street. Stirling clothed the museum in a banded pattern of tan stone which matched the color of its older neighbor, but he accented the suede-colored stone with brilliant red and green metal handrails and window framing (Fig. **8.54**). The regularity of the plan, which is

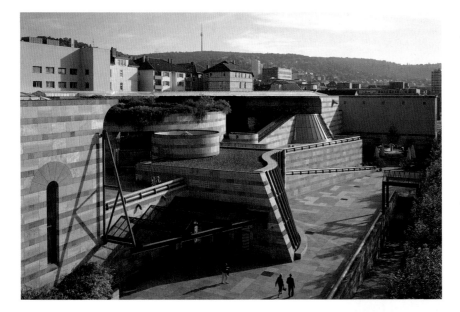

8.54 (*left*)
JAMES STIRLING,
New State Gallery, Stuttgart,
Germany,
1977.

8.55 (*right*)
JAMES STIRLING,
the interior courtyard, New
State Gallery, Stuttgart,
Germany,
1977.

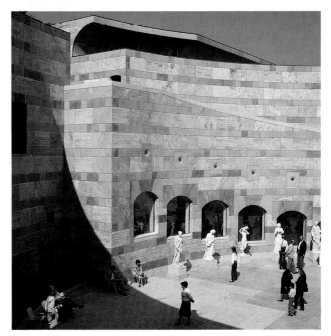

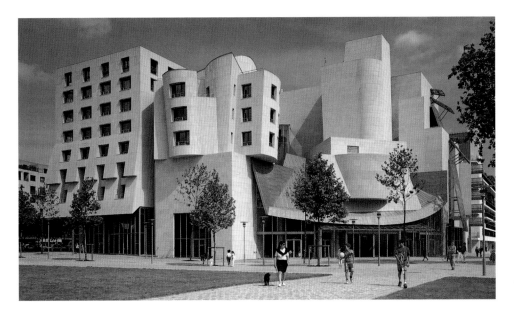

8.56
FRANK GEHRY,
American Center, Paris,
1994.

a rectangle with an open circular courtyard in the center (Fig. **8.55**), contrasts with the irregular path the visitor must take into and through the museum. The entrance is off-center and the shapes and angles of walls, ramps, and roof lines are all irregular, providing an intriguing variety. Brilliant color spreads into the lobby areas of the museum, but not into the galleries, where it would compete with the works of art. All the gallery areas are pure white and lit from above by natural light to permit the true colors of the paintings to be seen.

The most recent of these examples is the American Center in Paris (Fig. **8.56**), the new headquarters of a private American organization dedicated to sponsoring American art events in Paris. The organization chose Los Angeles architect Frank Gehry (b. 1929) to design the new building, which was to be located along a park on the banks of the River Seine. Set on a fairly small lot, the eight-story building is inviting, practical, and surprising—which sound like modern translations of Vitruvius's "durability, convenience, and beauty" (see page 247). The relatively small scale, the design that breaks up into sections as if it were composed of several separate structures, and the use of customary local materials are all adaptations to a neighborhood of houses and small buildings.

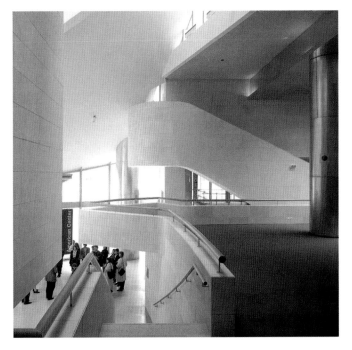

8.57
FRANK GEHRY,
the interior of the lobby,
American Center, Paris,
1994.

The exterior is clad in a light tan limestone and roofed with silvery zinc, which are common traditional materials for buildings in Paris. The upper stories have the varied vertical shapes and irregular roof lines that remind us of the tightly clustered houses of old Paris. The lower stories expand outward in tilted shapes, hinting at the multitude of activities with which the building seems ready to burst.

Wide glass doors roll open to draw us into the complex tall spaces of the lobby (Fig. **8.57**): this is where we begin to understand the multiple functions the building was designed to serve. From the lobby we can reach a 400-seat theater, a 100-seat movie theater, an art gallery, an audiovisual center and two studios for sound-and-film recording, not to speak of offices, apartments for visiting artists, a restaurant,

and parking. At the dedication ceremonies for the building in 1994 Gehry described his vision of the building as a place "with different activities colliding and causing a joyful effect."[13] With those words in mind, we can take a second look at the exterior of the building, whose bulging and slanting forms have caused much comment.

These three buildings set themselves apart from Modernism in three ways: they are more concerned to adapt to their environment, particularly to the size, materials and style of the surrounding buildings; the function of the structure has higher priority than before, when the purity or coherence of the design was given priority; and architectural traditions are respected. Modernism was revolutionary and felt it had nothing to learn from the past and by 1970 architects had begun to feel that the revolution had been won and it was time to look back at older achievements. Frank Lloyd Wright placed his Guggenheim Museum in urban surroundings, which he imagined would sooner or later be replaced by the park-like environment he really wanted for his building.[14] These recent buildings call into question the Modern idea that a good building will fit in anywhere. All of them refined the design to emphasize function, adapted the design to the materials and styles of neighboring buildings, and paid respectful attention to the building traditions of the place. Although none of this sounds at all revolutionary, in the context of Modernism these ideas and the buildings that embody them have made a new revolution of their own.

FOR REVIEW

Evaluate your comprehension. Can you:
- explain how straight beams were built to become the Classical Greek temple style?
- discuss the use of arches, vaults, and domes in Roman and Gothic buildings, mentioning a few important examples?
- describe the differences in personal outlook and architectural style we see in the work of Frank Lloyd Wright and Le Corbusier?
- give a brief history of city planning, including contemporary attempts to balance the functions of the city in its design?
- describe the new ideas that were emerging in architecture since 1970?

Suggestions for further reading:
- Peter Blake, *The Master Builders* (New York: Knopf, 1976)
- Charles A. Jencks, *The Language of Post-Modern Architecture* (New York: Rizzoli, 6th ed. 1991)
- ———, *Le Corbusier and the Tragic View of Architecture* (Cambridge, Mass.: Harvard University Press, 1973)
- Tony Hiss, *The Experience of Place* (New York: Knopf, 1990)
- H. Allen Brooks, *Frank Lloyd Wright and the Prairie School* (New York: Braziller, 1984)

9

Design Applications

Many of the world's great artists have designed interiors, furniture, clothing, and cars, but these days design is usually a team project and the drawing is done on computers. Although the design workshop has changed, the aim remains to produce a functional

product that users consider beautiful. We will look at furniture, clothing, ceramics, glass, metal, and automobiles as examples of applied design. The history of design is inspiration for contemporary designers, who may look at Persian and Turkish examples as well as French (the Palace of Versailles) and German (the Bauhaus) design traditions. Recent furniture and interiors have rejected all past forms and sought ideas in new materials, shapes, and colors. Recent clothing also departs from tradition, reflecting the similar roles men and women play these days. Coco Chanel and Donna Karan have been innovators in simplified, layered clothing for women, different from the more ample and elaborately cut clothing favored in earlier centuries and different from the simple squares of draped cloth of Greek and Pre-Columbian times. In the crafts based on fire—ceramics, glass, and metal—the materials remain strongly appealing, but ideas of art and design change to reflect their periods, as in all the arts. Automobiles also reject old styles based on the wagon and use designs based on an aerodynamic body produced by engineering and design. Computer-aided design (CAD) is beginning to make rapid production of designers' ideas a reality, especially in car design. Design is at the cutting edge where lifestyle, social relationships, and economic realities conflict; we might say, where dreams and needs meet.

DESIGN IS THE APPLICATION OF THE MIND to the shaping of the world around us. One of the basic ideas of the 20th century has been that good design is at the root of a good society; to improve our people we must first improve the design of everything we use. Although the definition of good design depends entirely on cultural ideas, carrying out those ideas depends on craft skills. That is why the first brochure advertising the Bauhaus art and design school, in 1919, said: "Architects, sculptors and painters, we must all return to the crafts. ... There is no essential difference between the artist and the craftsman. ... Let us conceive and create the new building of the future."[1]

These days most of the people we call designers work on computers, and there are important differences between their work and that of craftsmen who produce prototypes, or models, of products to be produced commercially. Designing products for the commercial market is done almost entirely by teams of specialists, who cooperate to produce a successful design. We think of this as quite different from earlier times, but most inventive design was always done cooperatively in workshops led by a chief designer. Electronic tools, new materials, and the expansion and dispersion of the design team have not really changed the mental

9.1
FRANK LLOYD WRIGHT, dining table and eight side chairs, designed for the Joseph M. Husser House, Chicago, Illinois, c. 1899. Oak with leather-covered slip seats; table 2 ft 4 in x 4 ft 6 in x 5 ft (0.7 x 1.4 x 1.5 m); each chair 4 ft 3⅞ in x 1 ft 5¼ in x 1 ft 5¼ in (1.3 x 0.4 x 0.4 m). Private collection.

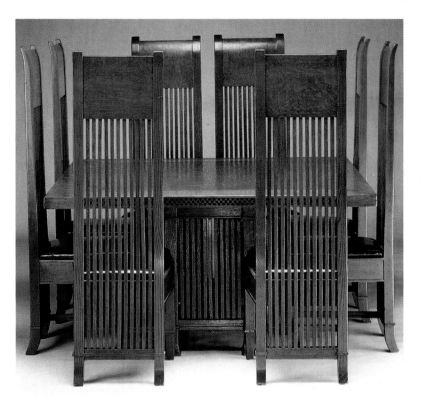

9.2
LE CORBUSIER AND PIERRE JEANNERET, design for a small car, "voiture maximum," 1928. Pen and ink. Fondation Le Corbusier, Paris.

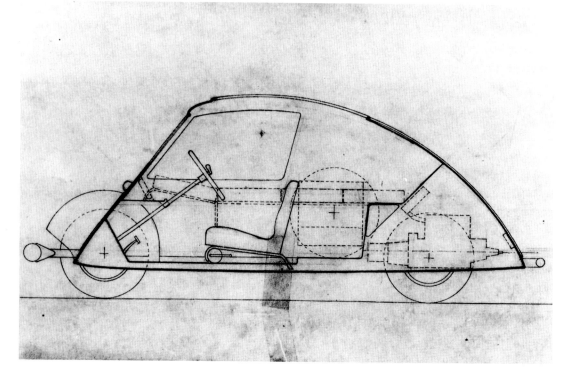

processes of design. While the techniques of designers and the organization of the "workshop" have undergone major changes, the search for functional efficiency and an appearance that will be defined as beautiful by the audience of users remain the same as ever.

Although the world faces many problems that cannot be solved by design, the conviction remains that good design plays an important part in the good life. Just as there is no single definition of the good life, there is no single definition of good design. Each way of life creates its own style, and that style transmits the way of life.

Many of the great figures of art and architecture have designed furniture, lamps, tableware, and cars. If you know the history of modern design, almost everything in your house or office whispers a famous name to you: Frank Lloyd Wright's chairs and table of 1899 (Fig. **9.1**), Le Corbusier's idea of 1928 for an economical car that inspired the Volkswagen "Beetle" (Fig. **9.2**), or Mies van der Rohe's original 1926 cantilevered chair of steel tubing (Fig. **9.3**). The early 20th century invented many of the forms we still consider new ideas. Despite intense competition to design commercially successful forms, developments in applied design come slowly, and they usually depend on knowledge of what has been done before. As contemporary designers search for styles suitable for our time, they consider the whole range of global design. "Globalism," which we think of as characteristic of our time, has been found in earlier times, especially in the applied arts. We have only to look at Figure

9.3
LUDWIG MIES VAN DER ROHE,
armchair, 1926.
Chrome-plated steel tubing, leather,
32 in (81 cm) high.
Museum of Modern Art, New York. (Gift of Edgar Kaufmann, Jr.)

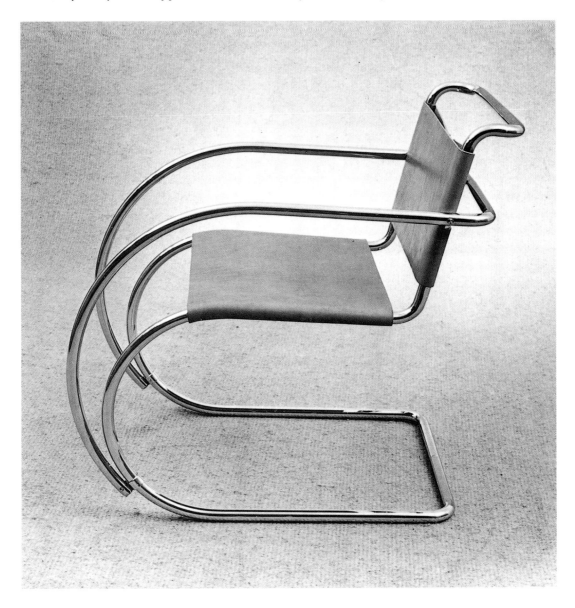

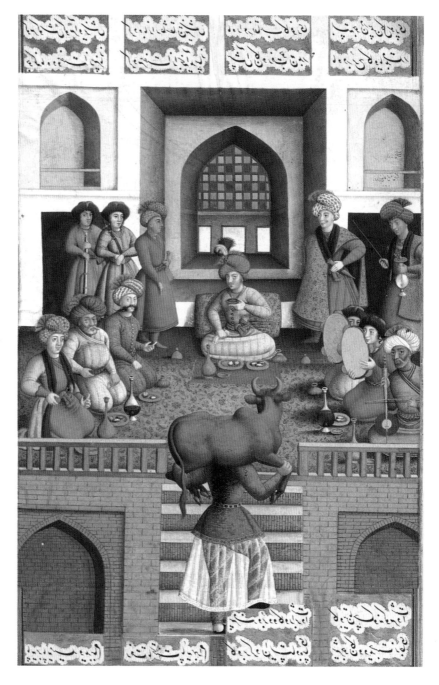

9.4

9.4 to see carpets and pillows that became popular in the West, or at the Turkish interior (Fig. **9.5**) to see the source of furniture types common in American houses. Two historic Western design studios, the Palace of Versailles and the Bauhaus, are well-known models for the role of the designer in modern life.

THE ARCHITECTURAL INTERIOR

As you sit in a contemporary room it may be hard to imagine that anyone ever really lived in a different kind of space, differently furnished. We take tables and chairs for granted and assume that they always existed, but in fact our furnished rooms are an invention of the early Renaissance (see Jan van Eyck's *Arnolfini Wedding Portrait*, Fig. **12.12**, for an early example). Such comfortable furnishing spread only slowly from the wealthiest houses to those of most people in Western countries. In most of the world entirely different traditions prevailed, many of them based on a soft floor covered with mats or carpets (which usually required visitors to remove their shoes

at the entrance), with seating on the floor. This ancient and widespread tradition was raised to a high artistic level in several Asian countries, among them Persia (modern Iran) and Turkey.

Muhammad Zaman (d. *c.* 1689) shows us a Persian palace (see Fig. **9.4**), with a king, the legendary Bahram Gur, seated in the center with a cushion at his back, surrounded by courtiers and musicians, with food and drink set before them. The painting, in an unusual Westernized style with perspective space and shading and shadows, gives an easily understandable view of the interior of a royal house about 1675. In Bahram Gur's story, the young woman carrying an ox up the stairs is a character who said to the king "practice makes perfect."

A later chamber in the Topkapi Palace of the Ottoman Empire in Istanbul, Turkey, shows a style both in building and in furnishing different from the West European styles (see Fig. **9.5**). The glass walls and delicate supports reflect Persian and Turkish traditions of the summerhouse, which opens on a garden, and the furniture is what we might call sofas or divans (both Turkish words), on which one usually sat crosslegged. The influence of this Turkish tradition on modern interiors is obvious.

A carpet (see Fig. **11.26**) and entertainment in a garden (see Fig. **11.28**) help us visualize these Eastern furnishings.

9.5
Topkapi Palace, The Kara Mustafa, Pasha Köschkü, Istanbul.
Interior view.

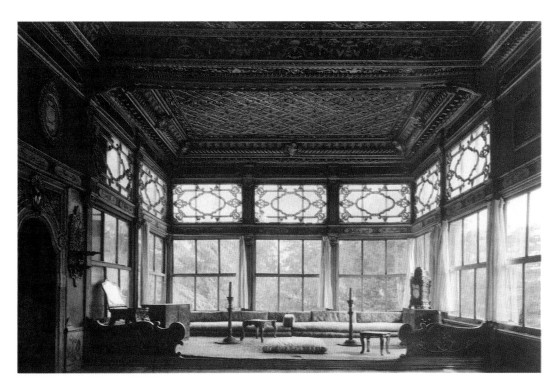

THE PALACE OF VERSAILLES AND FRENCH DESIGN

Louis XIV, king of France from 1643 to 1715, and his finance minister Jean-Baptiste Colbert devised a scheme to promote French industry and international trade by building an impressive new palace and stocking it with French products, like a modern trade fair. Manufacturing in that period meant artisans working in such materials as wood, metal, fibers, ceramics, and glass. The king decided to build the new palace near Paris at Versailles (*vare-SI*), where he had a hunting lodge. A huge park was built around the palace, and a support city grew up outside its gates. The palace was stocked with such French luxury products as furniture, tapestries, and carpets; ornate interior design and decorative art of every kind were used. Visiting diplomats and royalty were overwhelmed by the variety and quality of French products to be seen at Versailles and went home eager to buy their own. Finance Minister Colbert kept all the arts and crafts under centralized control, designs and standards of quality being strictly enforced by government officials. But there was still room for individual creativity, and artists and artisans were attracted to France from all over Europe.

The interiors of the Palace of Versailles (see Fig. **9.6**) were largely destroyed during the French Revolution and only in the past twenty years have they begun to be reconstructed at great expense. They show that the wealthy and powerful could employ tremendous numbers of highly skilled artists and artisans—the sheer amount of time, skill, and effort expended on furniture, textiles, light fixtures, and interior finishing of the buildings defies imagination. Artists and artisans were organized in craft guilds, with strict rules dividing up the labor. The joiners (*menuisiers*) did all woodwork, such as furniture, but if there was important carving a member of the sculptors' guild was called in. The joiners could attach handles and decorative metalwork, but they were not allowed to make them. *Ebenistes* did special veneer work in wood; *tapissiers* did all the upholstery.

Furniture changed during the two centuries of French cultural dominance, and it reflected changes in the way of life. In Louis XIV's day a social event meant a ceremony or a dance, so the king did not provide many chairs for his guests. A century later the rise of wealthy merchant families led to a more modest form of social life, the salon, in which conversation was the main form of entertainment, and so comfortable armchairs were essential.

The royal bureaucracy took over the long-established carpet and tapestry factories and had their designs made by artists of the Royal Academy of Fine Arts, the chosen artists of the court, in an approved style. Charles Le Brun, the president of the Academy and Louis XIV's art dictator, designed the tapestry *The Triumph of Alexander*, which decorated the king's bedroom (Fig. **9.6**). Because the European nobility had no interest in the personalities of the artists who worked for them, they had no doubt that a pictorial tapestry was more valuable than a painting. In the 20th century we are interested in the personality of the artist as it is revealed by the brush stroke, but at Versailles the beauty of the texture and color of the woven fabric and the insulation it provided in drafty palaces were of much greater appeal. (The Gobelin Tapestry Factory is still producing tapestries in Paris, often copying modern paintings and converting them into the richer textures of tapestry.)

9.6
JULES HARDOUIN-
MANSART,
Louis XIV's bedroom,
Palace of Versailles,
1661–88.
Tapestry: Charles Le Brun,
The Triumph of Alexander.

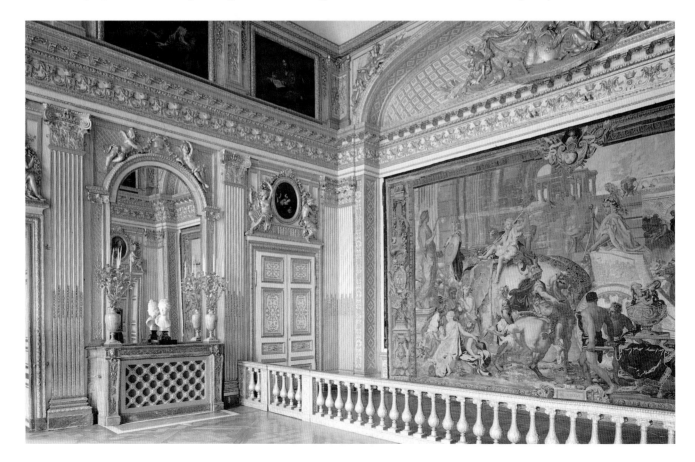

The clock on a tall pedestal (Fig. **9.7**) was a new item in the interiors of Louis XIV's period. Its design and the marquetry (design of inlaid woods) on the pedestal are the work of the greatest of the royal furniture-makers, André Charles Boulle (*bool*), about 1700. The combination of skillful work in wood and metal with the exuberant, but refined, design, gives a good sense of what life was like at Versailles. Life, like this clock, was luxurious and ostentatious, but very disciplined and formal. It is the grandfather of our grandfather clocks, which have a noble background.

THE BAUHAUS

When it is compared with Versailles, the Bauhaus (*BOW-howss*) presents a surprising set of similarities and differences. Organized in 1919 in Germany as a state school of architecture and design (*bau* = building, *haus* = house or institute), it was dedicated to training artists and designers for work in modern industry, although it also offered courses in painting, music, and drama. The school, long considered a nest of radicals, was suppressed by the Nazi government in 1933, and most of the faculty came to the United States, where they became influential teachers. The idealistic plan of the Bauhaus to improve machine-made products through better design had strong appeal in America and led American educators to use it as a model for art and design education. Like Versailles, the Bauhaus was connected with industry and commerce, but while Versailles and French design received government patronage for about 200 years, the Bauhaus survived only twenty-four years and was in political turmoil much of the time. Its director, the architect Walter Gropius (1883–1969), defined its goal as "the collective work of art—the Building—in which no barriers exist between the structural and the decorative arts."[2] Students could specialize in any of seven studios: stone, wood, metal, clay, glass, color, and textiles. Architecture was not taught, although the director was an architect and the program would be considered "pre-architectural" today. Basic design emphasized the study of nature, the analysis of materials, drawing and geometry, and composition. "Building," wrote Gropius, "unites both manual and mental workers in a common task. Therefore all alike, artist as well as artisan, should have a common training."[3]

The dining room (Fig. **9.8**), which Gropius designed for an exhibition in 1928, shows the lightweight, industrially produced chairs, tables, and lamp that are typical of Bauhaus design. The personality of an individual, whether artist or resident, finds

9.7 (*above*)
ANDRÉ CHARLES BOULLE, clock and pedestal, c. 1700.
Ebony, brass, 8 ft 6 in (2.6 m) high.
Private collection.

9.8 (*left*)
WALTER GROPIUS, dining room designed for the Werkbund Exhibition, Stuttgart, Germany, 1928.

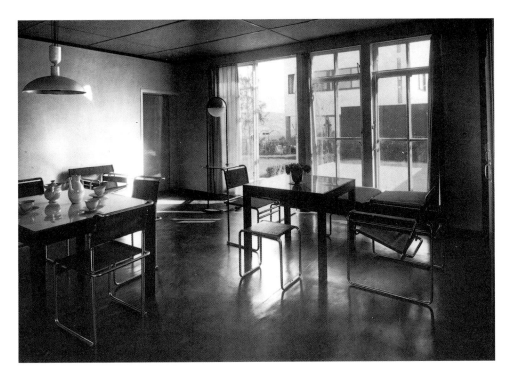

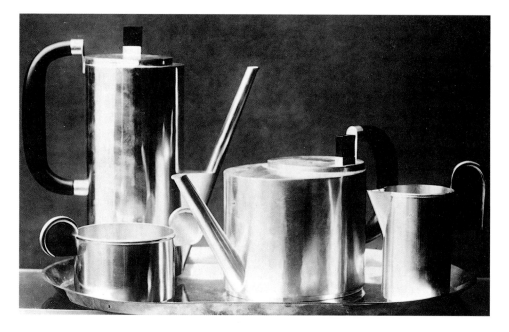

little expression in these furnishings, which are designed to be inexpensive by using a minimum of material and by being almost entirely machine-made. Some of the Bauhaus designs have become classics, remaining popular year after year and copied by generations of younger designers. The springy chrome-plated steel chair with leather seat and back designed by Ludwig Mies van der Rohe (see Fig. **9.3**), who succeeded Gropius as director of the Bauhaus, is one of the classics of Modern design. Another classic, which is even rarer today, is Wilhem Wagenfeld's (*VAHG-en-felt*) coffee and tea service of German silver (an alloy of copper, zinc, and nickel) (Fig. **9.9**). One of the basic considerations of Bauhaus designers was improvement in the design of objects for daily use which could be produced by machines. Only by machine production could the cost be kept low, but only by the work of the best designers could the quality be kept high. Although Wagenfeld knew that machines could produce almost any metal form, he believed that these simple forms conveyed an elegance appropriate to a new age.

9.9
WILHELM WAGENFELD, coffee and tea service, 1924.
Silver with ebony handles, coffee pot 8⅞ in (23 cm) high.
Kunstsammlungen, Weimar, Germany.

RECENT FURNITURE AND INTERIORS

In recent years the Modern ideas of the Bauhaus have been rejected by a Post-Modern generation of designers who set visual image above both function and form. Italian designers have been among the leaders, calling their work of the 1980s "New Design." Some work with established manufacturers; others form studios that operate as art galleries, which, since they are largely out of contact with industry, rely on exhibits and publications to spread their ideas. Paolo Deganello designed the easy chair (Fig. **9.10**) as part of a series entitled "Torso" for a furniture manufacturer, with the appearance of an accidental mixture of supporting legs, arms, and seats, a table, and a back upholstered with a computer-designed fabric. Its subtle mixture of blue, tan, black, white, and gray enhances the low-key, casual mood of the varied shapes. Deganello's easy chair contrasts strongly with Mies van der Rohe's chair (see Fig. **9.3**), which takes the basic form of the human body as its functional standard. Deganello bases his work on the history of furniture, designing something that suggests knowledge of older styles but considers all the parts movable.

A seventy-year-old house in Santa Monica, California, was remodeled by the architect Brian Murphy in a mixture of its original 1920s style and Post-Modern materials and details. The breakfast alcove (Fig. **9.11**) looks out to a swimming pool through an original round window of tinted glass. The other features are Post-Modern: a skylight and industrial lamps light the room, which is furnished with a breakfast table and stools shaped like vegetables by Lisa Lombardi.

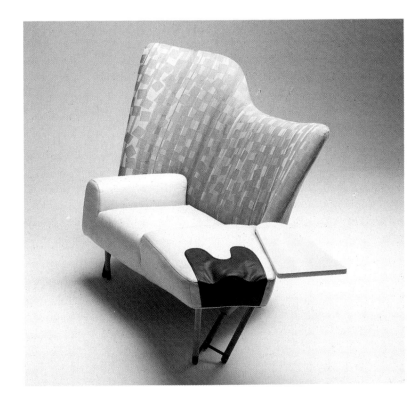

9.10 (left)
PAOLO DEGANELLO,
easy chair in "Torso"
series, 1982.
Cassina Company, Milan,
Italy.

9.11 (below left)
BRIAN MURPHY,
breakfast alcove,
remodeled house, Santa
Monica, California,
c. 1983.
Furniture by Lisa
Lombardi.

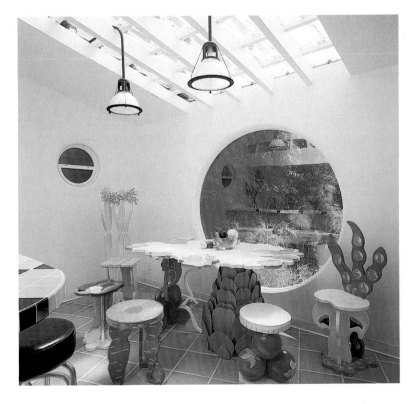

9.12 (above)
SCOTT BURTON, *Two-part Chair, Obtuse Angle,*
1984. Polished pink granite, 33 x 24 x 33 in
(84 x 61 x 84 cm). Whitney Museum of
American Art, New York. (Purchase with
funds from Lemberg Foundation.)

 Furniture has become more than something to use—it asks us to think about it.
Designers specialize in thinking about contemporary ways of life and inventing
forms that express and enhance that life. Post-Modern designers have not agreed on
one set of forms that express our way of life, but you can draw some conclusions
about their views from their work. It is certain that furniture, which we had begun
to ignore, is again a serious field of art. The stone chairs (Fig. 9.12) of Scott Burton
(b. 1939) were intended as sculpture, even though it is sculpture which can be
contemplated as you sit on them.

TEXTILES AND CLOTHING

The use of fibers and textiles probably began with the making of cords and baskets, but when people began to adorn themselves and to shelter themselves from the weather in garments made of fibers a new art came to life. Textiles have been used in many kinds of art—in tapestries (see Fig. **9.6**) and in sculptures—but it is in clothing that textiles have by far the richest history.

ANCIENT GREEK CLOTHING

The Classical Greeks of the 5th and 4th centuries B.C. were very proud of their clothing style. It consisted of a rectangular piece of cloth taken straight from the loom without cutting or sewing, its size depending on how it was to be worn. Cutting and sewing were done by neighboring peoples, but Classical Greeks considered the draped costume more beautiful than the fitted. They expressed that idea over and over in their sculpture, which makes a special point of elegant drapery.

The basic garment for men was the himation (*hi-ma-TEE-on*), a large square of natural-colored wool about 6 by 9 feet (1.8 by 2.7 meters), wrapped around the body (Fig. **9.13**). When he went to war a Greek wore a smaller cloak—about 3 by 9 feet (0.9 by 2.7 meters)—called a chlamys (*KLAY-mis*), which was pinned together at one shoulder. The first sewn garment was the chiton (*KI-tun*), a wool or linen tunic sewn up the sides, with or without sleeves, and long enough to be belted. It became the basic shirt, often worn under the himation.

For women the same rectangle of cloth was worn wrapped around the body under the arms and fastened over both shoulders with pins; this dress was called a peplos (*PEP-lus*). Greek women usually sewed up the open side and often belted it, allowing folds of cloth to fall over the belt (see Fig. **9.13**). Women also wore the chiton, often fastening it with a series of pins at the shoulders and down the arms to make a kind of ornamental sleeve.

Greek clothing has to be seen in conjunction with Greek architecture and sculpture, for they enhance each other in a remarkable way. Just as the Greeks took

9.13
PHIDIAS,
panel from the
Panathenaic frieze of the
Parthenon, Athens,
c. 440 B.C.
White marble,
43 in (109 cm) high.
Louvre, Paris.

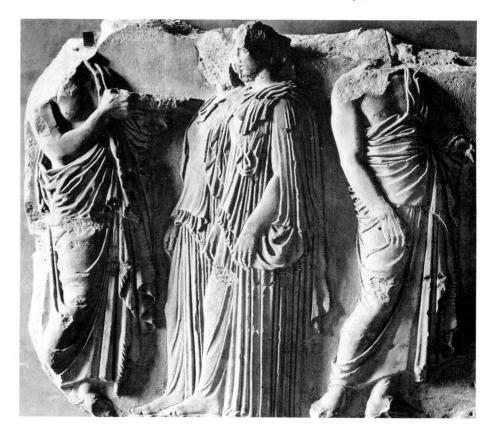

the simplest architectural form, the post-and-lintel, and designed natural and dramatic ways to show its parts and forces, they took the simplest rectangle of cloth and wrapped and folded it to make clothing that was natural and dramatic. The natural movement of the human body, naked or revealed by the flow of drapery over it, was the principal concern of sculptors. The studied simplicity of these arts reveals more about the Classical attitude than anything written by the Greek philosophers. It also reveals that clothing is not mere protection against the weather, but also an art designed to express ideals of truth and harmony with nature.

AN ANCIENT TEXTILE INDUSTRY IN PERU

We usually think of applied design as belonging to the modern industrial world, but that is partly because we do not know very much about earlier practices. Ancient Peru is one place whose textile design and industry are unusually well known because the west coast of Peru is one of the driest regions on the globe and much ancient cloth has been preserved.

Scenes painted on the broad rim of a bowl show a textile factory on the coast of Peru about A.D. 600 (Fig. **9.14**). Eight women are shown working on belt looms, which are strung between the wooden posts of their shelters and held in tension by a belt around their waists. By the standards of the Inca Empire, hundreds of years later, this would be a very small factory, for we know that the Incas had cloth factories employing a thousand weavers. Perhaps these painted figures are symbolic of a larger number, but they are so individualized that one wonders if they are portraits, some with neat short hair, one with messy hair, some with wrinkles, others smiling. They are all making cloth with patterns typical of well-known Peruvian styles, with their shuttles of thread at their sides and their beaters in their hands ready to comb down the weft threads (the horizontal threads woven in with the shuttles). The extremely high quality of most of the ancient Peruvian cloth is an indication that such a factory was not engaged in mass production, but considered each piece of cloth a work of art. Designs were traditional, but weavers used their own judgment and invented variations. Since commercial trade was practically unknown in ancient Peru, most cloth production went into state warehouses and was distributed to people according to their rank, or used in diplomatic relations as gifts to other nations.

9.14
Scenes in a textile factory, painted on the inner rim of a ceramic flaring bowl of the Moche kingdom, Peru, A.D. 100–700. Drawing by Donna McClelland. Bowl in British Museum, London.

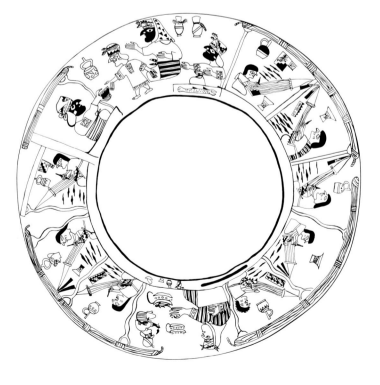

Navajo Blankets and Rugs

9.16 (*left*)
Navajo third phase chief's blanket, c. 1880. Germantown yarns with cotton warp,
4 ft 6½ in x 5 ft 2½ in (1.4 x 1.6 m).
Millicent Rogers Museum, Taos, New Mexico.

9.15 (*right*)
LAURA GILPIN, Navajo weaver, 1951. © Amol Carter Museum, Fort Worth, Texas.

A distinctive American contribution to interior design has been the Navajo (*NAH-vuh-ho*) rug. The Navajos, the largest Indian nation in the United States, have reservation lands in Arizona and New Mexico, where their traditional occupation has been sheep-herding. Traditional Navajo clothing includes a man's hand-woven wool blanket very much like a Greek himation, which was woven by his wife and was the most valuable and prestigious item of clothing. When trading posts began to be established in Navajo country in the mid-19th century, the traders were eager to find ways for the Navajos to earn money so they would be able to buy trade goods. The beautiful heavy blankets worn by the men were suitable for use as rugs, the traders thought, so they encouraged the women to make extra blankets for sale. From about 1850 to the present day Navajo blankets and rugs show continuous evolution in style.

Laura Gilpin's photograph (Fig. **9.15**) shows a woman at her vertical loom weaving a design of bands with chevrons. In her right hand she holds a ball of hand-dyed and hand-spun wool and a comb-like beater to pack the colored wool so tightly between the white wool warp threads that only the colored design shows. Weaving is done seated on the ground, usually outdoors. Navajo rugs often show subtle slanted lines in the weave, called "lazy lines," where the weft turns back, though the color does not change. They are produced when the rug is too wide to reach across from one position and the weaver weaves higher on one side before moving to work on the other side. They reveal the process of work and are considered interesting, not a flaw.

The design of a rug made about 1880 (Fig. **9.16**) begins with a traditional pattern of black-and-white stripes called a "chief's blanket." Over the stripes five crosses have been placed, of red, green, and blue, with lozenges in the middle of each cross. This is one of the classic Navajo rug designs.

With their strong colors and geometric shapes, Navajo rugs were an excellent complement to a simple Modern interior. Because they originate as blankets they have a flat plain weave, not the knotted pile we have come to expect in carpets. The Navajo design style is a uniquely native American contribution to interior design.

A shirt or tunic (Fig. **9.17**) from Paracas on the coast of Peru shows us that ancient Peruvians wore items of clothing that were unique to their own culture. This tapestry tunic, wide and fairly short in the body, is typical of ancient Peruvian tunics. The fringed sleeves were common during its early period, about 300–100 B.C., although sewn cloth sleeves were used in later periods. This garment would have been worn with a wraparound loincloth, a mantle, or blanket in cold weather, and a turban or hat, all of these items bearing colorful decoration. Ancient Peruvian cloth differs from ancient Greek work not only in the types of clothing made, but even more in the great interest the Peruvians had in dye colors and in the creation of rich color effects. Some of the oldest identified dyes have been discovered in Peruvian cloth dating from more than 4,000 years ago, and by the time this tunic was made, weavers at Paracas had many colors available; one authority says 190 colors,[4] which indicates that color was their special preoccupation. The ancient Peruvian ideal was not Classical simplicity, but richness conveyed by texture, color, and pattern.

9.17
Shirt with fringed sleeves from Paracas culture, Peru, 300–100 B.C. Cotton and wool, body 21¾ in (55 cm) wide. Etnografiska Museet, Göteborg, Sweden.

Ancient Peruvian textiles have been an inspiration to modern weavers and designers, but the modern idea is to adapt Peruvian design sense to machine production. Hand-weaving of cloth comparable to the Peruvian work is rarely considered by modern textile artists, because the individualized product of such handwork would be very expensive.

The shapes and designs of Greek and ancient Peruvian clothing were comparable, with uncut cloth off the loom being basic to both. Cloth in ancient North and South America was generally more decorated than Greek cloth, with a variety of techniques and a multitude of colors used to enrich the cloth. The ancient American ideal was not Classical simplicity, but richness of color and design.

EUROPEAN CLOTHING OF THE 16TH TO 19TH CENTURIES

Trade in cloth was important in ancient Greece, but by the 16th century cloth-making was the greatest industry in Europe. As early as 1589 a machine had been invented to knit cloth, and over the next three centuries most of the cloth that was traded gradually came to be the product of machines rather than of hand-weavers.

For 16th- and 17th-century Japanese clothing, see Figures **12.25** and **12.26**.

An unparalleled extravagance in European clothing followed. Industrialization was one factor in this; another was the immense wealth looted from the defeated kingdoms of Mexico and Peru.

François I, king of France (Fig. **9.18**), was painted about 1525 by his court painter Jean Clouet (*zhan* kloo-AY; *c.* 1485–1540/41), wearing a matched shirt, doublet, and dogaline. The shirt has a wide horizontal neck and ruffles at the cuffs. The doublet, or tight-fitting jacket, has slashes in the sleeves and body to show the shirt. The dogaline is a long coat with very wide sleeves which were folded back and fastened to the shoulders. All these voluminous clothes appear to be of silk, with an embroidered design in gold thread. With this outfit the king would have worn bulbous breeches, hose, and low shoes. His costume is completed by a flat hat trimmed with a white feather, gloves, and an ornate sword. Conspicuous luxury clearly takes the form of extra cloth of the finest quality with extra decoration on it.

9.18
Jean Clouet,
François I, c. 1525.
Oil on wood panel,
38 x 29¼ in
(97 x 74 cm).
Louvre, Paris.

Over the next 200 years the clothing of the wealthy changed slowly toward simpler styles with fewer layers. There was a consistent tendency to use as public wear clothing at first thought suitable only for private occasions. The sack gown or sack-back gown, derived from a nightgown or peignoir, appeared early in the 18th century and remained very popular for several decades, probably because it was comfortable. This sack-back gown (Fig. **9.19**) is French, of green silk with multicolored flowers woven into the cloth (brocade technique). In the back it hangs loose from the shoulders and is open at the front over a chemise. It was worn with a small hat. Elegant as this outfit is, it is far simpler in pattern than the formal dress of the upper classes had been for centuries. In that respect it led the way toward 20th-century styles.

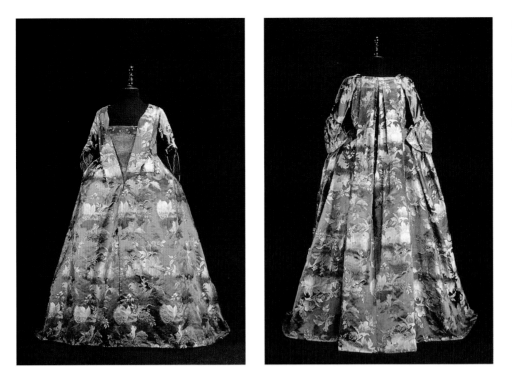

9.19
French sack-back gown,
c. 1730.
Green silk damask,
multicolored brocade
flowers. Union Française
des Arts du Costume,
Paris.

MODERN DRESS

The early years of the 20th century saw an unprecedented shift in clothing styles. In 1906 the actress Sarah Bernhardt (1844-1923) appeared in a lavish costume (Fig. **9.20**): a floor-length dress with a slight flare and a long coat with multiple flounces on the capelike shoulders. A large hat with bows and plumes and an umbrella completed the outfit. The sumptuous effect of such costumes was based on corsets that were flat in front and sharply curved behind, with the waist unaccented, but the skirt tight at the hips and flaring at the hem.[5] Every piece of cloth bears a pattern, pleat, flounce, or some elaboration.

9.20
Fashionable outdoor wear
in the early years of the
20th century. Sarah
Bernhardt in a long dress
and coat, 1906.

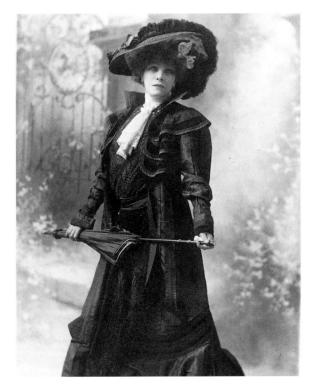

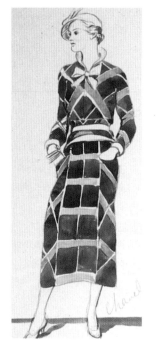

9.21
Gabrielle (Coco) Chanel,
suit in large plaid checks,
1928.
Wool jersey.
Union Française des Arts
du Costume, Paris.

9.22
Donna Karan,
double-breasted wool suit
with ribbed stockings,
1994.

By 1914, when World War I began, the clothing of both men and women had grown simpler than that worn even a few years earlier. The catastrophe of the world war changed the lives of all Europeans, eliminating the extravagance of cloth and workmanship of traditional styles. The "liberated" hard-working life of 20th-century men and women demanded clothing that permitted free movement and little care. Among the designers who first defined the new style, Gabrielle Chanel (*shah-NEL*; 1883–1971), always called Coco, was most influential. Her soft suit in large plaid checks (Fig. **9.21**) has a skirt at mid-calf, a reaction to the much shorter "flapper" styles of the early 1920s. With very short hair, a practical small hat, low shoes, and a suit that permitted free movement, a Modern woman took on new roles in life.

Chanel's introduction of the suit for women made it possible for women to begin to compete on equal terms with men in more aspects of life. Men's suits, which began to take on their current form about 200 years ago as part of the Neo-Classic revival of an ancient Greek ideal of the male body,[6] had overlapping parts that permitted free movement despite their formality, one of the qualities that accounts for its perennial popularity.

In 1985 Donna Karan (b. 1949) took the next step in liberating and democratizing women's clothing when she designed black body suits in Lycra® Spandex, short wraparound skirts, and trim jackets as office wear, as well as more casual T-shirts, jeans, and trenchcoats. The model in her ribbed stockings and double-breasted wool suit (Fig. **9.22**) dramatizes the action potential of the new styles and fabrics. The long-term trend toward removing outer layers and revealing undergarments, traceable over 500 years, continues in Donna Karan's designs, which reduce the layers to a few essentials of comfortable, interchangeable garments.

Styles in clothing change in their essentials much more slowly than we often imagine. Real change reflects actual changes in the way of life and the self-perception of the people wearing the clothing.

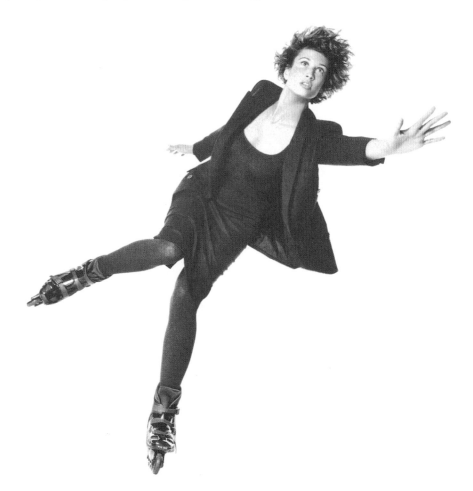

Coco Chanel

9.23
Coco Chanel in her Paris apartment,
1954.
Photograph by Louise Dahl-Wolfe.

She had an eye to quality and proportion that was unbeatable. She had daring, freshness, authenticity, conviction. She was exceptional and she knew it. She was unfeminine in character, but totally feminine in her ability to entice, and she had great sex appeal. Chanel had qualities and talents that are very rare. She was a genius, and all her faults must be forgiven for that one reason.*

These words were written by the famous photographer Cecil Beaton when Chanel died in 1971.

Coco Chanel (Fig. **9.23**) dominated Paris fashions from about 1920 until her death, and she revolutionized women's clothing. When she was thirty she opened a tiny dressmaker's shop at a French beach resort and began offering her own "poor girl" creations in soft jersey fabric. Influential women, tired of uncomfortable corseted clothing, took an interest in her, and she was soon established in Paris with a variety of fashion products. In 1922 the perfume Chanel No. 5 was introduced, and it remained a basic product in her line. Her enterprises at their height employed 3,500 people in fashion design, a textile business, perfumes, and costume jewelry.

Women's clothing of the 20th century largely reflects Chanel's ideas: the classic "little black dress," jersey dresses and suits, bell-bottom slacks, formal dress pajamas, turtleneck sweaters, short hair, and costume jewelry. Coco Chanel appears in her 1954 portrait wearing a cardigan with a mid-length skirt and a single piece of jewelry. A big-city business woman, single but with notorious romantic liaisons, Chanel dressed and designed for the way she lived: a busy life demanding a lot of energy, a city life tempered by leisure time in the country.

She said, *La mode passe, le style reste* ("Fashions change, style endures"). Her influence on women's clothing produced a modern classical style of comfortable, soft, simple clothing for an active life.

*Quotation from Cecil Beaton, *Self-Portrait with Friends* (London: Book Club Associates, 1980), p. 412

THREE TECHNOLOGIES OF FIRE

Three materials are worked with fire—clay, glass, and metal. Fire plays a different role in each technique: it hardens modeled clay into ceramics, but it softens glass and metal so that they can then be modeled with tools and cast in molds. We take all this for granted, because our civilization is based on these fire technologies or **pyrotechnologies**, and it is hard to imagine that the earliest workers in glass considered it a stone and worked it cold by chipping and polishing.

Craft: Art or Science?

"In America, craft is the most materials-obsessed of all the genres of visual art," wrote critic Janet Koplos. That obsession with the materials, she writes, "seems to be one of the liabilities that prevents craft from being treated seriously in the pages of art magazines." An obsession with material is characteristic of science, which explains the existence of a Metals and Ceramics Division at the Oak Ridge National Laboratory, where advanced research is carried out on high-temperature engines and materials for exploration in space.

9.24
Peter Voulkos giving a demonstration at "the wheel," University of California at Berkeley, c. 1976.

Glassfiber transmission cables, ceramic turbine engines, and replacement joints for people are just a few of the applications of these pyrotechnologies in science and industry.

Janet Koplos contrasts Japanese potters with American. Working in a strong male-oriented tradition dedicated to forming *utsuwa* (containers, hollow useful forms), Japanese potters are part of a tight-knit society that recognizes their value. American potters, and all craftspeople, work in "such an unsupportive context," Koplos says, that their work must reflect "an enormous individual or cultural longing." Without a tradition, thrown back on their individual inventiveness, American craftspeople have "a freedom the Japanese can only envy—or maybe copy." Since Americans lack the craft tradition that is essential for folk artists and traditional artisans, American craftspeople must be either artists or scientists, professions based on individual creativity (**9.24**).

Nuclear physicist Alexander Zucker says there is one fundamental difference between art and science. "It comes back to truth," he writes. "Art knows no barriers in time. Many schools [of thought] flourish concurrently, many forms of expression are valid; there are many truths. Not so in science. It marches in lockstep, one truth is all it knows. That truth may and does change as new things are discovered—but there are no two schools of [thought in] astronomy." But art and science share an enemy, he says: "The enemy is dogma: judgmental positions taken by institutions, governments, religions, philosophies." Artists and scientists share much of the best in mankind's work and thought: "We regard our work with equal passion, we seek new ground at the cost of many failures."

When we look at craftspeople we see them focused on their materials and on functional form, like scientists; but also seeking their own truth that can stand beside many other truths, like artists. What are they, artists or scientists?

Based on Janet Koplos, "Japanese and American Potters" in *The Studio Potter*, December, 1992, pp. 27–8; Alexander Zucker, "Art and Science," *The Studio Potter*, December, 1993, pp. 42–3

In art we cannot take the technology for granted, because it is basic to the form the art takes. How the clay was formed can never be ignored, and whether the glass was molded or blown, or the metal hammered or cast, are basic to understanding the work of art. Those techniques are the framework in which the artist places symbolism and expression.

CERAMICS

Ceramics (from the Greek word for potter's clay) includes all the forms of art made of fired clay, including pottery, **terra cotta** sculpture, and even brick. All of these are made by forming the wet clay into the desired form, letting it dry, and "firing" the form by placing it in a kiln (*kill* or *kiln*) where it is raised to a red- or white-hot temperature for a few hours. Right from the first, ceramics was an art associated with civilized life; since fired clay is relatively heavy and fragile, it is not of much use to nomadic or unsettled people.

Pottery-making is still a useful craft in many parts of the world. The water jars by a Guatemalan potter (Fig. **9.25**) are formed by coils built up by hand; yet the walls of the pots are smooth, round, and very thin. A potter's wheel is often used to speed this process of forming the vessel. This is the craft that lies behind all art in ceramics—the skill to dominate the clay before it can be used for symbolic expression. The Guatemalan potter has no intention of expressing symbolic meaning or making art; she intends only to make good, useful water jars. For us, living in an industrial world of machine-made objects, functional handmade pottery such as these water jars becomes art, symbolic of a life close to nature. Such pottery is background for modern ceramic art.

As the Industrial Revolution eliminated such pottery from our world during the 19th century, to replace it with mass-production pottery from factories, some people began to miss the unique handmade pottery. In England, where "china" (as porcelain ceramics are often called in testimony to their Asian ancestry) was a huge industry, the modern artist-potter first appeared. A reaction to industrialization of pottery and other traditional crafts was the Arts and Crafts Movement, which was led by William Morris (1834–96). Morris and his colleagues meant to revive handcrafts that had been put out of business by machine production. The weaving and decoration of cloth and the making of pottery were only two of the many crafts that Morris and his followers practiced, and they tried to improve the quality by having a person, instead of a machine, make the product.

Bernard Leach (1887–1979) was the most influential potter to follow Morris's ideas. Leach, who considered the making of pots a search for the deepest universal

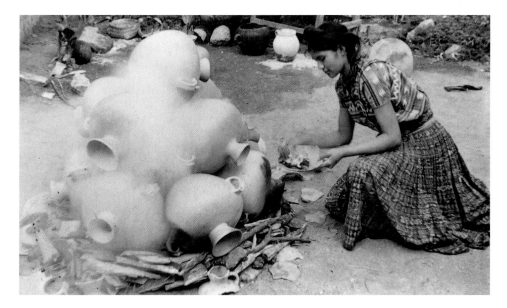

9.25
Potter of the Vasquez family, Chinautla, Guatemala, firing water jars in the open, without a kiln, 1960.

philosophy, wrote: "The pot is the man; his virtues and vices are shown therein—no disguise is possible."[7]

New York potter Karen Karnes works in the tradition of Morris and Leach. Her jar with lid (Fig. **9.26**) reveals in its form the interactions of the clay and the potter. Looking at the base of the jar we can imagine the lump of clay spinning on the potter's wheel, then being pressed in the center by the potter's thumbs to make a hollow center and the walls being drawn up smoothly from the base. The in-and-out pressure of the fingers and thumbs is recorded in the clay wall that spun between them. The inward pressure registers in the narrowing of the neck, and the strong pressure of a fingertip shows in the rapid upward whirl of the neck. The heavy lid, its top cut to shape with a wire, and the heavy flange at the rim hold down the rising line of the neck. In the form of the jar we see the drama of its making. "The pot is the woman," to rephrase Leach, and we see the personality traits of strength and generosity in the form of the vessel. In her recent work Karnes has turned away from containers toward abstract sculptural forms, but containers are equally expressive, as we see by this simple jar.

One of the uses of glass is to coat pottery to make it hold liquids without leaking. Most of our pottery is **glazed** (meaning covered with glass). Not only does glazing make pottery more useful, it also provides opportunities for decoration. Pottery can be decorated with paints made of liquefied clay (called **slip**), which gives a matt surface, as well as with shiny glazes, which also give a wider range of colors. In the ceramic "collage" *Canyon* (Fig. **9.27**) by Margie Hughto we see both slips and glazes, along with the natural colors of clay and an added piece of copper, with oxidized patches on it. All those materials were chosen for their colors and textures. *Canyon* is a relief sculpture to be hung on the wall, a use we sometimes forget when we think of pottery, although it has been a traditional part of the medium. The special qualities of color and texture that ceramics provide, along with their mass and thickness, give a sense of earthly reality that can be found in no other material.

Early use of colored glazes can be seen in Persian and Chinese ceramics (see Figs **11.25** and **11.43**).

9.26
KAREN KARNES,
jar with lid, 1980.
Stoneware,
15½ in (39 cm) high,
11 in (29 cm) in diameter.
Courtesy of the artist.

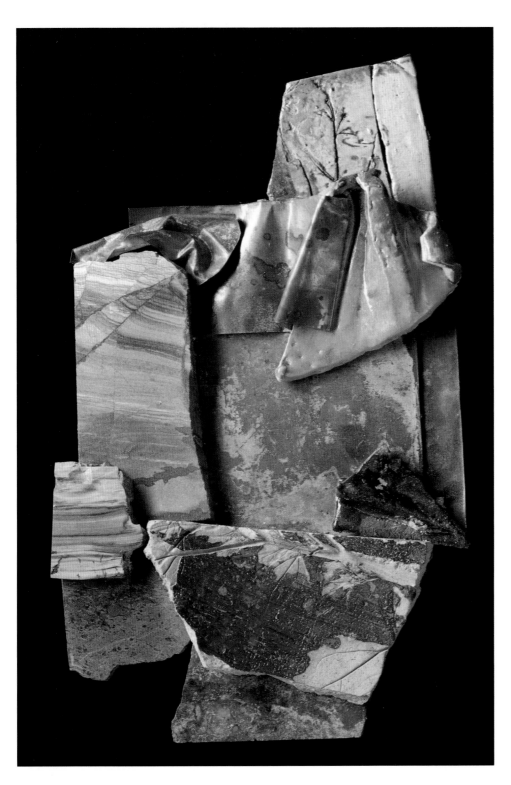

9.27
Margie Hughto,
Canyon, 1991.
Colored clays, slips,
glazes, copper,
11 x 7 in (28 x 18 cm).

GLASS

The art of glass-making goes back more than 3,500 years, but in recent years it has taken on great vitality in American art. One influential artist-teacher, Harvey Littleton, who introduced classes in glass at the University of Wisconsin in 1962, is largely responsible for this development. Glass can be worked cold by abrasives, treating it as stone, but it is commonly melted and blown into bubbles or blown into molds, or poured as a liquid into molds, or worked with tools in a molten condition. It can be opaque or transparent, clear or colored, and its uses are as varied as jewelry and architecture.

An ancient Egyptian cosmetic bottle shows the skill of glassmakers of that era (see Fig. **10.19**). Glass was also used for pictorial enamels, as in a medieval Spanish bookcover (see Fig. **11.9**).

Two examples give us a hint of the potential of glass. The fact that glass is a mineral, a kind of rock that has been melted and cast in a form, is part of the appeal of John Lewis's *Key Hole Table* (Fig. **9.28**). Its powerful architectural forms are a careful balance of square and curved, solids and spaces. The transparency and ice-like color of the glass make it seem lighter than it really is.

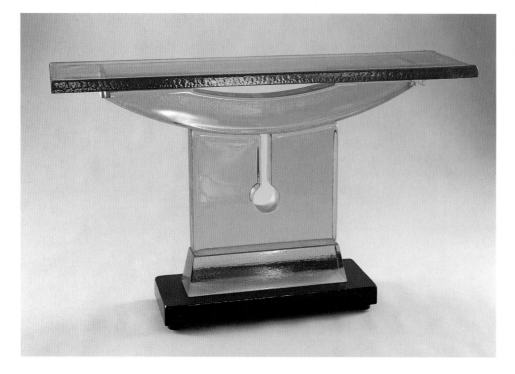

9.28
JOHN LEWIS,
Key Hole Table,
1955.
Glass, 16 x 60 x 36 in
(41 x 152 x 91 cm).
Rachael Collection, Aspen,
Colorado.

The mysterious horn or tusk shapes that make up William Morris's *Artifact (Tusks)* (Fig. **9.29**) are actually blown glass that has been worked with tools and abrasives to achieve a remarkable naturalistic texture and form. We do not ordinarily think of glass as a representational medium—as one that imitates the natural appearance of other materials—which adds an element of surprise to this Seattle artist's work.

9.29
WILLIAM MORRIS,
Artifact (Tusks),
1992.
Blown and tooled glass,
12 x 24 x 18 in
(30 x 60 x 45 cm).

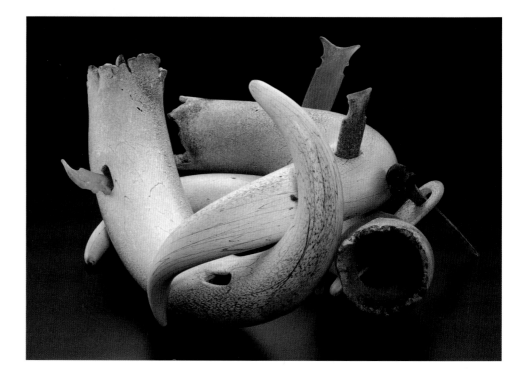

Between these two examples we get an idea of the range of possibilities in the medium. Lewis's *Key Hole Table* implies a wide range of architectural forms that could be made of massive, heavy, but transparent glass, while Morris's *Artifact* (*Tusks*) is at the opposite extreme: thin, delicately curving forms that look as if they were grown rather than made. Between them lie an infinite number of bottles and bowls, bricks and jewelry, sculptures, and wall ornaments in colored or transparent glass, all waiting to be made.

METAL

It is a surprising fact that metals were first used as ornaments and art before they were used for tools or weapons. The qualities of metal that appealed to early peoples were their sounds (in bells) and colors, which still appeal to us. Gold and copper were among the first metals to be used because both are found naturally as nuggets of pure metal, which can be hammered into shapes or into thin sheets. Hammering, or **repoussé** (*ruh-poo-SAY*), continued to be a common method of working metal even after artisans had learned to refine metal from ores and cast it in molds. The 4,000-year-old gold bracelet from Hungary (Fig. **9.30**) was cut from a sheet of metal and hammered over molds into its complicated shape. A pointed punch was used to make the dotted lines. Unlike copper, which requires periodic heating to reduce its brittleness, gold can be hammered without fire. This bracelet required only simple techniques, but it is far from simple in design.

When artisans learned to apply sufficient heat to melt metal and cast it in molds, its usefulness for art and tools expanded tremendously. Until the last couple of centuries, metal casting was high technology, at least as important for casting tools and weapons (such as cannons) as it was for art. The ancient Chinese grew very skillful at casting bronze (an alloy, or mixture, of copper with a little tin), which they

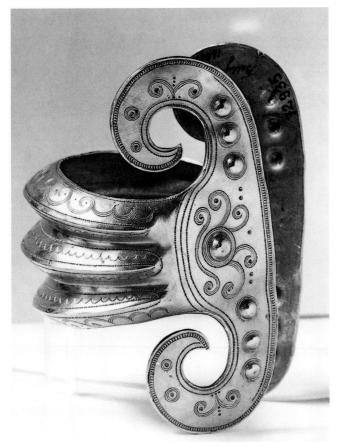

9.30
Bronze Age Hungarian bracelet,
2000–1000 B.C.
Gold, 4⅓ in (11 cm).
Naturhistorisches Museum, Vienna.

used especially for making vessels for religious rituals. The ceremonial wine vessel (Fig. **9.31**) was made by pouring molten bronze into pottery molds. All the details of the decoration were in the original mold. The green patina, or oxidation of the surface, is the only change these vessels have suffered in more than 2,000 years. Although many ancient Chinese ritual vessels survive and show a variety of forms, we have no detailed idea of the ceremonies in which they were used.

Ironworking, which requires high temperatures, was a later development, and steel (iron alloyed with carbon) still later. Iron and steel are so useful that we forget that they are also art materials, but in the Middle Ages and Renaissance art and function met in the arts of war: weapons for attack and armor for defense. One of the most elaborate sets of armor ever made was that for Charles V, king of Spain and Holy Roman Emperor, and his horse, which was also encased in ornamental steel (Fig. **9.32**). Made about 1520, probably by Kolman Helmschmid (Kolman the Helmet-maker; *c.* 1470–1532) in Augsburg in southern Germany, it converted the emperor into something like a modern tank. The horse, with ram's horns protecting its ears, was carrying 97 pounds (44 kilograms) without counting the saddle and rider, whose helmet alone weighed nearly 20 pounds (9 kilograms). The main purpose of this outfit was to impress, rather than protect, because the emperor was obviously not obliged to defend himself. The construction of overlapping plates, elaborately shaped joints, cast, etched, and engraved ornament were the real importance of this fantastic work of art, and they have the same appeal now that they had nearly 500 years ago.

Marie Zimmermann (1879–1972) was a New York artist in metal, working very much as earlier armorers had done but expressing more peaceful ideas in an elegant, classical style. Although she produced highly decorated enamel and inlaid art objects, some of her most impressive work is the simplest and that which shows

9.31
Chinese Jia tripod
wine vessel,
500–400 B.C.
(Middle Shang dynasty).
Cast bronze,
13 in (33 cm) high.
Asian Art Museum of San
Francisco. (Avery
Brundage Collection.)

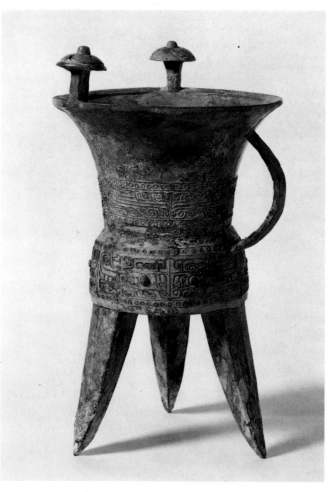

9.32 *(opposite)*
Attributed to
KOLMAN HELMSCHMID,
tournament armor of
Emperor Charles V,
c. 1520.
Royal Armory, Madrid.

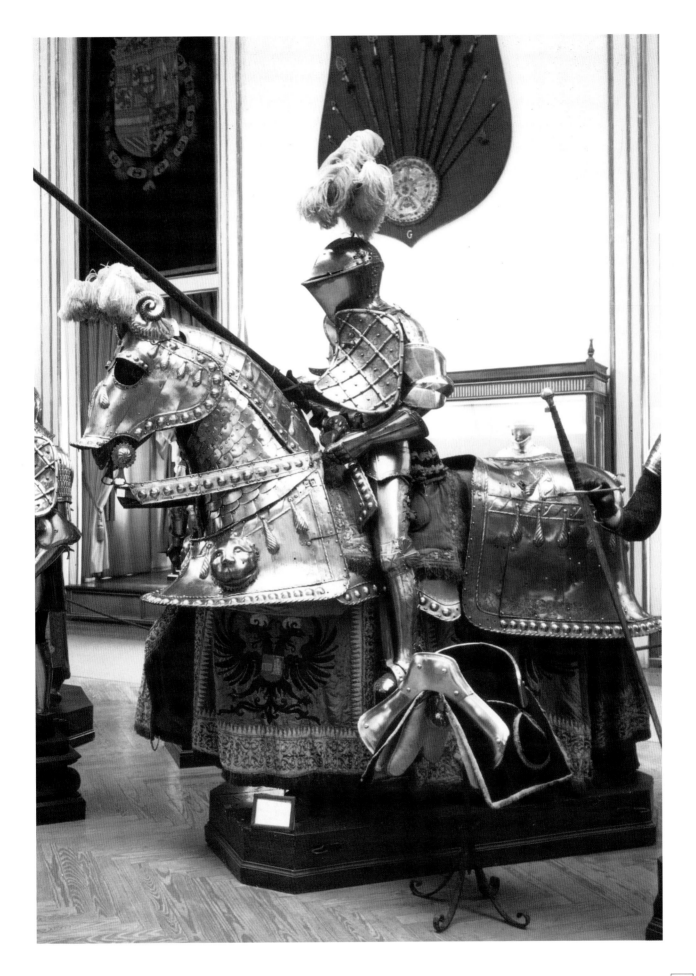

"each hammer stroke, each tool mark" of the individual artist, as she wrote.[8] A candlestick made of handworked copper (Fig. **9.33**), with a natural green patina, has its intertwined, vinelike supports ending in small elephant heads, which hold the cup in which the candle was set. Zimmermann's reputation, which was at its height during the 1920s and 1930s, was eclipsed by the rise of Bauhaus design styles in the later decades, but a new public is interested in her art now.

A fibula pin (Fig. **9.34**) made by Stephen Walker in 1991 is both recent and also reflective of the ancient attraction of color in metalworking. Formed of joined parts of five variously colored metals (sterling silver, nickel silver, brass, copper, bronze), it relies on the interplay of the materials for much of its effect. The rectangular panels, which seem to be closer than the slanting stripes that suggest perspective, are part of contemporary abstract design, but the iridescent effects, like oil shining on water, also recall ancient traditions in which metallic colors were associated with the gods.[9] The variety of effects artists can achieve in metal, making use of its strength and its textures and colors, have only begun to be explored, despite the thousands of years of work we have done.

DESIGN IN MOTION

An area that belongs nearly exclusively to our century is the design of such movable forms as the automobile, with designs that must change every year in response to intense market competition. Our cars must reflect our way of life. A person with four children who uses the car for short trips around town will not seriously consider the Alfa Romeo sports car (Fig. **9.35**), although all of us like to look at it

9.33 (*above*)
MARIE ZIMMERMANN,
Candlestick with elephant heads, c. 1930.
Handworked copper, patinated,
12½ x 4½ in
(31.5 x 11.5 cm).

9.34 (*right*)
STEPHEN WALKER,
fibula pin,
1991.
Sterling silver, nickel silver, brass, copper, bronze, mokume-gane,
3 x 4 in (7.5 x 10 cm).

9.35
MARCELLO GANDINI
and staff of Carrozzeria Bertone, Grugliasco, Italy,
Alfa Romeo,
Model 33, 1968.
Aluminum and fiberglass body, leather interior.

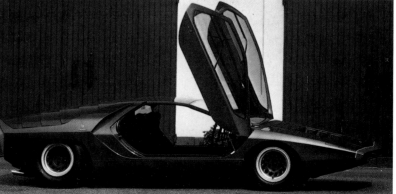

and dream a little. High-speed motion is everything in that car—the form, the function, and the visual image, too. It represents a large category of car designs since the 1920s, the early ones built for racing, the later ones incorporating the engineering and design features of the successful racing cars.

The Renault town car of 1910 (Fig. **9.36**) represents another category of car design in which passenger comfort and dignity are the main considerations. The design of the Renault is clearly only a small step from the carriage, although the technology is a big step away from the horse. Improvements in the engineering were the driving force for design improvements. Wind resistance hardly counted at the speeds reached by the 1910 Renault, but as speed increased, the form of the body had to be adjusted to reduce resistance and noise. We hear automobile design called "styling," which implies that it is superficial, like a haircut, but in fact it contributes to and is controlled by the function of the car.

Those two factors, speed and passenger comfort, have controlled the development of car design. The 1932 Packard touring car (Fig. **9.37**) owned by movie star Jean Harlow shows a compromise between those factors—a powerful eight-cylinder engine combined with spacious and luxurious passenger accommodations. As the highway system expanded and roads improved, speed increased and the distances people were willing to drive also increased. Though long-distance travel by car began to be feasible by the 1930s, speed and comfort still favored the train, whose diesel engines and streamlined design were ahead of most

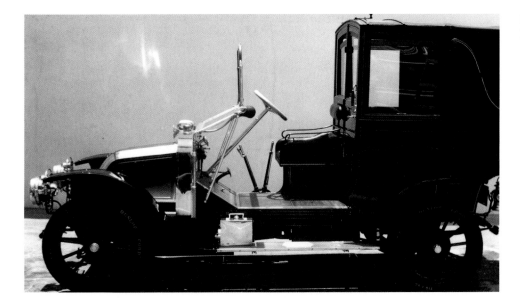

9.36
Renault town car,
1910.

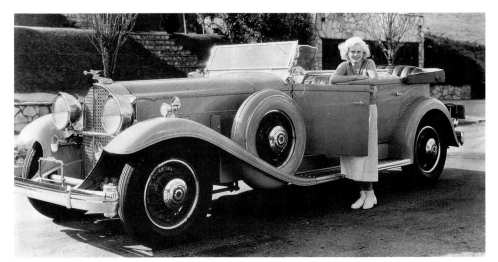

9.37
Packard Deluxe Eight
phaeton, 1932.
Shown with its owner,
movie star Jean Harlow.

cars. The Chrysler Airflow of 1934 (Fig. **9.38**) was the first car design to combine a family-size sedan with a streamlined shape that had been used earlier only on racing and sports models and in trains.

The factors dictating automobile development now include government regulations on safety, gasoline mileage, pollution emissions, and many other considerations besides speed and comfort. Wind-tunnel studies of aerodynamics now take the place of the designer's intuitive sense of form, with the perfect teardrop form, whose mathematical coefficient of drag (C_d) is 0.07, being the ideal form.

The designers for Ford Motor Company, like all the auto designers, build "concept cars" about ten years ahead of the mass-production models. Working with the Italian Ghia Bodyworks, Ford designers began work on the fourth in the Probe series (Fig. **9.39**) about 1980, with the aim of designing the most aerodynamic body possible. To make a lower, smoother hood the radiator was moved from the front of the hood and the four-cylinder engine rotated downward. The windshield was given a steeper angle, and all glass was made flush with the body. The wheels were given fender skirts and as speed increased, the body of the car was designed to ride lower to become more aerodynamic. This design had the lowest coefficient of drag (0.15) that had been attained by a car, and at a constant speed of 50 miles per hour required only 2.5 horsepower to maintain speed, less than the power needed to propel the average lawnmower.

Chrysler Corporation's Neon (Fig. **9.40**), a production model first available in 1994, incorporated many of these concepts. Its low, short hood, and steeply raked windshield lead to a smooth curve over the passenger compartment. This shape is achieved by moving the windshield forward, giving the passengers extra space and headroom. Chrysler has speeded up the design process by incorporating stereolithography into its computer-aided design (CAD) process, adding lasers, optical scanning, and photochemistry. Design data from the computer is analyzed into cross-section slices of parts, which are traced by a laser onto the surface of a liquid polymer plastic. The laser beam solidifies a thin (0.003-0.0005 inch) film of the polymer, which is coated to become one layer of the designed part, which is built up layer by layer. This chemical-computerized adaptation of the lithographic principle is part of the revolutionary progress going on in what we once thought of as "drawing." The mental processes of the designers are still really drawing, but the tools they use convert the concepts into three-dimensional car parts with unprecedented speed. The efficiency of the engine and the aerodynamic

9.38
Chrysler Airflow sedan, 1934.
Shown parked next to a Union Pacific Streamliner, introduced in 1934.

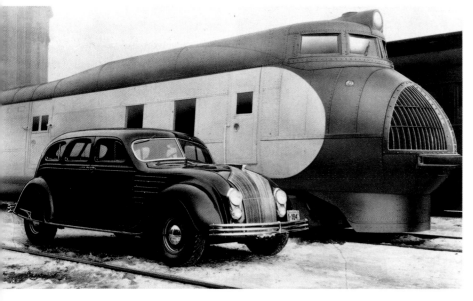

9.39
Ford Motor Company, Probe IV, 1984.

9.40
Chrysler Corporation, Neon, 1995 production model.

efficiency of the body have shown remarkable increases in recent years, but just as important is the tremendous increase in the efficiency of the design-to-production process. In a sense we could say that the art of automobile design has been offered a new independence and importance by these efficient methods, which are just beginning to be applied in industry.

Applied design is truly the pulse beat of a people, remaining stable when the society is stable or changing as the people change. Designers, even more clearly than other kinds of artists, are searching for a shared expression, not the expression of their own personalities. Yet when we examine the work of individual designers we find that their work has individuality and that the audience understands it as sincerity. Each period in the history of art finds its characteristic expression in its works of applied design, which makes it interesting to examine our own products as expressions of our times.

FOR REVIEW

Evaluate your comprehension. Can you:

- discuss how our concept of a room to live in developed, with its mixture of ideas from many places and many traditions?
- describe the differences in construction of clothing from ancient traditions (such as Greek and Native American) to Coco Chanel and Donna Karan?
- define the meaning of "pyrotechnologies" and describe some works of art that show the range of these arts?
- discuss the problems facing the designers of automobiles, mentioning some recent solutions?

Suggestions for further reading:

- Whitney Museum of American Art, *High Styles: Twentieth-Century American Design* (New York, 1985)
- Barbara Radice, *Memphis* (New York: Rizzoli, 1984)
- Dan Friedman, *Radical Modernism* (New Haven: Yale University Press, 1994)
- Barbara Perry (editor), *American Ceramics* (New York: Rizzoli/Syracuse: Everson Museum of Art, 1989)
- Gerald Silk, *Automobile and Culture* (New York: Harry N. Abrams/Los Angeles: Museum of Contemporary Art, 1984)

PART

V

RECOGNIZING THE GREAT STYLES

One of the distinctive features of Western culture is its use of art styles to define the periods in its history. If we examine the names we use for periods in human history we find that most of them are names that were first given to styles in the arts: Classical, Gothic, Renaissance, and Baroque are such names. If we look at other world regions, such as China, India, or Southeast Asia, we discover the periods of history are named for kingdoms and empires rather than art styles: Tang and Soong in China, Kushan and Gupta in India, or Khmer in Cambodia. Western art historians have thus defined art styles as the external evidence, or you might say as symptoms, of the spirit or intellect of an age. The architectural historian Nikolaus Pevsner, for example, insists that Gothic and Modern architectural styles "were worked out because a new spirit required them." An architectural style, he says, "is the spirit of an age that pervades its social life, its religion, its scholarship, and its arts."[1] This Western point of view will be basic to the following chapters, which use Western art styles as the framework for a vision of the spirit of past ages. Although it reflects a Western conception of history, this way of seeing history as art adapts very well to other regions, which produced their own great art to express the spirit of the times.

The spirit of our own times, which is the subject of Chapter 14, is torn between revivals of ethnic traditions on one hand and global unity on the other. Electronic communication has brought us all together into what is, in many ways, a global village, but we still find our local traditions valuable. A truly multicultural world is developing, with painting and sculpture becoming a means of expression that enables us to transcend barriers of language and that allows us to speak to each other in our own pictorial languages.

V.1
ANA MENDIETA,
Silueta Series in Mexico, 1973-
77, mold of the artist's body in
the earth, with red pigment,
Photograph by the artist.
Portfolio of 12 color photos
20 x 13¼ in (50.8 x 33.6 cm)
Edition of 20.

In another sense these styles are timeless. Pablo Picasso told an interviewer: "To me there is no past or future in art. If a work of art cannot live in the present it must not be considered at all. The art of the Greeks, of the Egyptians, of the great painters who lived in other times, is not an art of the past; perhaps it is more alive today than it ever was."[2] Ana Mendieta (1948–85), a Cuban refugee educated in Iowa, turned to ancient sources, especially in the Taíno culture of Cuba, for inspiration, taking its stories and art as sources for her own work. In the 1970s she made videotapes and photographs of performances and earth art based on an art style that had been extinguished in the early 16th century. The mold of Ana Mendieta's body pressed deeply into the earth and scattered with brilliant red pigment (Fig. V.1) shows that the ancient style was not used up, but remains as raw material for contemporary use. Any style that has a living audience remains alive. The "great styles," as that term is used here, are those that inspired artists and audiences over long periods, that have often revived, and that continue to have living audiences today.

10

Ancient Styles

What we call "ancient times" endured for about 30,000 years, from the beginnings of art to the end of the Roman Empire, the long period in which we humans discovered the world and our own abilities. It begins with painting the walls of caves, and ends with

PREVIEW

building some of the largest and finest buildings ever. It begins with carving small figures of people and animals, and ends with Egyptian, Greek, and Roman sculpture, which is still regarded by many as unsurpassed. Art sprang into existence in all parts of the globe, but in this chapter we will examine European cave art and the art of early cities in Mesopotamia, the Maya region of Central America, and Egypt, and finally we will look at the development of Classical art in Greece, in the kingdoms founded by Alexander the Great (called Hellenistic art), and in the Roman Empire. By A.D. 410, when Rome fell to "barbarian" armies, the art world as we know it had been largely invented, with professional artists, critics and historians, patrons and collectors, and the idea that art was intended not only as offerings to gods, but for an audience of living people.

THE GREATEST OBSTACLE TO UNDERSTANDING THE PAST is the feeling that the world came into existence when we were born. Everyone naturally feels that way. How will you convince your own children that your life before they were born was real, with real problems and real pleasures?

The size of the numbers is another obstacle. We know people who were alive fifty years ago and every day we see things that were in use then, but very few of us can know anyone who was alive even a century ago, and things used then are becoming scarce in our lives. That is one of the uses of art, which is saved from earlier times because people admire it: it provides a solid link between our time and earlier people, something we can see and touch, just as they saw and touched it.

Today we are so time-conscious, wearing watches and watching clocks, that a century seems like a very long time—so long that a century has little meaning in human life. A more realistic measure of time is a generation, which is usually calculated as thirty years. By that measure about sixty-seven generations of children have been born since the time of Jesus and the foundation of the Roman Empire (in 27 B.C.). Recent research has pushed back the date of the earliest appearance of the modern human species, to which all living people belong, to about 900 centuries

Ancient Styles,
25,000 B.C.–A.D.1000

| 25,000 B.C. | 20,000 | 15,000 | 10,000 | 5000 | 1000 A.D. |

EUROPE

Upper Paleolithic styles, c.35,000–8000 B.C.

"Venus" figurines, 24,000–21,000 B.C.

Cave art (Lascaux Cave), 18,000–10,000 B.C.

AMERICAS

Frederick Head, Oklahoma, c.18,000 B.C.?

Pecos style, Texas, c.6000–1000 B.C.

Tiahuanaco, Bolivia, c.100 B.C.–A.D. 700

Maya civilization, Mexico and Guatemala,
c.100 B.C.–A.D. 900

ago, which amounts to about 3,000 generations. That is a large number, but not an unimaginable one. In this chapter we will look back at some of the things made by those earlier generations and, through those things, try to grasp the reality of their lives. Styles exist only to convey messages about people's experience. To examine a style is to try to understand the experiences of others' lives.

One of the common ancient experiences was migration into uninhabited territories. The modern *Homo sapiens* species first developed, as far as we know now, somewhere in eastern Africa or western Asia and slowly spread around the globe. As we consider ancient styles it is not so much dates we must remember as stages of cultural development. The dense populations of western Asia and its nearer neighbors developed new ways of life first, and the styles that go with them, while more isolated groups on the frontiers adopted those ways and styles much later. That is why we use such terms as Stone Age instead of the dates of a period.

THE STONE AGE

It is a strange fact that the oldest art tradition is also one of the newest. Old Stone Age, or Paleolithic, art lay unknown for several thousand years and was discovered only in the past hundred or so years. It reappeared as part of world art at the time the Impressionist painters were working! It has had a large impact on our ideas of world history, and even on our idea of what art is. Modern artists, as we shall see, were deeply influenced by the discovery of Stone Age art. Researchers and archaeologists are constantly making new discoveries on this frontier in time. The abundant paintings discovered by explorers in Chauvet (*sho-VAY*) Cave in southern France in 1994 show that Stone Age artists still have hidden surprises for us. Dated at about 20,000 years old, the paintings show herds of wild horses and cattle, with rhinoceros, panthers, bears, hyenas, deer, owls, and other animals among the 300 paintings and engravings on the limestone walls (Fig. **10.1**). A pair of fighting woolly rhinoceroses can be seen at lower right. Outlines and prints of the artists' hands are also found, and a bear's skull set on a stone as if on an altar. Chauvet is a large cave—one of its chambers measures about 130 by 230 feet (40 by 70 meters).[1]

Of the Stone Age styles, that of western Europe is by far the best known. European Stone Age style can be summarized as unified by its concentration on single figures of animals, more rarely humans, without a setting. The main element is a contour line that expresses the natural action of a three-dimensional form, painted or incised on natural rock walls. Color was applied within the contours,

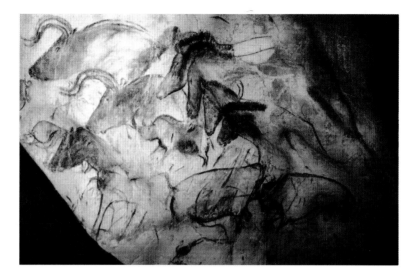

10.1 (*left*)
Paleolithic wall paintings,
Chauvet Cave, Ardèche,
France,
c. 20,000–17,000 B.C.

10.2 (*below*)
Venus of Willendorf,
Czech Republic,
c. 23,000 B.C.
Limestone,
4⅓ in (11 cm) high.
Naturhistorisches
Museum, Vienna.

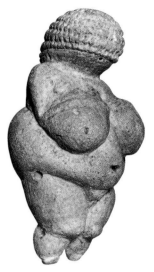

with variations that enhance the sense of mass. Figurines of people and animals, of a size to hold in the hand, were carved of stone, bone, and ivory, the masses simplified and bounded by lines.

By 12,000 B.C. people who were physically and mentally identical to modern people already had a long cultural tradition behind them. The newest modern art to them was painted in the caves of Altamira (*alta-MEE-rah*) in Spain and Lascaux (*lah-SKO*) in France (see Fig. **10.4**), while the oldest art, from thousands of years earlier, was in the form of stone figurines, such as the Venus of Willendorf (*VIL-len-dorf*) (Fig. **10.2**). Even though the little figurine was by then very old, people would still have understood its content, as we instinctively do today. Holding this plump little carving in the palm of your hand, it is easy to understand that it is concerned with the fertility of women. The power of human beings, and all living things, to reproduce themselves was the great mystery that dominated religion and art. The featureless face of the "Venus" (a name assigned later; this is not the Roman goddess Venus) suggests that for Stone Age people the mind, in which men and women are alike, was of less concern than their role in reproduction, in which they are different. That round figurine tells us that the female power to give a body and nourishment to babies was a sacred mystery.

Since it is obvious from looking at children that they also inherit from their fathers, ancient people conceptualized the father's role as giving the soul. The whole universe was explained in terms of this relation of female to male, the earth being "Mother" and the sky "Father."

But animals, not humans, were the most popular subject in Stone Age art. Hunting and butchering of animals was the business of life, and everyone was expert on the appearance and anatomy of animals. The tiny ivory carving of a horse (Fig. **10.3**), which was found in ancient deposits (more than 25,000 years old) in a cave in Germany, is the work of an artist confident in his knowledge of animals and

10.3
Horse found in Vogelherd
Cave, Württemberg.
Germany,
Before 25,000 B.C. Ivory,
c. 2 in (5 cm) long.
Institut für Vor- und
Frühgeschichte, Tübingen,
Germany.

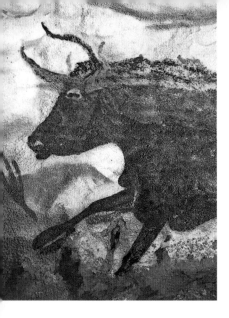

experienced in shaping his hard material. Artists sometimes made abstract patterns, but they were most interested in lifelike representation. The graceful movement of the animal is part of the message of this small sculpture. Hunting weapons and tools were often decorated with carving, but this horse is pure art—what we call "art for art's sake." Modern people sometimes doubt that Stone Age people had such an idea of art, but they have the problem of explaining why such objects as this horse was made. Probably people always treasured such things, just as we do.

Few modern people ever see animals free in nature as Stone Age people did, and everyone who has is overwhelmed with a sense of the bursting power of life. That was surely what the painters of Lascaux Cave (Fig. **10.4**) were trying to express in the herds of animals—deer, wild cattle, horses, bison—painted on the walls and ceilings. Lascaux is a small, dry cave where the ancient painters could bring their children, whose footprints are still to be seen. (Other caves, hundreds of yards deep, have art in inaccessible chambers that were blocked even in ancient times by water and could have been reached only by the hardiest adventurers.) Probably we should

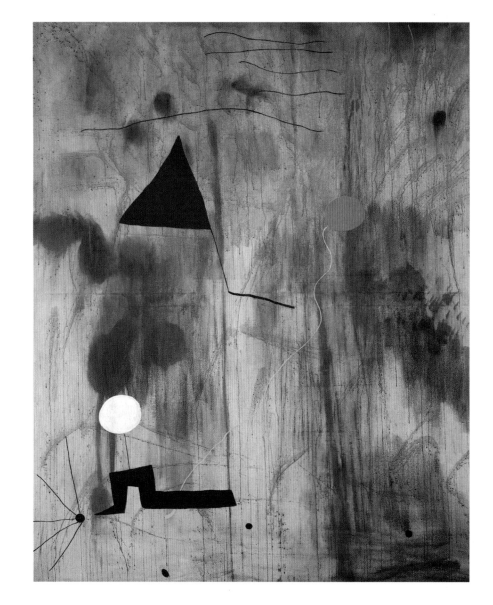

Miró's Use of the Past

10.5 (left)
JOAN MIRÓ,
The Birth of the World,
1925.
Oil on canvas,
8 ft 2¾ in x 6 ft 6¾ in
(2.5 x 2 m).
Museum of Modern Art, New York

10.6 (opposite)
Horses and handprints,
Pêche-Merle Cave, France,
c. 15,000 B.C.
Natural pigments on cave wall,
14 ft 6 in (4.4 m) wide.

imagine those family visits as being more like going to church than like going to a museum. People naturally think first of the content of art, which in Lascaux and the other ancient caves showed images of a fertility religion.

The journalist Shana Alexander wrote of her visit to Lascaux:

> Surely it is the cave of caves. Oval, arched, domed, jagged yet surprisingly symmetrical in form, it gave me an intense impression of standing inside a living body. Images of scarab or of whale came to mind—interiors of carapace or of rib cage; of silence, darkness, waiting to be born. ... Ancient man, who knew all caves as I know none, surely felt the perfection of this one particular cave. It was no accident that he chose in this rock to build his church.[2]

That sense of the cave as a living body was surely shared by ancient people, for the idea of caves as the womb of Mother Earth, from which all life—animal and human—emerges, is one of the basic ideas of early times. Lascaux Cave is the womb of earth, pregnant with the herds of animals on which human life depended.

10.4 (*opposite*)
Lascaux Cave, Dordogne, France, c. 15,000 B.C.

A POINT IN TIME

The Spanish painter Joan Miró (*hwahn mee-RO*; 1893–1984) was working in Paris as a young man when some poets, writers, and artists formed a group to practice art based on the new psychological discoveries of Sigmund Freud (*froyd*) and Carl Jung (*yoong*). They were interested in cultivating the creative powers that were believed to lie in the unconscious parts of the mind. They called themselves Surrealists—we might translate that "super-

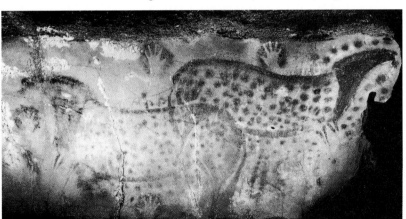

realists." Miró had several friends in the group and seemed to join mostly out of friendship. No one thought of the young painter as an intellectual type. He never said much, but his art changed so much in the next few years it is clear he was listening.

Miró came from northern Spain and was familiar with the famous and controversial discoveries of cave art, which were accepted as the authentic work of ancient people only during Miró's youth. "Miró's beloved Altamira caves"* were part of his own national heritage.

Prehistoric art of the caves seemed to fit into a theory of the psychological development of human beings that was popular with the Surrealists. They accepted the idea that the human personality had begun with only unconscious instincts, what Freud called the id, and they assumed that ancient people had never developed the conscious personalities, which psychologists call the *ego* and *superego*. Since cave art was the oldest art known at that time, it must be the product of the pure unconscious mind, they thought. In the 1920s it was hard to know what unconscious art should look like—all the people the Surrealists knew were extremely conscious, driven by their egos and their superegos, Freud would have said. Joan Miró said nothing, but in *The Birth of the World* (Fig. **10.5**) he began to treat his canvas as if it were the flat wall of a cave, rather than a window into space. He was inspired by the spots and lines as abstract marks, as we see in the horses of Pêche-Merle (*pesh-mairl*) (Fig. **10.6**), discovered and copied at just that time. Those, surely, were perfect examples of instinctive art, free of the contamination of intellect and calculation as the Surrealists believed it should be.

Art is inspired by art, but it is a surprising occurrence when the most advanced art is inspired by the oldest.

*William Rubin, *Miró in the Collection of the Museum of Modern Art* (New York: Museum of Modern Art, 1973), p. 60

Although the most famous Stone Age art is found in western Europe, there are also important examples in the United States. Many of these are hard to date with much precision (though a guess of 18,000 B.C. was suggested by one authority[3]) and are still poorly understood, such as the moon-like face, called the Frederick Head, carved in stone and found in southwestern Oklahoma (Fig. **10.7**). It is one of several oversize heads from the Great Plains region and, like some others, this one was found in gravel deposits more than 15 feet (4.6 meters) below the surface. The geology dates the Frederick Head to the Old Stone Age, but we still know nothing more about the artist than we can read from the sculpture itself. That tells us that the artist was able to grind stone into patterns of pits and grooves, a style of stone-working known worldwide and going back into pre-*Homo sapiens* remains in Europe. Only in America do the pits and grooves turn into faces, which hints that they may be relatively late Stone Age works, done by artists who invented new uses for old ways of marking stone.

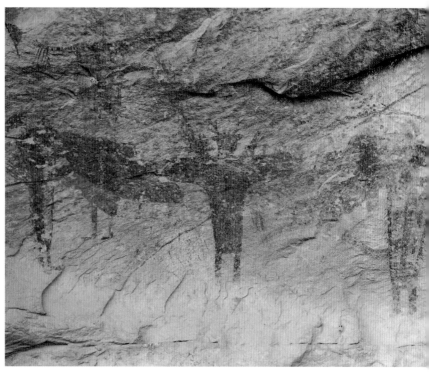

10.7 *(above)*
Frederick Head,
c. 18,000 B.C.
Stone, c. 10 in (25 cm)
in diameter.
Great Plains Museum,
Lawton, Oklahoma.

10.8 *(above right)*
Horned and winged
shaman figures, Fate Bell
Shelter, Seminole Canyon,
Texas, c. 4000 B.C.
Pigment on natural rock
wall, figures
c. 7 ft (2.1 m) tall.

Along the Pecos (*PAY-kose*) and Rio Grande rivers, in southwestern Texas, there are paintings in shallow caves—usually called "rock shelters"—which represent a later (6000–2000 B.C.) phase of art, called the Pecos style (Fig. **10.8**). They are different from the Lascaux Cave paintings because the main subjects are human—or humanlike, at least. These figures are considered to be "medicine men," or shamans (*SHAH-mahnz* or *SHAY-mahnz*), with antler headdresses, sometimes with wings, holding spear-throwers (the common ancient weapon worldwide). Animals appear, especially mountain lions and deer, perhaps symbolizing the hunter and his prey. You will notice that the Pecos style is more abstract than that found at Lascaux, often with straight-lined geometric shapes and sharply defined areas of color. Those are considered features of later Stone Age (or Neolithic) style, of which the Pecos style could be considered a part, although the pottery and agriculture common in Neolithic cultures are absent in the Pecos culture. But the style does suggest that the Pecos people were beginning to think in abstract symbols, not the visual images that dominate in Lascaux Cave. Abstract symbols were later to grow so important that they separated from art to become writing and numbers, leaving the pictorial parts behind to be what we still call "art." The Pecos style shows the image and the abstract symbol still united.

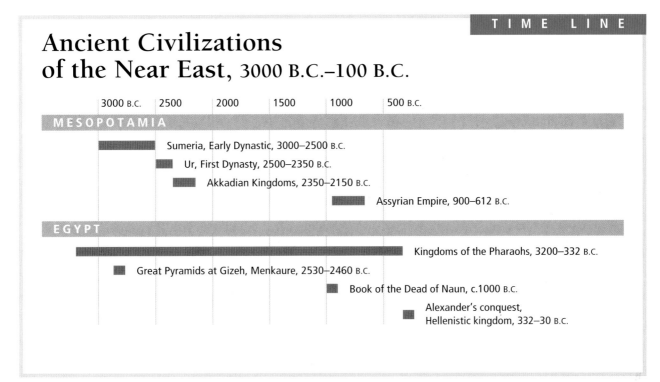

Ancient Civilizations
of the Near East, 3000 B.C.–100 B.C.

3000 B.C.	2500	2000	1500	1000	500 B.C.

MESOPOTAMIA

Sumeria, Early Dynastic, 3000–2500 B.C.

Ur, First Dynasty, 2500–2350 B.C.

Akkadian Kingdoms, 2350–2150 B.C.

Assyrian Empire, 900–612 B.C.

EGYPT

Kingdoms of the Pharaohs, 3200–332 B.C.

Great Pyramids at Gizeh, Menkaure, 2530–2460 B.C.

Book of the Dead of Naun, c.1000 B.C.

Alexander's conquest,
Hellenistic kingdom, 332–30 B.C.

ART IN THE EARLY CITIES

One of the most important changes in social life was that from rural life to city life. That change followed an earlier one in which plants and animals were domesticated and people settled down in villages near their fields and pastures. Cities developed from densely inhabited farming villages in the fertile lands on the banks of large rivers in Iraq, Egypt, Pakistan, and India and later in China, Mexico, and Peru. Despite their wide separation in time and space, all these ancient cities shared a preference for certain features of style, such as the gigantic and the miniature, story-telling art, and art produced by the use of fire, and they had systems of record-keeping that grew out of art. Stone Age art could mostly be made by one artist and would fit in the hand or on a cave wall, but in the ancient cities there was a new preference for works so large that many people had to work together to make them or, in contrast, so tiny that it is hard to imagine that a human being made them. While older art usually showed single figures or a single event, the new art of the cities preferred many figures and several events, which told a story. The technology of art also changed, with fire the main new tool used to make pottery, metal, and glass. The audience also changed: the democratic family groups of earlier times had combined into large societies in which powerful leaders had emerged. The most elaborate and expensive forms of art were sponsored by this class of leaders, who could demand much more labor and skill than had ever been available before. These ancient cities are considered the beginning of civilization, a word usually signifying people who live in organized settlements (cities) and have developed a form of writing. But the ancient cities varied dramatically, and their systems of record-keeping and communication differed.

Despite the wide differences among these cites, they had some features in common. An idea that was shared among these ancient societies was that there were many gods who were in charge of all aspects of the natural world. The most powerful of the gods could be found on the mountaintops or in caves within the high mountains. Since there are ordinarily no mountains in the fertile river valleys where the ancient cities were located, the people worked in teams to make their largest constructions, the artificial mountains used as temples and as tombs for their leaders. Perhaps the oldest of these are the towers in Mesopotamian temples, called

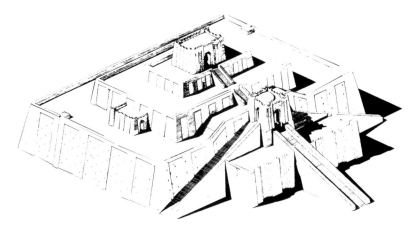

10.9 (*right*)
Ziggurat at Ur,
Mesopotamia (Iraq),
2250–2233 B.C.
Reconstruction drawing
(adapted from a drawing
at the British Museum,
London).

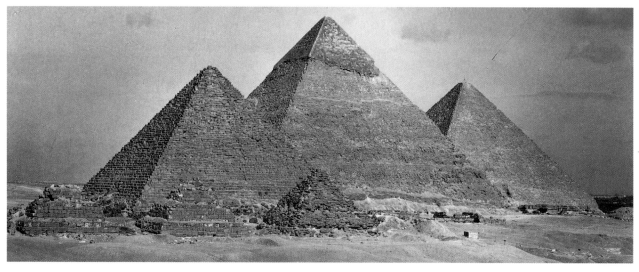

10.10 (*above*)
Pyramids, Gizeh, Egypt,
2530–2460 B.C.
Limestone,
tallest originally 480 ft
(146 m) high.

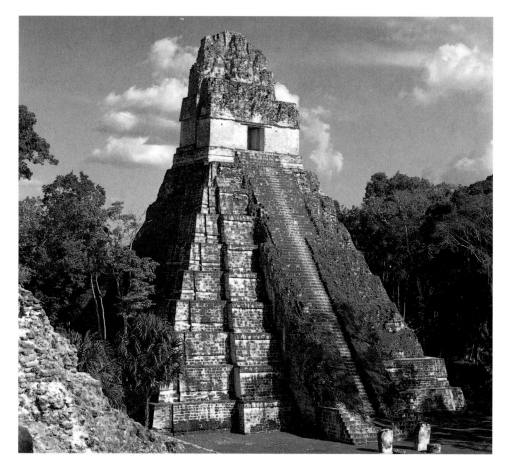

10.11
Temple I at Tikal,
Guatemala,
C. A.D. 700.
Limestone,
155 ft (47.2 m) high.

ziggurats, a word meaning "mountaintop" (Fig. **10.9**). In almost all the early cities there is some kind of artificial mountain as part of their temple or royal tomb. The pharaohs (kings) of Egypt in early times were buried within gigantic stone pyramids, as if in a cave in the sacred mountain (Fig. **10.10**). The Maya of Guatemala and Mexico built artificial mountains in their own style over the tombs of their kings (Fig. **10.11**). The amount of labor that went into many of these constructions amazes modern observers. To the ancient Mesopotamians, Egyptians, and Maya the interesting fact was how large a construction human beings could build when they worked together.

The building of pyramids is a common feature of the early cities. It is one of the features, along with those enumerated above, which define the great family of ancient civilized styles. But each of these ancient civilizations had its own particular style and must be considered apart from the others.

A 5,000-year-old tomb in France inspired a modern architect's design for a chapel (see Fig. **8.50**).

MESOPOTAMIA

Mesopotamia (*mes-uh-puh-TA-mya*; from the Greek for "between the rivers") was a marshy region between the Tigris and Euphrates rivers in what is now Iraq. Civilization flourished there about 4000–500 B.C., and the oldest cities were built here about 6,000 years ago. By about 5,000 years ago the Sumerian people of this region had developed a system of writing with a wedge-pointed stick on clay tablets, called cuneiform (*kyu-NE-uh-form*) writing. Besides clay tablets, cuneiform inscriptions have survived on stone cylinder seals (Fig. **10.12**), which were rolled onto the clay as a signature. These tiny sculptures were at the opposite extreme from the colossal ziggurats. The small stone cylinder was cut with a pattern, sometimes abstract but often representing mythical figures. The identities of the beings on this cylinder seal are unknown, but we can guess that the idea was the conflict between the herdsman with his domestic cattle and the wild animals that preyed on them. The seal-cutters were the forerunners of the designers of coins; we are usually concerned only with the value of coins, but they are works of art in approximately the same category as the ancient seals.

Pyrotechnologies, or the technologies of fire, were the "high tech" of the ancient cities, as the artisans learned the effects of fire on different kinds of clay (which produced pottery and glass) and stone (whose ores produced metal). The life-size bronze head of a Mesopotamian king (Fig. **10.13**), who ruled the Akkadian kingdom about 2300 B.C., is the oldest existing portrait in metal. (Its eyes were originally inlaid with precious stones, torn from their

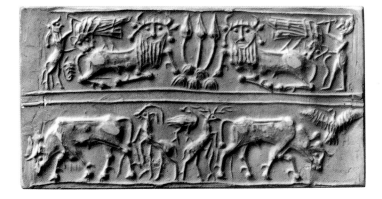

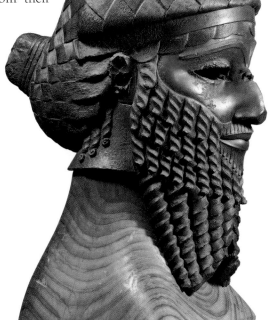

10.12 (*above*)
Print from a Mesopotamian cylinder seal, c. 2700 B.C.
Original in the British Museum, London.

10.13 (*right*)
King of Akkad
(perhaps Naram-Sin),
c. 2300 B.C.
Bronze, 14⅜ in (36 cm) high.
Iraq Museum, Baghdad.

sockets by robbers long ago.) This is an idealized portrait, with every part simplified and perfected, as we see in the eyebrows. The king's hair is braided into a knot at the back of his head, and his full beard, the pride of Mesopotamian men, is shown in elaborate curls.

Mesopotamian art was especially good at telling stories. One of the oldest surviving works of art, called *The Standard of Ur* (Fig. **10.14**), is a strange wooden box inlaid with shell and deep blue lapis lazuli. The side shown here represents the Sumerian army as it enters battle; on the other side is the king's victory feast. Dividing the scene into three registers helps tell the story. The king is the largest figure in the top register, with his infantry and prisoners in the middle register, and four-wheeled chariots at the bottom. The artist had other tricks available as well: the four wild asses pulling each of the four-wheeled chariots are indicated by quadrupling the lines of their heads, legs, and tails, and you can see the story clearly as the asses in the bottom register seem to be walking slowly at the lower left, trotting in the next scene, and at full gallop at the right as they charge the enemy.

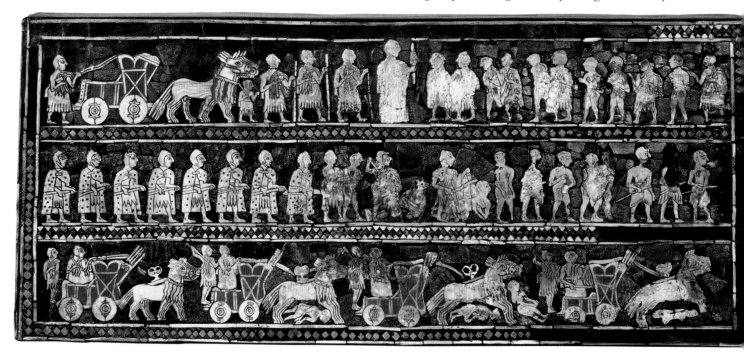

10.14
Scenes of war from
The Standard of Ur,
c. 2685–2645 B.C.
Wooden box inlaid with
white shell and lapis
lazuli, 19 in (48 cm) long.
British Museum, London.

The stories told in much Mesopotamian art are about the fighting, hunting, and feasting of the kings. A terrific series of low-relief panels was carved for the Assyrian king's palace at Nineveh about 650 B.C. showing the king shooting lions from his chariot (Fig. **10.15**). The lions, previously captured, had been released from cages. The artists knew the anatomy of the lion perfectly, but they show no sympathy for the dying beasts. The actions of the king are treated as godlike, and the opinions and feelings of mere people (and lions) count for nothing before such grandeur. The power of this ancient king was so great that he and the nobles who supported him were both the only patrons and the only audience that needed to be considered by the artists.

Mesopotamian artists employed a style that differed from the other styles of its stage of history in its emphasis on the texture of shapes, as you see in the hair, beards, lions' manes, and chariot. Texture gives those shapes greater mass, even though there is little setting to show a space for it. The dense packing of figures and the repetitions of lines (spears, reins) also contribute a sense of physical solidity which is much more pronounced than in Egyptian or Maya art, which, as we shall see, looks slender and ethereal by comparison. Mesopotamian art in general, and Assyrian reliefs especially, show by their style that life in this world, with its fighting, hunting, and feasting, was the main concern.

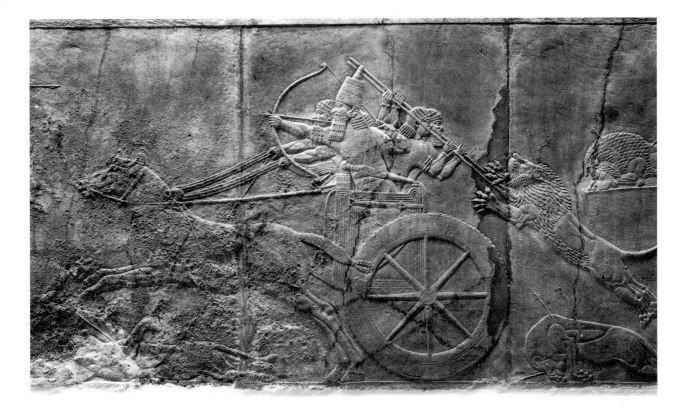

10.15
Ashurbanipal shooting
lions from his chariot,
c. 668–627 B.C.
Stone low-relief panel,
c. 5 ft (1.5 m) high.
British Museum, London.

EGYPT

The pharaohs of Egypt were even more powerful and godlike than the Mesopotamian rulers, and the pharaoh's court, which was moved to a new location near his projected tomb by each new ruler, was always the most important city. The pharaoh, or king, was responsible for maintaining the principle of *ma-at* (*MAH-aht*), which means order, justice, and truth. Like all Egyptian religious ideas, *ma-at* was personified and considered to live in a world that included all nature. Even death was merely an incident in a perpetually living world ruled by eternal gods, and in that sense Egyptian life and art are optimistic. To the Egyptians only the permanent and changeless had importance; even the changes of nature were significant only when they were part of a permanently repeating cycle.

Ancient Egyptian style, which endured for about 3,000 years with only minor changes, emphasized unity by dividing its compositional field (or block of stone) into a grid pattern of vertical and horizontal lines into which the subject was fitted, with parts reserved for writing when needed. Line was used as the boundary of shapes, which were mainly parallel to the picture plane. Masses in sculpture were likewise parallel to the planes of the rectangular block and were simplified to reduce the impression of movement. Color was flat and unaffected by light and shadow. All of these features of style expressed that sense of permanence and order.

Frontal poses were the result when that style was used for sculptures in the round; in relief sculptures the head and legs were in profile, the shoulders in front view. The original Egyptian observers of this art saw these poses as simply true—true in somewhat the same way that a statement in **hieroglyphic writing** is true. This is a clear case of ideas about reality dictating an art style.

Artists did not think of their skills as something belonging to them, but as a power of the gods they worked for. When a statue was completed, a ceremony was held in which the figure's name was carved in hieroglyphic writing, to give it an identity, and "its mouth was opened," which gave it life. It is clear that Egyptian artists were not making art in the sense we use the term, for the pleasure of a living audience. Nor was the artist an individualist; on the contrary, artists were part of a professional group that had a collective identity and tradition.

An Egyptian relief is discussed on pp.116-17 (see Fig. **4.1**).

The double portrait of the pharaoh Men-kau-re (*men-KOW-rah*) supported by his wife (Fig. **10.16**) shows the style in its massive form. Even so, you could easily make a drawing of it with lines, joining the lines to form simple shapes. The sculpture suggests a perfectly orderly eternal world where people remain forever young. To make the sculpture truly eternal for placement in the tomb, a very hard stone was used; and to make the sculpture still harder to break, it was not pierced with holes between the two figures, between their arms and bodies, or between their legs.

The lower classes were sometimes portrayed in more relaxed or active poses, as we see in the musicians entertaining at a dinner party painted on the wall of the tomb of Nakht at Thebes (Fig. **10.17**). Their faces and legs are in profile and their shoulders frontal, but they play their instruments in a natural way. The girl in the center is unusual in having her head turned away from the movement of her body, giving an impression of greater action, but both her head and body are parallel to the wall surface. Egyptian artists accepted what seems to us a rigid formula for human figures and such minor departures from the ideal pattern were always rare.

10.16 *(below)*
Pharaoh Men-kau-re and his queen, 2599–2571 B.C. Slate, 4 ft 6½ in (1.4 m) tall.
Museum of Fine Arts, Boston, Massachusetts. (Harvard MFA Expedition.)

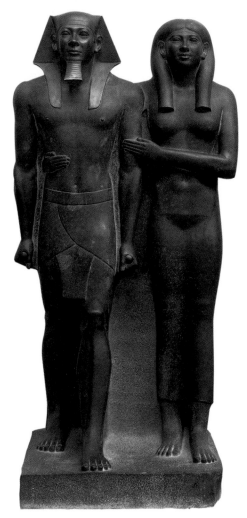

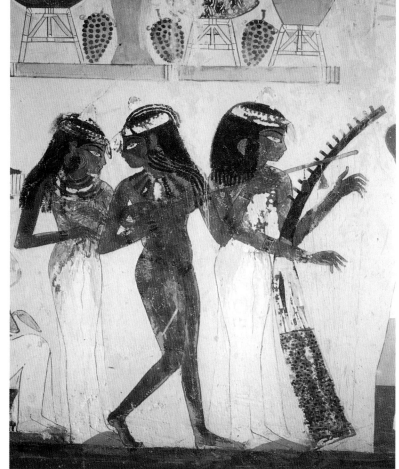

10.17 *(above right)*
Musicians entertaining, wall painting in the tomb of Nakht, Thebes, Egypt, c. 1420 B.C.
Tempera, 16 x 15 in (40 x 37.5 cm)

A common offering in upper-class tombs was a Book of the Dead, a papyrus manuscript of magic spells to aid and protect the spirit of the dead on its journey to the afterworld. *Weighing the Soul of the Dead* (Fig. **10.18**) shows the dead woman, Naun, at the ceremony in which her heart (on the left side of the scale) is weighed against the small figure of the goddess Ma-at (on the right) as Naun recites the list of sins she did not commit in life. Naun, who was a temple musician, is accompanied by the goddess Isis (at left) as the jackal-headed god Anubis, who is in charge of the dead, balances the scales. Thoth, the divine scribe represented as a baboon, sits on the scale and records the result. Osiris, the god of the dead, at right, proclaims "Give

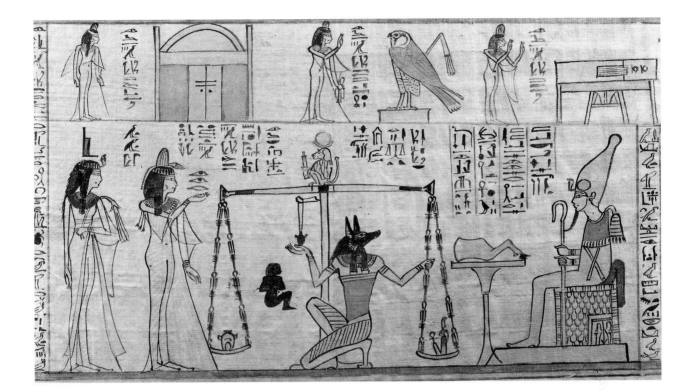

her her eyes and her mouth," meaning that her heart balances with order, truth, and justice and she is returned to life in the afterlife. No matter that these beliefs may seem bizarre to us; the design makes them clear and orderly.

Ancient craftspeople were so adept with their simple tools that sometimes we can hardly imagine how their works were made. The Egyptians were particularly skillful in many different materials, including ivory and glass. The glass cosmetic bottle in the shape of a fish (Fig. **10.19**), found in the Egyptian city of El-Amarna, shows the fusing of several colors of glass. The flowing of the molten glass in the designs of the body and the shapes of the fins shows that the artist was considering the characteristics of the medium in the same way a 20th-century artist would. Art in glass was first perfected in Egypt and has passed down to our day through a tradition that has been continuous in the Mesopotamian and Mediterranean regions.

10.18 (*above*)
Weighing the Soul of the Dead
from the Book of the Dead of Naun, at Deir el Bahari, Egypt, c. 1025 B.C.
Paint on papyrus.
Metropolitan Museum of Art, New York. (Museum excavations, 1928–29, and Rogers Fund, 1930.)

10.19
Cosmetic bottle in the shape of a fish, from El-Amarna, Egypt,
c. 1410–1320 B.C.
Glass,
5½ in (14 cm) long.
British Museum, London.

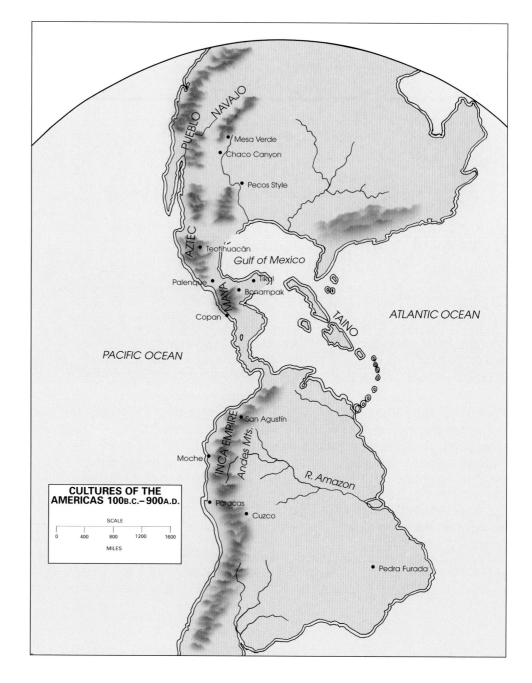

CULTURES OF THE AMERICAS 100 B.C.–900 A.D.

SCALE

0 400 800 1200 1600

MILES

THE MAYA

Large towns and cities began to appear on the American continents by about 3000 B.C., but by far the best known of these ancient American civilizations is that of the Maya (*MAH-yah*), who established city-states in the tropical forests of Guatemala, Mexico, and Belize. One of their greatest cities was Tikal (*tee-KAHL*), which flourished 100 B.C.–A.D. 900. The central sector of the city held several tall temples covering the tombs of kings (see Fig. **10.11**). Maya buildings, like all ancient construction in the Americas, were built by human labor alone, there being no cattle or horses to be domesticated to haul loads of stone and earth.

Maya style was based on drawing with a brush made of flexible hair, which produced the flowing, varied line that was the main characteristic of their art. Maya line shows contours of three-dimensional forms, not flat shapes. Human figures are usually shown with their heads in profile or from the front view, but their bodies are frequently twisted and foreshortened in a way the Egyptian artists avoided. Color was bright and varied, but flat, with no indications of light and shadow. Sculpture

The Tomb of Pacal

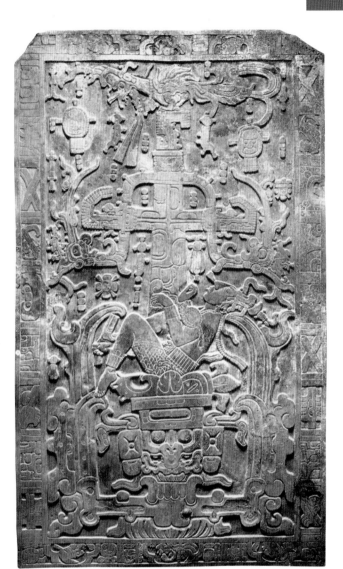

10.20
Maya, Palenque, Mexico. Cover of the sarcophagus of Pacal, ruler of Palenque, A.D. 683. Limestone, 7 ft 3 in x 12 ft 5 in (2.2 x 3.8 m).

On August 31, in the year 683, Pacal, the ruler of the Maya city of Palenque, died at the age of eighty-one. His tomb had already been built deep inside its pyramid that was crowned by a temple. The massive limestone sarcophagus (*sar-KOFF-uh-gus*, a stone coffin) had been carved to receive his body, and the elaborately carved stone lid (Fig. **10.20**), measuring over 7 by 12 feet (2.2 by 3.8 meters), was ready to be rolled into place.

The relief carving on the lid shows Pacal at the moment of death falling into the Underworld, the land of the dead, which is ruled by the Earth Monster, whose mask dominates the lower part of the design on the lid. Sticking out from the lower jaw of the Earth Monster mask are two sets of curving jaws, about to draw the dead king into the Underworld. Above him rises the cross-shaped tree which represents the center of the world. A quetzal bird with its blue-green tail

feathers (which are the color of the sky) sits on top, symbolizing the sky. A border of symbols for the heavenly bodies and celestial events frames the scene. On the edge of the massive limestone slab there are portraits of the king's ancestors.

The elegant carving is in low relief, which stands out sharply from the background plane. But the details on the relief areas still reveal their origin in a drawing with a pointed, flexible brush. Like the art deposited in an Egyptian tomb, this carving was not meant to be seen by living people. Its intended audience was the gods and ancestors living in eternity. It testifies to the superhuman status of the Maya king, who is shown as, in death, he takes his place in the eternal universe.

From L. Schele and M. E. Miller, *The Blood of Kings* (Forth Worth: Kimbell Art Museum, 1986); Merle Green Robertson, *The Sculpture of Palenque* (Princeton, NJ: Princeton University Press, 1984)

was usually in low relief and still close to the drawing done on the stone. But deeper relief and occasionally real sculpture in the round were done, with deeply cut linear designs dominating the masses.

The painted vase (Fig. **10.21**) shows that firm flowing line drawn with a brush. The old man seated on a throne is one of the Lords of the Underworld, the land of the dead, who is attended by beautiful bald young women and a rabbit scribe writing in a book bound in jaguar skin. Some color washes have been added, but they do not suggest illumination. The depth of the figures is shown in a manner seen in all the styles of the ancient cities, by overlapping body parts and doubling lines (woman's legs, rabbit's ears); notice that the faces are all in profile. The form of the vase is very simple, serving mainly as a support for the painting.

Painting on pottery is the most abundant type of Maya art, but the Maya also painted the walls of many of their public buildings with scenes of political, military, and ceremonial life. The murals at Bonampak (*bo-nahm-PAHK*), painted in southern Mexico about A.D. 800, are the best known. This detail (Fig. **10.22**) shows prisoners brought before the ruler of the city. The victors are still in their fantastic battle gear, but the captives have been stripped and are soon to be sacrificed. Inscriptions in hieroglyphics above the figures identify the ruling family on the top of the stepped platform. Notice the poses of the captives, with the heads always in profile but the parts of the bodies foreshortened and overlapping. The colorful clothing and strange mask-headdresses of the warriors give us an idea of Maya arts of textiles and costume, but there are no examples surviving.

10.21
A Maya Lord of the Underworld,
A.D. 600–900.
Painted ceramic, 6½ in (17 cm) in diameter, 8½ in (22 cm) high.
Art Museum, Princeton University, New Jersey.
(Gift of Hans and Dorothy Widenmann Foundation.)

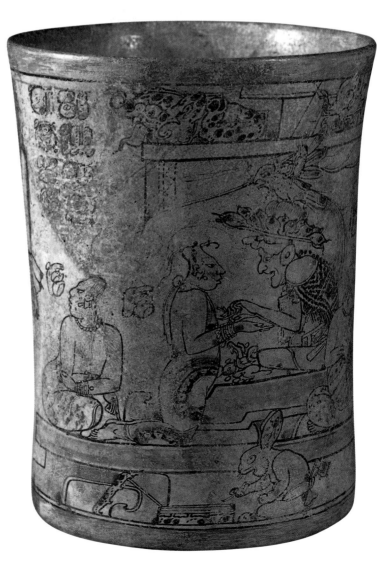

On stone monuments or stelae (*STEE-lee, singular is* **stela**, pronounced *STEE-luh*), which the Maya leaders erected to commemorate events in the lives of the kings, a brush drawing was done first on the stone. Then the sculptor carved away the background in as many levels as needed to make the design clear, leaving low, flat planes of relief. Stela 14 (Fig. **10.23**), from the Maya city of Piedras Negras, shows a young king newly seated on his throne, which he inherited through his mother, who stands below. Symbols of the gods that rule the universe surround the scene. The queen mother, the ladder leading to the throne, and the god symbols are all in very low relief, with the background just barely cut away from the drawn lines. The young king, however, is given much more mass by the cutting away of a deeper space around his body. The green plumes of the quetzal (*ket-SAHL*) bird, which ornamented the crowns of Maya kings, are carved in low relief on that deeper background area. Color may have been added to Maya sculptures such as this, but only traces of it are left now.

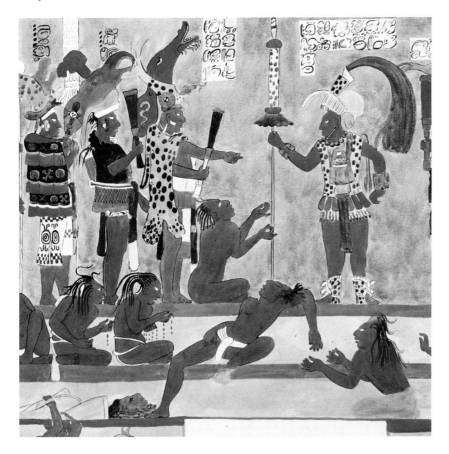

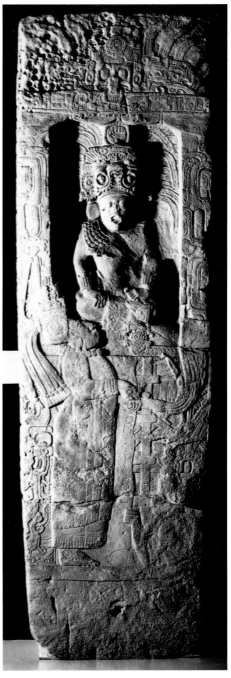

10.22 (*above*)
Maya mural painting at Bonampak, Mexico, c. A.D. 800. Fresco secco, figures c. 24 in (61 cm) high. Watercolor reproduction by A. Tejeda. Peabody Museum, Harvard University.

10.23 (*right*)
Stela 14, the accession of a Maya ruler, A.D. 761. Limestone, 9 ft 3 in (2.8 m) high. Museo Nacional de Antropología y Arqueología, Guatemala City.

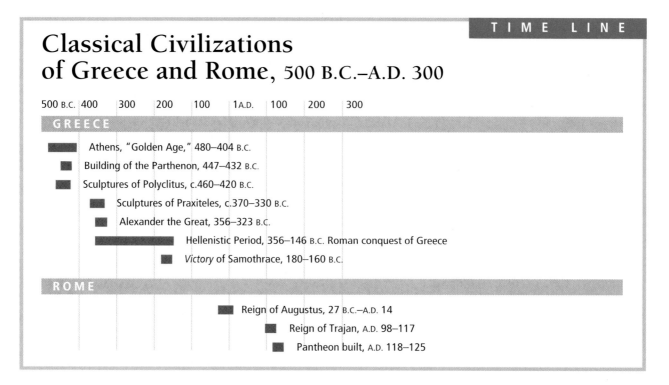

Classical Civilizations of Greece and Rome, 500 B.C.–A.D. 300

500 B.C. | 400 | 300 | 200 | 100 | 1 A.D. | 100 | 200 | 300

GREECE

Athens, "Golden Age," 480–404 B.C.

Building of the Parthenon, 447–432 B.C.

Sculptures of Polyclitus, c.460–420 B.C.

Sculptures of Praxiteles, c.370–330 B.C.

Alexander the Great, 356–323 B.C.

Hellenistic Period, 356–146 B.C. Roman conquest of Greece

Victory of Samothrace, 180–160 B.C.

ROME

Reign of Augustus, 27 B.C.–A.D. 14

Reign of Trajan, A.D. 98–117

Pantheon built, A.D. 118–125

THE CLASSICAL STYLES OF GREECE AND ROME

Ancient Greece and Rome are set apart from the other ancient civilizations. These civilizations, which endured nearly a thousand years (500 B.C.–A.D. 400), are called the "Classical civilizations," and they are classical in two different senses: the first refers to Greek style itself, the second to the admiration of later peoples for it. The word "classic" expresses the belief that there is one way to do something that is better than any other. The Greeks believed that there are particular forms, designs, and customs that are ideal in the sense that they really exist only in our minds as timeless truths—we might say that "they are in the mind of God," although they are very poorly reflected in the chaos of the natural world. For example, the Greeks tried to design architectural forms that would never need to be changed, that everyone would always recognize as the ideal (that is, an idea given physical form). As we saw in Chapter 8, in architecture they came surprisingly close to success in this impossible endeavor. In sculpture and painting they experienced a short period, often called "The Golden Age," when classical idealization reigned. One authority describes Greek classicism as "the emphasis on generic life, on harmonious relation of body and soul, a belief in rational construction of artistic form, in preponderance of rhythm and proportion over naturalistic observation."[4] Classical style emphasized unity, which it achieved by regular repetitions of standardized motifs or elements, usually using a single material for each work. The elements of art that were emphasized were mass and line used as the contour of a mass.

But by 320 B.C. the conquering Greek king Alexander the Great had spread the Greek style from Egypt to India, and artists and their varied new audiences had begun to reject the classical ideal. In the process they invented a new style, though one still part of the Classical family. Called the **Hellenistic** style, it is unified by its single material (for example, marble) and by its use of traditional standard subjects (mainly the human figure), but greater variety appears in the use of the elements of art, especially in effects of highlight and shadow, in lines used to suggest gesture and movement, as in draperies, and in more complex compositions. This dramatic new style was inherited by the Romans of the Imperial age (27 B.C.–A.D. 410), who modified it into something a little more sober and closer to the appearance of nature.

Greece and Rome were classical civilizations in another sense for later European societies and their descendants. Long after the fall of Rome people considered the styles and languages of Greece and Rome to represent the highest standard. Although many other styles have been invented, we still use the term Classical (with a capital C) for the style of Greece and the Greek heritage in the Hellenistic states and in Rome, suggesting that it still has a special prestige. Classical style has been revived over and over and it would surely be a rash prophet who would predict that it would never again be taken as the model for our art. It is not so surprising that we feel close to those styles, for ancient Greece is as close to us in time as the Greeks were to Pharaoh Men-kau-re and his queen (see Fig. **10.16**).

GREECE

Although Greek artists worked in painting, architecture, ceramics, and other arts, sculpture was the basic discipline. Sculpture played such an important part in architecture that to a Greek it would have seemed artificial to discuss one without the other, and painters concentrated on human figures just as they appear in sculpture, with little attention given to setting. Variety found expression in Greek sculpture mainly in materials—carved marble and cast bronze were both common, and a few important works were made in gold and ivory.

In the mountains of Greece there are excellent marble quarries, and this fine stone was used for temples and their sculptural decorations. The most famous are the sculptures of the temple in Athens dedicated to the goddess who protected the city, the virgin Athena (Athena Parthenos); the temple is called the Parthenon, or "shrine of the virgin goddess" (Fig. **10.24**; see Fig. **8.9**). The most important sculpture was the image of the goddess herself, which stood inside. It was made of

10.24

ICTINOS AND CALLICRATES
The Parthenon,
Acropolis, Athens,
447-438 B.C.

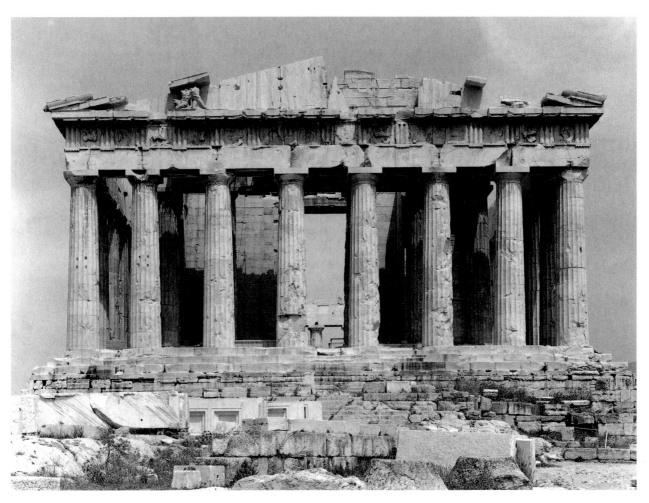

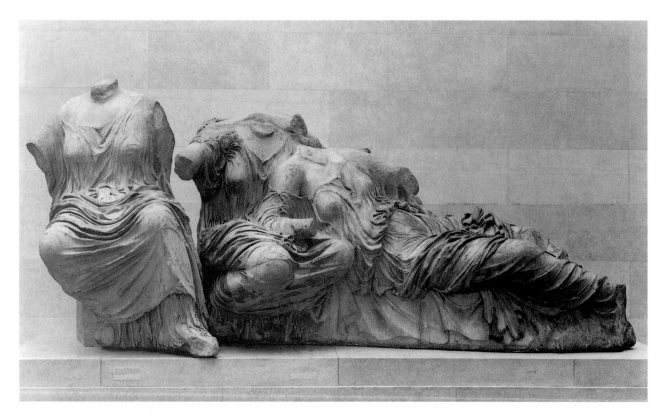

10.25
PHIDIAS,
three goddesses or "Three Fates," east pediment of the Parthenon, Athens, 437–432 B.C. Marble, 4 ft (1.2 m) high. British Museum, London.

thin plates of ivory (for the flesh) and gold (for the clothing). Not surprisingly, that sculpture disappeared long ago, probably when the Parthenon was converted to a Christian church in the early Middle Ages, but what has survived are many of the marble sculptures which adorned the outside of the building: full round figures in the pediments (or gable ends); low-relief sculptures in **friezes** around the **cella** (or sanctuary chamber). The figures in the pediments told two old myths about the life of Athena: her birth from the head of the supreme god Zeus, on the east pediment, and her victory over the sea god Poseidon in a contest for the rule of Athens, on the west pediment. The main figures on both ends were destroyed when the building was blown up in warfare in the 17th century, but many of the "supporting players" in these dramatic scenes have survived in museums in Athens and London. Since they were set nearer the corners of the triangular pediments, they are seated or reclining, as are the goddesses often called "Three Fates" (Fig. **10.25**). The identities

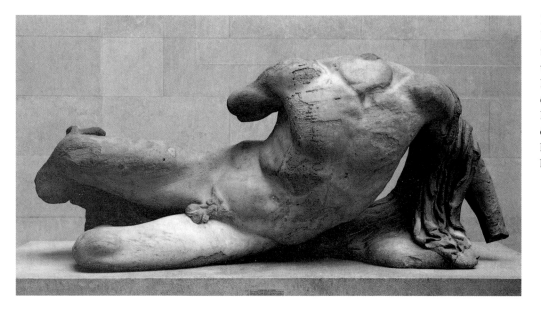

10.26
PHIDIAS,
river god,
west pediment of the Parthenon, Athens, c. 430 B.C.
Marble,
over lifesize.
British Museum, London.

of these figures are uncertain, but the sculptor's mastery of the human figure is not, and the flow of the heavy draperies, far from concealing the forms of the bodies, enhances them. A reclining male figure from the left corner of the west pediment probably represents a river god—the flow of the drapery over the arm, as well as the flowing form of the figure itself suggest the flow of water (Fig. **10.26**). The sculptor had carefully observed the human body to depict the twist of the torso and the pressure of the ribs into the stomach. The Greek philosopher Plato said that the mission of the artist was to hold a mirror up to nature. From the Parthenon

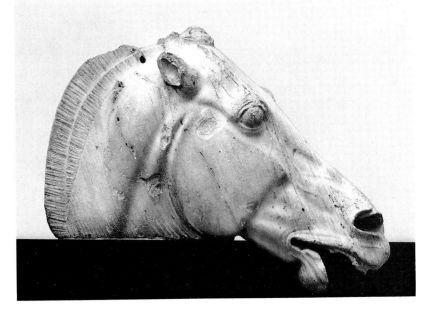

10.27
PHIDIAS,
chariot horse of the sun,
east pediment of the
Parthenon, Athens,
c. 430 B.C.
Marble,
over lifesize.
British Museum, London.

sculptures we can see that what the sculptors meant was not what we mean by the word "nature," with its infinite variation. These human bodies are idealizations: young adults with perfect builds, not one of them too fat or too thin.

The Parthenon sculptures were all made under the supervision of the master Phidias, who probably concentrated his own work on the famous gold-and-ivory image of Athena inside the temple. Nevertheless, we can be sure that all these sculptures conformed to his style and ideas. Classic simplification extended even to the animals in Phidias' style, as we see in the head of the exhausted horse drawing the chariot of the sun as it sinks beneath the horizon at sunset (Fig. **10.27**). The bronze bit which was once in the mouth, pulls the horse's lips back in a very natural way, yet the whole effect is a grand simplification. It is truly an idea given form.

It could also be said that Egyptian art gave form to ideas, but the Greeks revolutionized art so thoroughly that as one authority has put it, "to say that the Greeks invented art ... is a mere sober statement of fact."[5] That statement is perhaps clarified if we amend it to say that the Greeks invented the role of the artist as an imaginative creator. The Egyptians and the Mesopotamians never granted their artists the liberty to try out new patterns for common subjects; their styles remained classical in the sense of an accepted pattern more than the Greek style ever was. What was new in Greek art, which makes it the foundation of our own, was the idea that the artist should invent a world in the imagination, and that each artist should create a new vision. This was a shocking new idea to many people of the time, the philosopher Plato among them. He banned all artists in his description of the perfect civilization because, in his opinion, they were all professional tricksters, showing mere illusions.

If we look at two vase paintings done about a hundred years apart, it is clear that artists were working seriously to develop their inventive powers, despite the objections of Plato and other conservatives, who would have preferred to settle on one pattern and never change it. In the earlier painting, of about 530 B.C., five men compete in a sprint, their bodies painted black on the brick red ground of the clay

10.28
Runners in the
Panathenaic games, from
an amphora,
c. 530 B.C.
Black-figured pottery.
Metropolitan Museum of
Art, New York. (Rogers
Fund, 1912.)

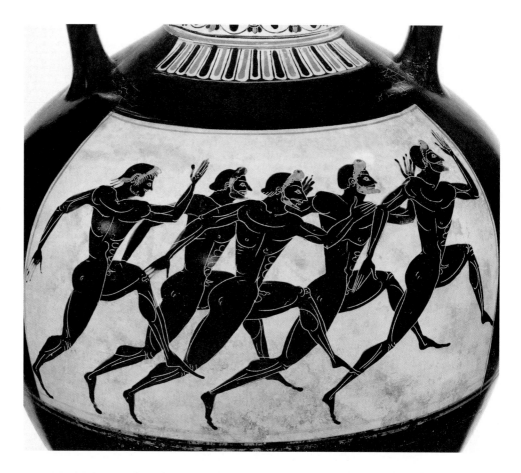

10.29 *(below)*
POLION,
boxers and runners
practicing, from an Attic
volute krater (mixing
bowl), c. 420 B.C.
Red-figured pottery.
Metropolitan Museum of
Art, New York. (Fletcher
Fund, 1927.)

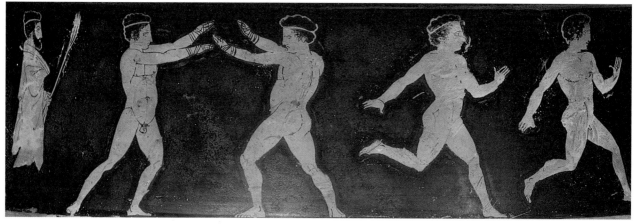

(Fig. **10.28**). You will notice that their heads and legs are in profile, their eyes and chests in front view, similar to the Egyptian stylization. The later painting, from about 420 B.C., shows boys practicing athletics, their bodies left red with the black background painted around them (Fig. **10.29**). The change from black figures to red, which occurred about 480 B.C., gave the bodies more mass by giving them the warm color, rather than the black, which had the flattening effect of a silhouette. But beyond the color change, the boys are in a variety of poses seen from a front or back angle. Starting with an accepted pattern for the male figure, the artists have begun to observe people and make additions to the traditional patterns, arriving at new and more natural patterns. One right way no longer existed, and from this point on, art was open to a constant process of invention—a process that still upsets people today.

The active poses that Greek sculptors began using for their figures early in the 5th century B.C. opened the way for an infinity of poses (see Chapter 7 for a discussion of the contrast between frontal and contrapposto figures). The figures Phidias designed

for the Parthenon are in a tremendous variety of poses, and it is hard to believe that little more than fifty years had passed since the first contrapposto figures had been carved. In later centuries the contrapposto figure became the new standard pose in Greek and Roman art, used almost as universally for the single figure as the frontal figure had been in Egyptian art. The gentle movement of the contrapposto pose always carried a double meaning: that the figure represents a mortal, who lives in time and who is posing beautifully for a living audience. For that reason, Greek art is the first that was art in the modern sense, made to appeal to the aesthetic taste of living people. That is why the first true art collectors were people of the Greek world who cherished art not because it served some useful purpose, such as decorating their houses or sheltering their souls after death, but because they liked it.

The name of the sculptor Praxiteles is associated with such figures in relaxed walking poses, with idealized faces. The *Marathon Boy* (Fig. **10.30**), a bronze sculpture rescued from the sea off Marathon, in Greece, is probably about as close as we can get to Praxiteles' style, since no original by him is known. The graceful gesture, probably one of pouring wine, is an extreme version of the contrapposto pose.

HELLENISTIC ART: 330–30 B.C.

Greek art of the earlier periods especially appealed to early 20th-century people because they shared its concern for abstract forms and geometric compositions. For example, the work of such early 20th-century sculptors as Constantin Brancusi and Aristide Maillol is the result of a modern style sharing features with an old style because both sculptors were searching for ideal forms. Later Greek art of the Hellenistic period especially appeals to the late 20th century because we share its interests in dramatic subjects and the psychology of the figures.

"Hellenistic" refers to the Greek (or Hellenic) style carried by the conquests of Alexander the Great to non-Greek lands—Persia, Mesopotamia, Phoenicia, and Egypt. Alexander, who succeeded to the throne of the Greek state of Macedon at the age of twenty and died of malaria in the Mesopotamian city of Babylon at the age of thirty-three (in 323 B.C.), was the focus of the whole period. On his death his generals divided up their conquests into kingdoms and one of them put a portrait of Alexander on his silver coins (Fig. **10.31**). The face is idealized, but the inspired look in the deep-set eyes is found in all Alexander's portraits; the ram's horns on his head are the sign of the Egyptian god Ammon and remind us that the conqueror, after being crowned pharaoh, made a strange pilgrimage to that god's desert shrine where it was said Ammon claimed him as a son. In this union of Greek and Egyptian we have a key to the Hellenistic world: it had the first "world culture," when trade, travel, and all kinds of contacts brought peoples together. Greeks settled in new cities, such as Alexandria, in Egypt, bringing traditional Greek style with them. Non-Greek peoples in Egypt and western Asia adopted many of the basic elements of Greek Classicism. The absorption by Rome 300 years later of large parts of Alexander's empire spread Greek culture to western Europe and North Africa and made it the foundation for western European culture.

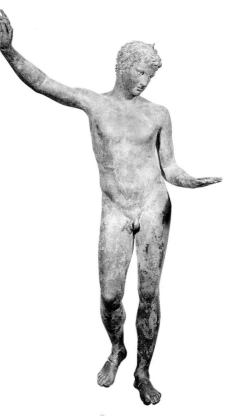

10.30 (*above*)
In the style of Praxiteles,
Marathon Boy,
c. 350 B.C.
Bronze, 4 ft 3 in (1.3 m) high.
National Museum, Athens.

10.31 (*left*)
Tetradrachm (coin) from Thrace, showing head of Alexander the Great with ram's horn of Zeus Ammon and diadem,
c. 286–281 B.C.
Silver, 1¼ in (3 cm) in diameter.
Museum of Fine Arts, Boston. (Theodora Wilbour Fund in Memory of Zöe Wilbour.)

The restrained poses and expressions that were typical of earlier Greek art gave way in Hellenistic art to unabashed exuberance. *Dancing Satyr* (SAY-ter or SAT-er; Fig. **10.32**) was cast in bronze, probably at the city of Pergamon on the Turkish coast about 200 B.C., but, like much Hellenistic art, it is known to us in a Roman copy found in the ruins of Pompeii, where it decorated a courtyard. Half-goat and half-human, satyrs could not control their love of wine, women, and dancing; this one seems to burst with animal high spirits, dancing and snapping his fingers. The horns on his head differ from Alexander's godly horns; here, they go with his tail to show his goat nature.

Another Hellenistic work from Pergamon which was copied by the Romans is the fresco painting of *Hercules Discovering His Son Telephos* (Fig. **10.33**). The kings of Pergamon claimed that their dynasty was founded by Telephos, shown as a baby being suckled by a doe after he was abandoned in the wilderness by his mother. His father, Hercules (son of the god Zeus, represented by the eagle), has finally found his son and looks on approvingly, with the nymph who is the spirit of the mountain where the child was left. The great goddess Arcadia, who rules that abundant land, is seated at the left, accompanied by a young satyr. The land and ancestry of the kings of Pergamon are thus represented by human and animal figures—we could almost call them actors since they are more expressive in pose and more individual in face and body type than personifications in earlier Greek art—many of them standing for places (such as mountain) or a quality (such as fertility).

One of the most popular sculptures of all time, even though the head and arms are missing, is the *Winged Victory of Samothrace* (Fig. **10.34**), which was set up at the city of Samothrace to commemorate a victory in a naval battle. Modern audiences

10.32 (below)
Dancing Satyr, Roman copy from Pompeii of Hellenistic sculpture, c. 200 B.C. (original). Bronze, 28 in (71 cm) high. Museo Nazionale, Naples, Italy.

10.33 (below right)
Hercules Discovering his Son Telephos, Roman copy from Herculaneum of lost Hellenistic painting at Pergamon, c. 150–133 B.C. (original; copy c. 70 B.C.). Fresco, 7 ft 2 in (2.2 m) high. Museo Nazionale, Naples, Italy.

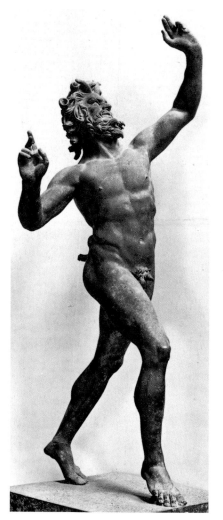

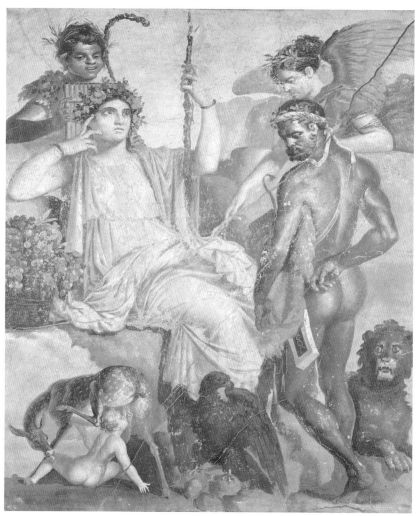

have forgotten its original symbolism, but it has a new meaning for us as the triumphant human spirit. In her original setting she seemed as if alighting on the prow of a ship coming into port and holding out a wreath of victory in her right hand. Below the gray marble base shaped like a ship prow were two large pools of water, one with a rippled floor to produce waves, the lower one holding some great boulders, symbolizing the harbor. "Victory" seems to stride against the wind, her body dramatized by the drapery and lifted by the broad wings. Such picturesque and sensational art was a Hellenistic invention. The theatrical quality of Hellenistic

10.34
Winged Victory of Samothrace, 180–160 B.C. Marble, 8 ft (2.4 m) tall. Louvre, Paris.

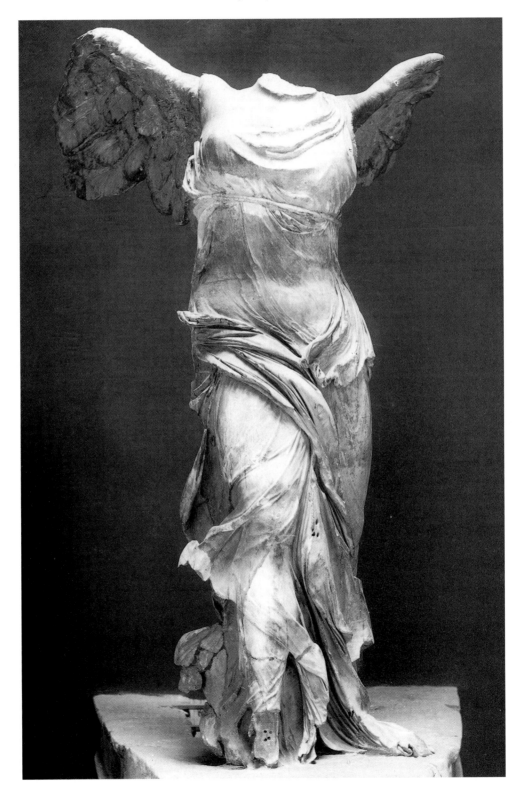

10.35
Detail from *View of the Nile Valley,* c. 75 B.C. Floor mosaic, entire floor 16 x 20 ft (4.9 x 6.1 m). Archaeological Museum, Palestrina, Italy.

sculpture was enhanced by the elaborate settings they were given; actually, their style shares something with popular 20th-century films more than with our more intellectual fine arts.

Hellenistic artists were the first to make pictorial **mosaics**, using small *tesserae* (singular is *tessera*), that is, squares of colored stone, or later of colored glass, set in cement or plaster. *View of the Nile Valley* (Fig. **10.35**) was a large pictorial floor mosaic done in Italy, about 75 B.C., the work of a Hellenistic Greek artist patronized by the Roman dictator Sulla. Egypt at that time was still ruled by Hellenistic Greeks (of whom Cleopatra was the last). The annual flooding of the Nile River was a phenomenon that fascinated the civilized world. The artist gives us a bird's-eye view over the flooded delta, showing boatmen poling their small reed canoes and larger pleasure boats, with many native animals (crocodiles and hippopotami in the lower left, for example). The artist was acquainted with Egypt, for he shows typical Egyptian tower houses, with classical temples and farm buildings mixed among them. The whole mosaic measures 16 by 20 feet (4.9 by 6.1 meters)—the illustration is a detail—but it was intended to be examined up close by people walking over it, so the artist wrote in the names of many of the animals that were strange to Roman eyes.

The Romans took over the Hellenistic kingdoms piece by piece, ending up with Egypt, which was incorporated into Roman territory in 31 B.C. by Augustus in the process of founding the empire. The Romans had native Italian art traditions of their own, but by that time they had developed a passion for Hellenistic Greek art, which they purchased, patronized, copied, or stole at every opportunity. Yet there are features of the art of Rome that belong to it alone.

THE ROMAN EMPIRE

When Julius Caesar was assassinated in 44 B.C., Rome was plunged into civil war for thirteen years. Caesar's nephew Octavius emerged the victor, and he became the first emperor of the Roman Empire, adopting the name Augustus. "Augustus was remarkably handsome and of very graceful gait even as an old man," wrote an early biographer, "but negligent of his personal appearance." He lived very simply, considering that he was the most powerful individual in the world. It is interesting to compare a description of this man of simple tastes with his portrait carved in sardonyx by the gem-engraver Dioscorides (Fig. **10.36**). "Augustus' eyes were clear and bright, and he liked to believe they shone with a sort of divine radiance ... his hair [was] yellowish and rather curly, his eyebrows met above the nose; he had ears of normal size, a Roman nose, and a complexion intermediate between dark and fair."[6] This cameo 5 inches (13 centimeters) high appears to be a good likeness, but it is an amazingly luxurious object. It is only one of a group of cameo portraits of the imperial family done by that artist.

Sculptured portraits were popular among the Romans in much the same way that photographic portraits are popular with us, as a way to remember the appearance of our loved ones. The white marble usually used was painted to bring it to life, but quite a number of Roman portraits are grim faces, based on casts made from the features after death. The best of the portraits, such as that of the general and statesman Pompey (*PAHM-pe*; Fig. **10.37**), give us a wonderful sense of personality. Far from the idealized faces of Greek Classical and Hellenistic sculptures, Pompey's face is unique, with its curling locks of hair over a broad brow, his small eyes under their raised eyebrows, and his tight-lipped mouth. It is a face that suggests a politician rather than a military leader.

The military life was an inescapable part of leadership for men of the Roman upper class as they tried to regulate and expand a vast empire of people with little in common. The Emperor Trajan, who was a soldier by preference, spent most of his

10.36 (*below left*)
DIOSCORIDES,
cameo portrait of the
Emperor Augustus,
c. A.D. 10.
Engraved sardonynx,
5 in (13 cm) high.
British Museum, London.

10.37 (*below*)
Pompey the Great,
c. A.D. 30.
Marble, life-size. Ny
Carlsberg Glyptotek,
Copenhagen.

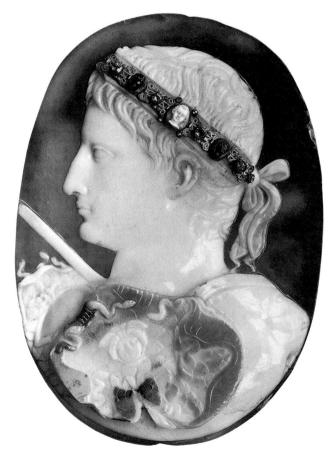

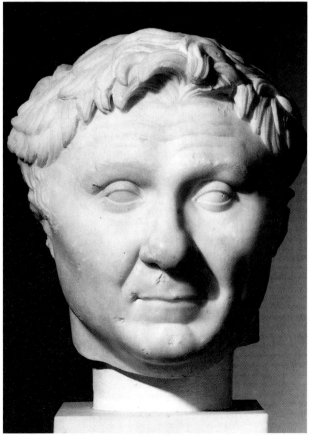

life on campaign and recorded the conquest of Dacia (now Romania) on a famous monument in Rome (Fig. **10.38**). The Column of Trajan carries on the tradition of victory monuments that the Mesopotamian leaders erected, but the Roman monument is more factual and less mythological, despite the presence of some mythological figures such as the river god below the pontoon bridge (bottom row). The column and its base are 123 feet (37.5 meters) tall, the shaft is carved with a spiral scroll-like design, which tells the history of the war in much the way a movie would, with as much accurate detail as possible. The attention to engineering, shown by the emphasis on the pontoon bridge (bottom row) and the erection of the fortified camp (next two rows), is surely a clue to the success of Roman armies. Trajan appears over and over, as the star of this "movie."

10.38 (right)
Trajan's Column, Rome, A.D. 113.
Marble relief, 123 ft (37.5 m) high, bands c. 36 in (61 cm) wide.

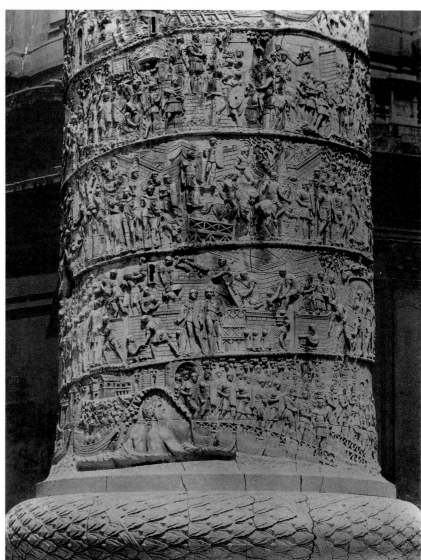

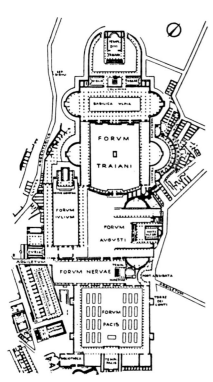

10.39 (above)
Plan of the forum of Trajan, Rome, with neighboring areas, c. A.D. 100.

The column stood in front of the temple dedicated to the emperor as a god (at the top of the plan, Fig. **10.39**). It might seem impossible to see a design wound around such a tall column, but the monument was set between two buildings (famous libraries, one for Greek, the other for Latin, books) from which it may have been more easily seen. All these structures were part of a vast forum, or public mall, built by the emperor for his city. Besides the temple dedicated to the emperor as a god and the two libraries (top of the plan), it also included a concert hall, market buildings, and administrative offices. Such large architectural complexes were the specialty of the Romans and perhaps their greatest art.

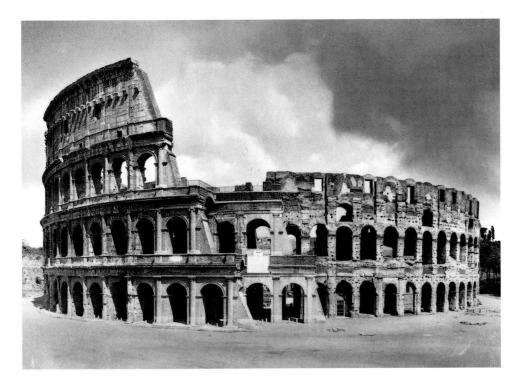

10.40
The Colosseum, Rome,
A.D. 72–80.
Long axis 620 ft (189 m),
short axis 513 ft 156 m),
160 ft (48.8 m) high.

The best known of all their great buildings is the Colosseum (Fig. **10.40**), an oval amphitheater that accommodated about 45,000 people. Its name does not come from its size, however, but from a huge statue of the Emperor Nero that once stood near it. When it was opened the show lasted for 100 days, with animal shows, gladiatorial battles, and even a sea battle staged in the flooded arena. Later people admired many Roman achievements, but probably none more than the architectural skills to build such a practical and efficient structure. We may not approve of the gory shows put on there, but from the architectural viewpoint it provided easy access and good visibility for large crowds. The Colosseum would serve as a definition for the Roman version of Classical architectural style: where the Greek was rectangular in plan and structure (using the post and lintel), the Roman added curving and circular plans and structures (arches, vaults). Where Greek public buildings were often mainly to be seen from the outside and rarely had large interior spaces, Roman public buildings were designed to hold large crowds and to permit all sorts of events (bathing, combats) to be carried out inside. Even the Colosseum, which had no permanent roof, could be covered with a tremendous canvas sunshade suspended from the upper parts of the walls.

We know only a little about the relationships between Roman artists and their audience from literature, which was more concerned with other topics. Art critics then were not specialists, but works of art were often the subject of short witty poems or descriptive essays, and artists were sometimes the subjects of biographies. Most of the ancient writings on art were used by the Roman scholar Pliny (*PLIN-ee*; he died at Pompeii in the eruption of Vesuvius in A.D. 79) as sources for his encyclopedia, called *Natural History*. Pliny himself was not much interested in art, but he knew there was a large audience with a passionate interest in art and artists. His writings on art brought together a storehouse of Classical art history and criticism and were passed down to later ages as models.

Relations between the artists and their patrons were conditioned by their somewhat contradictory desires: the artists to follow the traditional Hellenistic style while making some fashionable innovations and the patrons to have something uniquely their own. Thus the anonymous painters of a room in the country house of P. Fannius Sinistor at Boscoreale, near Pompeii, painted between 65 and 30 B.C., used a traditional set of architectural and landscape subjects, but they also seem to show the patron's own house, somewhat idealized and improved, but individualized

10.41
Mural in the Villa Boscoreale, near Pompeii, 65–30 B.C.
Fresco on lime plaster, average height 8 ft (2.4 m).
Metropolitan Museum of Art, New York. (Rogers Fund, 1903.)

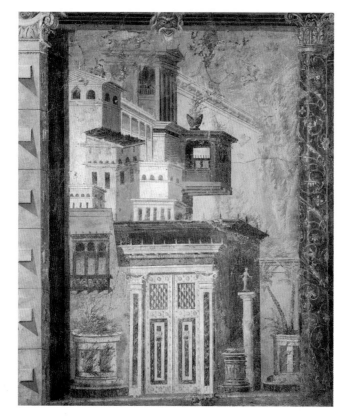

and not merely traditional[7] (Fig. **10.41**). Both artists and patrons worked within firm traditions which indicated appropriate subjects for particular places.

By the end of the Classical civilizations, all the elements of the art world (as we conceive it in our time) were in place: the artist as imaginative creator, the patron, the critic and writer on art, and the audience.

FOR REVIEW

Evaluate your comprehension. Can you:
- describe the kinds of art Stone Age people created, where it is found, and what its main themes are?
- describe at least one of the styles associated with early cities, mentioning the temple-tombs of rulers, royal portraits, sculptures, or paintings?
- explain the meaning of "Classical" in reference to ancient Greek art, mentioning buildings, sculptures, and painted pottery?
- explain how Hellenistic and Roman art differs from Greek Classical art?

Suggestions for further reading:
- Mario Ruspoli, *The Cave of Lascaux: The Final Photographs* (New York: Harry N. Abrams, 1988)
- Harry Shafer, *Ancient Texans* (Austin: Texas Monthly Press, 1986)
- Kurt Lange and Max Hirmer, *Egypt: Architecture, Sculpture, Painting in Three Thousand Years* (London: Phaidon, 1968)
- Linda Schele and Mary Ellen Miller, *The Blood of Kings* (Maya) (Fort Worth: Kimbell Art Museum, 1986)
- George M. A. Hanfmann, *Classical Sculpture* (Greenwich, Conn.: New York Graphic Society, 1967)
- Richard Brilliant, *Roman Art* (London: Phaidon, 1974)

11

Styles of the Middle Ages: 400–1400

Four world regions—Europe, Africa, and eastern and western Asia—generated great civilizations during this 1,000-year period. Each of them was energized by a dominant religion that used art to express its ideas. Christian art in Europe emphasized line and color to show an energetic spirit, adapting a drawing style to architecture and sculpture. In West Africa the polytheistic worship of the creator centered in royal courts, which used durable materials (ceramic, metal, ivory), for royal portraits, while common people made art for ritual use of perishable wood, fiber, or mud. Islam in western Asia rejected most representational art, preferring calligraphic inscriptions from the Koran, used in books, the decoration of mosques, and in the polychrome ceramics and fine carpets that were widely famed. Visions of paradise were the basic subject. In China Buddhism competed with native traditions, its style and subjects stressing serenity in a chaotic world. Artists were often educated officials in the imperial government, who painted with the same brush and ink that were used for writing. During the Middle Ages art in all these places was an expression of spiritual education and knowledge, and was patronized by powerful rulers.

P R E V I E W

BETWEEN THE FALL OF ROME to Germanic armies (in 410) and the Renaissance, beginning about 1400, lie the Middle Ages. Three great world religions spread their own special art styles around the globe during the Middle Ages: Christianity, centered in Europe; Islam, which had its main centers in western Asia and North Africa; and Buddhism, which dominated eastern Asia. All three of those religions were in competition with older traditions. The Vikings in northern Europe converted to Christianity only in the year 1000; Islam had to contend with ancient traditions in Africa; Buddhist missionaries in China never succeeded in eliminating Daoism (DOW-izm) and Confucianism. You can easily imagine that art quickly became a weapon and a tool to win converts, teach the faithful, and glorify the special virtues of each of these different religions. In those days it was hard for a Buddhist to be tolerant of Daoist art or a Moslem to admire Christian art. Educated followers of all these faiths have learned that it is possible to study art styles of other religions without damaging one's own, but in those days religion was a public matter—when the king changed religions, so did all his people, with art playing roles we assign to magazines and television.

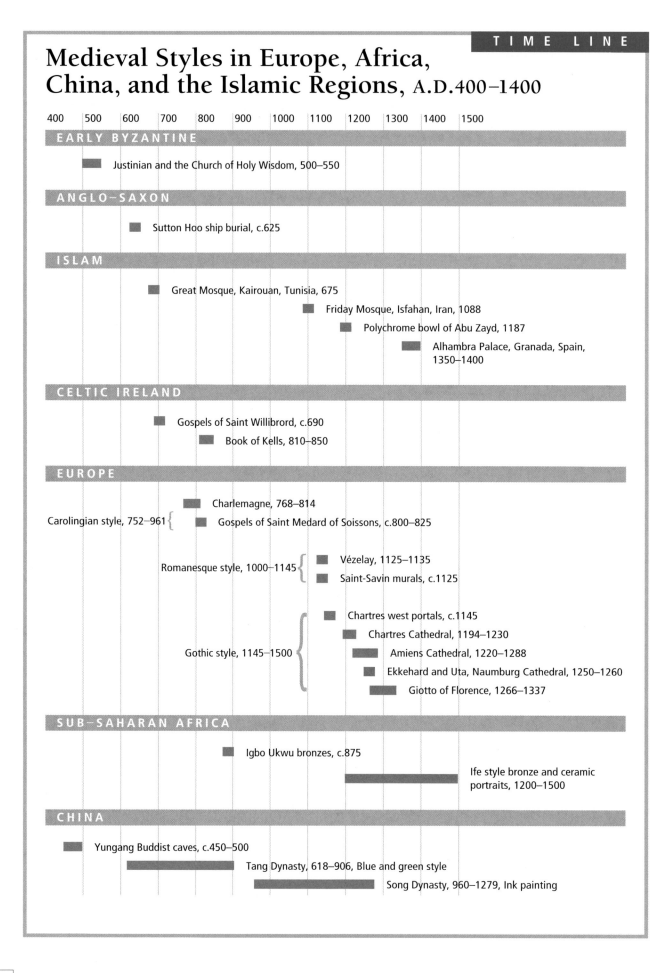

Medieval Styles in Europe, Africa, China, and the Islamic Regions, A.D. 400–1400

TIME LINE

| 400 | 500 | 600 | 700 | 800 | 900 | 1000 | 1100 | 1200 | 1300 | 1400 | 1500 |

EARLY BYZANTINE

Justinian and the Church of Holy Wisdom, 500–550

ANGLO–SAXON

Sutton Hoo ship burial, c.625

ISLAM

Great Mosque, Kairouan, Tunisia, 675

Friday Mosque, Isfahan, Iran, 1088

Polychrome bowl of Abu Zayd, 1187

Alhambra Palace, Granada, Spain, 1350–1400

CELTIC IRELAND

Gospels of Saint Willibrord, c.690

Book of Kells, 810–850

EUROPE

Charlemagne, 768–814

Carolingian style, 752–961 { Gospels of Saint Medard of Soissons, c.800–825

Romanesque style, 1000–1145 { Vézelay, 1125–1135

Saint-Savin murals, c.1125

Chartres west portals, c.1145

Chartres Cathedral, 1194–1230

Gothic style, 1145–1500 { Amiens Cathedral, 1220–1288

Ekkehard and Uta, Naumburg Cathedral, 1250–1260

Giotto of Florence, 1266–1337

SUB–SAHARAN AFRICA

Igbo Ukwu bronzes, c.875

Ife style bronze and ceramic portraits, 1200–1500

CHINA

Yungang Buddist caves, c.450–500

Tang Dynasty, 618–906, Blue and green style

Song Dynasty, 960–1279, Ink painting

CHRISTIAN STYLES OF EUROPE

The major event in Europe was the migration of hordes of people out of the plains of western Asia into Europe, where they settled down and created a new civilization based on the Christian religion. The patrons of art were the less than five percent of the population who led the Church and the secular state. The church was ruled by the pope, just as the state was ruled by the emperor, the heir, at least theoretically, of the rulers of the ancient Roman Empire. Under the pope there were cardinals, bishops, abbots of monasteries, and the clergy and members of religious orders. The secular state was divided into many political units, large and small, but in theory the Roman Empire still survived, and powerful central European rulers kept the title of emperor. Under the emperor were kings, dukes, counts and earls, barons and knights. The secular state depended on the church for leadership in religious, intellectual, and artistic matters, and the church depended on the state for military leadership, but the two realms were very closely linked.

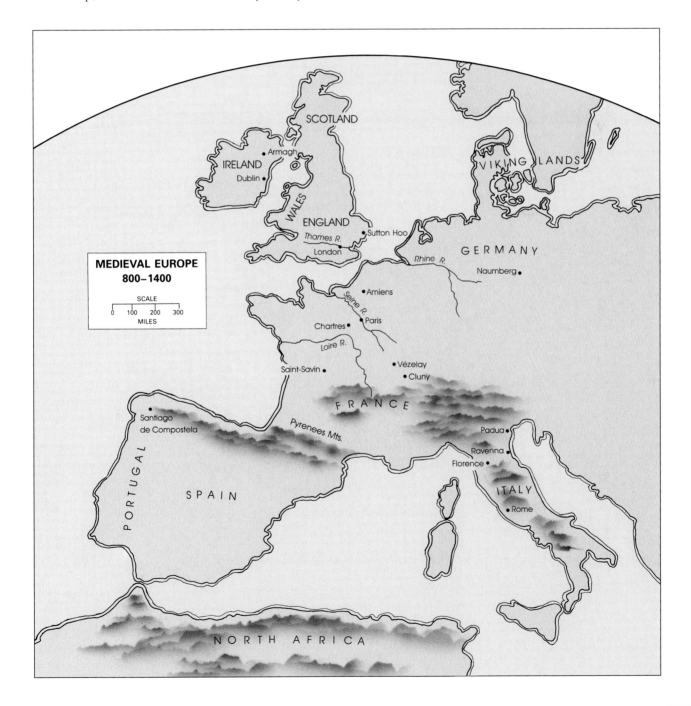

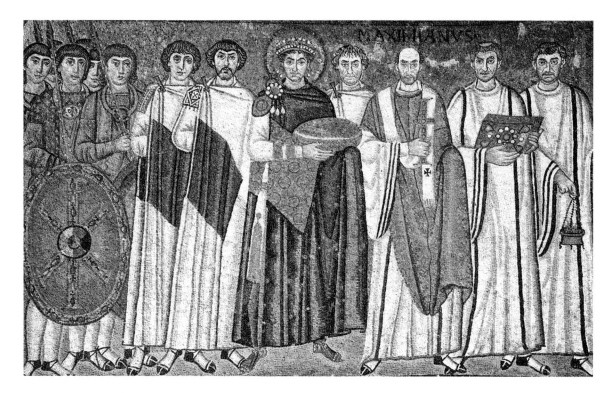

11.1
Emperor Justinian with his attendants, c. A.D. 547.
Mosaic.
Church of San Vitale, Ravenna, Italy.

11.2 (*opposite*)
Church of the Holy Wisdom (Hagia Sophia), Byzantium (now Istanbul), A.D. 532–537.
Dome 180 ft (55 m) high, 108 ft (33 m) in diameter.

BYZANTINE ART

Europe was divided another way too, between the Byzantine Empire, with its capital at Byzantium (*biz-ZAN-tee-um*; now Istanbul, Turkey), and the Holy Roman Empire and other independent nations in central and western Europe. The Byzantine emperor did not recognize the authority of the pope, but ruled as head of the church as well as the state. That explains the halo around the head of the Byzantine Emperor Justinian in a mosaic (Fig. **11.1**) on the wall of a church in Ravenna, a Byzantine outpost in Italy. Justinian is accompanied by his bodyguards and by leaders of the church led by Bishop Maximianus, whose name appears above his head. But you will notice that it is the emperor who has the halo, an idea carried on from ancient Roman times to indicate that the ruler himself was a god. The scene is not as natural as ancient Roman artists would have made it, partly because the gold background takes the place of a landscape or interior of a building, suggesting that the scene is surrounded by a heavenly light. The disregard of spatial illusions might have suggested to an earlier Roman artist that the figures were stepping on each other's toes. But the Byzantine people who saw the mosaic understood the spiritual reality it was meant to show, the eye contact of every figure in the picture with the observer enhancing the sense of spiritual communication.

Mosaic was an important technique in the Byzantine Empire, despite its expense. Unlike Roman mosaic, which was made of stone, each bit of color was fired enamel or gold leaf on glass set into cement so that the gold or color was sandwiched between a glass surface and the cement on the wall. Durable and brilliant, mosaic favored decorative abstract patterns more than natural illusions, and that unworldly appearance was just what Byzantine artists and their audience were looking for.

Justinian had one of the world's great churches built in his capital in 532, called the Church of Holy Wisdom—or, in Greek, Hagia Sophia (*HAG-ya so-FEE-uh*)— with the interior almost entirely covered with mosaic (Fig. **11.2**). It also had the second largest dome in the world (after the Pantheon in Rome): 108 feet (33 meters) in diameter and 180 feet (55 meters) above the floor. The forty small windows around the base of the dome and the gold mosaic background which reflected their light made the dome seem to float in air. A writer of Justinian's period said it seemed "not to rest upon a solid foundation, but to cover the space as though it were suspended by a golden chain from heaven."[1]

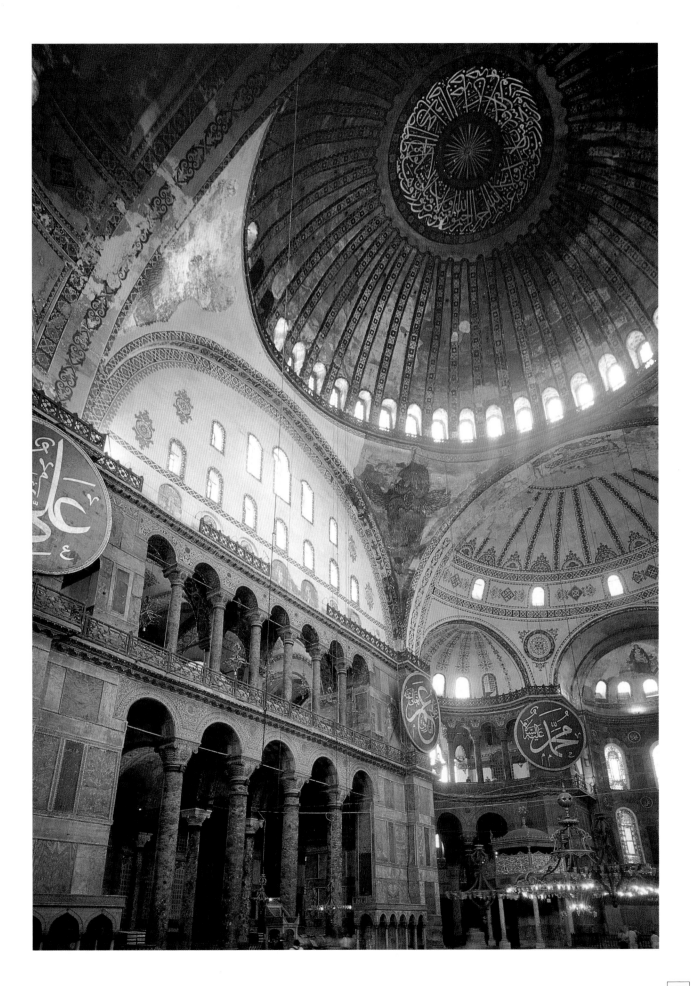

11.3 (below)
Prow of Oseberg ship,
c. A.D. 800.
University Museum of
National Antiquities, Oslo.

11.4 (below right)
Buckle from ship burial at
Sutton Hoo, eastern
England, c. A.D. 625.
Gold and enamel,
5¼ in (13 cm) long, 14⅝
oz (414 g).
British Museum, London.

WESTERN EUROPEAN ART

The Byzantine Empire was the direct descendant of the Roman Empire, but in northern and western Europe some people had either never been part of the Roman Empire or had preserved traditions of their own throughout the centuries of Roman rule. Medieval art in western Europe is varied in style and falls into several major periods: Celtic art in Ireland (600–850); Carolingian (*ca-rol-IN-jee-un*), named for the Frankish emperor Charlemagne (*SHAR-luh-main*; meaning Charles the Great, *Carolus Magnus* in Latin, 800–900); Ottonian (named for German emperors named Otto, 900–1002); Romanesque from 1000 to 1150; and Gothic, beginning about 1150 and remaining popular as late as the early 1500s.

The Celtic and Carolingian Periods

Two separate styles, the abstract art of the northern people and the representational art of the Romans, were competing and merging during the Celtic and Carolingian periods. Celtic and other northern artists specialized in jewelry, weapons, horse gear, and ship prows, such as the graceful prow of the Oseberg Viking ship from Norway (Fig. **11.3**). Ornamental richness was always the aim of the northern artists, as opposed to the naturalistic pictures and story-telling of Roman art. This struggle between northern abstraction and Mediterranean naturalism was more than an artistic competition. The Christian church in Ireland, with its headquarters at Armagh (*ar-MAH*), was busy founding monasteries in Switzerland and even in Italy, monasteries where the Celtic decorative style was used and political allegiance was to Armagh, not to Rome. The conversion of England to Roman Christian allegiance

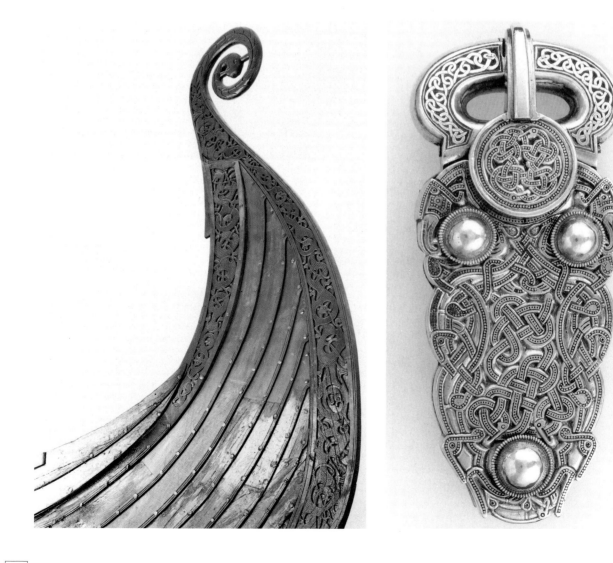

(about 600) and the coronation of the Frankish king Charlemagne as Holy Roman Emperor on Christmas Day in 800 marked Rome and its pictorial style as the eventual winners of this competition.

The northern people who worshiped the ancient pagan god Wotan had a tradition of burying their kings in ships accompanied by their treasure. Such a buried treasure ship was discovered in a long earth mound in eastern England at a place called Sutton Hoo. It was a memorial to a king, probably one named Redwald who died about A.D. 630, just at the time the British Isles were turning to Christianity. An ornamental helmet with a protective face mask, a sword and shield, silver bowls and dishes, a drinking horn, and a purse containing thirty-seven gold coins minted in France are among the buried treasures. One of the items of personal jewelry is a gold buckle (Fig. **11.4**), more than 5 inches (13 centimeters) long and nearly a pound (414 grams) in weight, ornamented with bosses and an interlace design. The interlace was the favorite design of all the northern peoples, and one they continued to use after their conversion to Christianity.

As a general rule, the farther from Rome, the weaker the Roman classical elements in the new Christian art, and the more it looks like the Oseberg ship (see Fig. **11.3**). A wonderful example of the meeting of Roman representational art and northern abstraction is found in Saint Mark's lion in the *Gospels of Saint Willibrord* (Fig. **11.5**), which was painted in Ireland about 690. The artist sprang from a long tradition of artists in metal, such as those who made the Sutton Hoo treasure, but he must have had a naturalistic picture of a lion to copy, a picture imported from the lands around the Mediterranean. But if you compare the lion's coat with the Oseberg ship (see Fig. **11.3**) or the Sutton Hoo belt buckle (see Fig. **11.4**), the inspiration for that curly pattern is clear. The frame is not merely a window; it is as important as the lion, with an intriguing mirror symmetry. To an artist living in the vast and undisciplined world of the end of the 7th century, that frame design must have suggested a heavenly order and dependability.

An elaborate monogram from the Book of Kells (see Fig. **6.19**) can be compared with these works.

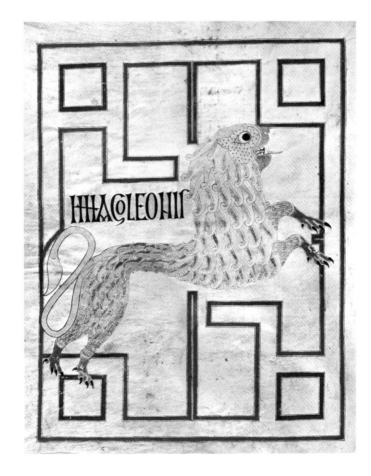

11.5
Lion of Saint Mark from the *Gospels of Saint Willibrord*, c. A.D. 690. Celtic manuscript illumination, 10$\frac{1}{16}$ x 7$\frac{9}{16}$ in (25 x 19 cm) Bibliothèque Nationale, Paris.

Charlemagne was a king of the Franks who conquered most of western Europe to create a new empire in lands that had been part of the Roman Empire four and five hundred years earlier. In 800, when he was crowned Roman Emperor by the pope in Rome, his ambition was actually to revive the Roman Empire, with the stability, security, grandeur, and cultural achievements that went with that name. A revival of education and literacy was a basic necessity. Monasteries were established which functioned like modern universities in their educational and cultural roles, and they became centers for the copying and illustration of books. Because all books were hand-written, hand-copying was the only way to obtain another copy, and hand-painted ornament became an indispensable part of a book. The story-telling power of Mediterranean pictorial art had an obvious appeal to Charlemagne and his advisers. Pictures could serve an educational and propaganda function that Celtic abstraction, beautiful and spiritual as it was, could not. Thus Charlemagne's sponsorship went to the copying of books with Roman-style illustrations.

In Roman books a portrait of the author was customary, shown with his muse, the messenger from God who told him what to write, and that became a Christian tradition. Bibles and prayer books were the most beautiful books produced by Charlemagne's scribes; they included portraits of Matthew, Mark, Luke, and John, who wrote the Gospels, the four chapters (or "books") of the Bible which recount the life of Christ. In the *Gospels of Saint Medard of Soisson* (Fig. **11.6**), Mark is shown as a young man who turns to look up at a winged lion, God's messenger and the symbol usually used to identify Mark. (Each of the four "evangelists," or Gospel authors, had a standard symbol; the others are a winged ox for Luke, an eagle for John, and an angel for Matthew. They are very common subjects in medieval art.) Mark is listening to the lion, who reads to him the word of God, which Mark will transcribe. In a similar way, the scribe, who did the lettering, and the artist, who painted the illustrations, were also copying from earlier books.

The *Gospels of Saint Medard of Soisson* was copied at Charlemagne's court about 800, probably for the emperor himself. The artist was surely copying from an older book in a more Roman or Hellenistic style. The actual book he was copying no longer exists, but we can imagine its style as similar to Roman and Hellenistic wall painting (see Fig. **10.41**). Traces of that Mediterranean style are still found in the little "cameos" in the frame and the arch, as well as in the angel and saint in landscapes in the upper corners. Despite his patronage and the book given him to copy, the artist was more interested in the abstract patterns he could make. The draperies become a set of angular lines, the capitals of the columns become flowerlike shapes. The bench and desk he put into a reverse perspective so they seem to grow larger as they recede in space, a system of representation not used by Roman artists. The result is a new style that is more abstract than its classical ancestors, but still much more naturalistic than that found in traditional Celtic and Viking art.

11.6
Saint Mark from *the Gospels of Saint Medard of Soisson*, c. A.D. 800. Carolingian manuscript illumination.
14³/₁₆ x 10³/₁₆ in (36 x 26 cm)
Bibliothèque Nationale, Paris.

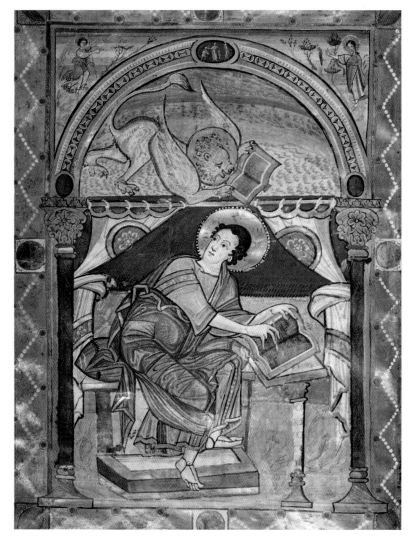

Romanesque Style

Many Christians expected the end of the world and the Last Judgment to occur during the year 1000, but when it became clear that the world would continue they began to build more ambitious and durable churches and to ornament them with art in the **Romanesque** style: massive religious buildings using round, Roman-like arches, ornamented with relief sculptures and mural painting executed in a dynamic linear style.

After 1000, with the vast migrations of earlier times a thing of the past and the Vikings, pagan raiders for centuries, turning to more settled and Christian ways, life in western Europe was much more peaceful and orderly, and large building and artistic projects could be organized. The great project of the period, however, was the Crusades, which were religious-military missions to try to reconquer Jerusalem from the Muslims, efforts that took people out of their provincial villages into the great world. Pilgrimages to religious shrines, a peaceful form of travel, were even more popular. After Jerusalem, the second most popular pilgrimage was to the tomb of the apostle Saint James (in Spanish, Santiago) at Compostela in northwestern Spain, but there were shorter pilgrimages to many famous shrines. In other words, religion was the unifying factor in medieval life and art.

The Romanesque church at Vézelay (*vay-zuh-LAY*) in eastern France was an especially fine building of that time. Vézelay was a pilgrimage shrine dedicated to Mary Magdalene and a starting place for the pilgrimages to Santiago in Spain. Perhaps most importantly, it was the starting point for the Second and Third Crusades, whose members confidently set out to save the souls of strange foreign peoples, the same mission that Christ gave to his apostles as he sent them out into the world. The sculpture of the main portal (Fig. **11.7**) shows Christ above the door in the area called the **tympanum** (*TIM-pah-num*), with rays of light bursting from his hands, giving their mission to the apostles. Below and in frames around the main scene the people of those unknown lands are shown as humans with gigantic ears, pig snouts, and dog heads, all dressed as pilgrims to the shrine of Vézelay. Healing, one of the missionary's duties, is shown around the arch above, and the zodiac, representing God's control of time, appears in the outer border.

The sculptor was able to represent clouds behind Christ, a subject you might not expect in carved stone. Incised lines and shapes with sharp edges in the clouds, but also in the clothing and other subjects, show a sculptural style based on drawing. Originally these sculptures were painted (the paint has long since worn off), which must have made them look even more like drawings or paintings. You can see that Romanesque sculptors learned their art in large measure from decorated books. The

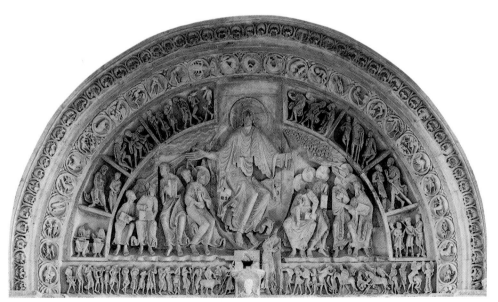

11.7

The Descent of the Holy Spirit
in the tympanum of the portal of the Abbey Church of La Madeleine, Vézelay, France, 1125–35.

shallow space of the relief and the restless lines give the composition terrific nervous energy—enough to send you off on a crusade or a pilgrimage.

Medieval churches used a standardized floor plan in the shape of a cross, the vertical post of the cross symbolized by the main area of the church, called the **nave**, and the crossbar of the cross symbolized by two wings on the building, called the north and south **transepts**. The transepts always faced north and south because the church always had its main doors toward the west, and the congregation inside always faced east, toward the altar and the hopeful symbol of the sunrise, which symbolized rebirth. If you look at Figure **11.10**, which shows the plan of the great monastery church of Cluny, you notice that worshipers entered at the main gateway (bottom) and proceeded through a series of structures into the nave of the church, with its four rows of columns. Standing there and looking toward the altar, you actually faced southeast (rather than the standard east), and the north transept was on your left. This exceptionally large church had two sets of transepts, but that was unusual. Cluny was one of the major buildings whose main construction was begun just after the year 1000. As church buildings began to grow, more elaborate stone vaults replaced wooden ceilings to make the churches more fireproof and to improve the sound of the musical services held in them. At Vézelay the vaulted ceiling is dramatized by alternating light and dark stone in the main ribs of the vault (Fig. **11.8**). The builders were proud of the vaults, which were expensive and hard to build, and they wanted to be sure they were noticed.

Like the sculpture above the doorway of the church at Vézelay (see Fig. **11.7**), other arts also showed the influence of book illustration. A metal book cover (Fig. **11.9**) shows another impact of the pictures in books. Gold wires, which form lines in the colored glass enamel of the design, look like pen lines, and the brilliant colors of the glass enamel fired onto the gold background reflect a tradition of painted book illustrations. Only the cast bronze heads attached to the surface (and then covered with gold) remind us of a sculptural tradition. The jewel-like art of enamel was very popular because its unearthly richness and brilliance suggested the spiritual richness of heaven. It was used to emphasize the preciousness of the things it was used to ornament: books of sacred writings, for example, or boxes holding relics of a saint. In the corners of this cover you will notice the four symbols of the Evangelists again: Matthew's angel and John's eagle at the top, and Mark's lion and Luke's ox at the bottom.

11.8 (below)
Abbey Church of La Madeleine, Vézelay, France,
1125–35.
The interior.

11.9 (below right)
Christ in Majesty,
book cover,
1100–50.
Cloisonné enamel on gilt copper,
9½ x 5½ in (24 x 14 cm).
Probably made in western France or northern Spain.

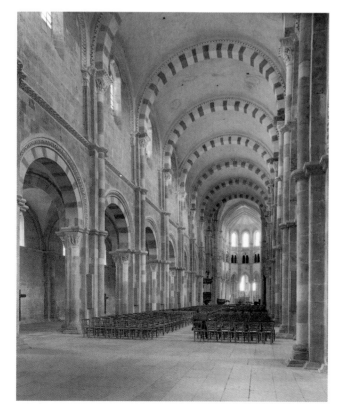

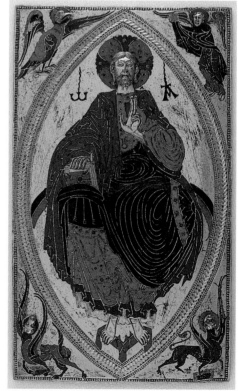

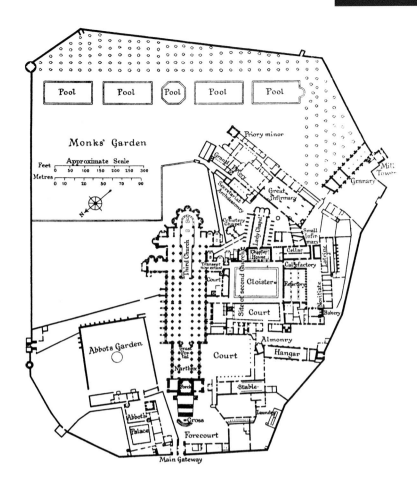

Monks' Garden

Approximate Scale

Feet 0 50 100 150 200 250 300

Metres 0 10 20 50 70 90

N

The Medieval Monastery

11.10
French Romanesque. Plan of the monastery of Cluny, Saône-et-Loire, France, showing the abbey church and monastic buildings as they were in the 17th century.

One of the greatest of all medieval Christian monasteries was the Benedictine Abbey of Cluny, in eastern France, the mother church of about 1,450 monastery churches spread far and wide in western Europe between about 1000 and 1100, one of which was the church at Vézelay.

A plan of the monastery of Cluny (Fig. **11.10**) shows the huge church like a double-armed cross (today only one "arm," or transept, still stands). To the right of the church are the cloister and the refectory (dining hall), the chapter house for meetings, the infirmary, and the priory, where the monks had rooms. At the main entrance through the monastery walls was the abbot's palace. Mixed among these buildings were stables, laundry, bakery, granary, and gardens. About 300 monks lived here in 1100, which was an unusually large number for a monastery.

Religious services were the main duty of the monks, who were called by the bell to services every three or four hours, beginning with Matins at midnight. In winter and in Lent they ate only one meal; in summer, when food was more plentiful and more farm work was required, a noon meal and a supper were served. Meat was forbidden, but fish, fowl, and eggs were

eaten, and meat was allowed in the infirmary. No talk was permitted—speech and song were reserved for the religious services—and at meals a monk read aloud from a religious book. In the smaller monasteries there was much work to be done: growing food, cooking, cleaning, weaving cloth, and so on. At wealthy Cluny hired servants and specialists did much of the hard work, leaving the monks free to develop elaborate rituals and church music.

Monastic life is hard for us to imagine, but secular life of that period is equally foreign to us. Even great nobles lived in one or two main rooms, with no privacy and almost no furniture, while peasants had one-room hovels. Joan Evans wrote of "the fantastic ecstasy and the ascetic ferocity of medieval religion," and of the churches of the Cluny monks as "irradiated by an entirely human love of beauty, dignity and splendour." The beauties of ritual, music, architecture, and art were rare in medieval times but abundant in the life of Cluny's monks.

Quotations from Joan Evans, *The Romanesque Architecture of the Order of Cluny* (Cambridge: Cambridge University Press, 1938), p. 152

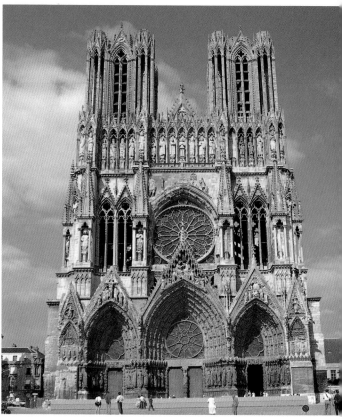

11.12 *(right)*
Reims Cathedral, France,
1211–90.
The west front.

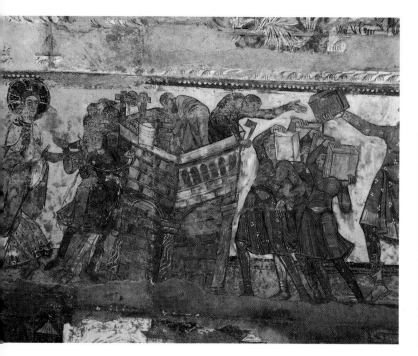

11.11 *(above)*
The building of the Tower
of Babel, Church of Saint
Savin-sur-Gartempe,
France, c. 1125.
Ceiling fresco in the vault.

Enamel, which has a colored glass surface, is similar to Byzantine mosaic (see Fig. **11.1**), and both are expensive to produce. The modest churches of western Europe had painted walls and ceilings, a much less expensive form of decoration. The monastery church at Saint Savin in western France has some of the best preserved paintings of this period in its stone vaulted ceilings. Painted in a few earth colors in a slashing linear style, they tell stories from the Old Testament with the energy of news photographs. At the building of the Tower of Babel God suddenly appears to the toiling masons hauling stones on their shoulders (Fig. **11.11**). The dynamism of God is manifest in his whirling pose and flying robes, both expressed by strong open lines. Judging by its art, the religion of the Romanesque period would seem to have been active and energetic, not much given to quiet meditation.

Gothic Style

The Gothic style was the final statement of the Middle Ages, and we must look to its churches for its greatest achievements in all the arts. The buildings themselves are the supreme works. Reims Cathedral (Fig. **11.12**) was built in one great campaign of construction between 1211 and 1290, which accounts for its unified style, with matching towers (in contrast with Chartres Cathedral's unmatched ones; see Fig. **8.20**). It is a huge stone scaffold to support stone sculptures telling the whole history of the world as envisioned in Christian teaching. A kind of band, or crown, of statues of the kings of France runs across the top, just under the towers, to emphasize that Reims was where French kings were crowned. The soft stone has been eroded by weather, but we can imagine how it originally looked when the details on the sculptures were accented with paint. Notice also the long, slender stone columns forming tracery within the main arches. If you examine the masses of the towers and the structures supporting them, with their many open spaces, you will see why modern engineers hold Gothic buildings, still standing after 700 years, in such high esteem.

Although the front of Reims Cathedral is symmetrical, unity was not the dominant idea in the Gothic style. On the contrary, variety was the key, and the

Compare Amiens Cathedral, built
during the same period (see Fig.
8.21 and pp. 260-2).

Villard de Honnecourt's Sketchbook

11.13
Villard de Honnecourt,
"Leo" from the
Sketchbook of Villard de Honnecourt,
c. 1240.
Lead or silverpoint on parchment,
drawn over in brown ink (probably
bistre),
c. 10½ x 6¼ in (27 x 16 cm).
Bibliothèque Nationale, Paris.

Villard de Honnecourt salutes you, and implores all who will work with the aid of this book to pray for his soul, and remember him. For in this book one may find good advice for the great art of masonry, and the construction of carpentry; and you will find therein the art of drawing, the elements being such as the discipline of geometry requires and teaches.

With those words the French master mason Villard introduced his book of drawings, covering architectural plans and elevations, building-machine designs, human figures, and sacred scenes, animals, and even a fly and a grasshopper. The drawings in the book were collected over Villard's whole lifetime, between about 1230 and 1280, beginning as sketches done for himself and finally left as a manual for his successors. It is now in the National Library in Paris.

"Leo" (Fig. **11.13**) was inscribed by Villard: "Here is a lion seen from the front. Please remember that he was drawn from life." Although to our eyes the drawing may not look very natural, it is important that Villard drew from the living animal in a traveling menagerie, not from his imagination. Perhaps he mentioned that to impress us with his courage, for the lion looks fierce. We often think of Gothic art as devoted solely to religious subjects, but Villard reminds us that Gothic artists were also fascinated by nature.

Even so, it was hard to overcome the training in geometry that was especially important for a mason and architect. The head of the lion still shows traces of the perfect circle Villard drew as a basis for the top of the head down to the nose.

Villard also drew pictures of the training of a lion, commenting:

> I will tell you of the training of the lion. He who trains the lion has two dogs. When he wants to make the lion do anything, he commands him to do it. If the lion growls, the man beats the dogs. When the lion sees how the dogs are beaten he becomes afraid. His courage disappears and he does what he is commanded. I will not speak of when he is in a rage, for then he would not obey anyone's wish either good or bad.

Villard's understanding of the psychology of the lion reflects the ideas of his time in the same way that his drawing reflects the style of his time, with its regular pattern of curls in the mane and its flat shapes for the head and body.

All quotations are from H. R. Hahnloser, *Villard de Honnecourt* (Vienna, 1935)

visitor to Reims finds an infinity of varied sculptures to examine, every one different. An important idea of the time was that God created each thing as a unique entity, not as a member of a category (such as a species), which were considered to be human inventions. This challenging idea often found expression in art, but perhaps never more clearly than in the "Summer Landscape" (Fig. **11.14**). It is one of the earliest medieval landscapes, but it represents nature in a way similar to Villard de Honnecourt's drawing of a lion (see Fig. **11.13**), although the landscape is even more inventive. If the Benedictine monk who painted this believed that God never exactly repeated a creation, then he may have felt it was his duty to create a new design for each plant and tree, and each bird and animal, to make a truthful picture.

11.14
"Summer Landscape" from *Carmina Burana*, 1200–50.
Parchment, 7 x 4¾ in (18 x 12 cm).
Bayerische Staatsbibliothek, Munich.

It looks fantastic to us because we believe in the reality of species, but if uniqueness is the reality, this is an accurate picture of the most important element in the medieval art style. We see that variety in such things as Chartres Cathedral's two different church towers, in the uniqueness of each figure carved on the churches, and each stained-glass window.

Chartres Cathedral also has 394 stained-glass windows, the largest number of any medieval church, and no two are alike. The term "stained glass" gives the wrong impression, because the glass was colored all the way through, cut into solid-color shapes, and fitted together in lead frames (called "cames") to form designs. "Mosaic glass" would be a more accurate name. The only color painted onto the glass was a brownish-black enamel, which was used for details. A window in the south aisle of Chartres shows the creation of Adam, Adam in the Garden of Eden, the creation of Eve, and the temptation (Fig. **11.15**). The illustration is just a small part of a large window put together with innumerable small pieces of colored glass, which make the figures and the background patterns. The heaviest black lines are iron bars that frame the window in sections. The smaller black lines are lead cames that hold each piece of glass in place. That technology led to the simplified forms and landscape elements. Light makes the frames less noticeable and brings out the jewel-like brilliance of the colors: a powerful ruby red, a deep celestial blue. Having walls mostly of colored glass (see Figs **8.1** and **8.24**) allowed sunlight to filter into the church, light colored by the windows.

Despite the variety, certain subjects appear on every church. One is Mary with the baby Jesus, as we see between the side doors of Amiens Cathedral (Fig. **11.16**). The tall and elegant figure of Mary, as Queen of Heaven, effortlessly holds her Child with the orb symbolizing his kingship. This sculpture, which was nicknamed "The Golden Virgin," expressed perfectly the aristocratic mood we find in later Gothic art, where kings and queens seem to be everywhere. Even the men battling a seven-headed dragon at the end of the world move with the studied elegance of fashion models in a manuscript, probably painted in northern France, about 1320 (Fig.

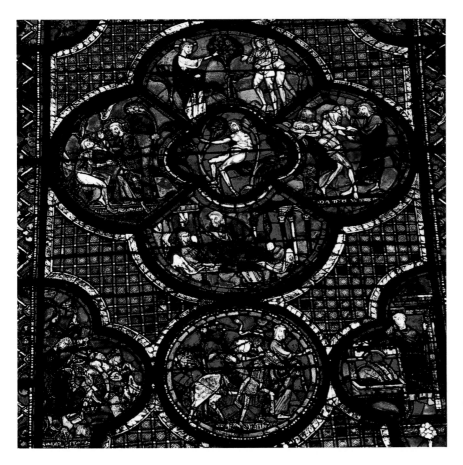

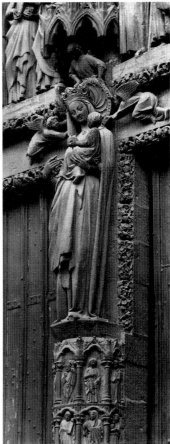

11.15 (left)
The creation of Adam and
Eve and the temptation,
1200–25.
Stained-glass window,
south aisle, Chartres
Cathedral, France.

11.17). Saint John's vision of the end of the world, entitled Revelation, which is the
last book of the New Testament, inspired many works of art under the title
"Apocalypse" (or Revelation). John's vision is a great source of visual imagery, of
monsters, battles and plagues, and encounters with God, angels, and devils. It is
noteworthy that even in this stylized and visionary subject the painter still hints at a
landscape, with small trees and brown areas of ground, and natural actions in his
human figures.

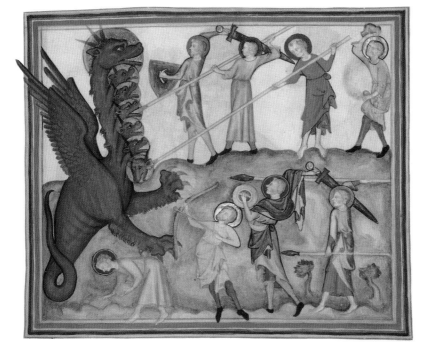

11.16 (above)
"The Golden Virgin,"
south transept portal,
Amiens Cathedral, France,
c. 1250.
Limestone, over life-size.

11.17 (left)
"And the dragon was
angered and went away to
wage war against those
who keep the
commandments of God"
from The Cloisters
Apocalypse, c. 1320.
Parchment, framed area
6¼ x 7¼ in (16 x 18 cm).
Metropolitan Museum of
Art, New York.

Along with aristocratic elegance in Gothic art we find a striking new naturalism, which depended on looking at nature, rather than an idea about nature as we see in "Summer Landscape." A striking sample of Gothic naturalism is *Saint Martin Dividing his Cloak with the Beggar* (Fig. **11.18**), a relief carving by a sculptor known only as the Master of Naumburg, named for the place he died about 1250. The actors burst out of their stagelike box, which has a frieze of leaves and flowers at the top to suggest a setting. The youthful saint turns back to slash his cloak in half with a huge sword, the line of the sword dividing him forever from the desperate beggar, who, naked and emaciated, forms a pitiful contrast with the great beast of a horse and the powerful-looking saint. The naturalistic achievements of the following centuries, which we will examine in the next chapter, are presaged by sculptures and paintings of the Gothic artists of the 13th and 14th centuries.

Most famous of the painters working during that period is Giotto (*JAH-to*; 1266/7–1337) of Florence. In Italy, where the sun is stronger than in France, there was less desire to replace the walls of churches with stained-glass windows, and there were many more opportunities for mural painters such as Giotto. One of his most important commissions was the whole interior of the Scrovegni (Arena) Chapel in Padua, painted about 1305. *The Kiss of Judas* (Fig. **11.19**) is part of that series of scenes on the walls.

11.18
The Master of Naumburg, *Saint Martin Dividing his Cloak with the Beggar,* 1235–40.
Sandstone relief, originally for Mainz Cathedral, Germany, now at the parish church, Bassenheim, Germany.

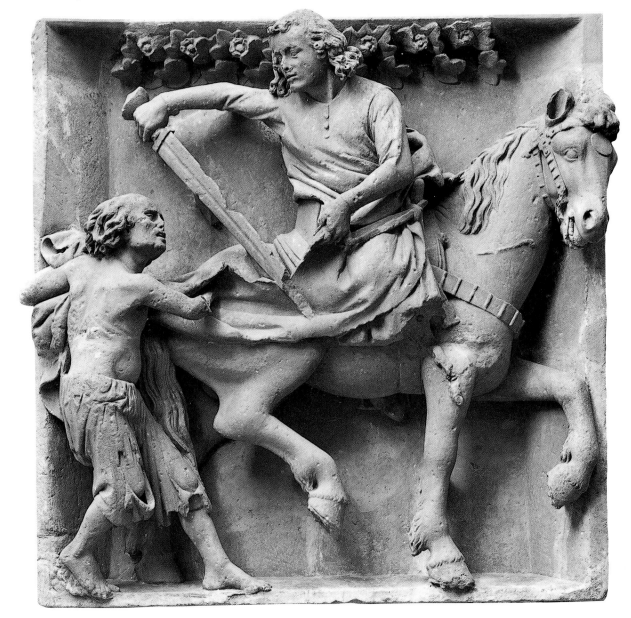

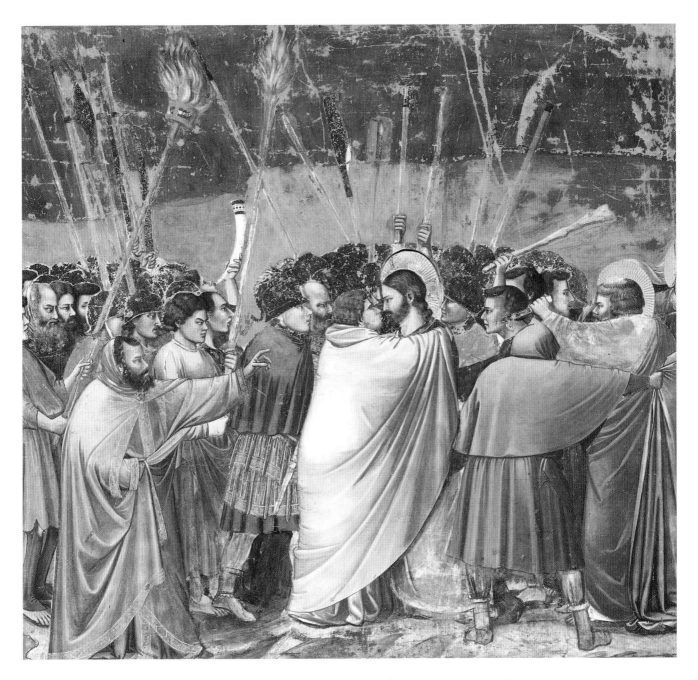

For an audience long accustomed to the style we see in the Saint Savin murals (see Fig. **11.11**), Giotto's style was amazingly natural, but it was in harmony with the main trend in Gothic style toward expressions of mass and psychology. Giotto shaded the figures in light and shadow as had not been done in many centuries, and in scale and action they appear lifelike. In the center Judas kisses Christ to identify him to the soldiers who have come to arrest him. Peter, at left, as he tries to protect Christ, cuts off the ear of the high priest's servant. Earlier painters were often effective story-tellers, but Giotto's lifelike figures expressed the drama of the story by the naturalness of their facial expressions and the movement of their bodies. That naturalness was the part of Gothic art that later Renaissance painters wanted to keep and improve. Long after Giotto's death the then ruler of Florence had an inscription put up on his tomb: "Lo, I am he by whom dead painting was restored to life, to whose right hand all was possible, by whom art became one with nature." After Giotto's time, it was not until the 20th century that artists and the public began once more to grow interested in the kind of abstract art found in the early medieval illustrated manuscripts.

11.19
GIOTTO,
The Kiss of Judas, 1305–6.
Fresco, 7 ft 7 in x 7 ft 9 in
(2.3 x 2.4 m).
Scrovegni (Arena) Chapel,
Padua, Italy.

THE ART OF ISLAM

When Islam (which means "submission" to God) burst upon the world scene in 622, the year Mohammed founded the new religion in Arabia, its followers rapidly conquered a vast territory. In 639 Islamic armies invaded Egypt (then part of the Christian empire of Byzantium) and in forty years they conquered all of North Africa. The Great Mosque of Kairouan (Fig. **11.20**), in Tunisia, founded in 675, shows the large, flat-roofed assembly hall, open courtyard, and tower (minaret) built by the Islamic conquerors. Eventually all the desert regions of northern Africa were converted to Islam, but the forest and agricultural lands of central Africa continued to follow their own traditions in religion and art (see later in this chapter, page 373).

Although Islam inherited many varied art traditions—among them Mesopotamian, Roman, and Christian—it molded them together into one of the most integrated styles in the world. Besides the laws and lore of the religion and the use of the Arabic language in its observance, Muslims (the followers of Islam) were

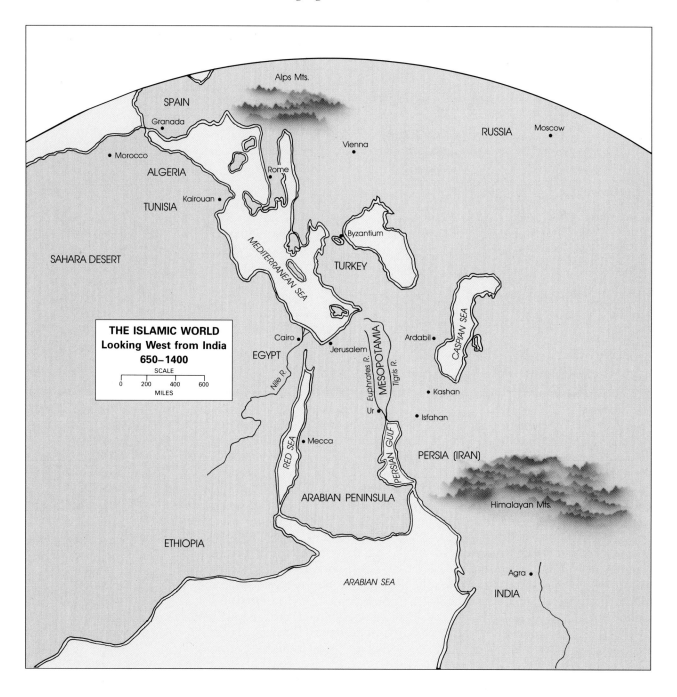

THE ISLAMIC WORLD
Looking West from India
650–1400

SCALE

0 200 400 600
MILES

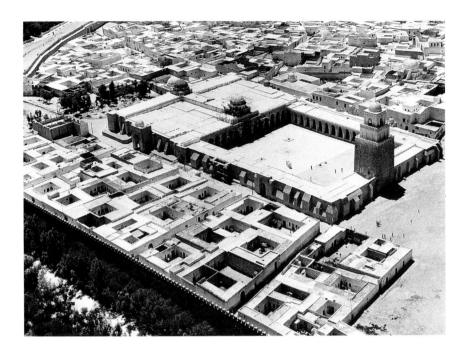

11.20
Great Mosque, Kairouan,
Tunisia,
c. A.D. 675.
Aerial view.

unified by a sense of the contrast between the earthly and the infinite. Unlike
Christianity, Islam provided no religious patronage for representational art (which
might encourage idolatry), so we find no statues or paintings in religious buildings
or books. Instead representational art is found only in the regions that already had a
picture-making tradition, where it was limited to secular subjects. The religion was
expressed by abstraction and writing or by any design that conveyed the perfection
of the eternal or the infinite.

A page from the Koran, the Islamic holy book (Fig. **11.21**), shows the most
admired kind of early Islamic art: the holy word turned into a pattern, unmarred by
any image of a mortal thing. **Calligraphy**, the art of writing, is the supreme art of
Islam; it serves as the basic ornament on buildings, pottery, and metalwork and to a

A 19th-century Persian inscription
shows a later elaboration of
calligraphy (see Fig. **2.38**).

11.21
Page from the Koran in
Kufic script, c. A.D. 1000.
Ink and opaque
watercolor on vellum,
12⅜ x 15⅝ in
(32 x 40 cm).
Los Angeles County
Museum of Art, California.
(Nesli M. Heeramaneck
Collection, gift of Joan
Palevsky.)

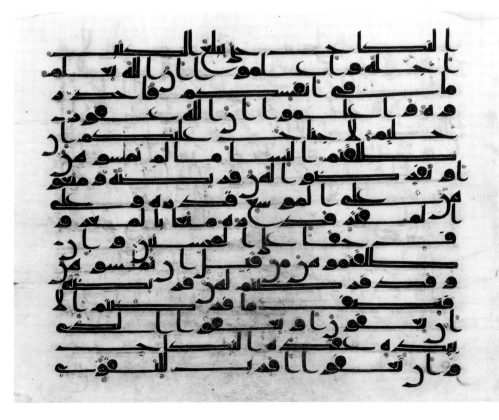

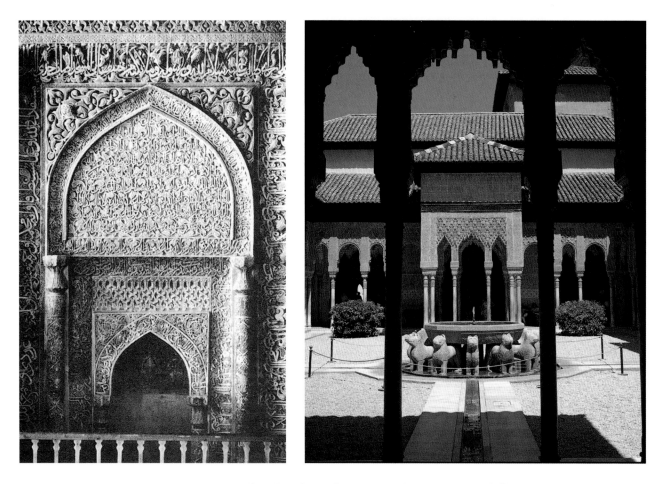

11.22 (above)
Mihrab of Oljaytu, Friday Mosque, Isfahan, Iran, 14th century.

11.23 (above right)
The Court of Lions, Alhambra Palace, Granada, Spain, 1354–91.

great extent takes the place of painting. There are many different writing styles, each with its own expressive character; this example is in Kufic script of about A.D. 1000 from North Africa.

Written inscriptions from the Koran naturally were common decorations on religious assembly halls, or **mosques**. In each mosque the direction of Mecca, the center of Islam, is indicated by an empty niche, which is especially decorated. In the Friday Mosque in Isfahan, Iran, the niche (called a mihrab) has bands of writing forming the decoration around both the pointed arches, in their rectangular frames, and even worked into the vine pattern filling the larger arch (Fig. **11.22**).

The Islamic rulers of southern Spain built a famous palace in Granada called the Alhambra (*ahl-AHM-brah*), and ornamented it in ways typical of Islamic architecture. The Court of Lions (Fig. **11.23**), named for its fountain surrounded by stone lions spouting water, shows the profusion of delicate carved and cast patterns on the walls contrasted with plain surfaces. One of the popular architectural forms, called a "stalactite vault" or "honeycomb vault" (*mugarnas* in Arabic), appears in the ceiling of the Hall of the Two Sisters in the Alhambra (Fig. **11.24**). Made of wood and plaster in an uncountable number of tiny dome segments, such a ceiling is very light in weight. The vaulting shown in Figure **11.24** has sixteen windows around the base of the dome, and it appears almost to float in the air, weightless and filled with light. These delicate and densely patterned architectural decorations convey the religious idea of infinity—that which is beyond counting or analyzing.

Two arts, ceramics and rugs, developed early in the Islamic lands of western Asia and remained their most famous products. A bowl (Fig. **11.25**), signed and dated 1187 by the ceramic artist Abu Zayd of Kashan, shows a mounted prince with his retinue painted with underglaze enamels on a glazed soft porcelain (or frit-ware). Abu Zayd, who worked between about 1180 and 1220, was the leading artist in Kashan pottery. Painted ceramics spread east and west from Iran; a Chinese example (see Fig. **11.43**) shows the adoption of the technique in China about 200 years later

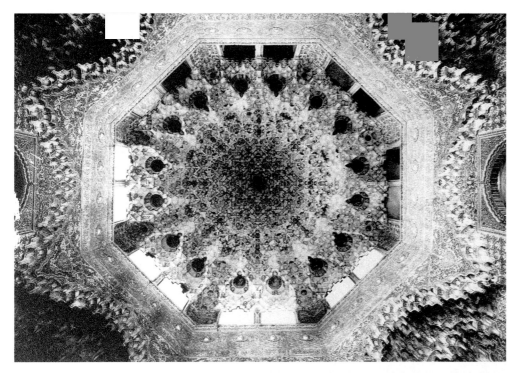

11.24 (*left*)
"Stalactite vaulting,"
the ceiling of the Hall
of the Two Sisters,
Alhambra Palace,
Granada, Spain,
1354–91.

11.25 (*below*)
ABU ZAYD OF KASHAN,
A Mounted Prince and his Retinue, C. A.D.
1187.
Glazed ceramic bowl,
4 in (10 cm) high,
8½ in (22 cm) in diameter.
Metropolitan Museum of Art, New York.
(Fletcher Fund, 1964.)

11.26 (*right*)
MAKSUD OF KASHAN,
detail of Ardabil rug, 1539–40.
Silk warp and weft, wool pile,
36 ft 6 in x 17 ft 6 in (11.1 x 5.3 m).

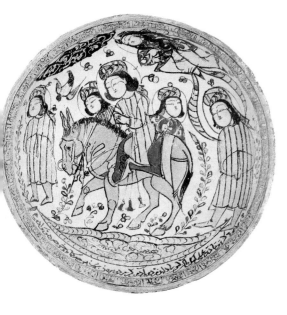

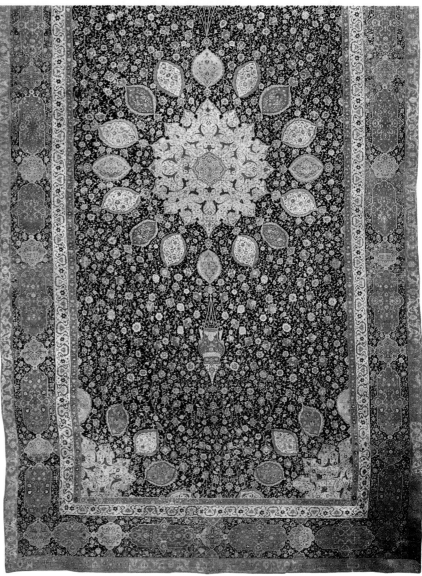

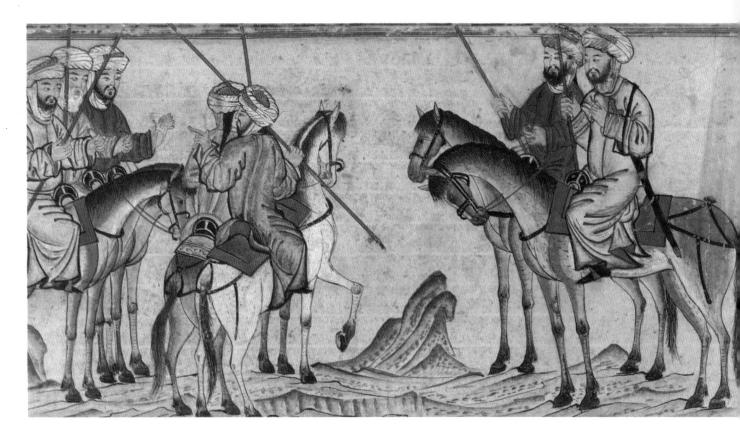

RASHID AL-DIN,
"Muslim Nobles Consult
before the Battle of Badr"
from World History,
1314.
Ink and watercolor on
paper, 4¾ x 9⅞ in
(12 x 25 cm) high.
The Nasser D. Khalili
Collection of Islamic Art,
MS.727 f5 recto.

for an entirely different painting style. Kashan, in Iran, was an early center for polychrome (that is, multicolor) ceramics. In the form of tiles it became a popular veneer for fine buildings inside and out.

Central and western Asia was a great center for textile arts from the earliest times. The oldest pile carpet known in the world, made about 500 B.C., was found in a central Asian tomb and "Persian" rugs (many of them made in other countries) have been treasured for more than 2,000 years. Used to cover floors, tables, or walls, they are a basic element of interior design in that region, but they have also been a very valuable export to other regions. Because rugs wear out, examples made before 1400 are extremely rare, so we can only look at a famous example from a later time. The Ardabil rug (Fig. **11.26**, see p.369) is one of a pair woven in wool pile cloth in northwestern Iran in 1539–40. It has what is called a yellow "medallion" in the center and a deep blue background with a complicated pattern of plants and flowers. This famous pair of rugs was made for an important mosque in Ardabil, and their design was intended to conjure up a perfect flower garden, which was a symbol of heaven.

Compare this carpet with the dome in the Alhambra (see Fig. **11.24**), which is similar in pattern. If you think the Islamic builders and artists were trying to design a paradise on earth, you are not far from the truth.

Islamic art is noted for its prohibition of pictures in religious books and buildings, but pictures were accepted in books dedicated to history or biography. Rashid al-Din's *World History*, written and illustrated at Tabriz, Iran, in 1314, is an important early example. Rashid al-Din interviewed foreign residents of Tabriz—Christians from the West, Mongol and Chinese scholars from the East—to write the history of those regions, and we see many foreign traits incorporated in the illustrations. The Chinese-like landscape behind "Muslim Nobles Consult before the Battle of Badr" (Fig. **11.27**) is an example. Both the text and the pictures are evidence of the cosmopolitan culture of the scribes and artists working in the scriptorium (called the Rashiddiya) in Tabriz. Although such story-telling art is rare in that period, the artist was an expert at gesture and pose, the movement of the horses, and the low viewpoint, which has the effect of making it seem that we are looking up at the horsemen.

The later history of Islamic manuscript painting is important, and we must look ahead here to 1620 for a sample of painting from the Mughal Empire, which was founded in northern India by Persian (Iranian) conquerors who brought Persian artists to their courts. Like their predecessors in Tabriz centuries earlier, the Mughal rulers were cosmopolitan in their tastes, and they included works of European art in their collections, along with Persian and Indian art. Bichitr (*BICH-it-er*), a Hindu artist from India who was patronized by Emperor Jahangir (reigned 1605–27), was mainly a portrait painter, and his ability to make convincing likenesses is displayed in *A Mughal Prince in a Garden* (Fig. **11.28**). It has a wonderful mood of serenity, with refreshments being served, a singer entertaining, and in the background a flower garden and a beautiful sunset. The subject is not religious, but secular, and cosmopolitan in its sources. Persian manuscript painting stands behind the flat decorative colors and patterns. European Renaissance art suggested the natural, three-dimensional poses of the figures, but these sources are brought together and combined in an original style.

With their own distinctive art tradition, the Islamic countries were engaged in a constant interchange with their neighbors in Europe, Africa, and Asia, that enriched the styles of all these regions.

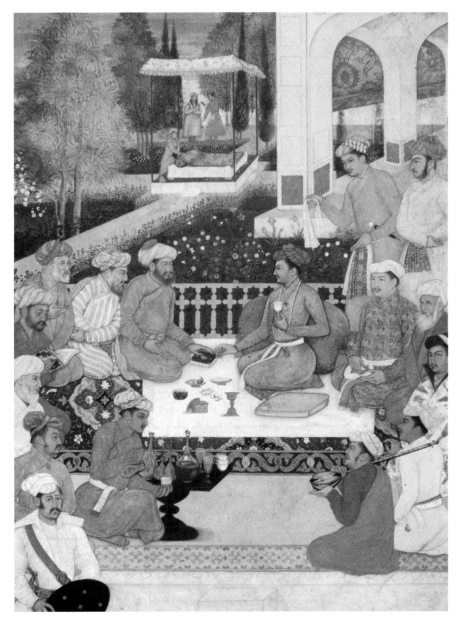

11.28
BICHITR,
A Mughal Prince in a Garden, c. 1620.
Tempera, 15¼ x 10½ in (39 x 27 cm).
Chester Beatty Library, Dublin.

Who Owns History?

11.29
Members of the punitive expedition against Benin, 1897, with ivories and bronzes captured in the raid.

History is not only a set of stories, it is also the objects that document and demonstrate the culture and continuity of groups of people. Ownership of those objects—books, pictures, statues, buildings, and all sorts of things—may be desired by many different people with a variety of motives. Are there things in our own culture that we would hate to see removed to a foreign museum?

In a sense human history belongs to all people, but particular groups have an interest in keeping their own historical objects around them to educate their children and to inspire the loyalty of their people. National treasures are usually preserved in museums, but defeat and conquest may result in the looting of the treasures of the defeated, and such treasures may end up in the museums of the victors. Sometimes an unpatriotic official abuses his office and sells a national treasure for a bribe, or treasure hunters may simply steal works of art. When thefts or looting are discovered, or as once-defeated nations regain their liberty, people demand the return of their historical treasures. This has become a problem for diplomats and the courts.

The British raid on the royal court of Benin in 1897 (Fig. **11.29**) resulted in the capture of a huge treasure—over 2,000 sculptures in bronze and many in ivory and other materials—which was sold to pay for the military campaign. The largest collections of Benin art are now in the British Museum, London, and in the Berlin Museum. The third largest collection is in Nigeria, the modern country of which the ancient kingdom of Benin is a part, but the Nigerians have had to buy back much of this collection on the open market. This is just one example of a common situation. People want art and they are not very considerate of other people's "sentimental values," the term we tend to use to refer to other people's historical and cultural values.

Among those most seriously affected have been Native American communities in the United States, who have lost ownership of most of their ancient lands. The Zuni of New Mexico regarded the ruins of Hoshoda Imk'osk'wa as one of their ancestral towns, but only a quarter of the site was within the Zuni Reservation. When the land adjoining the reservation was bought in 1982 the new owner brought in backhoes and destroyed the site (including the part on Zuni land), scattering the bones of graves and selling the burial offerings to dealers and collectors. This is a very common story, and it represents a continuing outrage to the Native American community.

Can we continue to collect the arts of other peoples? There are times when it is probably the right thing to do. During the droughts of the 1970s modest works of art poured out of West Africa as desperate people sold anything they had to buy food, but the art was recent work and not national treasures. The purchase of Japanese art by Ernest Fenollosa (see page 412) in the 19th century is another case in which collecting foreign art was a good thing to do, because Japan was in the process of modernizing, and at the time old art was unfashionable and neglected in Japan. But there is no need for collectors to seek out national treasures, because an abundance of art is available. When in doubt, a collector can always buy the work of living artists, who are usually happy to sell their work even if it will end up in a foreign country.

Yet theft and looting continue on a huge scale. What can be done about the sacred art and historical treasures, clearly broken from altars or stolen from ancient ruins, that are offered for sale? Should you buy it in order to preserve it? Is that just encouraging the theft of more? Should American and other Western museums give back all art to whatever other countries can make a convincing claim?

Based on Deborah L. Nichols, Anthony L. Klesert, Roger Anyon, "Ancestral Sites, Shrines, and Graves" in *The Ethics of Collecting Cultural Property: Whose Culture? Whose Property?*, edited by Phyllis M. Messenger (University of New Mexico Press, 1989); Jeanette Greenfield, *The Return of Cultural Treasures* (Cambridge University Press, 1989).

THE ART OF AFRICA

It is interesting to look at African and Islamic art together because they complement each other so well. Architecture and its decoration were the principal arts in Islam, with sculpture practically unknown, but sculpture is the greatest of the African arts.

Among the peoples who have developed the institution of kingship, as have the Yoruba (YOR-uh-buh) of Nigeria, there are important differences between the art made for the royal court and the art of the common people. This difference is largely attributed to the belief that kings are descendants of the god, Odua, who created the earth. Odua is, however, only one of many competing gods who intervene in the lives of humans, while above them all is the supreme creator of the gods, Olorun, the sky god, who acts in human lives when they are reincarnated, a belief widely held in West Africa. The special spiritual status of the king calls for an art that is more durable and more precious than that used by the common people. Thus we find ceramics and metal, both worked with fire, as early evidence of royal art.

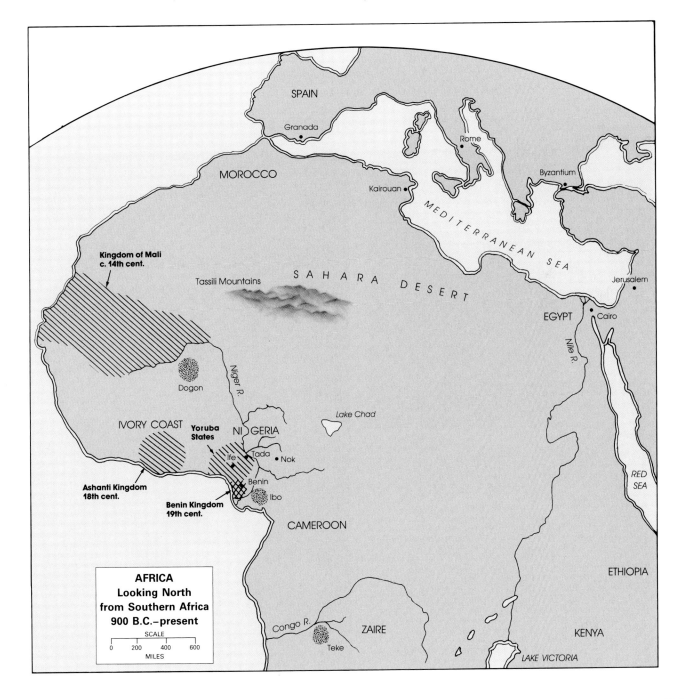

AFRICA
Looking North
from Southern Africa
900 B.C.–present

SCALE

0 200 400 600
MILES

Commoners did not have free access to metal techniques, particularly because the royal courts controlled the forging and casting of metal into weapons and tools, as well as into art, and they treated the craft as a kind of religious ritual. The spiritual symbolism of fire is based on its power to transform and refine materials that pass through it, as ore and clay are transformed. Ivory was also a royal material, but only because it was rare and valuable. In more recent times arts and crafts using fire have spread beyond the traditional courts, but even today art used for popular ceremonies is usually carved of wood or is made of unfired clay or mud. It is easy to see why almost all the most ancient African art is royal art: ceramics and metal are much more durable than wood and unfired clay or mud.

The little ceramic head from Nok (*nahk*; Fig. **11.30**), in Nigeria, is so old—maybe as early as 900 B.C.—that we do not know much about the people who made it, except that they were using fire to work iron as well as pottery clay. Some of their ceramic figures are as large as 4 feet (1.2 meters) tall, and all of them have a simplified or stylized naturalism that we see in this head. It has a childlike look, with its bulbous head and big eyes, but the beard and moustache tell us it is a grown man. From the strange hairstyle, as well as the ceramic material, we might guess that it represents someone associated with a royal court.

The head from Nok also tells us some important things about the African style. Although it has sometimes been thought that African art lacks a long history, the Nok figure shows us there is a tradition of art going back nearly 3,000 years in the core region, the African coast from the Ivory Coast to Cameroon, where the style of sub-Saharan Africa was first established. The African style is defined by its concern

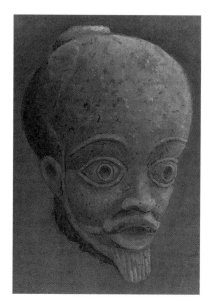

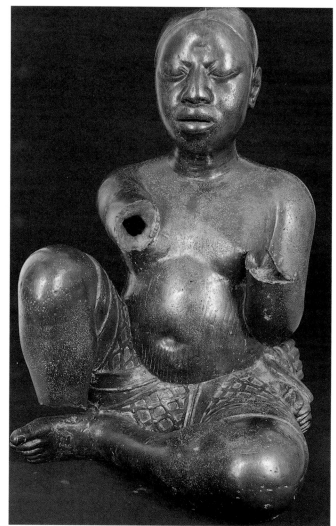

11.30 (*above*)
The head of a man,
900 B.C.–A.D. 200.
Ceramic.
5½ in (14 cm) high.
Jos Museum, Nigeria.

11.31 (*right*)
A seated king of Tada,
c. 10th century.
Bronze,
21 in (53 cm) high.
Ife Museum, Nigeria.

11.32
A queen of Ife,
c. 1200.
Ceramic,
9¼ in (24 cm) high.
Ife Museum, Nigeria.

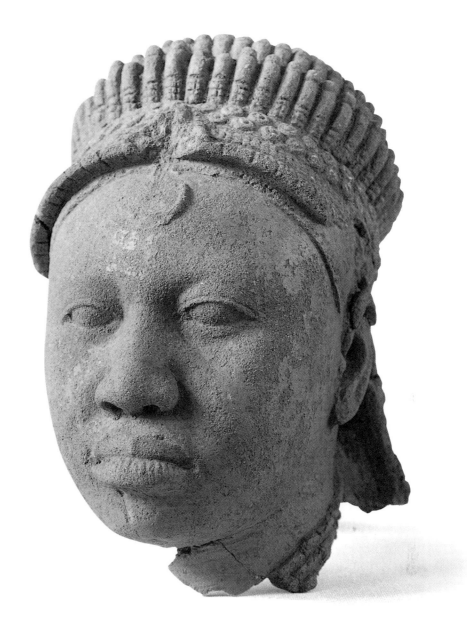

for simplified sculptural masses, as we see in the forms of the Nok head, with references to nature but with abstraction dominant. Lines, shapes, textures, and colors may be applied to the large masses, but the unity of the design always depends on the main masses. In two-dimensional arts, such as painting and textiles, shape replaces mass as the element that unifies designs.

From about 800 to 1400 is the finest period of African royal art in the lands of the Ibo and Yoruba peoples of Nigeria. A seated king (Fig. **11.31**) is represented a little under life-size in a bronze sculpture from the town of Tada. It has been damaged by a thousand years of ritual washing and polishing. This plump man is surely no hardworking farmer, but probably a king, as his proud and serious face seems to tell us. Although the figure is smooth and made to look perfect, it is not abstract. The artist's intention to make the figure true to nature is evident if you look at the ear or the foot.

Several noble portraits of ancient kings and queens of Ife (*EE-fay*; now a city in Nigeria) have been found in excavations there, most of them just heads (Fig. **11.32**). They seem to have been attached to clothed wooden bodies for the funeral and for preservation in a memorial shrine. We do not know the name of that thoughtful young woman of 800 years ago, but her crown tells us she was a ruler. She probably

died of old age, but she was portrayed as youthful and beautiful. African sculptors, like the classical Greeks, idealized the subjects of their portraits. That, along with the artist's skill, led Europeans to imagine, when these sculptures were first discovered, that a Greek artist must have made them, or at least taught the Ife sculptors. But these portraits are entirely African in style and technology: they were made of the royal materials—metal or ceramic—in a sculptural style using large abstract masses to represent natural forms, with lines, patterns, and textures for contrast with smooth masses.

Although metal and ceramic began as royal materials, and always remained the work of specialists, as time passed those materials began to appear in popular arts. Ceramic figurines, a foot or two in height, have been found in the ruins of Old Jenne (*juh-NAY*), a great trading city on the Niger River in Mali. Their rough, unpolished surfaces and pot-like forms show their connections to pottery-making, but their sculptural qualities and emotional expression put them in the category of art. The reclining figure (Fig. **11.33**)—the gender is uncertain—wears a dagger and an

A Benin plaque shows a later ruler represented in metal (see Fig. **4.19**).

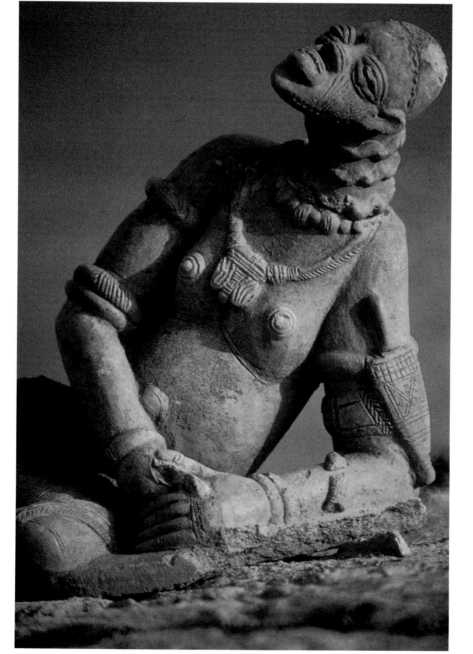

11.33
Reclining figure from Old Jenne,
A.D. 800–1200.
Ceramic,
10⅝ in (27 cm) high.

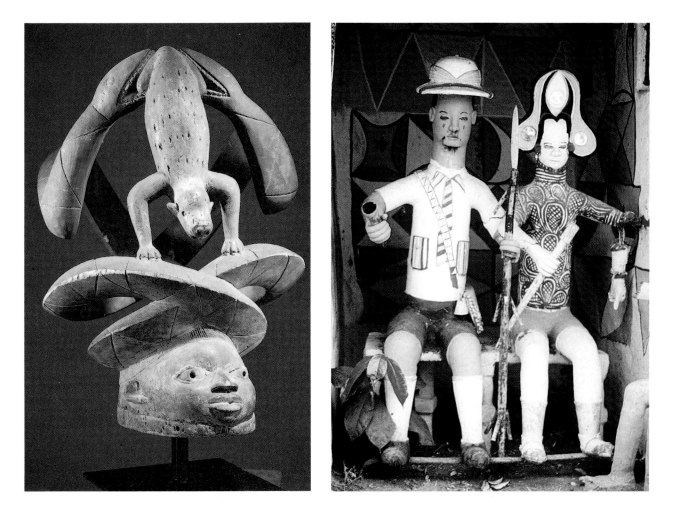

amulet on a necklace, and has snakes around the neck and arm, which indicate that this is no ordinary person. The neck was broken, and although the parts were found touching, this head might not go with the body. Surely the original pose was more casual. Popular art produced by commoners was mostly made of perishable materials—wood, unfired mud, or fiber—and this Jenne figure, which was part of a popular tradition in earlier times, provides an example of art outside the royal courts before 1400. But to find numerous examples of the popular arts we must look at art of later periods.

Woodcarving was the most widespread of the arts, and it could be practiced by anyone without restriction. Nevertheless, the African audience has always had definite ideas about quality, and a master wood sculptor was well known and admired, and might be patronized by the rulers as well as by the common people. The modern mask (Fig. **11.34**) used in the annual Gelede (*guh-luh-DAY*) ceremony, which honors the feminine powers of the universe, has been attributed to Mashudi,[2] a sculptor who lives in Meko in the Republic of Benin. A male dancer wore this mask on top of his head like a hat, with parts of a cloth costume hiding his face. When it was in its original condition, the porcupine, which is being eaten by two snakes, had quills on its back and the whole thing was brightly painted. This mask illustrated a popular saying about not biting off something you can't swallow, which is typical of Gelede masks, which refer to all sorts of current topics.

The other material used in popular religious art is mud, a material that has deep meaning as the flesh of the earth spirit. Mud sculptures are made to honor the gods, especially Ala, the earth goddess, and Amadioha, the sky god (Fig. **11.35**). A framework of wood and string supports the dried mud, which is painted. The mud sculptures are not meant to last more than a few days, however, and when the ceremony is over the sculptures are allowed to return to the earth from which they

11.34 (*above left*)
African, Republic of Benin, Yoruba. Attributed to Mashudi, Gelede mask, early 20th century.
Wood, paint,
14½ in (37 cm) high.
Metropolitan Museum of Art. Gift of Paul and Ruth W. Tishman, 1990.

11.35 (*above*)
The traditional Ibo god of thunder, in modern dress, with his wife. Owerri, 1966.
Mud, wood, string, earth pigments, iron,
4 ft 6 in (1.4 m) high.

came. For that reason we have only recent examples, despite the fact that this kind of art has a long tradition. The careful work lavished on such ephemeral art, made to last no more than a day, points up another feature of much popular art in Africa: the process of making it and the occasion of showing it are important, but keeping it later as a treasure is of no concern.

European and American artists and their public suddenly became interested in African art at the beginning of this century. African sculpture provided models for an art entirely different from the late Renaissance styles, which at that time seemed exhausted. Although everyone admitted the Ife sculptures were fine, it was the more abstract styles that inspired modern artists on other continents. The colorful low-relief disk of the Kidumu mask (Fig. **11.36**) made by the Teke people of Zaire barely suggests a face, with its tiny eyes and nose. The symmetrical design is roughly cut in geometric designs and colored red and white. Hanks of fiber were laced through the holes at the edge to hide the dancer who wore the mask. The inventiveness and power of the design, which seems to copy nothing in nature but is just pure art, appealed to people who knew nothing about its use or symbolism in Africa. Kidumu masks may originally have been used in rituals of political power, but the meaning of the design remains unknown, even though such masks are still made. The power of the design, with its simple geometric shapes in a symmetrical order, each shape bordered by a line and a relief frame and given a flat white paint, satisfies a human desire for order that appears here in a purely African style. Artists and audiences in other countries felt no need to understand the original African subject and content; they simply adopted African wood sculpture as a part of Modern art, giving it new meanings of naturalness, purity, and spontaneity.

Both the royal and the popular arts in Africa differ in one important respect from those of the countries of the West that have been inspired by African art. The element of irony or criticism of basic cultural values, which is so common in Western Modernism, plays no part in African art, which expresses the basic cultural values and beliefs of the societies in which it is made and used. A member of the African audience finds his ideas shared and expressed by the work of the artists in his society.

A system of aesthetic values from West Africa is discussed on p. 117.

11.36
Kidumu mask,
19th or early 20th
century.
Wood, fiber,
14 in (36 cm) high,
12¼ in (31 cm) wide.
Walt Disney–Tishman
Collection of African Art,
Glendale, California.

ART IN CHINA

The thousand years from about A.D. 400 to 1400 were the greatest period in Chinese history. For nearly three centuries (618–907, the Tang dynasty) the Chinese Empire stretched across most of eastern Asia, from the Caspian Sea to Korea and Vietnam. Just as Christianity dominated European cultural life, Buddhism gradually spread from India into China and the other Asian countries and inspired most of the art of this period. But China in her greatness was tolerant of other religions and progressive in her government.

Nevertheless, it is a miracle that any art survives from this period, since wars and revolutions destroyed so much art at the imperial courts, and religious persecutions had the same effect on the great temples and monasteries. Fortunately, making copies and new versions of older masterworks was a respected artistic practice, so there are often good copies of famous works whose originals were long ago destroyed.

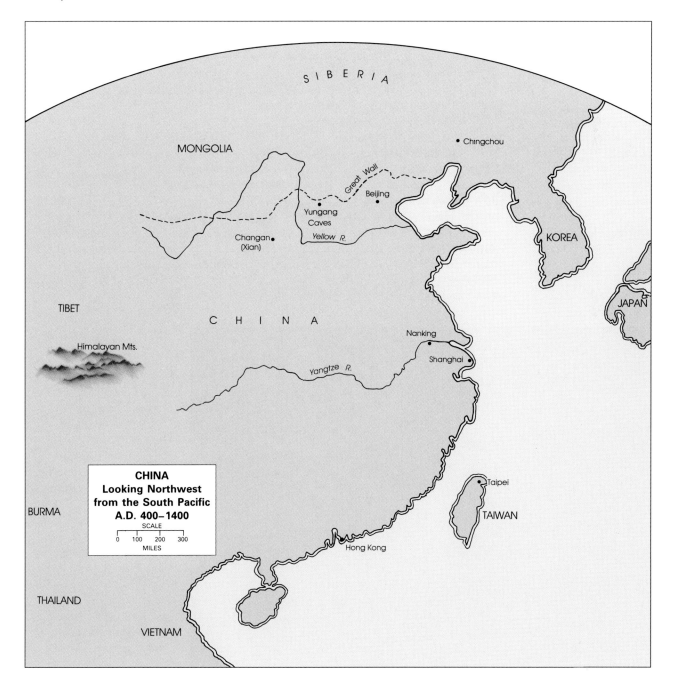

**CHINA
Looking Northwest
from the South Pacific
A.D. 400–1400**
SCALE
0 100 200 300
MILES

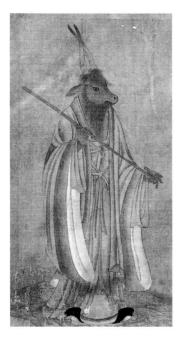

11.37
In the style of Zhang Sengyou, "The Ox Constellation" from *Deities of the Constellations*, c. A.D. 500–550.
Ink and color on silk, 10¾ in (27 cm) high.
Municipal Museum, Osaka, Japan.

The pre-Buddhist Daoist religion inspired the strange figure of a humanized ox (Fig. **11.37**), which represents one of the constellations of the zodiac, like our Taurus. This painting is an ancient copy of a lost original by Zhang Sengyou (*seng-yo; c.* 470–550), who was a general and court official. Like many educated people, he was also a serious painter. His audience was made up of people like himself, educated officials of the imperial administration. The strange figure in its graceful flowing robes was painted with watercolor on silk and delicately tinted, the technique most characteristic of Chinese art through the ages. A mound of churning seawater is the only setting. Background settings were usually ignored in paintings of people and animals in this period, but it is, in any case, hard to imagine what could serve as an appropriate setting for this figure. To our eyes the subject is pure fantasy, but its original audience took it more seriously as a symbol for a season of the year as defined by the stars. Part of the emperor's duties, in which he was assisted by the court, was to carry out rituals to keep the stars and seasons working properly.

"The Ox Constellation" (see Fig. **11.37**) serves as a first step toward defining a Chinese style. The use of the writing brush as the basic tool led to a style dominated by lines, with the flowing gestural quality produced by the brush. Lines make the contours of masses or the edges of shapes; subtly shaded tones of color suggest rounded forms but do not show shadows and highlights. A setting or landscape is absent or minimal in this work and in much early Chinese art.

By 600, however, a wonderful style of landscape painting had been invented. Called "the blue and green manner," it was supposedly invented by General Li of the Imperial Guards, but no paintings by that famous artist have survived. We can see his style in *Emperor Ming-huang's Journey to Shu* (Fig. **11.38**), copied by an unknown artist. The fingerlike rocks are blue and green, the trees a deeper green, and the sky the tan of the ancient silk, making the scene a fantasy from a storybook. The emperor's caravan enters at right with its horses, mules, and camels, stops to rest in the center—notice the horse rolling on its back—and disappears into a deep canyon on the left. This style of landscape may have old roots in Buddhist versions of paradise, and it is still a popular style with humble artisans who are content with old traditions. Note the similarities and differences between Figures **11.37** and **11.38**: the linear organization of the forms and the modeling of colors are similar, but the landscape introduces a complex composition with foreground, middle, and vast misty background areas, with richer color.

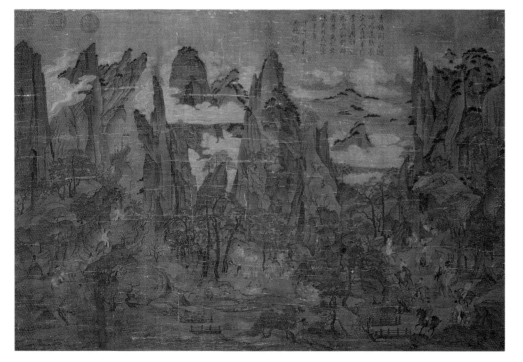

11.38 (*left*)
Emperor Ming-huang's Journey to Shu,
8th century (Tang dynasty).
Watercolor on silk,
22 x 32 in (56 x 81 cm).
National Palace Museum, Taipei, Taiwan, China.

11.40 (*opposite*)
Gung Kai,
Jung Kuei, the Demon-queller, on his Travels,
13th century (Southern Song dynasty).
Ink on paper,
1 ft 1 in x 5 ft 6¾ in
(0.3 x 1.7 m).
Freer Gallery, Smithsonian Institution, Washington, D.C.

It is not an accident that the "Ox" and the *Journey* were both painted by officers of the imperial army. The subjects of both paintings refer to the whole expanse of the world and the universe, which was the way the Chinese rulers saw their duty: as a universal mandate from heaven to bring order to the world. In a similar way, modern media convey to an audience the sense of mission and the framework of ideas held by modern governments.

"With one small brush I can draw the vast universe," wrote the poet Wang Wei.[3] He is credited with the invention of a poet's style of landscape painting using the writing brush and black ink, sometimes with a little soft color. Although none of Wang Wei's own paintings survive, the style is easy to find among his many successors. This style is considered especially close to writing—the Chinese, like the Muslims, hold calligraphy to be the noblest art of all—but it is a development from earlier Chinese pictorial conventions.

A Solitary Temple amid Clearing Peaks (Fig. **11.39**) was painted by one of the most famous of those successors, Li Cheng, between 940 and 967. Li Cheng was a well-educated man of the upper class who painted as a hobby. The Chinese have especially admired that kind of artist, who paints as a form of spiritual meditation, never selling his work but perhaps giving the paintings as gifts to friends. In the country inn in the foreground we see people at their meal. Beyond the temple spreads an immeasurable world of misty mountains animated by long waterfalls, not much different in conception from *Emperor Ming-huang's Journey to Shu*. Li Cheng's style blends lines and tones more subtly, achieving a more natural expression of masses and spaces by the gradations of gray tones. Light and shadow still play no part, however.

There is still another side of Chinese fantasy to be found in *Jung Kuei, the Demon-queller, on his Travels* (Fig. **11.40**), painted by Gung Kai in the 1200s. Jung Kuei was a scholar's ghost who was appointed Great Spiritual Demon-Chaser of the Whole Empire by the emperor, who met him in a dream. The Demon-Queller, accompanied by his sister, casts a suspicious look back over his retinue of subdued demons. Here the poet uses black ink as a modern cartoonist might do to express weird and funny characters in the simplest possible style. It is hard to believe that 700 years separate the ox-headed figure by Zhang Sengyou (see Fig. **11.37**) and this painting, they are so similar in technique and style. That style, which was formulated during the Middle Ages, has remained basic in Chinese art down to the present day.

Buddhism, which was founded by the Buddha in India about 500 B.C., was brought to China by missionaries and became very popular, especially after A.D. 452, when the Wei dynasty emperor became a Buddhist. He sponsored a great project, inspired by rock-carved temples in India, to carve cave temples into a sandstone cliff at Yungang. Inside the first five caves enormous Buddha images, up to 45 feet (13.7 meters) tall, were carved by the thousands of sculptors employed there. In Cave 13

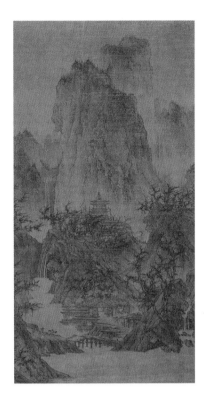

11.39 (*above*)
LI CHENG,
A Solitary Temple amid Clearing Peaks,
c. 940–967.
Ink and slight color on silk, hanging scroll,
44 in (112 cm) high,
22 in (56 cm) wide.
Nelson-Atkins Museum of Art, Kansas City, Missouri.
(Purchase: Nelson Trust.)

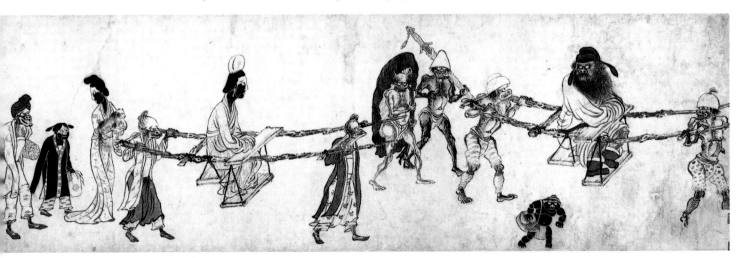

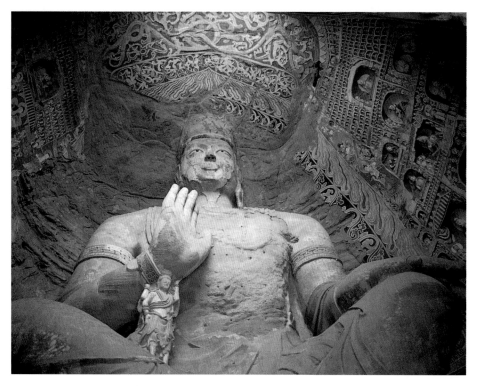

(Fig. **11.41**) it is not merely the size of the figures, but their number, that overwhelms the viewer, along with the architectural forms and ornaments carved into the sandstone walls. All the carvings were painted, presenting a multimedia experience that remained a forceful influence in Chinese art for centuries. One must imagine viewing the cave by the flickering light of a lantern.

By 1200, when Guanyin (Fig. **11.42**) was carved in wood and painted, Buddhist art had become very refined. Guanyin, a bodhisattva, or enlightened being, who remains in this world to aid suffering humanity, was a very popular subject.

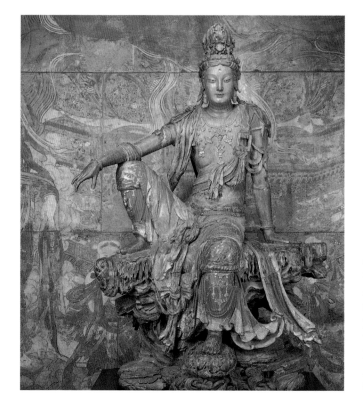

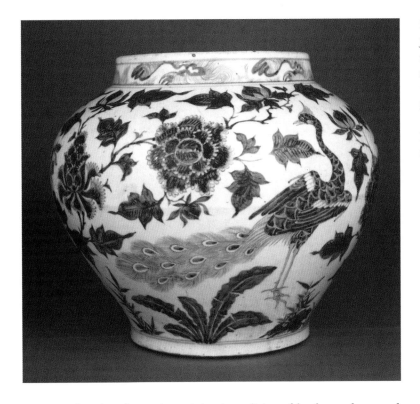

11.43
Jar painted with underglaze enamels showing peacocks, 14th century. Porcelain, 12½ in (32 cm) high. British Museum, London. (Brooke Sewell Bequest.)

Buddhist deities are considered to have the spiritual qualities of both genders, and by these later years the feminine qualities were accentuated. Guanyin seems about to rise from the rocky base on his/her home on the fabled island mountain of Potala. This figure, in this same pose, was popular in painting as well as sculpture, and the technical proficiency of this image reflects the fact that the subject and style had become conventional, with little encouragement for experiment.

During these later years of what in Europe we call the Middle Ages—in China the Song and Yuan dynasties—one of the new arts was painted ceramics. Fine pottery and porcelain already had a long history in China, but pictures in underglaze enamels, using a technique developed earlier in Persia (see page 368), were a new addition to Chinese ceramics in the 14th century. The heavy white jar painted with cobalt-blue plants and peacocks (Fig. **11.43**) is an early example of a type of Chinese porcelain that gained a worldwide market, and it was later copied by European (especially Dutch) potters to compete with it. During the Southern Song dynasty (960–1279) competition among the potters produced some of the finest ceramics ever made, and a great diversity of decorations. Blue and white was especially popular, with an amazing abundance of lively paintings.

While European art of the 12th and 13th centuries was growing more naturalistic and lifelike in its expressions, Chinese art was developing in the opposite direction, toward the highest level of technical expertise and refinement in its expression.

When you think of China you probably think of pagodas, the traditional Buddhist towers that originally marked the tombs of saints. Wooden pagodas were once common in China, but the only surviving old pagodas are of brick and stone, plus three mast-like pagodas of cast iron built around 1100. The White Pagoda (Fig. **11.44**) at Qingzhou (ching-sho) in northeastern China shows what the pagoda style was like around 1200: seven octagonal stories with a pointed-dome top. The ornaments on this stone tower are based on traditional ways of building roofs on wooden brackets, but converted into pure decoration on these stone walls.

The imperial palaces of the Middle Ages have long since perished in wars, but the "Forbidden City" district, which was the old imperial palace, in Beijing preserves the old styles pretty much as they were. Beijing still has an ancient city plan described by Marco Polo as built to resemble a chessboard, with straight streets running between city gates and each family allotted one square of land (see Chapter 8).

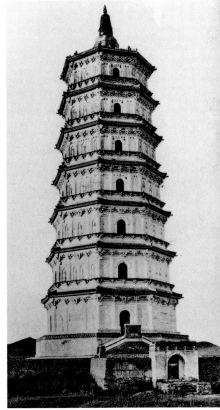

11.44
White Pagoda, Qingzhou, Jehol, China, 11th or early 12th century. Brick.

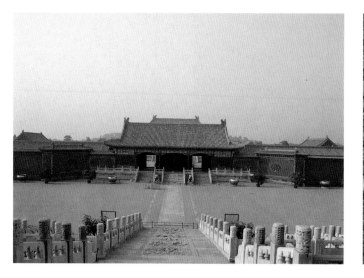

11.45 (*above*)
The Hall of Supreme
Harmony, Imperial
Audience Hall, Beijing,
17th-century
reconstruction of an
ancient form.

11.46 (*above right*)
Ceiling (cupola),
Buddha Hall,
Chih-hua-ssu Temple,
Beijing, c. 1450.
Carved cypress, gilded
and painted red,
15 ft 1½ in x 14 ft 7 in
(4.6 x 4.4 m).
Nelson-Atkins Museum of
Art, Kansas City, Missouri.
(Purchase: Nelson Trust.)

The Hall of Supreme Harmony (Fig. **11.45**) is one of three great audience halls where the emperor met ambassadors and other dignitaries. In both its plan and elevation, this large wooden building, with its perfect symmetry, follows designs that were at least 2,000 years old. The great curving roofs with their deep overhanging eaves were new features of Chinese buildings in the Middle Ages.

The interiors of these palaces were basically post-and-lintel constructions in wood decorated with sculpture and painting. A wooden ceiling (Fig. **11.46**) from a 15th-century Buddhist temple in Beijing shows the kind of elaborate design that could result: the beams form an octagonal cupola with a small dragon in each segment and a super-dragon in the center, all symbolizing the mystic powers of the sky. Like most Chinese sculpture, this cupola was painted. Temple and palace interiors were also ornamented in strong colors, including a powerful red, giving a sumptuous effect that is distinctly Chinese.

FOR REVIEW

Evaluate your comprehension. Can you:

- describe some examples of medieval European art that show the dominance of the principle of variety?
- describe some examples that make clear the differences between Celtic, Romanesque, and Gothic art?
- explain how religious ideas are expressed in Islamic buildings and decorative arts?
- compare the traditions of court art with those of popular art in Africa? How do the materials and styles differ?
- describe what it means to say that Chinese sculptures have "shapes and lines that look as if they could be drawn with a brush."

Suggestions for further reading:

- Marilyn Stokstad, *Medieval Art* (New York: Harper & Row, 1986)
- Wim Swaan, *The Gothic Cathedral* (Garden City, NY: Doubleday, 1969)
- Nurhan Atasoy, Afif Bahnassi, Michael Rogers, *The Art of Islam* (Paris: UNESCO/Flammarion, 1990)
- Frank Willett, *African Art* (New York: Thames & Hudson, 1993)
- Sherman E. Lee, *A History of Far Eastern Art* (Englewood Cliffs, N.J.: Prentice-Hall, 4th ed., 1982)

12

Styles of the Columbian Age: 15th–18th Centuries

PREVIEW

During this period all parts of the globe began to be integrated into a world economy by conquest, colonization, and trade. Exploitation and commerce had many negative effects, but they also produced cultural contacts. In Europe and Japan a new class of art patrons appeared about 1400, people who considered that understanding art was a mark of prestige. In Europe artists and scholars began to call their own times "the Renaissance" ("rebirth"), because of the revival of ancient Greek and Roman art and literature, and the new interest in representing nature, using anatomy, perspective, and chiaroscuro, that occurred then. Portraits and ancient myths began to rival religious subjects in art. Oil painting, which was invented in the rich commercial cities of Flanders, provided new opportunities for detailed illusions, and by 1500 its use had spread throughout Europe. Older media remained popular: fresco in Italy, and ink or watercolors on paper screens in Japan. European traders and missionaries settled in Japan for a century, but then for two centuries all foreigners were banned and Japan cultivated its native styles.

About 1600 Europe adopted the optimistic, theatrical Baroque style, concentrating on the climax of action and heroic themes, and the Spanish Empire carried the style around the world, to Mexico and the Philippine Islands. By 1715 cultured upper-middle-class Europeans were looking for a less serious art, seeking good-humored subjects from the theater, mythology, and middle-class life. This Rococo style was centered in France, which began to replace Italy as the center of Western cultural life.

THE FIVE HUNDREDTH ANNIVERSARY of Christopher Columbus' discovery of the Americas in 1992 focused attention on the changes produced by the many explorations of the Columbian Age. The growth of powerful European styles, which were carried by explorers to every other continent, and the struggle for survival by native traditions, such as that of the Japanese, against the encroaching European styles are major themes in the history of world art during that period.

Beginning about 1400, the Renaissance (REN-nuh-sahns, from the French for "rebirth," a wide-ranging cultural movement) laid the foundations for the modern

From Renaissance to Rococo,
1400–1750

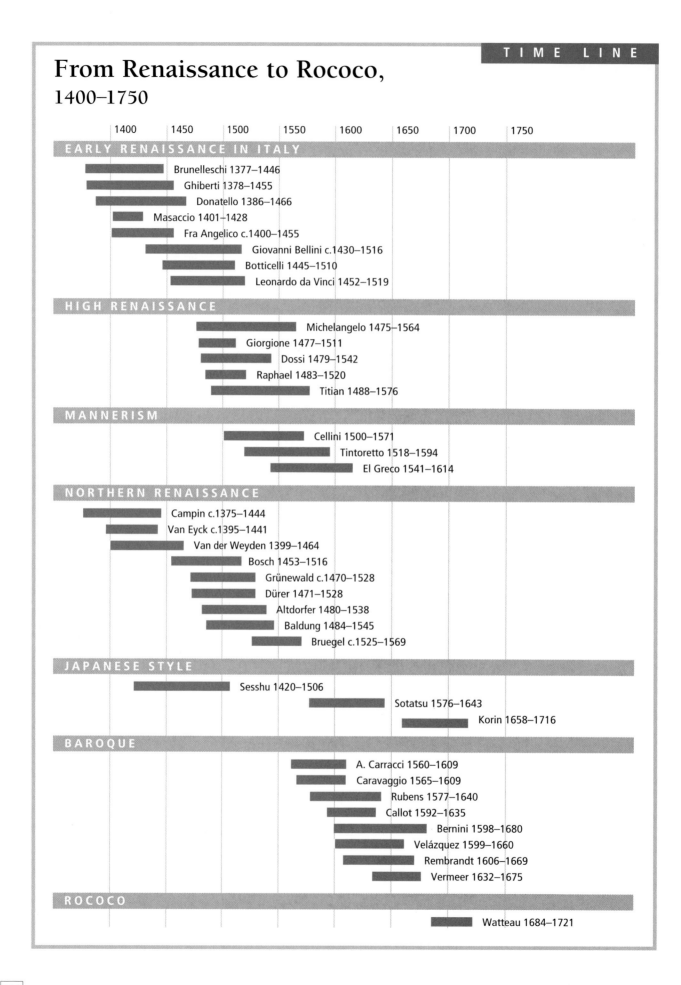

| | 1400 | 1450 | 1500 | 1550 | 1600 | 1650 | 1700 | 1750 |

EARLY RENAISSANCE IN ITALY

Brunelleschi 1377–1446
Ghiberti 1378–1455
Donatello 1386–1466
Masaccio 1401–1428
Fra Angelico c.1400–1455
Giovanni Bellini c.1430–1516
Botticelli 1445–1510
Leonardo da Vinci 1452–1519

HIGH RENAISSANCE

Michelangelo 1475–1564
Giorgione 1477–1511
Dossi 1479–1542
Raphael 1483–1520
Titian 1488–1576

MANNERISM

Cellini 1500–1571
Tintoretto 1518–1594
El Greco 1541–1614

NORTHERN RENAISSANCE

Campin c.1375–1444
Van Eyck c.1395–1441
Van der Weyden 1399–1464
Bosch 1453–1516
Grünewald c.1470–1528
Dürer 1471–1528
Altdorfer 1480–1538
Baldung 1484–1545
Bruegel c.1525–1569

JAPANESE STYLE

Sesshu 1420–1506
Sotatsu 1576–1643
Korin 1658–1716

BAROQUE

A. Carracci 1560–1609
Caravaggio 1565–1609
Rubens 1577–1640
Callot 1592–1635
Bernini 1598–1680
Velázquez 1599–1660
Rembrandt 1606–1669
Vermeer 1632–1675

ROCOCO

Watteau 1684–1721

world. The many small principalities of the Middle Ages began to consolidate into the modern nation-states, using the modern languages. The growing populations began to concentrate in towns and cities, and trade expanded widely. Though pilgrimages and crusades had accounted for most of the European contacts with other regions in the Middle Ages, by 1400 European commercial interests were leading toward exploration of the whole planet. We often think of modern art as being essentially one style all over the globe, despite many local variations. That tendency toward a global style began with Renaissance (1400–1600) and, especially, Baroque (*buh-ROKE*; 1600–1750) art, which were carried around the world by explorers and colonizers.

The American continents were discovered at least twice by the Europeans, and the different outcomes of those two discoveries are illuminating. Leif Ericsson landed in eastern North America about A.D. 1000, which led to a short-lived colony, but in that period Europe had too few people and too little commerce to take advantage of the new lands. Five hundred years later, with Columbus' discovery, the Europeans were eager to seize the opportunities for the exploitation of capital, raw materials, labor, and markets that the new lands offered. European expansion after 1488 (when the Portuguese first rounded the southern cape of Africa) was responsible for the global unification we see in our own time. The Portuguese reached Japan in 1543, the first contact between the Western counties and that Far Eastern nation—contacts that are still increasing today. Baroque art flourished in such distant regions as Peru and the Philippine Islands, and archaeologists and art historians can scarcely catalogue the abundant remains.

In this chapter we will begin with the art of Italy, Flanders (modern Belgium), and Japan, three countries that made especially distinctive contributions to art during the period after 1400. Each has a style that you will find easy to recognize, yet they share some fundamental attitudes about art and about how societies should manage and use their art. After 1600 Spain, France, Holland, and Germany were all making important contributions to Baroque and Rococo (*ro-KO-ko*) art, the latter a fanciful and refined style that brought the Renaissance period to a close.

The Renaissance and Baroque styles are close enough to the taste of our own day that many people still think of them as the way "real art" should look. When people speak of the "Old Masters" they mean artists working in the Renaissance and Baroque styles. The Renaissance was a major revolution in art, one that required nearly a century to accomplish, but a revolution, nevertheless: different groups in society began to play the roles in art, different kinds of materials came into use, and different subjects became popular. The Baroque style represents the secure establishment of the new order in art, one which in many respects lasted right up to the beginning of our century. Many people still accept ideas about art that are the inventions of the Renaissance and Baroque critics and audience. As you read about these periods and look at their art, ask yourself whether those attitudes and styles still have contemporary validity for you.

THE RENAISSANCE IN ITALY

The Renaissance is unusual among historical periods in having named itself. The contrast of a modern cultural renewal with the age of medieval "barbarism" was first suggested by the Italian poet Petrarch (1304–74), but it was artists, like Brunelleschi and Ghiberti (see pages 105 and 264–5), who considered the new age to have begun, calling Giotto the beginning of a rebirth of naturalism and a revival of ancient Greek and Roman styles. Those two things—a revival of ancient styles and the accurate representation of nature—might seem to be opposites, but for Italians of the 15th century they went together. *La rinascita*, as the Italians called it, is usually considered the work of artists, poets, and scholars, but there were other segments of society playing important parts in these changes. Behind the new interest in nature and antiquity was the emergence of bankers and business people as a new class of art patrons. Their interests played a large part in shaping the new style.

ARTISTS AND PATRONS

Now we take it for granted that wealthy individuals patronize the arts, but we inherited that assumption directly from the Renaissance. The patrons of art in earlier periods were the nobility and the church. In the 15th century a new class of business people attained wealth and rank by their own efforts and intelligence, unlike the nobility, who had inherited rank and property, or the leaders of the church, whose positions depended on the institution. The children of successful business people were often happy to accept a noble title or a position in the church; the younger members of the Medici (*MED-ih-chee*) family, most important of the Florentine bankers, became dukes and even popes. But it was their banker grandparents who were the greatest patrons of art.

These new patrons were first of all interested in immortalizing themselves. Lorenzo de' Medici, nicknamed "the Magnificent," was the third generation of a long line of his family to rule the city of Florence. His portrait (Fig. **12.1**), modeled by Verrocchio (*vuh-ROCK-ee-o*; another nickname, meaning "True Eye"; *c.* 1435–88), shows Lorenzo as tough, humorous, and clever, dressed in the simple clothing of the middle class, not what we would expect from his nickname. An older generation must have wondered why Lorenzo's portrait should be made at all, for he had no title or public position, though in fact he ruled his city-state from behind the scenes. His claim to a place in our memories, and our museums, rests on his personal abilities and achievements, one of which was the patronage of great art.

With the emergence of a new class of patrons, a new class of artists also developed. Gradually freeing themselves from the courts of the nobility and the monasteries of the religious orders, they became independent business people, with studios full of apprentices and assistants, capable of producing almost any kind of art or craft, from a decorated plate to a chapel.

Patrons were expected to take an active part in the planning and design of the works they commissioned. The Renaissance was different from our times, when most of our consumer goods are factory-made and the buyer chooses from among finished products. A Renaissance merchant and his wife wore tailor-made clothing, lived in an architect-designed house, sat on furniture designed and made especially for them and, naturally, enjoyed paintings made especially to their requirements. The ideas of the artists are recorded mostly in their art, but we know a great deal about the ideas of the patrons from their letters.

Isabella d'Este, who became Marchesa of Mantua upon her marriage, was an outstanding patron. Her portrait was painted by the Venetian painter Titian and drawn by Leonardo da Vinci, to whom she offered several other commissions. Isabella delighted in inventing elaborate subjects for paintings, which created difficulties for the painters. She asked Leonardo for a painting of a youthful Christ, "about twelve years old," as she wrote in her letter to Leonardo, but the painter declined the commission.[1]

The wealthy merchant Giovanni Rucellai explained his heavy expenditures on art and architecture by mentioning that these things gave him "the greatest contentment and the greatest pleasure because they serve the glory of God, the honor of the city [of Florence], and the commemoration of myself," and added that "buying such things is an outlet for the pleasure and virtue of spending money well."[2] Patronizing art was one of the marks of the gentleman. The author of *On Noble Behavior*, a how-to book for gentlemen of 1404, remarks: "The beauty and grace of objects, both natural ones and those made by man's art, are things it is proper for men of distinction to be able to discuss with each other and appreciate."[3]

THE ARTISTS

The inclusion of art, along with nature, among objects of beauty and grace tells us something about the style these Renaissance patrons admired. When we look at *Saint Lawrence Distributing Alms to the Poor* (Fig. **12.2**) by Fra Angelico (*c.* 1400–55) we see the skillful drawing, the illusions of space and mass produced by an

A portrait of the city of Florence and a description of its plan are on pp. 267-8 (see Fig. **8.33**).

12.1
Andrea del Verrocchio, *Lorenzo de' Medici,* 1480. Painted terra cotta, 26 in (66 in) high. National Gallery of Art, Washington D.C. (Samuel H. Kress Collection.)

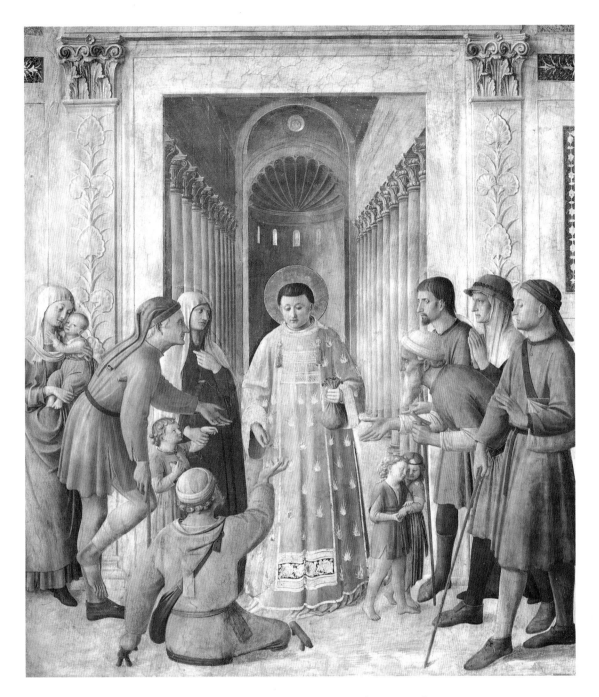

12.2
FRA ANGELICO,
*Saint Lawrence Distributing
Alms to the Poor,*
c. 1450.
Fresco, 9 ft x 6 ft 6 in
(2.7 x 2 m).
Vatican, Rome.

understanding of the geometry of form and of linear perspective, the use of chiaroscuro to make a convincing effect of light and shade, and a narrative subject, which can be discussed by an educated person. The Classical architecture is not only beautiful but proves that the artist was well educated in the ancient style. The figures are natural, and each one represents a misfortune or disability—the blind, the aged, the poor, the legless man in the foreground, each has a story to be told. Yet each one makes a graceful gesture. These are the basic hallmarks of the Renaissance style. If "beauty and grace" are present, they mostly take forms familiar to us from nature: beautiful people and buildings, graceful gestures.

Working for patrons who were mostly concerned about life in this world, artists achieved an ability to represent this world with an accuracy rarely imagined before even in Hellenistic and Roman times. It was for these highly developed skills that the masters such as Fra Angelico were paid far more than their less skillful helpers. In 1447, while he painted one work, Fra Angelico was paid 200 florins plus his living expenses. His best assistant was paid only eighty-four florins, and their two

helpers were paid twelve florins each. Since artistic skill was rewarded, it had to be clearly visible in skillful drawing of natural forms and in demonstration of a thorough knowledge of basic mathematics and geometry in the design. Boys were sent to school in Florence to learn mathematics and geometry and they were taught how to draw in perspective and to represent volumes in space—and to criticize art in those terms. (Girls in those days gained what education they could at home.) Paper was becoming common in Europe for the first time and with it drawing became a common and much-collected art. Besides being able to draw, an artist was expected to be at the forefront of technology in his field, in metal casting if he was a sculptor or the chemistry of paint if he was a painter.

THE AUDIENCE AND THE CRITICS

The casting of this bronze sculpture is described and illustrated on p. 227.

As he examined Benvenuto Cellini's (chel-LEE-nee) bronze *Perseus with the Head of Medusa* (see Fig. **7.15**) the Duke of Florence commented: "Although this statue seems in our eyes a very fine piece, still it has yet to win the favor of the people." "The people" who formed the serious audience for art were a fairly small proportion of the whole population: educated business and professional people, members of the church and the nobility. Later, when Cellini reluctantly exposed the not quite finished statue to public view "a shout of boundless enthusiasm went up in commendation of my work," he wrote in his *Memoirs*. Then the critics went to work. "The folk kept on attaching sonnets to the posts of the door. ... More than twenty were nailed up, all of them overflowing with the highest panegyrics [praise]."[4] The audience was far from passive, and not all works were so enthusiastically received by the public. It was just as common to find a sarcastic poem posted alongside a work of art as one of praise. Since the poems were signed, the poet revealed not only his opinion but also his critical ability.

SUBJECTS

The name of the period—the Renaissance, or Rebirth—refers more to the subject matter of art and literature than it does to style. There were two principal categories of subject matter in Italian art of this period: Christian subjects and Greek and Roman Classical mythology. The difference between them would have been described as the Christian subjects being true, the pagan ones being entirely fictional. Only in Christian subjects, they thought, could anything really serious be expressed. Classical mythology was a kind of alternative reality, full of stories and characters known mainly to educated people. But Renaissance people were especially intrigued by the history and style of the pagan Greeks and Romans, whom they began to see as their own ancestors. *The Adoration of the Magi* (Fig. **12.3**) by Botticelli (bah-tih-CHEL-lee; c. 1445–1510) is a good example of a Christian subject, but it is set in the ruins of a Classical temple. Christianity is modern, he shows us, in contrast to the religion and architecture of ancient times.

Those characteristics of the Renaissance style mentioned earlier all add up to the power to produce illusions, to take a raw material and make it seem to be something else. It is hard to tell what the portrait of Lorenzo de' Medici (see Fig. **12.1**) is made of—it might be wood, or bronze, but actually it is fired clay, or terra cotta. Verrocchio so completely dominated his clay that we cannot see it at all. We see only Lorenzo de' Medici.

The power to dominate and transform was the great preoccupation of the Italian Renaissance. A typical political book of the period was Machiavelli's *The Prince*, a manual on how to gain and retain political power or, you might say, how to mold people to your will. Another kind of book was invented by Renaissance writers, the novel, in which words gained the power, never so fully realized before, to transport us into an experience so completely that we cannot remember having read the words. Similarly, Renaissance painting draws us into the experience, making us forget the paint and canvas.

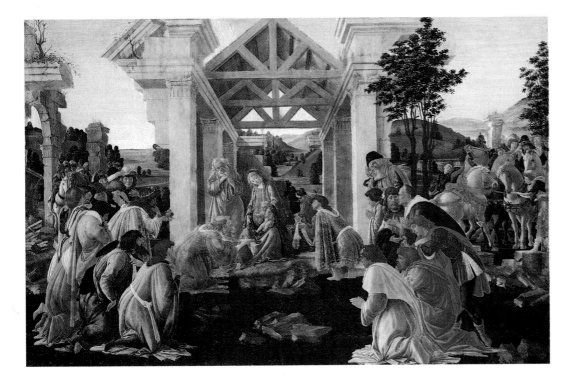

In Titian's *Bacchus and Ariadne* (Fig. **12.4**), Bacchus, the god of wine, leaps from his leopard-drawn chariot, transfixed by the power of love at first sight. You can imagine the artist's pleasure in his craftsmanship, which makes us see flesh and hair, cloth and leopard pelt, distant mountains and open sky. To Renaissance eyes the skill is admirable precisely because it has become invisible, like an actor who is so convincing that we forget he is acting. For the Renaissance and Baroque audience, an artist was admirable to the degree he could dominate the imagination of the

12.3 (*above*)
BOTTICELLI,
The Adoration of the Magi,
1481–82.
Tempera and oil
on wood panel,
27⅝ x 41 in
(70 x 104 cm).
National Gallery of Art,
Washington, D.C.
(Andrew W. Mellon
Collection.)

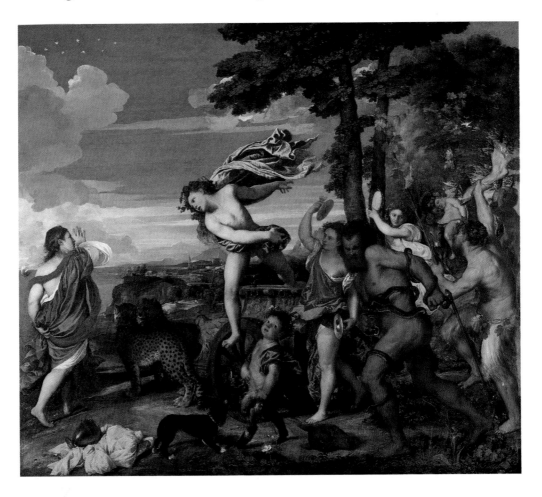

12.4 (*right*)
TITIAN,
Bacchus and Ariadne,
1520.
Oil on canvas,
5 ft 8 in x 6 ft ⅞ in
(1.7 x 1.8 m).
National Gallery, London.

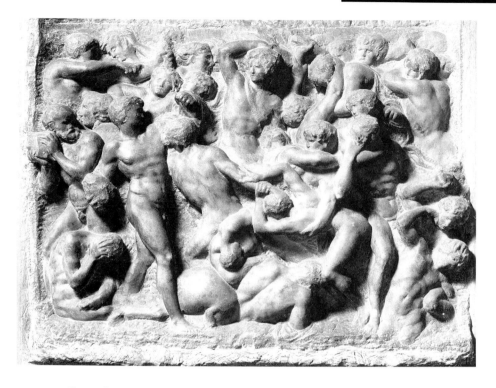

12.5
MICHELANGELO,
*Battle of the
Centaurs,*
c. 1492.
Marble,
33¼ x 35⅝ in
(84 x 90 cm).
Casa Buonarroti,
Florence, Italy.

Michelangelo's Youth

During the summer of 1489, when Michelangelo was a boy of fourteen, he was selected as one of about six to form the first sculpture class in the Medici Gardens under the supervision of the aged sculptor Bertoldo. The ruler of Florence, Lorenzo de' Medici, "the Magnificent," had set up the school to assure a supply of sculptors to adorn his beloved city. Michelangelo was delighted at the opportunity to work freely, carving stone, after three years of unhappy schooling and a year of apprenticeship to a painter.

Michelangelo's frail mother (who died when he was six) had been unable to nurse him when he was born, and the baby was given to the wife of a quarry worker in the town of Settignano, where Michelangelo remained until he was ten. In later years Michelangelo said: "I also sucked in with my nurse's milk the chisels and hammer with which I make my figures."* Although he received many commissions to make paintings, he always considered himself a sculptor, and especially a carver of marble.

The first few carvings the boy made after he entered the Medici Gardens were so impressive that Lorenzo the Magnificent called in Michelangelo's father, Ludovico Buonarroti, to arrange for the boy to be taken into the ruler's own household. Ludovico objected to his son becoming "a stonecutter," a mere laborer with his hands. Michelangelo had to struggle all his life

against that prejudice as he tried to gain the respect he thought artists deserved. The ruler's will prevailed, and the boy became virtually the foster son of the Medici family. His father was rewarded with a position as customs official.

Three years later, in 1492, the young sculptor carved a marble relief, *Battle of the Centaurs* (Fig. **12.5**), taking a Greek myth as his subject. For a seventeen-year-old, it is a remarkable achievement, and Michelangelo kept it for himself all his life. Its churning action and powerful muscular bodies forecast the direction of his work for the rest of his long life (he died at age eighty-eight in 1564). The sculpture was never completely finished. You can see the marks of the pointed chisel at the top, used to rough out the basic forms, and the marks of the toothed chisels in various places between the figures, used to refine the forms. Those two kinds of chisels were Michelangelo's favorite tools all his life. More than any other sculptor in history, Michelangelo was a direct carver in stone, visualizing the figure within the block and cutting away the meaningless masses of stone that hide it. It is amazing to see forecast in this youthful work the direction of a whole lifetime.

*Quotation from Giorgio Vasari, *The Great Masters*, translated by Gaston Duc de Vere, edited by M. Sonino (New York: Hugh Lauter Levin Assoc., 1986), p. 208

viewer by his illusions. Educated Italians of Titian's period were well acquainted with the ancient story of Ariadne, who was abandoned by her lover on the lonely island of Naxos, where she met and married Bacchus. Titian's problem was not to tell the familiar story, but to reveal it in a convincing setting. Venice, where Titian worked, preferred sumptuous color to the more intellectual linear style popular in Florence. That fact helps to explain the greater emphasis on aerial perspective in the deep blue background, instead of the linear perspective of the ruined stable which makes a setting for Botticelli's *The Adoration of the Magi* (see Fig. **12.3**), in good Florentine style.

That admiration for skill, which we see reflected in contracts, gave special prestige to the best artists. The new class of patrons understood that greatness was achieved by effort and intelligence, and a few artists in each generation were picked out as especially distinguished. That was possible only because the audience was exceptionally cultivated and had produced many patrons, critics, and historians, such as Giorgio Vasari, painter and author of *Lives of the Artists*. The people of that period immortalized themselves by the richness of their cultural life, which keeps them still fresh in our memories.

THREE PHASES OF RENAISSANCE STYLE

We can divide the style of the Renaissance in Italy into three phases: Early Renaissance (1400–1500), High Renaissance (1500–20), and Mannerism (1520–1600). Those phases are particularly applicable to Florence and Rome. Venice, as we shall see, developed on a pattern of its own, prolonging the High Renaissance style and skipping the Mannerist.

Early Renaissance
The artists of the first phase laid the groundwork for reviving Roman Classical types of architecture and human figure, they invented linear perspective, and they developed a painting style that emphasized the illumination of masses. All these achievements have been discussed in other chapters, but we might stop to consider Masaccio (*ma-ZAH-cho*), who died at the age of twenty-seven but whose work "became a school for the most celebrated sculptors and painters," as Vasari wrote.[5] Masaccio's fresco, *The Tribute Money* (Fig. **12.6**), showing Christ instructing his

12.6
MASACCIO,
The Tribute Money,
c. 1427.
Fresco, 8 ft 4 in x
19 ft 8 in (2.5 x 6 m).
Church of Santa Maria del
Carmine, Florence, Italy.

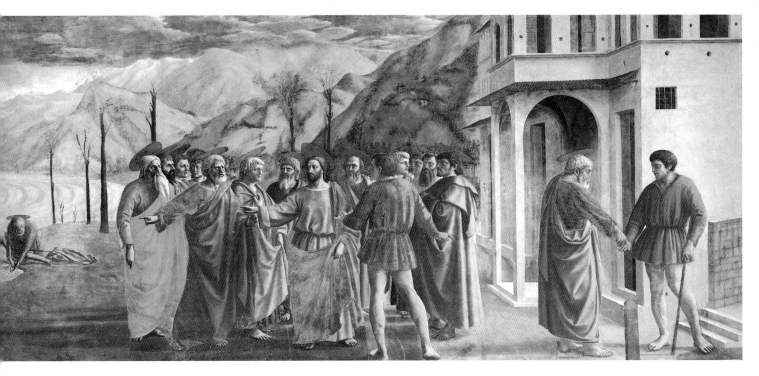

disciples to "give unto Caesar that which is Caesar's," helps us understand why it was that both painters and sculptors studied his work. The most important new element in art of this time was the third dimension in space and mass, and Masaccio's figures, painted in very simple large areas of color, are given solidity by their illumination, or, as the Italians said, by chiaroscuro, or light and shade.

The middle of the 1400s saw Florence still the dominant city culturally, but artists in other cities began to achieve fame that even the Florentines recognized. The mathematician and painter Piero della Francesca, in central Italy, and Giovanni Bellini and Andrea Mantegna in northern Italy, are among the great names that show the spread of Renaissance style. Florence retained its importance with three distinctive masters: the painter Botticelli (see Fig. **12.3**), the sculptor Verrocchio (see Fig. **12.1**), and his pupil, the painter, draftsman, scientist, and inventor, Leonardo da Vinci.

It is impossible to sum up the achievements of this important period in a few words, but the distinctive new elements are fully expressed in Leonardo's *Madonna of the Rocks* (see Fig. **12.9**), a painting so much admired that he painted it twice for different patrons. One of the first oil paintings by a Florentine painter, it has the rich, dark sheen of that medium. Leonardo had learned Masaccio's lesson so well that we take for granted the golden light streaming into the scene from the upper left. Leonardo's study of nature turns the rocks and plants into geological and botanical specimens, but most impressive of all is the personality revealed in the face and gesture of each of the figures. The stable pyramidal composition—you can trace it out by following the imaginary lines that run from the top of Mary's head through her hands to form a large triangle—is also characteristic of this period, which preferred a calm, dignified design and expression. In all these respects Leonardo led the way into the next period, the High Renaissance.

High Renaissance

The High Renaissance was a short period during the first twenty years of the 1500s, when the popes were building and decorating Saint Peter's and the Vatican Palace in

12.7
RAPHAEL,
The School of Athens,
1501–11.
Fresco, 18 x 26 ft
(5.5 x 7.9 m).
Stanza della Signatura,
Vatican Palace, Rome.

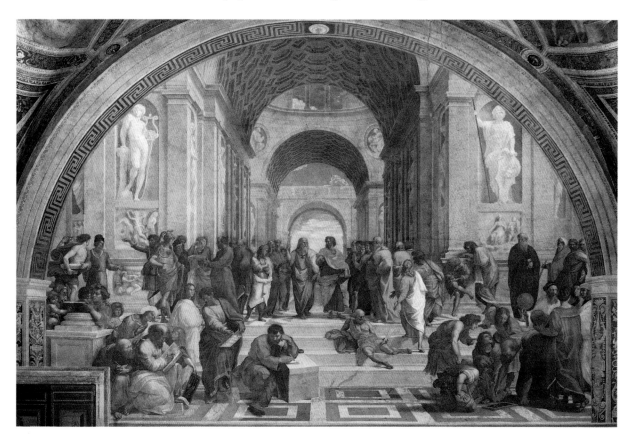

Rome. Both in size and in quality, the projects carried out in that short time have been considered among the supreme achievements of Western civilization. The massive forms of Masaccio and Leonardo led to a style in both painting and sculpture in which balanced, massive forms were dominant, movement appeared to be rational and controlled, and unity was the dominant principle. Primary colors played a major role, suggesting optimism and openness. Michelangelo's sculptured *Moses*, his Sistine Chapel ceiling, and his architectural designs for Saint Peter's, along with Raphael's paintings, are considered high points. You may wish to look back to Chapter 6 to review Michelangelo's Sistine Chapel ceiling, but here we will take Raphael's *The School of Athens* as our example.

Raphael (RAF-ay-el; 1483–1520) painted *The School of Athens* (Fig. **12.7**) in fresco on a wall in the Vatican Palace. The setting, in which Plato (left center) and Aristotle stand among ancient scholars and poets, is modeled on the new Saint Peter's church, which was under construction next door. No Athenian of Plato's day ever stood in such a building, of course, since the architecture shown in the painting is in a later Roman style, but it makes a powerful and impressive perspective, centering behind the heads of the two great philosophers. The painting was much admired as an illustration of ancient learning, each figure being identifiable and shown in a characteristic pose. The symmetry adds great dignity to the figures, who stand erect or move in calm, geometrically ordered, postures.

A century earlier such a subject and design would have been impossible to paint. The perspective system was still barely a hundred years old, the ancient Greek philosophers and poets had become well known only during more recent years, and the exact knowledge of Roman architecture in the background shown by Raphael was an even more recent achievement. *The School of Athens* was at the forefront of knowledge in several fields when it was painted.

Mannerism

Raphael died young (at the age of thirty-seven) in 1520, and that is usually taken as the end of the High Renaissance despite the fact that Michelangelo lived for another forty-four years. But the mood had changed from confidence to pessimism, expressed in art by exaggeration: figures became elongated or massive, contrasts of scale were extreme, colors were dominated by subtle mixtures that blend from hue to hue and tint to shade. The later work of Michelangelo dominated and inspired the period called Mannerism (1520–1600), in which doubt and introspection ruled in art, at least in Rome and Florence.

Michelangelo's fresco *The Last Judgment* (Fig. **12.8**, overleaf), on the front wall of the Sistine Chapel, is the greatest work of the period, but a tragic and frightening scene. The calm geometry of the earlier compositions has given way to a churning mass of figures. Without the straight lines provided by an architectural framework, the crowds of saved or damned souls seem to whirl in space. A powerful figure of Christ implacably condemns the sinners as the trumpets sound in the heavens. Viewed from Rome, the world was in unprecedented danger of damnation, for Protestantism had risen in northern Europe to challenge the rule of the pope. It was not until 1600 that Catholicism recovered its self-confidence and found a new form of expression in the Baroque style.

VENICE IN THE 1500s

Venice had no such crisis of confidence and it was unrivaled as an art center throughout that century. The mantle of the older master Giovanni Bellini (c. 1430–1516) fell to two great disciples, Giorgione (1478–1511), who died young, and the very long-lived Titian (1477–1576; see Fig. **12.4**). Because Venice was built on islands and pilings in a shallow sea, the walls of its buildings were mostly considered too damp for fresco, so mural decoration began to be done in oil on canvas, which hung free of the wall. Venice was one of the first places in Italy to adopt oil painting, which was invented in northern Europe early in the 1400s.

Michelangelo's *David* can be found in Figure **7.4**, his frescoed ceiling of the Sistine Chapel in Figures **6.4** to **6.7**, and his dome for St. Peter's in Figure **8.25**.

A painting by both Giovanni Bellini and Titian is shown in Figure **6.26**.

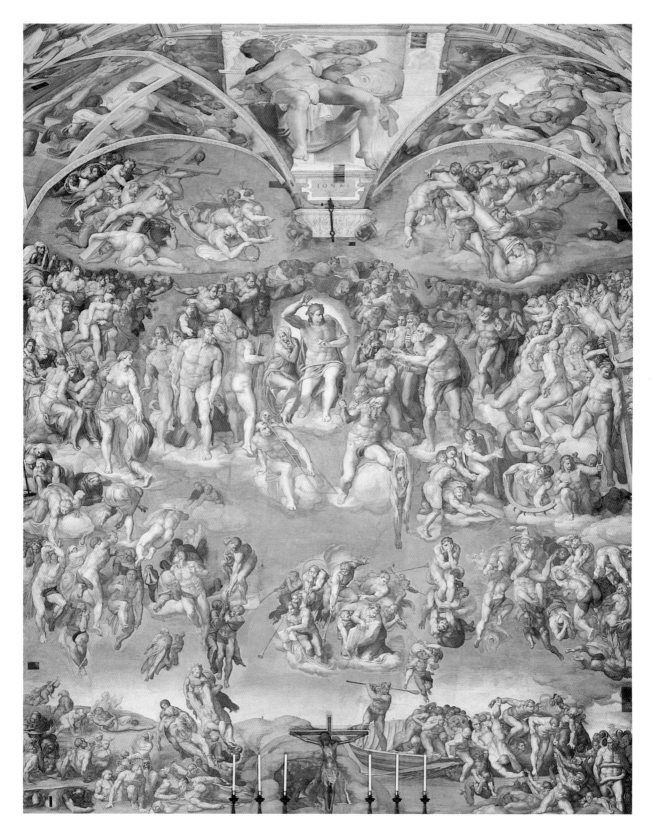

12.8

MICHELANGELO, *The Last Judgment,* 1536–41.
Fresco, 48 x 44 ft (14.6 x 13.4 m).
Sistine Chapel, Vatican, Rome.

Tintoretto (1518–94) marks the transition from the Renaissance to the Baroque, as we can see in his *Adoration of the Shepherds* (Fig. **12.9**), an oil mural from the vast set of decorations for the School of San Rocco, a religious fraternity. The complicated scene, in which the Holy Family is set back in a loft lit by shafts of light through the ruined roof, anticipates the theatrical space and light in the art of the next century. It is not the serene dignity of the early Renaissance style, but an energetic and emotional style. The contrasts of light and dark are extreme, the gestures are muscular (notice especially the men in the lower left corner), and the spaces are organized in surprising ways—this may be the only Nativity scene in which the Mother and Child are shown in a loft. Tintoretto gives us a solid barn built of strong beams to act as the framework and perspective for this scene, but removes the roof to let in a divine radiance.

12.9

TINTORETTO, *Adoration of the Shepherds*,1576–81. Oil on canvas, 17 ft 9 in x 14 ft 5 in (5.4 x 4.4 m). School of San Rocco, Venice, Italy.

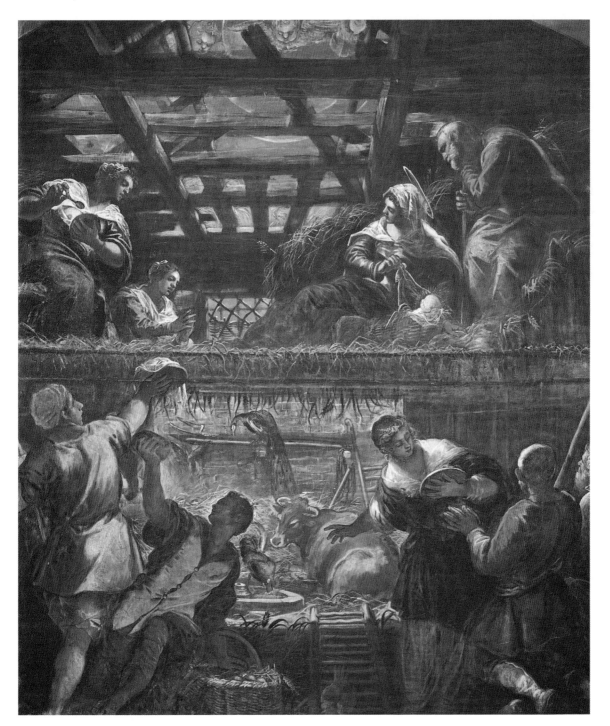

Leonardo, Artist–Scientist

12.10 (*left*) LEONARDO DA VINCI, *Madonna of the Rocks*, 1483–85. Oil on panel, transferred to canvas, 6 ft 6½ in x 4 ft (2 x 1.2 m). Louvre, Paris.

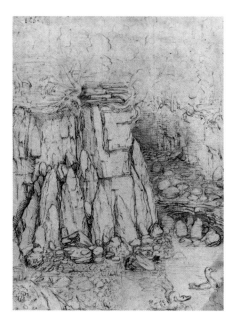

12.11 (*right*)
LEONARDO DA VINCI, *Ravine with Water Birds*, 1478–80. Pen and ink on pinkish paper, 8¾ x 6¼ in (22 x 16 cm). Royal Library, Windsor Castle, UK.

These days we speak of a "Renaissance man" as one who is interested in many things. Leonardo da Vinci (1452–1519) is the model Renaissance man—we can see the evidence for this in the *Madonna of the Rocks* (Fig. **12.10**).

The wild rocky caverns and peaks in the background were a common symbol of wilderness, but Leonardo was not content with symbols of rocks. He took pains to show the texture and stratification; we can imagine him setting up small rocks to use as models. We know that in later years Leonardo made trips into the Alps to study geology and botany. He was particularly interested in fossils of sea life which he found high in the mountains and which he theorized must have been left when the sea once covered the mountains, an idea unheard of in his time.

The drawing of rocks on the bank of a pond (Fig. **12.11**) was done about five years before the *Madonna of the Rocks*, when the painter was about twenty-six.

You can see the kinds of natural rocks that were the source of the background in the painting and how carefully Leonardo considered them. All sorts of vertical and horizontal stratification and erosion are examined in detail. Leonardo is admired as an early scientist, but his greatest weakness as a scientist—his inability to generalize—was his strength as an artist. Art and truth for Leonardo came only from "experience, mother of all certainty, first-hand experience," as he wrote. "If you despise painting, which is the sole means of reproducing all the known works of nature, you despise an invention which with subtle and philosophic speculation considers all qualities of forms: seas, plants, animals, grasses, flowers, all of which are encircled in light and shadow."

Quotations from Leonardo's *Trattado*, chapters 8, 29, in Kenneth Clark, *Leonardo da Vinci* (London and Baltimore: Penguin, 1958), pp. 75, 135

THE RENAISSANCE IN NORTHERN EUROPE

Flanders, then an independent county (ruled by a count) and now part of Belgium, was the center of art development in northern Europe during this period. It was also a center of trade. The city of Bruges, for example, was a busy port with canals leading to the brick warehouses of the Hanseatic League, a vast trading association of northern cities. English wool, Russian furs, almonds from Spain, and spices from the East passed through her markets. Throughout Flanders, industry and labor were organized in guilds similar to modern unions and trade associations.

There were also trade and art connections between Flanders and Italy. Jan van Eyck's *Arnolfini Wedding Portrait* (Fig. **12.12**) provides clues to these connections and also shows some of the differences between the two regions. The groom, Giovanni Arnolfini, was an Italian who managed the Medici bank in Bruges. He and his Paris-born Italian bride, Jeanne Cenami, patronized the leading Flemish painter, Jan van Eyck (1370?–1440?) to record their marriage vows. Flemish painting was admired in Italy; fifteen years after his death Van Eyck was described by an Italian critic as the foremost painter of the age. The Arnolfinis seem at home in their Flemish bedroom with its Gothic decoration, and they are both shown with the delicate proportions of the Gothic tradition in figure art, quite different from the Classical athletes who had again become the models for the human figure in Italy.

You can learn to recognize the style of the Flemish painters just by a careful examination of this painting. First of all, notice the dimensions: 33 by 22½ inches (84 by 57 centimeters). You might compare that with the painting by Fra Angelico, *Saint Lawrence Distributing Alms to the Poor* (see Fig. **12.2**), which measures about 9 by 6½ feet (2.7 by 2 meters). Some very large paintings were made in northern Europe, but on average Italian paintings were larger for one good reason: they were more often painted in fresco directly on the walls of buildings, as was the Saint Lawrence painting. The *Arnolfini Wedding Portrait* is painted on a wooden panel in a mixture that included oil paint, of which Jan van Eyck was one of the inventors.

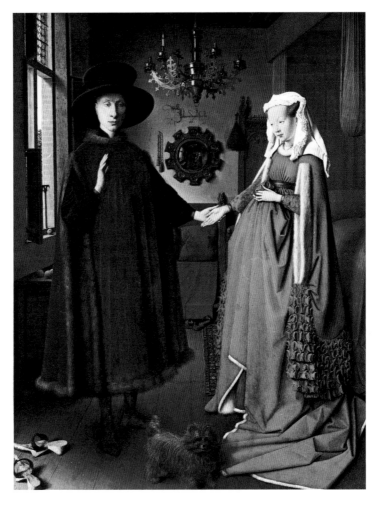

12.12
JAN VAN EYCK,
Arnolfini Wedding Portrait,
1434.
Oil on wood panel,
33 x 22½ in
(84 x 57 cm).
National Gallery, London.

Saint Lawrence is shown in a large public building, presumably a church, despite its Classical columns. The Arnolfinis are in a small bedroom of their own home, ornamented with Gothic carving on the bed and chair. To a northern European that room looks cozy, and the Italian church looks cold and drafty. It seems contradictory that the Arnolfinis' home is decorated in the Gothic style, which we think of as a church style, not the Classical style (which was pagan in origin) of Fra Angelico's church; notice the carving on the bed and the arm of the chair, as well as the ornate brass chandelier. The cool northern climate, of course, accounts for the warmer clothing the Arnolfinis wear, but it does not explain the difference in their body

proportions from people in Italian paintings. The question always arises whether Jeanne was pregnant on her wedding day. Kenneth Clark, in his book *The Nude*, describes what he calls the Gothic ideal of the feminine figure: "Her pelvis is wider, her chest narrower, her waist higher; above all, there is the prominence given to her stomach."[6] This Italian couple is portrayed in a Gothic figure style that remained popular in the North into the 1400s, and Jeanne's prominent stomach only tells us about art and clothing style, not about her behavior.

The northern style was also strongly affected by its use of oil paint, which came into Italian art about two generations later. Oil permits very fine gradations of color blending, such as we see on the back wall, and fantastic illusions of natural textures, as in the fur trim of Arnolfini's robe, the shine of the chandelier, and the texture of the bride's dress. All these features of the Flemish style were so impressive that the Italian painters were worried by the competition and began to experiment with linseed oil and turpentine to mix and thin their colors.

The setting in a middle-class house was also typical of the North. The northern cities were important commercial centers, with a middle class whose power rested on industry and trade. The merchant class of Bruges, to which the Arnolfinis belonged, grew wealthy and began to adopt the pleasures and privileges of the nobility, including the patronage of artists. Perhaps in reaction, the nobility cultivated a fairy-tale kind of elegance, emphasizing chivalry and knightly virtues after they had become obsolete in warfare. Wherever there was wealth, among the merchants or the nobility, the patronage of art was a supreme pleasure of the time.

Jan van Eyck, like many of the leading artists of his day, was a courtier and diplomat, employed often by the powerful Duke of Burgundy. Court artists such as Van Eyck were expected to design floats, costumes, and mechanical apparatus for festivals, decorate manuscripts, design furniture and paint it, organize and mount state ceremonies, as well as paint state portraits which were supposed to be perfect likenesses. They might be asked to design a tomb, decorate a ship, or paint an altarpiece, with the help of their students and apprentices.

REALISM AND SPIRITUALITY IN NORTHERN ART

Realism based on careful looking at nature is an important feature of northern art. About the time Jan van Eyck was painting the Arnolfinis, Robert Campin (*c.* 1375–1444) painted the portrait of an unknown woman of Tournai (Fig. **12.13**) in that city. It was painted about seventy-five years before Leonardo da Vinci painted the *Mona Lisa* (Fig. **12.14**), but they make an interesting comparison. Both women were members of the middle class—Mona Lisa was the wife of a banker in Florence—each fashionably dressed for her time and place. Campin concentrated on the face, but in the *Mona Lisa* there is a balance between the head and the body, which the revived Classical ideas required. Leonardo also gives us a generalized, superhuman character whose face is designed by abstract geometry to fit the mouth and veil on a perfect circle. That kind of dehumanized abstraction was the opposite of northern realism, which took nature, not an abstract ideal, as the model.

Saint Luke Drawing the Virgin (Fig. **12.15**) may be a self-portrait of the painter Rogier van der Weyden (1399–1464) in the guise of the writer of the Gospel. Saint Luke, who was supposed to have been an artist, seems frozen in a genuflection before the stiff but cheerful Child and his gentle mother. Luke is making a silverpoint drawing, which would be a study for a painting. Rogier made designs in which lines and shapes played a strong part—notice the elaborate folds of the garments and the strong pattern of light and dark. Line and shape gave special elegance and spirituality to his style, which was extremely popular with the audience of his time. Those two trends, realism and spirituality, were both strong in northern art.

A drawing by Rogier van der Weyden shows the same serious mood, human types, and clothing style with the same sharp folds (see Fig. **3.7**).

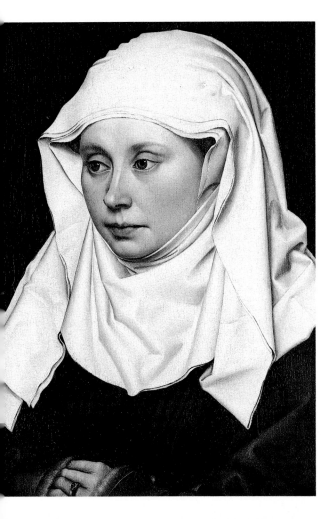

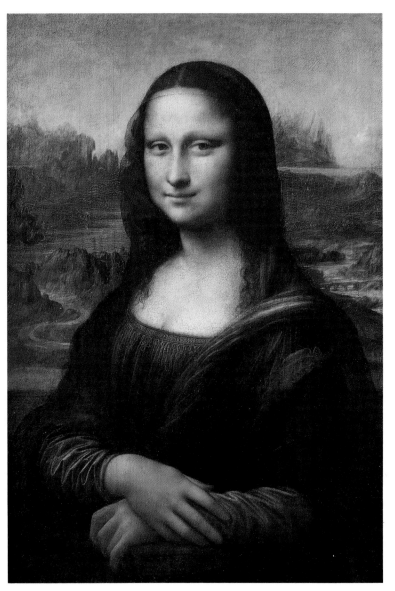

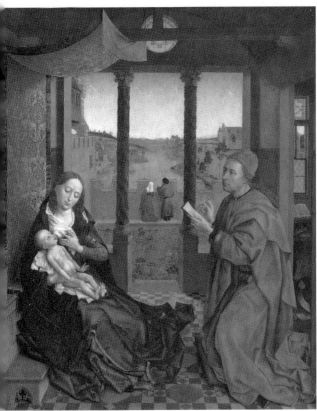

12.13 (*above left*)
ROBERT CAMPIN,
Portrait of a Woman of Tournai,
1425–30.
Oil on wood panel,
16½ x 11½ in
(42 x 29 cm).
National Gallery, London.

12.14 (*above*)
LEONARDO DA VINCI,
Mona Lisa,
c. 1503–5.
Oil on wood panel,
30½ x 21 in (77 x 53 cm).
Louvre, Paris.

12.15 (*left*)
ROGIER VAN DER
WEYDEN,
*Saint Luke Drawing the
Virgin,* 1435–37.
Oil and tempera on wood
panel,
4 ft 6⅛ in x 3 ft 7⅝ in
(1.4 x 1.1 m).
Museum of Fine Arts,
Boston. (Gift of Mr and
Mrs Henry Lee.)

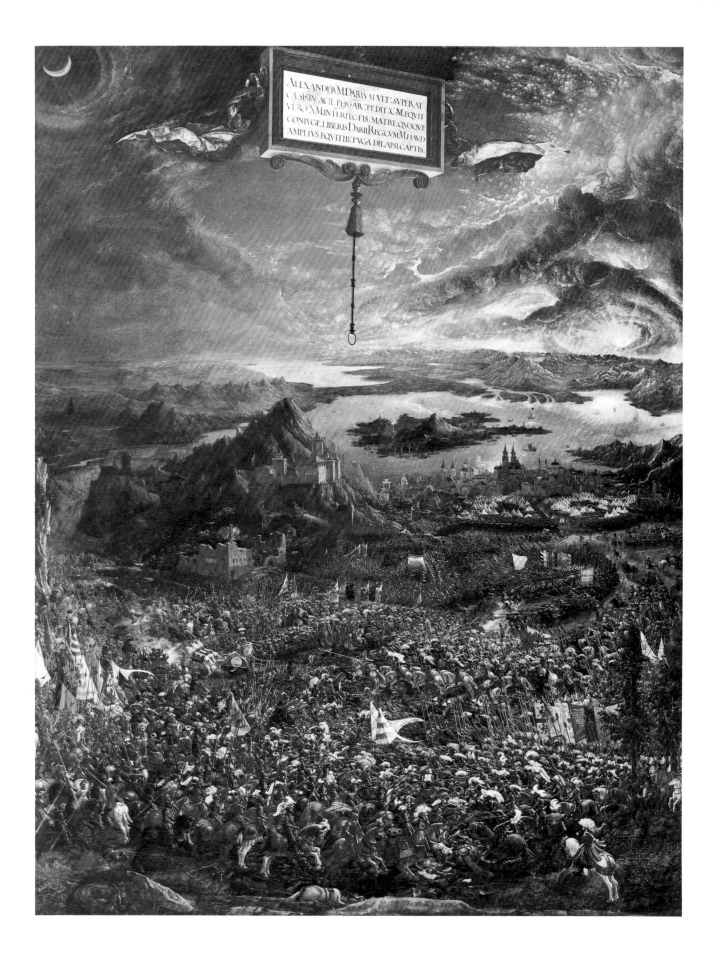

SUBJECTS

Ancient Greece and Rome, which seemed to the Italians like their own heritage, meant far less to these northerners, whose ancestors had been conquered by Rome and who knew of Greek Classicism only from books. Having no Greek and little Roman art around to study, they made no attempt to revive the ancient style, but they used the newly fashionable stories and characters in their art. *The Battle of Alexander and Darius* (Fig. **12.16**) was painted by Albrecht Altdorfer (1480–1538) for the Duke of Bavaria, who saw no inconsistency in the medieval armor and castles, nor in the vast Alpine setting, which made Alexander seem part of medieval German history instead of ancient Greek.

BOSCH, GRÜNEWALD, BRUEGEL

Although the supreme individual artist of this period, Albrecht Dürer (1471–1528), was more important as a printmaker than as a painter (see Chapter 5), three great painters sum up the achievements of a hundred years of northern art from about 1470 to 1570—Jerome (or Hieronymus) Bosch (1453–1516); Mathis Gothart Neithardt, called Grünewald (*GRU-nuh-valt*; c. 1470–1528), and Pieter Bruegel (*BROO-gul* or *BROY-gul*; c. 1525–69). In both Italy and northern Europe, Renaissance art drew on two contrary sources, one of them an objective study of the natural world, the other an imaginative world carried down in the traditions of each region. In Italy, Greek and Roman Classicism provided that imaginative world, but in the North it was the ancient pagan religion that survived on the margins of Christianity in the form of fantastic folktales. These three painters made especially potent use of the fantastic.

Philip II, king of Spain and a religious fanatic, had ten paintings by Jerome Bosch. Among Philip's purchases was *The Hay Wain Triptych* (Fig. **12.17**), which is still in

12.16 (*opposite*)
ALBRECHT ALTDORFER,
The Battle of Alexander and Darius, 1529.
Oil on wood panel,
5 ft 2 in x 3 ft 11 in
(1.6 x 1.2 m).
Alte Pinakothek, Munich,
Germany.

12.17
JEROME (HIERONYMUS)
BOSCH,
The Hay Wain Triptych,
1490–95.
Oil on wood panels,
center panel 4 ft 7⅛ in x
3 ft 3⅜ in (1.4 x 1 m),
each wing 4 ft 9⅞ in x
2 ft 2 in (1.5 x 0.7 m).
El Escorial, near Madrid.

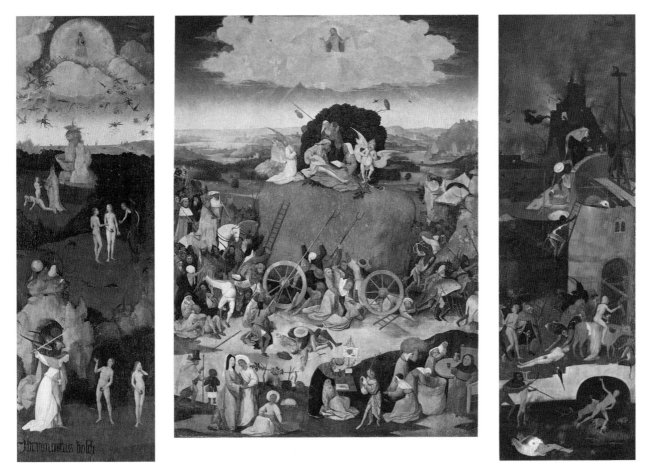

Philip's palace near Madrid. The critics at Philip's court considered it an illustration of Isaiah 11:6–8 ("the lion will eat straw like the ox"), but modern historians have suggested that Bosch was thinking of a Flemish proverb that says the world is a pile of hay from which each seeks to grab what he can. In the left wing, as God creates Eve in Paradise, the rebel angels are expelled from heaven like a swarm of insects. In the center Christ looks down from the clouds as everyone on earth fights for material goods, even those supposedly committed to the spiritual life. The great hay wagon rolls toward Hell, drawn by weird demons. In the right panel is the fiery landscape of Hell. Bosch's visions suited a pessimistic period of religious war and persecution, but behind their fantasy is a cool, rational design of incredible complexity and richness. Notice the wide landscapes, with aerial perspective, that provide a stage for fantastic events.

Grünewald's greatest work is another altarpiece, the Isenheim Altarpiece, which is a polytych (a painting composed of many panels, in this case ten). The multiple-panel painting, with folding wings painted on both front and back, was the northern answer to the problem of major public art. It might be compared to an Italian chapel frescoed on all four walls, or to a medieval manuscript with paintings on every page. Patrons and the public found it a satisfactory way to tell elaborate stories, and the triptych and polytych became the standard format for the northern masterpiece until around 1600.

12.18

MATHIS GOTHART NEITHARDT, called Grünewald, *The Crucifixion* from the Isenheim Altarpiece, 1515. Oil on wood panel, 9 ft 9½ in x 10 ft 9 in (2.9 x 3.3 m). Musée d'Unterlinden, Colmar, France.

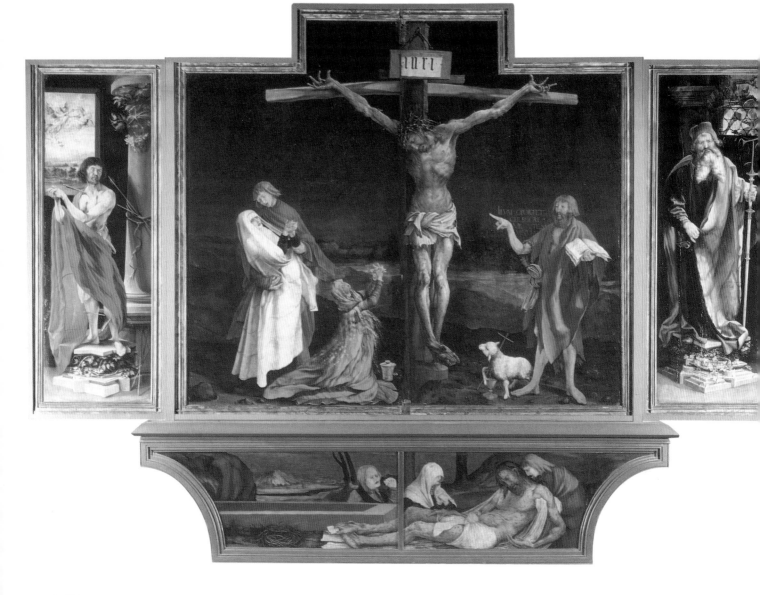

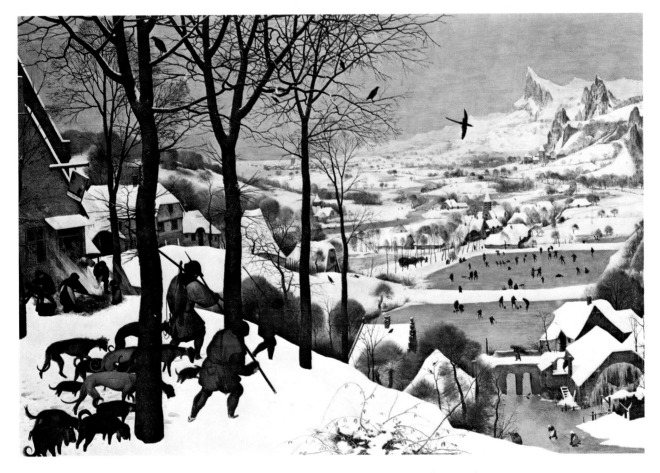

The Isenheim Altarpiece has a set of wood sculptures at the center, by another artist, which are overshadowed by Grünewald's powerful paintings. *The Crucifixion* (Fig. **12.18**), 9 feet 9½ inches (2.9 meters) high, at the center of the outside of the altarpiece, has the Christ, fearfully wounded, larger than the other figures, unnatural in scale but true in a spiritual sense. On the left Mary swoons in the arms of John the Evangelist, as Mary Magdalen gives expression to an agony of grief. John the Baptist, who had died before the Crucifixion, is placed on our right, with the inscription "He must increase, but I must decrease." Perhaps it is the color that conveys the expression even more than the tortured shapes and the extremes of light and dark. The strong contrast of Mary's white robes with John's red and green shading of the body of Christ shine like jewels in the darkness of the scene.

Dated 1515, the Isenheim Altarpiece was painted at almost the same time as Michelangelo's Sistine Chapel ceiling. When we speak of beauty being a cultural value, not an objective absolute, these two complex works are good examples. Michelangelo's sculptural figures seem serene compared with the passion and color of Grünewald's. The difference between fresco and oil paint is also a factor, for oil provided a much greater color range as well as a shiny surface, which gives the shadows greater depth.

Pieter Bruegel was described as "Bosch reborn" by a contemporary because his first works were engravings of Flemish proverbs ("The Big Fish Eat the Little Fish") elaborated with Bosch-like fantasies. Bruegel brought this northern tradition to a close, for during his time the Italian style had begun to be copied by Flemish painters. In his mature work Bruegel turned away from fantasy toward realistic portrayal of the daily life of common people. His patrons were middle- and upper-class collectors, including the German emperor Rudolf II, who enjoyed Bruegel's paintings of peasant life. His original audience saw vulgar humor in Bruegel's work, but that is largely lost to modern eyes.

Hunters in the Snow (Fig. **12.19**), which belonged to Rudolf II, is one of the best of Bruegel's later paintings. Bruegel never painted a portrait, but sought to portray

12.19
Pieter Bruegel the Elder,
Hunters in the Snow,
1560–65.
Oil on wood panel,
3 ft 10⅛ in x 5 ft 3⅜ in
(1.2 x 1.6 m).
Kunsthistorisches Museum, Vienna.

humanity as a type, not an individual. A master of body language, he makes every pose and gesture tell. Examine the legs of the hunters, the bent bodies of the fire-tenders, or the movements of the skaters—what more could their faces tell us? From a hill we can scan a vast craggy landscape in which people live a rough, but evidently harmonious, life in nature.

When Pieter Bruegel painted *Hunters in the Snow* about 1565, the first Europeans had reached Japan, on the far side of the globe, only twenty-two years before. *Hunters in the Snow* was one of a set of four paintings on the seasons of the year, a favorite subject in Japanese art and one they would have understood immediately, despite the great difference in style. Compared with the varied textures and colors in Bruegel's painting, and the mountains with their definite horizon, Japanese paintings (such as Fig. **12.23**) look abstract and ethereal. Yet in their attitude toward nature they have something in common.

THE WAVE AND THE ROCK—ART IN JAPAN: 1500–1700

When Columbus set off on his voyages of discovery, it was not America he hoped to reach (since its existence was unknown to him), but Zipangu, described by Marco Polo as islands of incredible wealth off the coast of China. Zipangu—or, as we would say, Japan—was reached fifty years later, in 1543, by Portuguese explorers who were busy establishing trading colonies throughout the Far East. They were followed by Saint Francis Xavier, founder of the Jesuit order of monks, who succeeded in converting many Japanese to Christianity. A century of close contact ended in 1638, when the Portuguese were expelled and Japan turned inward, cutting off almost all foreign contacts until 1854, when the American Commodore Perry forced a trade treaty on a reluctant Japan. The East and the West, so different from each other in some respects, had enough in common that both sides were enriched, not by the gold that the early explorers hoped to find, but by the stimulus of contact with a different culture.

The Japanese were most interested in the technical devices of the Namban ("southern barbarians"), as they called the Europeans: large sailing ships, guns, eyeglasses, and clocks. Western art had little perceptible influence in Japan before the 19th century. The Japanese arts described by the Portuguese Christian missionaries between 1543 and 1638 comprised two distinct traditions, one native Japanese, the other introduced from China and naturalized with a Japanese form.

THE CULT OF SHINTO AND THE YAMATO STYLE

During the period when the Europeans were in Japan, the greatest painter was Tawaraya Sotatsu (*SO-tahts*; 1576–1643), a freelance artist in the old capital and temple city of Kyoto. None of the Europeans seem to have met him, and his art shows no awareness of European art. But a Jesuit missionary describes paintings much like those of Sotatsu:

> I was taken to see one of their country houses, which was adorned with byobu [screens], or pictures about the height of a man. Each one of them was made up of four panels which folded into one when they were closed up. They were made of wood and covered with paper, on which the pictures were painted; and when these byobu were erected and set up, they covered the walls. ... They were painted so realistically that the spectator seemed to be looking at the actual thing.[7]

Sotatsu painted the *God of Wind* (Fig. **12.20**) on such a screen, which made a pair with a *God of Thunder*. The green demon charges through smoke-like clouds, his long hair flying. Nature divinities were traditional subjects, but the large size—just over 5 feet (1.5 meters) high—and free style were new. In the subdued light of a Japanese house, the gold-foil background would have given the painting a rich

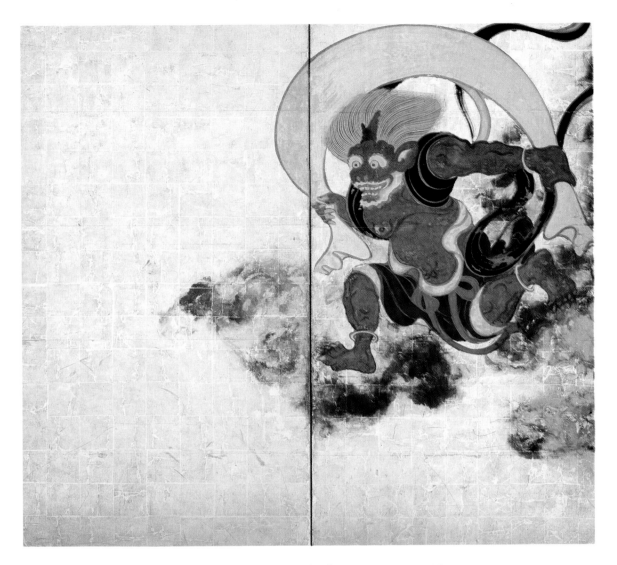

radiance. A Japanese critic writes of "the sense of vitality and vehement movement"[8] in these paintings, which catch the adventurous spirit of the age.

Sotatsu was patronized by a well-to-do merchant class in Kyoto, not too different from the emerging merchant class in Europe. Their preferences were for subjects from history or nature, rather than from religion. The subjects of the *God of Thunder* and *God of Wind* screens come from the active Japanese religious tradition called Shinto. It is assumed that Sotatsu chose the subjects himself, which would show him to have been very original.

The cult of Shinto formalized ancient ideas about the origin and form of the universe, which were the basis of Japanese ideas about proper behavior and cultural value. Every natural thing, place, or process had its spirit, was in a sense living, and must be treated with the respect due a powerful being. Such a belief does not lend itself to art. After all, if the stone is entirely inhabited by a spirit, it is hard to chisel off parts to give the stone more meaning. Thus, it is mostly in attitudes toward nature and materials that we see the effect of Shinto, rather than in works of representational art. João Rodrigues, one of the Portuguese Jesuit missionaries, tell us: "There are many rules regarding the way of putting flowers into the vase and private people learn them by reading books and practising under teachers, always making it their best endeavor to imitate nature and its lack of artificiality." Another Jesuit missionary wrote that "the king of Bungo [actually a local nobleman, and a Christian convert] once showed me a small earthenware tea bowl for which in all truth we would have no other use than to put it in a bird's cage as a drinking trough; nevertheless, he had paid 9,000 silver *taels* for it, although I would certainly not

12.20
TAWARAYA SOTATSU,
God of Wind,
c. 1630.
Watercolor and gold foil
on paper screen,
5 ft 2 in x 5 ft 8 in
(1.6 x 1.7 m).
Kenninji, Kyoto, Japan.

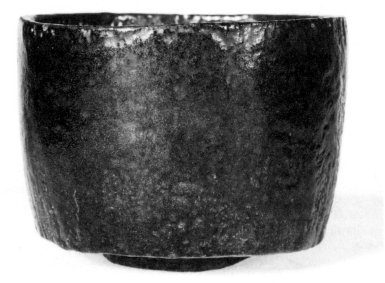

12.21
Hon-Ami Koetsu, tea
bowl, 1558–1637
(Edo period).
Raku ware,
3⁷/₁₆ x 14¹⁵/₁₆ in
(8.7 x 12.5 cm).
Freer Gallery of Art,
Smithsonian Institution,
Washington, D.C.

12.22
*The Burning of the Sanjo
Palace,*
13th century
(Kamakura period).
Ink and colors on
horizontal paper hand
scroll,
1 ft 4¼ in x 22 ft 10 in
(0.4 x 7 m).
Museum of Fine Arts,
Boston, Massachusetts.
(Fenollosa-Weld
Collection.)

have given two farthings for it."⁹ The tea bowl (Fig. **12.21**) was made by Hon-Ami Koetsu (*Ko-ETS*; 1558–1637), friend and patron of Sotatsu and an artist as well as a powerful court figure. Tea bowls that appeared to be crude, natural objects, flowers arranged as if by nature, gardens carefully designed to hide the fact that they had been constructed by humans—those were the purest expressions of the Japanese sensibility and tradition.

As a young painter, Sotatsu had the unusual opportunity to restore some 400-year-old scrolls in a native Japanese style, from which he learned at first-hand to paint in that style. Those old scrolls must have been similar to *The Burning of the Sanjo Palace* (Fig. **12.22**). That scroll, painted in the 13th century, tells the story of a battle that started a civil war in 1159, a battle in which the imperial palace was burned. Like the warrior kings in Europe at the same time, the military leaders who ruled Japan enjoyed seeing the exploits of war raised to the level of mythology. Small figures race across the scene, and horses gallop and prance as flames rage from the palace. Defenders who survived the slaughter were cast down the well. "Alas," reads the text, "the lowermost are drowned in water, those in between are crushed to death, while those on top are engulfed in flames."

From an examination of *The Burning of the Sanjo Palace*, *God of Wind*, and the tea bowl, we can define the native Japanese style, what the Japanese call the Yamato style: natural materials and processes are respected, in line with Shinto beliefs, and in painting, line, shape, and color dominate, expressing dynamic action by curvilinear shapes. Designs are usually asymmetrically balanced between figure and ground, with empty ground often being the larger area and implying space.

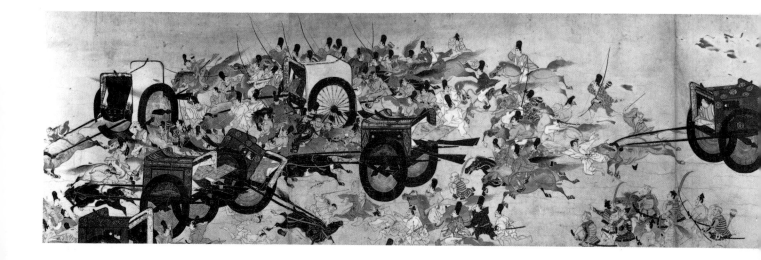

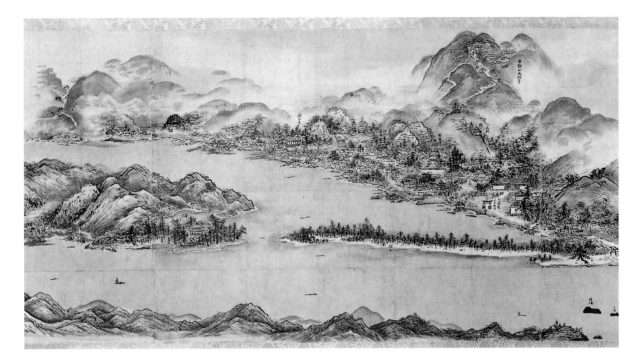

ZEN BUDDHISM

Another style was also in use in Japan during this period: Buddhism, which had come into Japan in the 6th century from India and China and had long existed harmoniously with the active Shinto beliefs. One Buddhist sect, Zen, was particularly identified with a painting style with Chinese roots. Zen Buddhism taught that salvation is achieved by a mystical experience that comes like a lightning bolt in the midst of everyday life. Zen lifestyle, which emphasized simplicity and the renunciation of luxury, fitted harmoniously with the native ideas of Shinto, but its painting style was quite different from that of Sotatsu. The Zen style is brush painting with black ink, very freely drawn, with each stroke symbolizing some natural feature. Tones or washes of ink were supplementary to line. Landscape was the principal subject.

Most of the great painters in the Zen style were monks. The greatest of all was Sesshu (1420–1506), and it was paintings in his style that the Portuguese missionary João Rodrigues saw and described: "In keeping with their melancholy temperament they are usually inclined towards paintings of lovely and poignant scenes, such as those portraying the four seasons of the year."[10]

Bridge of Heaven (Fig. **12.23**) was painted about 1503 when Sesshu was eighty-three years old. This is not an imaginary place, but a famous spot considered one of the three most beautiful places in Japan. You will recognize the painting style as a development from the style of Wang Wei and Li Cheng in China (see Chapter 11). Sesshu traveled in China in middle age to study religion and art, but found no painters there who were his equal. On his return home he established a studio, which he named the Heaven-Created Painting Pavilion, where he received more commissions than he could fulfill. Before painting he would look from his window over the landscape of mountains and seashore, drink a cup of sake wine, and play a melody on his flute.

Once he was in the right mood, he would paint with brush and ink scenes of the precipitous mountains he had seen in China. Though the basic style is Chinese, Sesshu's combination of soft gray tones and powerful slashes and stabs of the brush is unique, and it was a model for many other Japanese painters. Sesshu's paintings were surely known to Sotatsu, but Sotatsu turned to a more purely Japanese painting tradition. Those two painters represent the opposite poles of Japanese painting during this period.

12.23
SESSHU,
Bridge of Heaven,
c. 1503.
Ink on paper with faint
watercolor,
2 ft 11 in x 5 ft 8 in
(0.9 x 1.7 m).
National Museum, Kyoto,
Japan.

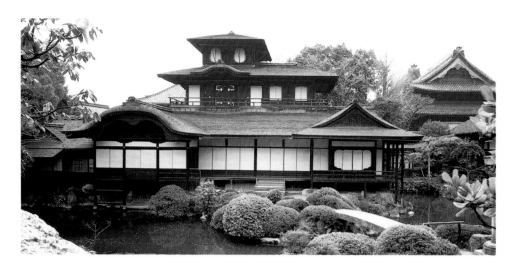

12.24
Flying-Cloud Pavilion
(Hiunkaku), Kyoto, Japan,
1594.

12.25
Uchikake overrobe worn
by the wife of Shogun
Hideyoshi,
late 16th century
(Momoyama period).
Silk brocade imprinted
with silver leaf,
47¼ in (1.2 m).
Kodaiji, Kyoto, Japan.

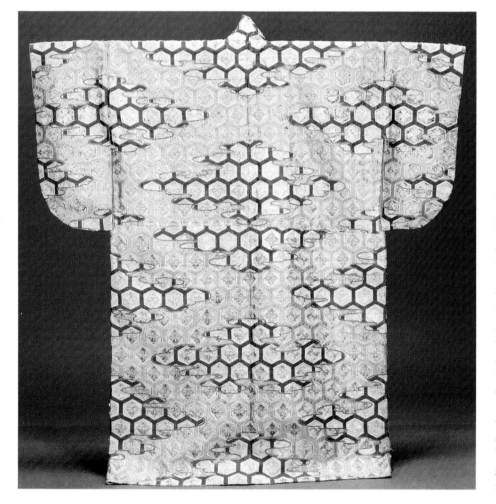

In 1594 the ruler, or shogun, Hideyoshi built the Flying-Cloud Pavilion (Fig. **12.24**) in Kyoto as one of his palaces. To the Europeans it must have seemed hardly grander than a country inn, with its irregular plan, unfinished wood, and thatched roof. Hideyoshi, a peasant boy who had risen by courage and diplomacy to be dictator of his country, could have had anything he wanted; why did he choose this?

The Flying-Cloud Pavilion is actually unusually grand for a Japanese house, rising in Chinese style to three stories in the center. Japanese critics use the term *sukiya*, "artless," to describe this palace as if it were a product of nature rather than of human skill. Several basic principles of Japanese aesthetics—irregularity, simplicity, and perishability—all find expression in this building, which appears to have grown like a plant in its natural-appearing garden. The interior shares that *sukiya* simplicity—elegance achieved by severe understatement.[11]

Hideyoshi was devoted to the tea ceremony and kept at his court one of the famous "tea masters" who specialized in that ceremony in which naturalness and simplicity were raised to rituals. With roots in Shinto ideals and in Zen Buddhism, it appealed especially to powerful people who craved relief from extravagant luxury. It was held in a tiny, primitive-looking teahouse with a door so low you had to bend over to creep in. The utensils were carefully chosen to be as rough and natural as possible. Every move of dipping tea and pouring was ritualized; in fact, the tea ceremony is like 20th-century "performance art" in which the whole activity is symbolic. The cup (see Fig. **12.21**)—really a bowl with no handle—was also simple and rough, as if made by nature instead of human hands.

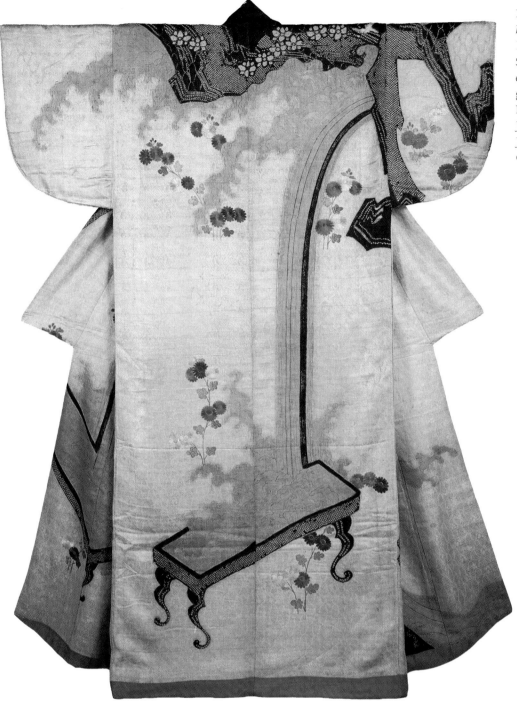

12.26
Kosode robe,
17th century.
Silk satin brocade with
embroidery, ink painting,
gold leaf.
National Museum of
Japanese History, Sakura,
Japan. (Nomura
Collection.)

The tea ceremony was a composite work of art in which the setting and every object and motion was part of the design.

In contrast to the simplicity of the tea ceremony, clothing developed to an amazing richness. Hideyoshi's wife, for example, wore the gorgeous robe with a cloud pattern over a yellow-green and purple honeycomb design (Fig. **12.25**). The kimono, a robe tied with a sash, was a simplification of older costumes worn at the imperial court, and, worn by both men and women in slightly different ways, it became an important way to display personal style. The designs were woven into the cloth in a brocade technique.

Another beautiful robe of white satin (Fig. **12.26**) from the 1600s has a design of a golden waterfall that plunges from black rocks, at the neck and shoulders, to a black-footed flower-arranging tray, near the hem. Varicolored flowers and splashing

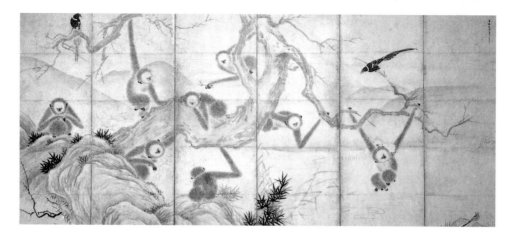

Ernest Fenollosa Synthesizes East and West

12.27
SESSHU,
Monkeys and Birds in Trees, 1491.
Ink, watercolor on six-fold screen,
5 ft 3¼ in (1.6 m) high, 24 in (61 cm) wide.
Museum of Fine Arts, Boston,
Massachusetts. (Fenollosa-Weld Collection.)

"Japan! What romantic thoughts and memories arise at the name!" Writing those words, Ernest Fenollosa was recalling his arrival as a twenty-five-year-old philosophy professor at Tokyo University. Japan had opened to foreigners only a quarter-century before, and there was still suspicion of outsiders, but Ernest's enthusiasm for Japanese culture and art overwhelmed all obstacles. He learned Japanese and adopted the Buddhist religion. Rapidly Westernizing, many Japanese were ready to discard their past, but Ernest preached loyalty to tradition. Old works of art were being cast aside, and he took the opportunity to build a great collection, later purchased for the Boston Museum of Fine Art by Dr. G. C. Weld. Many of the most important Japanese paintings in the United States, such as Sesshu's *Monkeys and Birds in Trees* (Fig. **12.27**) and Korin's *Waves at Matsushima* (see Fig. **12.28**), were part of Ernest's collection.

Ernest discovered the visual arts only after graduation from Harvard. He took his first drawing and painting classes at the new Art School of the Boston Museum. Recruited for Tokyo University, he soon began to concentrate on art, first as national chief of art education, later as founder and director of the national art museum. Children were being taught to write and draw with a pencil, Western style, but Ernest directed the revival of traditional brush drawing. He brought American organizational skills to the task of fostering Japanese culture.

In 1890 Ernest returned to Boston as first curator of oriental art at the Boston Museum and soon became friends with the painter Arthur Dow, recently returned from studies in Paris. Kindred spirits, Ernest and Arthur embarked on the invention of a method of art instruction that would synthesize East and West. Ernest had a vision of an emerging world culture which the system of art instruction would help create. Arthur became his assistant curator and began studying Japanese woodcuts, even making his own woodcuts following examples in the Boston Museum collection. Ernest and Arthur became a team, teaching drawing, design, and art history at Pratt Institute in Brooklyn; later in his career Dow moved to Columbia University where he became an influential teacher of methods of art instruction.

The American art world, bored with copying Renaissance styles, was ripe for the new system, which concentrated on expression through abstract lines, shapes, values, and compositions. The Japanese word *Notan*, meaning dark against light, was a key idea, along with "spacing," Ernest's term for composition. Georgia O'Keeffe and many of her contemporaries were frank about their debt to the Fenollosa-Dow system. Nearly a century later, this book still uses concepts of the elements of art and the principles of design given their first formulation by Ernest and Arthur. American art has become the synthesis of East and West that caught Arthur Dow's imagination when Ernest described it to him in the fall of 1893.

Based on E. F. Fenollosa, *Epochs of Chinese and Japanese Art* (New York: Dover, reprint, 1963) and Frederick C. Moffat, *Arthur Wesley Dow, 1857–1922* (Washington, D.C.: Smithsonian, 1977)

golden foam make an irregular design that recalls the compositions of Sotatsu. Although it represents natural subjects, the design is disciplined like a Zen ritual. The audience for these great painters had cultivated a sensitivity to design, color, and craft that integrated daily life and art. These people of the audience decorated their walls with screens and carefully designed their houses to express the *sukiya* spirit, so it is not surprising that a Japanese lover might be discouraged if "a disillusioning glimpse of her sleeve...suggested the lady lacked a perfect sensitivity to color harmonies."[12]

By the time Ogata Korin (1658–1716) painted the screen *Waves at Matsushima* (see Fig. **12.28**) in the tradition of Sotatsu in about 1700, Japan had expelled the Europeans (in 1638) and closed its borders to foreign contact for what would be 200 years. The painting epitomizes the place of Japan in the age of Columbus: rocky islands in a turbulent sea, fortresslike against the wave of European exploration and colonization, cultivating its own ancient traditions of naturalness, beauty, and skill.

For woodcuts of the 18th and 19th centuries, see Figures **3.14** and **5.13**. They maintain elements of these earlier styles.

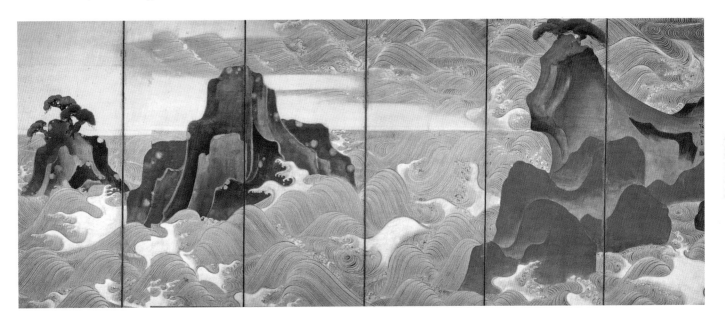

EUROPEAN ART FROM 1600 TO 1750

BAROQUE STYLE

We still look back to the time of the **Baroque** style as a period when art reached unsurpassed heights. The seriousness of the artists, their great ambitions, and the prestige accorded them by their audience combined to produce a period of exceptional achievement.

By 1600 Europeans knew they were living in a new period of history. The last of the great Renaissance artists had died, and people were ready for new styles and ideas. The division of Europe and her colonies into Catholic and Protestant nations, which began when Martin Luther nailed his "ninety-five theses" to a church door in 1517, was recognized as irreversible by 1600, and both sides began to take positive approaches to their own religious interpretations. Italy, Spain, and Belgium became great centers of Catholic Counter-Reformation art, while the Netherlands and northern Germany became strongholds of Protestant art. Music and drama were the most inventive arts of the period, taking especially significant form in combination as opera. These new performing arts, whose main centers of development were in Italy, were so impressive that visual artists could not help but adopt theatrical poses and settings in their own work. You can learn to recognize Baroque art by these theatrical qualities.

An etching by Jacques Callot (*kah-LO*; 1592–1635) shows an opera-ballet performance at the court of the Grand Duke of Tuscany in Florence in 1616

12.28
OGATA KORIN,
Waves at Matsushima,
c. 1700.
Watercolor on paper screen,
5 ft 1 in x 12 ft 1½ in
(1.5 x 3.7 m).
Museum of Fine Arts, Boston, Massachusetts.
(Fenollosa-Weld Collection.)

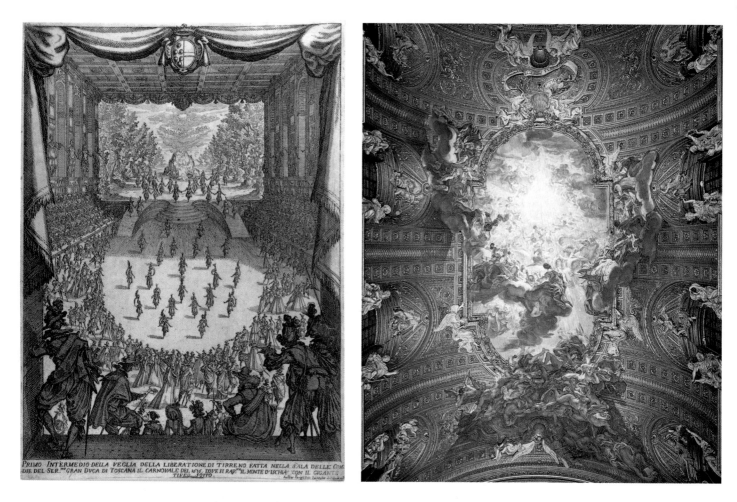

PRIMO INTERMEDIO DELLA VEGLIA DELLA LIBERATIONE DI TIRRENO FATTA NELLA SALA DELLE COM
DIE DEL SER.mo GRAN DVCA DI TOSCANA IL CARNOVALE DEL 1616. DOVE SI RAP.ta IL MONTE D'ISCHIA CON IL GIGANTE
TIFEO SOTTO.

12.29 (*above*)
JACQUES CALLOT,
*First Interlude: The Giant
Typhon on Mount Ischia,*
1617.
Etching, 11⅞ x 9⅜ in
(30 x 24 cm).
Art Museum, Princeton
University, New Jersey.
(Bequest of Junius S.
Morgan.)

12.30 (*above right*)
GIOVANNI BATTISTA
GAULLI,
*The Triumph of the Name of
Jesus,* 1674–79.
Fresco, ceiling of the nave.
Il Gésu Church, Rome.

(Fig. **12.29**). The large stage, with elaborate scenery of forest and mountain, expands down curving stairways to permit performers on the main floor, like an arena. The breadth of the scene was a challenge to the artist; notice the clever changes in perspective from the nearer figures backstage. He also exaggerated, but only a little, the fantastic costumes and animated poses of the audience to make the scene more theatrical. Baroque period audiences enjoyed distortion of perspective, of pose and costume—of anything that made the effect more dramatic.

There were great differences between the Catholic and Protestant countries, but also much in common. Protestant England, for example, produced far less visual art than Catholic Italy; England's greatest Baroque artist was Shakespeare, who set many of his plays in Italy because that was the center of theatrical art. In the Protestant countries, art, including religious subjects, was usually done for private patrons, not for the churches, and many Protestants opposed art as promoting idolatry. The Protestants rightly considered that abundant use of art would make their churches look like Catholic churches, for the Catholic Church had adopted art as one of its main educational and missionary tools.

The Society of Jesus, often called the Jesuit order, was one of the typical Catholic organizations of the period. Its mother church, Il Gésu in Rome, was decorated in the Baroque style, with a ceiling fresco by Giovanni Battista Gaulli (1639–1709) representing *The Triumph of the Name of Jesus* (Fig. **12.30**). Although Baroque artists were not the first to paint ceilings, it was typical of Baroque art to try to envelop the audience in an illusionistic world. Sections of the painting cross the frame into the real space of the church, to confuse the observer about what is real and what imaginary. The boundary between the reality of your own body and its space and the fresco and its illusion of heaven is so hard to define that you begin to accept the idea that the ceiling really has opened up to show crowds of angels adoring the radiant name of Jesus.

Gianlorenzo Bernini

Gianlorenzo Bernini (1598–1680) was not only the greatest sculptor of the Italian Baroque but typical in his mixture of theater and religion. He was deeply devout and attended Mass every morning. He numbered among his friends and patrons eight popes, various cardinals, and the head of the Jesuit order. He was also fascinated by the theater—an art that gave scope to his versatility. John Evelyn wrote in his diary of having attended a performance in Rome at which Bernini gave a "Publique Opera … where in he painted the seanes, cut the Statues, invented the Engines, composed the Musique, writ the Comedy, and built the Theater all himselfe."[13]

In *Apollo and Daphne* (Fig. **12.31**) the young Bernini (he was aged between twenty-four and twenty-six) turned the immobile block of white marble into agitated movement. The god Apollo, in love with Daphne, has pursued her and is about to seize her when he is amazed to see her turn into a laurel tree, the answer to her prayer to the earth goddess for help. Dramatic expressions and gestures are basic to this sculpture, in which marble takes on the shapes and textures of flesh, hair, cloth, bark, and leaves.

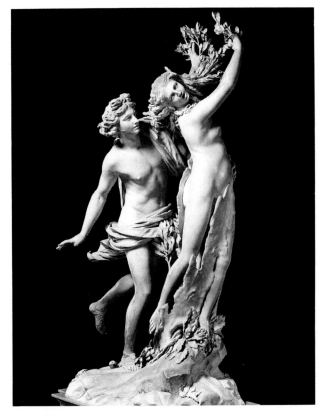

12.31
GIANLORENZO BERNINI,
Apollo and Daphne,
1622–24.
Marble, life-size.
Borghese Gallery, Rome.

Among stones white marble is a good actor whose neutral color and texture permit it to play many parts. That is one reason Baroque sculptors favored it, the other reason being its use by Greek and Roman sculptors. When the ancient sculptures were new they were finished with paint and wax, but when they were dug up after a thousand years all the paint had worn off. That established a new taste for unpainted stone, which first affected Renaissance sculptors. Bernini was conscious of the problem of expressing color in a colorless material and tried to overcome it by subtle hollows and bulges, making a play of light and shadow that substitutes for color.

Compared to Renaissance sculptures such as Michelangelo's *David* (see Fig. **7.4**), Bernini's *Apollo and Daphne* helps us define the Baroque style: the Renaissance figure is shown in a moment of stillness, poised for action, but Bernini's figures are shown at the climax of action. The Baroque also chose the climactic moment, when a personality or story is fully revealed and the audience attains insights into the meaning of the subject. Renaissance artists sought balance and unity, but Bernini

and the other Baroque artists considered variety and movement among the most important principles. That led to contrasts of light and shadow, of texture, and of color in painting that are much stronger—more dramatic, you might say—than those found in Renaissance art. The patrons of the Baroque were popes and kings, such as Louis XIV of France (who patronized Bernini but finally decided his style was too agitated to conform to the royal dignity).

Peter Paul Rubens

Peter Paul Rubens (1577–1640) exemplifies the Baroque style in painting, as Bernini did in sculpture. Both men were extroverts, as you can tell just by looking at their art, prolific workers, and the favorites of powerful rulers. Rubens, a Belgian, absorbed the Italian style at its source when he was a court painter in Italy between the ages of twenty-three and thirty-one. His painting *The Horrors of War* (Fig. **12.32**) was in the collection of the Grand Duke of Tuscany, a descendant of the Medici family, whose opera-ballet was drawn by Callot (see Fig. **12.29**).

In a letter to a friend, Rubens described *The Horrors of War* mainly in terms of the subject of the picture:

> The principal figure is Mars [god of war], who rushes forth with shield and blood-stained sword, threatening the people with disaster. He pays little heed to Venus, his mistress, who ... strives with caresses and embraces to hold him. From the other side, Mars is dragged forward by the Fury Alekto, with a torch in her hand. Nearby are monsters personifying Pestilence and Famine, those inseparable partners of War. ... That grief-stricken woman clothed in black, with torn veil, robbed of all her jewels and other ornaments, is the unfortunate Europe who, for so many years now, has suffered plunder, outrage, and misery.[14]

The painting is only secondarily about physical solids, but mainly is a field for the interaction of forces. Notice Rubens' use of verbs in his description: rushes, strives, dragged. Venus, for example, performs a spiral movement beloved by Baroque artists: her feet are planted toward the left, showing that she had been facing toward the figure symbolizing Europe, and her shoulders turn to the right as she clutches at her warlike lover. Notice that war and peace, Europe and fury, are all personified as

12.32
PETER PAUL RUBENS,
The Horrors of War,
1637.
Oil on canvas,
6 ft 9 in x 11 ft 3 in
(2.1 x 3.4 m).
Palatine Gallery, Florence,
Italy.

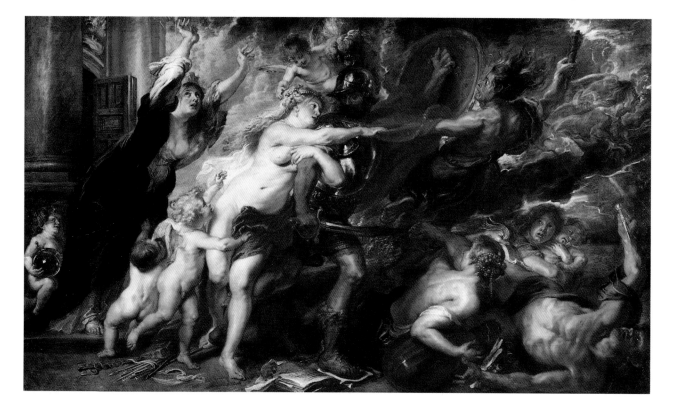

they would be in a play, and everything is acted out—overacted, we might say, since a different acting style is in use today. We sometimes think of Baroque art as worldly and voluptuous, but it was also deeply concerned with moral and spiritual matters. Rubens' painting, which seems sensual and unserious to people now, to the artist and his audience was a serious statement about tragic conditions.

Caravaggio

The theatrical appearance so common in Baroque art gave rise, as you might expect, to its opposite, though it may be hard for us today to see the opposition which was so clear to people at the beginning of the 17th century. Michelangelo Merisi (1565–1609), called Caravaggio after his hometown, aimed to represent nothing but the visible truth, eliminating the imaginary and conventional. *The Death of the Virgin* (Fig. **12.33**), begun by Caravaggio in 1605 for an altar in a Roman church, was not accepted by the patrons because the painter rejected the customary idealized figures acting out traditional stories. Caravaggio's figures were painted from models chosen from the streets of Rome; they pose in his dark studio illuminated only by a shaft of light from a single window; they are shown as objectively as possible, without idealization. Still more shocking to the Roman audience, Mary is shown as simply dead, although the ancient traditional way to show Mary's death was to include the ascent of her spirit to heaven to be welcomed by Christ. The ascent of the spirit was invisible to Caravaggio, who insisted that accurate representation of the visible was the whole job of the artist.

To our eyes the shaft of light and the deep red curtain in the upper right still seem theatrical; Caravaggio's innovations were more superficial, but more significant to his

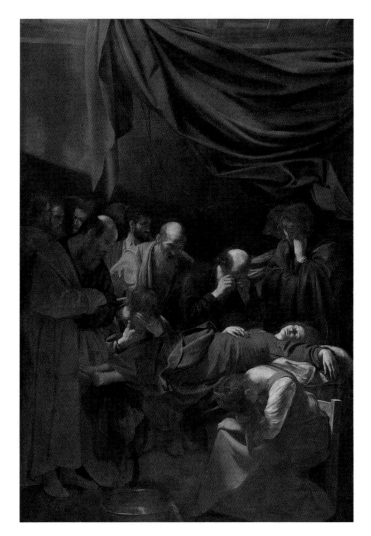

12.33
CARAVAGGIO,
The Death of the Virgin,
1605.
Oil on canvas,
12 x 8 ft (3.7 x 2.4 m).
Louvre, Paris.

audience, since they showed that the sacred stories had a foundation of material truth in this world. Although conservative members of the audience objected to this worldly idea, artists were impressed. Rubens was in Rome buying paintings for the collection of the Duke of Mantua when *The Death of the Virgin* was rejected and immediately arranged to have it purchased. Before the painting could leave Rome an exhibition was arranged at which great crowds came to see the notorious work.

Two aspects of Caravaggio's style reverberated through the art world: the dramatic spotlighting of significant features in a deeply shadowed space, called tenebrism ("shadowism"), and his expression of the idea that spiritual realities are believable only when they affect common people. Both those features of Caravaggio's style were learned by the young Velázquez, but it was Rembrandt, especially, who brought them to the highest development.

Rembrandt

Movement and emotion—those are key words for the Baroque. Emotion is expressed in gesture and facial expression and we find artists studying those. Several artists left portraits of themselves making faces in the mirror to study different kinds of expressions. Rembrandt (1606–69) did several small etchings like the one here (Fig. **12.34**) of himself frowning, smiling, or snarling. On a deeper analysis, these expressions do not appear to show real moods; instead they are dramatizations, typical of their period.

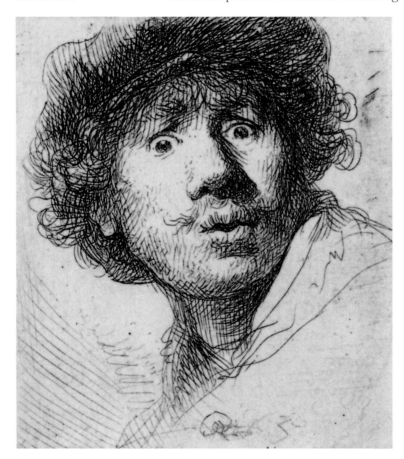

12.34
REMBRANDT VAN RIJN, *Self-portrait in a cap, open-mouthed,* 1630. Etching, 2 x 1¾ in (5 x 4 cm). Rijksmuseum, Amsterdam.

Rembrandt, who worked in Amsterdam, was the greatest artist of the Protestant Christian North. Amsterdam had a large Jewish population whose members were often portrayed by the artist, especially in scenes from the Bible. Study of the Bible was encouraged in the Protestant countries, and Rembrandt knew it thoroughly, to the point that he sometimes illustrated events that probably happened but are not exactly described. *Christ Preaching the Forgiveness of Sins* is one of those (Fig. **12.35**). The humble crowd gathers around, each one an individual with a unique personality. In the foreground a child is absorbed in his drawing in the dust. Every pose and face has been observed in the real world, yet the result is a spiritual statement. Both features of Caravaggio's style are found here, but completely absorbed by Rembrandt. Although some of the figures, such as the turbaned men on the left, were not to be found on the streets of Amsterdam, there are no idealized types. Even Christ is not idealized nor given any mark of his superhuman status, so that it comes as a surprise to find an unobtrusive halo over his head. Yet Christ is clearly the focus of the light in the picture, his lighted figure with its contrasting dark hair standing out against the deeply shadowed background areas. In his paintings Rembrandt increased this effect of spotlighting for very dramatic effects.

The Optical Record in Baroque Painting

Two important Baroque artists, Jan Vermeer and Diego Velázquez, were mainly concerned with the creation of a perfect record of vision. This cool, scientific

REMBRANDT VAN RIJN,
*Christ Preaching the
Forgiveness of Sins,*
c. 1650–58.
Etching, 6 x 8¼ in
(15 x 21 cm).
Rijksmuseum,
Amsterdam.

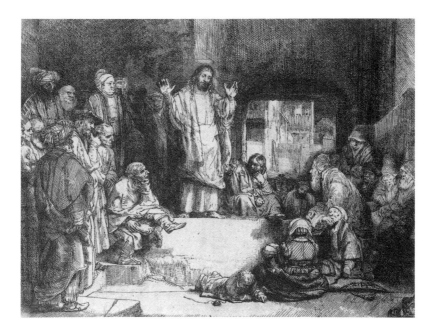

objectivity sets them apart from the main trend of the Baroque, but it has contributed to their continued popularity throughout many changes of artistic fashion; they have seemed "modern" to generations of art lovers.

The Dutch artist Jan Vermeer (*vur-MERE*; 1632–75) painted *The Art of Painting* (Fig. **12.36**) for himself, for it was still in his possession at his death, yet it is one of his larger and more ambitious works, and collectors could never get enough of his work. It is not a self-portrait, but shows an artist in fine clothes of the previous

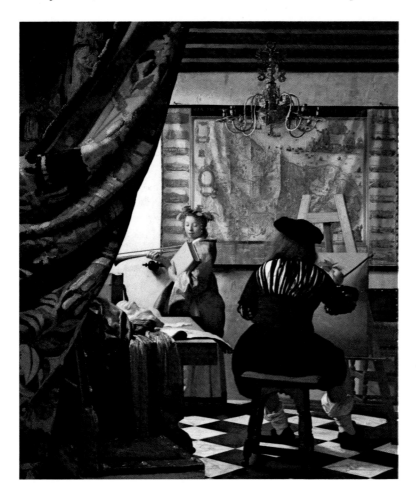

12.36
JAN VERMEER,
The Art of Painting,
1665–70.
Oil on canvas,
4 ft 3¼ in x 3 ft 7¼ in
(1.3 x 1.1 m).
Kunsthistorisches
Museum, Vienna.

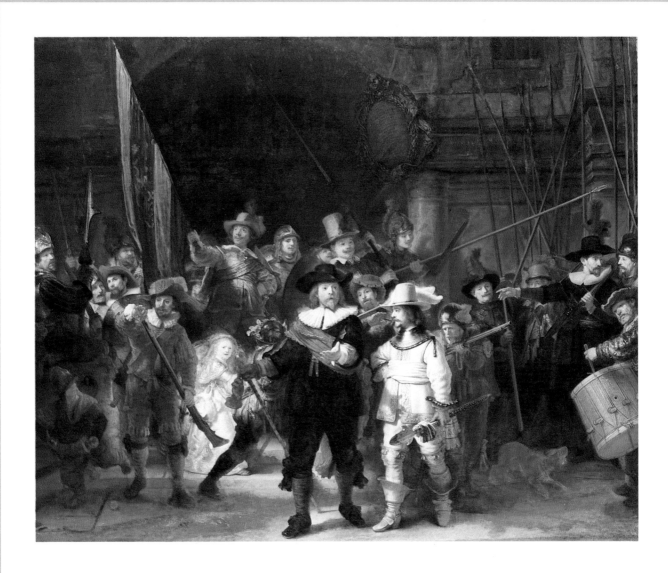

century, his studio wall decorated with a map of the Low Countries in that earlier time, before Belgium and Holland separated. The model is costumed as the Muse of History, and on the table is a plaster cast of an ancient sculpture. Painting, Vermeer seems to say, is a record of history; its practitioners devote themselves to the spirit of history and are rewarded by fame—the book and the trumpet carried by the muse. Vermeer himself painted quiet scenes from middle-class life, never historical events, but he evidently saw this painting as especially relevant to his own life and work. The scene is imaginary but probably based in some measure on a set-up of furniture and a model that could be painted from life. The dark curtain has been drawn back to reveal a room lit only by a hidden window on the left, and it is that light which unites the design, reveals the masses, and sets each thing in its place in space. Vermeer appeals mainly to our eyes, whose sensitivity is primarily to light; he ignores the muscular (or kinesthetic) and the dramatic emotions which are basic elements of Baroque style. Fame came to Vermeer on his own terms, which stressed the optical in place of the theatrical.

The optical style of Baroque painting transcended political and religious borders, for its other great practitioner was the painter of the Spanish court, Diego Velázquez (*ve-LATH-keth*; 1599–1660). In *The Surrender of Breda* (Fig. **12.38**), he shows the

Rembrandt's Bankruptcy

In 1656, the year he turned the age of fifty, Rembrandt declared bankruptcy. Yet after his bankruptcy Rembrandt continued to receive many commissions. Historians have been trying for years to understand the relationship between Rembrandt's art, his audience, and his finances.

Rembrandt's most famous painting, *The Sortie of the Civic Guard*, usually called *The Night Watch* (Fig. **12.37**), painted fourteen years earlier, in 1642, has been considered one of the clues to this puzzle. One of Rembrandt's pupils later described *The Night Watch* as the basis of Rembrandt's fame, but it also marks the high point of his patronage and the beginning of his descent into poverty. Was this painting somehow flawed in the eyes of his patrons?

The subject of the painting, according to art historian Gary Schwartz, is the marching out of a company of musketeers to welcome the queen of France on her visit to Amsterdam in 1638. The painting was one of six large group portraits to be hung in the musketeers' clubhouse at their shooting range. Membership in a civic guard company was a social and political advantage and the officers were all wealthy and powerful. Frans Banning Cocq, in black, is shown as captain, with Willem van Ruytenburgh, in white, as lieutenant, with the musketeers loading their weapons and preparing to march. Sixteen members of the troop

contributed to the cost of the painting and were included as portraits. Originally the painting was a little larger on all sides; it was cut down to fit a later location.

Earlier historians suggested that the patrons were dissatisfied with the painting because many of the faces were not clearly portrayed, but that was not the case. The painting was accepted and admired; its storytelling style of group portrait was adopted by other painters. Even the contrast of brilliant light and deep shadow, which was a distinctive feature of Rembrandt's style, was acceptable.

But it is true that Rembrandt's personal fortunes began to decline the year the painting was finished. In June of that year his wife Saskia died, leaving Rembrandt with a baby son, Titus, and Saskia's will left all the joint property to Titus. Never again could Rembrandt claim personal ownership of any property he owned at the time of her death, when he was thirty-six. In addition, Saskia's death deprived Rembrandt of the social connections she had brought him, which were indispensable for patronage in Amsterdam. Patronage by the state administrators also declined about this time. Rembrandt's problems with money, family, patrons, and political connections each made the others worse. In later years the painter was rumored to have had an excessive love of money, but that fault is easy to understand under the circumstances. Rembrandt's art always attracted patrons and admirers, but important patronage of the sort that resulted in *The Night Watch* depended on social and political connections, which Rembrandt lost when Saskia died.

Gary Schwartz, *Rembrandt: His Life, His Paintings* (New York: Viking, 1985)

12.37
REMBRANDT VAN RIJN, *The Night Watch*, 1642.
Oil on canvas, 11 ft 10 in x 14 ft 4 in (3.6 x 4.4 m).
Rijksmuseum, Amsterdam.

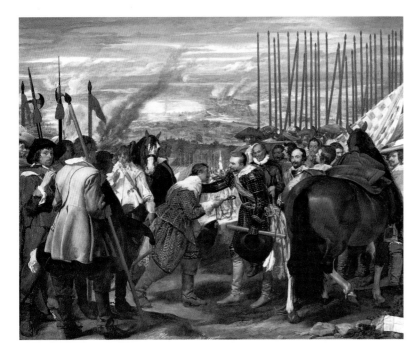

12.38
DIEGO VELÁZQUEZ,
The Surrender of Breda,
1634.
Oil on canvas,
10 ft x 12 ft 2 in
(3 x 3.7 m).
Prado, Madrid.

surrender in 1625 of a Dutch town to Spanish forces after a long siege. The Dutch general offers his sword to the Spanish leader, who generously refuses it. This large painting hung in the palace in Madrid and was testimony to the gallantry of the Spanish general and the power of Spanish arms. Although the surrender is a satisfying dramatic incident, it is a minor part of the appeal of the painting, which rests mainly on the visual contrast between the figures ranged across the foreground and the vast misty landscape of the battlefield. That contrast is enhanced by the view of landscape through the fence-like ranks of Spanish lances on the right. Like Vermeer, Velázquez preferred to paint from things he could see. Although he did not witness this historical event, he could set up soldiers and horses as models, but the main unifying features—light and color—had to be imagined.

Vermeer and Velázquez were on opposite sides of the great religious and political questions of their period, but they agreed on the question of style. Painting for them was a record of vision in which light and color were the main actors.

ROCOCO STYLE

The Rococo style (1700–50) developed from the Baroque and carried on most features of its style, but it turned away from the heroic and the melodramatic toward more modest, good-humored art. The patrons of the Baroque were popes and kings,

Vermeer and Velázquez also appear together (see Figs **4.20** and **4.25**) in discussions of emphasis and proportion, both optical qualities of compositions.

12.39
ANTOINE WATTEAU,
Venetian Festival,
1717.
Oil on canvas,
22 x 18 in (56 x 46 cm).
National Galleries of
Scotland, Edinburgh.

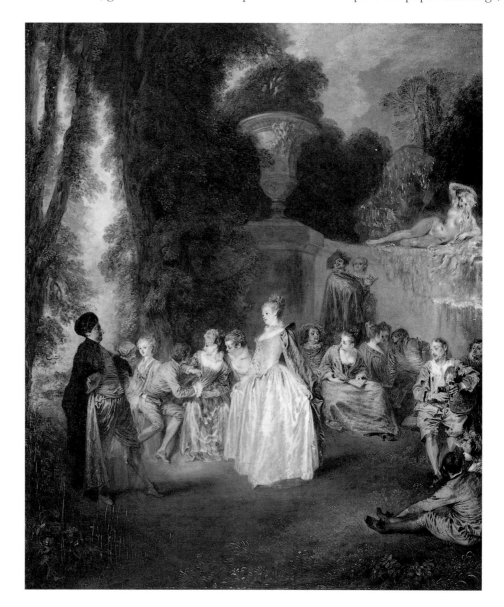

such as Louis XIV of France. When Louis XIV died in 1715, the Baroque style died with him, but France became the center of the new Rococo style. To followers of the Rococo style the grandeur of the super-colossal began to look old-fashioned; something on a human scale had more appeal. Patrons of the new style were members of the upper middle class, who preferred its charm and its escapist mood, for most of them were working hard for a living. Parklike landscapes and scenes from the theater and from comfortable daily life were preferred, in subtle light and color. If the Baroque was masculine and heroic in tone, the Rococo is feminine, reflecting a period when women began to play more active roles in public life.

Antoine Watteau

A young painter in Paris, Antoine Watteau (1684–1721), who was a great admirer of the paintings of Rubens, created a new image for the new period, one that sums up the Rococo style. In his painting *Venetian Festival* (Fig. **12.39**), Watteau brought together many of the threads that formed the style of his time. The gods and goddesses of Baroque art have turned into statues in the background, with slim young people in beautiful clothes dancing and making music in the foreground. Watteau showed himself as the bagpiper in this scene. A picnic with music, conversation, and flirtation appears to be the ideal of Rococo life. In his own time such scenes were considered entirely cheerful, but later times have found a subtle undercurrent of melancholy, for pleasure always ends, just as the Rococo ended in the French Revolution of 1789.

The theater, which in the 17th century belonged to the nobility, began to belong to the people in the 18th century, becoming so much a part of life that life itself was often seen as a comedy. Watteau did a fine portrait of his friend Gilles (Fig. **12.40**),

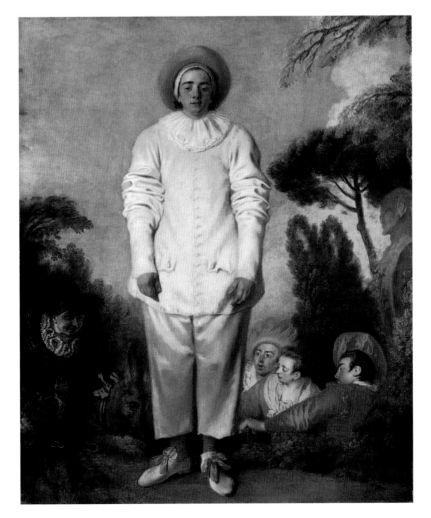

12.40
ANTOINE WATTEAU,
Gilles,
1717–19.
Oil on canvas,
6 ft ½ in x 4 ft 11 in
(1.8 x 1.5 m).
Louvre, Paris.

who had retired from the stage to open a restaurant. Like all Watteau's patrons, he was a private citizen, not a king or a noble. Gilles is shown playing the part of Pierrot, one of the stock characters of the *commedia dell'arte* (Italian comedy), a lover who is clever, sentimental, and poetic. The high seriousness of the Baroque has given way to subtle personal attitudes and moods.

France as the Center of Culture

This was the period when educated people everywhere spoke French and adopted French manners and styles. Paris, which had become a great cultural center in the Baroque period, consolidated that position in the Rococo and retained it until 1940. It was the reasonableness, charm, and good manners that shine out of the art of Watteau and his contemporaries which attracted people all over the world to the Rococo culture of France. That style is recognizable mainly by its modest scale, its good humor, the charm of individual personalities, and very often its glorification of women and feminine qualities, all in strong contrast to the masculine virility of the Baroque that preceded it. This sensitivity to personality runs through the whole of Baroque and Rococo art, and the gradual rise to economic power of the middle class during these periods allowed them to become both the patrons and the subjects of art. Those periods laid the foundations on which we have erected the art and culture of our times.

FOR REVIEW

Evaluate your comprehension. Can you:

- describe the kind of people who patronized Renaissance artists—how were they educated, how did they make their living, and what did they admire?
- describe two important Italian oil paintings of the 1500s, mentioning the special features of their style?
- compare the work of one of the Flemish or German Renaissance painters with the works of Italian painters of the same period?
- describe several works of art that are characteristic of Japanese culture of 1500–1700, mentioning their techniques and meaning?
- contrast the work of Antoine Watteau with one (or more) of the major Baroque painters, with some good description of the Baroque work?

Suggestions for further reading:

- Michael Baxendall, *Painting and Experience in Fifteenth-Century Italy* (Oxford: Oxford University Press, 1972)
- Kenneth Clark, *Leonardo da Vinci* (Baltimore: Penguin, 1958)
- Giorgio Vasari, *Lives of the Painters, Sculptors, and Architects* (New York: E. P. Dutton, 1927)
- Frederick Hartt, *Michelangelo: The Complete Sculpture* (New York: Harry N. Abrams, 1968)
- Frans Baudouin, *Peter Paul Rubens* (New York: Harry N. Abrams, 1977)
- Michael Cooper (ed.), *They Came to Japan: An Anthology of European Reports on Japan, 1543–1640* (Berkeley: University of California Press, 1965)
- Jonathan Brown, *Velázquez, Painter and Courtier* (New Haven: Yale University Press, 1986)

13

Neo-Classicism, Romanticism, and the Beginnings of Modernism— European Art: 1740–1940

P R E V I E W

It is as if time began to move faster during these two centuries. Middle-class social and scientific interests are reflected in European art as much as purely artistic concerns. Neo-Classic art, which glorified rationality and took Classical antiquity as its model, reflects the beginnings of modern science and archaeology. By 1800 there was a reaction, called Romanticism, which favored the emotions, spirituality, and individuality, and preferred the Gothic as a model. Concerns about the harshness of the life of the lower classes led to Realism, which may be defined mainly by its subjects, and about 1870 Impressionism emerged, representing the life of the new urban middle class in Paris.

Impressionism was controversial, but it reflected the scientific interests of its time in its objective study of light and color. By 1890 there were reactions against its objectivity in favor of more expression (Van Gogh), more formal abstraction (Seurat), more structure (Cézanne), or more decorative color and design (Gauguin). The results of a century of discovery and colonialism in Africa and the Pacific suddenly burst into European art at the beginning of the 20th century, with the discovery of arts based on non-European principles. Those new influences were felt in almost all early 20th-century painting and sculpture, which developed along various lines, including those inspired by their European predecessors. Cubism, for example, developed from the example of Cézanne, Expressionism from that of Van Gogh and Gauguin, and Non-objective styles from Seurat and Cézanne. Other important influences on art were World War I and the new science of psychology, which inspired styles that coalesced in Surrealism. The period ends with World War II and the rise of New York as a major art center to rival Paris.

From Neo-Classicism to Modern Architecture, 1750–1950

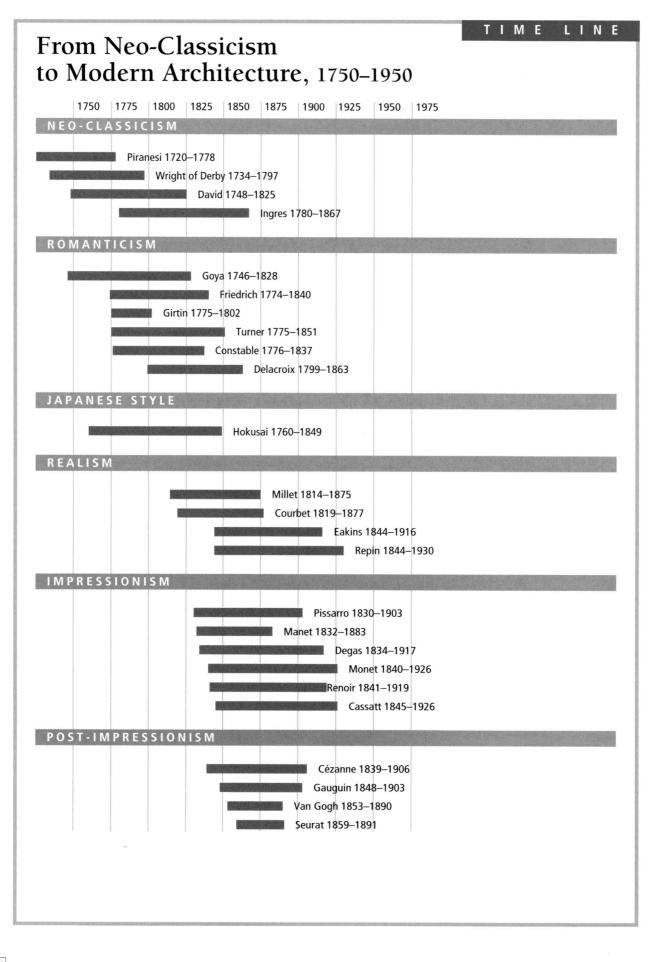

| | 1750 | 1775 | 1800 | 1825 | 1850 | 1875 | 1900 | 1925 | 1950 | 1975 |

NEO-CLASSICISM

Piranesi 1720–1778
Wright of Derby 1734–1797
David 1748–1825
Ingres 1780–1867

ROMANTICISM

Goya 1746–1828
Friedrich 1774–1840
Girtin 1775–1802
Turner 1775–1851
Constable 1776–1837
Delacroix 1799–1863

JAPANESE STYLE

Hokusai 1760–1849

REALISM

Millet 1814–1875
Courbet 1819–1877
Eakins 1844–1916
Repin 1844–1930

IMPRESSIONISM

Pissarro 1830–1903
Manet 1832–1883
Degas 1834–1917
Monet 1840–1926
Renoir 1841–1919
Cassatt 1845–1926

POST-IMPRESSIONISM

Cézanne 1839–1906
Gauguin 1848–1903
Van Gogh 1853–1890
Seurat 1859–1891

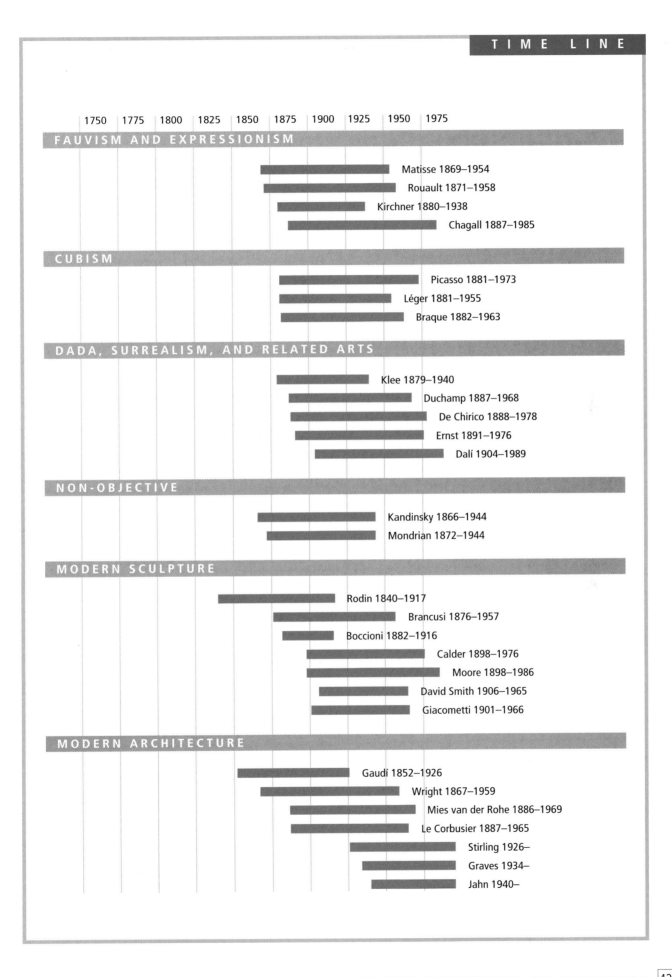

1750 | 1775 | 1800 | 1825 | 1850 | 1875 | 1900 | 1925 | 1950 | 1975

FAUVISM AND EXPRESSIONISM

Matisse 1869–1954
Rouault 1871–1958
Kirchner 1880–1938
Chagall 1887–1985

CUBISM

Picasso 1881–1973
Léger 1881–1955
Braque 1882–1963

DADA, SURREALISM, AND RELATED ARTS

Klee 1879–1940
Duchamp 1887–1968
De Chirico 1888–1978
Ernst 1891–1976
Dalí 1904–1989

NON-OBJECTIVE

Kandinsky 1866–1944
Mondrian 1872–1944

MODERN SCULPTURE

Rodin 1840–1917
Brancusi 1876–1957
Boccioni 1882–1916
Calder 1898–1976
Moore 1898–1986
David Smith 1906–1965
Giacometti 1901–1966

MODERN ARCHITECTURE

Gaudí 1852–1926
Wright 1867–1959
Mies van der Rohe 1886–1969
Le Corbusier 1887–1965
Stirling 1926–
Graves 1934–
Jahn 1940–

I N EARLIER SECTIONS WE HAVE SEEN EUROPEAN NATIONS exploring the globe and discovering other peoples with different ways of life. The first reaction of the European explorers was to conquer and exploit whatever wealth was easily available, then to convert the conquered nations to Christianity and make them as much like the Europeans as possible. (The Japanese were among the few who successfully resisted this wave of European expansion.) But by the middle of the 18th century there were already signs that the European nations and their Western culture were in turn being deeply changed by their contacts with other peoples and by their explorations of history and nature. In this chapter we will examine what happened to the Europeans—and their descendants in the new nations such as the United States, Canada, and Mexico—as shown by changes in their art.

Few periods in the history of the world have been so rich in change. People were fascinated by new discoveries and often overwhelmed by political turmoil. Looking back at the beautiful art of that period, we often believe it was made to be simply beautiful. Strangely, it seems that in every period both the artists and their audience considered the art of the previous period beautiful but believed that their own art must sacrifice beauty for the higher goal of truth. Truth looks different to every generation, and in the 18th and 19th centuries we begin to see the rapid give-and-take of ideas and styles that is so characteristic of our own century. The great styles of the period—Neo-Classicism, Romanticism, Realism, Impressionism, and finally Post-Impressionism—were associated with social and political ideas whose truth was a matter of public debate. It is sometimes hard for a 20th-century audience to take a deep interest in 19th-century politics, but we must remember that 19th-century art was often considered by its original audience to be ugly but important because it reflected political issues.

Each of these styles had particular strengths and weaknesses. For example, Neo-Classicism, like any classical style, was based on the principle that there is one best answer to any problem. This produced a high general level of art, because the best answer could be learned by anyone willing to make the effort, but it eliminated the genius who refused to follow the rules. Romanticism, on the other hand, was based on the belief that there are no absolutely right answers, only answers that are right for the individual. That resulted in a breakdown of the standards of quality, since no one could say that a work was bad; the work only needed to find an audience that liked it. As we shall see, the career of Francisco Goya dramatizes this conflict.

Although these arguments are now a century or two old, they are by no means settled. The art world today struggles with the same questions, and we are still asking ourselves such questions as: "Are there no standards? How can anyone tell whether the work is good? Why don't artists paint about real life?"

NEO-CLASSICISM: THE ART OF REASON

The discovery of other cultures based on entirely different ways of life stimulated Europeans to reconsider their own beliefs and ways. The increasing pace of scientific discoveries and new inventions and their application in the Industrial Revolution contributed to the feeling that by using the mind people could build a better world. The Scottish philosopher John Locke (1632–1704) had proposed that there were rights with which humans were born that did not depend on the goodness of a king, and the French writer Jean Jacques Rousseau (1712–78) believed there were more natural ways of life than were lived in Europe and that they produced better people. Voltaire (1694–1778) noted that the world was full of devout and moral people who had never heard of Christianity. These ideas were in large part the result of contacts with Asian, African, and American nations, whose very existence called into question everything the Europeans had always believed. An early result was a burst of scientific experimentation produced by the new mood of looking at the world and asking "why?"

ART AND SCIENCE

The English painter Joseph Wright (1734–97), known as "Wright of Derby," may have produced the first depiction of the "mad scientist," now a stock character, in his thrilling and mysterious *An Experiment on a Bird in an Air Pump* (Fig. **13.1**). The scientist looks out at us, inviting us to witness the experiment, illuminated only by a hidden candle on the table. One girl hides her eyes as the dove flutters in the increasing vacuum of the bell jar. The deep seriousness of this varied group of people gathered around the table on a moonlit night helps us understand the excitement of the new age. As early as 1768, the image appears of the scientist playing with life and death in his resolute search for truth. This English painter is usually classified among the Neo-Classic artists, those who believed a firmly drawn line was the basis of style (as opposed to those who preferred color as the most important element), but this painting is more important in the history of science and general culture than for any stylistic innovation.

Neo-Classic style looks so familiar to us now that it is surprising to realize that it was the first of many styles to be developed in Western culture as a result of exploration; in this case the explorations founded the field we call archaeology. Two explorations were especially influential. One was the discovery of the ruins of the Roman cities of Pompeii and Herculaneum beneath the volcanic dust and lava that had covered them since A.D. 79, revealing for the first time an intimate glimpse of ancient Roman life. The other was the first exploration of Greece, then a province of the hostile Turkish Empire. Historians and critics joined in promoting the importance of Greek and Roman art. In *Thoughts on the Imitation of Greek Works*, which was published in 1755, the author, Johann Winckelmann, thought that Greek art "marked for us the outermost limits of human and divine beauty." The Parthenon sculptures, which were purchased by the British ambassador to the Turkish court

13.1
JOSEPH WRIGHT,
An Experiment on a Bird in an Air Pump, 1768.
Oil on canvas,
6 x 8 ft (1.8 x 2.4 m).
National Gallery, London.

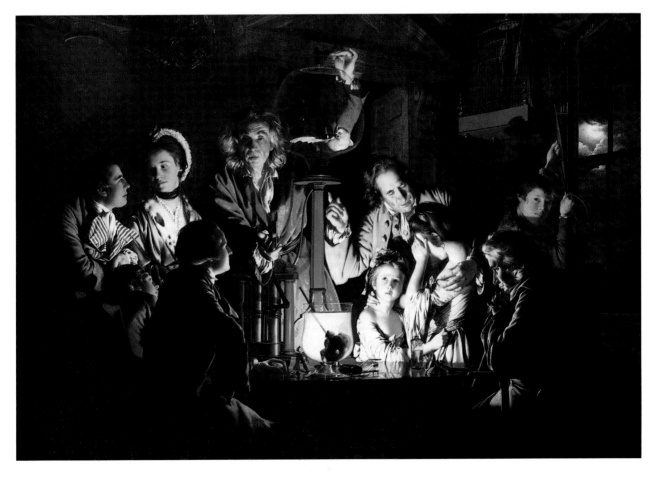

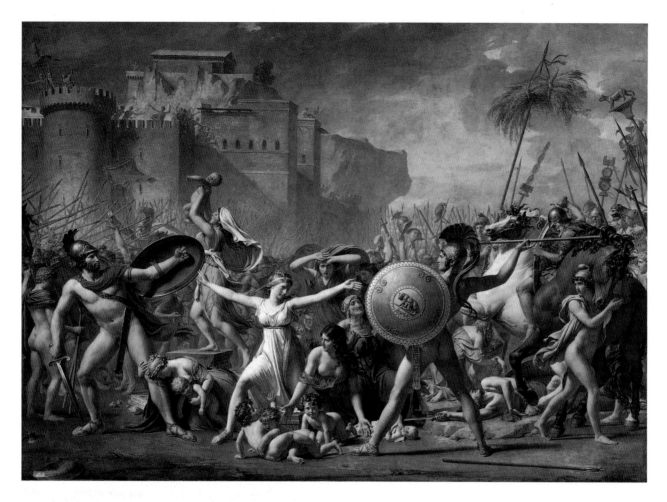

13.2

JACQUES LOUIS DAVID,
The Sabine Women,
1800.
Oil on canvas,
12 ft 8 in x 17 ft ¾ in
(3.85 x 5.22 m).
Louvre, Paris.

and brought back to London, had such an impact on the European public that everything Greek was suddenly fashionable.

Neo-Classic art was aimed at an educated audience that considered history and politics interesting subjects. Ten years after the French Revolution, Jacques Louis David (1748–1825) painted *The Sabine Women* (Fig. **13.2**), a huge canvas showing the battle between Roman men and their neighbors, the Sabines, which had been caused by the abduction of Sabine women by the Romans. In the center the Sabine woman Hersilia thrusts herself between her Roman husband Romulus, on the right, and her kinsman Tatius, who are locked in single combat. A critic wrote that the subject is "the suspension of arms," the sudden break in the combat, which the audience understood as referring to France, still in turmoil ten years after the Revolution. People stand before this painting talking about it, considering its story, examining its figures, who are shown in Greek style nudity instead of historically accurate Roman armor. David defended that choice: "It was an accepted custom," he said, "among painters, sculptors, and poets of classical antiquity to show gods, heroes, and male subjects in general in the nude." The audience understood the political message of peace and reconciliation, but many wanted to argue with the artist about the suitability of nude warriors in a Roman subject. The audience, as you see, were even more Neo-Classic than the artist.

The Neo-Classic style looks cool and restrained, but it was the chosen style of a great period of liberation. A portrait of an unknown woman (Fig. **13.3**) "had the character of a manifesto both of feminism and black emancipation,"[1] when it was shown in Paris for the first time in 1800. The artist was Marie Guillemine Benoist (*ma-REE ghee-yuh-MEEN ben-WAH*; 1768–1826), a successful artist who had studied with two of the best-known artists of her day, Elisabeth Vigée-Lebrun (*vee-ZHAY luh-BRUNH*; 1755–1842) and Jacques Louis David, through whose influence she was commissioned to paint several portraits of Napoleon, then Emperor of France. Her

most admired painting, however, remained this portrait of an unknown woman. France had abolished slavery in 1794, shortly before this painting was made, and the dignity of the subject expresses her independent personality. Both women and people of African descent achieved liberation from many restrictions during this period, as Benoist's career shows, but progress was uneven. In 1815 Benoist's husband was appointed to a position in a new conservative government and asked her to stop exhibiting her work in public. Lawrence Gowing tells us that "her heartbroken letter to him ended, 'let's not talk about it again or the wound will open up once more.' "[2]

In the 18th century artists discovered a new specialty, the painting of ruins, brought to great popularity by Pannini (see his *Interior of the Pantheon, Rome*, Fig. **8.19**) and Giovanni Battista Piranesi (1720–78). *Temple of Saturn* (Fig. **13.4**) is one of a series of etchings of views of Rome by Piranesi which established in the public mind the grandeur of the Classical ruins. Architects had been using a more or less Classical style since the early Renaissance, but archaeological studies gave them a new understanding of Greek and Roman buildings.

Greek and Roman art, reinforced by philosophy and literature, had an especially strong appeal to European people, who naturally regarded those ancient cultures as their own remote ancestors, but it was not long before other ancient and exotic cultures were discovered. When Napoleon invaded Egypt in 1798 he took with his army a company of scientists and artists to study the ruins of ancient Egypt. The pyramids and the Sphinx, painted reliefs, and hieroglyphic writing amazed the public. Similar explorations were going on in Central America, where Frederick Catherwood portrayed the ruins of Maya temples using a camera obscura. It was only a short step to the use of photographic film, which permitted still more accurate and objective views of distant foreign places.

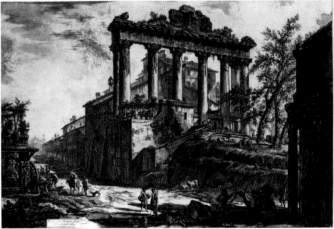

13.4 *(below)*
GIOVANNI BATTISTA PIRANESI, *Temple of Saturn from Views of Rome*, c. 1774.
Etching, 18⅞ x 27½ in (48 x 70 cm).
Metropolitan Museum of Art, New York.
(Rogers Fund, 1941.)

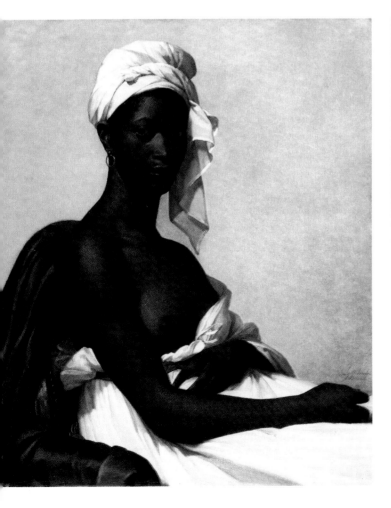

13.3 *(left)*
MARIE GUILLEMINE BENOIST, *Portrait of a Woman*, c. 1795.
Oil on canvas, 32 x 25⅝ in (81 x 65 cm). Louvre, Paris.

Ingres' style of drawing was also Neo-Classic, as shown by his pencil portrait (see Fig. **3.10**).

Jean-Auguste-Dominique Ingres (1780–1867) dominated French painting throughout the first half of the 19th century. He painted subjects from Classical mythology and portraits, but in the long run it seems to be paintings such as his *Odalisque with Slave* (Fig. **13.5**) (an odalisque is a Turkish harem woman) that remain popular and influential. Ingres depended on travelers' accounts for the setting, and the precision of his style and the calculation of the design take it out of real experience into a world of fantasy. Yet the Islamic countries were no mere fantasy for the French public at the time this was painted, for France was fighting for an empire in the Islamic regions of North Africa, and many men had been there in military service. Ingres, who was a good draftsman, considered himself among the Neo-Classic artists and defended the style of sharply defined lines and shapes, but in subjects he shared a Romantic taste for the exotic.

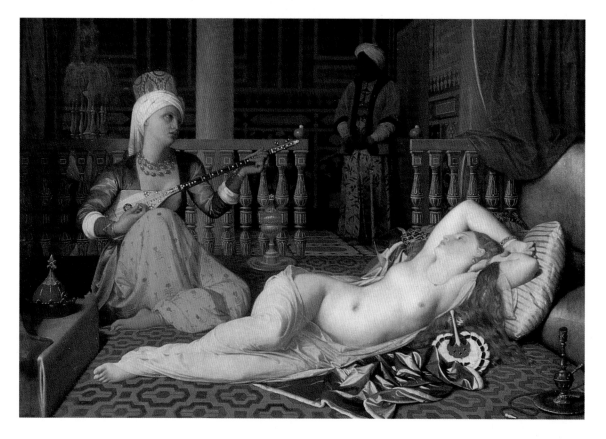

13.5

JEAN-AUGUSTE-
DOMINIQUE INGRES,
Odalisque with Slave,
1840.
Oil on canvas mounted on
panel, 28⅜ x 39⅜ in
(72 x 100 cm).
Fogg Art Museum,
Harvard University,
Cambridge,
Massachusetts. (Bequest of
Grenville L. Winthrop.)

ROMANTICISM: EMOTION REVALUED

"To say the word Romanticism is to say modern art—that is, intimacy, spirituality, color, aspiration toward the infinite, expressed by every means available to art."[3] Charles Baudelaire, the French poet-critic, wrote that definition in 1846, and it marks a late period in the Romantic movement. The English statesman and writer Edmund Burke laid the groundwork ninety years earlier in an essay entitled *The Sublime and the Beautiful*, in which he described beautiful things as small, smooth, delicate, and tending to arouse love. Sublime things were vast, difficult, magnificent, dark, and rugged, and "fill the mind with that sort of delightful horror." Romanticism aimed at the sublime rather than the beautiful. It was especially at home in England, Germany, and Spain. It was also a style of music, represented by Beethoven and Chopin, among others, which aimed at the sublime. If rationalism was a powerful movement, one that we associate especially with the 18th century, it was followed by a reaction in the Romantic movement, no less powerful and widespread, that reached its climax in the first half of the 19th century.

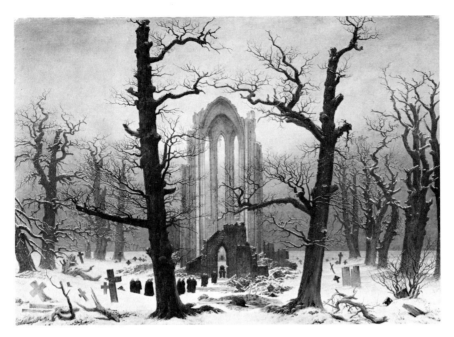

13.6
CASPAR DAVID
FRIEDRICH,
*Monastery Graveyard in
Snow*, 1819.
Oil on canvas,
c. 3 ft 11 in x 5 ft 10 in
(1.2 x 1.8 m).
Formerly National Gallery,
Berlin (now destroyed).

There was great variety in the Romantic style, as one might expect from its emphasis on individuality. Expression of the artist's personality was one of the unifying features, often leading to strong color with the brushstrokes revealed, strong contrasts of dark and light, and subjects given an emotional meaning. Subjects were chosen from modern life, or almost any place except ancient Greece and Rome. Landscape became a popular subject, with its awe-inspiring mountains and storms, the most characteristically Romantic themes.

A procession of monks makes its way through the snowy graveyard of the ruined monastery, carrying a coffin, in *Monastery Graveyard in Snow* (Fig. **13.6**) by Caspar David Friedrich (1774–1840). The irregularity of Gothic architecture appealed to Romantic taste, seeming closer to nature than the more symmetrical Classical style: the ruined church fits with the gnarled and broken oaks. Spirituality, aspiration toward the infinite, were Friedrich's subjects, and he found them mainly in nature—the sea, hills, and forests, often at dusk or night. Nature exceeds the powers of the mind and we can only marvel at it, not understand it, the Romantics believed.

The still-wild American continents practically demanded a Romantic approach from the artist, so awe-inspiring were the landscapes. Thomas Cole (1801–48), recognized as "America's first great landscape painter,"[4] caught the immensity of the Hudson River landscape (Fig. **13.7**). Although the artist entitled it *"Sunny Morning*

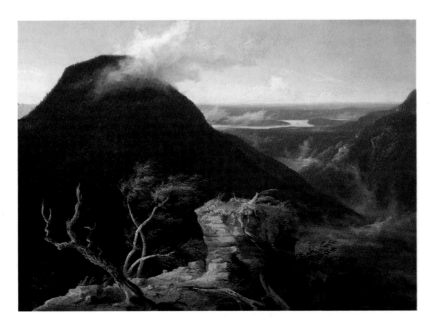

13.7
THOMAS COLE,
*Sunny Morning on the
Hudson River,*
c. 1827.
Oil on panel,
18¼ x 25¼ in
(49 x 64 cm).
Museum of Fine Arts,
Boston, Massachusetts.
(Gift of Mrs Maxim
Karolik for the Karolik
Collection of American
Paintings, 1815–65.)

...," a powerful wind propels scraps of cloud through the mountains looming over the distant valley. The American public was well prepared for such scenes and had the concepts and vocabulary to deal with them from reading such writings as William Bartram's account of his travels in Georgia. Bartram, a scientific naturalist, wrote:

> It was now after noon; I approached a charming vale, amidst sublimely high forests, awful shades! darkness gathers around, far distant thunder rolls over the trembling hills; ... threatening all the destruction of a thunder storm; ... the mighty cloud now expands its sable wings, ... and is driven irresistibly on by the tumultuous winds, spreading its livid wings around the gloomy concave, armed with the terrors of thunder and fiery shafts of lightning; now the lofty forests bend low beneath its fury, their limbs and wavy boughs are tossed about and catch hold of each other; the mountains tremble and seem to reel about, the ancient hills to be shaken to their foundations.[5]

The appreciation of nature and awe at its powers were a fundamental part of the audience's outlook. People such as William Bartram found satisfaction in the recognition of a kindred spirit in the artist.

EUGÈNE DELACROIX

The French stand apart in their preoccupation with modern life in the city—in Paris, to be precise. Eugène Delacroix (*del-la-KRWAH*; 1799–1863), the greatest of the French Romantic painters and the artist Baudelaire had in mind when he defined Romanticism, was set up by the audience as the opposition to Ingres. Anyone could easily see the difference between their work: in that of Ingres (see Fig. **13.5**) you

13.8

Eugène Delacroix, *Liberty Leading the People,* 1830.
Oil on canvas, 8 ft 6 in x 10 ft 8 in (2.6 x 3.3 m). Louvre, Paris.

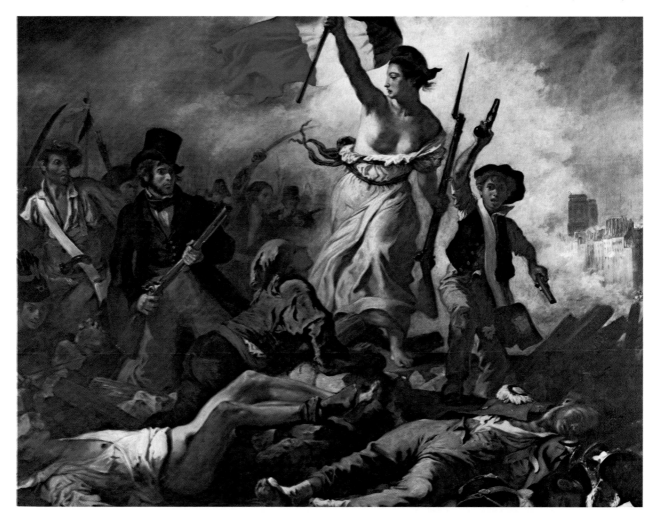

could not see the brushstrokes, but in Delacroix's paintings each stroke was identifiable; in Ingres's each area of color had a definite edge that could be seen or imagined as a line, but in Delacroix's the color belonged to the brushstroke and flickered in and out of the shapes. Although both Ingres and Delacroix painted scenes of Turkish or Algerian life, Delacroix avoided Greek and Roman history and mythology. An unusual subject for Delacroix has surely become his most famous painting, *Liberty Leading the People* (Fig. **13.8**) in which he created a kind of modern mythology, with the heroic figure of Liberty—or, more properly, the personification of the nation—leading the people. The painting was inspired by an uprising of the people of Paris during July, 1830, when the government began systematically withdrawing the right to vote and other democratic privileges from the citizens. Delacroix witnessed the street fighting, but apparently did not participate in it. Among the thousands of scenes of revolutionary fighting that have been produced in the last 200 years, Delacroix's is one of the few to have retained an audience beyond its own period, even beyond its own country. Although the details of the clothing and setting, with Notre Dame in the distance, are specific to Paris in 1830, the inclusion of the superhuman figure of Liberty, a Classical goddess given new life by her modern setting, makes the scene timeless and universal. This is as close as Delacroix came to a Neo-Classic subject, and the Classical goddess lent her prestige and dignity to the modern political movement.

GOYA AND THE IRRATIONAL

Francisco Goya (1746–1828) lived through the period when the Neo-Classic style was replaced by the Romantic, and he contributed powerfully to the change. The Neo-Classic standards taught in art academies of Goya's day emphasized "one right way" of linear drawing, with sculpturesque shading which was accepted as the rational, intelligent way to make art. That style was never natural to Goya, but he learned to use it well enough that he became director of the Royal Academy in Madrid, where he began to introduce the Romantic style. Once established as a successful artist, Goya found it easier to give his imagination free rein.

In Goya's abundant production it is hard to pick out the most important works, but *The Burial of the Sardine* (Fig. **13.9**) is typical. The title refers to a celebration during Carnival season in Madrid when masked celebrants took to the streets. Goya often painted crowds in which the irrational dominates and people are in a waking state not far from that of a dream or nightmare. Anything but a tourist scene of folklore, *The Burial of the Sardine* is a commentary on the general madness of mankind. In style, Goya is the bridge from the great 17th-century painters such as Velázquez, whose work he studied, to the Impressionists, who learned from him. His quick, sketchy brushwork has been taken as a model of expert painting by generations of painters.

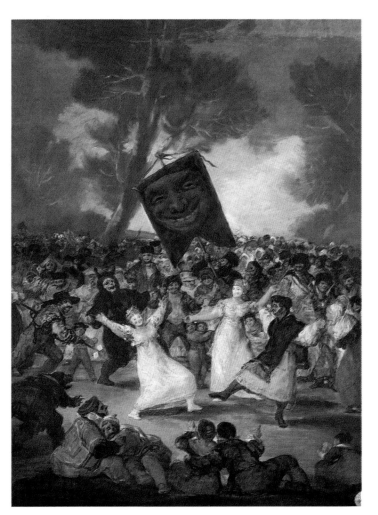

13.9
FRANCISCO GOYA,
The Burial of the Sardine,
1812–19.
Oil on canvas,
32½ x 20½ in
(83 x 52 cm).
Academia Real de San
Fernando, Madrid.

During his own lifetime Goya was better known to a wide public for prints such as *The Dream of Reason Produces Monsters* (Fig. **13.10**). Dreams, and especially nightmares, were an obsession of the Romantics, and Goya used the subject for an attack on rationalism. He issued four sets of etchings, the first and most popular under the title *Los Caprichos*, fantastic or imaginative subjects, which made the name Goya a byword for imagination.

REALISM: NOTHING BUT THE TRUTH

The early Realist painters claimed to paint just what they saw. This sounds quite sensible to us now, but when Gustave Courbet said the artist must represent "the ideas and things of the period in which he lives," many members of the audience disagreed with him, maintaining that the whole tradition of art was the depiction of the imaginative. "Show me an angel and I'll paint one," was Courbet's famous retort. But the artists who accepted the name of Realists were part of a larger movement in literature and politics that was determined to show the grim reality of life for the great majority of people.

GUSTAVE COURBET AND JEAN-FRANÇOIS MILLET

Gustave Courbet (*koor-BAY*; 1819–77) and Jean-François Millet (*mee-LAY*; 1814–75) both exhibited paintings in the Paris Salon of 1850–51, the important exhibition when Realist art was first shown. *The Stonebreakers* (Fig. **13.11**) shows the lifelong hard work and poverty of unskilled laborers building the roads; Courbet made no effort to glamorize the scene—it is intentionally crude and graceless in design to emphasize its meaning. A flamboyant personality, Courbet reveled in political and artistic battles in Paris. Millet, like Courbet, came from a well-to-do farming family and was also well acquainted with both the pleasures and pains of rural life. Of a more retiring personality, Millet settled in the village of Barbizon to escape the turmoil of the city.

Laundresses (Fig. **13.12**) shows two country women by the river where they have been washing clothing. Like Courbet, Millet shows no faces, but concentrates on the

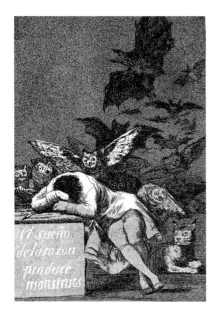

13.10 (*above*)
FRANCISCO GOYA,
The Dream of Reason Produces Monsters from *Los Caprichos*, 1796–98.
Etching, aquatint,
8½ x 6 in (22 x 15 cm).
Metropolitan Museum of Art, New York. (Gift of M. Knoedler & Company, 1918.)

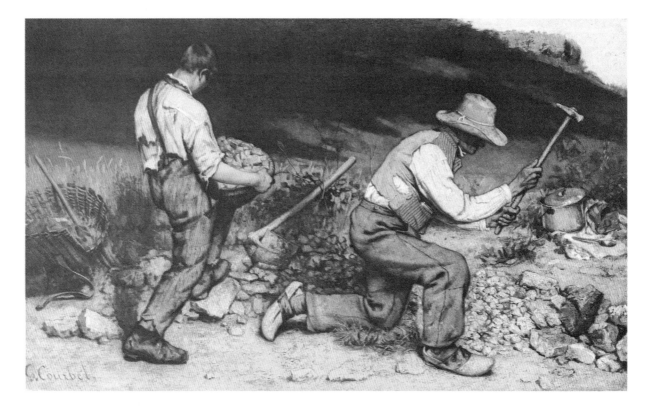

silhouettes that reveal the action. Such country people made up three-quarters of the population of France when this was painted, but the audience for art was almost entirely drawn from the upper classes of city-dwellers. For this audience Millet's work could have only one of two possible interpretations: the sentimental, imagining a simpler world of rustic innocence, or the political, arguing that the life of poverty and grinding labor of the poor should be improved by some kind of political action. Millet himself seems to have rejected both those interpretations as shallow and felt that his main theme was the close relationship of humans to the earth. That is probably closer to the way we see Millet's art, now that the political and social situation has changed.

Millet was able to sell his work consistently, mostly, it appears, to city-dwellers who gave it a political interpretation. Millet was among the first generation of artists to work on contract with a dealer, who paid him a salary to deliver twenty-five paintings a year.

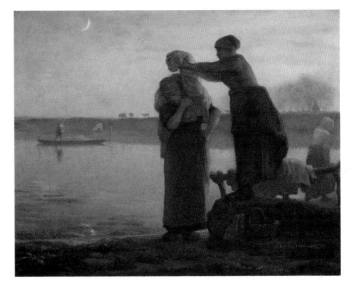

AN INTERNATIONAL MOVEMENT

Realism was an international movement that attracted important artists in many countries. Artists were divided, just as Courbet and Millet were, by the question of what their work meant: was it a simple statement of the facts, or even a celebration of a way of life, or was it a call to reform? The answer, of course, always rests with the audience, which changes its mind as conditions change. In *The Unexpected* (Fig. **13.13**) by the Russian painter Ilya Repin (*RyEP-in*; 1844–1930) the drama of the young man suddenly returned from exile in Siberia appeals to audiences who may have forgotten Czarist injustices. The expressions on the faces of his wife and children, slow to recognize him, and the shock of his mother, seen from the back,

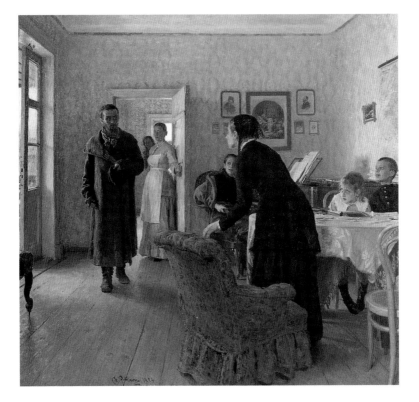

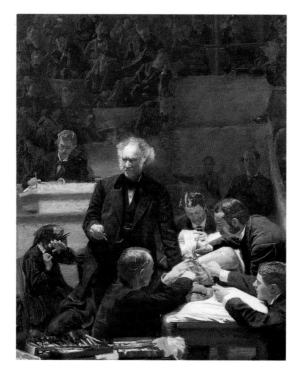

along with the cool northern light and casual-seeming composition, draw us into the reality of the scene.

On the other side of the world, in Philadelphia, Thomas Eakins (1844–1916) employed a Realist style with the seemingly simple aim of telling the truth. He would have approved of Courbet's insistence that art should be about the visible world around us. *The Gross Clinic* (Fig. **13.14**) shows the famous surgeon Dr. Samuel David Gross performing an operation on a young man's leg and lecturing to the assembled students and observers, including the patient's mother, whose presence as a witness was required in charity cases.

Eakins frequently had difficulty with his audience and critics, who considered his paintings too harshly realistic. The blood on the surgeon's hand bothered them. Neither a criticism nor a call to reform, the painting celebrates the achievements of modern medicine. Dr. Gross is shown brilliantly lighted by the surgical lights, deeply serious and thoughtful, practicing a profession calling for heroic work against illness and disease. Although surgical garb has changed, the interpretation of Eakins' painting has changed little in a century.

13.14

Thomas Eakins, *The Gross Clinic,* 1875. Oil on canvas, 8 ft x 6 ft 6 in (2.4 x 2 m). Jefferson Medical College, Philadelphia, Pennsylvania.

MANET AND THE FOUNDATIONS OF MODERNISM

Édouard Manet (mah-NAY) (1832–83) played a unique role in European art, building on Renaissance and Baroque art, sharing in the Realism of his time, adopting Impressionism, and finally transcending it into a kind of visual abstraction. *Olympia* (Fig. **13.15**), which provoked "scandalous laughter" at the Paris Salon of 1865 but is now treasured, shows Manet's work when he was thirty-one. Deeply indebted to the history of paintings in the nude, which he had studied in the Louvre, Manet took that time-worn subject and brought it up to date—by simply telling the truth like a good Realist. In 1865 Paris, a city of about 2.6 million people, was estimated to have as many as 120,000 prostitutes. That was one of the noticeable results of industrialization, which occurred in the 19th century in France and caused the impoverishment of women in particular. Manet was aware of these problems through his friend, the writer Emile Zola, who wrote: "everyone recognizes that Parisian women are not paid a living wage. A working-class woman can only choose between two solutions: either prostitution, or hunger and a slow death."[6] The painting's audience was well aware of that truth, but found Manet's young prostitute shocking. Her frank gaze, her individual personality, and the simplicity of the painting style, which records the visual information without sentimentality, gave no shelter for the hypocrisy of the audience. "Olympia," with her cat, her maid with a bouquet, and her flowered dressing gown, all suggest a courtesan living in comfort, not really the harsh reality of the streets. The large, flatly lit shapes, enhancing the frankness of the subject, were a surprise, too.

In mid-career, inspired by the work of Monet and the other Impressionists, Manet experimented with the sensation of light in outdoor paintings. In his last, and perhaps his greatest, painting, *The Bar at the Folies-Bergère* (Fig. **13.16**), he revolutionized Impressionism and, returning the favor to Monet, left a model for Monet's last works. Exactly in the center—the buttons of her dress bisect the canvas—is the grand figure of the barmaid, modeled by a young woman named Suzon, who really was a barmaid at the Folies-Bergère, a popular vaudeville theater in Paris. Her vacant expression suggests she is exhausted, despite the lively surroundings. Behind her a mirror reflects the bar, the back of a barmaid (not

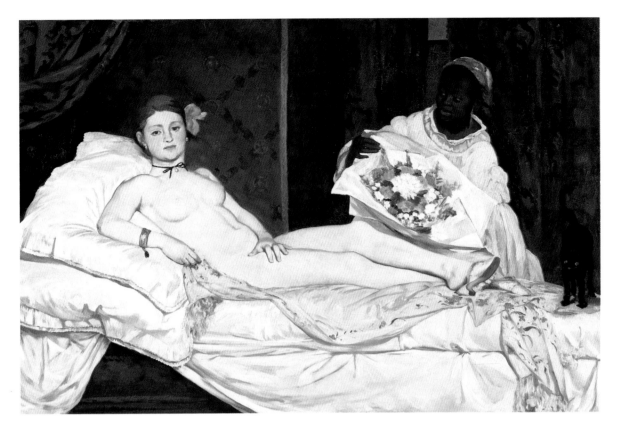

herself, to judge from the pose), and a customer. The reflected scene includes a balcony with seated figures and the feet of an aerialist on a trapeze, which belong inside the theater rather than in the lobby with the bar. The painting is *about* the Folies-Bergère, but not an accurate record of a view there, as pure Impressionist theory would require. Instead it is an imaginative record, constructed in the mind and painted in an Impressionist style. In the 20th century painters admired Manet's sense of painting as an abstract process in which patches of color record mental activity more than vision.

13.15
ÉDOUARD MANET,
Olympia, 1863.
Oil on canvas,
4 ft 3 in x 6 ft 1¾ in
(1.3 x 1.9 m).
Musée d'Orsay, Paris.

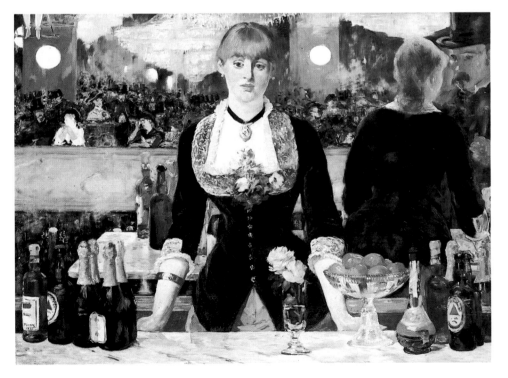

13.16
ÉDOUARD MANET,
The Bar at the Folies-Bergère, 1881–82.
Oil on canvas,
3 ft 1½ in x 4 ft 3 in
(0.9 x 1.3 m).
Courtauld Institute
Galleries, London.

IMPRESSIONISM

Impressionist painting has become the most beloved art of the 20th century; yet it was the most maligned of the late 19th century. For a few years a chasm of misunderstanding opened between many artists and a large part of their audience. The principal factor in that unusual situation was a great broadening of the audience for art. Cities everywhere were growing, with people hungry for a better life, which included all the things that the old noble classes had enjoyed, especially education, leisure, and the arts. The members of this large new audience had little experience of art and were not confident of their ability to tell good art from bad, but they knew by experience that hard work and a skilled hand were valuable. The people in that audience admired the careful drawing and the highly finished paint surface, with brushstrokes invisible, of the late Neo-Classic style, and it took many years for this general audience to grow accustomed to the unblended colors and visible brushstrokes of Impressionism.

After about 1860, artists began to think that a spontaneous record of the scene before their eyes was the most satisfactory work of art. Impressionist painting—the name, given by the critics, originally in derision, came from the title of a painting by Monet, *Impression, Sunrise*, of 1872—allowed the brushwork to show, a frank record of the process by which the picture was made. The name, both of the painting and of the style, was no accident, for the word "impression" referred to the imprint on a human mind made by an event in real life. Critics distinguished between art that was a "photographic" record of appearance and Impressionism, which they considered poetic and which had "soul." The Impressionist style was part of a new idea of experience theorizing that our eyes can tell us nothing about the solidity of objects, that our eyes receive information only from the colored light that strikes them. The critic Jules Castagnary wrote in 1874: "They are *impressionists* in the sense that they render not the landscape, but the sensation produced by the landscape."[7]

13.17

CLAUDE MONET,
Saint-Lazare Station,
1877.
Oil on canvas,
2 ft 10¾ in x 3 ft 4 in
(83 x 102 cm).
Fogg Art Museum,
Harvard University,
Cambridge,
Massachusetts. (Bequest of
Maurice Wetheim, Class
of 1906.)

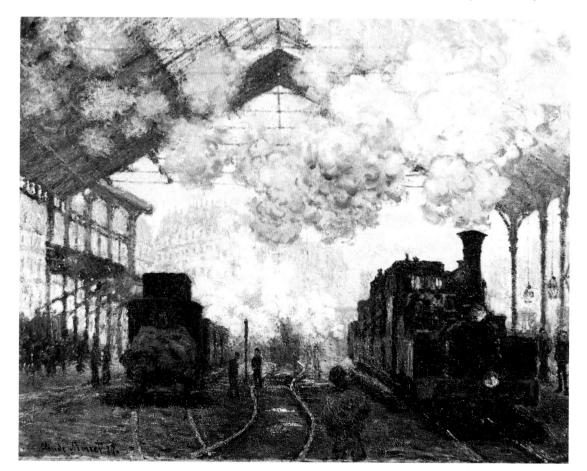

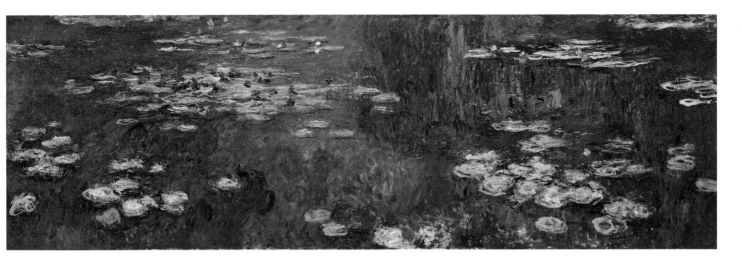

A painting, the Impressionists maintained, to be true to nature and itself must be the record of an impression of colored light. To give color its greatest intensity, they relied on the eye to mix primary colors laid as spots on the canvas. A red spot next to a blue spot, seen from a certain distance, gives the visual sensation of purple, and so on. From a certain distance the paintings looked very natural, but seen close to, they looked rough and unfinished, especially to members of the audience whose visual education was just beginning. Even granting the subjectivity of the impression, the new style set itself apart from earlier styles as much in its color as in its brushwork. The Baroque style, for example, had assumed tactile and kinesthetic (muscular) knowledge of reality, in which chiaroscuro and illusions of mass and motion are expressed. Impressionism represented only light, not darkness (which is invisibility), and only the light from surfaces, not their mass.

Impressionism found some audience right from the start, but the first large exhibit of the new style, in 1874, in which Monet, Renoir, Degas, and twenty-seven other artists exhibited, was rewarded with hostile criticism of the unfinished appearance of the paintings and their "tasteless" modern subject matter.

13.18
Claude Monet,
Nympheas (Water Lilies)
1920–1.
Oil on canvas,
6 ft 6 in x 19 ft 7 in
(2 x 6 m).
The Carnegie Museum of Art, Pittsburgh; acquired through the generosity of Mrs Alan M. Scaife.

For Renoir's Impressionist ideas about the use of color, see p. 96.

CLAUDE MONET

Claude Monet (*mo-NAY*; 1840–1926) was one of the leading Impressionists and the one most faithful to its basic intentions. In 1877 he exhibited eight views of *Saint-Lazare Station* (Fig. **13.17**), one of the Paris railroad stations. This was the first of many sets of paintings of the same subject—a cathedral, haystacks, a lily pond—in which the natural change of light and color was the real subject. Monet made a point of painting only what his eyes could see, which might have made him a Realist, except that his eyes focused on the total scene, not on the human figures, and he did not make any comment on the lives of the people in his paintings. Paul Cézanne joked about Monet: "He is only an eye, but what an eye."[8] Monet might have considered that praise, if the eye is imagined as having "soul."

Monet was not a camera; his subjects were carefully chosen and composed, and he often touched up the work in his studio, though the basic idea was to paint exactly what he saw on the spot. Monet preferred to call the style *plein-airisme* (*play-nair-eezm*, meaning "outdoorism"), to make it clear that he painted from his vision, not his imagination.

When Monet painted the station, the railroads were new, the latest in modern transport. The powerful engines, with their smoke and steam, and the cast-iron structure of the station were dramatic evidence that this was an art about modern life. In his later work, Monet grew more abstract, creating color harmonies based on landscapes reflected in water, such as *Nympheas* (fig. **13.18**), based on the scene in his own beloved garden in Giverny in Normandy. But even in this work Monet focuses on what his eyes could see rather than what his mind could invent.

PIERRE AUGUSTE RENOIR

In the early 1870s Monet and his friend Pierre Auguste Renoir (*ruh-NWAHR*; 1841–1919) sometimes painted the same scenes together, but Renoir's basic interest was the human figure, especially women and girls, who have never been more lovingly depicted. *Dancing at the Moulin de la Galette* (Fig. **13.19**) shows the crowd at a popular outdoor Paris café. All the main characters are Renoir's friends, many of them artists and models. We have learned to see through Renoir's eyes and to see nature as he did. But the softly flicking strokes of color were surprising to the first audience, even though Renoir had learned much of his technique by studying 17th- and 18th-century paintings in the Louvre. Far from the grim reporting of the Realists, this tells a delightful truth about the pleasures of middle-class life in the city. This painting was composed in the studio, although based on studies made from the scene. In spite of Monet's idea that the new painting style could be done only outdoors, few of the Impressionists attempted many paintings outdoors. It was simply too inconvenient. Instead they relied on their sketchbooks, painting from sketches made on the spot to keep their work true to nature.

EDGAR DEGAS

You can practically relive Parisian life of a century ago by looking at Impressionist paintings. Edgar Degas (*duh-GAH*; 1834–1917) shows people in the streets, playing music, at the horse races; he painted portraits of the well-to-do, studies of laundresses at their work, prostitutes, and ballet dancers, all created thoughtfully in the studio from sketches. Although Degas exhibited with the Impressionists and is

13.19
Pierre Auguste Renoir, *Dancing at the Moulin de la Galette,* 1876.
Oil on canvas,
4 ft 3½ in x 5 ft 9 in
(1.3 x 1.6 m).
Louvre, Paris.

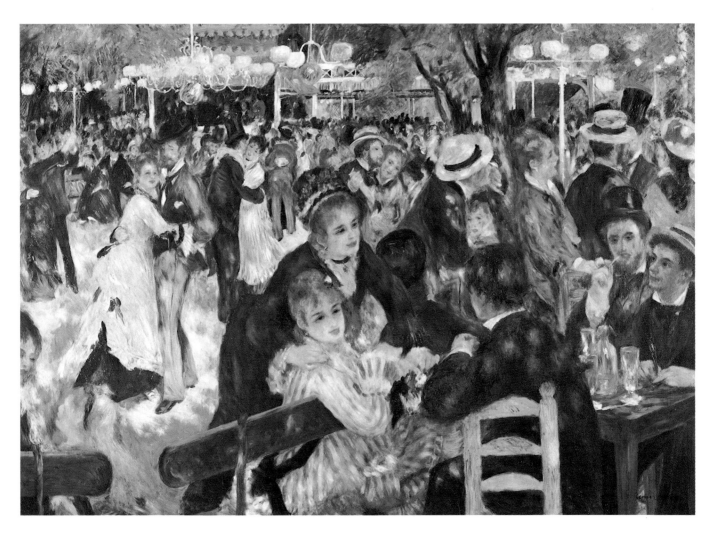

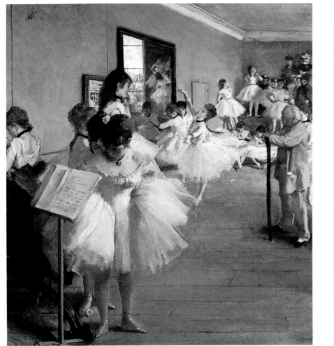

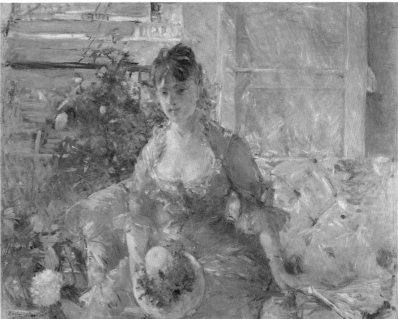

ordinarily classified with them, he did not paint outdoors ("Painting is not a sport,"[9] he said), and his use of color is controlled by the composition, not the visual experience of nature.

Degas's compositions were unusual. A friend, Edmond Duranty, wrote a book on the new painting, which must reflect what he saw in Degas's work and learned from conversations with the artist. He wrote that "views of people and things have a thousand ways of being unexpected in reality" and mentions that in Degas's paintings a figure "is never in the center of the canvas, or of the setting... not always seen as a whole, and sometimes appears cut off at mid-leg, half-length, or longitudinally." The compositions described by Duranty show Degas consciously adopting poses and compositions from photography to increase the impression of objective reality in his paintings. Photographic plates (the ancestors of our film) were invented during the 1830s, and Degas, fascinated with the record of the unposed and the momentary, was one of the earliest artists to incorporate features of photographic recording into his compositions.

The Dance Class (Fig. **13.20**) of ballet dancers at the Paris Opera is one of several versions of this subject. It shows the ballet master, Jules Perrot, leaning on his stick surrounded by a crowd of young dancers. A dancer is cut off at the left margin and the next group overlaps, hiding the faces of two of them, just as Duranty describes. The scene recedes in perspective, the dancers becoming smaller, to the far wall where their mothers wait. The blankness of the left wall is opened up by the mirror reflecting the windows, out of sight on the right. The subtle color—black and white, pale greens and tans, and a few accents of red and pink—is typical of Degas.

BERTHE MORISOT

Berthe Morisot (*BEAR-tuh mor-ee-SO*; 1841–95) was in the center of the Paris art world of her time. Granddaughter of the painter Jean-Honoré Fragonard, sister-in-law of Édouard Manet, and friend of many artists, including Mary Cassatt, she began her career exhibiting in the conservative Salons. Under the influence of the progressive artists around Manet, she adopted a personal form of Impressionism, emphasizing a calligraphic, linear style in light values that fitted her subjects, which were almost always women in comfortable situations. *Young Woman Seated on a Sofa* (Fig. **13.21**), which was painted about 1879 during her most creative period, shows

13.20 (*above left*)
EDGAR DEGAS,
The Dance Class,
c. 1874. Oil on canvas,
2 ft 10⅝ in x 2 ft 5⅞ in
(83 x 76 cm)
Metropolitan Museum of
Art, New York.
(Bequest of Mrs Harry
Payne Bingham, 1986.)

13.21 (*above*)
BERTHE MORISOT,
*Young Woman Seated on a
Sofa,* c. 1879.
Oil on canvas,
2 ft 7¾ in x 3 ft 3¼ in
(81 x 100 cm).
Metropolitan Museum of
Art, New York. (Partial
and promised gift of Mr
and Mrs Douglas Dillon,
1992.)

Mary Cassatt's "Japanese" Prints

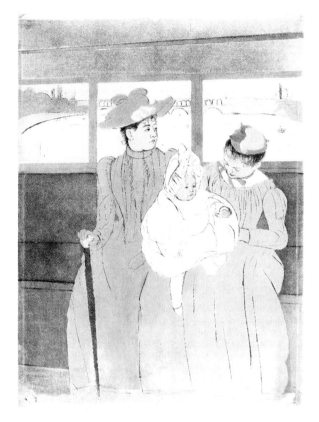

13.22
MARY CASSATT,
In the Omnibus,
c. 1891.
Soft-ground etching,
drypoint and aquatint in
color,
$14^{3}/8$ x $10^{1}/2$ in
(36 x 26 cm).
National Gallery of Art,
Washington, D.C.
(Chester Dale Collection.)

From April 25 to May 22, 1890, a large exhibition of Japanese woodcut prints was shown in Paris, and its effects were both instantaneous and long-lasting. The painters Berthe Morisot and Mary Cassatt (*kuh-SAHT*; 1845–1926) visited the show together, and Cassatt bought a number of prints. The daughter of a Philadelphia banker, Cassatt felt that only in Paris was it possible to be an artist, and she took advantage of the many exhibits. She settled in France, was friends with Degas and the Impressionist group, and became one of the best Impressionist painters born in America.

Cassatt returned inspired from the exhibit of Japanese prints and began work on a series of a dozen prints in the difficult medium of color etching. "It amused me very much to do them," she wrote in a letter, "though it was hard work."

In the Omnibus (Fig. **13.22**) was shown with the other prints in the series at Durand-Ruel's gallery in April 1891, in Cassatt's first Paris show. Camille Pissarro wrote his artist son about Cassatt's prints: "It is absolutely necessary, while what I saw yesterday at Miss Cassatt's is still fresh in mind, to tell you about the colored etchings she is to show ... rare and exquisite works ... the result is admirable, as beautiful as Japanese work."

The Japanese look is produced by the contrast of flat areas of very subtle color with lines that are independent of the colors. The delicate, varied lines are quite different from the heavier Japanese woodcut lines, being cut into the copper plate with acid and a steel etcher's needle. Though these prints were some of Cassatt's most original and influential work, for years they found no buyers either in Paris or New York. But artists had seen them. They established Cassatt's reputation in Paris as a serious artist and they made a strong contribution to print and illustration style of the next thirty years.

Quotations from Nancy Hale, *Mary Cassatt* (New York: Doubleday, 1975)

her typical pastel color scheme, dominated in this case by blues, with the long, dashing strokes that blend the figure into the space and light of the scene. Within the limits of a place and period when women were notoriously excluded from public life, Morisot made a strong career and was noted for the expression of a feminine sensibility. Surely those "feminine" qualities were partly a response to audience expectations.

RODIN AND IMPRESSIONISM IN SCULPTURE

Despite the importance of painting during this period, the most famous artist of the later part of the 19th century was a sculptor, Auguste Rodin (*ro-DAN*; 1840–1917). Not only was his work a sculptural declaration of independence from Greek and Roman styles, from Michelangelo and Bernini—it simply created a period of its own. Rodin worked in marble and in plaster to be cast in bronze. He was a popular portrait artist, but he also received important commissions for public monuments, practically none of them satisfactory to the commissioners. The public monument, by its nature a statement about history, seems to demand a traditional style. The new, original, or personal are slow to find acceptance by public committees, who usually compromise on the most conservative opinion.

A good example is the case of the monument to the writer Honoré de Balzac that was commissioned by a literary society in 1891. Balzac, who had died in 1850, was short and fat, with a powerful head and well-developed ego. Rodin obtained Balzac's measurements from his old tailor, only to conclude that a figure in modern dress would not do. He made some nude studies that have a wonderful vigor, very appropriate to this vigorous writer, and a rough surface that appears truly Impressionist (Fig. **13.23**). In the end Rodin decided to clothe the figure in a long dressing gown thrown over his shoulders, which Balzac is supposed to have worn when he wrote at night (Fig. **13.24**). The originality of the design and the roughness

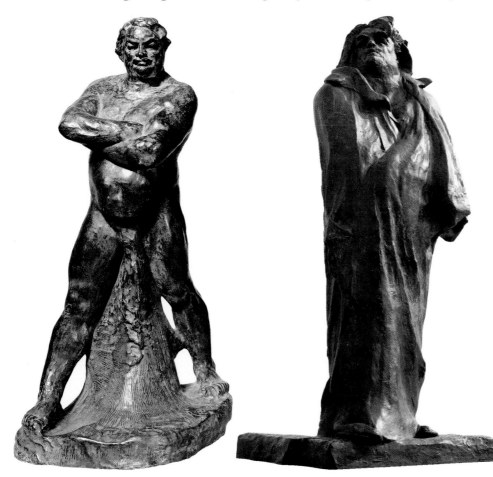

13.23 *(far left)*
AUGUSTE RODIN,
Balzac,
1893–95.
Bronze study
4 ft 2½ in (1.3 m) high.
Private collection.

13.24 *(left)*
AUGUSTE RODIN,
Monument to Balzac,
1898.
Bronze, 9 ft 10 in
(3 m) high.
Hirshhorn Museum and
Sculpture Garden,
Smithsonian Institution,
Washington, D.C. (Gift of
Joseph H. Hirshhorn,
1966.)

of the surface, whose many irregularities can be compared to the color spots of Impressionist painting, annoyed the commissioners, and the society refused to accept the statue. Rodin wrote, "Without doubt the decision of the Société is a material disaster for me, but my work as an artist remains my supreme satisfaction. ... I sought in 'Balzac' to render in sculpture what was not photographic. ... My principle is to imitate not only form but also life."[10]

Photography could not be ignored by artists of this period, whether they adopted its effects or rejected them, as Rodin said he did. The visual impressions that Monet received outdoors, Rodin found drawing from the model in the studio. Thousands of quick pencil and watercolor sketches from models as they posed or moved around the studio provided the record of "life," which Rodin contrasted with the photographic record of mere "form."

Balzac gives the effect of such a spontaneous sketch, full of life but irregular in form. It is still astonishing, not the kind of monument you walk by without noticing. Private patrons wanted to buy casts of Balzac, and though none were made during Rodin's lifetime, several have been erected as monuments since then.

POST-IMPRESSIONISM

Impressionism was based on the idea that painting was the record of a visual sensation received by a subjective individual, not the scientific recording of light before the eyes. But by the 1880s even the theory of an art based mainly on vision was beginning to be unacceptable to the most advanced artists.

Four painters made major contributions to a new art, each quite different from the others, but all derived in some way from Impressionism: Georges Seurat, Paul Cézanne, Vincent van Gogh, and Paul Gauguin. For Seurat and Cézanne it was an intellectual order—a geometry—that was lacking in Impressionism; for van Gogh and Gauguin it was the expression of emotion and deeper, invisible spiritual meanings. These four artists represent the main line of development in art as it has been envisioned by 20th-century artists and art historians.

13.25

Georges Seurat, *Sunday Afternoon on the Island of La Grande Jatte,* 1884–86. Oil on canvas, 6 ft 9 in x 10 ft 6 in (2.1 x 3.2 m) Art Institute of Chicago, Illinois. (Helen Birch Bartlett Memorial Collection.)

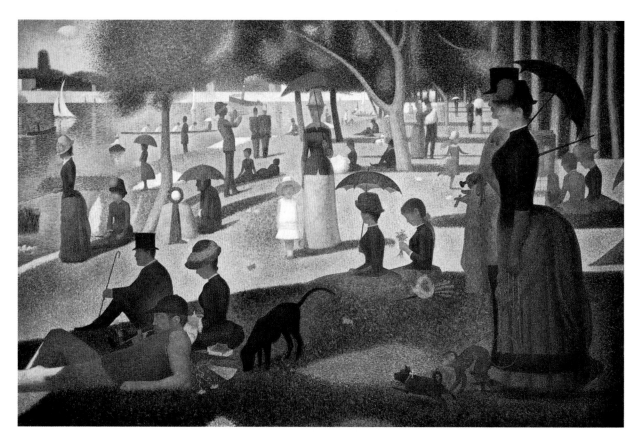

SEURAT AND POINTILLISM

Georges Seurat (*suh-RAH*; 1859–91), who died at the age of thirty-one, nevertheless left ten years of work, including several large and influential paintings. *Sunday Afternoon on the Island of La Grande Jatte* (Fig. **13.25**) is nearly 7 feet (2.1 meters) high and more than 10 feet (3 meters) wide. Although the scene shows people at leisure in a city park, it "ticks like a Swiss watch," as one critic has written. The rough brushwork of the Impressionists has been disciplined so that each stroke is a similar dot or point of pure color—a technique called "divisionism," or pointillism. The same discipline has been imposed on the shapes, as firm and smooth as if carved of stone. Seurat's style has been called Neo-Impressionism, but if Impressionism gives a sense of the spontaneity of life, Seurat's work seems to be about some imaginary ideal world of perfect order. Color printing in the 20th century adopted Seurat's method of combining colors by printing dots of pure color side by side. (Look at a section of a color reproduction in a newspaper through a magnifying glass.) It is no wonder his paintings look mechanistic to us, for his method was one ideally adapted to the discipline of the machine.

PAUL CÉZANNE

Paul Cézanne (*say-ZAHN*; 1839–1906) said his intention was "to make out of Impressionism something enduring and solid like the art of the museums."[11] From Impressionism Cézanne accepted brushwork of pure colors mixed in the eye of the viewer, but the strokes of color were used for a new goal, to represent—"construct" might be a better word—a world of solid forms in space. That, of course, had been the aim of painting from the Renaissance up to the Realists, but Cézanne followed the Impressionists in rejecting the use of Renaissance chiaroscuro, and he went one step farther and also rejected Renaissance perspective. Of the methods used by earlier painters to represent solid forms in space Cézanne kept nothing, and so he had to invent an entirely new method. Alone at his family estate at Aix-en-Provence, in southern France, the intense and introspective artist succeeded at this gigantic task. It was not until 1895, when he was fifty-six, that Cézanne had his first solo show in Paris and other artists began to appreciate his achievement.

 The Bay of Marseilles, Seen from L'Estaque (Fig. **13.26**) is a good demonstration of his method. The composition, with an arm of the Mediterranean Sea separating two

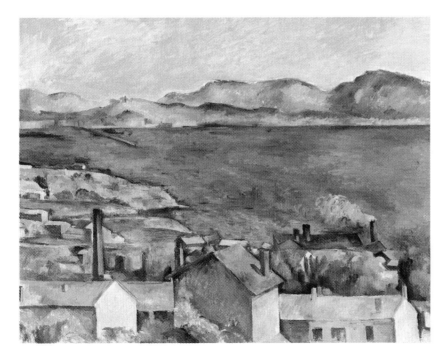

13.26
PAUL CÉZANNE,
The Bay of Marseilles, Seen from L'Estaque,
1886–90.
Oil on canvas,
2 ft 7⅝ in x 3 ft 3⅝ in
(80 x 101 cm).
Art Institute of Chicago,
Illinois. (Mr and Mrs
Martin A. Ryerson
Collection, 1933.)

13.27 (opposite)
Vincent van Gogh,
Road with Cypresses,
1890.
Oil on canvas,
2 ft 11¾ in x 2 ft 4 in
(91 x 71 cm).
Kröller-Müller State
Museum, Otterloo, The
Netherlands.

A Van Gogh self-portrait is
considered on p. 47 (see Fig. **2.5**)
as a revelation of personality.

shores, would offer some difficulties in a linear perspective view since there are no buildings or roads on the water, but it is ideal for Cézanne, who relies on color to locate objects in space. Using aerial perspective as the sole system of construction for the first time, he keeps the entire foreground in warm colors—yellows, oranges, browns, with green as the coolest color. Note that the roofs and walls do not obey the rules of linear perspective, although objects are shown smaller in the distance. On the farther shore all the colors are cool—blue, blue-gray, with touches of very grayed reds, yellows, and browns so you will know it is earth. This system of indicating closer parts with warm colors and farther parts with cool colors, which we call aerial perspective, had a history going back at least to the 17th century, but it had never been used exclusively and systematically before. Other artists recognized this representational world built of color as a basic invention.

No one looks at the work of Cézanne and Seurat for purely intellectual stimulation; it is the emotional satisfaction of finding a world that is orderly and logical. Both those men also lived normally orderly lives, different from the spectacularly disorderly lives of Van Gogh and Gauguin (it is Van Gogh and Gauguin who have been the subjects of movie biographies, not Cézanne and Seurat). Van Gogh and Gauguin were friends and housemates for a short period, but the tensions and emotions that powered their art also made them unusually difficult companions. Although both had learned to paint in a purely Impressionist style, both sought an art that showed more truth than could be seen by the eyes.

VAN GOGH AND EXPRESSIONISM

The Dutchman Vincent van Gogh (*van GO*; 1853–90), who was the son of a Protestant minister, first dedicated himself to caring for the poor and exploited, serving as a lay preacher among the Belgian coal miners—men, women, and children working under conditions we can scarcely imagine. But he had always been interested in art and finally, in 1880, he decided to devote himself to it as a way of bringing the plight of the poor to public attention. His early work is powerful but crude. It was not until he went to Paris in 1886 to educate himself in the new styles that his mature style appeared. Much of his best work was done in the sun-drenched landscape of Arles in southern France. During the last four years of his life he produced several hundred paintings, only one of which was sold before he ended his life at the age of thirty-seven. Van Gogh is often taken as the example of a great artist neglected by an indifferent public, but the public had merely had insufficient time to get acquainted with his work. A few months before his death he was invited to exhibit in an important show in Brussels, and he was the subject of an article in a well-known Paris magazine. In the 1890s the professional audience was already aware of his work, and it reached a vast audience in later years.

Road with Cypresses (Fig. **13.27**) was done in May 1890, and he wrote about it in a letter to Gauguin:

> I still have a cypress with a star from down there [in southern France], a last attempt—a night sky with a moon without brilliance, the slender crescent barely emerging from the opaque shadow cast by the earth—a star with an exaggerated radiance, if you like, a soft brilliance of pink and green in the ultramarine sky, where some clouds are hurrying. Below, a road bordered with tall yellow canes, behind these the blue Lower Alps, an old inn with orange lighted windows, and a very tall cypress, very straight, very somber.[12]

This down-to-earth description hardly prepares you for the intensity of the experience, in which not only the trees and sky, but even the building and the road writhe with uncontrollable emotional tensions. A careful examination of Van Gogh's brushwork shows the discipline of his craftsmanship, even when it was in the service of his emotions. Painters copying or faking Van Gogh's style sometimes think a wild, uncontrolled brush is called for, but Van Gogh painted very much as he wrote in his numerous letters, carefully and with conscious intellectual control.

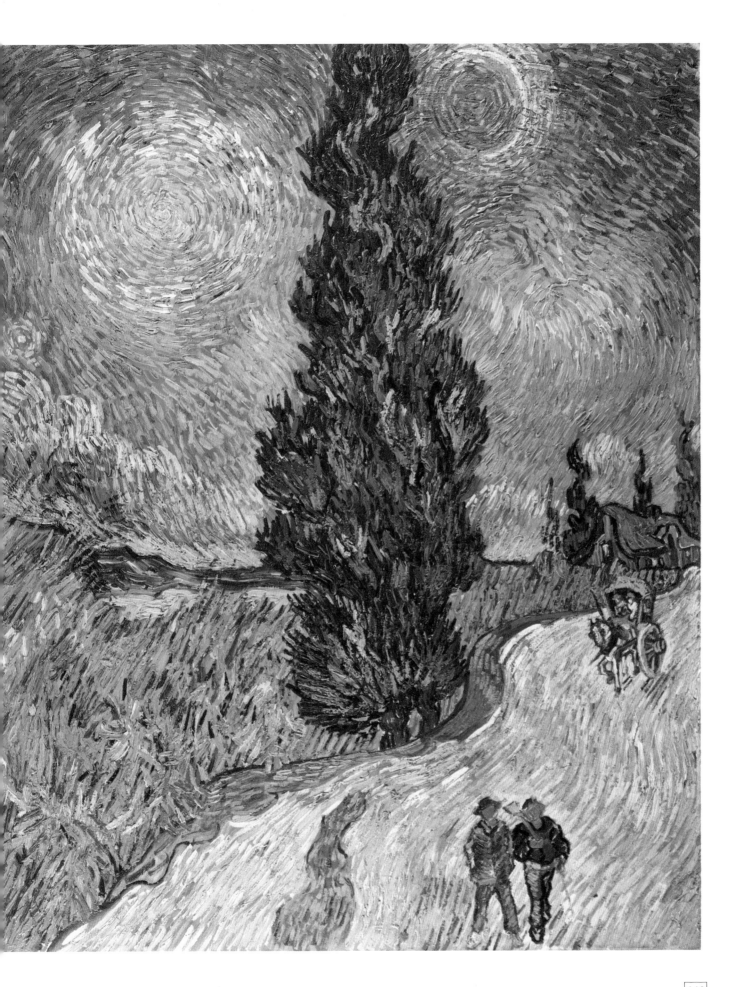

Describing his style in a letter to his brother, he wrote: "instead of trying to reproduce exactly what I have before my eyes, I use color more arbitrarily, in order to express myself forcibly."[13] The search for expression through intensification of color and exaggeration of shape became in the early 20th century the defining features of the style called Expressionism. Van Gogh was seen as the precursor of that movement.

GAUGUIN AND SYNTHETISM

Like the other Post-Impressionist painters, Paul Gauguin (go-GAN; 1848–1903) learned to paint in an Impressionist style, but, also like them, he sought a style that gave more personal expression. Synthetism, as Gauguin called his style, did not come easily to him, but was slowly worked out between 1883 and 1889. He had begun painting as a hobby while working as a stockbroker, then began taking lessons from the Impressionist Pissarro. Finally, in 1883, he gave up his job, left his wife and family, and dedicated himself to art, ultimately sailing away to Polynesia. That he was not an average drop-out is shown by his productivity in all kinds of art—painting, printmaking (see Chapter 5), and sculpture.

The title Gauguin gave *The Spirit of the Dead Watching* (Fig. **13.28**) was "Manao Tupapau," which, Gauguin wrote, "has two meanings, either 'she thinks of the spirit of the dead,' or 'the spirit of the dead remembers her.'" Painted in Tahiti, it shows a Tahitian girl lying face down with an anxious expression and tense hands; "these people are very much afraid of the spirit of the dead," Gauguin continued. "There are some flowers in the background, but being imagined, they must not be real. I made them resemble sparks. The Maoris [i.e., Tahitians] believe that the phosphorescences of the light are the spirits of the dead. Finally, I made the ghost look very simply like a small, harmless woman, because the girl cannot help but imagine dead people when she thinks of the spirit of the dead."[14]

13.28
PAUL GAUGUIN,
The Spirit of the Dead Watching, 1892.
Oil on canvas,
3 ft ¼ in x 3 ft 2¾ in
(92 x 98 cm).
Albright-Knox Art Gallery,
Buffalo, New York.
(A. Conger Goodyear
Collection, 1965.)

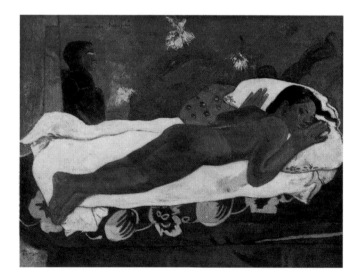

Gauguin's personal style is examined on pp. 141-2.

This mixture of the natural and the supernatural is as carefully composed as a Cézanne or a Seurat, but its shapes are organic-looking and the colors are somber—"sounding to the eye like a death knell: violet, dark blue, and orange yellow,"[15] wrote Gauguin. An Impressionist such as Monet surely must have wondered what it means to say "sounding to the eye," since it suggests that the eye has powers that go beyond seeing. To Gauguin the whole intention of art was to go beyond seeing into imagining—imagining decorative patterns, colors that affect our emotions the way music does, and subjects that have a reality in our minds and emotions, but not necessarily in the visible world. That defines the Synthetist style, which was Gauguin's personal style, but a style that was so fully developed that it was adopted by other artists and was influential in the evolution of 20th-century painting.

THE BATTLEFIELDS OF ART

Art was one of the great public battlegrounds during the 19th century as the ever-growing audience argued with the artists. The public, which was deeply worried about the frightening changes in their way of life, in both technology and society, longed for the security of traditional depictions of beauty and good taste. But many of the artists and their patrons—and a considerable group of critics—did not want art to be an escape from the real world, but wanted to find new ways to show reality. As the public began to understand the new styles, the artists, supported by a body of patrons and critics, marched on ahead to make art that was still harder to understand and to like. So much has this situation characterized the art world of the last 150 years that many people have begun to think it is the natural and inevitable relationship between new art and the public. But looked at as a part of the long history of art, this period of disagreement between artists and the general public is very unusual and tells us much about the instability of the period.

The beginning of the 20th century saw the argument between the artists and their audience reach unprecedented levels. Three major ideas inspired the work of artists during the first half of the 20th century. They may be summarized as follows:

1. At the beginning of the century many believed that artists and their audience must reject everything that had been done in art during the past 500 years and start over from scratch. There was a widespread feeling that Western culture had become overdeveloped, too civilized, and needed to return to basics. Paul Klee, for example, wrote in his diary in 1902: "I want to be as though new-born, knowing nothing about Europe, nothing, knowing no pictures, entirely without impulses, almost in an original state."[16]

2. Another powerful set of ideas developed in psychology, especially from the writings on psychoanalysis of Sigmund Freud and Carl Jung, which proposed that the sources of creativity were in the unconscious parts of the mind and could be reached most easily in dreams, daydreams, slips of the tongue, and other moments when the unconscious makes its appearance. Those two ideas led to another:

3. The models for a new art had to come from outside the European Renaissance tradition, especially from arts which seemed to Europeans and Americans to be closer to the unconscious sources of art and less technically developed in terms of illusions of the third dimension, light and shadow, and natural textures.

Every one of the 20th-century styles has been greeted with controversy—something unheard of before the end of the 19th century. It is strange to discover the passions aroused by something as seemingly harmless as a painting, particularly one made up of nothing but abstract shapes and colors, which you might think could hardly offend anyone. But everyone involved enjoyed the situation—the artists were happy to shock if it made people look at their work, the audience mocked them with glee or defended them passionately, the critics unleashed their most sarcastic attacks and most high-toned defenses, and—most important of all—the patrons bought their work. Despite much lamenting of the plight of the artists, they have been more successful, influential, and admired by a much larger audience in this century than at any other period in history.

While the more conservative members of the audience have charged modern artists with playing tricks on the public, the motivation for all the modern styles was to be as truthful as possible. The popular words were "authentic," "primitive," "original," and "sincere." An artist who could be described by those words was surely truthful and must be avoiding technical tricks that fool the eye with illusions. It was a virtual requirement for art to be, or to appear to be, technically primitive to be accepted as authentic and original. A primitive technology was a guarantee that the artist was rejecting the Renaissance tradition and starting over and that the art was an authentic expression of the unconscious mind, not a product of the

calculating conscious mind. The great importance of the unconscious mind in modern art theory was that it was considered the part of the mind where most of the basic human experiences are stored, such as hunger, sex drive, loves and hates, fears and needs. The conscious mind was considered the home of all the concerns that make us individuals and separate us, making communication more difficult. While this theory can be very persuasive and is basic to the understanding of modern art, it has not, as we shall see, been accepted by most artists and their audience after 1970.

ART IN PARIS: 1900–40

Paris remained the center of world art through the first four decades of the century and was home to two of the major art movements of the period—Cubism and Surrealism—and a major center of Expressionism and Abstraction.

CUBISM

The art of this century has been defined by painting, and of all the painters Pablo Picasso (1881–1973), a Spaniard who settled in Paris when he was nineteen, played the leading role.

The Cubist style was the product of a few years of work toward a more geometric and nonrepresentational style. Between 1907 and 1920 Cubist painting developed from depicting simple, sculptural human figures in simple backgrounds to a very abstract style, emphasizing shape, pattern, and texture. In the earlier paintings there are geometric shapes in tones of brown and gray, textured with brushstrokes to give an architectural or sculptural effect. In later years there is more color, often in flat areas, which reduce the sense of space and mass, but with clearer representation of a subject. Although Cubist art at first looks unemotional, the artists all considered it a means for expressing ideas and emotions. "We have kept our eyes open to our surroundings, and also our brains,"[17] as Picasso said.

13.29 (below)
PABLO PICASSO
Les Demoiselles d'Avignon,
1907.
Oil on canvas,
6 ft x 7 ft 8 in
(2.4 x 2.3 m).
Museum of Modern Art,
New York. (Acquired
through the Lillie P. Bliss
bequest.)

13.30 (below right)
PABLO PICASSO,
Mandolin,
1914.
Wood construction,
1 ft 11⅝ in (60 cm) high.
Musée Picasso, Paris.

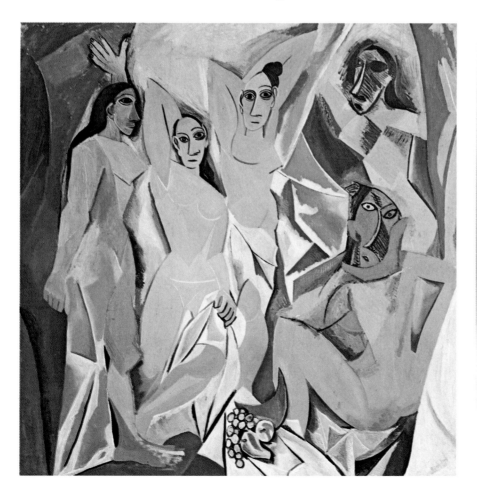

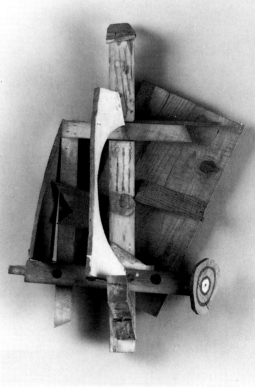

Pablo Picasso

Picasso took the first step toward Cubism in his famous 8-foot- (2.4-meter-) high painting later named *Les Demoiselles d'Avignon* ("Girls of Avignon") (Fig. **13.29**) in 1907, which shows the young artist considering ancient Spanish and African sculpture as sources of new geometric faces. The composition began as a moralistic picture of a sailor surrounded by nude women, food, and flowers, with an intruder carrying a skull entering from the left. Months of work on the painting, during which Picasso's friends expected to find the artist had hanged himself behind the canvas, transformed it into a figure study with no story at all. Although it was abandoned unfinished, it is important as evidence of the struggle to form a new style. Each figure is an angular shape divided into smaller angular shapes by geometric lines. The African-looking masks of the faces on the right seem to be a declaration of independence from the European tradition and the adoption of a more abstract design.

Picasso made sculpture throughout his life, but among his most influential are those in the Cubist style, such as *Mandolin* (Fig. **13.30**), a small relief designed to hang on the wall. This construction was a result of about two years of inventive work in drawing and collage (cut and pasted paper) which was flat but suggested the third dimension. As carpentry, *Mandolin* is not to be taken seriously, but it set an entirely new path for 20th-century painting and sculpture, one still being explored creatively in the late 20th century. The flat planes of rough wood, with a little color added, are a simplified version of the painted compositions Picasso and Georges Braque had been making. *Mandolin* took Cubism to its logical conclusion, and revealed a whole new range of possibilities in the style. "When we invented Cubism," Picasso said later, "we had no intention whatever of inventing Cubism. We wanted simply to express what was in us."[18]

Georges Braque

Only a real expert can tell the work of Picasso from that of Georges Braque (*brock*; 1882–1963) during those years. Braque's *The Portuguese* (Fig. **13.31**) was based on a

The genesis of Picasso's most famous mural, *Guernica*, is discussed on pp. 149-52.

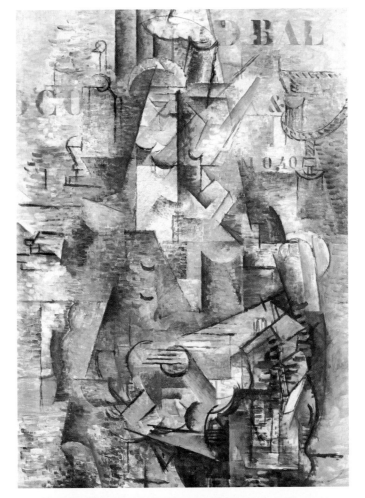

13.31
GEORGES BRAQUE,
The Portuguese,
1911.
Oil on canvas,
3 ft 10 in x 2 ft 8 in
(117 x 82 cm).
Kunstmuseum, Basel,
Switzerland. (Gift of Dr.
H. C. Raoul La Roche,
1952.)

man playing a guitar in a bar; people playing stringed instruments were a favorite subject of both artists, mainly because the instruments had a cubistic set of curves and straight lines that established a design vocabulary for the painting. Braque introduces letters and numbers as if they were stenciled on, like signs and posters, but suggesting as well that the figure is also a sign, simplified to become part of a language of forms, shapes, and colors. With these ideas the Cubist style set the ground rules for a large part of art for the following fifty years.

Fernand Léger

Léger (*lay-ZHAY*; 1881–1955), who was born the same year as Picasso, developed a Cubism of his own, one that was inspired not by sculpture and musical instruments, but by machines. More than any other artist, Léger took an optimistic view of the machine age. Even service in the artillery, in which he was wounded, did not discourage him; he said, "I was dazzled by the breech of a 75-millimeter gun which was standing uncovered in the sunlight: the magic of light on white metal."[19] *Soldiers Playing at Cards* (Fig. **13.32**), painted in 1917 after his discharge from the army, was inspired by a tradition of paintings on that subject, including a famous one by Cézanne. But Léger's version is composed of gray, robotlike figures in a machine environment. Shades of primary colors brighten the scene. No negative idea about a mechanical world was intended, just the smooth, shiny, functional beauty of machines. Léger used a Cubist style throughout his career as a way of expressing the classical perfection of a machinelike world.

Constantin Brancusi

We usually think of Cubism as a painting style, but there is a considerable amount of Cubist sculpture. The most influential sculptor of the early 20th century, who is usually associated with Cubism, was Constantin Brancusi (*brahn-KOO-see*; 1876–1957). Born and educated in Romania, he settled in Paris in 1904 and soon came under the influence of Rodin (see page 445), but it is the geometric simplification of Cubism that distinguishes his work. In fact, Brancusi's work belongs to no single style. Instead, it reflects all the main artistic interests of his period, from African and Polynesian art, to Romanian folk designs, and European industrial design. *Mademoiselle Pogany III* (Fig. **13.33**), a marble portrait of a young woman, grows out of these many influences but goes beyond them. One glance at the work of Rodin shows the great changes in style that occurred in one generation. While the Cubists were, as we have seen in Picasso's *Mandolin* (see Fig. **13.30**), seeking complex structures that would reveal several points of view that could be represented as planes, Brancusi was looking for clearly defined three-dimensional forms that were the essential forms of nature. "Simplicity is not an end in art, but

13.32
FERNAND LÉGER,
Soldiers Playing at Cards,
1917.
Oil on canvas,
4 ft 2¾ in x 6 ft 3¾ in
(1.3 x 1.9 m).
Kröller-Müller State
Museum, Otterloo, The
Netherlands.

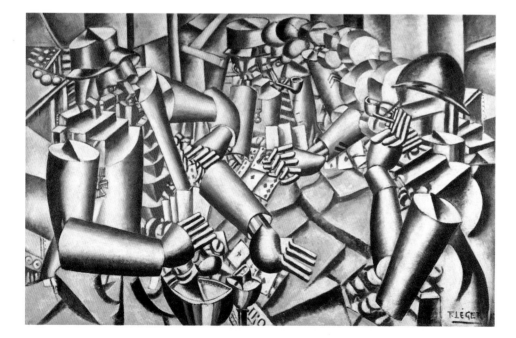

one reaches simplicity in spite of oneself by approaching the real meaning of things,"[20] Brancusi said. The egglike form, with its sleek supports (neck and hair) and simplified curves for eyes, shares more of Léger's fascination with the perfection of machine parts.

EXPRESSIONISM

The broadest current in modern art is Expressionism, which means just what it says: the artist aims to express a subjective reaction to experience. That is true of a great many styles, but artists working independently in the anonymity of modern cities, without the demands of a patron to consider, have been much freer to consider their own feelings than artists in earlier times. Although Expressionist style is varied, common features are strong color, chosen for its emotional effect, and representational subjects, drawn with distortions that express emotion. We often think of Expressionist art as anguished, but the early-20th-century movements in France and Germany tended to concentrate on a joyous mood.

Henri Matisse and André Derain

Henri Matisse (*mah-TEECE*; 1869–1954) was the leader of the first group of Expressionist painters in Paris about 1905, producing colorful paintings that earned the painters the joking name "wild beasts," or Fauves (*fove*) in French. Matisse and his friend André Derain (*duh-RAN*; 1880–1954) spent the summer of 1905 at the Mediterranean beach resort of Collioure. Derain wrote a friend: "Light here is very strong, shadows very luminous," and described the new style they were working on in which light and shadow were expressed by pure color, without mixing black and white or even complements. These artists were far from being "wild beasts" in person; Derain invited Matisse to meet his parents to show that artists were respectable types. But Matisse's *Girl Reading (La Lecture)* (Fig. **13.34**) shows an

13.33 (*below left*)
CONSTANTIN BRANCUSI,
Mademoiselle Pogany III,
1930.
Marble on stone base,
2 ft 3½ in (69 cm) high.
Philadelphia Museum of
Art, Pennsylvania. (Louise
and Walter Arensberg
Collection.)

13.34 (*below*)
HENRI MATISSE,
Girl Reading (La Lecture),
1905–6.
Oil on canvas,
2 ft 4½ x 1 ft 11⅜ in
(72 x 59 cm).
Museum of Modern Art,
New York. (Promised gift
of Mr and Mrs David
Rockefeller.)

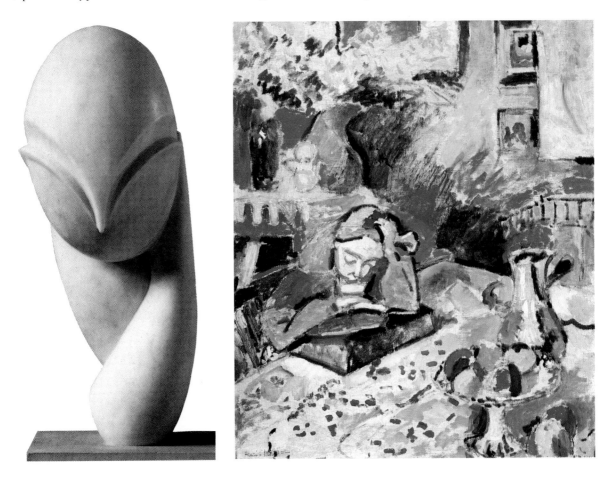

unrestrained use of color that was something new. Its ancestors were the paintings of Vincent van Gogh and Paul Gauguin, but Matisse allowed his work to retain a "quick sketch" appearance unlike the more finished appearance of the earlier work. You can see by the lively style why Matisse gave the title "The Happiness of Life" to one of his paintings.

Fauvism was not simply an explosion of emotion. It had an idea about how nature could be represented using color without black and white. Personal expression was limited by that system, but the results were a richness of color that had never been seen before. Fauve painting, and especially the work of Matisse, has sometimes been considered purely decorative—without expression or meaning—by those who think of Expressionism as anguished and tragic. Pleasure, serenity, and generosity are the expressions that dominate in Fauvism and Matisse's work.

Kirchner and German Expressionism

Matisse and his friends were not the only ones who studied van Gogh and Gauguin. Artists all over Europe were fascinated with their work, and Expressionist styles sprang up in many cities. The German Expressionist movement is the best known. It was first organized by a group of young architecture students in Dresden in 1905 who called their group The Bridge Artists' Group (usually shortened to Die Brücke, "The Bridge"). Ernst Ludwig Kirchner (KIRK-ner; 1880–1938) was one of the leaders. *Girl under Japanese Umbrella* (Fig. **13.35**) shows Kirchner's version of Expressionism: brilliant color, with colored lines and color used to indicate light and shade (in place of black and white or complements), a very free, spontaneous brushwork, and a subject suggesting romance, pleasure, and the exotic. Kirchner and his friends were especially interested in African and Oceanic arts, which they saw in the local museum and which they tried to duplicate for their own living and studio areas, hanging draperies printed with New Guinea and African designs. They were also exhibiting prints, both woodcuts (which became some of their most famous works) and etchings.

Expressionism was a popular and widespread style in Germany and throughout northern Europe. It was both decorative and exciting. Those two aspects were in Kirchner's mind when he painted the design of active figures across the background,

Matisse made important contributions to the theory of modern art. For his ideas on perspective, see p. 110; on sculpture, see p. 100; and on pictorial composition, see p. 118.

13.35

Ernst Ludwig Kirchner, *Girl under Japanese Umbrella*, c. 1909. Oil on canvas, 3 ft ½ in x 2 ft 7 in (93 x 81 cm). Collection of Dr. Frederic Bauer, Davos, Switzerland/Kunstsammlung Nordrhein-Westfalen, Düsseldorf, Germany.

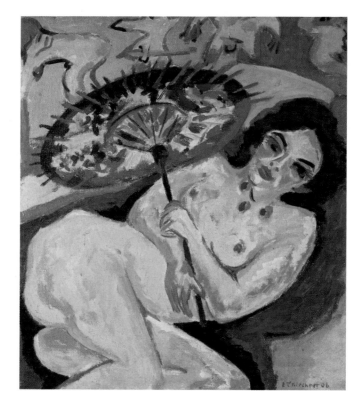

like a hanging. The feeling of a freer, more primitive life is the main message of this painting. We have to remember that it was painted at a time and place in which the harsh discipline of industrial labor in factories dominated every aspect of life. The appeal of Expressionist art for people surrounded by an industrial revolution is easy to see.

Marc Chagall

While many artists passed through periods of Expressionist style, for others it formed the basis of their life work. The Russian Marc Chagall (*shuh-GAHL*; 1887–1985) tried out some Cubist compositions, but a more emotional style suited him better. *Peasant Life* (Fig. **13.36**) was painted in France, which became his home after 1924, but it is about memories of his youth in Vitebsk, in Russia. At the time this painting was done, Chagall had been offered membership in the Surrealist group in Paris, but had refused. We can only imagine his reasons by comparing his work with that of Ernst or Dalí (see Figs **13.39** and **13.40**). Perhaps it was a feeling that the psychological probing that fascinated the Surrealists was inappropriate to his style, in which color—the most emotional and decorative element—had always been most important. Memories were Chagall's main subject, but he never psychoanalyzed them.

Chagall did important illustrations for books, most important of all for the Bible, as well as stained-glass windows and murals. Expressionism has been the vehicle for important religious art, a subject we sometimes overlook when we think of our own century. Chagall, with his Jewish heritage, emphasized Old Testament subjects, while Georges Rouault, a Christian, concentrated on the New Testament in both prints and paintings.

Georges Rouault

Head of Christ (Fig. **13.37**) by Georges Rouault (*roo-OH*; 1871–1958) is over life-size, very thickly painted in oil, with heavy black lines and encrusted areas of color. It looks like medieval stained glass, which is no accident, since Rouault had worked as a young man in a stained-glass studio. Christ has huge dark eyes, which look a little to the left of the observer, full of sadness and suffering, but not accusing.

13.36 (*below left*)
MARC CHAGALL,
Peasant Life,
1925.
Oil on canvas,
3 ft 3⅜ in x 2 ft 7½ in
(100 x 80 cm).
Albright-Knox Art Gallery,
Buffalo, New York. (Room
of Contemporary Art
Fund, 1941.)

13.37 (*below*)
GEORGES ROUAULT,
Head of Christ,
1938.
Oil on canvas,
3 ft 5¼ in x 2 ft 5½ in
(105 x 75 cm).
Museum of Art, Cleveland,
Ohio. (Purchase from the
Hanna Fund.)

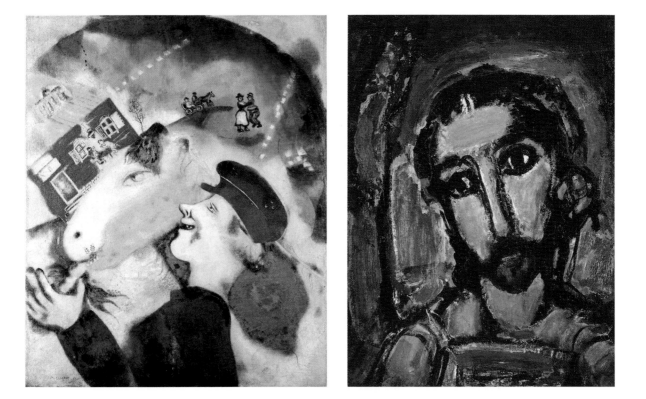

Rouault's art is more concerned with moral and spiritual subjects than Chagall's, which was more varied in subject. The work Rouault has left us pays little attention to problems of artistic form; he was an exceptional master, but not an experimenter. He was entirely involved in the subject and its meaning, which is exactly what one would expect of an Expressionist.

Expressionism is the broadest of the modern styles, with representational and abstract wings and political and religious specialists; just about every kind of art had some connection with it. That fact can be explained by the definition we commonly give art, as "self-expression." As we saw in Chapters 1 and 2, artists are never trying to express only themselves, but always—even when they deny it—seeking something in themselves with which others can identify. That art is the artist's self-expression has not been a common idea in other periods, when credit for the creation of a work of art was given to the community or the patron that sponsored it, with little interest in the personality or ideas of the person who actually did the work. In this sense, Expressionism, with its emphasis on the feelings, ideas, and brushmark of the artist, is an especially 20th-century style.

PSYCHOLOGICAL STYLES

Psychology was still a new science at the beginning of the century and its basic ideas were just beginning to become widely known. That the "reality" we all experience in our minds is more real to us than the material world that surrounds us, which is by now a commonplace idea, was a shocking revelation. As early as 1914 we find artists using perspective distortions, dreamlike mixtures of subjects, and unnatural colors to achieve a different kind of reality, one that could exist only in the mind. This

13.38
GIORGIO DE CHIRICO,
The Evil Genius of a King,
1914–15.
Oil on canvas,
2 ft x 1 ft 7¾ in
(61 x 50 cm).
Museum of Modern Art,
New York.

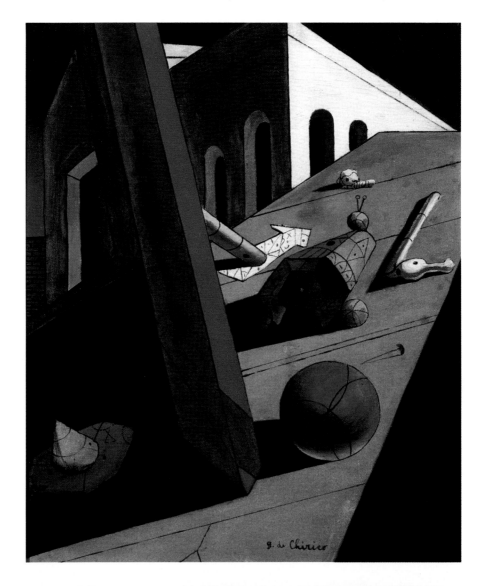

remained an important aim for many artists throughout the first half of the 20th century.

The horrors of World War I revealed the vulnerability of the human mind in ways not imagined before. André Breton, a writer and critic who had worked with "shell-shocked" psychological cases during the war, was convinced that artists must find new ways to reach the mind of the audience. After the war, in 1924, he founded the **Surrealist** group in Paris, which incorporated antiwar activists from the **Dada** movement along with other advanced thinkers in the arts. Dada was an antiwar movement founded in Zurich in 1916. The name Dada was meant to be a nonsense word, implying that since the world was insane the only way to cope was to be absurd. The search for the absurd, it turned out, had great creative potential, and Dada has remained interesting as a movement. Surrealism, meaning "super realism," implies that our mental experience has a greater reality (at least for us) than the material world around us. Art in the 20th century has been deeply affected by psychology and the art movements it produced. We will look at just three of the more important artists in this category—Giorgio de Chirico, Max Ernst, and Salvador Dalí. De Chirico and Ernst served in World War I, Ernst was a member of the Dada group, and both Ernst and Dalí were members of the Surrealist group in Paris in the 1920s.

Giorgio de Chirico

The Italian Giorgio de Chirico (*KEE-ree-ko*; 1888–1978) arrived in Paris the summer of 1911, when he was twenty-three, to spend four years painting in the atmosphere of tremendous creative excitement that was Paris before World War I. (In 1915 he returned to Italy to enlist in the army.) In *The Evil Genius of a King* (Fig. **13.38**) a late afternoon light illuminates a scene that could exist only in the mind: a building obscured by a slanting plaza on which some strange geometric forms rest. Although the things depicted could exist in the natural world, the total composition could not. That became a basic theme of Surrealist art, as it is of our dreams: objects from the real world in an unnatural setting. As the critic Guillaume Apollinaire wrote: "Monsieur de Chirico has just bought a pink rubber glove, one of the most impressive articles that are for sale. Copied by the artist, it is destined to render his future works even more moving and frightening than his previous paintings. And if you ask him about the terror that this glove might arouse, he will immediately tell you of toothbrushes still more frightening.[21]

Salvador Dalí

The youngest of the artists associated with Parisian Surrealism was Salvador Dalí (1904–89), an internationalized Spaniard. He said, "To tell the truth, I am nothing but an automaton recording, without judging and as exactly as possible, the dictates of my subconscious." Another remark: "The only difference between me and a madman is that I am not mad."[23] By this Dalí meant that everyone has an unconscious mind full of dreams and metaphors, and to examine it is not a sign of madness.

Dalí's conservative training and his interest in Renaissance painting led him to a very detailed illusionistic style which set him apart from the mainstream of the Modern movement, but it made his visions very convincing. *Soft Construction with Boiled Beans* (*Premonition of the Spanish Civil War*) (Fig. **13.39**) was painted in 1936 and suggests a

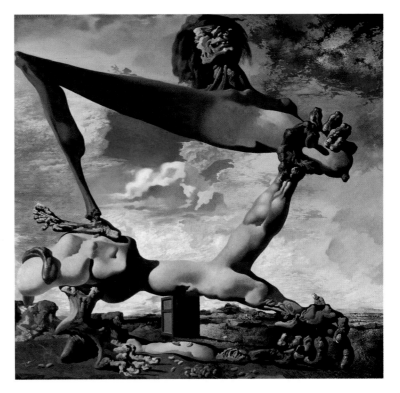

13.39
Salvador Dalí,
Soft Construction with Boiled Beans (Premonition of the Spanish Civil War),
1936.
Oil on canvas,
3 ft 3½ in x 2 ft 9 in
(100 x 84 cm).
Philadelphia Museum of Art, Pennsylvania. (Louise and Walter Arensberg Collection.)

nation tearing itself apart, as Spain was then about to do. Dalí's reaction to Spain's troubles took the form of a nightmare; Picasso's *Guernica* (see Fig. **5.6**), painted a year later, dealt with the same subject in a style derived from Synthetic Cubism.

Dalí has been criticized as calculating rather than being in the grip of his dreams, but that reflects a misunderstanding of psychological art.

Max Ernst

"On the first of August 1914 M.E. died. He was resurrected on the eleventh of November 1918 as a young man who aspired to find the myths of his time."[22] Thus Max Ernst (1891–1976) described his four years of war and his postwar dedication to art. Well educated and articulate, Ernst became the leading artist, among writers and poets, in the Surrealist group in Paris. *Elephant of the Celebes* (Fig. **13.40**), painted before the group was organized, was bought by a Surrealist poet. The mechanical vat with a bull's head is huge, but powerless, and everything is in the wrong place: fish in the sky, a broken statue in the foreground of a vast plain. Ernst was not looking for any traditional myths, but was searching for the "collective unconscious" in which psychoanalysis taught there were shared dreams and visions. Anything that could be explained by the conscious mind was automatically rejected by the Surrealists, in favor of the unpredictable, the inexplicable. The sources of the subjects and compositions of de Chirico, Dalí, and Ernst are in the imagination, in the unconscious and dreams, but the pictures they made are conscious products, the fruit of learning and controlled work.

13.40
MAX ERNST,
Elephant of the Celebes,
1921.
Oil on canvas,
4 ft 1¼ in x 3 ft 6⅛ in
(1.2 x 1 m).
Tate Gallery, London.
(Roland Penrose
Collection.)

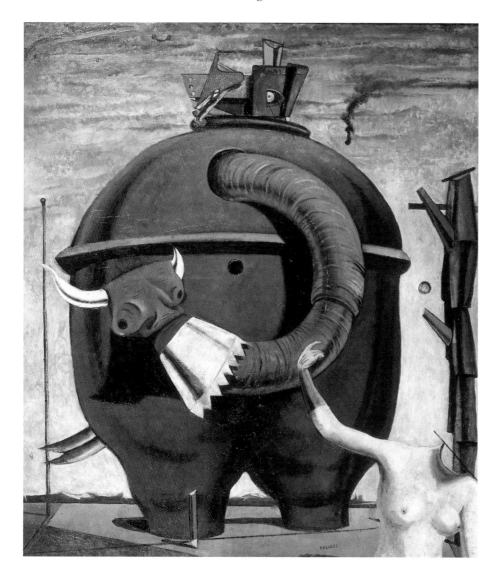

NON-OBJECTIVE ART

Non-objective art is a general term for art that *is* an object, but does not *depict* any object. Artists of the 20th century have divided Non-objective, or non-representational, art into two opposite categories: **abstract** and **concrete**. Abstract art symbolizes abstract qualities (heroism) and things that have no visible form (song). Concrete art is intended by the artist to exist as an object and to have no symbolism; that violates the accepted idea of art as a symbolic or communicative form. Although the idea of a concrete art has been proposed a number of times, and we shall examine examples later, the dominant tendency has been to consider Non-objective art as abstract—in other words, having reference to things outside the work itself, usually to spiritual or mental states which could not be adequately represented by visible things.

Non-objective art has appeared in two styles, Expressionist and Cubist-related, and they have acted as important connecting links between European and American art. Wassily Kandinsky and Piet Mondrian were among the most important European artists to adopt Non-objective styles, both of them with the idea that their work had references to the real world.

Wassily Kandinsky

In 1912 Wassily Kandinsky (1866–1944) wrote a book entitled *Concerning the Spiritual in Art*, which emphasized the need for an emotional commitment by the artist to the spiritual meaning of his work, a meaning that must be transferred to the observer through the form of the art. His *Improvisation 30* (Fig. **13.41**), painted in

13.41
WASSILY KANDINSKY,
Improvisation 30
(on a Warlike Theme),
1913.
Oil on canvas,
3 ft 7½ in (1 m) square.
Art Institute of Chicago,
Illinois. (Arthur Jerome
Eddy Memorial
Collection.)

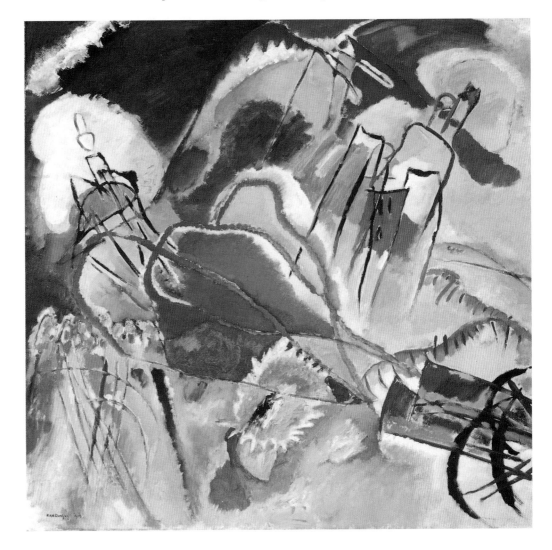

Discussion of abstract art and the Constructivist style (contemporary with Mondrian and Kandinsky) appears on pp. 68-70.

1913, shows his Expressionist style. Kandinsky was one of the first to paint Non-objective improvisations with the idea that they revealed his subconscious mind. That idea became a basic doctrine of Surrealism in the 1920s, usually in a less spontaneous style than Kandinsky's.

Kandinsky always believed that colors and shapes had meanings that the audience could learn to interpret. Then, as he wrote, "the artist will be able to dispense with natural forms and colors and use purely artistic means."[24] In *Concerning the Spiritual in Art* he provided a key to his interpretation of colors and shapes. "As a picture painted in yellow always radiates a spiritual warmth… green represents the passive principle," he wrote, and describes lines or shapes moving toward the right as "away from the spectator (spiritual)." Whether the rules Kandinsky discovered for himself have a universal validity has never been determined.

Piet Mondrian

The Dutch artist Piet Mondrian (1872–1944) worked in Paris during much of his mature career. But in Paris Non-objective art was never dominant; the Cubist, Surrealist, and Expressionist styles used there always retained a subject from nature. It was among the northern Europeans that abstraction and Non-objective art had most appeal: Kandinsky was Russian and Mondrian Dutch.

Mondrian was the purest of the Non-objective painters. In Chapter 4 we looked at *Composition Gray-Red* (see Fig. **4.27**), a white rectangle with solid black lines and some color fields. That is "classic Mondrian," the mature style he reached in his late

13.42

Piet Mondrian, *Composition No. 7: Façade,* 1914.

Oil on canvas, 3 ft 11½ in x 3 ft 3⅜ in (3 x 2.5 m). Kimbell Art Museum, Fort Worth, Texas.

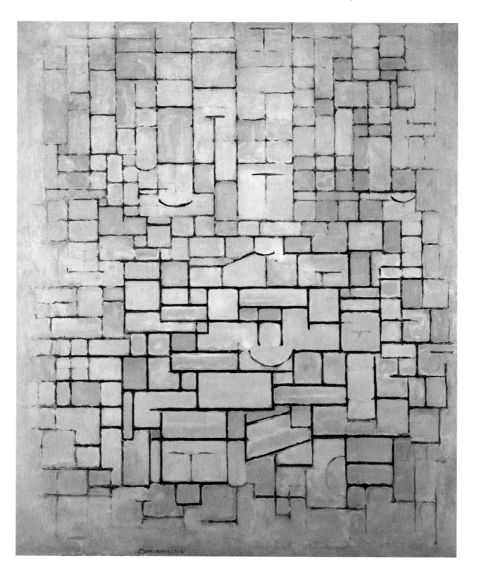

13.43
PIET MONDRIAN,
Broadway Boogie-Woogie,
1942–43.
Oil on canvas,
4 ft 2 in (1.3 m) square.
Museum of Modern Art,
New York. (Anonymous
gift.)

forties and used until near the end of his life. But there is a "before" and "after" in Mondrian's art which help us see the potential for self-expression in what seems, at first, like an expressionless style. By 1914, when he painted *Composition No. 7: Façade* (Fig. **13.42**), Mondrian had already eliminated almost the last trace of pictorial representation from his painting, though *Façade* still hints at depiction of the front of a church which appeared in earlier work. Black lines, pale tints of red, yellow, blue, and gray forecast his later work, but a few curves and diagonals remain. Mondrian's was an art of elimination: curves, diagonals, colors other than primaries; even the artificial flower in a vase in his room had its leaf painted white since Mondrian claimed he could not stand green.

Mondrian was searching for a universal language of art, which could be achieved only by simplification, by eliminating the purely personal, and specific examples from nature. "Art has to follow not nature's Appearance but its Laws," Mondrian wrote. "In order to approach the spiritual in art, one employs reality as little as possible. ... Art must transcend reality."[25] Neo-Plasticism was the name Mondrian and his Dutch colleagues gave the style.

In 1940, when he was sixty-eight, Mondrian left Europe to escape World War II, and he settled in New York, assisted by a young American painter friend, Harry Holtzman. Mondrian lived the last three years of his life in New York and discovered, unlike many European emigrés of that period, that he felt at home there. Holtzman introduced him to American jazz and Mondrian became a great fan of boogie-woogie. *Broadway Boogie-Woogie* (Fig. **13.43**), painted in New York, shows a new development of the style, with colored lines and many small color spots.

Mondrian's late work exhibits an exuberance and youth quite different from the severe black-lined paintings of earlier years, but it was the fruit of a single year of work. Pneumonia killed the painter before this late development of the style could appear in more than a few paintings.

The movement of artists, such as Mondrian, from Europe to the United States about 1940 to escape World War II marks a change in the international art world and the emergence of New York as a major international center. At the end of the war New York retained that position, and as a global integration of the art world began to emerge in the later years of the 20th century, the United States became one of the principal centers. That is the subject we must look into in the next chapter. The excitement that Mondrian found in New York forecast the emergence of new art, abstract like his, in the United States.

FOR REVIEW

Evaluate your comprehension. Can you:

- explain the similarities and differences in Neo-Classical and Romantic painting, describing examples that illustrate your points?
- describe the results of Realism in the work of Courbet and Manet?
- explain the scientific ideas that lie behind the Impressionist style and describe how they look in paint?
- describe the work of one or two of the Post-Impressionist painters and explain what antecedents inspired them, and how they were original?
- summarize the basic ideas that led to a revolution in art early in the 20th century, and mention a few examples of the revolutionary results?
- describe a couple of important works of art that show the character of Cubism, Expressionism, Surrealism, or Non-objective art?

Suggestions for further reading:

- Anne Coffin Hanson, *Manet and the Modern Tradition* (New Haven: Yale University Press, 1977)
- Robert L. Herbert, *Impressionism: Art, Leisure and Parisian Society* (New Haven: Yale University Press, 1988)
- John Rewald, *A History of Impressionism* (New York: Museum of Modern Art, 4th ed., 1973)
- ———, *Post-Impressionism* (New York: Museum of Modern Art. 3rd ed., 1978)

14
Late Twentieth–Century Globalism

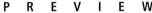

PREVIEW

After 1940 New York emerged as one of the main centers of world art. Abstract Expressionism, based on big, splashy paintings in unique personal styles, marked the first appearance of U.S. art on the world scene. The first reaction against Abstract Expressionism was Hard-edge abstraction and Minimalism, with large fields of flat color in simple shapes and patterns. Though some artists saw mystical meanings in their work, non-objective forms dominated throughout the period 1940 to 1960, the art world having agreed that meaning resides in form more than in subject. By 1960, new ideas began to appear, emphasizing styles based on popular, commercial art and design, called Pop Art. Photo-Realism, based on "sketches" made with a camera, took the next step, rejecting the irony and satirical mood of much Pop Art and making serious pictures of daily reality.

A new kind of artist became important. Abstract Expressionists saw themselves as nonintellectual, intuitive workers. Marcel Duchamp is the best-known example of the new type of intellectual mystic, making or finding strange symbolic objects. His influence suddenly became widespread after 1960, and after that date Joseph Beuys presented a new version of this type, more serious, politically and spiritually committed. Duchamp's "ready-made" art, abstract paintings and constructions, and a posthumously exhibited assemblage, and Beuys' performances and sculptures established the new category and attracted adherents.

With the growth of international travel and electronic communication, a global culture began to emerge, bringing with it many regional styles. Art history, making use of improved color photography and printing, became popular and influential. A larger and more varied audience inspired the revival of representational painting after 1980, often with mystical or historical imagery. At the end of the 20th century these parallel trends dominate a fluid world culture. In art sales and publication a few great centers still dominate the art world, but in art production there are no provinces and no dominant center. America is one of the great beneficiaries of globalism in culture, artists from everywhere showing here. As a communication medium for feelings and ideas, art has a special role to play in combating the isolation people often feel in modern mass societies.

Visual Arts after World War II,
1950–1995

| | 1875 | 1900 | 1925 | 1950 | 1975 | 2000 |

DADA/NEO-DADA

Duchamp 1887–1968
Beuys 1921–1986

ABSTRACT

O'Keeffe 1887–1986

ABSTRACT EXPRESSIONISM

Rothko 1903–1973
De Kooning 1904–
Pollock 1912–1956

COLOR FIELD/MINIMALISM

Newman 1905–1970
Stella 1936–
Morris 1931–
Judd 1928–
Christo 1935–

POP ART

Rauschenberg 1925–
Rosenquist 1933–
Oldenburg 1929–
Johns 1930–
Warhol 1931–1987

PHOTO-REALISM

Goings 1928–
Estes 1936–
Close 1940–
Flack 1931–

POST-MODERNISM

Arikha 1929–
Saul 1934–
Bartlett 1941–
Kiefer 1945–
Miller 1951–

GLOBALISM

Zhu 1892–
Colescott 1925–
Tsai 1928–
Kabakov 1933–
Teraoka 1936–
Quick-to-See Smith 1940–
Jiménez 1940

NEW YORK AS AN INTERNATIONAL CENTER

Today we usually imagine that the global culture we see emerging is entirely a product of the electronic communications that have become so important in recent years, but it has deeper and more varied roots. One contributor to globalism was the global war that raged for five years (1940–45) and scattered soldiers and refugees everywhere, leaving no country untouched. At the end of that catastrophe the United States emerged with its industry and domestic life intact, and with New York as its great cultural center. With its major museums and art schools, its publishing industry, and traditions of art criticism and collecting, it soon became the new world center for buying and selling art. The presence there of European refugee artists, and intellectuals, including Mondrian, André Breton, Chagall, Ernst, Léger, and Yves Tanguy, made it seem the true heir of the great European cities, which would require many years to recover from the war's devastation.

ABSTRACT EXPRESSIONISM

Art critics have always played a part in the art world, but they have been especially important in the development of art centered in the United States, perhaps because the audience today is widely dispersed and depends more than ever before on publications to keep track of new art. In 1952 the critic Harold Rosenberg described Abstract Expressionism as it had evolved in the previous ten years:

> At a certain moment the canvas began to appear to one American painter after another as an arena in which to act—rather than as a space in which to reproduce, re-design, analyze, or "express" an object, actual or imagined. What was to go on the canvas was not a picture but an event.

> The painter no longer approached his easel with an image in mind; he went up to it with material in hand to do something to that other piece of material in front of him. The image would be the result of this encounter.[1]

That article gave a name, Action Painting, and a description of a technique of painting, which many artists and their public accepted at that time, although the style is remembered now under the name Abstract Expressionism. It also launched an idea of art as an activity rather than an object, which led to various dramatic events such as Happenings and Performance Art in which no object resulted, but a more or less spontaneous activity took place. The Abstract Expressionist style was expressionist in its use of color and gesture as expressions of emotion or mood. It was abstract in its rejection of the depiction of natural subjects, although several of the most influential artists thought of art as having a basis in representation (Willem de Kooning among them). Paintings were large, usually 5 or 6 feet (1.5 or 1.8 meters) high, and the brushmarks are similarly large, suggesting sweeps with a housepainter's brush, to emphasize the mark of the artist's hand.

One of the characteristic features of Abstract Expressionism was the artist's search for a "breakthrough," a war term given the meaning of a unique personal style of unusual forcefulness. Once that was achieved, an artist was expected to repeat it; critics and dealers were not sympathetic to artists (such as Jackson Pollock) who changed their style. Artists felt differently: "Style is a fraud," de Kooning told an interviewer, implying that he does not cultivate style, but a truthful vision. Yet the search for a style led to great individuality in the work of these artists.

Jackson Pollock

The paintings by Jackson Pollock (1912–56) and filmed records of him at work were mainly responsible for the idea that performance was the essence of art, that the action was more important than the product. That idea had a wide popularity, but it was not shared by Pollock.

Pollock's abilities and education are discussed on pp. 21-3. His "drip painting" and its sources are described on p.214.

Jackson Pollock grew up in California and Arizona but was studying art in New York before he was twenty. By 1942, when he was thirty, Pollock was able to paint *Male and Female* (Fig. **14.1**), which summarized all the things he had been studying—Cubism, Surrealism, and Expressionism all contribute to it—but it also has a free-swinging vitality of its own. The two tall, rectangular human figures stand against a blue sky full of fireworks made of colored slashes, drips, and spatters. During the next five years subjects slowly disappeared as his method changed to "drip painting," which became his most famous technique. *Number 1, 1948* (Fig. **14.2**), more than 5 by 8 feet (1.5 by 2.4 meters), was painted by pouring the paint on the canvas as it lay on the floor. "In the arena" was where Pollock said he was as he painted, in action with the painting. "When I am *in* my painting, I'm not aware of what I'm doing," he wrote later. "It is only after a sort of 'get acquainted' period that I see what I have been about."[2] But Pollock always denied that accidents were responsible, or that chaos resulted. The large swinging rhythms of line, shape, and color in *Number 1A, 1948* reminded the audience not only of the artist's actions, but of galaxies, atomic reactions, microbiology, and all the complex interactions that were on people's minds. Surely the audience at the turn of the 21st century will see things in Pollock's art that he could never have imagined, just as these days we might see an image of the Internet.

14.1

JACKSON POLLOCK,
Male and Female,
1942.
Oil on canvas,
6 ft 1 in x 4 ft 1 in
(1.9 x 1.2 m).
Philadelphia Museum of
Art, Pennsylvania.
(Gift of Mr and Mrs H.
Gates Lloyd.)

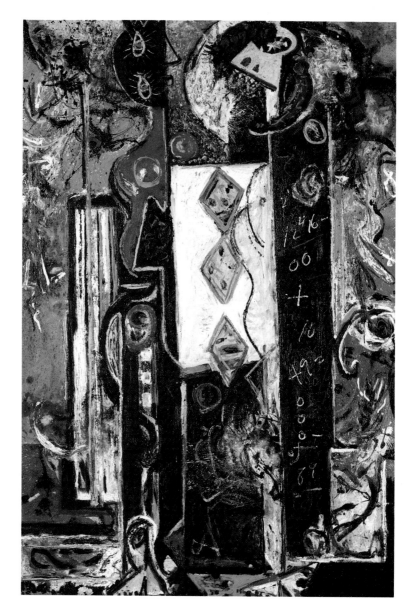

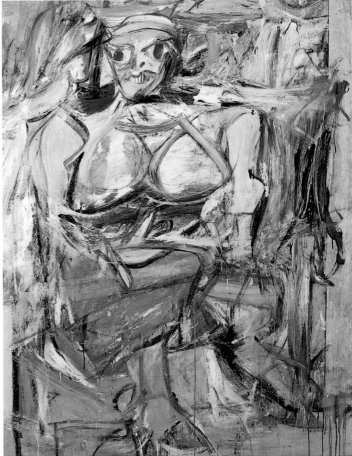

14.2
JACKSON POLLOCK,
Number 1, 1948, 1948.
Oil on canvas,
5 ft 8 in x 8 ft 8 in
(1.7 x 2.6 m).
Museum of Modern Art,
New York.

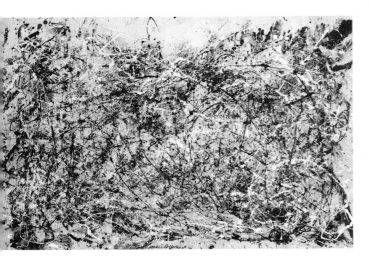

Willem de Kooning

The other dominant figure in the Abstract Expressionist movement was Willem de Kooning (b. 1904), the painter other artists most admired. Cubism was the main point of departure for de Kooning, but the controlled straight lines and curves of Picasso and Braque increased to mural size and the brush was swung from the shoulder instead of the wrist. If you compare Braque's *The Portuguese* (see Fig. **13.31**) with de Kooning's *Woman I* (Fig. **14.3**), you notice that the canvas has increased in size (from 46 to 76 inches, or 117 to 193 centimeters, high), but, more important, the brushstroke has increased in size. The geometric shapes in light and shade dominate Braque's painting, but the slashing stroke of color dominates in de Kooning's paintings. De Kooning has never completely eliminated representation from his paintings, often returning to female figures—usually rather ferocious women, as in *Woman I*—but other paintings, such as *Easter Monday* (Fig. **14.4**, overleaf), often have a landscape or cityscape quality. Whatever the subject, or lack of it, de Kooning's color scheme is distinctive: white, pink, pale yellow, pale green or blue, and gray, with black lines. His colors, which are easy to identify, have contributed to Post-Modern color preferences.

HARD-EDGE ABSTRACTION AND MINIMALISM

Non-objective art has been a powerful current since the 1940s, taking a slightly different form—and name—with each generation of artists. The first generation, of the 1940s and 1950s, were the "color-field" painters, followed by Hard-edge of the 1960s and Minimal and conceptual art of the 1970s. The artistic problem was defined differently by each generation, but they share the ideal of Kandinsky and Mondrian that meaning in art rests in the form—especially in color, shape, and size—not in the subject.

14.3
WILLEM DE KOONING,
Woman I, 1950–52.
Oil on canvas,
6 ft 3⅞ in x 4 ft 10 in
(1.9 x 1.5 m)
Museum of Modern Art,
New York.

14.4
WILLEM DE KOONING, *Easter Monday*, 1955–56.
Oil, newspaper transfer on canvas, 8 ft x 6 ft 2 in (2.4 x 1.8 m).
Metropolitan Museum of Art, New York. (Rogers Fund, 1956.)

Georgia O'Keeffe and New Mexico

14.5
GEORGIA O'KEEFFE, *From the Faraway Nearby*, 1937. Oil on canvas, 3 ft x 3 ft 40⅛ in (91 x 102 cm). Metropolitan Museum of Art.

Georgia O'Keeffe was one of the early abstract artists, making watercolors inspired by the stark landscapes of the Texas Panhandle when she was a young teacher there. The same year, 1917, she made her first trip to New Mexico, where Santa Fe and Taos were already well-known art colonies. "I loved it immediately," she said later. "From then on I was always on my way back." The space and color of the New Mexico desert and its traditional ways of life remained inspiring to her for the rest of her long life. She wrote:

> I have always wanted to paint the desert and I haven't known how. I always think that I cannot stay with it long enough. So I brought home the bleached bones as my symbols of the desert. To me they are as beautiful as anything I know. To me they are strangely more living than the animals walking around—hair, eyes and all with their tails switching. The bones seem to cut sharply to the center of something that is keenly alive on the desert even though it is vast and empty and untouchable—and knows no kindness with all its beauty.

From the Faraway Nearby (Fig. **14.5**), an oil painting done in 1937, brings together as almost a religious icon the elements of New Mexico that especially fascinated her: the red desert hills, the sky with its summer clouds, wild flowers, and the skull of an antlered deer.

O'Keeffe, who was born in Wisconsin in 1887, grew up at a time when it was hard for anyone to make a career in art, but she was determined. She turned away from several romances that were interfering with her concentration on art, but she finally married Alfred Stieglitz, photographer and gallery owner, because he shared the most important thing in her life, her work. O'Keeffe was apt to be curt with reporters and fans, but Stieglitz, a powerful promoter of modern art, acted as her dealer and agent. In 1924 he sold a set of six of her flower paintings to a French collector for $25,000, an amazing amount in those days. He told a reporter that European collectors were coming to buy American art, while American collectors still neglected it. O'Keeffe, overwhelmed by the publicity, fled New York to the cold, rainy coast of Maine.

In those days it was even harder for a young woman to become an artist than for men because there were few famous women artists to emulate. Georgia O'Keeffe became the famous woman artist for American women to model their careers on in the 1920s and 1930s. In more recent years artists and public do not seem to consider that the differences between men and women come out very strongly in art, but during much of O'Keeffe's life she was thought to exhibit a special feminine awareness that set her apart from the men.

In 1945, after years of migrating between New York and New Mexico, O'Keeffe bought a ruined adobe house and three acres at the tiny village of Abiquiu. There was a grand view of red desert hills— "red hills of apparently the same sort of earth that you mix with oil to make paint," O'Keeffe said. "A red hill doesn't touch everyone's heart as it touches mine." The house was rebuilt with big windows, fireplaces, and adobe benches in place of furniture, and finally was given a coat of mud plaster mixed by the local workmen and, following tradition, smeared on the walls by their wives. "Every inch has been smoothed by a woman's hand," O'Keeffe said of her house. She died there in 1986.

Source: Lloyd Goodrich and D. Bry, *Georgia O'Keeffe* (New York: Whitney Museum; Praeger, 1970)

Barnett Newman

Barnett Newman (1905–70), the founder of color-field painting, began a new kind of painting in 1948 when he tried out a red-brown canvas with a strip of tape down the center, which he painted orange. It dawned on him that he had something new: a powerful color divided symmetrically by a narrow stripe. Taped edges had been done before (by Mondrian, for example, who composed his paintings with strips of tape), but Newman used his tapes as breaks in a color field; he called them "zips," since he zipped off the tape after the color field was painted, exposing an undercoat. He raised his paintings to very large size—*Vir Heroicus Sublimis* (Fig. **14.6**) is 18 feet (5.5 meters) wide—so the stripes become divisions of a color environment, always with a numerical relation of area to area, usually with symmetry a factor. Newman composed his pictures not with drawings, but with a series of numbers. There is a mystical content in Newman's work that Mondrian would have appreciated, but it is often hard to express in words.

Although Barnett Newman is considered a painter, he made one great sculpture. *Broken Obelisk* (Fig. **14.7**) was designed in 1963, made in an edition of three out of steel plate in 1967, and dedicated to Martin Luther King after his assassination. Newman commented: "It is concerned with life, and I hope I have transformed its tragic content into a glimpse of the sublime." These ancient Egyptian forms of pyramid and obelisk, with their associations with life and death, turn geometry into

14.6
BARNETT NEWMAN,
Vir Heroicus Sublimis,
1950–51.
Oil on canvas,
7 ft 11⅜ in x 17 ft 9¼ in
(2.4 x 5.4 m).
Museum of Modern Art,
New York. (Gift of Mr and
Mrs Ben Heller.)

14.7
BARNETT NEWMAN,
Broken Obelisk,
1963–67.
Cor-ten steel, 25 ft 5 in x
10 ft 6 in x 10 ft 6 in
(7.75 x 3.23 x 3.23 m).
Institute of Religion and
Human Development,
Houston, Texas.

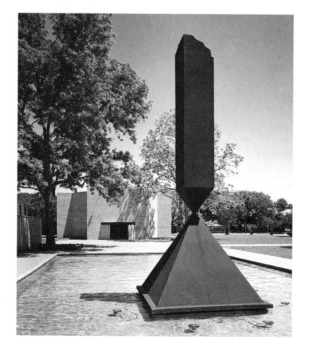

emotional expression. Newman referred to "the grip of geometry" as an image of death, always trying, by scale, color, interaction of forms, to break perfection of geometry with a sense of impending movement. This sculpture has been compared with Michelangelo's Creation of Adam from the Sistine Ceiling (see Fig. **6.6**), in which the finger of God reaches out to touch the inert hand of Adam and infuse him with life.[3]

Frank Stella

By the 1960s the audience for art was used to Abstract Expressionism and, despite the fact that it was a very popular style, artists were bored with emotional expression. The influential critic Clement Greenberg explained the change: "The look of the accidental had become an academic, conventional look."[4] Greenberg had argued for "purity" in the arts, by which he meant that painting should have no qualities that might belong to sculpture or any other art. Painting, he thought, could reach purity only by eliminating representations of nature, illusions, and subject matter. Greenberg thought, as Kandinsky had, that art would inevitably develop in that direction.

Although Greenberg was not impressed by the early paintings of Frank Stella (b. 1936), they were taken by the art world as fulfillment of Greenberg's prophecy and his demand for purity. Stella's *Jill* (Fig. **14.8**) was one of the young Stella's "black

14.8
FRANK STELLA,
Jill, 1959.
Enamel on canvas,
7 ft 6¾ in x 6 ft 6¾ in
(2.3 x 2 m).
Albright-Knox Art Gallery,
Buffalo, New York.
(Gift of Seymour H. Knox,
1962.)

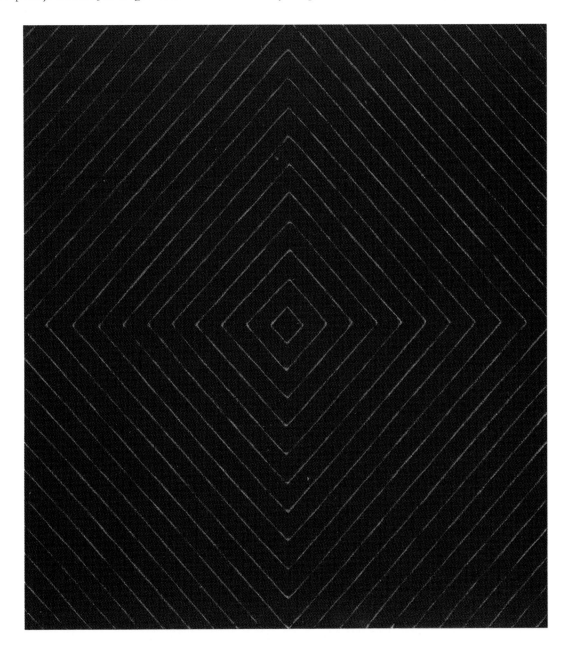

paintings," which were accepted by many artists and critics, especially those of his own age group, as defining a new direction. It was a direction mainly defined by negatives: no color (just white lines on black), no brushstrokes (just flat enamel and carefully smoothed lines), no subject, no illusions of space and form (just a regular symmetrical pattern). They were described as "poker-faced," cool, secretive works, just the opposite of the dramatic, colorful, emotional, personally revealing paintings of Pollock and de Kooning. Stella shared a Non-objective style with Newman and the other color-field painters, but led into the Hard-edge style in which geometric areas of flat color had sharp "hard" edges and the canvas was more evenly divided between two or more colors.

The emotionally cool was fashionable in the 1960s and 1970s in music and manners, as well as art. Artists took two contrasting approaches: Minimalist artists chose to make Non-objective art that was intended to have no spiritual or emotional meaning; Conceptual artists chose to write words on paper explaining actions they had done or would do, but which remained concepts for the audience in the sense that no form was available to be seen. The concepts were usually Minimalist, such as a line between two points or a mirror set at a certain place. Frank Stella was one of the earlier artists who preferred to think of their work as concrete, not abstract, having no reference to the real world, but existing in the real world as an object. As part of that aim, the canvases Stella used for his paintings were stretched over a framework (called stretchers) made of especially thick wooden bars to make the paintings more massive, more thinglike.[5]

Donald Judd

The Minimalist sculptor Donald Judd (1928–94) wrote: "Things that exist exist, and everything is on their side. They're here, which is pretty puzzling. Nothing can be said of things that don't exist."[6] Judd's sculpture exists (Fig. **14.9**), but emotions and ideas are not claimed for it: " I didn't want work that was general or universal in the usual sense. I didn't want it to claim too much. … A shape, a volume, a color, a surface is something itself."[7] Judd defines his sculpture in concrete terms, turning away from the spiritual interpretations of Mondrian and Kandinsky, who saw shapes and colors as symbols of ideas and moral qualities. Even personal expression is rejected by Judd, who drew the plans for his sculptures but had them built in a machine shop or carpenter's shop. All of these attitudes were reactions against the overpowering personalism of Abstract Expressionism, which had dominated American art for about fifteen years.

14.9
DONALD JUDD,
Untitled,
1966–68.
Stainless steel, plexiglass,
six cubes, each 3 ft
(91 cm) on each side,
8 in (20 cm) apart.
Art Museum, Milwaukee,
Wisconsin. (Layton
Collection.)

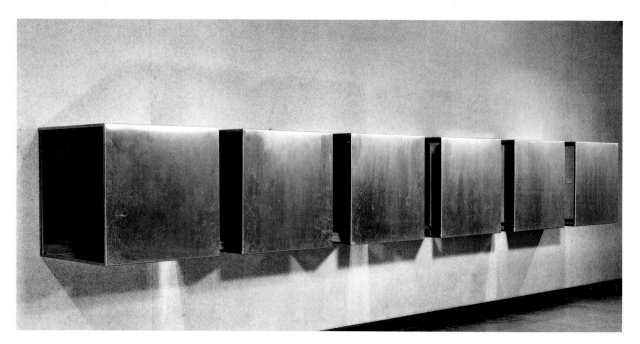

POP ART

The name Pop Art was based on "popular art," meaning "art of the people," and referring to advertising, commercial art, and industrial design—all the things that surround us in a consumer society. But there was more to it than making pictures of pots and pans, chairs, cars, and television sets. It was partly a response to the great abstract styles that had dominated the art world for about fifteen years. Many of its major names and works have appeared in earlier chapters: Andy Warhol, Robert Rauschenberg, Jasper Johns, and Claes Oldenberg. When Pop Art first appeared in the art galleries in the late 1950s it seemed to be a funny, cool response to an art world that was taking itself very seriously, but as time passed and the artists developed, it began to merge into other representational styles.

Wayne Thiebaud's still lifes are early examples (see Fig. **2.13**). For "Jasper Johns's First Show," see p. 191.

Andy Warhol

The most famous of the Pop artists was Andy Warhol (1931–87), but, as he said, everyone will be famous for fifteen minutes in this modern age, and Warhol's fame has declined as the novelty of his work has been absorbed. Working mostly in editions of silkscreen prints (see pages 163–5 and Fig. **5.23**), his print series of 1960s icons—Campbell's Soup cans, Coca-Cola bottles, Marilyn Monroe (Fig. **14.10**)—are among his more enduring works. In 1965, when his work was new, a critic wrote: "Not until our time has a culture known so many commodities which are absolutely impersonal, machine-made, and untouched by human hands. Warhol's art uses the visual strength and vitality which are the time-tested skills of the world of advertising that cares more for the container than the things contained. Warhol accepts rather than questions our popular habits and heroes."[8] These subjects, which are easy to understand, gave him instant fame. Warhol often multiplied faces of Marilyn or cans of Campbell's Soup into bands of repeated images that implied that they were commodities. Warhol called his studio The Factory, emphasizing that the characteristic art of this age is multiples, all made by factory processes rather than handcrafted, and their subjects and uses belong to a world of mass production and mass culture. The truth of these ideas accounts for the continued validity of Warhol's art, and his pictorial art also contributed to the renewed vitality of representation.

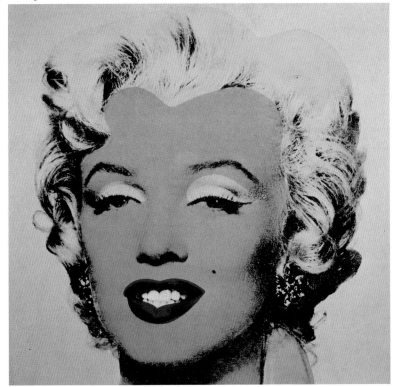

14.10
ANDY WARHOL,
Marilyn,
1964.
Silkscreen on canvas,
3 ft 4 in (102 cm) square.
Blum Helman Gallery,
New York.

James Rosenquist

James Rosenquist's *Silver Skies* (Fig. **14.11**) not only belongs exactly to its own Pop Art movement, but also forecasts painting styles of the next three decades. *Silver Skies* is large—16 feet 6 inches (5 meters) wide—and was seen as an arty billboard. The style of large, strongly shaded simple shapes with shiny highlights and including subjects associated with advertising (a girl, a car, tires, and a bottle) belonged to American commercial and street life. Actually, James Rosenquist (b. 1933) learned to paint at nineteen by painting billboards, which he later did to support himself while he studied art in New York. There he began to realize the difference between commercial art and fine art.

> When I met the top artists of the time, like Franz Kline and de Kooning, I realized I was in for a different experience than I had expected. They weren't bums, but they weren't successful like businessmen, and their paintings weren't selling well. But they had tremendous reputations for being very good. I felt I might never be an artist, that it might be a long journey and I might never achieve anything in my lifetime.[9]

But when he was twenty-seven he quit his job as a billboard artist, got married, rented a studio, and began trying to make serious paintings. "Abstract Expressionism had become this corny-looking habit. The drip had become a cliché... but I didn't want to do hard-edge paintings either," he said later. Jasper Johns' show in 1958 (see Chapter 6) inspired him. "I decided to make pictures of fragments. ... I wanted to find images that were in a 'nether-nether-land,' things that were a little out of style, but hadn't reached the point of nostalgia."[10] In 1962, when *Silver Skies* was painted, with its pale reds, blue, and grays and its geometric slices from a commercial reality, it was precisely in tune with the evolution of New York art. The critic Thomas Hess wrote: "The whole [Pop Art] movement evolves with a kind of awesome inevitability out of New York abstract art."[11]

14.11

JAMES ROSENQUIST, *Silver Skies*, 1962. Oil on canvas, 6 ft 6 in x 16 ft 6 in (2 x 5 m). Chrysler Museum, Norfolk, Virginia. (Gift of Walter P. Chrysler, Jr.)

PHOTO-REALISM

By the late 1960s artists were searching for ways to get back to subject matter free of the irony or commercial associations of Pop Art. The impact of history was beginning to make itself felt on young artists who had seen a lot of art in museums and had studied art history in college. Many of them wanted to show things beyond pure existence. But the truth about the way the world looked in the 20th century could not be found in the art of Rembrandt or Manet. When people in our day speak of the truth, the artists noted, they mean "true, as in a photograph." That led inevitably to the study of photography as a source of art.

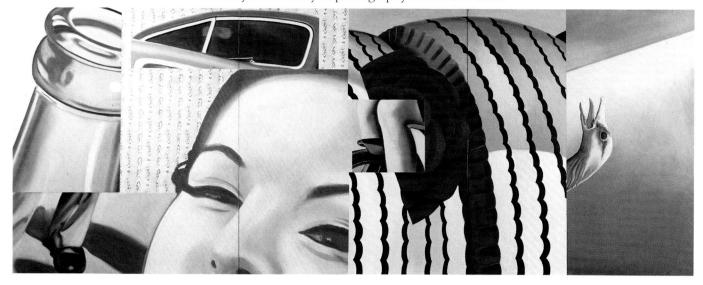

Chuck Close

Photography had been used as a sketching medium since it was invented, but Chuck Close (b. 1940) studied the image revealed by the camera and based a painting style on it. *Frank* (Fig. **14.12**) is a head 9 feet (2.7 meters) tall, painted in black and white on a pure white background. It records meticulously the textures of skin and hair, glasses and clothing, as the camera would see them. Even the focus of the camera lens on the front part of the face is recorded, with the farther edges of the hair and collar slightly out of focus. That shows the use of a single photograph to define the focus. Chuck Close was one of the most "photographic" of the Photo-Realists, which to his audience was a guarantee of seriousness about the search for visual realism. Close has used the airbrush (a miniature spray gun) to eliminate brushstrokes, or what he calls "art marks," but in another work he built up the face with fingerprints, which has a different kind of nonart neutrality. Limiting the paintings to black and white reinforced the connection with photography and limited the natural illusion, keeping the work within the realm of art even without "art marks."

14.12
CHUCK CLOSE,
Frank, 1969.
Airbrush,
acrylic on canvas;
9 x 7 ft (2.7 x 2.1 m).
Institute of Arts,
Minneapolis, Minnesota.
(John R. Van Derlip
Fund.)

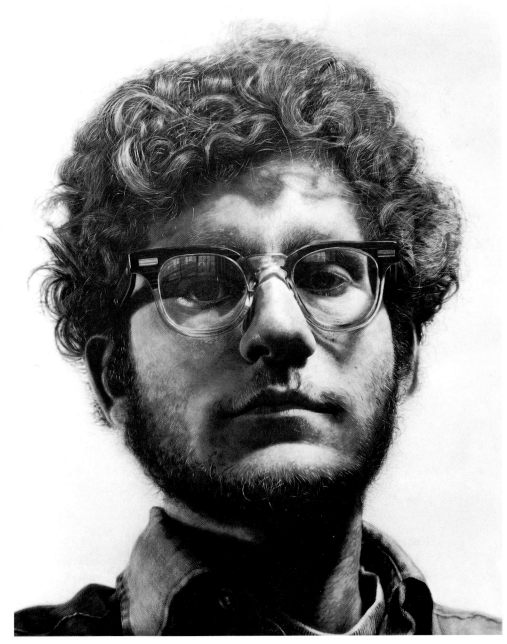

Ralph Goings

Many of the Photo-Realist artists relied almost entirely on the camera in place of drawing, usually developing their own photographs. They often specialized in certain subjects, preferring American car culture: cars, trailers, fast-food places, and the people around them. Ralph Goings (b. 1928) has painted several views of *Pee Wee's Diner, Warnerville, New York* (Fig. **14.13**). Goings' dust-free world has been described as "not the quaint and ingratiating view of America typified by Norman Rockwell. … Goings paints the small town and its inhabitants as they are."[12] That statement testifies to the power of the photograph to control our idea of reality. The smooth clear colors, reduction of textural difference, and concentration on reflections and highlights, not to speak of the stillness of the scene, come from the photographic sketches.

Photo-Realist art has often been compared to Norman Rockwell's illustrations, and the comparison is a fair one. *Saying Grace* (Fig. **14.14**) was a cover picture for the *Saturday Evening Post* magazine in 1951, when Rockwell was 57 and had been a top illustrator for about thirty years. All Rockwell's work was done in oil paint, the earlier work from live models, which gave it a sculptural massiveness produced by foreshortening and chiaroscuro. In the later 1930s he began to work from photographs, which allowed more active and more natural poses, but tended to flatten the paintings because he was working from a flat surface. Two differences between the 1970s-1980s Photo-Realist paintings and Rockwell's are immediately apparent: in Rockwell's work textural differences are much more pronounced, and the human figures are much more expressive. *Saying Grace* is unusual in Rockwell's work for the low-key acting—over-acting was common in his early work—but all his characters exhibit more feeling in their poses, gestures, hands, and faces than Goings allows his figures to show. One suspects that a Mondrian lay in Goings' unconscious mind, suggesting strong vertical and horizontal lines, and Baroque art in Rockwell's, prompting him to find the climax of an action, when the whole meaning of the story is revealed by poses and expressions. Goings and the other Photo-Realists developed from the emotional coolness of Hard-edge abstraction and Pop Art, which was reinforced by the coolness of the camera itself.

14.13
RALPH GOINGS,
*Pee Wee's Diner,
Warnerville, New York,*
1977.
Oil on canvas,
4 ft (1.2 m) square.
O.K. Harris Gallery, New
York.

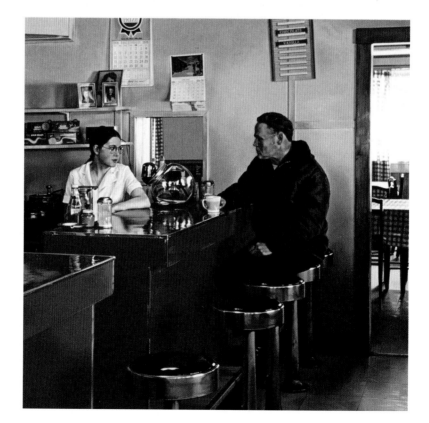

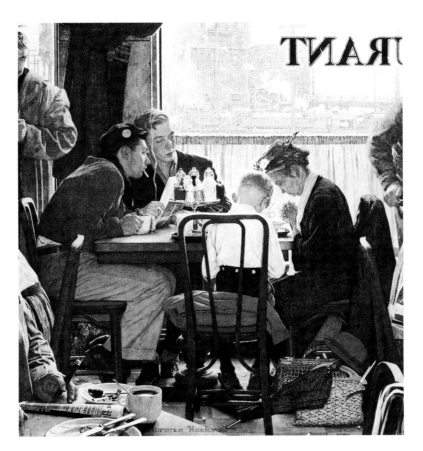

14.14
NORMAN ROCKWELL,
Saying Grace, 1951.
Oil on canvas,
3 ft 7 in x 3 ft 4 in
(109 x 102 cm).
Cover of *Saturday Evening
Post*, November 24, 1951.

Richard Estes

Richard Estes (b. 1936) rarely allows any human figures into his city scenes, concentrating on architecture and signs. Estes' *Central Savings* (Fig. **14.15**) also makes an interesting comparison with Goings' *Pee Wee's Diner*. Both have steel-rimmed stools and a red lunch counter in the foreground and both have the clean, smooth "photographic" surfaces. But *Pee Wee's Diner* represents entirely positive forms, while Estes elaborates the effects of plate glass. We see through it into the lunch counter, deserted at 10:15 in the morning, and out the other glass wall to the street ("tow away zone"). Reflected from the glass are the buildings and the street

14.15
RICHARD ESTES,
Central Savings,
1975.
Oil on canvas,
3 x 4 ft (0.9 x 1.2 m).
Nelson-Atkins Museum of
Art, Kansas City, Missouri.
(Gift of the Friends of
Art.)

14.16 (above)
Audrey Flack,
Wheel of Fortune (Vanitas),
1977–78.
Oil over acrylic on canvas,
8 ft (2.44 m) square.
Louis K. Meisel Gallery,
New York.

14.17 (above right)
Audrey Flack,
the artist, standing beside
the full-scale clay model of
Civitas, 1990–91, from
which wax molds were
made for casting in
bronze. The figure is 13 ft
(3.96 m) tall without the
base.

behind the observer, with the shadowy reflections of people. Estes makes many color photographs of his subjects, prints them himself, and uses them to compose an acrylic underpainting, in which each part is revised, its color adjusted, and the complexities of the design worked out. The kind of intricate natural appearance Estes creates could hardly be done without the aid of photography; imagine standing in the street with your easel while you worked out *Central Savings*.

We are not tempted to compare Estes with Rockwell, but he leads us to think of Cézanne and the Cubists. Art historian Alfred Barr, writing about the Cubist style, mentions "the cubist process of taking apart or breaking down the forms of nature… to analyze, to disintegrate the forms of nature in order to create out of the fragments a new form."[13] Estes lays out the main lines of his composition parallel to the edges of the canvas, like many Cubist pictures, in order to compose layers of reality and reflection which accomplish many of the aims of the Cubists. Photo-Realism is in these respects a natural heir of the early modern styles.

Audrey Flack

Audrey Flack (b. 1931) shows us a different kind of Photo-Realism, leaning toward the Baroque rather than toward Cubism. During the 1970s Flack achieved a wide reputation with a series of still life paintings full of symbolic references. *Wheel of Fortune (Vanitas)* (Fig. **14.16**) surrounds the viewer—it is 8 feet (2.44 meters) square—with symbols of chance and fate. Inevitable death dominates: the huge skull reflected in the mirror, as if looking obliquely at us. The candle burns low and the calendar counts out our days, but the die is still rolling and the tarot card is still in play, and lipstick still attracts, amid false-looking leaves and fruit. The cameo portrait, which might be taken for a self-portrait, is actually Flack's daughter Melissa, whose fate was to suffer from autism. All this has been revealed by drawing back the deep blue curtain, a color often used to symbolize faith. Such rich inventions as *Wheel of Fortune* give a human appeal to Flack's paintings that overcomes the essential coldness of the camera.

After gaining a reputation for Photo-Realist painting in the 1970s, in the 1980s Flack turned to sculpture. She explained that move in 1986: "The art world and the world outside of it seems to be going haywire—out of control, structureless, oversized, and temporary. I need the substance of sculpture, the compactness of scale reduction in the form of a recognizable human figure—something solid, real, tangible. Something to hold and to hold on to. Something that won't fly away or disintegrate."[14]

In Figure **14.17** we see Flack standing beside the full-scale clay figure of *Civitas* from which the wax mold was made for casting in bronze. The final sculpture, patinated and gilded, standing on a black granite globe, is one of four figures that form a gateway to the city of Rock Hill, South Carolina. This figure holds stars, symbolizing the city's goal to be a center of inspiration and creativity. These striking figures show Flack's desire to make art communicate to its audience, to be, as she wrote, "votive figures, some to be left as markers, some to be kept and carried off with their owners."

THE SHAMANS

Two significant figures played the role of shamans (*SHAH-mahnz*)—inspiring "medicine men," or spiritual leaders—in late 20th-century art: Marcel Duchamp (*du-SHAWM*; 1887–1968) and Joseph Beuys (*BOYZ*; 1921–86). Duchamp was born in France, but in 1913 he moved permanently to New York. Beuys was born in Germany, and is best known as a sculptor and performance artist. Duchamp painted *The Bride* (Fig. **14.18**) in 1912, but it forecasts ideas and ways of representing them that he followed the rest of his life. Although it is a serious-looking painting in brown tones, it is making fun of romantic love, suggesting that the bride is no more than a bizarre collection of tubes and containers. Science and technology provided models for Duchamp's lifelong examination of sexual desire and experience, which he expressed in poetic, abstract forms. Another early work is *Fountain* (Fig. **14.19**),

14.18 (*below left*)
MARCEL DUCHAMP,
The Bride,
1912.
Oil on canvas,
2 ft 11¼ in x 1 ft 9¾ in
(90 x 55 cm).
Philadelphia Museum of
Art, Pennsylvania. (Louise
and Walter Arensberg
Collection.)

14.19 (*below*)
MARCEL DUCHAMP,
Fountain, 1917.
Ready-made (porcelain
urinal).
Musée National d'Art
Modern, Centre Georges
Pompidou, Paris.

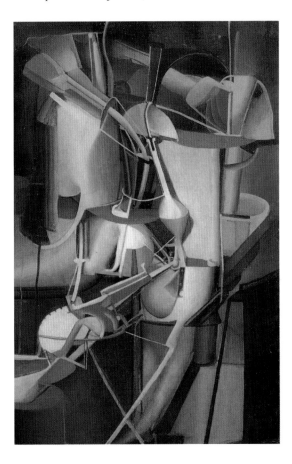

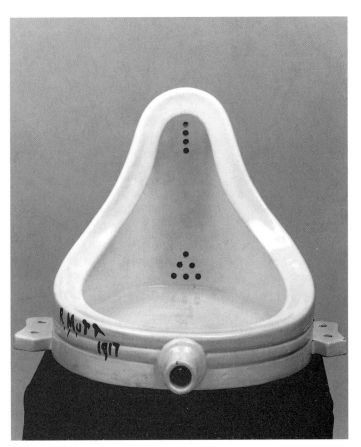

New Tools for Critics

14.20 MARK TANSEY,
Picasso and Braque, 1992.
Oil on canvas, 6 ft 8 in x 9 ft (2.3 x 2.74 m).
Curt Marcus Gallery, New York.

14.21 *(opposite)*
JOSEPH BEUYS,
Bathtub,
1960.
Ready-made (enameled
cast iron on steel legs).
Private collection.

purchased by Duchamp in 1917 in New York from a plumbing supplier and entered in an art exhibit. The organizing committee could see nothing but a common urinal lying on its back and rejected it. Although it was rejected, it keeps coming back because it presents us with the problem of what is art.

From a superficial look at his work, it is hard to see what has made Duchamp a spiritual influence in art. Nevertheless, in 1994 a French critic described *Fountain* as what could be "the most striking work of the 20th century. ... After it," he wrote, "'Art' would never be anything but what the artist decided, the 'work' having no significance until that moment; the common object would be made sacred by the artist's decision to make it enter the museum."[15] The many younger artists who have taken Duchamp as their model for the role of artist see him as having made art intellectually challenging, as having gone beyond craft to philosophy. His work seems to them to make a kind of scientific statement about reality, not depicting it, but speculating about it with humorous insight.

In 1960, in response to Duchamp, Beuys exhibited *Bathtub* (Fig. **14.21**). Large, gender-neutral, dedicated to cleanliness rather than elimination, it frankly challenged the dead-end in which Duchamp's ironic mockery of art-making had left

The main tools used by critics are ideas and the words that stand for them. In the last fifteen years art critics have adopted some new words, mostly taken from literary criticism, and have developed ideas around them. It is hard to read about art these days without running into these words and ideas. A sample of four words will give you a headstart: index, structuralism, deconstruction, and trope.

Everyone knows what the index of a book is—a kind of indicator—and the American philosopher Charles S. Peirce (*perse*) used the word to contrast kinds of evidence (signs, he called them). One kind of sign (or signifier, as it is sometimes called), an icon, is simply a picture of something that has some features in common with the thing it stands for, but an index is a result of the thing it stands for. It could be said, for example, that a brushmark is an index of the act of painting; a bullet hole is an index of firing a shot. Critics have paid new attention to marks of the process of making art, and artists will often leave marks as an index of their presence and skills.

The philosophy known as Structuralism argues that people do not just "understand" reality; they construct it from bits of information they receive through their senses. Sense data that do not fit or that seem meaningless are simply ignored and forgotten. Our minds tend to simplify the world and to see it as opposing pairs: living/dead, friendly/dangerous, and so on. Myths and many symbolic things, such as art, are capable of crossing those pairs: dead but still living, friendly and dangerous. No doubt you can think of more such pairs that are bridged by mythical or symbolic categories.

Structuralism suggested that all human minds are programed by the society in which they exist and that they have little room for creative imagination. Deconstruction is a revolt against that idea, suggesting that there is, in fact, much more disagreement among people about the meanings of experiences than we realize. Deconstructionists say, for instance, that two people looking at the same sculpture see different things. They also argue that meaning is created by writing, rather than being simply recorded from a prior thought, and that writing should be taken to include all sorts of expressive behavior equally—dancing, painting, inscribing words with a pen are all actions that create ideas that both artist and audience are capable of interpreting with great freedom.

Authors use "figures of speech," what literary critics call tropes, and art critics have used that term in studying representational art. In writing you may, for example, call a man a bear (using the trope called a metaphor) and be clearly understood, even though the man is not, of course, really a bear. What artists do in the visual arts is more complicated, because all art is metaphor: the block of wood is not a head, the mass of bronze is not a dancer, and the paint is not a field of flowers, yet—if the artist is successful—we understand the artist's intention.

Mark Tansey (b. 1949) paints "historical scenes" such as *Picasso and Braque* (Fig. **14.20**) that make use of these critical tools in ways that are entertaining if you understand his game. Picasso and Braque, who together invented Cubism, here play the roles of the Wright brothers at the first flight of a heavier-than-air craft, and a Cubist collage takes the role of the aircraft. Just as the Wright brothers launched the aviation age, so did Picasso and Braque launch the age of modern art. All these things represented are tropes that stand for comparisons. Often the metaphors in the visual arts are not as clear as this, nor are the ideas so easy to state in words, so this is a useful example. Tansey once stated his aims with remarkable clarity, again using a metaphor: "A painted picture is a vehicle. One can sit in one's driveway and take it apart or one can get in it and go somewhere."

Fort Worth Art Association, *10 + 10: Contemporary Soviet and American Painters* (New York: Harry N. Abrams, 1989), p. 130

artists. Four years later Beuys challenged Duchamp again with a performance piece (what he called an "action") entitled "The Silence of Marcel Duchamp is Overrated." In an interview Beuys explained that the silence of Duchamp (who was reputed, erroneously, to have stopped exhibiting art in 1923) was overrated because he had (allegedly) stopped exhibiting "at the moment when he could have developed a theory on the basis of work accomplished; and the theory that he could have developed, it is I," said Beuys, "who develop it today."

Beuys grew up in a devout Christian family and was interested in science as a boy. During World War II he served in the German air force, and he recounted his wartime experience of a plane crash in the Crimea, in southern Russia, when he nearly froze to death, and was rescued by Tatar people of the region, who dressed his wounds. They accepted him as one of their own people, covering him with their traditional felt blankets and warming him with animal fat,

JOSEPH BEUYS,
*Action Iphigenie/Titus
Andronicus,*
Theater am Turm,
Frankfurt-am-Main,
Germany, 1969.

14.25 (*opposite*)
SUSAN ROTHENBERG,
Mondrian Dancing
1984–85.
Oil on canvas,
6 ft 6 in x 7 ft 7 in
(2 x 2.3 m).
The Saint Louis Art
Museum, Missouri
(Purchase funds given by
the Schoenberg
Foundation, Inc.)

care that saved his life. This story became the legend on which much of his later art was based. In 1967 he suffered a severe depression, from which he emerged with new art forms made of felt and grease, which he himself interpreted as "elements of shamanistic initiation." From this beginning he created an art based on his own legend, interpreted as a spiritual quest. In Europe he has been accepted as a major figure, the subject of three important exhibitions in recent years, and a museum dedicated solely to his work is under construction near his birthplace.

Beuys produced three kinds of art: (1) drawings, mostly on small scraps of paper, with obscure lines and shapes suggesting humans and animals, in "ugly" brown paint; (2) sculptures, often made of materials that he had defined as having spiritual meaning—felt, grease, blocks or plates of different metals, and so on—and unusual objects from daily life, usually worn or battered; and (3), perhaps most important, his performances. The *Action Iphigenie/Titus Andronicus* (Fig. **14.22**) consisted of texts recited from plays by Shakespeare and Goethe about murder, war, sacrifice, and revenge. Beuys, wearing a spectacular fur coat along with the hat he always wore, played the role of shaman, acting out a mystic trip from chaos to order. The white horse was a symbol both of the lower world of beasts (his hoof beats on the floor echoing through the recited texts) and also the flight (like Pegasus) to a higher spiritual world, a flight mimed by Beuys.

These two artists represent two successive generations, spanning most of the 20th century, and they have provided intellectual and spiritual stimulation for art. Duchamp's art is individualistic, humorous, and ironic, using science, psychology, and especially sexual life as symbolic themes; Beuys' art is social, serious, and committed, and he uses a variety of spiritual sources in shamanism and the Christian tradition to deal with the themes of creativity, democratic liberty, and order emerging from war and chaos. Beuys' work has been most influential in Europe, especially on such younger artists as Anselm Kiefer (see Fig. **I.1**).

Duchamp's work, on the other hand, has been more influential in the United States, where he lived for many years. Writing in 1992 about the art of a selection of sculptors who were all around thirty years old, the painter Wolf Khan referred to

two works by "the ubiquitous Duchamp"—*Fountain* (Fig. **14.20**) and *Bottle Rack* (see Fig. **7.31**)—which had influenced most of the young artists he mentioned.[16] Andy Yoder's *Bowling Ball* (Fig. **14.23**), which duplicates in Vermont gray marble a bowling ball with unusually widespread finger holes, is a distant relative of Duchamp's ready-mades. It cannot actually be used as a bowling ball and serves only to undermine our belief in the ordinariness of common things, which suddenly become thought-provoking. That is one of the functions of art, the one that most interested Duchamp himself.

The knitted wool tights with socks (Fig. **14.24**), half marked plus and half marked minus, by the German artist Rosemarie Trockel, is designed to cross boundaries: between plus and minus, between women's traditional work (knitting) and men's (done by a machine), between art (nonfunctional) and clothing (functional). Trockel lives in Cologne, near Beuys' home, but her work reflects the ideas of both Duchamp and Beuys. Her intention to subvert the categories of real life and make us think more deeply about them was modeled in art by Duchamp, but like Beuys, she makes mysterious objects, although hers are less spiritual or mystical than his, and often have a feminist message and a humor that is absent in Beuys' work.

The work of the American painter Susan Rothenberg has sometimes been described in relation to Expressionist painters, such as Kiefer (see Fig. **I.1**), and sculptors, such as Baselitz (see Fig. **7.38**), who developed their styles out of Duchamp and Beuys. The most important common feature is a way of drawing intuitively, without a conscious plan, and letting the images appear spontaneously. Rothenberg made her reputation with large paintings, done in acrylics, of ghostly horses appearing as black lines on a color field. Since 1981, when she began using the subtler medium of oil paint, her color fields have become more complicated and her solids more modulated in light and dark. *Mondrian Dancing* (Fig. **14.25**) was one of a series of paintings that began with a ghostly figure in a

14.23 (*above left*)
ANDY YODER, *Bowling Ball*, 1988. Marble, 10 in (25 cm) in diameter.
Collection of the artist.

14.24 (*above*)
ROSEMARIE TROCKEL, untitled, 1987.
Machine-knitted wool tights with socks on a wooden mannequin,
4 ft x 1 ft 9 in x 1 ft 3½ in (122 x 53 x 40 cm).
Private collection.

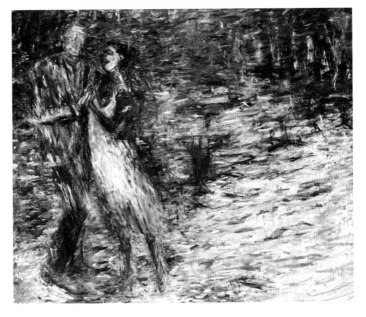

spontaneous drawing which reminded Rothenberg of the Dutch painter Mondrian (see Figs **13.42** and **13.43**), who stood stiffly but loved to dance. This mysteriously romantic painting, which seems to take place in a field, is one of Rothenberg's most specific images. A critic wrote of it: "As did Mondrian, she [Rothenberg] appreciates dancing, and one suspects we see the two of them hoofing it through an impressionistic field in *Mondrian Dancing*."[17] The elements that tie this painting to the tradition of Duchamp and Beuys are its emergence from the subconscious in a spontaneous drawing, and the retention of the drawing in the final product as rough black and white marks, which remind us that the image was "found," not invented consciously.

GLOBALISM

Since the 1980s electronic communication has unified the world of art, with American artists showing their work in Singapore, Tokyo, Moscow, and other places, while Australians, Chileans, and Africans show in the United States. Places we once thought of as "the provinces" have been incorporated into the electronic metropolis on equal terms with New York, Paris, and London. The global art world that has emerged in recent years is one result of profound changes in the Western art world, changes usually summed up by the name Post-Modernism.

About 1970 many people in the art world began to be alert to signs of change. The Modernist critic Harold Rosenberg surprised his readers with the first totally negative review of an avant-garde exhibit in the spring of that year.[18] Charles Jencks dated "the death of modern architecture" to 3:32 p.m. on July 15, 1972, when a large housing project in St. Louis was demolished; the American Institute of Architects had given it an award when it was built in 1951.[19] It was time for a change, it seemed, but the character of the change was not clear. "Modern art" was over, but what was here in its place? Slowly, over two decades, a new period began to define itself, carrying on many elements from the Modernism of the previous hundred years, but also based on a different outlook.

Admiration for art of other times and places has been the stimulus for artists' ambitions, but has not led to revivals of old styles. Willem de Kooning's remarks to an interviewer in 1972 are typical:

> I am an eclectic painter by chance; I can open almost any book of reproductions and find a painting I could be influenced by. It is so satisfying to do something that has been done for thirty thousand years the world over. When I look at a picture I couldn't care less for when it was done. … In other words I could be influenced by Rubens, but I would certainly not paint like Rubens.[20]

A dominant idea in Modernism was that art could save the world, that new ideas and new works were all that was needed to achieve a golden age of morality and social harmony. It was thrilling to take part in that enterprise in which only the new counted. By 1970 faith in the new had been lost and the mood was ironic and alienated. Artists and the public were ready to look back to see what could be learned from the past and from other cultures. The rejection of the past expressed by Paul Klee (see page 451) in 1902 is hard to imagine now, when both artists and the audience are serious students of art history, not only of the European tradition but of art of every time and place. The Post-Modern attitude is more realistic about what art can do and more modest in its evaluation of its place in history. The self-confidence of Modernism made only one prevailing style acceptable, but Post-Modernism values all kinds of expressions and styles. One result has been the re-emergence in Western art of representation as an important form. Another result has been an interest in other art traditions, which we now see as full of new ideas. The mood of pessimism and alienation seems to have passed and been replaced with enthusiasm for the creation of a global culture. Among the main communication media, playing a role parallel to electronic media, are painting and sculpture, in

which people from many cultures meet and show each other what they think and how they feel.

If you take a sample of artists who are currently participating in the American art world—exhibiting their work for an American audience, some sending their work from abroad, others born here, or visiting or living here—you will get an impression of globalism that is hard to match in any other medium. Television news, for example, shows us that lands, people, cities, and especially violence look rather similar throughout the world. It is only when we get inside people's minds, as we do in art, that cultural and individual differences are clearly revealed. "Global culture" means that we can show each other our work and become an audience for each other. It certainly does not yet, and probably never will, mean that one single style is in use everywhere.

"Culture shock" as we meet globally is a subject for many artists. Masami Teraoka, who was born in the inland sea area of Japan in 1936, studied art in California in the 1960s and discovered culture shock. In *Makapuu Sighting* (Fig. **14.26**) Teraoka, now an American citizen, imagines an encounter between a Japanese tourist couple and an American woman in the sea at Hawaii's Makapuu Beach. Basing his style on 19th-century Japanese prints (compare Fig. **5.13**), he casts his scene with an older Japanese man with a samurai haircut, a younger, prim but more casual Japanese woman, and a free-spirited blonde in a skimpy bikini. Teraoka brings space and time together in a style that assures us that a comedy will be played.

14.26
MASAMI TERAOKA,
Makapuu Sighting,
1991.
Watercolor on paper,
1 ft 5½ in x 3 ft 5⅛ in
(75 x 104 cm).
Pamela Auchincloss
Gallery, New York.

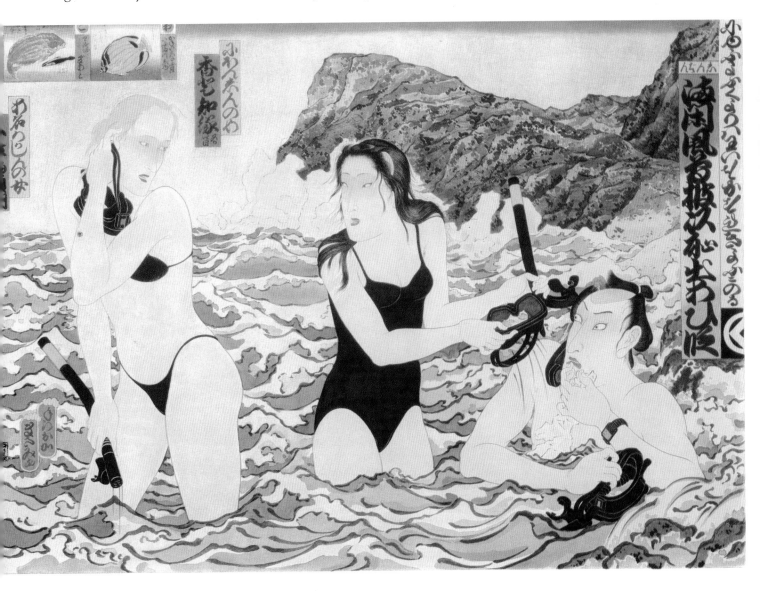

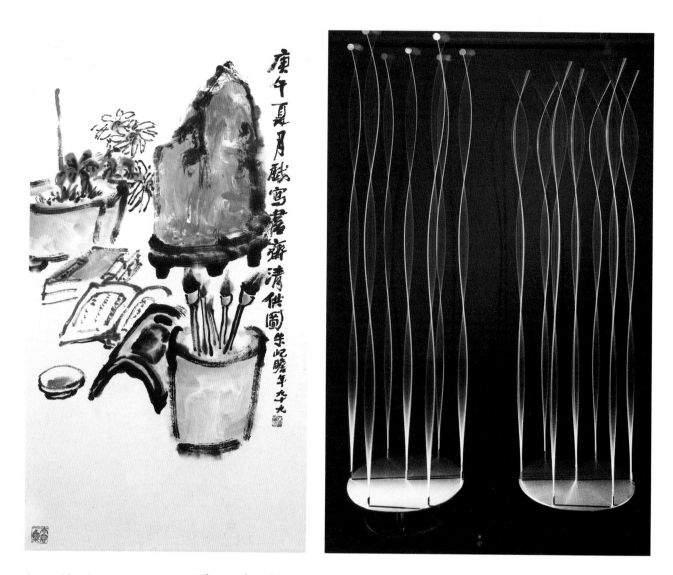

14.27 (above)
ZHU QIZHAN,
The Appreciation of the Scholar Ideal, 1990.
Watercolor on paper,
2 ft 11¼ in x 1 ft 7 in
(89 x 48 cm).
L. J. Wender Gallery,
New York.

14.28 (above right)
WEN-YING TSAI,
*Cybernetic Sculptures,
A and B,* 1975–86.
Fiberglass rods, electronic
vibrator, stroboscope,
electronic feedback
control, microprocessor;
A also has diffraction
gratings; A 6 ft 6 in x 2 ft
4 in (198 x 71 cm);
B 10 ft x 2 ft 4 in
(305 x 71 cm).

When cultural interaction has been maturing for a long time it may take more subtle forms. The watercolor *The Appreciation of the Scholar Ideal* (Fig. **14.27**) by Zhu Qizhan (*joo chee-jahn*; b. 1892) looks very Chinese and very traditional to Western eyes. Zhu, who is over a century old and still active, studied a Western Impressionist style in Japan in 1917 and incorporated brightly colored Western Expressionist colors into his watercolor paintings. From the medium and title you can tell that Zhu's values and attitudes are traditionally Chinese, and during the Cultural Revolution he was persecuted as a representative of old imperial ideas. His style, however, performs a subtle revolution by bringing Western techniques into the Chinese tradition.

Wen-Ying Tsai, an American citizen born in China in 1928, uses revolutionary techniques in other ways. His *Cybernetic Sculptures, A and B* (Fig. **14.28**) are composed of fiberglass rods, which vibrate at a constant rate. They are lighted by a stroboscopic light, controled by a microprocessor that permits variations in the speed of the strobe pulses in response to sound. By clapping your hands you can speed up the pulsing light, which makes the rods appear to vibrate faster, and this appears to increase the number of rods. The electronic revolution is truly global, no country having any special claim on its technology or style. Tsai's *Cybernetic Sculptures* are a leap beyond all national cultural expressions and represent a global tradition that is still just being formed.

These optimistic views of global connections are only part of the picture. Old wounds continue to give pain to those who suffered in wars and as refugees, those who find culture shock tragic rather than comic, and those who struggle to find

14.29

LONG NGUYEN,
Tales of Yellow Skin, No. 1,
1992.
Oil on canvas,
5 ft 6 in x 7 ft
(1.7 x 2.1 m).
Frederick Spratt Gallery,
San Jose, California.

themselves in a new cultural setting, cut off from traditions they love. Long Nguyen (*long win*), a refugee after the Vietnam War, came to the United States sixteen years after the war to attempt to find enough security to examine his life in paintings. *Tales of Yellow Skin, No. 1* (Fig. **14.29**) is a kind of spiritual self-portrait. Lost in a vast space punctuated by whirlwinds, the artist's body becomes a mere crutch for his mind or soul, which can take on the many faces supported by the fragile rod. Long Nguyen's art is based on memory, which is visualized in terms of Asian folklore, a combination of regional traditions of symbolism with experiences that are widespread. Probably any human being with a normal ability to empathize can understand the meanings in *Tales of Yellow Skin, No. 1*, partly because the painting medium Long Nguyen uses is known almost everywhere.

During the 20th century far too many people have experienced war, imprisonment, and flight, and many of the most poignant records of those experiences are in art. Eventually, however, art also heals by giving expression to our deepest visions. As a boy, Avigdor Arikha (*ah-REE-kah*; b. 1929) was a refugee and a prisoner. He escaped to Israel, where he was wounded in war, and finally became an artist. Now, long settled in Paris, he has evolved a style of painting and drawing based on the purest traditions of Western representation, a style that seems to turn away from personal memory into pure sensations of vision. When we think these days of "globalism" we tend to emphasize the Pacific Rim, Africa, or Latin America, but an important aspect of global culture is that the Western culture of Europe and North America plays its part in equality—neither dominant nor set apart—along with other traditions.

Arikha had a successful career as a painter of abstractions, but in 1965 he stopped painting and for eight years dedicated himself to drawing. His subjects were whatever was before his

14.30 (*below*)

AVIGDOR ARIKHA,
SoHo in Winter,
February 21, 1984.
Soft graphite on gray paper,
19 x 13½ in (49 x 34 cm).
Private collection.

eyes, such as *SoHo in Winter* (Fig. **14.30**), a pencil drawing made during a year when he lived in New York and rented a studio in the SoHo district. New York's architecture interested Arikha, but the midtown skyscrapers did not appeal—"No proportion, no roofs!" he said. The 19th-century buildings of SoHo suited him better. The dense, seemingly endless array of walls and roofs record his vision. His subjects must strike him, he says, "like a telephone call, when it rings, I run."[21]

In 1973 he returned to painting, using the style developed in his drawings. His subject is always before his eyes and the painting is finished in one sitting, with no retouching. *Studio Interior with Mirror* (Fig. **14.31**) is thinly painted in oil color on a white canvas. The composition centers on the face of the artist, seen in the mirror as he peeks from behind his canvas—the one on which this picture is painted. From that point the artist began his composition, working outward and composing as he went. The result is usually a surprising spontaneous composition, and a record of purely visual experience. This kind of painting has a long European tradition behind it, from Velázquez (see Fig. **4.25**) to Jacques Louis David (see Fig. **13.2**), though Arikha's version is so fresh it is hard to see it as anything but brand new. In a global

14.31
AVIGDOR ARIKHA,
Studio Interior with Mirror,
1987.
Oil on canvas,
5 ft 3¾ in x 4 ft 3 in
(1.6 x 1.3 m).
Musée Cantini, Marseilles,
France.

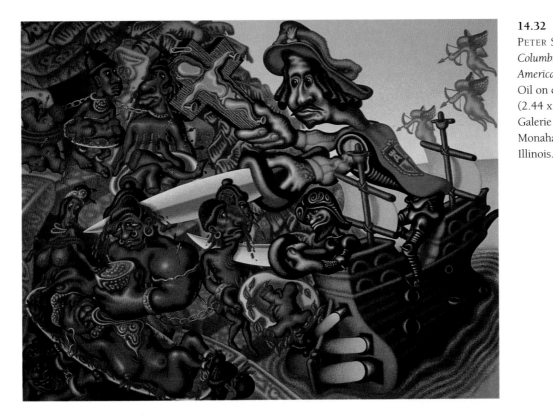

14.32
PETER SAUL,
*Columbus Discovers
America,* 1992.
Oil on canvas, 8 x 10 ft
(2.44 x 3.05 m).
Galerie Thomas R.
Monahan, Chicago,
Illinois.

context its European ancestry is evident, and the emphasis on the moment of vision rather than on memory, can be seen as a response to the difficulties of life.

Peter Saul (b. 1934) also works in a purely Western tradition, but one whose sources lie in the popular arts, in comic books and animated film. "Peter Saul knows exactly what he's doing," a critic wrote. "He is trying to make a painting as unbearable to look at as it is impossible to ignore, a painting one cannot like yet cannot turn away from, one that is, in his own term, 'hard core.'" [22] In 1992, during the commemoration of the 500th anniversary of Columbus' voyage, he painted *Columbus Discovers America* (Fig. **14.32**), an irreverent summary of the discovery that turned out to be typical of much of the commentary on that anniversary.

Saul plans his assault on our good taste very carefully. Designs are worked out in studies on gridded paper, such as the drawing for *Telephone Call* (Fig. **14.33**), in which each one-inch square will be enlarged to one-foot square on the canvas. The distortions, which would be taken for granted in action comics, are surprising in the dignified form of large paintings, and it is in the drawings that their complex interweavings are worked out. When the drawing has been transferred to the canvas, the painting is executed in acrylic, and a final adjustment of the colors and values is done in oil paint.

Most of Saul's paintings are about violent contacts between people. His chosen moment is the climax of action, when those relationships are made clear. "The excitement," he says, "is the actual happening, not five minutes later."[23] That is the slogan of the Baroque, and makes us aware of the baroque features of our popular arts, which are as full of action and interaction as any painting by Rubens (see page 416, Fig. **12.32**). Saul finds his subjects outside his own personal life, in the history and daily life of the world around him.

14.33
PETER SAUL,
Telephone Call,
1988.
Graphite pencil on paper,
6 x 7 in (15 x 18 cm).
Collection of the artist.

For Saul the voyage of Columbus is material for thought. Dan Namingha (b. 1950) finds no significance for his subjects in that event. A descendant of one of the most distinguished artistic families in the southwest of the United States and a member of the Hopi-Tewa community, Namingha takes for his subjects Hopi ritual life and the spirit-filled landscape in which it is lived. He deals with this sacred material in ways that make it accessible to non-Hopis. Dancers personifying the ancestral spirits (*kachinas*) appear, as in *Kiva Dancers* (Fig. **14.34**), in generalized form so that the depictions do not violate Hopi codes of secrecy. Such ceremonies were being conducted long before Columbus was born, and they show no sign of disappearing five centuries after his voyage.

Namingha's paintings represent timeless Native American traditions, but the form in which they exist is part of the global system of expression. The thick acrylic paint he uses is a 20th-century invention, and the portable canvases on which he paints became popular during the Renaissance in Europe. Native American life, like all the other regional cultural traditions, takes place in a modern world and makes use of modern forms of expression. Namingha takes part in the multicultural dialogue, learning from international modern art and showing his work in return.

Jaune Quick-to-See Smith (b. 1940), who is of Cree, Salish, Shoshone, and French descent, also belongs to a Native American community in Montana, and she reflects traditional values in an art whose artistic language is modern and international. Working in oils or pastels, she uses horses as her characters, showing the lines of descent of a family of horses in a pastel entitled *Family Tree*, for example.

14.34
DAN NAMINGHA,
Kiva Dancers,
1990.
Acrylic on canvas,
4 ft 2 in x 3 ft 4 in
(127 x 102 cm).
Collection of the artist.

Millennial Prophecies

14.35
HOLLY LANE,
The Splashdown of St. Sapia,
1995.
Mixed-media
construction,
9¼ x 8¹³/₁₆ x 1⅝ in
(23.5 x 22.2 x 4.1 cm).
Schmidt-Bingham Gallery,
New York.

Although the days will continue to pass as usual after the year 2000, the end of one thousand-year period and the beginning of another has great psychological importance. It calls forth the prophet in all of us. The video artist Nam June Paik prophesies the end of handmade art and its replacement by digital electronic projections on our walls. Others have prophesied the general adoption of body art, piercing and tattoo as a mainstream style of personal expression and adornment. What is your prophecy?

My own vision of the near future is of a world grown more crowded and competitive, with sharper differences between the rich and the poor all over the world. Large corporations will become important patrons of art, and among the masses body art and graffiti will be common forms of expression. We can expect art to be made by small groups, like rock bands, and exhibited under the group name. Group art will be found in many categories: the shocking, the technical and electronic, the religious, and the environmental.

Will the individual artist survive? Three paths will be open to individual artists. One is to find patronage from wealthy corporations and individuals. Another is to create a small business, producing in volume and marketing your own work. That path will attract artisans, because the handcrafts will revive and be valued as a welcome relief from our machine-made surroundings. The third and commonest path will be

that of the artist who makes art for personal satisfaction. We have many such artists now, who work at other jobs but are serious artists on their own time. Recognition is rare, but the satisfaction of producing your own vision is great.

Even now some artists with this distinctive vision have the satisfaction of seeing their work exhibited. Holly Lane (born 1954) makes small paintings inspired by the work of Jan van Eyck and Matthias Grünewald (see pages 65, 399, and 404), and places them in complicated frames she makes herself. A reader of poetry and philosophy, and observant of life from her suburban California home, she makes paintings so full of symbolism that she sometimes attaches explanatory captions. In college she slowly turned toward art, because, she says, "I felt a strong urge to work with ideas not only intellectually but also physically. I slowly gained the conviction that nothing but art would do." *
The Splashdown of St. Sapia (Fig. **14.35**) shows the personification of wisdom bailing out of the scales of balance and judgment, but evidently happy in her landing (lower right). Such distinctive personal art, I foresee, will flourish in the new age.

*Katherine Gregor, "Frame and Fiction." Art News, v. 91, summer 1992, pp. 63-64.

In *Petroglyph* (Fig. **14.36**) the blue horse in the upper right represents the observer, or the artist, looking back at the rock-carved designs of earlier generations, symbolized by the small, mummified body in the lower left. Like her horse-loving ancestors, Smith uses the horse to represent the vitality and energy of living people, and also like them, she uses color as an expression of spiritual energy. Yet no one could mistake her work for anything but late 20th-century art connected also with the history of Western Expressionism.

When the United States expanded into Mexican territory in the 19th century many people suddenly found themselves citizens of a new country. Neglected by the victors, those people retained their Spanish language and Mexican culture. Carmen Lomas Garza, who was born in Kingsville, in southern Texas, in 1948, has dedicated her art to recalling traditional family life in Mexican-American south Texas. The *curandera* or faith healer (Fig. **14.37**) was an important character in Mexican culture, using the healing lore handed down from earlier generations when modern medicine was not available. Lomas Garza's precise detail shows us everything we need to know about this family: photographs of parents and a soldier son, symbols of their faith, their sewing skills, the radio by the bed, and a bothersome little brother. Such memories survive in the minds of American women of many different cultural backgrounds. Carmen Lomas Garza's contribution to American and global culture is to record, and thus glorify, these memories of a traditional American life.

The history of his own family, which migrated north from Mexico to settle in El Paso, Texas, is one of the components that make up the art of Luis Jiménez Jr. Migration across that border is the subject of his lithographic study (Fig. **14.38**) and his sculpture with a painted background (Fig. **14.39**), both entitled *Crossing the Rio Bravo (Cruzando el Rio Bravo)*. His father was in business in El Paso making neon and fiberglass signs, and Jiménez learned that art and craft as an apprentice in his father's shop. After an academic training in art, he returned to the traditional family material, fiberglass, as a way of making monumental sculpture. First, he builds the

14.36
Jaune Quick-to-See Smith,
Petroglyph,
1986.
Pastel on paper,
2 ft 6 in x 1 ft 10 in
(76 x 56 cm).
Private collection.

14.37 (left)
CARMEN LOMAS GARZA,
Faith Healer (Curandera),
1989.
Oil on linen canvas,
2 ft x 2 ft 8 in
(61 x 81 cm).
Mexican Museum, San
Francisco, California.

14.38 (below left)
LUIS JIMÉNEZ, JR.,
*Crossing the Rio Bravo
(Cruzando el Rio Bravo),*
1987.
Color lithography with
chine colle 87/90,
2 ft 7 in x 1 ft 11⅛ in
(79 x 59 cm).
Mexican Fine Arts Center,
Chicago.

14.39 (below)
LUIS JIMÉNEZ, JR.,
*Crossing the Rio Bravo
(Cruzando el Rio Bravo),*
1987.
Fiberglass, no. 4 of edition
of five, 10 ft 6 in x
3 ft 5 in x 4 ft 6½ in
(3.2 x 1.04 x 1.38 m).
Mexican Fine Arts Center,
Chicago.

form with techniques we might use to build a boat hull, ending up with coats of brilliant color. "After spraying the colors with an airbrush," he says, "I recoat the sculpture with three coats of 'clear,' which intensifies the plastic look. It's the finish that critics love to hate."[24] Not only does he use sculptural materials and techniques that he learned as a child, but his subject material comes from his border background, too. Jiménez told an interviewer: "I use material that is familiar to me, but the issues involved go beyond personal or localized references. I am from the West and I'm an American so that's going to be in the work whether I want it or not.

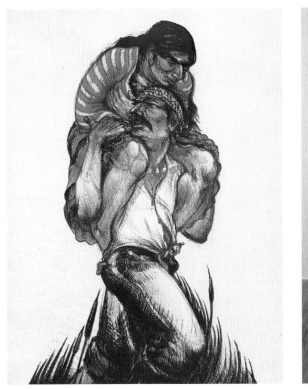

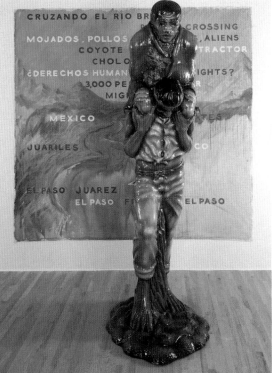

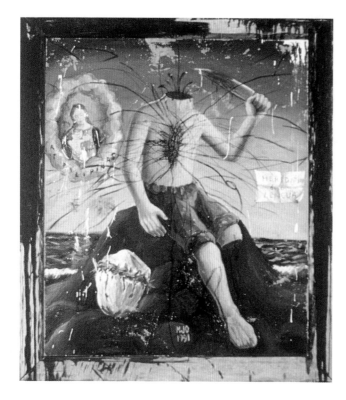

14.40

Manuel Ocampo,
Wounds of the Tongue
(Heridas de la Lengua),
1991.
Oil on canvas with
chewing gum and wooden
frame, 5 ft 11 in x 5 ft 1 in
(1.8 x 1.55 m).
Annina Nosei Gallery.

… It's coming out of the border perspective. I find myself totally fascinated with what happened when the Moors went into Spain, or what happens today in New York City. The cultures clash and you get a hybrid vigor. You get flashy signs, you get bright color, energy."[25]

Dedicating himself to public monuments and working closely with the communities among whom the work will stand, Jiménez embodies in himself and his work the energy that he sees in the border situation. In the lithograph, with its strong lines and defined shapes, the energy is especially conveyed, while in the sculpture with additional information in the painted background, the human struggle and pain are more manifest. The globe is crisscrossed with borders, where people of different cultures meet, and that meeting is a major focus of later 20th-century art.

A critic wrote about an exhibit of Manuel Ocampo's paintings in 1991: "Chaotic, angry, and 100 percent morbid, Ocampo's paintings are also fun to look at."[26] *Wounds of the Tongue* (*Heridas de la Lengua*) (Fig. **14.40**) is about 6 feet by 5 feet (2 by 1.5 meters), with strong colors accented by blood red; its larger than life-size figure has cut off its own head. Ocampo, who emigrated to the United States from the Philippines when he was a teenager, describes this as if it were a psychological self-portrait: "You don't know where your real culture is. You're lost and there's nothing to lean on, being Westernized and also not being a Westerner." Severing any part of his Filipino identity would be a mutilation, he says: "For me, no matter if you cut off your head, it's still going to be there hovering behind you. It's a self-defeating thing."

Using a style that recalls Spanish Catholic paintings of martyred saints, which were introduced into the Philippines by the Spanish colonists, Ocampo's work is not just gory. There is a feeling that the bloody images purge the violence of real life, and they remind us that we will live through the bad parts and, in the end, emerge stronger. Ocampo sees something like that in his own experience. For him, settling in the United States made "being a Filipino more important because you're an outsider," and it gave him a psychological distance that allowed him to consider the problems of life in the Philippines more objectively. In addition, by being in the United States, he says: "Filipinos can hear me more because I'm being published in widely read magazines and having shows."[27] There are good and bad sides to the global experience, but, on balance, both the artists and their audiences prefer connection to disconnection.

According to the artists who worked under it, disconnection was one of the most intolerable features of the Soviet system. Ilya Kabakov (b. 1933) was officially an illustrator of children's books; unofficially he was an artist producing advanced art. In 1987 he emigrated and settled in New York, where he has produced a series of large-scale installations—that is, complex works that fill a gallery with many different objects that together make unified works of art. In the fall of 1992, for example, he filled the Ronald Feldman Gallery in New York with an exhibition supposedly set in a provincial Russian museum with a show of paintings in the Soviet Social Realist style that had been popular in the 1920s and 1930s. The paintings were signed by S. Y. Kochalev, a painter no one had heard of—Kabakov had actually painted them himself. The red velvet furniture and dark red walls, gold frames, and spotlighting created a cozy, old-fashioned, and decaying setting, made extreme by a leaking roof that poured drips and drops into pans and pots tuned to produce a musical background. Parts of the gallery were sheltered with plastic

sheeting. Everything contributed to the environment of a musty corner of the past, sunk in decay and decline.

In 1988 he showed a large installation entitled *Ten Characters*, of which *The Man who Flew into Space from his Apartment* (Fig. **14.41**) is one. In a small room in a communal apartment in Moscow, where all the residents live out their obsessions, one man has found a way to join the space program. All that remains in his room, which is papered with Soviet posters, are his shoes, a huge catapult, and the hole blasted through the ceiling as he went into orbit. A written explanation accompanies the setting of each of the ten characters.

Kabakov begins these ambitious projects with drawings, which turn into a related series, with albums of pictures, and then boxes of objects. Finally, a total installation is developed. Each installation forms a vast extension of a child's story or a complicated Russian novel—that is, a narrative form of art is made by the construction and assemblage of materials, like a still play or performance. The theme of most of Kabakov's work is a poetic quest for personal expression and for the power to rise above the restrictions of daily life. This quest, raised to madness in Kabakov's amusing scene, is actually the same one that has motivated Kabakov himself, and probably all the other artists discussed here.

For about the last 200 years artists in the Western world have tended to think of themselves as marginal to the mainstream of their own societies. We know this because artists often express it in their art, and the abundant production of "unofficial" art (meaning it was officially forbidden) during the last years of the Soviet Union by artists such as Kabakov suggests that some sense of separation does not inhibit art. What we often do not realize is that the same feeling of being on the edge afflicts most people in modern societies. Most of us think that everyone else is confident and established in their own group, and that we are unusual in feeling

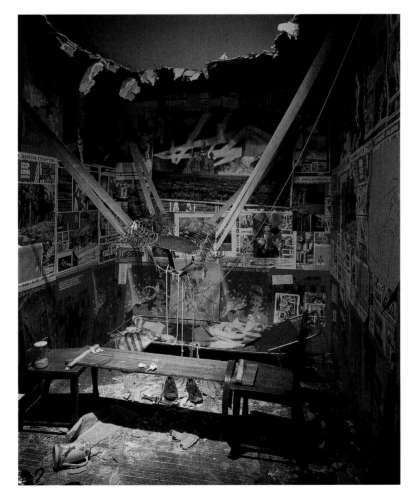

14.41

ILYA KABAKOV,
The Man who Flew into Space from his Apartment from *Ten Characters*, 1981–88.
Mixed media installation at Ronald Feldman Fine Arts, New York, 1988. Now Collection Centre Georges Pompidou, Paris.

slightly apart from it all. That sense of alienation is especially felt by immigrants from other countries who are trying to find their way in a foreign land and seeking to build connections in their new lives, and we have seen this experience in the lives and works of many of the artists discussed in this section. Perhaps it is reassuring to realize that most artists, even those who seem most at home, feel some sense of apartness from the society around them. Perhaps it is even more reassuring to discover that insecurity bothers almost everyone in modern societies, simply because the most distinctive feature of modern societies is the emphasis that is placed on individuality, on the separateness of each person, whose achievements and failures are their own.

Minority groups in the United States have always felt alienated from majority culture, which has usually been defined racially as white. Troubling relationships between the races have been a constant subject in the paintings of Robert Colescott, who was born in California in 1925, was educated at the University of California, and with Fernand Léger in Paris, and has taught at a number of American universities. A truly distinguished career in art, based entirely on his own personal achievement, has not entirely eliminated his sense of alienation. His reputation rests mainly on satirical black-face versions of famous masterpieces, such as *George Washington Carver Crossing the Delaware*, which are amusing but bitter expressions on the subject of race. Still feeling that he is *Between Two Worlds*, as he entitled a

14.42
Robert Colescott,
*Knowledge of the Past is the Key to the Future
(St. Sebastian)*, 1986.
Acrylic on canvas,
7 x 6 ft (2.1 x 1.8 m).
Phyllis Kind Gallery, New York.

painting in 1992, his occasional depictions of interracial harmony have been "treated with the most blistering irony," as a critic wrote.[28]

The role of art has always been to make connections between artists, who can be all of us, and audiences, which do include all of us. Colescott's paintings dramatize the true feelings of many people and communicate them to a large, multiracial audience. If there is a cure for alienation it surely lies in the communication of personal feelings, which is the special role of art as a medium of communication above all. Modern individualistic societies present us all with a terrible challenge: to find a cure for the social and spiritual alienation felt by members of society. That challenge may be met to some degree by interactive television and other electronic media, but in the personal expression of artists we may find some relief from alienation and some connection with others.

Robert Colescott seems to suggest something like that in his painting *Knowledge of the Past is the Key to the Future* (*St. Sebastian*) (Fig. **14.42**). This is typical of his large canvases, painted in acrylics in an Expressionist style that a critic described as "juicy," with strong, thick colors and contrasts of value. The free brushmarks and big color shapes are Colescott's way of connecting with real life, with its strong sense experiences. We feel as if we could touch these shapes and colors, and that heat radiates from the paint. St. Sebastian, who was shot to death with arrows for his religion, has turned into a symbolic figure, half-man, half-woman, and half-black, half-white. The past, symbolized by the pile of skulls, contrasts with the future, symbolized by the faces in the sky. They are roped together, and to the center figure. This large painting, which takes old altar paintings of saints as a model, says something Colescott evidently takes seriously: just as men and women must overcome the past and live together in harmony, so must all the world's races and cultures. This is the basic message of globalism at the end of the 20th century. Taking a step beyond alienation and irony, Colescott suggests here that our future depends on bringing everything together.

FOR REVIEW

Evaluate your comprehension. Can you:
- explain the idea of "action painting" in Abstract Expressionism, and describe paintings that show the emotional characteristics of the style?
- explain the difference between hard-edge abstraction/minimalism, Pop Art, and Photo-Realism. Can you name artists and give titles?
- explain why observers see an intellectual or spiritual message in the art of Duchamp and Beuys, and their followers. Each artist has different intellectual interests; can you describe some of them?
- explain how globalism in art is producing both "culture shock" and some real understanding of people of other world traditions?

Suggestions for further reading:
- William C. Seitz, *Abstract Expressionist Painting in America* (Cambridge, Mass.: Harvard University Press, 1983)
- Gloria Moure, *Marcel Duchamp* (New York: Rizzoli, 1988)
- Joseph Beuys, *Joseph Beuys in America* (New York: Four Walls Eight Windows, 1990)
- Audrey Flack, *Art and Soul: Notes on Creating* (New York: E. P. Dutton, 1986)
- Mexican Fine Arts Center Museum, *Art of the Other Mexico* (Chicago, 1993)
- The New Press, *Asia/America: Identities in Contemporary Asian American Art* (New York: Asia Society Galleries, 1994)

References

CHAPTER 1

1. Howard S. Becker, *Art Worlds* (Berkeley: University of California Press, 1982), p. 34
2. Suzanne Langer, *Feeling and Form* (New York: Scribner, 1953), pp. 407–9
3. T.H. Benton, *An Artist in America*, 4th ed. (Columbia: University of Missouri Press, 1983), p. 332
4. Francis V. O'Connor, "The Life of Jackson Pollock, 1912–1956: A Documentary Chronology," in vol. 4, F.V. O'Connor and E.V. Thaw (eds.), *Jackson Pollock: A Catalogue Raisonné of Paintings, Drawings and Other Works* (New Haven: Yale University Press, 1978), p. 208
5. Nigel Glendinning, *Goya and His Critics* (New Haven: Yale University Press, 1977), pp. 45–6
6. Benton, *op. cit.*, p. 333
7. John Rewald, *The History of Impressionism*, 4th rev. ed. (New York: Museum of Modern Art, 1973), p. 272
8. Gary Schwartz, *Rembrandt: His Life, His Paintings* (New York: Viking, 1985)
9. Based on Catherine Barnett, photographs by Duane Michals, "A Package Deal," *Art and Antiques*, Summer 1986, pp. 39–41
10. Quotations from Alexandra Anderson-Spivey, "Photo Player," *Connoisseur*, July 1991, pp. 68–73
11. Terry Barrett, *Criticizing Art* (Mountain View, California: Mayfield, 1994), p. 20
12. Jenefer M. Robinson, "Style and Significance in Art History and Art Criticism" in P. Alperson (ed.), *The Philosophy of the Visual Arts* (Oxford: Oxford University Press, 1992), pp. 481–9
13. E. Burns (ed.), *Gertrude Stein on Picasso*, 1970, p. 18; cited in J. Alsop, *Rare Art Traditions* (New York: Harper & Row, 1982), p. 4
14. Hans Kreitler and Shulamith Kreitler, *Psychology of the Arts* (Durham, N.C.: Duke University Press, 1972), pp. 5–6
15. This discussion is largely based on Elizabeth Hess, "A Tale of Two Memorials," *Art in America*, April 1983, pp. 120–8
16. Becker, *op. cit.*, p. 103
17. C.K., *New Republic*, November 29, 1982, p. 42
18. T.R.B., *New Republic*, December 6, 1982, pp. 6, 39
19. William Broyles, Jr, *Newsweek*, November 22, 1982, pp. 82–3
20. Eloise Spaeth, *American Art Museums*, 3rd ed. (New York: Harper & Row, 1975)
21. Karl E. Meyer, *The Art Museum* (New York: Morrow, 1979), p.13
22. The Frick Collection, *Masterpieces of the Frick Collection*, text by E. Munhall (New York: The Frick Collection, 1970), p. 4
23. Robert Coles, "The Art Museum and the Pressures of Society" in S.E. Lee (ed.), *On Understanding Art Museums* (© American Assembly Columbia University; Englewood Cliffs, N.J.: Prentice-Hall, 1975), p. 200

CHAPTER 2

1. Charles Sterling, *Still Life Painting*, 2nd ed. (New York, Harper & Row, 1981), p. 126
2. B. Conrad, III. "Wayne Thiebaud," *Horizon*, January/February 1986, pp. 6–8
3. For a good discussion of this subject see Kenneth Clark, *The Nude* (New York: Pantheon, 1956)
4. Sherman E. Lee, *A History of Far Eastern Art*, 4th ed. (Englewood Cliffs, N.J.: Prentice-Hall, 1982), p. 343
5. Malcolm Cormack, *Constable* (Cambridge; New York: Cambridge University Press, 1986), p. 20
6. *ibid.*, p. 111
7. Frank H. Goodyear, Jr, *Welliver*, (New York: Rizzoli, 1985), p. 127
8. *ibid.*, p. 13
9. Christina Lodder, *Russian Constructivism* (New Haven: Yale University Press, 1983), p. 45
10. Chiang Yee, *Chinese Calligraphy* (Cambridge: Harvard University Press, 1973), pp. 71, 75
11. Anthony Welch, *Calligraphy in the Arts of the Muslim World* (Austin: University of Texas Press, 1979), p. 162
12. Interview in *Eric Bulatov, Moscow* (London: Parkett Publishers with the Institute of Contemporary Arts, 1989), p. 33

CHAPTER 3

1. John Golding, Introduction to John Elderfield, *The Drawings of Henri Matisse* (New York: Thames & Hudson, 1985), p. 17
2. *ibid.*, p. 10
3. *The Elder Pliny's Chapters on the History of Art*, translated by K. Jex-Blake (Chicago: Argonaut, 1969; reprint of 1896 edition), Book XXXV, p. 67–8
4. Golding, *op. cit.*, p. 15
5. Rudolf Arnheim, *Art and Visual Perception* (Berkeley: University of California Press, 1954), p. 140
6. Judy Pfaff, "Sculptors' Interviews," *Art in America*, November 1985, p. 131
7. Guo Xi (Kuo Hsi), *An Essay on Landscape Painting*, translated by Shio Sakanishi (London: John Murray, 1959). For a modern analysis see Fritz van Briessen, *The Way of the Brush* (Rutland, Vermont: Charles E. Tuttle, 1962), pp. 125–9
8. Zong Bing (Tsung Ping), "Introduction to Landscape Painting," *The Spirit of the Brush*, translated by Shio Sakanishi (London: John Murray, 1939), p. 38
9. Ted Castle, "Nancy Holt, Siteseer," *Art in America*, March 1982, p. 88

CHAPTER 4

1. Robert Farris Thompson, *Flash of the Spirit* (New York: Random House, 1984), pp. 3–8
2. *ibid.*
3. Alfred H. Barr, Jr, *Matisse: His Art and His Public* (New

York: Museum of Modern Art, 1951), p. 552

4. Lawrence Alloway, *Agnes Martin* (Philadelphia: Institute of Contemporary Art, University of Pennsylvania, Philadelphia, 1973), p. 9; cited in Hermann Kern, *Agnes Martin* (Munich: Kunstraum, 1973), p. 9, note 7

5. Martica Sawin, "Kenneth Snelson: Unbounded Space," *Arts Magazine*, September 1981, pp. 171–3

6. Piet Mondrian, *The New Art—The New Life: The Collected Works of Piet Mondrian*, edited and translated by Harry Holtzman and Martin S. James (Boston: G.K. Hall, 1986), p. 224

7. *ibid.*, p. 201

8. Calvin Tomkins, "Profiles: Getting Everything In" (Jennifer Bartlett), *The New Yorker*, April 15, 1985, p. 66

9. *Willem de Kooning: The North Atlantic Light* (Amsterdam: Stedelijk Museum, 1983), p. 67

10. Thomas B. Hess, *Barnett Newman* (New York: Walker, 1969), p. 32

11. Richard Shiff, *Cézanne and the End of Impressionism: A Study of the Theory, Technique, and Critical Evaluation of Modern Art* (Chicago: University of Chicago Press, 1984, xvii)

12. Erwin Panofsky, "Renaissance and Renascences" in W.E. Kleinbauer (ed.), *Modern Perspectives in Western Art History* (Fort Worth: Holt, Rinehart & Winston, 1971), p. 315

13. Nikolaus Pevsner, *An Outline of European Architecture* (London: Penguin, 1957), pp. 24–5

14. Jenefer M. Robinson, "Style and Significance in Art History and Art Criticism" in P. Alperson (ed.), *The Philosophy of the Visual Arts* (Oxford: Oxford University Press, 1992), pp. 482–3

CHAPTER 5

1. Laurence Sickman, in Sickman and Soper, *The Art and Architecture of China* (Baltimore: Penguin, 1956), p 143

2. Jerry N. Uelsmann, *Uelsmann: Process and Perception* (Gainesville: University Presses of Florida, 1985), p. 3

3. Vicki Goldberg, "Militant with a Camera," *Connoisseur*, March 1991, pp. 40–44

4. Paul Joyce, *Hockney on Photography: Conversations with Paul Joyce* (New York: Harmony Books, 1988), p. 34

5. Robert Edmonds, *The Sights and Sounds of Cinema and Television* (New York: Teachers College Press, 1982), p. 3

6. Carol Littleton, quoted in David Chell, *Moviemakers at Work* (Redmond, Washington: Microsoft Press, 1987), pp. 49–65

7. Nam June Paik, "Input-Time and Output-Time," *Video Art, An Anthology*, compiled and edited by I. Schneider and B. Korot (New York: Harcourt Brace Jovanovich, 1976), p. 98

8. Edmonds, *op. cit.* pp. 22–9

9. Tracy Biga, "Blue Velvet," *Film Quarterly*, Fall 1987, pp. 44–9

10. Barbara London, *National Video Festival* (Washington, D.C.: American Film Institute, 1982), p. 85

11. Nam June Paik, "La Vie, Satellites, One Meeting—One Life," *Video Culture, A Critical Investigation*, J.G. Hanhardt (ed.) (New York: Visual Studies Workshop, 1986). From exhibition catalogue *Nam June Paik—*

Mostly Video, Tokyo Metropolitan Art Museum, 1984

12. Interview with Cynthia Goodman in *Digital Visions* (New York: Abrams, 1987), p. 12

13. Mikkel Aaland and Rudolph Burger, *Digital Photography* (New York: Random House, 1992), p. 85

14. Laurence Hooper, "Digital Hollywood," *Rolling Stone*, August 11, 1994, pp. 58, 75

15. J. Lanier in Linda Jacobson (ed.), *Cyberarts: Exploring Art and Technology* (Publisher, 1992), p. 272

16. Toni Dove, "Theatre without Actors—Immersion and Response in Installation," *Leonardo*, 27, 4, 1994, p. 286

17. Fred Ritchin, "Digital Imaging," review of *The Reconfigured Eye: Visual Truth in the Post-Photographic Era* by William J. Mitchell, in *Art in America*, January 1994, pp. 29–31

18. William J. Mitchell, *The Reconfigured Eye: Visual Truth in the Post-Photographic Era* (Cambridge, Massachusetts: MIT Press, 1992), p. 2

19. Anne Frances Collins, "The Digitization of Photography and its Implications for a New Understanding of Art," M.A. Thesis, University of Texas at Austin, 1994, pp. 21–2

CHAPTER 6

1. John Deredita in Stanton L. Catlin, *Art of Latin America since Independence* (New Haven: Yale University Art Gallery, 1966), p. 187

2. The Rev. William Gilpin quoted in Michael Clarke, *The Tempting Prospect* (London: British Museum, 1981), p. 53

3. *ibid.*, p. 49

4. Wanda Corn, *The Art of Andrew Wyeth* (San Francisco: Fine Arts Museums of San Francisco, 1973), p. 130

5. *Siqueiros, 70 Obras recientes* (Mexico City: Instituto Nacional de Bellas Artes, 1947), quoted in English in Antonio Rodriguez, *A History of Mexican Mural Painting* (New York: Putnam, 1969), p.378

CHAPTER 7

1. In Spanish it has a certain ring to it: *La escultura tiene el ser y la pintura el parecer.* Francisco Pacheco, *Arte de la pintura* (1949) (Madrid: Instituto de Valencia de Don Juan, 1956), p. 44

2. A. Giacometti, letter to Pierre Matisse, 1947, *Alberto Giacometti* (New York: Museum of Modern Art, 1965), p. 28

3. Quoted in *Magdalena Abakanowicz* (Chicago: Museum of Contemporary Art; New York: Abbeville Press, 1982), p. 147

4. Quoted in David Bourdon, "The Razed Sites of Carl Andre… ," *Artforum*, October 1986, p. 15

5. Robert Irwin, *Being and Circumstance* (Larkspur Landing, California: Lapis Press, 1985), p. 67

6. Dan Flavin, *Three installations in fluorescent light* (Cologne: Wallraf-Richartz Museums, 1973), p. 14

7. Quoted in M. Mathews, "Duane Hanson Super Realism," *American Artist*, September 1981, 97, p. 104

8. Curtia James, *Art News*, October 1993, p. 171

9. Francesco Bonami, *Flash Art*, January/February 1993, pp. 54–5

CHAPTER 8

1. Christopher Alexander, *A Pattern Language* (New York: Oxford University Press, 1977)
2. Tony Hiss, "Experiencing Places," *The New Yorker*, June 22, 1987, pp. 45 ff.
3. *ibid.*, p. 52
4. *ibid.*, p. 65
5. *ibid.*, p. 60
6. Henry N. Wright, "Radburn Revisited," *Architectural Forum*, July/August 1971, p. 53
7. Guy Davenport quoted in R.J. Onorato, "Richard Fleischner" in *Sitings* (La Jolla, California: Museum of Contemporary Art, 1986), p. 66
8. Le Corbusier, *Towards a New Architecture*, translated by F. Etchells (New York: Praeger, 1960), p. 114
9. *ibid*, p. 190
10. Charles Jencks, *Le Corbusier and the Tragic View of Architecture* (Cambridge: Harvard University Press, 1973), pp. 152–3
11. Le Corbusier, *op. cit.*, p. 165
12. Charles Jencks, *The Language of Post-Modern Architecture*, 4th ed., (New York: Rizzoli, 1984), p. 9
13. Brendan Gill, "The Sky Line: The American in Paris," *New Yorker*, October 10, 1994, pp. 91–4
14. Peter Black, *The Master Builders* (New York: Knopf, 1970), pp. 95, 279

CHAPTER 9

1. Bauhaus brochure, quoted in Walther Scheidig, *Crafts of the Weimar Bauhaus* (New York: Reinhold, 1967), p. 6
2. *ibid.*, p. 6
3. *ibid.*, p. 6
4. Lila M. O'Neale, quoted in W. C. Bennett and Junius B. Bird, *Andean Culture History* (New York: American Museum of Natural History, Handbook Series no. 15, 1949; rev. ed., 1964), p. 196
5. François Boucher, *20,000 Years of Fashion* (New York: Abrams, 1966), p. 108
6. Anne Hollander, *Sex and Suits* (New York: Knopf, 1994)
7. Bernard Leach, "Belief and Hope," *50 Years a Potter* (London: Arts Council of Great Britain, 1961), quoted in Garth Clark, *American Potters* (New York: Watson-Guptill, 1981), pp. 21–2
8. Marie Zimmermann in *Arts & Decoration*, vol. 52, May 1940, p. 39
9. Dorothy Hosler, *The Sounds and Colors of Power* (Cambridge, Massachusetts: MIT Press, 1994), pp. 228 ff.

PART V

1. Nikolaus Pevsner, *An Outline of European Architecture* (London: Penguin, rev. ed., 1957), p. 25
2. Pablo Picasso, "Picasso Speaks: A Statement by the Artist," *The Arts*, May 1923, p. 319

CHAPTER 10

1. Robert Hughes, "Behold the Stone Age," *Time*, February 13, 1995, pp. 54–67
2. Shana Alexander, "Feminine Eye: Visit to Lascaux Cave," *McCall's*, September 1970, p. 6

3. Elias Howard Sellards, "Stone Images from Henderson County, Texas," *American Antiquity*, 1941, vol. 7, pp. 29–38
4. George M. A. Hanfmann, *Classical Sculpture* (Greenwich, Connecticut: New York Graphic Society, 1967), p. 29
5. Ernst H. Gombrich, *Art and Illusion*, 2nd ed. (Princeton, N. J.: Princeton University Press, Bollingen Series XXXV, 5, 1961), p. 141
6. Gaius Suetonius Tranquillus, *The Twelve Caesars*, translated by Robert Graves (London: Penguin, 1957), Chapter 79, p. 94
7. Eleanor Winsor Leach, "Patrons, Painters, and Patterns: The Anonymity of Romano-Campanian Painting and the Transition from the Second to the Third Style" in Barbara K. Gold (ed.), *Literary and Artistic Patronage in Ancient Rome* (Austin: University of Texas Press, 1982), pp. 135–73

CHAPTER 11

1. Procopius (6th-century Byzantine writer), quoted in Steven Runciman, *Byzantine Style and Civilization* (Baltimore: Penguin, 1975), p. 53
2. Attribution made by Robert Thompson, *Sculpture of Black Africa*, *The Paul Tishman Collection* (Los Angeles Country Museum: 1968), p. 80
3. Wang Wei, *The Spirit of the Brush*, edited and translated by Shio Sakanishi (London: John Murray, 1939), p. 44

CHAPTER 12

1. Kenneth Clark, *Leonard da Vinci* (London and Baltimore: Penguin, 1958), p. 118
2. Michael Baxandall, *Painting and Experience and Fifteenth Century Italy*, 2nd ed. (Oxford: Oxford University Press, 1972), p. 2
3. *ibid.*, p. 34
4. Benvenuto Cellini, *Memoirs*, translated by J. A. Symonds (New York: Random House, c. 194), Book II, XC, p. 439
5. Giorgio Vasari, *Lives of the Artists*, edited by B. Burroughs (New York: Simon & Schuster, 1946), p. 67
6. Kenneth Clark, *The Nude* (New York: Pantheon, 1956), p. 413
7. Michael Cooper (ed.), *They Came to Japan: An Anthology of European Reports on Japan, 1543–1640* (Berkeley: University of California Press, 1965), pp. 260–1
8. Shuichi Kata, *Form, Style, Tradition: Reflections on Japanese Art and Society* (Berkeley: University of California Press, 1971), p. 137
9. Cooper, *op. cit.*, pp. 254–5
10. *ibid.*, p. 253
11. Alexander Soper in R. T. Paine and A. Soper, *The Art and Architecture of Japan* (London: Penguin, 1955), p. 263
12. Donald Keene, "Japanese Aesthetics," *Philosophy East and West*, Honolulu, July 1969, p. 294
13. John Evelyn, Diaries, edited by E. S. de Beer (Oxford: Oxford University Press, 1955), vol. 2, p. 261; Irving Lavin, *Bernini and the Unity of the Visual Arts* (New York: Oxford, 1980), p. 146
14. Frans Baudouin, *Peter Paul Rubens* (New York: Abrams, 1977), pp. 253–7

CHAPTER 13

1. Lawrence Gowing, *Paintings in the Louvre* (New York: Stewart, Tabori & Chang, 1987), p. 562
2. *Ibid.*
3. Charles Baudelaire, "The Salon of 1846," *The Mirror of Art*, translated and edited by J. Mayne (New York: Doubleday, 1956), p. 44
4. Earl A. Powell, *Thomas Cole* (New York: Harry N. Abrams, 1990), p. 7
5. William Bartram, *Travels Through North and South Carolina, Georgia, East and West Florida* (Savannah, Georgia: Beehive, 1973; 1st ed., 1791), p. 341
6. Quoted in Richard Thomson, *Degas, The Nudes* (London: Thames & Hudson, 1988), p. 98
7. Richard Shiff, *Cézanne and the End of Impressionism* (Chicago: University of Chicago Press, 1984), p. 2
8. Clement Greenberg, "The Later Monet," *Art News Annual*, 1957, p. 132
9. L. E. Duranty, *La Nouvelle Peinture*, edited by M. Guérin (Paris: H. Floury, 1946; 1st ed., 1876)
10. A. E. Elsen, S. C. McGough, and S. H. Wander, *Rodin and Balzac* (Beverly Hills, California: Cantor, Fitzgerald, 1973), p. 12
11. H. de la Croix and R.G. Tansey, *Art Through the Ages* (New York: Harcourt Brace Jovanovich, 1908), p. 783
12. Ronald Pickvance, *Van Gogh in Saint-Rémy and Auvers* (New York: Metropolitan Museum of Art; Abrams, 1986), p. 189
13. W. H. Auden (ed.), *Van Gogh, A Self-Portrait* (Greenwich, Connecticut: New York Graphic Society, 1961), p. 313
14. John Rewald, *Paul Gauguin* (New York: Abrams, 1952), p. 14
15. *Ibid.*, p. 14
16. W. Haftmann, *Paul Klee* (New York: Praeger, 1954), p. 53
17. Pablo Picasso, "Picasso Speaks> A Statement by the Artist," *The Arts*, May 1923, p. 326
18. Statement by Pablo Picasso from *Cahiers d'Art*, 1935, vol. 10, no. 10, pp. 173–8, reprinted in A. H. Barr, Jr., *Picasso: 50 Years of His Art* (New York: Museum of Modern Art, 1946), pp. 272–4 (translated by Myfanwy Evans)
19. Robert Rosenblum, *Cubism and Twentieth-Century Art* (Englewood Cliffs, N. J.: Prentice-Hall, 1966), p. 130
20. Quoted in Andrew Carnduff Ritchie, *Sculpture of the Twentieth Century* (New York: Museum of Modern Art, 1952), p. 40
21. M. Fagiolo dell'Arco in *De Chirico*, edited by W. Rubin (New York: Museum of Modern Art, 1982), pp. 11–34
22. W. S. Lieberman (ed.), Max Ernst (New York: Museum of Modern Art, 1961), p. 10
23. Ignacio Gómez de Liaño, *Dalí* (New York: Rizzoli, 1984), p. 29
24. Wassily Kandinsky, *Concerning the Spiritual in Art* (New York: G. Wittenborn, 1947), pp. 59, 60, 70
25. Piet Mondrian, *The New Art—The New Life: The Collected Works of Piet Mondrian*, edited and translated by Harry Holtzman and Martin S. James (Boston: G.K. Hall, 1986), pp. 370, 17

CHAPTER 14

1. Harold Rosenberg, *ArtNews*, December 1952, p. 22
2. Hans Namuth and Barbara Rose, *Pollock Painting* (New York: Agrinde, 1978), "Statements by Jackson Pollock"
3. Stephen Polcari, "Barnett Newman's *Broken Obelisk*," *Art Journal*, vol. 53, no. 4, winter 1994, pp. 48–55
4. Clement Greenberg, "The `Crisis' of Abstract Art," *Arts Yearbook: New York: The Art World*, no. 7, 1964, p. 91
5. Robert Rosenblum, Introduction to Lawrence Rubin, *Frank Stella* (New York: Tabori & Chang, 1986), p. 10
6. Donald Judd, "Black, White, and Gray," *Arts Magazine*, March 1964, p. 37
7. *Perspecta 11*, 1967 in W. C. Agee, *Don Judd* (New York: Whitney Museum, 1968), p. 16
8. Samuel Adams Green, *Introduction to Andy Warhol*, exhibition catalogue, Institute of Contemporary Art, University of Pennsylvania, Philadelphia, October/November 1965
9. J. Goldman, *James Rosenquist* (New York: Viking, 1985), p. 22
10. *Ibid.*, pp. 27–8
11. *Ibid.*, p. 33
12. J. Arthur, *Realism/PhotoRealism* (Tulsa, Oklahoma: Philbrook Art Center, 1980), p. 68
13. Alfred H. Barr, Jr., *Picasso, Fifty Years of his Art* (New York: Museum of Modern Art, 1946), pp. 66–8
14. Audrey Flack, *Art and Soul: Notes on Creating* (New York; E. P. Dutton, 1986), p. 26
15. Alain Borer, "Déploration de Joseph Beuys" in *Joseph Beuys*, (Paris: Centre Georges Pompidou, 1994), p. 13
16. Wolf Kahn, "Connecting Incongruities," *Art in America*, November 1992, pp. 116–21
17. Michael Auping, *Susan Rothenberg Paintings and Drawings* (New York: Rizzoli, 1992), p. 37
18. Harold Rosenberg, "The Art World," *The New Yorker*, May 9, 1970, p. 54
19. Charles Jencks, *The Language of Post-Modern Architecture*, 4th ed. (New York: Rizzoli, 1984), p. 9
20. Harold Rosenberg, "Interview… ," *ArtNews*, September 1972, p. 54
21. Dan Hofstadter, "Profiles: A Painting Dervish," *The New Yorker*, June 1, 1987, p. 49
22. Robert Storr, "Peter Saul: Radical Distaste," *Art in America*, January 1985, p. 92
23. *Peter Saul: New Paintings and Works on Paper* (New York: Alan Frumkin Gallery, 1987)
24. Nancy Bode Bussey, "Luis Jimenez: Artist of the People," *State of the Arts* (Newsletter of the University of Texas College of Fine Arts), no. 7, Spring 1995, p. 1
25. Amy Baker Sandback, "Signs: A Conversation with Luis Jimenez," *Artforum*, September 1984, pp. 84–7
26. Benjamin Weissman, *Artforum*, May 1991, p. 153
27. The New Press, *Asia/America: Identities in Contemporary Asian American Art*, Asia Society Galleries, New York, 1994, pp. 76, 105
28. Brooks Adams, "Robert Colescott," *Art in America*, July 1991, p. 119

Glossary

Terms italicized within the definitions are themselves defined in the Glossary, except the term "art," which is in italic type only when the definition is relevant to the definition of art.

abstract A *composition* of forms which exist in the mind and in *art*, but not in nature, though they may derive from nature.

Abstract Expressionism Art movement of the 1940s and 1950s, especially in the United States.

academy Art school in which art is taught as an intellectual discipline, first established in Italy in the 16th century.

acrylic A painting *medium* in which the *binder* is a synthetic resin.

aerial perspective System of representing masses and spaces by the relative distances colors seem to have, warm colors seeming closer than cool ones.

aesthetics Philosophy concerned with the questions: what is beauty? why is it a cultural value?

alla prima All at once, or wet-into-wet, *oil painting* technique; in contrast to *impasto-glaze* technique.

altarpiece A painting or sculpture placed on or behind an altar.

aquatint A printmaking technique, to make areas of tone in *etching* by dusting the plate with resin dust. The acid bites through the resin making a rough area which prints a gray tone.

arcade A series of arches.

arch A curved construction of brick or stone which spans an opening above a room or doorway, with wedge-shaped blocks held in place by their pressure against each other and by *buttresses*.

art A symbolic communication of more than instrumental value (that is, it must have more than a practical use) by a human being.

artisan A person who works at a *craft*.

art world All the people whose activities are necessary to the production of a particular kind of art.

assemblage A constructed sculpture of found objects, a three-dimensional form of *collage*.

asymmetry Not symmetrical; a design in which the two halves are different, not mirror images.

Autochrome The first commercially available (1907) color photography process.

automaton A robot or mechanized kinetic sculpture.

avant-garde The "advance group" in the arts, whose works are unorthodox and experimental.

balance *Principle of design* requiring the parts of a *composition* to appear in equilibrium around some axis.

Baroque A European style of the 17th century: dramatic, energetic, sensuous style; applied (small "b") to any style with those qualities.

barrel vault A semicircular *arch* repeated to make a *vault*.

bay One of a set of equal spaces in a building, such as a *Gothic* church, usually formed by four columns or *piers* at the corners of a rectangular floor, supporting a *groin-vaulted* ceiling.

beam A long piece of wood used in construction.

Benin Ancient kingdom in West Africa, now part of Nigeria.

binder A glue or glue-like substance in paint which binds *pigment* together and attaches it to a surface.

block A three-dimensional mass of stone or other solid material (such as brick), normally in rectangular form, used in construction.

bronze Alloy of copper and tin, the commonest metal for *casting*.

burin The small steel chisel used to make *engravings*.

buttress A mass of masonry used to support a building—usually an *arch, vault,* or *dome*—by opposing the outward thrust of the arches.

calligraphy The art of writing; writing as an art form.

camera obscura A drawing tool composed of a box with a lens which projects a view onto ground glass or paper; a camera without film.

canon A rule or set of principles or standards, most commonly for the forms or *proportions* of architecture or the human body.

cantilever A structural technique in architecture in which a beam that projects beyond its support has a balancing weight on the other end.

cartoon (1) A preparatory drawing (*study*) in full scale; (2) a satirical or humorous drawing.

cast or **casting** The process of duplicating a model by making a mold of it and filling the mold with another material; commonly the mold is plaster, the casting bronze.

cella The chamber of a *Classical* temple.

ceramics Objects made of fired clay, including pottery, *porcelain,* and *terra-cotta* sculpture.

chase The application of finishing touches with tools to a metal *casting*.

chiaroscuro Light and shadow represented in art; a way of drawing with black and white on a gray or middle-value ground to show light and *shade*.

Classical Referring to Greek culture of the 5th century B.C. and its influence on *Hellenistic* and Roman cultures in the following eight centuries; small "c" (classical or classic): any style based on strict *canons* of *form*.

collage Two-dimensional art made by pasting shapes of paper or other materials onto a flat surface, usually with painting or drawing.

color wheel The arrangement of primary colors in a circle to show how they can be mixed to produce secondary and tertiary colors.

complementary colors Colors on opposite sides of the *color wheel* that make gray when mixed equally, such as red and green.

composition Arrangement of art *elements* according to the *principles of design*.

conceptual art Art movement of the 1970s showing diagrams and written proposals or descriptions ("concepts") of *forms* or actions, rather than forms themselves.

concrete art A work of art interpreted (by its creator or by its audience) as a material thing without symbolism, *subject,* or *representation*.

Constructivism A European art movement of the 1920s and 1930s that emphasized *non-objective* designs of lines, planes, and flat colors expressing mechanistic ideals.

content The meaning, message, or idea expressed by the *form* and *subject*.

contour Line showing the boundary of a three-dimensional mass.

contrapposto Natural action pose of the human figure as if walking, especially in sculpture. Opposite of *frontality*.

Corinthian Fanciest of the Greek Classical *orders*; the capital is ornamented with acanthus leaves.

craft The skill and knowledge to make some kind of material object; basic to *art*, which is considered to transcend craft by its expression of mental or spiritual powers usually defined as "genius."

critic A writer on art who is an expert on cultural value.

Cubism Art movement of 1907 and later emphasizing *abstractions* based on geometric analysis of natural forms; begun by Picasso and Braque.

Dada Art movement that originated in Germany in 1914 in the anti-war movement showing the absurd, shocking irrationality of life.

Dogon African tribe in Mali.

dome A circular *vault*, usually a portion of a sphere, used as a ceiling.

Doric Classical architectural *order*; the capital has a block (abacus) and curved molding (echinus).

drawing Marks on a surface produced by hand; a **finished drawing** is distinguished from a *sketch* and a *study* or *cartoon* by being a final work of art.

drypoint A technique in *intaglio* printing in which lines are cut into the plate by hand with the sharp point of a steel etcher's needle. Drypoint is often used to add details to an *etching* or *engraving*.

edition A set of prints made from the same plate, block, or stone. A "limited edition" does not exceed a predetermined number of prints.

elements of art The artist's marks: lines, shapes, masses, spaces, colors, values, textures.

elevation A drawing of a building showing its appearance from one side as it "elevates" from the ground (cf. *plan*).

emphasis *Principle of design* showing relative importance of parts by size, color, contrast, and so on. Parts may be equal or different in emphasis.

enamel A colored glass, usually forming a design, fused onto a metal or ceramic surface by fire. Paint that has a thick, shiny appearance may be called enamel because it looks like true enamel.

encaustic Painting medium; the *pigment* is mixed with wax, which is dissolved by heat.

engraving Printmaking medium in which a copper plate is cut with a *burin* to make an *intaglio* print.

etching Medium in which a copper (or zinc) plate is cut with acid to make an *intaglio* print.

Expressionism Group of 20th-century art movements stressing individual emotional expression.

Fauvism Art movement in France beginning about 1903 based on vivid color.

figure The solid or positive shape set against a background area in a two-dimensional art form; see *ground*. Often refers to "human figure."

flying buttress An *arch* used to span a space between an arch or *vault* which needs external support and the *buttress* which provides the support. In *Gothic* churches the space under the flying buttresses was used for aisles and chapels.

foreshortening Depiction of three-dimensional forms on a two-dimensional surface with the third dimension diminished to emphasize depth; a *perspective* method for irregular forms such as human bodies.

form All the things that are presented (as opposed to represented) in a work of art: canvas or stone, brush or chisel marks, colors, a design of lines and shapes, and so on.

frontality In sculpture, a figure in a *symmetrical* pose facing the front; a pose used for beings in eternity. Opposite of *contrapposto*.

forum A public mall in ancient Roman cities.

fresco Painting medium using *pigment* mixed with water on a wet lime plaster ground, usually used as a mural medium. Work must stop when the plaster begins to dry. Painting on dry plaster is called **fresco secco**; it is less durable than fresco.

frieze A strip of ornament on a building.

functionalism Aesthetic theory that utility is the ruling factor in design.

Futurism Art movement in Italy beginning in 1909 which glorified speed and machines.

geodesic *Dome* form made of trusses, an invention of Buckminster Fuller.

gesso Italian for gypsum, or "plaster of Paris," applied to paper or wooden panels as a *ground* for *tempera* painting or silverpoint drawing.

glaze Any glass-like surface: the finish coat of glass on *ceramics* or a thin transparent coat of *oil paint*.

Golden Mean An ancient *proportional* system which proposes that the most beautiful division of a line is: the shorter segment is to the longer as the longer is to the whole line—a proportion of 1 to 1.618. Those proportions can be used as the sides of a rectangle. Also called the Golden Section.

gouache Painting *medium*; the *pigment* is mixed with water-soluble glue forming an opaque watercolor. Paper is the usual *ground*.

Gothic Art movement mainly in northern Europe, c.1150–1500.

groin vault A *vault* formed of intersecting *barrel vaults*.

ground The surface on which a two-dimensional work of art is made. In "**figure and ground**" the word refers to background or space around the part of the design considered positive or solid. Also, in *etching*, the acid-resistant material applied to the surface of the metal plate.

hand-reduction A *silkscreen printing* technique using stencils covering successively smaller areas and successively darker colors in the printing.

hatching Parallel lines used as shading in a drawing; **crosshatching** (sets of parallel lines that cross) gives a darker shade.

Hellenistic Period c. 350–31 B.C. of Greek culture after Alexander the Great.

hieroglyphic writing A system of writing incorporating pictures of objects as symbols, along with conventional and/or phonetic signs; Egyptian and *Maya* are among the best-known systems of hieroglyphic writing.

hue A named color for a specific wave length of light reflected from a surface.

iconography Symbolism in art, either personal symbols or those of a culture.

impasto Thick paint, usually oil paint. Traditionally used for highlights in the *impasto-glaze* technique.

Impressionism Art movement, originating in France c. 1872, based on painting outdoors to record color as light is received by the eye.

intaglio Printmaking techniques (mainly *etching* and *engraving*) in which the design is cut into a metal plate. Opposite of *relief.*

intensity The purity and strength, or saturation, of a color.

International Style The 20th-century architectural style developed by Le Corbusier, Gropius, Mies van der Rohe, and others characterized by simple rectangular forms of reinforced concrete and glass.

in the round Sculptural form that can be seen from all sides, which has no background plane. Opposite of *relief* sculpture.

Ionic Classical architectural order; the capital has a volute (scroll).

isometric perspective System in which parallel lines are parallel, but angles are drawn to a standard, usually 60/30° for 90°.

kinetic art Art that employs actual movement, using wind, water, a motor, or some other power source. See *mobile.*

krater Ancient Greek jar used for mixing wine and water.

line A long narrow mark which may record a gesture of the artist's hand or be the boundary of a *shape,* the *contour* of a mass, or an *abstract* symbol or sign.

linocut A *relief* print made from a linoleum surface.

lithography Printing from stone using the chemical opposition of grease and water to make the design.

lost wax In French *cire perdue,* method of making a metal sculpture by *casting* it from a wax model that is melted out of the mold.

mandala Ancient design composed of a circle in a square (or a square in a circle) symbolizing the universe.

Maya Native American civilization in Mexico and Central America.

medium The material or technical means used for artistic expression (plural *mediums* or *media*). In painting, a process characterized by a specific *binder, solvent,* and *ground.*

Minimalism A non-objective art style of the period 1960s to 1980s using the simplest possible geometric shapes and forms.

mobile A kinetic sculpture, particularly Alexander Calder's wind-powered suspended sculptures.

Modernism, or **Modern movement** The art movement which emerged from the self-conscious break with past theory and practice in art that occurred at the beginning of the 20th century and lasted until about 1970. *Cubism, Expressionism, Futurism,* and *Surrealism* are styles within the Modern movement.

mosaic An art medium in which small pieces of colored stone or glass (*tesserae*) are embedded in a plaster or cement background.

mosque A Muslim, or Islamic, temple.

mural Any decoration on a wall; *fresco* is usually used for murals.

naturalistic Art depicting natural forms as they appear in nature.

nave The main space in a medieval church, where the congregation is accommodated.

non-objective Art representing no material object; usually used as a synonym for *abstract.*

non-representational Synonym for non-objective.

occult balance "Hidden" balance, asymmetrical balance.

oil painting A painting *medium* in which colored *pigments* are mixed with linseed oil used as the *binder,* which has turpentine as its *solvent;* usually applied to a canvas *ground.*

order A set of architectural forms and proportions, usually referring to the *Doric, Ionic,* and *Corinthian* columnar temple architecture invented by the ancient Greeks.

painting A work of art produced by applying *pigments* mixed with a *binder* to a *ground.*

pastel *Pigment* mixed with glue formed into a stick for *drawing.*

patina The natural or artificial oxidation of a metal sculpture as a surface finish.

patron The person who provides financial support for a work of art and usually sets certain requirements.

pediment The gable of a Classical temple.

pentimenti Italian for "repentances"; changes and corrections in a work of art which are still visible in the finished work.

peristyle A set of columns (called a colonnade) surrounding an open space or a building, most commonly used on the exterior of *Classical* temples.

personification A human figure representing an idea, such as Mother Nature.

perspective Any system for depicting in two dimensions the relative positions of three-dimensional forms in space. Compare *aerial perspective, foreshortening, isometric perspective.*

picture plane The actual surface of a two-dimensional work of art—the paper or canvas, for example—as opposed to the illusion of space.

pier A masonry (brick, stone, or concrete) pillar used as the support for a building; usually given the form of a cluster of columns in *Gothic* churches.

pigment Powdered color, usually of a mineral substance, used to make paint by mixing it with a *binder.*

pixel Word coined from "picture element," the dot that forms a computer or electronic image on a cathode ray tube screen.

plan A drawing of the shape a building makes on the ground, showing its architectural features (cf. *elevation*).

pointillism A late-19th-century painting style using dots of pure color, also called divisionism.

polyptych A work of art made of more than three separate panels or canvases.

Pop Art A 1960s style based on popular commercial art.

porcelain Fine-grained white translucent pottery fired at a high temperature.

post-and-lintel A system of building using beams (of wood, stone, steel), some set vertically as posts to support others (lintels) laid horizontally across their tops.

Post-Modernism Art movement that began about 1970 characterized by renewed interest in the European art traditions, new attempts to incorporate varied mediums (for example, furniture) into the art tradition, and a search for styles independent of *Modernism;* important in architecture.

primary color One of the three colors from which all others can be mixed: red, blue, and green in the mixing of light; red, blue, and yellow in the mixing of pigments.

principles of design The fundamental considerations for the organization of visual art to produce understandable compositions. See *unity, variety, balance, rhythm, emphasis.*

proportion Relationships of size reflecting significance or function.

pyrotechnology The use of fire to work a material such as clay into pottery, or sand and other ingredients into glass, or ores into metal.

relief The projection of a design from a background plane, as in sculpture (opposite of *in the round*) and printmaking. Low relief in sculpture barely projects above the plane; high relief is barely attached to the background plane. In relief printing, such as woodcut, the ink is applied to the projecting parts, which are stamped on paper (opposite of *intaglio*).

repoussé Metal worked by hammering to make *relief* decorations.

representational Depiction of forms that have material existence.

rhythm Principle of design referring to repetition of an element of art according to a rule of location or spacing.

Romanesque A style of architecture and other arts in western Europe from about 1000 to about 1145 characterized by massive structures, semicircular *arches,* and sculpture and painting in expressive linear styles.

scumbling The process of partly covering a color with a thin coat of fairly dry, opaque paint of another color to allow traces of the first color to show; used as a way to blend or model colors.

secondary color A color made by mixing two primary colors, such as orange, green or purple in pigments.

serigraphy *Silkscreen printing,* using a stencil on a silk backing.

shade A color (*hue*) to which black has been added, or shadow, as in "light and shade."

shape A two-dimensional surface with a definite boundary or edge.

silkscreen printing See *serigraphy.*

sketch A drawing made as a note of something seen or thought.

slip A liquid mixture of clay and water used as a color coat or a paint on pottery.

solvent A liquid that dissolves the *binder* in a paint.

stela (plural *stelae*) An upright slab of stone used as a monument, usually bearing an inscription and/or a design; *stela* is used for Maya and other New World examples; *stele* is the common spelling for other regions (Egypt and Greece, for example).

still life A work of art, usually a painting, representing household objects and/or flowers, traditionally considered a *representation* of the pleasures of life.

study A drawing done to plan another work of art.

style Emphasis on certain elements of art or principles of design for expressive purposes. Period style represents a place and time; personal style represents an individual.

subject All the things that are represented in a work of art; the things in the picture or sculpture. Compare *form, content.*

Surrealism European art movement beginning about 1921 which emphasized psychology and the unconscious mind.

symmetry Term for a design in which the two halves are mirror images, meaning "same measure."

tapestry A decorated cloth hanging, usually made by weaving a design with weft (horizontal) into plain warp (vertical) threads.

tempera Painting medium in which *pigment* is mixed with egg yolk, whose *solvent* is water. The *ground* is usually paper or a *gesso* panel.

terra cotta Italian for "baked earth"; fired pottery clay.

tertiary color A color made by mixing a *primary* and a *secondary color,* such as yellow-green or blue-violet in pigments.

tessera (plural *tesserae*) The small pieces of stone or glass used to make a *mosaic.*

tint A color to which white has been added.

transept The wings of a cross-plan medieval church.

triptych A work of art composed of three separate panels or canvases.

trompe l'oeil "Fool the eye" in French, referring to a style of painting in which the observer might actually mistake the painted image for reality.

truss In architecture; a triangle of wood or metal; a rigid form, it can be combined in multiple triangles to make roofs, bridges, *geodesic domes.*

tympanum An arched area above the lintel of a door in a medieval church, often decorated with relief sculpture.

unity Oneness; the perception by an observer that a group of *elements* of art are parts of one *composition.*

value Light and dark as an element of art, the range of tones from white to black. Monetary value of art is market value. Beauty is a cultural value.

vanishing point A point on the horizon, or eye level, in a linear perspective drawing at which parallel receding lines meet.

variety Differences among *elements of art* in a *composition.* Variety opposes *unity* and offers contrast and change, but must be subordinate to unity.

vault A ceiling or roof made of *arches.*

watercolor Painting *medium* in which *pigment* is mixed with gum arabic, whose *solvent* is water, usually applied to paper.

woodcut A *relief* print made from a block of wood.

ziggurat Ancient Akkadian for "mountaintop" or "pinnacle"; an ancient Mesopotamian temple tower topped by a shrine reached by a stairway.

Index